REMBRANDT
the Printmaker

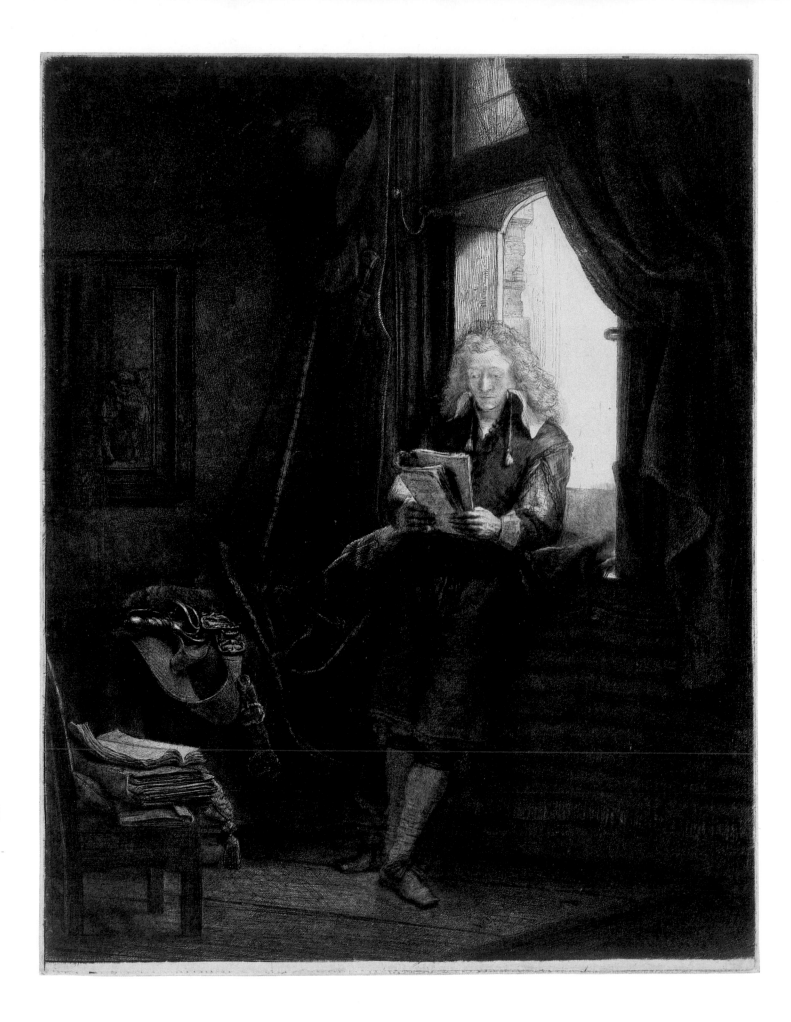

REMBRANDT
the Printmaker

Erik Hinterding, Ger Luijten
and Martin Royalton-Kisch

With contributions by
Marijn Schapelhouman,
Peter Schatborn and
Ernst van de Wetering

3 1571 00199 2836

FITZROY DEARBORN PUBLISHERS
CHICAGO · LONDON

Photographic acknowledgements

The majority of the illustrations are the copyright © of the two organizing institutions (British Museum, London and Rijksmuseum, Amsterdam). Others are copyright © of the institutions named in the captions, and were provided by: Amsterdam, Amsterdams Historisch Museum: cats 29, fig. d; 47, fig. c; 57, fig. b; Amsterdam, Museum Het Rembrandthuis: cats 36, fig. b; 44, fig. b; 58, fig. a; 62, fig. f; cat. 79 (book); Amsterdam, Collectie Six: p. 19, fig. 13; p. 65, fig. 1; p. 66, fig. 2; cats 57, fig. a, c, d; 66, fig. a; Baltimore, The Baltimore Museum of Art, The Garrett Collection BMA 1946.112.7730: cat. 35, fig. b; Basel, Kunstmuseum, Kupferstichkabinett: cat. 53, fig. d; Berlin, Staatliche Museen zu Berlin, Preussischer Kulturbesitz, Kupferstichkabinett, photo Jörg P. Anders: p. 68, fig. 7; p. 77, fig. 21; cats 29, fig. a; 37, fig. b; 61, fig. b; 63, fig. a; 65, fig. d; 70, fig. c; Berlin, Staatliche Museen zu Berlin, Preussischer Kulturbesitz, Gemäldegalerie, photo Jörg P. Anders: p. 48, fig. 12; cat. 45, fig. c; Bern, Galerie Kornfeld: p. 34, fig. 18; Birmingham, Barber Institute of Fine Art: cat. 33, fig. c; Boston, Isabella Stewart Gardner Museum: p. 54, fig. 19; Boston, Museum of Fine Arts, All rights reserved: cat. 37, fig. c; Braunschweig, Herzog Anton Ulrich-Museum: p. 42, fig. 8b; cat. 53, fig. c; Bremen, Kunsthalle: cat. 41, fig. a; Brighton, Royal Pavilion Art Gallery and Museum: cat. 17, fig. b; Budapest, Szépmüvészeti Múzeum: p. 80, fig. 25; Cambridge, Fitzwilliam Museum: cats 70, fig. a; 80, fig. a; Compiègne, Musée Antoine Vivenel: cat. 77, fig. b; Copenhagen, Statens Museum for Kunst, photo DOWIC Fotografi: p. 13, fig. 3; cat. 10, fig. b; Dresden, Staatliche Kunstsammlungen, Kupferstich-Kabinett, photo Fotostudio Herbert Boswank: cats 5, fig. b; 65, fig. f; Gdánsk, Muzeum Naradowe: cat. 46, fig. a; Glasgow, Glasgow Museums, The Burrell Collection: cat. 13, fig. c; Glasgow, Hunterian Art Gallery, University of Glasgow: p. 56, fig. 22; Haarlem, Frans Halsmuseum, photo Tom Haartsen: cat. 54, fig. d; Haarlem, Rijksarchief Noord-Holland: cat. 65, fig. a; Haarlem, Teyler Museum: p. 53, fig. 18; cat. 76, fig. a; The Hague, Koninklijke Bibliotheek, p. 41, fig. 5; Hamburg, Hamburger Kunsthalle, photo Elke Walford: p. 79, fig. 24; cat. 72, fig. a; Karlsruhe, Staatliche Kunsthalle: p. 21, fig. 15; Kassel, Gemäldegalerie: cat. 33, fig. d; Leiden, Prentenkabinet der Rijksuniversiteit/Printroom of the University: p. 69, fig. 9; cat. 30, fig. a; London, Courtauld Institute of Art, Courtauld Gallery: p. 78, fig. 22; cat. 61, fig. c; London, National Gallery: p. 40, fig. 2; p. 56, fig. 21; cats 24, fig. a; 34, fig. a, c; London, Warburg Institute: cat. 36, fig. a; Los Angeles, Los Angeles County Museum of Art: cat. 17, fig. a; Los Angeles, The J. Paul Getty Museum: cat. 64, fig. a; Montreal, The Montreal Museum of Fine Arts (stolen in 1972): cat. 70, fig. d; Moscow, Pushkin State Museum of Fine Arts, p. 55, fig. 20; Munich, Bayerische Staatsgemäldesammlungen, Alte Pinakothek: pp. 42-3, fig. 8e–h; p. 49, fig. 14; cats 22, fig. a; 42, fig. e; 67, fig. b; New York, The Metropolitan Museum of Art, Bequest of Mary Stillman Harkness, 1950 (50.145.33); photo © 2000 The Metropolitan Museum of Art: p. 60, fig. 27; cat. 89, fig. b; New York, The Pierpont Morgan Library: cats 38, fig. a; 66, fig. c; Oxford, Ashmolean Museum: p. 74, fig. 15; cats 9, fig. a; 36, fig. b; 87, fig. a; Paris, Cliché Bibliothèque Nationale de France: cats 3, fig. b, 13 IV; 27, fig. c; 52, fig. b, d; 53, fig. b; 59, a, f, b. b; Paris, Collection F. Lugt, Institut Néerlandais: cats 19, fig. e; 62, fig. d; 65, fig. d; 70, fig. e; Paris, Musée Jacquemart-André: cat. 82, fig. a; Paris, Musée du Louvre, Réunion des Musées Nationaux, photo

RMN – Thierry Ollivier: p. 76, fig. 18; p. 78, fig. 23; cats 47, fig. a; 61, fig. a; photo RMN – Michèle Bellot: cat. 51, fig. c; photo RMN: p. 67, fig. 5; cats 28, fig. d; 40, fig. b; 45, fig. b; 61, fig. f; St Petersburg, Hermitage: p. 20, fig. 14; cat. 77, fig. a; Princeton, The Art Museum, Princeton University: cat. 62, fig. c; Private Collection, Courtesy of Desmond Tage: cat. 31, fig. a; Private Collection, photo Peter Muscato: cat. 61, fig. e; Rotterdam, Museum Boijmans Van Beuningen: p. 57, fig. 23; p. 75, fig. 17; cats 18, fig. d; 31, fig. c; 65, fig. b; 70, fig. b; Stockholm, National Museum, photo The National Museum of Fine Art: p. 70. fig. 10; p. 73, fig. 14; cats 25, fig. a; 54, fig. b; Strasbourg, Musée de l'Oeuvre Notre-Dame: p. 14, fig. 4; Vienna, Graphische Sammlung Albertina: cats 12, fig. c; 16, fig. a; 33, fig. e; 34, fig. b; 51, fig. a; 67, fig. a; 81, fig. b; Zeist, Rijksdienst voor Monumentenzorg: cat. 80, fig. b We apologize for any omissions.

© 2000 The Trustees of the British Museum

Texts by Dutch contributors
© 2000 Rijksmuseum, Amsterdam

First published in the United Kingdom in 2000
by British Museum Press
A division of The British Museum Company Ltd
46 Bloomsbury Street, London WC1B 3QQ

First published in the United States of America in 2000 by
Fitzroy Dearborn Publishers, 919 North Michigan Avenue,
Chicago, Illinois 60611

Published to coincide with the exhibition shown in two parts at the
Rijksmuseum, Amsterdam
(cats 1-46, 22 July – 8 October 2000;
cats 47-90, 14 October 2000 – 7 January 2001)
and in one exhibition at the British Museum, London
(26 January 2001 – 8 April 2001)

A Cataloging-in-Publication record for this book is available from
the Library of Congress

ISBN 1-57958-304-0 Fitzroy Dearborn

All rights reserved, including the right of reproduction in whole or
in part in any form

Translator acknowledgements
Beverley Jackson: essay by Ger Luijten and cats 5, 12, 16, 18, 19, 20, 28, 29, 32, 33, 37, 38, 42, 43, 44, 46, 47, 52, 53, 60, 62, 66, 71, 80 and 86
Murray Pearson: essay by Ernst van de Wetering
Lynne Richards: essay by Erik Hinterding and cats 2, 4, 6, 7, 8, 17, 35, 51, 55, 58, 59, 67, 69, 72, 73, 75, 76, 78, 81, 82, 83, 85, 87, 88, 89 and 90
Yvette Rosenberg: cats 1, 3, 9, 14, 15, 26, 27, 36, 56 and 84
The Dutch texts were edited by Dorine Duyster
All texts have also been edited by Martin Royalton-Kisch

Designed by James Shurmer
Printed and bound in Spain

Cover: The *Three trees* (cat. 48, detail) by Rembrandt.
© The British Museum

Frontispiece: Jan Six, 1647 (cat. 57, I Amsterdam)

Contents

List of Lenders

Apart from the British Museum in London and the Rijksmuseum in Amsterdam, the works exhibited have been kindly lent by the following institutions:

Amsterdam, Amsterdams Historisch Museum (cat. 57, fig. b)

Amsterdam, Museum het Rembrandthuis (cats 36, 79)

Amsterdam, Six Collection (cat. 57, figs a, c, d)

Berlin, Staatliche Museen zu Berlin, Kupferstichkabinett (cat. 61, fig. b)

Boston, Museum of Fine Arts (cat. 37, fig. c)

Dresden, Kupferstich-Kabinett (cat. 4, fig. a)

Hamburg, Kunsthalle (cat. 72, fig. a)

Leiden, Prentenkabinet der Rijksuniversiteit (cat. 30, fig. a)

New York, Metropolitan Museum of Art (cat. 89, fig. b)

New York, Private Collection (cat. 31, fig. d)

Paris, Bibliothèque Nationale de France (cat. 13 IV)

Paris, Musée du Louvre, Département des arts graphiques (cat. 47, fig. a; cat. 51, fig. c; cat. 61, figs a, f)

Rotterdam, Museum Boijmans Van Beuningen (cat. 31, fig. c; cat. 65, fig. b)

Stockholm, Nationalmuseum (cat. 54, fig. b)

Vienna, Graphische Sammlung Albertina (cat. 51, fig. a)

Foreword

That the British Museum in London and the Rijksmuseum in Amsterdam own the finest collections of Rembrandt's prints in the world is generally acknowledged. Both contain in excess of 1,000 impressions, many of them of great rarity. By combining their forces in the present exhibition – something never before attempted – our ambition has been to mount the finest ever display of Rembrandt's prints. Whether judged by the choice of images, the quality of individual impressions, or the range of early states that tell us so much about Rembrandt's working method, the exhibition should transcend all its predecessors on this topic.

In addition we have called upon the resources of a few other collections, both public and private, for individual loans of significance. These chiefly consist of drawings and oil-sketches in which Rembrandt prepared his prints, allowing us an intimate glimpse into the workings of his mind. We are greatly indebted to these further lenders, who are listed on p. 6, for their generosity.

The strength of the collections in Amsterdam and London depends largely on the determination of both institutions to complete their holdings of Rembrandt's prints during the nineteenth century. The etchings were acquired as examples for the instruction of future artists and designers, and the completeness of the collections became a matter of national pride. The British Museum was fortunate to receive the bequest in 1799 of the outstanding collection formed by its erstwhile trustee Clayton Mordaunt Cracherode (1730-99). The vast majority of the impressions from the British Museum included here are from this source. Other significant holdings came to the Museum through the bequests of Felix Slade (1868) and George Salting (1910) and the purchase of John Malcolm of Poltalloch's collection in 1895. Added to these riches were the many purchases made from the 1830s until the First World War from the Museum's purchase grant in order to fill individual gaps in the collection whenever possible.

The Dutch National Printroom (Rijksprentenkabinet) was founded in 1807 with the purchase by Louis Napoleon, the then King of Holland, of the extraordinary print collection assembled by Pieter Cornelis, Baron van Leyden (1717-88). He had brought together some 100,000 prints, including a complete array of Rembrandt's etchings. Many came from the collection of the engraver Jacob Houbraken (1698-1780), who had acquired them from the heirs of Rembrandt's friend, Jan Six. In the twentieth century the Rijksmuseum received a very significant addition in the form of the I. and J.G. de Bruijn–van der Leeuw bequest. This collecting couple had been buying Rembrandt's etchings since the important sales of the 1920s, and after a time they focused on acquiring states and impressions that would enhance the Amsterdam holdings. Their acquisition by the Rijksmuseum was completed in 1962.

Among the staff in both institutions we are fortunate to have the experts best qualified to write about Rembrandt the printmaker. We are grateful to them for working to produce such a fine result. Much research has been undertaken on Rembrandt's prints in recent years, in particular with regard to the papers he used. The resulting discoveries inform the discussion of Rembrandt's etchings in this catalogue as never before, and we were able to welcome Erik Hinterding, who has been responsible for much of the research, as a partner in this project. We were also flattered to be approached by Professor Ernst van de Wetering of Amsterdam University, head of the Rembrandt Research Project, who saw this publication as presenting an ideal opportunity to publish his findings on Rembrandt's use of oil-paintings as preparatory tools for etchings. His essay includes some significant reattributions to Rembrandt of paintings that had previously been rejected because their function in the studio had been misunderstood, and extends our knowledge of Rembrandt's printmaking plans in the 1630s.

Our search for sponsorship led to a grant being made to the Rijksmuseum through C. R. Bloys van Treslong of the bankers Mees Pierson, and we are very grateful for this support. The British Museum was also able to remount all its Rembrandt etchings and make X-radiographs of the watermarks in the paper (using equipment donated by the Josefowitz family) through the generosity of the Michael Marks Charitable Trust. We thank the Lady Marks and her co-trustees most warmly.

Dr R. A. Anderson
Director, British Museum, London

Ronald de Leeuw
Director General, Rijksmuseum, Amsterdam

Preface and Acknowledgements

In 1877 Sir Francis Seymour Haden mounted an extensive display of Rembrandt's etchings at the Burlington Fine Arts Club in London. Himself an etcher, and highly regarded as a collector and authority on Rembrandt's prints, he was a difficult man with an axe to grind: that some of Rembrandt's etchings were not the work of the master himself.

Significantly, Seymour Haden arranged his display in the 'rational order of *the date of production*', the first time that this had been attempted, and we have chosen the same approach today. In the intervening years art history has moved on with a plethora of new research, ideas and agendas, but in the field of Rembrandt's prints, two refrains have remained constant: first, a desire to demonstrate the extraordinary power of Rembrandt's graphic work, which we believe the present catalogue will accomplish without difficulty. Images such as the *Self-portrait drawing at a window* and the *Three crosses* have entered the canon of icons of western European art in the second millennium. Secondly, the interest in the taxonomy of Rembrandt's etchings has not abated, a topic of great complexity because of the many states in which they were printed, and the different papers used, both oriental and European. We make no apology for concentrating on these matters, about which we are especially qualified to write because of the rich collections in our care. But that we should so devote our energies is dictated by recent events in research. For the first time, techniques have been employed for the 'soft' X-radiography of paper that have allowed a large sample of Rembrandt's prints to be examined in detail, and this has produced far-reaching results. Many of Rembrandt's undated etchings can now be fixed more exactly in his chronology. Furthermore, individual states of his prints are now datable for the first time, allowing us to differentiate between separate editions of each plate and some-times revealing that a new state was created, not in the heat of the original production of the plate, but after it was dusted down for reprinting, perhaps more than a decade later. Other states that have been attributed to Rembrandt himself can now be demonstrated to be from posthumous editions, reworkings by other hands made long after Rembrandt had died. Almost all this information is new.

The use of 'soft' X-radiography, although pioneered decades ago, was first deployed on Rembrandt's prints in the 1980s by a Dutch dentist and collector, Harry van Hugten, in association with the print-dealer Theo Laurentius. In the same years Nancy Ash and Shelley Fletcher, using the slower method of Beta-radiography, had begun a survey of Rembrandt's etchings in American collections, leading in 1998 to the publication, in association with staff from the Rijksmuseum, of their fundamental tome, *Watermarks in Rembrandt's Prints*. We have used this book, along with two standard catalogues *raisonnés* of Rembrandt's etchings, that by A. M. Hind of 1924 (the first full catalogue to be arranged chronologically) and that compiled by Christopher White and K. G. Boon and published in

1969 in the Hollstein series of print catalogues, as the foundation stones of our work. In every essay and catalogue entry we feel conscious of standing on their shoulders, grateful also for Christopher White's recently republished *Rembrandt as an etcher*, the standard work on the subject.

But lest this gives the impression that ours is a drily academic publication, the reader may rest assured that Rembrandt's etchings, which continue to influence artists today, cannot fail to inspire any writer investigating them. Whether confronted by a rare, early impression, or spectacular proofs of the great masterpieces of printmaking that Rembrandt produced, we have found ourselves questioning the material in a wide-ranging fashion. What concept did Rembrandt have of his print *oeuvre*? Why do sketches survive for some etchings, but not others? Why does such a prominent nail appear in the wall behind the preacher Cornelis Claesz. Anslo? Why did Rembrandt only once represent the *Circumcision of Christ* as occurring in a stable rather than the temple? Was he himself always responsible for publishing his plates? Were his images informed more by the work of his contemporaries or his predecessors?

We cannot claim to know all the answers, but have proposed a few new ones. Whether they will stand the test of time remains to be seen, but we hope that the publication will convey something of the sense of adventure that we have experienced while re-examining Rembrandt's extraordinary prints as minutely as the time available would allow.

No project of this kind could be made without assistance of every kind from colleagues both within and outside the institutions in which we work. We would particularly like to thank all the lenders, whose contributions bring many aspects of our subject to life (they are all listed on p. 6). In addition we would like to thank the following for their particular help: Reinier Baarsen, Boudewijn Bakker, Lisa Baylis, Mària van Berge-Gerbaud, Jenny Bescoby, Jan Bloemendaal, Marjolein de Boer, Bob van den Boogert, Jan Piet Filedt Kok, Carina Greven, Antony Griffiths, Peter Hecht, Ed de Heer, Harry van Hugten, Wendy Jansen, Ivor Kerslake, Kornfeld Galerie (Bern), Madeleine ter Kuile, Janet Lang, Huigen Leeflang, Walter Liedtke, Dietmar Lüdke, Hans Luijten, Norbert Middelkoop, Peter Mookhoek, Robert Noortman, Henk Porck, Maxime Préaud, Janice Reading, Otto de Rijk, Marian van Schijndel, Erik Schmitz, Frits Scholten, Ad Stijnman, Eli Valeton, Els Verhaak, Emma Way, Cindy van Weele, Gerard van Wezel and Christopher White.

At the British Museum Press we have been lucky enough to work alongside Coralie Hepburn and Susan Walby, who in turn asked James Shurmer to design the catalogue. They have had to work to a tight schedule, as have our translators, Beverley Jackson, Murray Pearson, Lynne Richards and Yvette Rosenberg. We are extremely grateful to them all.

Finally, we wish to reiterate the thanks expressed in the Directors' foreword to our sponsors and supporters.

The authors

Rembrandt the printmaker: the shaping of an *oeuvre*

Ger Luijten

A seventeenth-century artist lived in a world full of prints. In many houses they hung on the walls, framed or pinned, and were stored in wrappers, folders and – loose or pasted – in bound albums. Shops offered them for sale singly or in series, and they were often purchased not only for their subject-matter, or for purposes of study, but also because of the fame of the printmaker or designer. In the case of an artist of repute, the purchaser was able to acquaint himself with their art. Artists themselves were always among the most enthusiastic collectors: from prints they could learn at a distance about the creations of renowned masters and acquire a wealth of motifs and figures to use in their own works. Some were content to see a few examples of others' skills, but there were also insatiable enthusiasts who sought to build up a comprehensive fund of prints going back to the invention of the medium. Rembrandt Harmenszoon van Rijn belonged to this latter category. What he accumulated, driven by a passionate collector's zest, can be reconstructed to some extent on the basis of the 1656 inventory of his property. The riches of his *kunstcaemer* (art cabinet) included scores of prints and drawings – 'art on paper', as it was described – that he stored in a large number of albums.[1]

To have built up over many years what immediately strikes us as an impressive collection, buying some items at shops and others at auctions, must have generated an intimate knowledge of the history of printmaking. We know that from 1635 onwards Rembrandt was a constant buyer at public sales, but he must have started his collection before then,[2] as echoes of other artists' prints occur in his early work. His presence is documented at the auction of Jan Bassé (*c*.1571–1637), which lasted from 9 to 30 March 1637. Besides plaster models and shells he purchased prints and drawings by various artists. Though the makers' names are not given on the auction list, we can infer what came under the hammer by studying the inventory of Bassé's property, drawn up on 6 January of the same year. Aside from works by Rembrandt himself, 'certain of [whose] prints' were kept together with those by Adam Elsheimer, the inventory lists Maarten van Heemskerck, Lucas van Leyden ('certain wood-cuts' and 'a book of prints'), Albrecht Altdorfer, Hans Sebald Beham, Georg Pencz, Heinrich Aldegrever, Dirck Vellert and Albrecht Dürer.[3]

Like other devotees, Rembrandt would often buy a large lot or a complete collector's album in a single purchase, but his actions on 9 February 1638, at the auction of Gommer Spranger, nephew of Bartholomeus the painter, show that he also made measured choices from an abundance of material, though presumably he could not afford all that he wanted. In this case he selected prints after Polidoro da Caravaggio and after Raphael, Albrecht Dürer's *Passion* and various loose sheets, some by Lucas van Leyden.[4] Gommer Spranger had owned some of Dürer's copper plates. He had pulled impressions from them, and Rembrandt purchased several bundles, acquiring twelve 'cooks by Dürer' (*cockjes Alborduer*), twelve 'fleecing women' (*tas vloyers*) and twelve 'dreamers'(*dromers*; see fig. 1), prints he could trade or exchange, which was as common a practice among collectors then as it is today.[5] The few other documented details of his purchases confirm that he could be a determined bidder: in 1642 he paid 179 guilders – 'bidding himself' – for an impression of Lucas van Leyden's 'Owlglass' (*Eulenspiegel*), which was already notoriously rare by then (see cat. 60). Rembrandt's German pupil Johann Ulrich Mayr testified that on another occasion he saw his master purchase several important prints by Lucas, described as the 'freshest impressions' (*saubersten Abdrucken*) for the astonishing sum of 1,400 guilders.[6]

Rembrandt's collection of prints and drawings focused squarely on the maker: he was interested in the artist rather than in the thematic categories that many of his contemporaries still used as a basis for classification. To them, a collection of art on paper was an encyclopedia of the world and its natural phenomena, divided into sections such as topography, architecture, ancient and contemporary history, plants and animals, exotica, portraits and so forth.[7] If there was anything encyclopedic in Rembrandt's endeavour, it was the desire to build up a survey of the art of the great masters. His shelves held prints of work by Martin Schongauer, Israhel van Meckenem, Albrecht

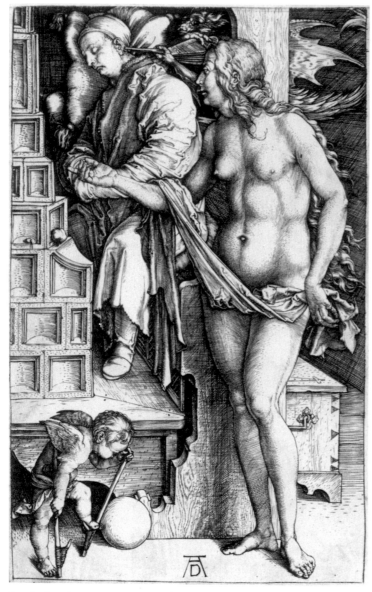

fig. 1 Albrecht Dürer, *The dream of the doctor*. Engraving, 191 × 123 mm. Amsterdam, Rijksmuseum

Dürer, Holbein, Hans Brosamer, Lucas Cranach, Andrea Mantegna, Raphael (four volumes), Michelangelo, Titian, Francesco Vanni, Federigo Barocci, Annibale, Agostino and Lodovico Carracci, Antonio Tempesta (four volumes), Guido Reni, Jusepe Ribera, Lucas van Leyden, 'the Elder Bruegel', Frans Floris, Maarten van Heemskerck ('the complete works'), Hendrick Goltzius, Jan Muller, Willem Buytewech, Abraham Bloemaert, Rubens, Anthony van Dyck and Jacob Jordaens, Jacques Callot – and of his contemporaries and associates there were Jan Lievens and Ferdinand Bol. Other volumes contained, for instance, engravings of various types of 'dragt' (presumably costume prints), Turkish buildings and scenes from Turkish life

by Melchior Lorck and Pieter Coecke van Aelst, images of sculpture, 'landscapes by various renowned masters' (two albums), erotic scenes by several artists (one album; see cat. 52), and 'drawings and prints by the principal masters of the whole world'. The descriptions in the inventory are so specific ('a small moonlit scene retouched by Rembrandt') and the notary's clerk so well-informed that the artist himself most probably showed the man around and briefed him. In a phrase such as 'the principal masters of the whole world' we seem to hear Rembrandt's own voice. The phrase encapsulates his endeavour: to gather together prints by the greatest artists of all time.

An intimate knowledge of so many forms of artistic expression on paper left its mark on Rembrandt. It was not just a question of using an Italian engraving or a painting by Rubens as an aid to a compositional scheme or for the rendering of a classical or biblical figure – as many of his contemporaries were wont to do – but the prints helped Rembrandt to determine the whole direction of his work. He was singularly receptive to the creations of others, and where he perceived quality, an ingenious twist or a compositional innovation, it fired his own creativity, not only while he was still an apprentice, but until the very end of his career. 'In matters of art Rembrandt possessed a rich store of ideas', wrote Arnold Houbraken, and wherever he saw inventiveness in others, the spark was communicated to him.[8] His collection has sometimes been described as a status symbol, but the part devoted to prints amounted to far more than that.[9] It would appear that Rembrandt himself wanted to produce an *oeuvre* of etchings that followed on from those with which he was familiar and which he had in his collection: by creating a rich variety of prints, he produced an ideal vehicle to demonstrate his versatility.

Thanks to the development of the technique of etching, a gifted draughtsman could make prints for himself. Theoretically speaking, he could be given a prepared copper plate and scratch an image into the ground, after which a competent printmaker could complete the process before the plate went to the press. Numerous painters made brief excursions into the world of etching, and one-off experiments exist by Bartholomeus Spranger, who drew three figures in wax one day in Prague in 1589, and by Pieter Bruegel, by whom only one etching is known, the superb *Hare hunt* of 1560. Although many more compositions by both these masters appeared in print, these were executed by other, specialist printmakers.

Rembrandt, on the other hand, produced an impressive out-

put of some 300 prints. His first etchings have a somewhat unfocused quality; but while not yet guided by great, earlier prints, they certainly reflect his familiarity with contemporary works in the medium. Elsewhere in this catalogue there are references to the influence of Antonio Tempesta on Rembrandt's technically immature *Rest on the flight into Egypt* (cat. 1); and the *Circumcision* (fig. 2) of around 1625–6, with the address of the Haarlem publisher Jan Pietersz. Berendrecht, is stylistically akin to the loose, open etchings of Willem Buytewech and Pieter Feddes van Harlingen, who were also on Berendrecht's list (fig. 3). It has sometimes been suggested that the latter urged Rembrandt and Jan Lievens – with whom Rembrandt had close ties at this time and by whom an early etching also exists that was published by Berendrecht – to start producing etchings.[10]

Rembrandt was not to collaborate with the publisher again, and there followed a period of several years in which he

fig. 3 Willem Buytewech, *Rest on the flight into Egypt*. Etching, 96 × 105 mm. Copenhagen, Statens Museum for Konst, Kongelige Kobberstiksamling

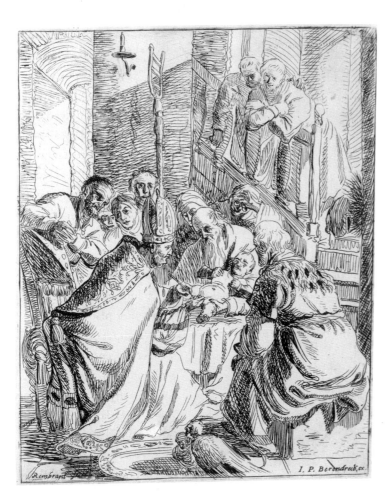

fig. 2 Rembrandt, *The circumcision*, c.1626. Etching, 214 × 165 mm. Amsterdam, Rijksmuseum (White & Boon, S.398)

developed and experimented with his characteristic style as a printmaker and draughtsman. He conducted numerous informal trials in a wide variety of techniques. He himself was the model for many of these small, painstaking etchings, and his mother seems also to have been an obliging sitter. After this, *tronies* – bust-length figures – of wrinkled old men and sheets of studies with miscellaneous motifs started appearing in print. Most of the motifs were heads, occasionally adorned with an extravagant item of headgear. Rembrandt evidently filled a number of plates with models of this kind and sawed them down later, which explains why we have numerous heads by him the size of postage stamps. In this period, any full-length figures that he etched were almost always beggars and other people of the street, rendered from life. The images are simple: one figure or half-figure against a blank background. Many of these prints are extremely rare, and one wonders if they were ever printed in a substantial edition. In the main they are *preliminaria*: while they merit study, if we are trying to reconstruct the master's *oeuvre* as a purposeful endeavour, they rather distort the main picture. Yet they were important for the maturing of Rembrandt's etching skills and taught him how to retain the sketch-like qualities that he sought to achieve in his finished works. His fully elaborated beggars followed on from the series by Jacques

fig. 4 Sebastian Stoskopff, *The five senses*, c.1630–35. Canvas, 49 × 66 cm. Strasbourg, Musée de l'Oeuvre Notre-Dame

(*right*)
fig. 5 Rembrandt, *Joseph's coat brought to Jacob*, c.1633. Etching and drypoint, 107 × 80 mm. Amsterdam, Rijksmuseum (B.38)

Callot, which were so popular in the Netherlands that other printmakers also copied and paraphrased them, including Salomon Savery and Pieter Quast.

In this period, when Rembrandt set out to render a scene with several figures, he chose types that he had previously depicted separately in etchings or drawings and grouped them into a single composition (cat. 18). These prints still lack conviction, as the artist himself realised only too well, and he resolutely took the saw to one of them (cat. 2). In another case he erased the image altogether to recycle the plate (cat. 5), something he must have done quite often in his early years as an etcher.

In the case of self-portraits, too, it is important to distinguish between those that Rembrandt was proud to display to the public and impromptu efforts intended solely for his own eyes and those of his workshop assistants. It is quite remarkable, of course, that an artist who was still finding his way in a technique should have etched his own features in the copper time and again, although several examples were probably intended as studies of psychological states and how they are expressed in the face rather than as self-portraits through which the artist wished to present himself.[11]

In 1630–31, at the end of his Leiden period, Rembrandt started signing and dating his etchings fairly consistently and completing or developing them in several states. From then on

he also widened his choice of subjects. Small biblical scenes started to appear, and nudes (cats 10–11), although he did not abandon his *tronies* and half-length figures. The results were now elaborated more thoroughly and despatched to the wider world. Shortly after publication they were already being collected in other parts of Europe, and even figured as *trompe l'oeil* elements in still lifes (fig. 4).[12]

Some of Rembrandt's etchings from this period are virtual echoes in print of his own paintings. For a while, starting in 1631, he availed himself of the services of Johannes (Jan) van Vliet for the more literal reproduction of some of his canvases. Perhaps he wanted to arrange a division of labour by analogy with that of Raphael with Marcantonio Raimondi and Rubens with, among others, Lucas Vorsterman. Rembrandt's choice of the somewhat unsophisticated Van Vliet may have been prompted by the fact that the latter also lived in Leiden. After Rembrandt moved to Amsterdam, probably in 1631, he continued to employ Van Vliet as an engraver for a few years, especially for large reproductive prints (see pp. 36–8 and cats 22–4).[13]

Rembrandt's own output of prints accelerated considerably in Amsterdam, and the work must have yielded a substantial income. The spectrum of subjects is strikingly similar to that of his painted *oeuvre*. Narrative scenes predominate, mostly with biblical themes (fig. 5), in which the moment depicted is

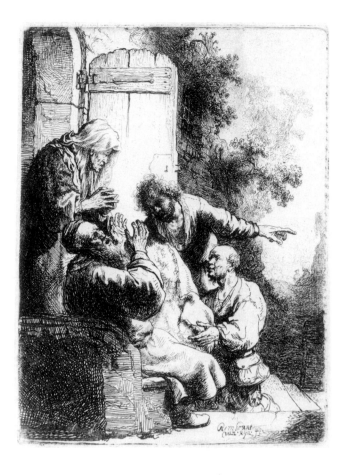

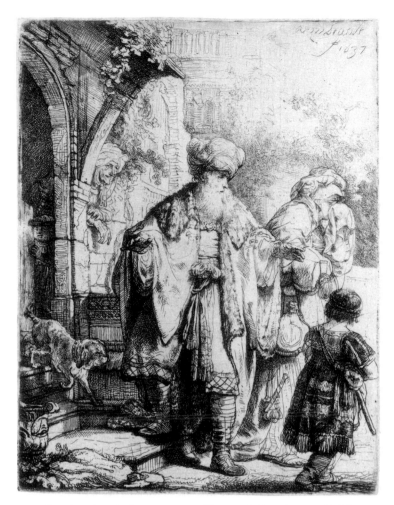

fig. 7 Rembrandt, *Abraham casting out Hagar and Ishmael*, 1637. Etching and drypoint, 125 × 95 mm. Amsterdam, Rijksmuseum (B.30)

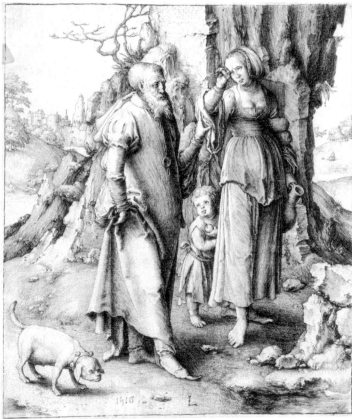

fig. 6 Lucas van Leyden, *Abraham casting out Hagar and Ishmael*, 1516. Engraving, 148 × 125 mm. Amsterdam, Rijksmuseum

rendered with such intensity that it is easy to understand why Rembrandt's pupil Samuel van Hoogstraten characterized the most essential quality of his master's art as the expression of emotional states (*lijdingen des gemoeds*).[14] Rembrandt would often take up subjects with a long history in printmaking and, as it were, 'juxtapose' his own version with previous ones according to the principle which was coined *aemulatio* in contemporary art-theory. A case in point is the *Abraham casting out Hagar and Ishmael* of 1637. A classic engraving of this subject existed by Lucas van Leyden (fig. 6), to which Rembrandt's etching constitutes a response. In the same quotation by Hoogstraten, Lucas van Leyden is aptly described as striving to achieve dignified restraint (*zedicheyd*) in his art, and it is to this precise quality that Rembrandt made his riposte in his own depiction of the chilling event (fig. 7). He chose the same format but rendered Abraham, an expressionless figure in Lucas, as a man appalled by what God has commanded him to do. While in the older picture Hagar blinks away a tear, here she is sobbing unashamedly. Essential to the story is the presence both of the toothless Sarah, who is

chuckling at the prospect of Hagar and Ishmael suffering a terrible death in the wilderness, and of her son Isaac, whom we glimpse through the doorway in the safety of his home. Lucas' shifty looking mongrel has been replaced by a pattering dog that is assigned the same place in the picture. Far from producing the umpteenth *Hagar and Ishmael*, Rembrandt thus created his own personal and imaginative work of art. He was offered so much money for the plate that he sold it to the Portuguese painter Samuel D'Orta that same year. But he insisted on being allowed to pull a few impressions first, not for sale but 'for himself and to satisfy his own curiosity'.[15]

Rembrandt's prints are replete with allusions to existing ones, and it is often wrongly said that the artist stole – or plundered ('raapte', as Karel van Mander put it) – for lack of imagination.[16] Yet for example Rembrandt had no need to go looking for ways of depicting Christ driving the money-changers and tradesmen from the temple. Whereas someone intent on *rapen* would preferably disguise their source by casting their find in a totally different role, he took Dürer's Christ thrashing about him and reproduced him in exactly the same role (figs 8–9).[17] The aim was not to plunder but to quote, to show that he could depict the terror instilled by Jesus's fury far more dramatically and realistically than Dürer. In the Dürer a man is seen slipping away with a sheep under his arm, but in the Rembrandt there is total chaos. A cow drags its owner along with it, a peasant makes off with a basket full of chickens on his head, a large purse on a stick spills coins all over the foreground table, and all this takes place in a real temple. Dozens of such adaptations can be found in Rembrandt's etchings (several are mentioned in the individual entries in this catalogue), that may be deemed illustrative of his deliberate effort to create an *oeuvre* alongside, and partly inspired by, the 'principal masters of the whole world'. In fact, certain of Rembrandt's etchings owe their existence to an older print to which the artist apparently felt impelled to respond. No print lover failed to admire the virtuosity that he displayed, and as early as 1641 he was mentioned in a treatise by the Italian Tommaso Garzoni in the same sentence as the great printmakers, with special reference to his skill in what was then described as the new art of etching.[18]

In building up his *oeuvre*, Rembrandt resembled an author who demonstrates his mastery of numerous genres by producing consecutively a novel, an epic poem, a play, an ode to a celebrity and a libretto for an opera. Not for him the path of the specialists of his age, like the landscapists Jan van Goyen and Jacob van Ruisdael, or the portrait-painters Frans Hals and Michiel van Mierevelt. Rembrandt also turned his hand to relatively new genres in printmaking, such as landscapes and studies from life, though once he did feel the urge to render on the plate a lifeless object from the natural world, a marbled cone shell imported from the Orient, listed in inventories as 'the little conch' ('het horentje'; cat.62). He did not build up his *oeuvre* according to a fixed plan; it grew rather fitfully. Thus his etched landscapes were made in the 1640s and 1650s, and there was a relatively brief period during which he produced a string of brilliant portraits (see cats 81–4).

Unlike Anthony van Dyck, who embarked on his huge *Iconography* project on his own initiative, Rembrandt produced many of his portraits on commission.[19] Several of the people whose portraits he had painted also ordered their likenesses in print. Rembrandt was particularly concerned here to distinguish his works from the mass-produced portraits that were starting to

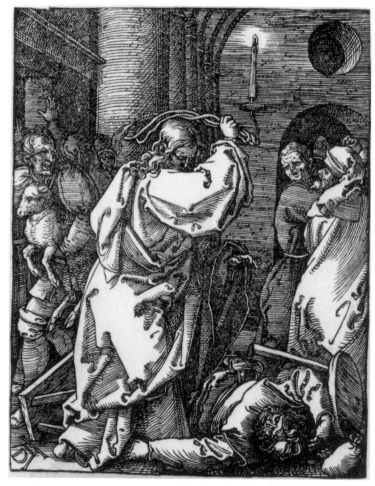

fig. 8 Albrecht Dürer, *Christ driving the money-changers from the temple.* Woodcut, 126 × 97 mm. Amsterdam, Rijksmuseum

fig. 9 Rembrandt,
*Christ driving the
money-changers
from the temple*,
1635. Etching,
136 × 169 mm.
Amsterdam,
Rijksmuseum
(B.69)

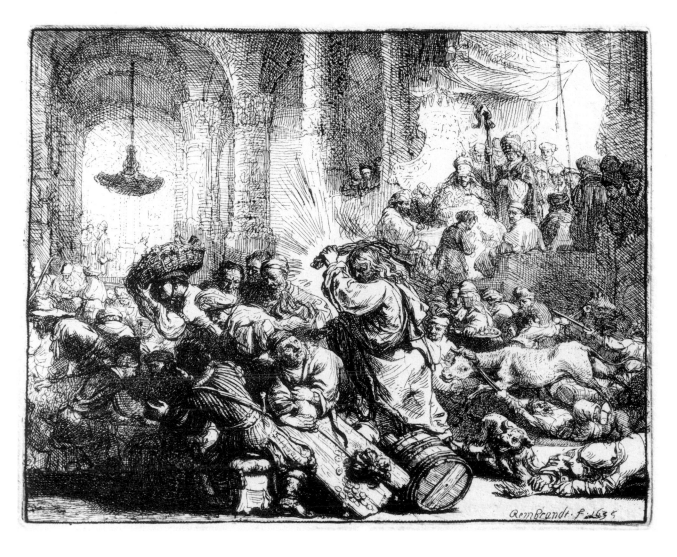

flood the market in the seventeenth century. The mere fact that he executed several in the delicate drypoint technique (which could only produce a limited number of good impressions) lent them an air of exclusivity, and it was therefore primarily art lovers who found their way to his door. Making portrait prints must have been a lucrative business, and his output soared when bankruptcy was looming. It can be inferred from a document dating from December 1655 that someone was willing to pay no less than 400 guilders for a 'likeness to be etched from life by the aforesaid van Rijn' provided that the result was 'equal in quality to the likeness of Jan Six' (see cat. 57).[20] With portraits, the plate usually became the sitter's property, and in consequence impressions of certain portraits, such as those of Jan Six and Arnold Tholinx, are extremely rare. Unlike most of the master's other prints, he had no control over their marketing.

Aside from Rembrandt's portraits and certain obvious book illustrations, some of his other etchings must also have been commissioned, but we have little evidence to go on. Most of his output seems to have been made spontaneously, with – thinking in terms of an *oeuvre* – a number of distinct groups or individual plates, including prints inspired by works in his own collection. Rembrandt produced three hunting scenes in total, over a number of years. He also attempted several *nocturnes*, which had become a specialist branch of printmaking, notably after Hendrick Goudt's highly successful reproductions of paintings by Adam Elsheimer, but Rembrandt added variety to the subjects: the *Woman at a door* (B.128), the *Student at a table by candlelight* (fig. 10), the *St Jerome in a dark chamber* (B.105), the *Star of the Kings* (B.113), the *Adoration of the Shepherds* (cat. 67), the *Flight into Egypt* (B.53); one rather isolated piece is the nocturnal landscape with the majestic *Angel appearing to the Shepherds* (cat. 21). These provided experience that was to bear fruit in the *Three crosses* of 1653 (cat. 73).

Rather late in his career he produced a series of nudes: four

in 1658 (see cats 87–8), the sleeping woman who is ogled so lasciviously by a satyr in 1659 (cat.90), and in 1661 the *Nude with the arrow*, viewed by a figure with a rather foolish gaze – one of Rembrandt's very last prints (fig.11). They cannot be separated from Rembrandt's drawn figure studies of nude female models, of which he filled an entire album, though few are known today.[21] The link with drawings also applies in the case of Rembrandt's landscapes and all sorts of other images, such as his genre scenes. They are based on studies from life, and in the case of several extremely sketch-like etchings one is tempted to believe that the artist drew them on the plate directly from life. Houbraken too looked on Rembrandt's prints as sketches in print. He also noted Rembrandt's tendency to return to the same subjects time and again, citing the *Christ at Emmaus*, of which 'various sketches (besides the two that appeared in print) are known to lovers of drawings'.[22]

These art lovers were a category that Rembrandt must have specifically targeted with parts of his *oeuvre*, such as the cursorily etched *Christ disputing with the doctors* from 1652 (fig.12). It is no coincidence that this etching is very similar in execution to Rembrandt's contribution of the same year to the

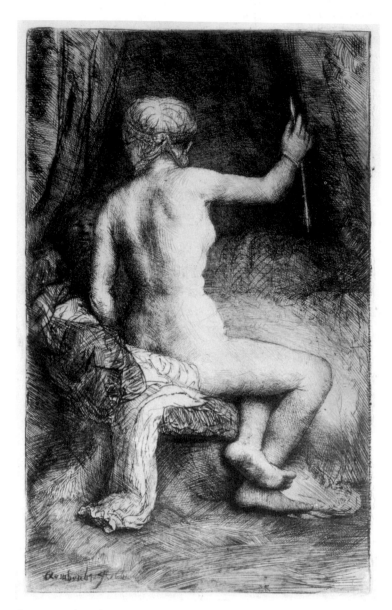

fig. 11 Rembrandt, *Nude with the arrow*, 1661. Etching, 205 × 123 mm. Amsterdam, Rijksmuseum (B.202)

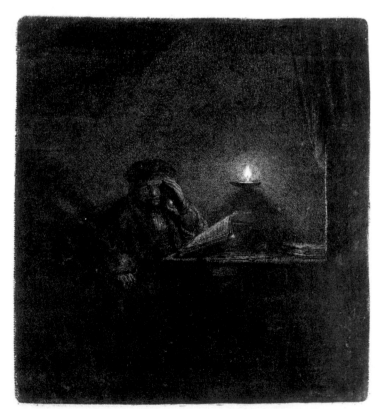

fig. 10 Rembrandt, *Student at a table by candlight*, *c*.1642. Etching, 147 × 133 mm. Amsterdam, Rijksmuseum (B.148)

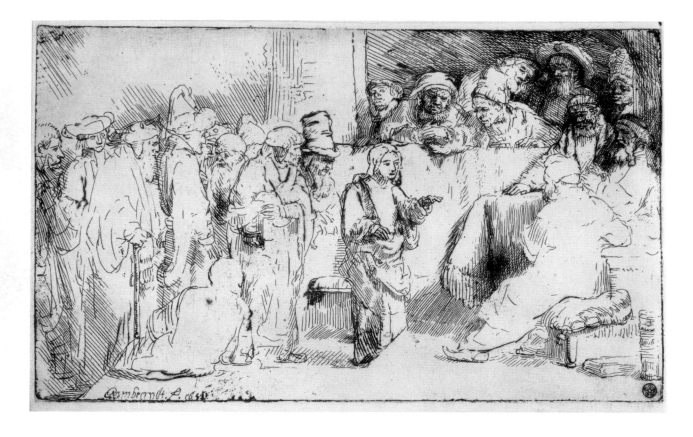

fig. 12
Rembrandt,
*Christ disputing
with the doctors,*
1652. Etching
and drypoint,
126 × 214 mm.
London, British
Museum (B.65)

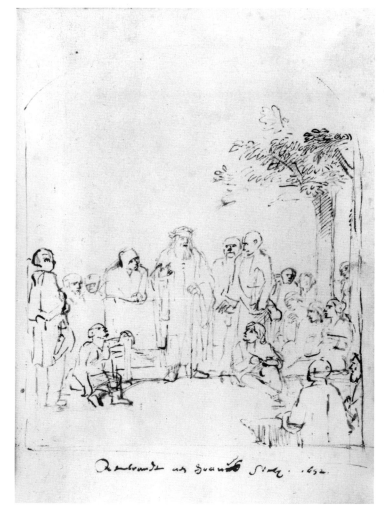

album amicorum of Jan Six (fig. 13), someone well able to appreciate such conciseness of presentation.[23] Others, including Houbraken, shook their heads: 'But one thing is regrettable, that he was so quick to change direction, or impelled to take up something else, that he left many things half done (*ten halven opgemaakt*), in his paintings and even more so in his etchings.'[24] In fact some of the master's works were fully elaborated, some half elaborated and some scarcely elaborated at all, and he also varied the degree to which he etched a plate, so that some prints came to be described as 'lightly etched'. According to Houbraken, Rembrandt had a ready answer to any complaint about works that were apparently unfinished: 'A piece is finished if the artist has achieved what he set out to achieve.'[25] Houbraken was more enamoured of the high finish of the *Hundred guilder print* (cat. 61), which indeed had countless admirers from the start. As early as 1654, five years after it was made, an impression had been sold for the price to which the etching owes its famous nickname.[26] Rembrandt's last pupil, Aert de Gelder, painted a collector who was so proud of owning one that he immortalized himself holding it (fig. 14).[27]

Curious as to the effect, Rembrandt was one of the first to experiment with oriental and other kinds of paper and with

fig. 13 Rembrandt, *Homer reciting,* 1652. Pen and brown ink, 265 × 190 mm. Amsterdam, Six Collection (Benesch 913)

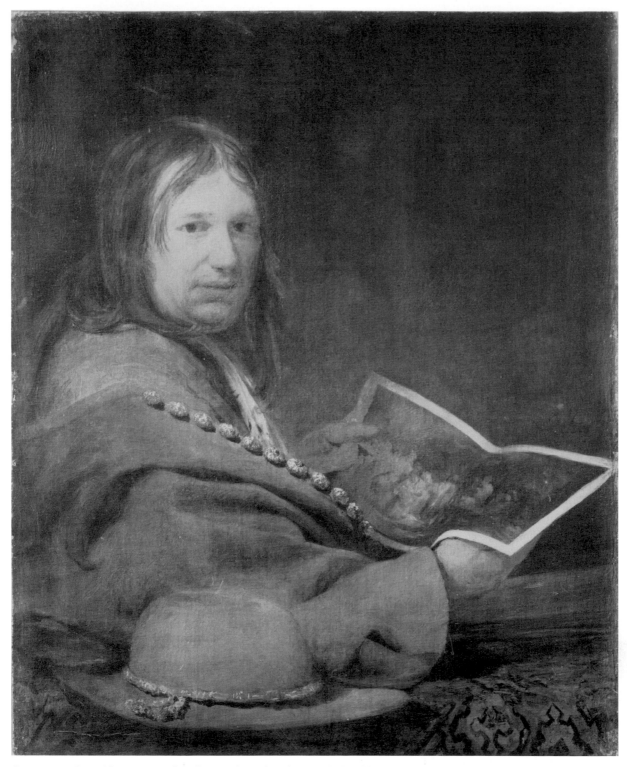

fig. 14 Aert de Gelder, *Portrait of a collector with Rembrandt's Hundred guilder print*. Canvas, 79.5 × 64.5 cm.
St Petersburg, Hermitage

vellum, producing considerable variations between impressions, quite apart from the distinction between successive states. Sometimes he apparently obliged avid collectors by printing a number of proofs that were obviously unfinished and by creating extra states – a practice to which Houbraken devoted a few colourful and rather facetious comments – since he knew that a loyal group of devotees collected his prints in several states and variants.[28] The Frenchman Roger de Piles noted in 1699 that impressions on oriental paper ('papier de la Chine') were particularly sought after.[29] The concept of the proof impression was also important to Rembrandt the collector, and he himself owned an album with *proefdrucken* after designs by Rubens and Jacob Jordaens. Inscriptions on the backs of prints testify to an eye for detail among dealers and collectors; for instance, aside from the obligatory description 'rare' or 'extremely rare' you may read in seventeenth-century hand, on the *verso* of the first state of *Rembrandt's mother with her hand on her breast* (B.348): 'this is Uncommon: with hatching behind the back'.[30]

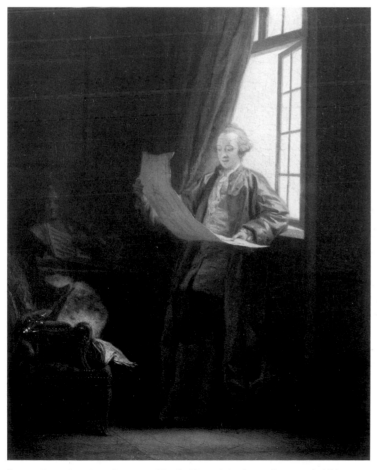

fig. 15 Jean-Baptiste Greuze, *Claude-Henri Watelet in the attitude of Jan Six*, 1765. Canvas, 26 × 20.5 cm. Karlsruhe, Staatliche Kunsthalle

In many respects Rembrandt would have worked to ensure that his prints were collectable, and enthusiasts abounded, both close to home and in other parts of Europe.[31] His print *oeuvre*, or *Werk*, as it was called in Dutch art albums, commanded much respect. Anyone who visited his *kunstcaemer* could see that he had already assigned himself a place among the greats of art history: there were his drawings, classified by subject, and his etchings ('a book of all Rembrandt's works')[32] ranked among those of the masters he admired.

That Rembrandt counted every etching as part of his *oeuvre*, in the sense of being suitable for distribution, is unlikely. Possible criteria for assessing his point of view could be the extent of the use he made of certain copper plates and the mere fact of its preservation. Plates for prints with which Rembrandt was happy to advertise his talents have certainly survived. In that sense, the research into the fate of his copper plates, a large number of which remained together until 1993, has proved extremely rewarding.[33] It has also confirmed that the plates for portraits, with a few exceptions, were the sitters' property, and often turn up in the inventories of their descendants' possessions. Of the self-portraits, only the plates of the more pictorial examples have been preserved. Why all the ones for landscapes, with one exception, have vanished, remains puzzling; and it would appear that towards the end of his life, Rembrandt no longer possessed the plates that, with his unprecedented creativity, were for so long a vital part of the business capital he relied on.[34] He did, however, keep one impression of each, 'for curiosity's sake' as he said himself, and the biographer Filippo Baldinucci states that on occasion he bought back his own prints.[35] The inventory of Rembrandt's daughter-in-law Magdalena van Loo, Titus's widow, who died the same year as Rembrandt himself, contained 'three volumes filled with all the most precious prints that Rembrandt van Rijn produced in his life'.[36] The guardian of Titia, the artist's granddaughter, sold these albums in the following year. The earliest literature contains several references to a complete collection that may be identical to this treasure that Rembrandt so cherished.[37]

One of the earliest catalogues to describe an artist's prints one by one, with extreme meticulousness, was devoted to Rembrandt, and appeared in 1751. The author was Edmé-François Gersaint. Few etchings are lacking from his book, which even includes many of the informal printed scribbles from the artist's early years. He himself writes that the basis for his work was the collection of the portrait engraver Jacob

Houbraken, the son of Arnold, in which all sorts of rarities were present. With a few exceptions, these later ended up, by way of the collection of Pieter Cornelis, Baron van Leyden, in the Rijksprentenkabinet.[38]

Gersaint's catalogue and later those by Daniel Daulby (1796) in England and Adam von Bartsch (1797) on the Continent served as beacons for collectors. Just as Rembrandt the printmaker had consistently emulated the work of his illustrious predecessors, his own etchings became a major source of inspiration for other artists, down to our own times (see cat. 62). Indeed, as an entrepreneur in the realm of printmaking, he became a role model. Numerous etchers followed in his footsteps by producing a proliferation of states, sometimes on special papers; and time and again Rembrandt's inventions in print were paraphrased by others (fig. 15). Their quotations and allusions paid tribute to Rembrandt as the creator of one of the most substantial print *oeuvres* of all time.[39]

★ With thanks to Erik Hinterding, without whom I could not have written this essay, and to Martin Royalton-Kisch and Hans Luijten for their valuable suggestions. An extended version of this text is published separately under the title *Rembrandt's etchings,* Amsterdam (Rijksmuseum) and Zwolle 2000 (also in Dutch as *Rembrandts etsen*).

1 The inventory has been published several times; see Strauss & Van der Meulen 1979, pp. 349–88, 1656/12 (with facsimile) and the new transcription by Jaap van der Veen in Amsterdam 1999–2000, pp. 146–52, Appendix 2.

2 At the Barent van Someren auction in Amsterdam, from 22 to 29 February 1635, Rembrandt purchased a large variety of prints and drawings. Aside from two lots each with a drawing by Adriaen Brouwer, the auction catalogue gives no details; see Strauss & Van de Meulen 1979, 1635/1.

3 Ibid., 1637/2; for the inventory see ibid., 1637/1.

4 For Rembrandt's purchases at the Gommer Spranger auction, see Strauss & Van der Meulen 1979, 1638/2 and Van Eeghen 1985, pp. 65–7.

5 The *tasvloyer* is the apt title for Unrequited love (B.93); the *cockje* alludes to B.85; see Hollstein German 70, 77 and 84, where the plates are mentioned.

6 Sandrart 1675–80, I, fol. 240.

7 Van der Waals 1988.

8 '[Rembrandt] was in opzicht van de konst ryk van gedachten'; Houbraken 1718–21, I, p. 257.

9 Scheller 1969.

10 Wyckoff 1998, pp. 157–8.

11 Ernst van de Wetering in London-The Hague 1999–2000, pp. 20–22.

12 For the still life by Stoskopff, see Strasbourg-Aachen 1997, pp. 160–61, no. 15; the painting of c.1631–5 discussed there under no. 3 on pp. 136–7, also contains a print by Rembrandt (B.343).

13 For Rembrandt and Van Vliet, see Amsterdam 1996.

14 Hoogstraten 1678, p.75.

15 Strauss & Van der Meulen 1979, 1637/7. This reconstruction follows from the description in sworn testimony from which it emerges that Rembrandt made several other impressions for himself; it cannot be ruled out that the print was commissioned.

16 For this phenomenon, see Ben Broos in Amsterdam 1985, pp. 4–7 and in Amsterdam 1999–2000, pp. 91–139.

17 See Amsterdam 1985, nos 33–4.

18 For Garzoni's text see Enschedé 1913 and Strauss & Van der Meulen 1979, 1641/10.

19 Ger Luijten in Antwerp-Amsterdam 1999–2000, pp. 74 and 84.

20 The client wanted 'een conterfeijtsel 't welck de voorsz. van Rijn sal naer 't leven etsen' which had to be 'van deucht als het conterfeijtsel van d'Heer Jan Six'; Strauss & Van der Meulen 1979, 1655/8.

21 See Schatborn 1987.

22 Houbraken commented that 'verscheiden schetzen (behalve de twee die 'er in druk uitgaan) by de beminnaars van de teekenkonst bekend [zijn]'; Houbraken 1718–21, I, p.258.

23 For this drawing see Peter Schatborn in Berlin-Amsterdam-London 1991–2, pp. 109–12, no. 31a.

24 'Maar een ding is te beklagen dat hy zoo schigtig tot verandering, of tot wat anders gedreven, vele dingen maar ten halven op gemaakt heeft, zoo in zyne schilderyen, als nog meer in zyn geëtste printkonst'; Houbraken 1718–21, I, pp. 258–9.

25 'een stuk is voldaan als de meester zyn voornemen daar in bereikt heeft'; ibid., I, p. 259.

26 Vanden Bussche 1880, pp. 358–9 (letter from the print publisher Joannes Meijssens to the collector Karel van den Bossche).

27 The painting was until recently thought to be a self-portrait (see Von Moltke 1994, no. 93).

28 Houbraken 1718–21, I, p. 271; see also Alpers 1988, pp. 100–101.

29 De Piles 1699, p. 433.

30 On the impression in Amsterdam, Rijksmuseum, Rijksprentenkabinet, inv. no. RP-P-OB-740; 'dit is Ongemeen: met asseerin[g] achter de rugh'.

31 Christopher White gives an excellent survey of the early distribution; see White 1999, pp. 255–6; for the slightly later period in England, see Ellen G. D'Oench, '"A madness to have his prints": Rembrandt and Georgian taste 1720–1800' in New Haven 1983, pp. 63–97.

32 'Een boeck van all' de wercken van Rembrant'. For an attempt to reconstruct the fate of Rembrandt's own impressions, see Royalton-Kisch 1993.

33 Hinterding 1993–4.

34 Ibid., pp. 257–63.

35 Baldinucci 1686, p. 80.

36 'Drie constboecken gevult met al [de] costelijckste prenten die Rembrandt van Rijn in sijn leve gemaekt heeft'; Boon 1956, pp. 53–4.

37 Ibid., pp. 52–3; see also White 1999, p. 255 and n. 32 above.

38 Boon 1956, especially p. 54.

39 See e.g. Cailleux 1975, New Haven 1983, Bremen-Lübeck 1986–7 and Amsterdam-Salzburg-Freiburg 1998–9. The painting by Greuze on the basis of which Watelet produced an etching in 1765 is discussed in Karlsruhe 1984, pp. 37–8. A similar adaptation of Rembrandt's *Portrait of Jan Six* is also known by the Englishman Thomas Worlidge (1700–66); see New Haven 1983, no. 158, fig. 48.

Watermark research as a tool for the study of Rembrandt's etchings

Erik Hinterding

Watermark research is nothing new. Two studies, of the prints of Albrecht Dürer and Anthony van Dyck, published as early as the nineteenth century already focus on the watermarks found in different impressions;[1] and the first person to produce a concise description of the marks found in Rembrandt's etchings was Eugène Dutuit in 1883.[2] At that time watermarks were recorded by drawing or tracing them. But the usefulness of these drawings is limited, since they almost never provide an exact reproduction of a watermark down to the smallest detail. This makes comparing different marks a tricky business.

The research into the watermarks in Rembrandt's etchings recently entered a new era as a result of the use of modern technologies.[3] Since 1981 Nancy Ash and Shelley Fletcher have been using beta-radiography to record the watermarks in a large number of Rembrandt prints in collections in the United States.[4] In 1988 Theo Laurentius photographed the watermarks of all the Rembrandt prints in the Rijksmuseum in Amsterdam using low-energy or 'soft' X-rays.[5] Working on this project was the starting-point for my own research, which aims to elucidate the way the etchings were created and published. As part of this work, with the assistance of Harry van Hugten, who designed the Amsterdam X-radiograph equipment, new records were made of the watermarks in Rembrandt's prints in several other major European collections, including the Lugt Collection and the Bibliothèque Nationale de France in Paris, the Hermitage in St Petersburg and the Herzog Anton Ulrich Museum in Braunschweig. The British Museum in London has meanwhile X-radiographed the watermarks in its Rembrandt etchings.

The use of X-radiography means that it is now possible not only to record a large number of watermarks in a short time, but also to compare them far more accurately than before, so that it can be established with a high degree of certainty whether or not two watermarks are absolutely identical. To understand why this should provide us with useful information, we need to look briefly at the way paper was made.

Until the nineteenth century, paper was made by hand. A flat sieve of brass wire, known as a mould, was used to scoop paper pulp out of a vat filled with water and pulp. A paper maker or 'vatman' used two moulds for this. When he had collected the pulp to make a sheet of paper in one mould, he passed it to his assistant, the 'couchman', who emptied it on to a flat surface, thus creating the sheet, ready to dry. Meanwhile the vatman took up the other mould to form a new sheet. This, too, he would then pass to the couchman, who gave him back the first mould, now emptied, so that the whole procedure started again (fig. 1). The sheets were then dried and bundled in stacks of around 500 sheets, or reams.[6]

When a whole sheet of paper made in this way is held up to the light, it is possible to discern a pattern of horizontal and vertical lines – the marks left by the wires in the mould. There is usually also a watermark in the shape of a coat-of-arms, for

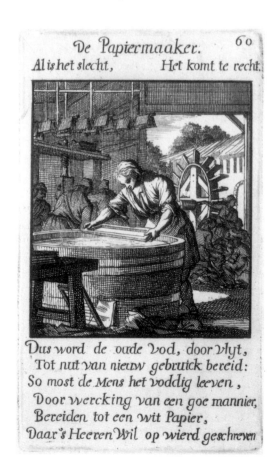

fig. 1 Jan Luyken, *The papermaker*, Emblem from *Het menselijk bedrijf*, Amsterdam 1694. Amsterdam, Rijksmuseum

fig. 2 Detail of a sieve with watermark (wire form), c.1900. The Hague, Koninklijke Bibliotheek

instance, or an animal, a hand, or some other device. These distinguishing marks, which not only varied from factory to factory but also changed over time, were created by bending wires into the correct shape and attaching them to the wire grid in the mould. The wire moulds and watermarks were made by hand, and consequently no two are exactly the same (fig. 2).[7] This also applies to the two moulds used simultaneously by the papermaker. Although they were meant to be a pair with identical watermarks, in practice minute differences can always be distinguished between them.[8] Watermarks that occur in the same stack of paper in this way, and belong together, are referred to as 'twinmarks'.[9] A ream of paper is thus made up of sheets with two nearly identical watermarks, half with one type, half with the other.[10]

First and foremost this means that sheets with absolutely identical watermarks must have been made in the same mould and must also have come from the same batch of paper. This can be verified by comparing the X-radiographs. We also know that a nearly identical watermark (the twinmark) must have existed within the same batch of paper. Thus if we work on the plausible assumption that a printmaker bought his paper in quantities of a modest size, in reams of 500 sheets or even in books of twenty-five sheets, and that he would have used this paper up within a relatively short space of time, we can deduce that prints with identical watermarks must have come off the press at around the same time.[11]

All the aspects involved in determining the moment when a particular paper was used can best be illustrated with the aid of an example. We have chosen the Strasbourg lily watermark with the initials BA (figs 3 and 4) because it occurs in a large number of impressions of Rembrandt's prints and because the twinmarks are both known.[12] The relevant impressions with this watermark are:

Self-portrait, frowning
 B.10 III(3) (Paris) 1630 s/d

Self-portrait [?] with plumed cap and sabre (bust)
 B.23 III(3) (Melbourne) 1634 s/d

The presentation in the temple with angel: small plate
 B.51 II(2) (Private collection) 1630 s/d

The crucifixion: small plate
 B.80 only state (Amsterdam) c.1635 s

The good Samaritan
 B.90 IV(4) (Amsterdam) 1633 s/d

The small lion hunt (with two lions)
 B.115 only state (Haarlem) c.1629

Man with oriental fur cap
 B.263 IV(4) (Paris) 1631 s/d

The fourth 'oriental' head
 B.289 II(2) (Amsterdam, Washington, Paris, Chicago) c.1635 s

Old man in a fur cap, with eyes closed
 B. 290 II(2) (Amsterdam) c.1635 s

The great Jewish bride
 B.340 II(5) (Boston, Amsterdam, London, Paris, 1635 s/d-iii
 New York (2))
 B.340 III(5) (Paris, London, Amsterdam (2)) 1635 s/d-iii

Rembrandt's mother: full face
 B.352 II(2) (Amsterdam) 1628 s/d

Bust of Rembrandt's mother
 B.354 II(2) (London) 1628 s/d

Thus the prints on this paper range in date from 1628 to 1635, but the impressions referred to here must all have been printed in about 1635. To begin with, this can be deduced from the varying quality of the individual impressions. Those of the *Fourth oriental head* (cat. 27) of around 1635 are fresh and early with strong contrasts, and that of the *Self-portrait* [?] *with plumed cap* (B.23) of 1634 is likewise very fine. The impression of *Rembrandt's mother, full face* (cat. 3) of 1628, on the other hand, is rather grey and was clearly printed from a plate that was already somewhat worn; and the same applies to the *Small lion hunt (with two lions)* (B.115) of about 1629. While the impressions of the other prints with early dates are still good, they are nonetheless discernibly not especially fine or early. Moreover none of these prints occurs on this paper in an early state. They are therefore not early impressions but slightly later ones, in this case dating from around 1635. We can be confident that they cannot have

(*left and above*) figs 3–4 Strasbourg lily with initials BA, twinmarks [Ash & Fletcher 36, initials BA.a–b], here X radiographed from B.263 IV, Paris, Bibliothèque Nationale de France (3) and B.23 III, Melbourne, National Gallery of Victoria (4)

been printed much later than this, not only because no prints with later dates have been found on this paper, but also bacause of the impressions of the *Great Jewish bride* (cat. 25): the second state, included here, which does occur on this paper, is an early proof in which the bottom half of the print has yet to be put in. This was only added in the third state, which is likewise found on this paper. Yet it was not until the third state that Rembrandt added his signature and the year – 1635 – to the copper plate.

This is a typical example of a phenomenon that is common in Rembrandt's prints. The dates inscribed on the prints that occur on paper with the same watermark often differ quite considerably – sometimes by almost twenty years. However, the impressions of the most recent prints – and hence those with the latest date – are always of the best quality, while those with earlier dates display greater wear of the copper plate; and the longer ago they were made, the more wear they exhibit.

Furthermore, the most recently dated prints are frequently found in an early state; and this is virtually never true of the prints with earlier dates. There can consequently be no doubt that, in the case of the prints dated earlier, we are dealing with reprints. More generally, the latest dated print in any group of impressions found on paper with the same watermark can be taken as the point of departure for dating the entire group. This assumption always has to be tested, however, against what we know about the successive states of the prints, and on the basis of the quality of the individual impressions.[13]

Although this method produces some clear results, there are also a number of significant limitations. It is, for example, only possible to arrive at a likely date when enough different impressions of various prints with the same watermark are known – the more, the merrier. However, in Rembrandt's graphic *oeuvre* there are several instances of watermarks that have, as yet, only been found in a single impression, so that few if any conclusions may be drawn.[14]

The fact that, from the late 1640s onwards, Rembrandt often printed his etchings on Japanese paper, Chinese paper,[15] oatmeal paper and vellum also presents us with something of a problem. These types of paper do not have watermarks, which means that the impressions cannot be dated. This lacuna is all the more strongly felt because it was above all early impressions and states that were printed on these papers, and these are of course the most crucial in dating the watermarks.

In addition, the fact that the latest-dated print in a group of impressions with the same watermark becomes the starting-point for dating the group as a whole means that late and, in particular, posthumous impressions are difficult to pinpoint in time because the necessary reference material is lacking. But often the watermark, in conjunction with the quality of the impression, can provide a general indication as to date; and sometimes other information, such as a rare state or a datable, handwritten inscription, can be of help. The provenance of a paper can also often offer points of reference to arrive at an approximate dating. Nevertheless, it is clear from the foregoing that while it is often possible to suggest a likely date for a watermark, this is by no means always the case.

Perhaps the most significant limitation of watermark research arises from the fact that by no means all the prints have watermarks. To date some 6,000 impressions of Rembrandt etchings have been examined, and something over 2,000 of them proved to have a watermark, or a fragment of one. This is a consequence of various factors, especially the size of the sheets of paper, the position of the watermarks in the uncut sheet and of the way in which works of different sizes were printed. In handmade paper the watermark was usually placed in the centre of one half of the sheet. In the course of the seventeenth century it became customary to give the paper what is known as a countermark in the centre of the other half of the sheet (fig. 5), usually a small device or a few letters. Small prints were often printed on the edges of sheets, where not even a fragment of the watermark occurs in the paper.

In the rest of this essay three examples will be used to illustrate how the information gleaned from watermark research can contribute to our understanding of the way the prints were created and how they were printed. The first example is the *Self-portrait in a soft hat and patterned cloak* (cat. 13) of 1631. In terms of size and degree of elaboration this was Rembrandt's most ambitious self-portrait to date. Not only did he devote the utmost care to rendering the fabric, he also succeeded, with the aid of lightly and more deeply bitten shadows, in achieving an almost painterly tonality. There are no fewer than eleven states of this print. In the first, Rembrandt etched only the head and the hat, to which he made subtle improvements in the next three states (see the second and fourth states included in this catalogue). It was not until the fifth state that he added the collar and the cloak; and he also signed the plate with his monogram RHL and the date 1631. The cloak was essentially a large dark plane, and in the next four states Rembrandt was primarily concerned to capture the look and feel of the fabric and to introduce an interesting texture to it: he improved the contrasts and the folds, added a glint on the shoulder, removed it again, and eventually added a brocade pattern to the cloak.[16] In the eighth state (included here) he also enlarged the spatial qualities of the image by hatching the background, while in the tenth he signed the plate again, this time in full: *Rembrandt f.*

As an example of Rembrandt's approach this print is interesting not just because of the large number of states, but also because on some of the early proofs on which only the head had been etched, he drew in the collar and cloak in chalk (see those of the second and fourth states shown here under cat. 13). Such additions are found not infrequently in Rembrandt's early etchings, and reveal that he used chalk to try out the state changes he had in mind before committing them to the plate.[17] For this reason it has generally been assumed in the past that the additions to this self-portrait should be viewed in the same

fig. 5 Uncut sheet of paper with watermark and countermark
(379 × 477 mm). Amsterdam, Rijksmuseum

light,[18] but this has recently been called into question.[19] While it is true that Rembrandt dated two of the three touched proofs 1631, he also signed the sheets in chalk with his full name – the form he only used in his etchings and paintings from 1633.[20] He also initially noted on these sheets that he was twenty-seven years old (his age in 1633–4), later altering this to twenty-four (his age in 1631). These indications suggest that the additions were not carried out until around 1633–4; and as a consequence it is not clear why he made them. It has been postulated that Rembrandt made only the first state of this portrait in 1631, and that he then put the plate to one side. According to this hypothesis he did not return to the plate until 1633–4, when he

retouched a few proof impressions in chalk first in order to work out what he wanted to do.[21]

Watermark research provides the ideal means of testing this hypothesis, since it enables us to check when the individual states were made. However, it is particularly in these early years that a limitation we have already referred to plays an important role: the prints are predominantly small and seldom have a watermark. This is also true of the impressions of the *Self-portrait in a soft hat and patterned cloak*: the ninth state is the first in which a recognizable watermark – the NA Countermark (fig. 6) – has been found.[22] This mark is not found in identical form in other prints, and consequently cannot be dated with precision. Nevertheless, as we have noted, countermarks always occur together with a watermark in a whole sheet of paper. Thus although only the countermark can be seen in the impression in

fig. 6
Countermark
'NA' [Ash &
Fletcher 26,
NA.a.], from B.7
IX, Amsterdam,
Rijksmuseum

fig. 7 Strasbourg bend [Ash & Fletcher, 35, G.], here X-radiographed from B.198 I, St Petersburg, Hermitage

question, it should be possible to identify the associated watermark; and this information would provide a general indication for dating the impression.

Three very similar countermarks occur in impressions of *Peter and John at the gate of the temple* (cat. 5) of about 1629, and in the first state of the *Naked woman seated on a mound* (cat. 11) of about 1631. The only watermark that occurs in other impressions of these prints is the Strasbourg bend (fig. 7).[23] Both the *Peter and John* and the first state of the *Naked woman* are extremely rare – there are just four known examples of each – which leads us to suspect not only that Rembrandt probably just made a few impressions of them, but also that he is unlikely to have printed them on different papers. It therefore seems safe to assume that the NA Countermark belongs with this Strasbourg bend watermark.[24]

This would appear to justify the assumption that the NA Countermark which occurs in the ninth state of the *Self-portrait in a soft hat and patterned cloak* also belongs with a variant of the Strasbourg bend watermark [Ash & Fletcher 35, G.]. Which variant this is has yet to be established, not least because this bend also occurs in a closely related form in several other early prints, including an early impression of the *Beggar in a high cap, leaning on a stick* (B.162) of around 1629, the second state of the *Old man looking down* (B.260) and the second state of the *Man with oriental fur cap* (B.263), both of 1631. Given the rarity and dates of these etchings, and the fact that they are fine early impressions, they too must have been made between 1629 and 1631. This conjecture is supported by the fact that two very closely related watermarks occur in material in the Leiden archives dating from 1630.[25]

These facts not only make it likely that the NA Countermark

found in the ninth state of the *Self-portrait in a soft hat and patterned cloak* belongs with the Strasbourg bend watermark, but also suggest that this paper was in use in the Leiden studio between 1629 and 1631. This means that the ninth state of the *Self-portrait* was probably executed in 1631 or very soon afterwards, and not in around 1633–4.

Unfortunately too few watermarks are known to enable us to establish when the tenth state, signed *Rembrandt f.*, was made. What is clear, however, is that Rembrandt considered the plate to be finished in this state. All the impressions that have been examined bear a Strasbourg lily watermark (fig. 8), which is also found in several other prints, among them the *Young man in a velvet cap* (B.268) of 1637 and *Adam and Eve* (cat. 30) of 1638; the latest dated print with this watermark is the first state of the *Beggars receiving alms at the door of a house* (cat. 60) of 1648. It can therefore be concluded that the eleventh and last state of this 1631 self-portrait – in which the background and both signatures have been removed – was not made before 1648.

As we have already observed, the prints dating from the early part of Rembrandt's career were usually small, and they so seldom bear a watermark that there is generally little that may be deduced from them. Nevertheless there are a few exceptions. One of them is another etching dating from 1631, the *Old man looking down* (B.260). Three states of this print are known. The first state shows the old man, half-length. Rembrandt made corrections in pen and brown ink on the only known impression of this state, from which it appears that he was playing with

fig. 8 Strasbourg lily [not in Ash & Fletcher] here X-radiographed from B.266 I. Private collection

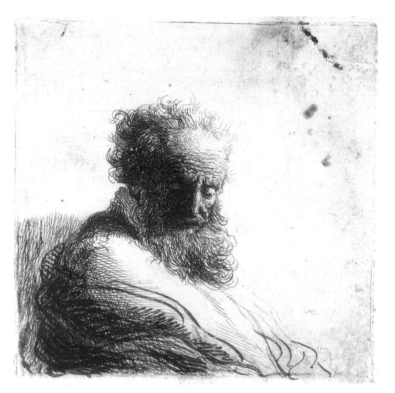

fig. 9 Rembrandt, *Old man looking down*, 1631. Etching, 119 × 117 mm. Amsterdam, Rijksmuseum (B.260 I)

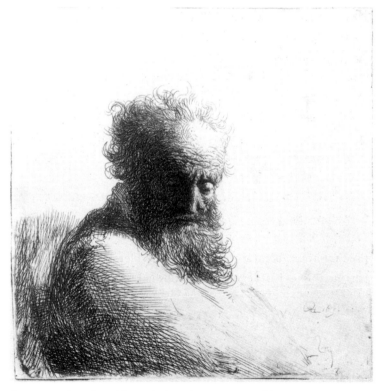

fig. 10 Rembrandt, *Old man looking down*, 1631. Etching, 119 × 117 mm. Amsterdam, Rijksmuseum (B.260 II)

the idea of strengthening the man's back and forearm (fig. 9).[26] However, he did not carry out these corrections in the second state but simply reinforced the shadows in and around the man's head[27] and burnished out several lines on the torso, so that this area became more brightly lit (fig. 10). Rembrandt made no further changes to the image in the third state – he just reduced the size of the copper plate slightly down the right side, thus improving the position of the figure in the picture plane. A consequence of this was that he cut off the last two digits of the date, 1631, in the lower right corner.

The unique impression of the first state unfortunately has no watermark, but a good impression of the second state with strong contrasts has the Strasbourg bend watermark referred to above (fig. 7), and this can be dated to around 1631. What is most interesting, however, is the fact that the second state also occurs with other watermarks. This indicates that the plate had already been reprinted a few times before its reduction in the

fig. 11 Posthorn [Ash & Fletcher 31, A.a.], B.260 II. St Petersburg, Hermitage

third state. This is confirmed by the wear on the impressions of this state: in particular the shadows on the man's head rapidly became less homogeneous, and white patches started to appear between the lines. Such slightly greyish impressions occur with the Posthorn watermark (fig. 11),[28] which is also found in a good impression of the second state of *Rembrandt's mother seated at a table* (cat. 14) of around 1631 and in an early, crisp impression of the second state of the *Old man with a fur cap and a velvet cloak* (cat. 15) of around 1632. These are comparable in terms of quality with the impressions on paper with a Basilisk watermark (fig. 12),[29] which can be dated fairly accurately. This watermark occurs in both the first and second states of the *Self-portrait* [?] *with plumed cap and sabre* (B.23); and Rembrandt already dated this print 1634 in the first state, but in the second – in which he cut the original rectangular plate down to an irregular oval – he put the same date on the plate again. There can consequently be no doubt that this watermark and hence the reprints of the second state of the *Old man looking down* (B.260) on this paper have to be dated to about 1634.

We can only arrive at an approximate date for the third state, but it was probably also executed in the 1630s. A rather grey impression with fine horizontal scratches in the background has the Arms of Württemberg watermark (fig. 13).[30] Although this mark cannot be dated precisely, it is nonetheless evidently south German paper, and we know that paper from this source was predominantly used for Rembrandt's prints prior to 1636.[31] A slightly later edition of the third state occurs with the Foolscap, five-pointed collar watermark (fig. 14).[32] This is found in various

fig. 12a–b Basilisk [Ash & Fletcher 12, B.c and B.d.], here X-radiographed from B.73 VIII [V]. Melbourne, National Gallery of Victoria and B.260 II, London, British Museum

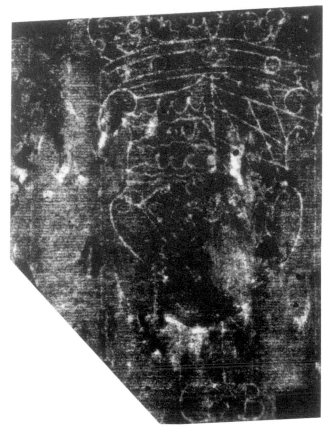

fig. 13 Arms of Württemberg [Ash & Fletcher 9, B.a.], here
X-radiographed from B.121 III. Boston, Museum of Fine Arts

only a general compositional kinship with the etching, and
only the figure of the frightened woman next to Christ occurs
in virtually identical form in both works. However, an X-
radiograph of the panel reveals that it was drastically reworked
twice; and on the basis of an analysis of these changes it has
been argued that the early states of the etching reproduce an
earlier version of the painting in reverse.[34] The relationship
between the etching and the painting is probably more complex
than this, however, because the former also shows traces of
reworking; yet it is clear that the two works resembled each
other more than the present appearance of the painting would
lead us to suppose.[35]

Given the changes that Rembrandt made to the etching plate,
we can be sure that the print in its final form was not intended
as an accurate reproduction. Of particular interest in this context
is the fact that the number of states that Rembrandt needed to
complete the work is smaller than has hitherto been thought.

other prints, and the one with the latest date is an impression of
the second state of the famous *Self-portrait leaning on a stone sill*
(cat. 34) of 1639. This is a superb impression, comparable in
quality to impressions of the first state. This leads us to suppose
that it, as well as the whole group of works on this paper, were
printed in 1639 or very shortly thereafter.[33]

Another example of a print whose evolution can be traced
with some accuracy is the *Raising of Lazarus: larger plate* (cat. 17)
of around 1632. This monumental etching can be seen as the
high point of Rembrandt's early years, and provides a clear
picture of his approach to his work and his technical skills. The
elaborate detail and the great range of grey tones that Rembrandt
achieved by varying the hatching and by biting some areas of
the plate more deeply than others is very reminiscent of the
methods used by reproductive engravers who worked after
paintings. This characteristic of Rembrandt's print is reinforced
by his inclusion of a heavy frame, as if it were a painting.

There is in fact an oil on panel of the same subject, painted
by Rembrandt in around 1630–31 (see cat. 17, fig. a). It bears

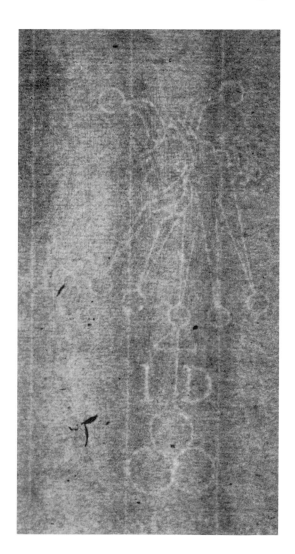

fig. 14
Foolscap, five-
pointed collar
[Ash & Fletcher
19, E.a.], here
X-radiographed
from B.162.
St Petersburg,
Hermitage

The so-called second state, the only impression of which is in Amsterdam, is in fact an impression of the first state that has been unobtrusively but extensively retouched in pen and grey ink. In the fourth state Rembrandt was supposed solely to have darkened the frame around the composition. But again, the only known impression, which is in Paris, is an impression of the third state from which the original border has been cut away and replaced with another.[36] Equally, the supposed seventh state, known in a single impression in St Petersburg, is actually a very worn impression of the eighth state.[37]

If we remove these three states from the history of the evolution of the print, the following picture emerges; the first state appears to be a proof; and although the scene was complete on the plate, which Rembrandt had also signed, the contrasts, particularly those on the right, were rather weak, while some of the details and the border were not satisfactorily bitten. Rembrandt corrected these defects in the 'new' second state (included under cat. 17). In the next states he worked only on the group of figures to the right of Lazarus' grave. In the third state, for instance, the pose of the woman in the lower right corner was changed from shrinking back to leaning forward,[38] while in the fourth state the terrified man with the outstretched arms acquired a tall cap. In the fifth (formerly the eighth) state, also included here, Rembrandt altered several other details in this group. He evidently regarded the work as finished at this point, since he made no further changes in the sixth and later states; any further work was solely intended to remedy the wear on the plate.

Although Rembrandt needed five states to achieve the result he wanted, the watermarks make it clear that this was a more or less continuous process. The rare first state is printed on large-format paper with the Strasbourg bend watermark (fig. 15). The second and fifth states are printed on the same paper,[39] and from this we can infer that the impressions were all made within a relatively short space of time.[40]

The watermarks also confirm that the fifth state of the *Raising of Lazarus* is the finished state, and to date we know of no fewer than eight different editions of it. The first reprints were probably made as early as about 1632, on paper with the Basilisk watermark (fig. 16).[41] This watermark is found in a large group of prints, including fine, clear impressions of the *Old man with a fur cap and a velvet cloak* (cat. 15) of around 1632, and also in prints with earlier dates, including some early impressions of *Rembrandt's mother seated: with oriental headdress* (B.348) of 1631,

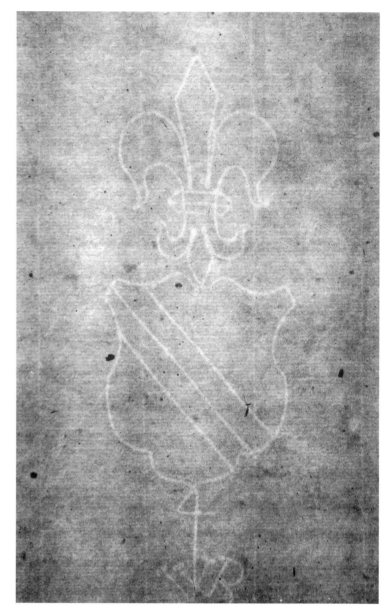

fig. 15 Strasbourg bend [not in Ash & Fletcher], from B.73 III [II]. Paris, Bibliothèque Nationale de France

and a good impression of the *Self-portrait, open-mouthed* (B.13) of 1630. A slightly later impression of the *Raising of Lazarus* occurs with the Basilisk watermark (fig. 12)[42] that we encountered previously in impressions of the first and second states of the *Self-portrait [?] with plumed cap and sabre* (B.23) of 1634. As the impressions of the *Raising of Lazarus* on this paper already look rather grey and worn, they must have been printed in about 1634.[43]

By no means can all the other editions be dated, but one thing is clear: the fifth state was still being printed, its condition unchanged, almost ten years after it was created. Examples are

found with the Basilisk watermark (fig. 17),[44] which occurs in a large group of prints, including the extremely rare first state of the *Baptism of the eunuch* (B.98) and the first state of the *Angel departing from the family of Tobit* (B.43), both dating from 1641. The impressions of the *Raising of Lazarus* on this paper are striking in that they are so grey and worn that without the watermarks to guide us it could easily be assumed that they were posthumous impressions (fig. 18).[45]

The severe wear on the copper plate by around 1641 can be explained in part by the large number of impressions that had been pulled from it by then. However, the way that Rembrandt etched the print also contributed to its rapid wear. The composition is built up of a varied web of very fine lines, interspersed with more heavily bitten passages. This produced superb tonal effects, but the fine etched lines on the plate wore quickly so that these areas soon became grey. These grey passages caused an unbalanced contrast with the more deeply etched lines, which

fig. 17 Basilisk [Ash & Fletcher 12, A´.a.], here X-radiographed from B.40. St Petersburg, Hermitage

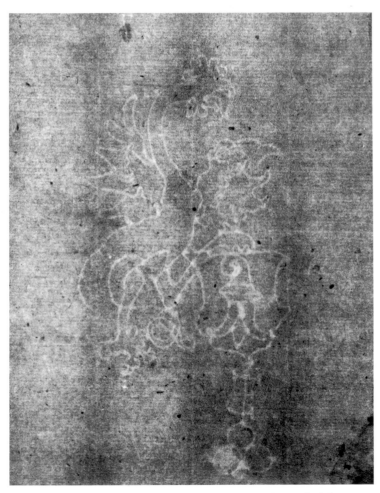

fig. 16 Basilisk [Ash & Fletcher 12, C´.a.], here X-radiographed from B.348 II. St Petersburg, Hermitage

stayed black for much longer. This susceptibility to wear is not unique to the *Raising of Lazarus*, but arises from Rembrandt's etching style during these years. For example, it can also be clearly seen in impressions of the *Diana at the bath* (cat. 10) or the *Self-portrait in a soft hat and patterned cloak* (cat. 13), both of 1631. Rembrandt appears to have been aware of this problem, since from 1634 onwards we see him biting out his etchings more deeply and avoiding the combination of extremes of light and heavy lines.[46] A clear example is his next large and elaborate print, the *Angel appearing to the shepherds* (cat. 21) of 1634. Of interest is the fact that, despite the considerable wear that the plate was already showing in 1641, Rembrandt never reworked the *Raising of Lazarus* himself; the sixth (formerly ninth) state, in which the shadows have been darkened with rather mechanical lines, was not executed until after his death.

Using the watermarks gathered so far, it is possible to clarify the evolution of other prints in the same way and to find out

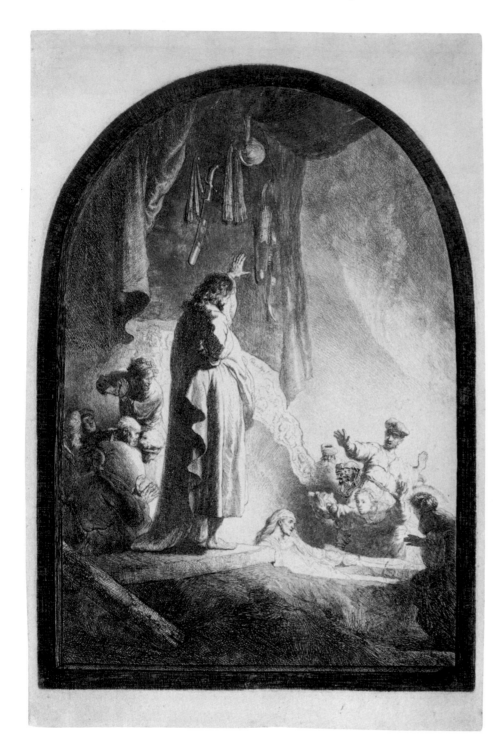

fig. 18 Rembrandt, *The raising of Lazarus: the larger plate, c.*1632. Etching and burin, 366 × 258 mm. Present whereabouts unknown

how – once finished – the plates were printed and reprinted. In so far as the watermarks in the print impressions included in this catalogue give rise to an explanation, the information is provided in the individual entries. It is, however, important to note that the research is still far from complete. Any additions to the file of watermarks that has been compiled will not only improve our understanding of Rembrandt's progress on his plates, but will also enable us to test and refine the conclusions reached so far.[47]

★ The findings presented in this essay are based on my doctoral thesis on the production and distribution of Rembrandt's etchings, which is being written at Utrecht University with financial support from the Netherlands Organization for Scientific Research (NWO).

1 For Dürer, see Hausmann 1861, who published fifty-six tracings of watermarks; for Van Dyck, see Wibiral 1877.

2 See Dutuit 1883, p. 173.

3 For a general overview of the most recent recording methods, see De la Chapelle & Le Prat 1996.

4 See Ash 1986, pp. 64–9.

5 The American and Dutch data were combined in a single systematic list in 1989 and published by the National Gallery in Washington; see Ash & Fletcher. Partial studies of this material can be found in: Ash & Fletcher 1990, pp. 263–81; Laurentius *et al.* 1992, pp. 353–84. See also Laurentius 1993 and Laurentius 1996.

6 For paper making, see Voorn 1960, pp. 5–60. A ream of paper often consisted of 480 sheets, or 20 quires of 24 sheets each, but reams of 500 sheets, or 20 quires of 25 sheets, were also quite common. See ibid, p. 56; Hunter 1978, p. 179. Labarre 1937, pp. 194–5.

7 For the manufacture of moulds, see Loeber 1982, especially pp. 47–54.

8 For the manufacture of watermarks in particular, see Grosse-Stoltenberg 1965, pp. 73–9 and Loeber 1982, pp. 31–6.

9 See Stevenson 1951–2, pp. 57–91.

10 In practice, in larger factories more than one pair of twin moulds were sometimes used simultaneously in creating the same ream.

11 The question as to how long a mould lasted is obviously relevant here. Voorn states that a mould in constant use would last for about a year, but moulds that were used only occasionally, for example because the types of paper made in them were not particularly common, could last for twenty years. This is not to say that all the paper from a given mould has exactly the same watermark. A mould that was in use had to be brushed clean daily, and this inevitably led in due course to wear and distortion. We can identify clear examples of this in Rembrandt's works: all the subvariants of the Pascal lamb watermark [Ash & Fletcher 29, A.] that have been identified seem to be merely deformations of one pair of moulds, and the whole variant has to be regarded as a single pair of watermarks (twinmarks). The same applies to the subvariants of the Strasbourg lily [Ash & Fletcher 36, G.]. In the present study the deformation has only been discounted in extreme cases, and only watermarks that are absolutely identical are regarded as coming from the same mould. We may therefore assume that papers with such completely identical watermarks were indeed made at around the same time and with the same mould. See Voorn 1960, pp. 95–6

12 Ash & Fletcher 36, initials BA, a–b (twinmarks). There can be no doubt in this case that these are twinmarks; the marks are not only very similar in shape, but they also both occur in impressions of the same prints of comparable quality. Moreover, no similar marks have been found. The watermarks also satisfy the ten criteria for the recognition of twinmarks formulated by Alan Stevenson 1951–2.

13 Other possible interpretations are also put forward in the introduction to Ash & Fletcher, pp. 15–16. The quality of the individual impressions is not used as a criterion in Ash and Fletcher's research.

14 This also applies to identical watermarks that are only found in impressions of a single print. We can only say that they were printed in the same period and, if they are also impressions of the same state, that they almost certainly belong to a single edition.

15 For the composition and origin of this paper, see Van Breda 1997.

16 Cf. also the etched studies of Rembrandt's father and mother (?) of 1631 (B.263 and 348, and also cats 14 and 15), in which Rembrandt likewise experimented with various ways of rendering fabric effectively and tackled the question of how to make large planes interesting.

17 See for example cats 3 and 9.

18 For example White 1969, pp. 109–12.

19 See Amsterdam 1981, p. 10; Broos 1981–2, p. 251.

20 Until 1632 Rembrandt signed his prints *RHL f.* (Rembrandt Harmensz. Leidensis fecit), and in 1632 he sometimes used *RHL van Rijn* or *Rembrant van Rijn f.* See Royalton-Kisch 1992, p. 46, n. 5.

21 Broos 1981–2, Royalton-Kisch 1993, pp. 111–16; Royalton-Kisch 1991, p. 307.

22 Ash & Fletcher 26, NA.a. Fragments of watermarks do occur in a few impressions of earlier states, but they are too small to identify.

23 Ash & Fletcher 35, G.a–b (twinmarks).

24 This assumption is supported by the fact that the texture and the characteristics of the paper in the impressions are very similar, while the distance between the chain-lines also corresponds closely.

25 See Heawood 1950, nos 138–9. This specific type of Strasbourg bend is not found anywhere else in the literature.

26 See Van Regteren Altena 1961, pp. 3–10.

27 White and Boon I, p. 117 state erroneously that this was not done until the third state.

28 Ash & Fletcher 31. A.a.

29 Ash & Fletcher 12, B.c–d. (twinmarks)

30 Ash & Fletcher 9, B.a.

31 See Voorn 1986, pp. 312–27, especially p. 327. Also Laurentius 1996, p. 45. Heawood illustrates a similar watermark that can be dated 1625. See Heawood 1950, no. 485.

32 Ash & Fletcher 19, E.a.

33 Another impression has the Strasbourg lily watermark with the initials LB [Ash & Fletcher 36, initials LB.a.] that cannot be precisely dated. The same is true of several impressions with an unidentified Foolscap. These watermarks do make it clear that the third state of this print was also reprinted several times.

34 See *Corpus* I, pp. 293–308, no. A30.

35 See cat. 17.

36 This discovery was published by Lambert & Séveno 1997, p. 41.

37 The impression could be studied in the autumn of 1997, while the Rovinski collection was in Amsterdam for restoration.

38 There is an impression of the second state in London on which Rembrandt tried out this alteration in graphite first. See cat. 17.

39 This is paper of *royal* format (approximately 48 x 58 cm). The etching was printed on half sheets (*folio*) of this paper. The large-paper format probably explains why the watermark has not to date been found in any other prints. The watermark is not described by Ash and Fletcher. Their report of a first state in Boston with a different watermark [Ash & Fletcher 26, RL´.a.] is based on an error: this is actually an impression of the ninth state. See Ash & Fletcher, p. 138.

40 The third (formerly the fifth) state was printed on another paper, with the Arms of Bern watermark [Ash & Fletcher 3, B.a.]. Unlike the paper with the Strasbourg bend, this paper is a small standard (*gemeen*) format. Why this state was not printed on the same paper as the earlier and later states is unclear.

41 Ash & Fletcher 12, C´.a–b (twinmarks).

42 Ash & Fletcher 12, B.c.

43 It is, however, one of the twinmarks that occurs in the self-portrait.

44 Ash & Fletcher 12, A´.a.

45 The example illustrated could be seen in Kornfeld 1979, no. 43. Another example with the same watermark is now in the Maecenas Collection in Amsterdam; see for this Laurentius 1996, pp. 62 3.

46 Of course there is also visible wear in later etchings, where the lighter lines contrast with the heavier ones. However, the effect is never as extreme as in the early etchings.

47 The Kupferstichkabinett in Berlin has plans to record the watermarks in the Rembrandt etchings in its collection, and Het Nederlands Kunsthistorisch Instituut in Florence is researching the possibilities of doing the same in several Italian collections.

Remarks on Rembrandt's oil-sketches for etchings

Ernst van de Wetering

In Rembrandt's day, reproductive prints constituted the ideal medium for giving artistic ideas wide circulation. In the absence of museums, paintings often disappeared into private possession or behind the walls of palaces. Reproductive prints therefore offered artists and art lovers the welcome chance to see something of what was happening – and what had happened – in the field of art. For the ambitious painter, getting such reproductions of his paintings into circulation was the best way to win fame, and in the seventeenth century he was fully aware of this. Samuel van Hoogstraten, Rembrandt's pupil, wrote: 'get your works out as prints, and your name will the sooner be winged over the whole world'.[1] Rembrandt's own extensive collection of graphic works and the manner in which he made use of prints after the work of his illustrious predecessors provide a good demonstration of this thesis.[2]

Such prints, certainly where it was a question of graphic reproduction, were as a rule executed by specialists. Between 1631 and 1634, a number of paintings that the young Rembrandt had executed between 1628 and 1631 were copied as prints by the Leiden engraver Johannes (Jan) van Vliet (1600/10–1668?), including some five of Rembrandt's history pieces (one of which was copied only in part) and six separate half-figures, or busts

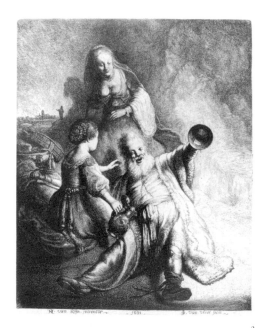

a

fig. 1 a–k Reproductive prints by Jan van Vliet after paintings made by Rembrandt between 1628 and 1631. Amsterdam, Rijksmuseum. Only of d, f, h, i, j and k are Rembrandt's prototypes still known.

b

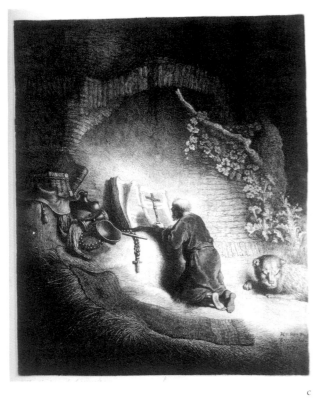

c

f

i

d

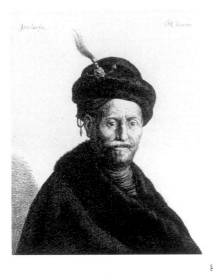

g

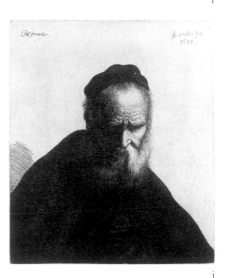

j

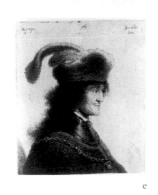

e

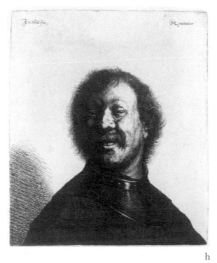

h

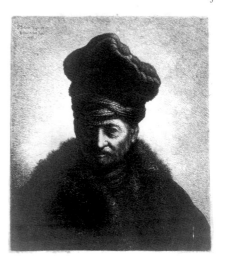

k

('tronies') (fig. 1 a–k).[3] But it is almost certain that none of these paintings was deliberately made with an eye to producing prints. These 'inventions' were apparently so representative of Rembrandt's ideas on the art of painting that it must have been decided to circulate them more widely in the form of printed reproductions. However, it should not necessarily be assumed that Rembrandt himself took the initiative, as will be discussed below.

On the other hand, Rembrandt also created paintings exclusively and intentionally with the aim of producing prints. These paintings are usually called oil-sketches.

The oil-sketch

The oil-sketch has a rich history beginning in sixteenth-century Venice and continuing right up to the present.[4] But it is no accident that whereas painters had already begun using oil paints by the early fifteenth century,[5] the oil-sketch should have to wait some one hundred and fifty years for its first flowering. Tintoretto was the first to make quick sketches in oils, and subsequently it became a quite common practice. In many cases such sketches served a role in the preparation of larger paintings, cycles of paintings or large decorative ensembles – projects on such a scale that the masters could not hope to execute the entire work on their own. Sketches could provide assistants with a basic image from which to execute paintings or frescoes. It goes without saying that large projects and large workshops were to be found well before Tintoretto began to make use of the oil-sketch, but previously the usual practice had been to use drawings when preparing such large works.

An important reason for the introduction and increasing use of the oil-sketch is that the role of light underwent a radical change in the art of painting in the Venice of Tintoretto's time. Previously, light and shadow had mainly been used to suggest plasticity – the *rilievo* – of depicted forms. In Tintoretto's Venice, forms were so organized within the space of the painting and with respect to each other that large parts of the composition remained in shadow. And through a balanced limitation of lit and shadowed passages, a practice which Rembrandt would later take further, not only was there an amplification in the power of suggesting light but also the composition as such was radically affected: illuminated zones, together with shadows, painted on a tinted ground that served as a median tone, began to organize the image. But what was

more important, as a result of this organization of the image by means of light and shade the viewer could – and can – take in the painting as a whole in a single glance before beginning to explore the details. In previous painting, the eye had first to apprise the different parts of the painting, one by one, in order to grasp the whole. It was this revolutionary change in the application of the pictorial means in the art of painting that would lead to the development of the style later known as Baroque.

Where small-scale oil-sketches were made it almost always had to do with a division of labour. In other cases they were made when the artist wanted or was required to give the patron an idea of the future work, and such a sketch was then known as a *modello*.[6] A variety of different kinds of oil-sketches emerged from Rubens' studio.[7] However, Rembrandt had little reason to use oil-sketches on the same scale as the Antwerp master, as he was never involved in such vast projects as Rubens, who as the manager of a large firm coordinated a more or less systematized division of labour. Rembrandt's style and artistic ambitions moreover lent themselves less obviously to this kind of collaboration,[8] not least in his etchings, which as a rule he executed himself. But in his mid-twenties the highly ambitious Rembrandt for some time modelled himself on Rubens.

On the whole, most surviving preliminary designs for prints are drawings, mostly with washes. Several painters, Rubens and Van Dyck in particular, but also such artists as Frans Hals and Thomas de Keyzer, executed rather elaborate oil-sketches for prints. The oil-sketches that Rubens made for the title pages of books,[9] or that Van Dyck made for his series of etched portraits, the *Iconography*,[10] were in the main done in browns and greys since, after all, the prints subsequently produced would also be monochromatic. The young Rembrandt also made a number of such monochrome sketches with which we shall be mainly concerned in the following section.

On the original function of Rembrandt's scenes from the life of Christ *in 't graeuw (in grey)*

Although it is highly likely that almost all of Rembrandt's oil-sketches originated for the purpose of making prints, in only three cases is this demonstrable, because we know the prints for which they were made. In the majority of cases we do not have this certainty. Given the loose brushwork employed by

Rembrandt in many of his works, and his own self-willed attitude toward 'finish', it is difficult to draw a definitive line between his oil-sketches and 'normal' paintings: it is not always clear which oils should be considered as sketches in the strict sense outlined above. One feature which might serve to characterize the oil-sketch, it would seem, is their relatively small format. It is, however, risky in Rembrandt's case to draw fast distinctions in this way between different categories of paintings. It is evident in his etchings what an enormous variety in format and degrees of detail could co-exist within a single category of products which he signed and clearly intended to be sold as independent works.

In the case of two small, unsigned portraits in oil, we know for certain that they were made in preparation for etchings, as we know the etchings based on them (see figs 26 and 29), whereas when it comes to Rembrandt's history pieces only one case is absolutely certain: the monochrome *Ecce Homo* oil-sketch executed in browns and greys (fig. 2; see cat. 24), which will be dealt with below in more detail. But does this sketch allow us to assume that *all* monochrome oil sketches were made with a print in mind? There is a strong temptation to make this inference given that prints themselves are also monochrome. But Rembrandt, like Frans Hals, for instance, used colour in his oil-sketches for portrait etchings, notably for the flesh tones of faces and hands (see figs 25 and 28). On the other hand, would a small monochrome painting on paper like the *Bust of an old man* of 1633 (fig. 4) have been intended for an etching? The possibility cannot be excluded, but the fact that this tiny painting, the execution of which has been taken to some lengths, is so emphatically signed and dated argues against it. Perhaps it ought to be considered as a contribution, taken out of its original context, to a *Liber Amicorum,* or some other type of album; it is, for instance, comparable to the pen and wash drawing of an old man that Rembrandt supplied a year later for the *Album of Burchard Grossmann* (fig. 5).[11] How is it then possible to determine whether a monochrome oil-sketch was intended for a print?

What is striking in the *Ecce Homo* is that some parts of the composition are extremely roughly indicated – e.g. the head of the negro bending over the balcony, or the Pharisee gesturing toward the mob (figs 6–7) – while other elements of the composition have been painted in close detail. That parts of this oil-sketch have been so summarily painted might be taken as evidence that Rembrandt did not expect the entire print to

be executed by another hand, but that he himself would have a hand in it. There is just as much variation in the execution of the four monochrome oil-sketches to be discussed below (see figs 11, 12, 21 and 22). Even though in the case of these sketches no prints were ever executed, given that they have a similar provisional character as the *Ecce Homo*, we may safely assume they were, indeed, intended for etchings. The question of why these etchings were never made becomes one of the central problems of this essay.

The Ecce Homo

The *Ecce Homo*, as mentioned above, was painted by Rembrandt in 1634. The sketch shows a scene from the Passion, the presentation of the prisoner Christ to the people of Jerusalem (see fig. 2).

It is a painting *in 't graeuw* (in grey), as Rembrandt himself called it (see below), a 'grisaille' as it is now usually called. The sketch with the *Ecce Homo* is neither on panel nor canvas, as was Rembrandt's usual custom, but on the more vulnerable paper. The choice of this support alone indicates that this oil-sketch had a temporary function.[12] This grisaille served as a preparation for an etching of exactly the same size which bears the date 1635 in the first unfinished state and 1636 in the second, finished state (see fig. 3).[13] Martin Royalton-Kisch demonstrated convincingly in 1984 that, by means of a tracing technique, the outlines of the composition of the grisaille were transferred on to the etching plate using a blunt-pointed instrument or stylus, the same method that Rembrandt used in the case of the preliminary drawings for the *Diana at the bath* (cat. 10) and the portrait etchings of *Cornelis Claesz. Anslo* and *Jan Six* (cats 45 and 57; see also pp. 64–81). Even more significant was Royalton-Kisch's demonstration that the etching was not entirely executed by Rembrandt, as had long been assumed, but is largely the work of Jan van Vliet, the same etcher who, as discussed above, had produced prints after eleven of Rembrandt's paintings from his Leiden period (see fig. 1 a–k).[14]

In other large etchings with complex compositions, e.g. the *Angel appearing to the shepherds* of 1634 (cat. 21) or the so-called *Pygmalion (the Artist drawing from the model)* of c.1639 (cat. 36) Rembrandt sketched directly on to the etching ground on the plate and elaborated the print on the basis of this sketch. This is very evident in these two etchings because we have proof impressions from a halfway stage in the working process. This is

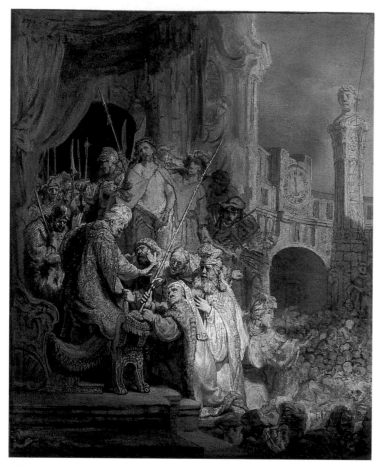

fig. 2 Rembrandt, *Ecce Homo*, 1634. Grisaille in oils on paper,
54.5 × 44.5 cm. London, The National Gallery

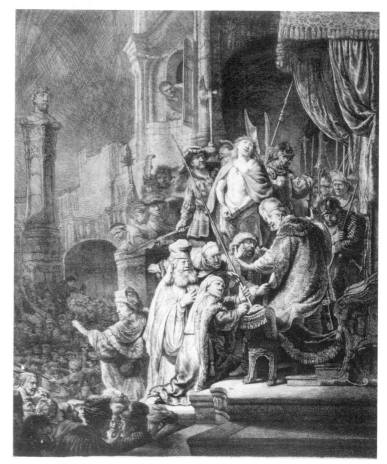

fig. 3 Jan van Vliet and Rembrandt, *Ecce Homo*, 1635–6. Etching,
55.3 × 44.2 cm. London, British Museum

also a proof of the *Ecce Homo* from a stage in which the main
group had not yet been executed (see cat. 24, first state) but here
there are no sketchy etched lines visible, which amply confirms
that in this case the oil grisaille must have been transferred with
a method of tracing on to the etching ground.

The centre of the composition is occupied by a group of
Pharisees beleaguering Pilate, thrusting into his hands a rod
of the type that a Dutch judge of Rembrandt's time would
take up when about to pronounce a death sentence.[15] In the
grisaille, the light, suggested by opaque, pale paint, falls on this
group. Slightly toned down, it also reaches the figure of Christ,
illuminating his torso and face. This more or less diagonal
light passage in the painting has an important function, both in
compositional and iconographic terms. The *Ecce Homo* scene as
a whole, with its scores of teeming figures, is resolved into
an ordered compositional structure that can be taken in at a
single glance. But before Jan van Vliet, who executed most of

the print, could set to work, he would have needed to know
exactly what Rembrandt's intentions were in this crucial organ-
ization of the light and shadow. Which is why the oil-sketch, as
argued in the first section above, is the ideal preparation for such
a complex scene.

When Rembrandt's goods were inventoried in 1656, in all
probability he took the clerk through his possessions himself.
Included on the list drawn up on this occasion was the grisaille
which, presumably in Rembrandt's own words, is described as
Een excehomo in 't graeuw, van Rembrand.[16] The oil-sketch had
therefore not been sold. The print after the sketch, on the other
hand, entered the world in large numbers, in such a way that
Rembrandt's name – in his pupil, Van Hoogstraten's words – *al
de werelt over (zou) vliegen* (would be winged all over the world).[17]

In the same period as the *excehomo in 't graeuw* Rembrandt also
painted four other grisailles – in fact, five, one of which was
not, however, done in oils, as we will see (figs 5 a–f); and

fig. 4 Rembrandt,
Bust of an old man, 1633.
Grisaille in oils, 10.6 × 7.2 cm.
Private collection

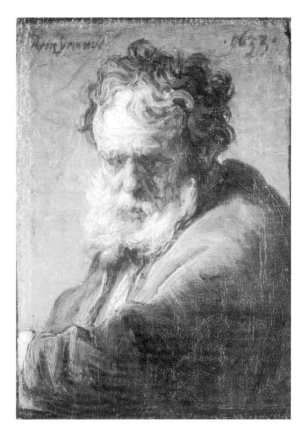

(below left)
fig. 6 Detail of fig. 2.

(below right)
fig. 7 Detail of fig. 3.

fig. 5 Rembrandt, *Bust of an old man*, 1634.
Pen and brown ink with brown wash, 89 × 71 mm,
in the *album amicorum* of Burchard Grossmann,
18 June 1634. The Hague, Koninklijke Bibliotheek

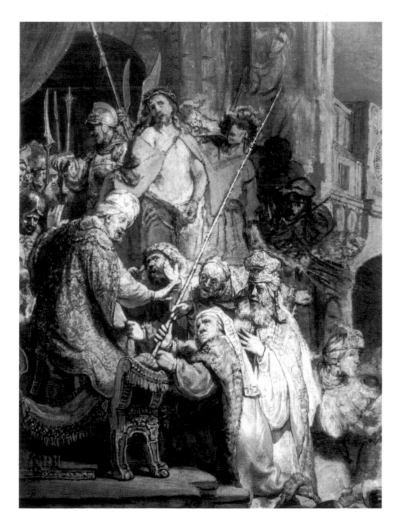

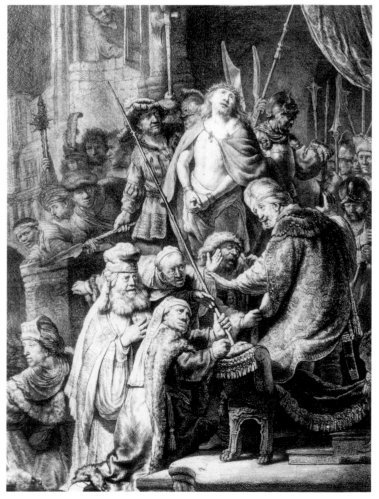

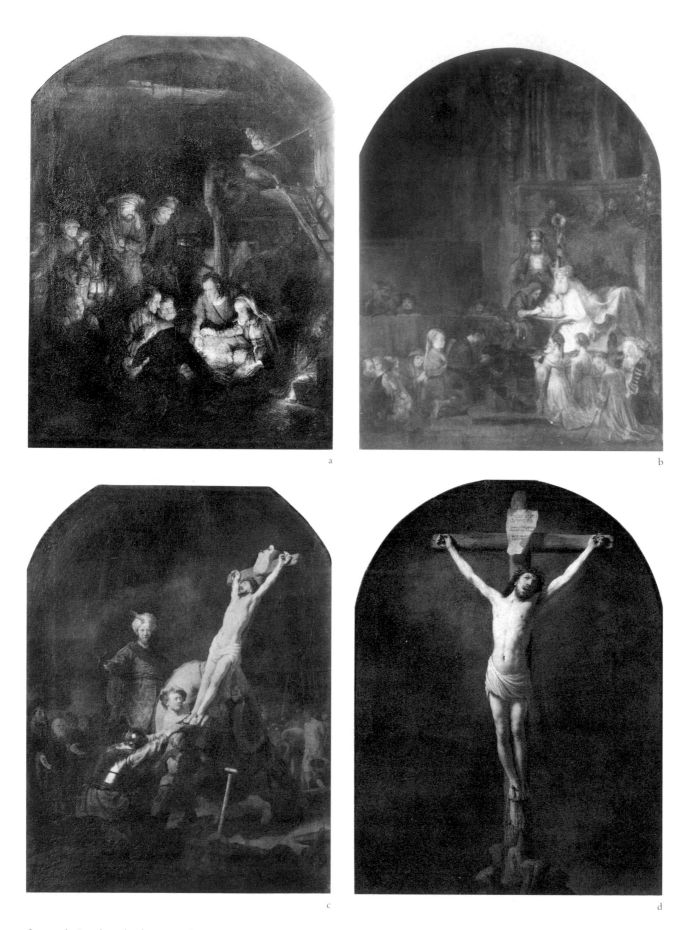

fig. 8 a–h Rembrandt, the painted *Passion series*. a, c and e–h Munich, Alte Pinakothek; b (copy after a lost original)
Braunschweig, Herzog Anton Ulrich-Museum; d Le Mas d'Agenais, parish church (see Table I)

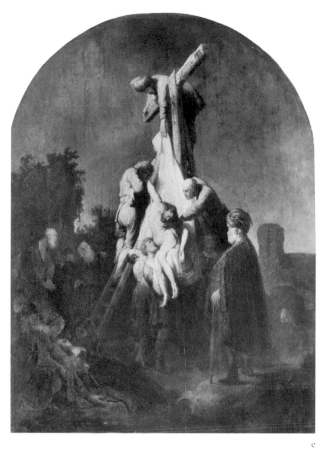

e

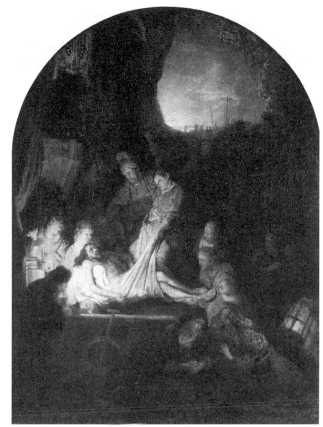

f

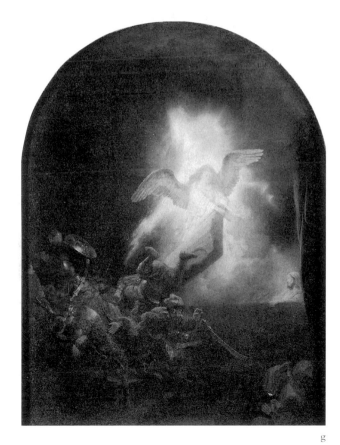

g

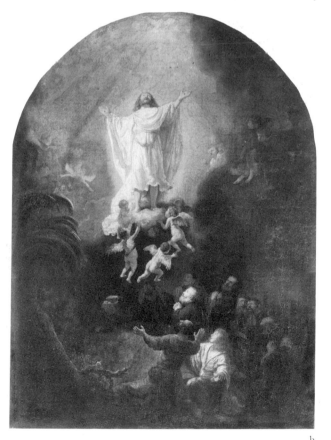

h

they all represent scenes from the Bible. The fact that three of them almost certainly originally had the same format as the *Ecce Homo* suggests the possibility that Rembrandt was preparing to bring out a *series* or some other succession of such monumental, equally large prints.[18]

At first sight it would seem obvious that Rembrandt should have considered bringing out such a series. After all, those 'painter-engravers' whom he so much admired, Albrecht Dürer and Lucas van Leyden, had done just that; and yet this would conflict with the current image of Rembrandt's artistic bent. Did not Rembrandt's first biographer, Arnold Houbraken (1660–1719), write: 'But one thing is to be regretted and that is that he was so quick to change and move on to other things that many of his works were left only half-way finished'?[19] How should one expect such an artist to have the stamina to make a series of prints? The image of the artist patiently at work turning out a series also conflicts with the image of the inspired artist – Rembrandt serving as the prototype of such an image in our own time. This view of Rembrandt would seem to be corroborated by the uneven way in which his sole series of paintings came into being, the *Passion series*. The origin of this series is usually taken to be the result of a commission, but that is not entirely the case. The commission, from Prince Frederik Hendrik, arrived only after three of the paintings in the series were finished, the *Christ on the cross*, the *Raising the cross* and the *Descent from the cross*. Frederik Hendrik, doubtless through the agency of his secretary Constantijn Huygens, had bought the latter two of these three and subsequently commissioned three more, the *Entombment*, the *Resurrection* and the *Ascension*. Only later did Rembrandt receive the commission for the *Birth of Christ* – usually referred to as the *Adoration of the shepherds* – and the *Circumcision*. The first painting of the series, the *Christ on the cross*, must presumably have been painted initially as an independent work, in competition with Jan Lievens (and Rubens). Nonetheless, it has the same format and should be seen as the germ of the series. This painting has ended up in a French parish church; the six remaining works for Frederik Hendrik now hang in the Alte Pinakothek in Munich, while a reliable studio copy of the seventh, lost work is to be found in Braunschweig (fig. 8 a–h).

TABLE I

Rembrandt's painted *Passion series* in iconographic order

Title	Date	Height	Width
a. *The birth of Christ*	1646	97 cm	71.3 cm
b. *The circumcision* (copy)	1646	98 cm	73 cm
c. *The raising of the cross*	1632/33	96.2 cm	72.2 cm
d. *Christ on the cross*	1631	99.9 cm	72.6 cm
e. *The descent from the cross*	1632/33	89.4 cm	65.2 cm
f. *The entombment*	1636–39	92.5 cm	68.9 cm
g. *The resurrection*	163(9)	91.9 cm	67 cm
h. *The ascension*	1636	92.7 cm	68.3 cm

The rather laborious genesis of this series would seem to confirm Rembrandt's image as a capricious artist. Remarkably, the fact that he – apparently on his own initiative – prepared two series of etchings in and about the year 1654 has received very little attention in the Rembrandt literature.[20] One of these series consists of six etchings of a horizontal format with scenes from Christ's childhood (fig. 9 a–f).

TABLE II

The childhood of Christ in iconographic order

Title	Date	Height	Width
a. *The adoration of the shepherds* (B.45)	1654	10.6 cm	12.9 cm
b. *The circumcision* (B.47)	1654	9.7 cm	14.4 cm
c. *The flight into Egypt* (B.55)	1654	9.5 cm	14.4 cm
d. *Virgin and child* (B.63)	1654	9.5 cm	14.5 cm
e. *Christ disputing with the doctors* (B.64)	1654	9.5 cm	14.4 cm
f. *Christ and his parents returning from the Temple* (B.60)	1654	9.5 cm	14.4 cm

The second sequence intended as (part of) a series, all sharing the same format, consists of four etchings with scenes from the life of Christ (fig. 10 a–d).

TABLE III

Title	Date	Height	Width
a. *The presentation in the temple* (B.50)	c.1654	21 cm	16.2 cm
b. *The descent from the cross* (B.83)	1654	20.7 cm	16 cm
c. *The entombment* (B.86)	c.1654	21.1 cm	16.1 cm
d. *The supper at Emmaus* (B.87)	1654	21.2 cm	16 cm

There are several reasons for this lack of attention to the fact that we are dealing here with a series. Firstly, the relevant prints are never treated as a series, or reproduced as such, in surveys of

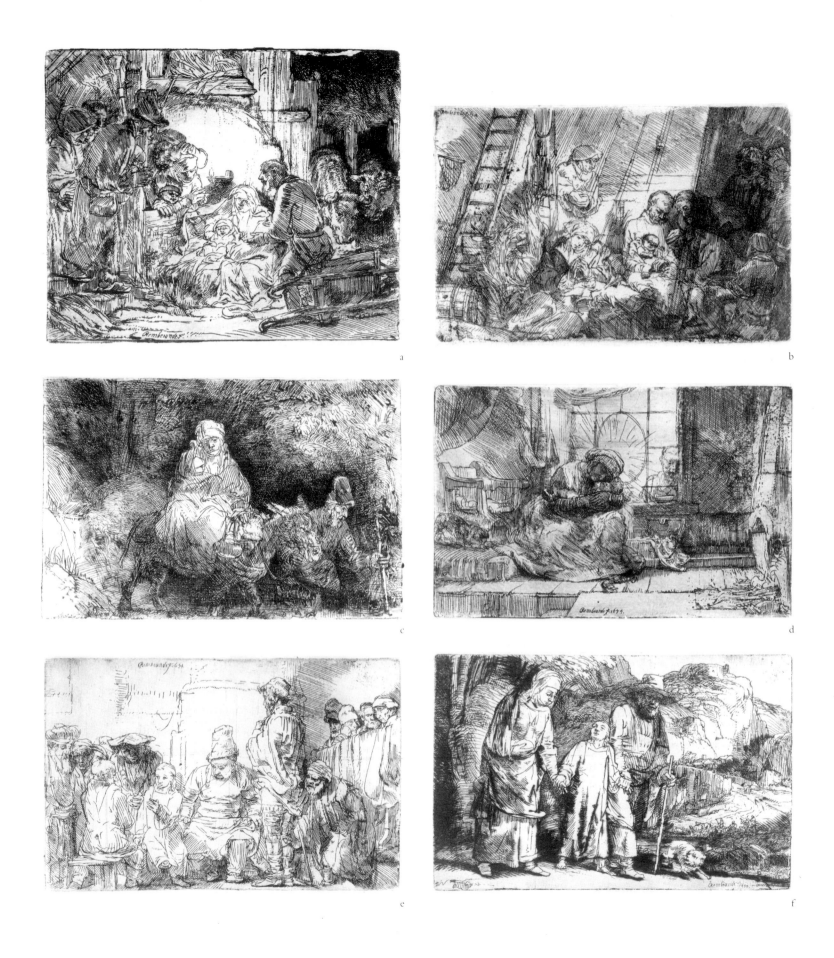

fig. 9 a–f Rembrandt, series of etchings with scenes from the childhood of Christ. Amsterdam, Rijksmuseum (see Table II)

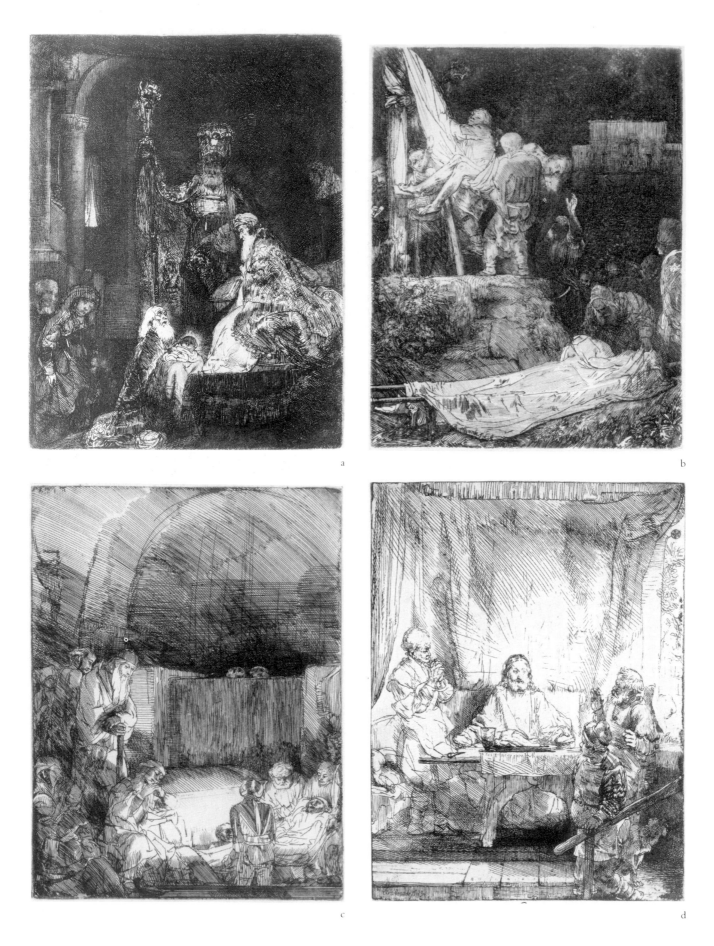

fig. 10 a–d Rembrandt, series of etchings with scenes from the life of Christ. Amsterdam, Rijksmuseum (see Table III)

Rembrandt's graphic work. Secondly, both series give the impression of being incomplete. The first of them contains only scenes from Christ's childhood and leads to the expectation that more ought to have followed. The second series seems to be highly heterogeneous: a scene from Christ's childhood, two from the Passion and another from the period following the resurrection.

That Rembrandt did really think in terms of series of prints is testified in a document of 1671 concerning the rights of ownership of the *Simeon with the Christ child in the temple*, painted in 1669 and now in Stockholm. Following that discussion, Cornelis van Everdingen, who states that he had been in Rembrandt's studio many times, adds to his testimony 'that he [Rembrandt] had in his possession some polished plates from Kattenburgh [a gentleman-dealer] on which to carry out the passion'. [21]

In the foreground of our discussion, as announced above, stands another possible series or suite of loosely connected prints. But these were exceptionally large plates. On the basis of their approximately similar formats, there are at first sight three works that qualify for inclusion in this intended sequence of related prints. A possible objection to such an assumption might be that the similarity in the formats of the works concerned was merely the consequence of standard paper formats at the time; standardization of formats, however, only began to take shape in the second half of the seventeenth century. [22] Another more serious objection would be the fact that two of the works under discussion are of a vertical format, while the third is horizontal.

The two large oil-sketches executed in grisaille of about the same size as the *Ecce Homo* are the *Joseph telling his dreams* (fig. 11) and the central part (plus a small strip added on the right side) of the *St John the Baptist preaching* (figs 12 and 13; see Table IV). If there is a convincing case to be made that they were originally as large as the *Ecce Homo,* we now need to look more closely here at the changes in format that these two grisailles have undergone in the course of their existence. The grisaille of *Joseph telling his dreams* lacks small strips from both the right and left sides. This may be inferred from the fact that the last figure of the date is missing from the right-hand margin, while the passage with the figure of a woman on the left is incomplete in a way which suggests that here, too, a small strip of the original paper on which the sketch is painted must have been cut off. When one analyses the complex genesis of the painting of *St John the Baptist preaching* it becomes evident that in its

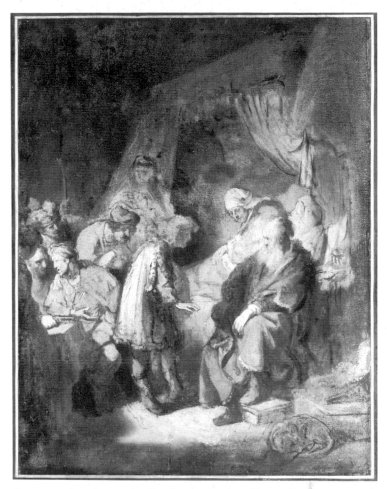

fig. 11 Rembrandt, *Joseph telling his dreams*. Grisaille in oils on paper stuck on card, 55.8 × 38.7 cm. Amsterdam, Rijksmuseum (exh.)

original form it, too, could have had the same format as the *Ecce Homo* grisaille and print. It consists of a central piece – with a small strip attached to the right edge at an early stage – and subsequent enlargements on all sides (see fig. 13). The central part with the attached strip (together slightly smaller than the *Ecce Homo*) was in fact cut down around the edges when the loose piece of canvas on which it was painted, together with a larger piece of canvas laid over it, were together glued on to a panel; after which both canvases, inside the border of the original canvas plus strip, were cut through with a sharp knife – much as a workman lays floor coverings today – so that old and new canvas were precisely aligned. The feet of the Pharisees in the foreground and other elements at the margins of the original composition were thus sacrificed and had to be painted afresh on the new canvas. Subsequently, the crowd surrounding the Baptist was extended on this new canvas. This operation was quite possibly executed some years after the central piece

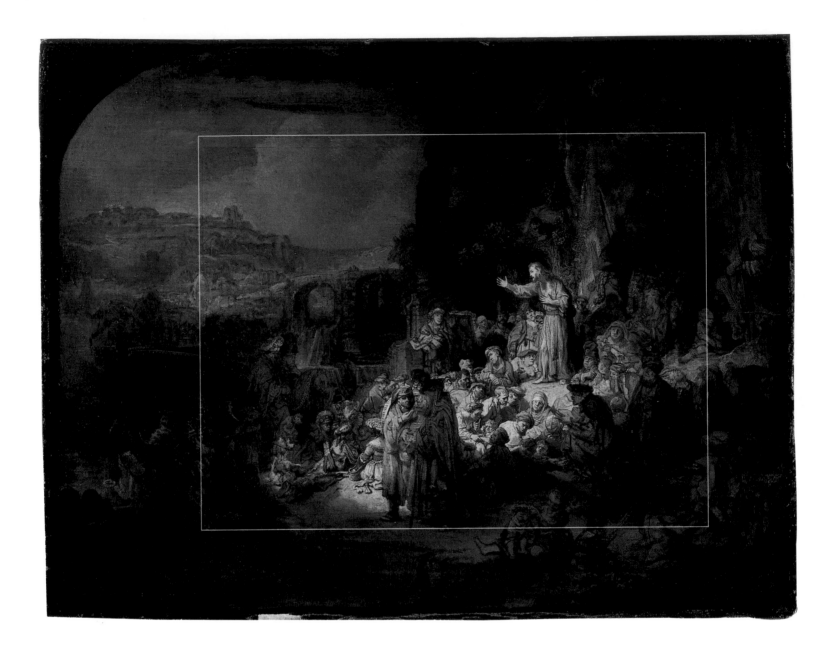

fig. 12 Rembrandt, *St John the Baptist preaching*. Grisaille in oil on canvas stuck to canvas, 62.7 × 81 cm (reproduced showing its hypothetical original format *c.*44 × 55 cm). Berlin, Staatliche Museen, Gemäldegalerie

was painted, with an eye to the sale of the grisaille as an independent work of art.[23] To grasp the original format of the *St John the Baptist preaching*, one therefore has to imagine one or a few centimetres added to the present-day format of the central piece plus strip; and this approximates to the format of the *Ecce Homo* (see Table IV).

Did Rembrandt really therefore have in mind a group of equally large prints, to be executed largely or entirely by Jan van Vliet, like the *Ecce Homo*, on the basis of his 'inventions' executed as oil-sketches? The fact that the *St John the Baptist preaching* is painted on canvas is not a decisive argument against

this assumption. Transferring the composition on to an etching plate could have easily been carried out by means of an indirect tracing method. The step from oil-sketch to etching plate, however, remained as unfulfilled here as it did with the *Joseph telling his dreams*. The fact that Rembrandt made a much smaller etching of the same subject some five years after completing the latter grisaille is of scant significance in the present context, even though that etching was largely based on the grisaille (see cat. 31).

What is crucial for the hypothesis of a series, planned but never completed, is that the three grisailles so far discussed have (or originally had) virtually the same format as the 1633 print after Rembrandt's *Descent from the cross*, one of the scenes from the painted *Passion series* (see fig. 8e; fig. 14, Table I and Table IV, cat. 23).

fig. 13 X-radiograph of fig. 12.

(below)
fig. 14 Rembrandt,
Descent from the cross, 1632–3.
Oil on panel, 89.6 × 65 cm.
Munich, Alte Pinakothek

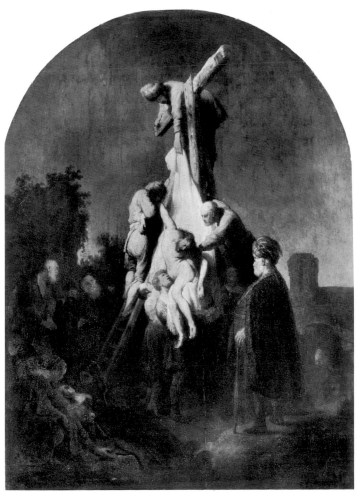

TABLE IV

Title	Date	Largest side	Smallest side	
a	*The Descent from the cross* etching (fig. 16)	1633	53.2 cm	41.3 cm
b.	*Joseph telling his dreams* grisaille (fig. 11)	c. 1633	55.8 cm	38.7+ x cm
c.	*Ecce Homo* etching (fig. 3)	1634/6	55.3 cm	44.2 cm
d.	*St John the Baptist preaching* grisaille (fig. 12)	c. 1635	53+ cm	39.8+ y cm

As previously mentioned, the *Descent from the cross*, together with the *Raising of the cross*, formed the beginning of a series of seven equally large paintings for Frederik Hendrik referred to as the *Passion series*, together with an eighth – the *Christ on the cross* – the germ of the series, all of them originally with an arch at the top.

At a very early stage, the idea may have been born of making prints after paintings from this series. Early in 1633, Jan van Vliet made his reproductive print after the *Descent from the cross* (cat. 22). The plate for this print failed because of a fault in the etching ground (fig. 15). A second attempt in the same year was more successful (fig. 16; cat. 23). It is important to point out that the composition of this second print now acquired a rectangular format instead of the arched top in the painting and in the failed print.

If the suspicion expressed above is correct, that the *Ecce Homo*, the *Joseph telling his dreams* and the *St John the Baptist preaching* belong to a planned sequence of prints, this immediately raises the question of whether the print of the *Descent from the cross* was also meant to belong to this hypothetical group. Given its dating in 1633, it is highly probable that it would, in that case, have been the first to be executed. In this context it is interesting to remember that Rembrandt took steps with precisely this print – as he did two years later with the *Ecce Homo* – to protect his authorial rights: in addition to the signature, both plates bear the inscription: *cum pryvl* [cum privilegio]. An addendum to this inscription in the *Descent from the cross* is equally interesting: *Amsterdam Hendrickus Ulenburgensis Excudebat* [Hendrick Uylenburgh published this]. This inscription was added in the third state which, as Hinterding has established, could already have existed in 1633 (fig. 17).[24] This inscription raises the question of whether, and to what extent, Hendrick Uylenburgh was involved in the plan, as tentatively proposed here, to bring out a series of prints. The answer to this question could throw an interesting light on a crucial period in Rembrandt's career – the period that begins in 1631 with Rembrandt's move from Leiden to Amsterdam, up to 1635 or early 1636. During this period he lived and worked in the house of Hendrick Uylenburgh. Most previous authors have tended to see this period as an informal lodging arrangement with the cousin of Rembrandt's future wife. It is much more probable, however, that the business aspects of the arrangement were far more significant than the personal.

Rembrandt and Uylenburgh

There is much to be said for the suggestion that Rembrandt's sojourn with Uylenburgh had to do with a rule in the guild system which prescribed that a young painter who wished to establish himself as master in another city should first have to serve a considerable time under a master already established in that city. This is set out, for instance, in the Hague and Haarlem ordinances. A great deal of information about the Amsterdam Guild of St Luke was lost in the nineteenth century, but the parallels with guilds in these other cities permit us to obtain a clear impression of the situation in Amsterdam. The fact that Rembrandt became a member of the guild only in 1634 does in fact indicate that there could have been just such a transitional period.[25]

Hendrick Uylenburgh, who refers to himself in one document as a painter and in another as an art dealer, can probably best be described as an 'entrepreneur in paintings and related art works'. Of his own works, nothing remains known, except for two drawings that have tentatively been ascribed to him.[26] There was a great deal going on in the art trade of Hendrick and later that of his son Gerrit, who continued the business. All conceivable kinds of painted product must have been traded in and manufactured in their workshop. In this connection, it is striking that the nature of Rembrandt's production changed from the moment he came to Uylenburgh and again changed significantly after he left Uylenburgh's house. What one most obviously notices in this regard is the large output of portraits by Rembrandt and (in part) anonymous assistants who worked in Rembrandt's style during this Uylenburgh period. The fact that Govert Flinck, according to Joachim von Sandrart, went to work for Uylenburgh as a portrait painter after his apprenticeship with Rembrandt lends support to the suggestion that there had been a similar relationship between Uylenburgh and Rembrandt – either in some form of service or, for instance, a kind of partnership.[27] A point of evidence for the latter kind of arrangement is that Rembrandt continued to sign his work with his own monogram or name, a privilege which the guilds usually did not permit to subordinates in the workshop.[28]

The fact that Uylenburgh functioned as the publisher in the instance of the print after the *Descent from the cross* could mean that the production of this and possibly other reproductive prints should be seen in the context of Uylenburgh's business. Furthermore the fact that it was once more the graphic artist Jan van Vliet who executed the print after the *Descent from the cross* throws light on Uylenburgh's firm and the roles played in it by Uylenburgh, Rembrandt and, it would seem, Van Vliet too. It was previously thought that after Rembrandt's departure from Leiden, Van Vliet had remained behind in that city and there produced the eleven reproductive prints of works by Rembrandt mentioned above (fig. 1 a–k).[29] It is now clear – particularly as a result of the research of recent years into watermarks – that the collaboration between Rembrandt and Van Vliet continued till 1635.[30] In view of the fact that of Van Vliet's eleven reproductive prints after paintings by Rembrandt, the first five are dated 1631 (fig. 1 a–e), and that production of the other six plates continued in 1633 (fig. 1f) and 1634 (fig. 1 g–k), one might even speculate that Uylenburgh was closely involved in

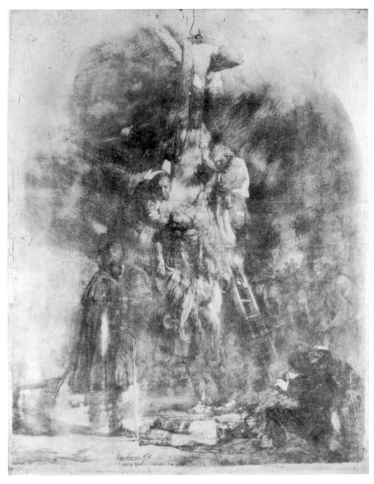

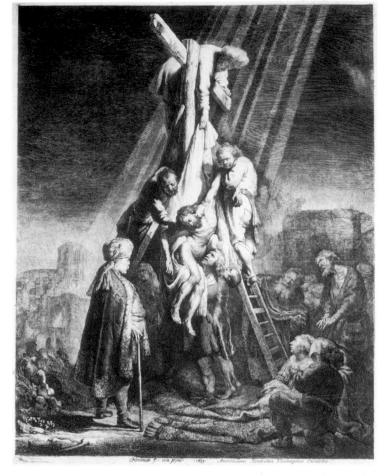

fig. 15 Jan van Vliet after Rembrandt, *Descent from the cross (first plate)*, 1633. Etching, 51.8 × 40.2 cm. Amsterdam, Rijksmuseum

fig. 16 Rembrandt, *Descent from the cross (second plate)*, 1633. Etching and engraving, 53.2 × 41.3 cm. London, British Museum (B.81)

fig. 17 Detail with inscription on third state of fig. 16. Amsterdam, Rijksmuseum

planning and implementing the production of that first series of reproductive prints after Rembrandt, and that part of this work may even have been carried out in Amsterdam. The fact that paper used in 1631–2 for some of the prints by Van Vliet as well as by Rembrandt had the same watermark led Hinterding to wonder whether Rembrandt kept returning to Leiden to work on his prints. However, since both artists made prints on paper with the same watermark in 1634 and 1635, one might equally ask whether perhaps Van Vliet and Rembrandt might have worked together in Amsterdam. Certainly, no document gives any indication as to where Van Vliet was residing during that period. An inscription on a drawing signed by Van Vliet may be read as [An]twer.1632, which might suggest that he was temporarily resident in Antwerp at the time.[31]

Hinterding pointed out that 1635, the date of the first state of Van Vliet's last print after a prototype by Rembrandt, the *Ecce Homo*, coincides with the year that Rembrandt left Uylenburgh's house[32] (at the very latest, February of 1636) and with it, in all probability, ended any business relationship between the three men. One may therefore justifiably wonder whether Van Vliet's activity as an engraver of Rembrandt's prototypes was initiated by Uylenburgh rather than by Rembrandt himself. Against this, however, must be set the fact that as late as 1656 *a box of prints of Van Vliet after paintings by Rembrandt* was found among Rembrandt's possessions.[33] The year 1635, when Van Vliet made the print after Rembrandt's *Ecce Homo* grisaille, was thus also the year when work on the presumed series stopped. The monochrome oil-sketches lying ready to be brought out as prints after the *Ecce Homo* were no longer to fulfil their purpose – not only the *St John the Baptist preaching* and the *Joseph telling his dreams*, but in all probability too, as I shall argue below, the *Christ with his disciples in Gethsemane* in Haarlem, done in pen and ink, with wash and chalk (fig. 18), and perhaps also the *Lamentation* in the National Gallery in London (fig. 21).

An intended Passion series or a suite of loosely related prints?

The core of the following speculations is that there may have been a plan to produce prints of one or possibly more paintings from the *Passion series*; and also to complement and extend this series with prints after the oil-sketches painted *in 't graeuw* by Rembrandt specifically for that purpose (plus one drawing with the same pictorial effects). By combining these two series, as it were, a single series of prints could be created depicting scenes of the life of Christ, approaching the compass of comparable print series by Dürer, Cranach, Lucas van Leyden and Hendrick Goltzius. Interestingly, Jan van Vliet, while transferring Rembrandt's inventions to copper, was inventing and executing a passion series of his own, consisting of six prints.

It has to be clearly acknowledged in advance that, neither for the painted *Passion series*, nor for the group of oil-sketches executed in grisaille (plus the Haarlem drawing, fig. 18) do we know the scope that was intended. Nor do we know whether the 'programme' for the painted *Passion series* was already determined before work began. The addition to this series of two scenes from Christ's early life, the *Birth of Christ* (as Rembrandt himself called the *Adoration of the shepherds* (fig. 8a and b) in a letter to Constantijn Huygens) and the *Circumcision* already suggests that the series may originally have been envisaged on a larger scale, possibly encompassing the entire life of Christ. It should be emphasized, however, that what are usually called 'passion series' were not primarily narrative sequences – like cartoon strips – relating the sacred story step by step. A comparison of different passion series can only impress us with the remarkable differences between them. When one thinks that the lost *Passion series* by Jacob Jordaens consisted of twelve paintings and that by Arent de Gelder runs to twenty-two pieces, it becomes evident how much such series could differ in compass. With print series there are even greater variations: Dürer's *Small Passion* includes thirty-seven prints, Goltzius' only twelve. Jan van Vliet's series contained only six. It is therefore impossible to estimate how big the series mooted here would have been.

Apparently there was no canon for such series. In this context, it is interesting that the fourteen Stations of the Cross found in Catholic churches and in Jerusalem were only established canonically in 1751. Previously there had been as great a variation as in the passion series discussed here. Rather than purely narrative sequences, such scenes embody a variety of theological lessons and devotional *foci*. This should be borne in mind in any consideration of the apparent incompleteness of Rembrandt's series – including the putative series discussed here. The most obvious 'irregularity' here, in an iconographic sense, is of course the scene from the life of Joseph, a figure from the Old Testament (see fig. 11). At first sight, this would appear a strong argument against the idea of a possible plan for a coherent series of scenes from the New Testament. Yet it is entirely possible for an isolated Old Testament scene to have its place within such a series, just as Albrecht Dürer's so-called 'Small Passion' begins with the *Fall* and the *Expulsion from Paradise*, followed by the *Annunciation* and the *Entry into Jerusalem*. In that case, however, such an Old Testament beginning would be entirely sound theologically, since the Crucifixion and Resurrection of Christ at the end of the series were – and are – regarded as the release from the original sin, punished by the expulsion from paradise. Another example of an apparently isolated Old Testament scene is the series of wood-cuts of New Testament scenes by Lucas van Leyden which begins with the *Slaying of Abel by Cain* (Hollstein 23). A print with the scene of *Joseph telling his dreams* need not therefore in itself discount the idea of a series of prints.

In fact, when one delves further into the currents of seventeenth-century Protestant thought, it turns out that precisely this scene of *Joseph telling his dreams* could very well fit into a series of prints with scenes from the life of Christ. What is even more interesting is that the choice of this particular scene would seem to be a further pointer to Hendrick van Uylenburgh having played an important role in the initiation of this project, for Uylenburgh belonged to the Mennonites, one of the Anabaptist sects of sixteenth- and seventeenth-century Protestantism. Two and possibly four of the intended prints appear to have specifically Mennonite connotations. This is certainly the case with the *Joseph telling his dreams* and the *John the Baptist preaching*.[34]

The following outline of the essence of Anabaptist/ Mennonite theology, necessary for my argument, relies heavily on Pieter Visser's doctoral thesis of 1988.[35]

Mennonites were united in fraternities of brethren. There were no clergy or clerical hierarchy, only elders. The Bible provided the sole touchstone for the life and teaching of all groups. One of their most important doctrines was, of course, the repudiation of infant baptism; they considered the circumcision – and the child baptism based on it – to have been superseded by Christ's baptism by John the Baptist, and from

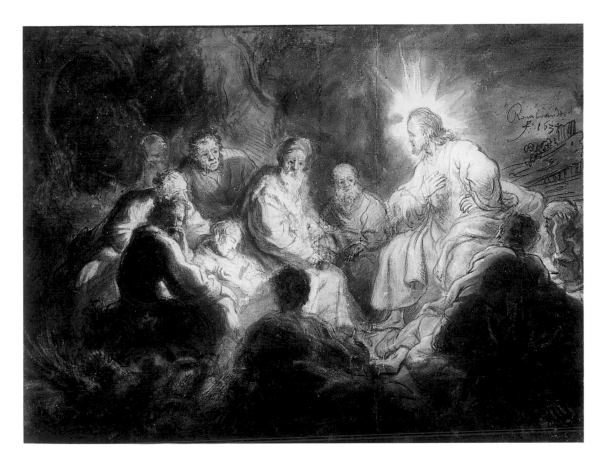

fig. 18 Rembrandt,
Christ with his disciples in Gethsemane, 1634.
Pen and brown ink with brown and other washes and red and black chalk,
357 × 478 mm.
Haarlem, Teyler Museum

this it followed that adult baptism alone was considered in accordance with the Bible. In other protestant communities, typological thinking and Old Testament prefigurations of the sacred history of the New Testament played a lesser role, but among the Anabaptists this aspect of theology was highly important. The Old Testament was seen as 'shadowing' the Truth made manifest in the New Testament. The scriptures were thus typologically interpreted in christocentric fashion, with all Old Testament types and ordinances referring to New Testament antitypes, to Christ and his commandments, while for the Reformed Church, for instance, the Old Testament carried the same weight as the New.

Joseph was among those prefigurations of Christ that were held by Anabaptists to be exceptionally significant, as the parallels between his life and that of Christ were considered outstandingly manifold. The Mennonite, Pieter Jansz. Twisck's Concordance of 1632 (his *Bybelsch Naem- ende Cronijck-Boeck*) was probably published shortly before Rembrandt painted the grisaille of *Joseph telling his dreams*. This book briefly summarized the biblical stories followed by commentaries and interpretations of their spiritual meaning (their *gheestelycke verklaringh ende leeringhe*). He summarizes the story of Joseph's dream as follows: 'He had a dream that his brothers' sheaves bowed down to his; in another dream the Sun, Moon and eleven stars bowed down

to him. For this his brothers hated him.' Twisck's 'spiritual explication and lesson' for this story reads: 'Joseph's dream is not only fulfilled in his own life [in reality Joseph's brothers did bow down to him when he had become 'ruler over the land of Egypt'] but also spiritually in Christ: for the schools of the Jewish brethren could not understand this elevation in Christ, despising him for speaking of his glorification or his elevation. But the sheaves of the faithful Brethren [meaning the disciples – with whom the Anabaptists identified themselves] who obey the will of the Father worshipped him directly after the resurrection and acknowledged him as their Lord and God.'[36] In the words of the Anabaptists, Joseph's dream is, as another Mennonite, Jan Philipsz. Schabaelje, noted in 1634: 'one of the figurations of the life and Passion of our Lord Jesus Christ ... as though seen through a mirror'.[37] Within this conceptual scheme, Rembrandt's grisaille with *Joseph telling his dreams* announces the way the faithful shall worship Christ after the resurrection, which may be considered the fulfilment of the Passion.

In biblical chronological terms, the next scene in Rembrandt's presumed series is the *St John the Baptist preaching*. The Anabaptist significance of this grisaille is glaringly obvious here, as it refers to one of the central tenets of Anabaptist theology: adult baptism, the symbol of a conscious choice for a life in Christ. In the scene depicted, the whole world – symbolized

by adults from all parts of the world, from Japan to America – listens attentively to John's words. The small scenes with children in Rembrandt's oil-sketch, which at first sight appear to be merely genre-like details, would seem to be intended to illustrate the 'foolishness' of children in matters of belief. The woman to the left of the Pharisees has a sleeping infant on her lap; to the right of the Pharisees, in the centre of the composition, a woman tries to silence a crying child; while close by two children fighting over a bunch of grapes are being scolded by an angry man. On the piece added later, Rembrandt painted further small scenes, emphasizing the foolish innocence of children (together with scenes of dogs which merely copulate and fight and are being watched by a child on his mother's lap and by two heathens on the extreme left who – like the Pharisees in the foreground – turn their backs to St John the Baptist). The Mennonite explanation of the baptism by John was that he was, in the words of Twisck, 'announcing through external baptism by water another, far higher baptism, that of the conversion, improvement, the inward baptism of the heart, the baptism in Christ. It is a conversion of heart and mind'.[38] Menno Simons, the initiator of the Mennonite movement in Anabaptism, was remarkably explicit about the position of children in this context when writing that Christ and the Apostles '... teach that this new birth happens through God's word ... which word is not for deaf, simple and foolish children'. In the margin to this passage is written 'Infantes non regenerantur' (children are not reborn).[39] In this interpretation, the word of John was more meaningful than the mere act of baptism itself.

The third grisaille in the biblical chronology – this time executed not in oil paints but with an equally powerful and organized treatment of light and shadow in ink, wash and chalk – shows *Christ with his disciples in Gethsemane* (fig. 18). The setting is recognizably a garden from the details of a tree and other growth, and the suggestion of a fence behind the figure of Christ. The drawing has been cut down both to the right and below, and now measures 35.7 × 47.8 cm. A strip roughly 8 cm wide may be missing from the right side with one or possibly two figures, one of which has been transferred very sketchily to the upper left of the group.[40] The view that the drawing was originally made with an eye to the hypothetical suite of prints is defensible on this basis. Also given is the fact that in all pictorial respects it matches the grisailles almost perfectly.

The iconography of this drawing has always been considered exceptional and generated much speculation which need not be summarized here.[41] In scenes of Christ in the Garden of Gethsemane, Christ is usually shown in prayer while the three accompanying disciples who were to keep watch are depicted sleeping. In the Haarlem drawing, Christ is shown speaking in the midst of his disciples. One of the disciples is strikingly shown yawning as he averts his head – the wide open mouth is emphatically rendered – while another is already asleep. Christ is apparently urging his disciples to stay awake. In St Luke's Gospel, where he speaks to all of them, not just the three as in the other Gospels, he says, 'Pray that ye enter not into temptation'. According to the Bible story, there were eleven disciples in the Garden of Gethsemane; the twelfth, Judas, had already betrayed Christ and would later arrive with the soldiers who would take the Messiah prisoner. In the drawing, only ten disciples are visible, one of the arguments for a figure having possibly been cut from the right side.[42] The unusual

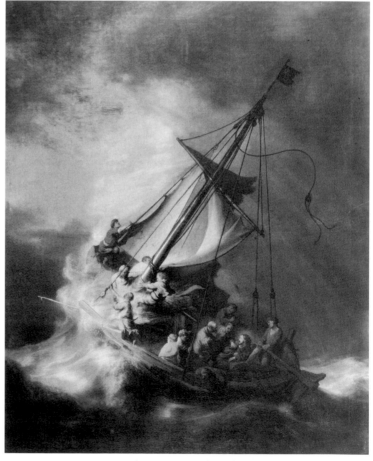

fig. 19 Rembrandt, *Christ in the storm on the Sea of Galilee*, 1633. Oil on canvas, 160 × 128 cm. Boston, Isabella Stewart Gardner Museum

iconography is wholly intelligible in an Anabaptist perspective. Thus, in Twisck's interpretation, the eleven apostles are considered to be the nucleus and the beginning of their own brotherhood.

The eleven brothers who, symbolized as stars, bowed down to Joseph in the second dream were seen as the prefiguration of the eleven apostles who worshipped Christ after his resurrection. These same brothers of Joseph, however, were also seen as prefiguring the Jews who wanted Christ put to death. As Twisck wrote in the commentary to the first dream, quoted above: 'the Jewish brethren … who could not understand the elevation in Christ, despised him, when he spoke of his glorification or elevation.' Twisck refers in this connection to a passage from John 5: 18, which reads: 'Therefore the Jews [in this context meaning the Pharisees] sought the more to kill him, because he … said also that God was his Father, making himself equal with God.'

It is in this web of typological references that perhaps one finds the explanation for the great emphasis – an emphasis that is unique in the pictorial tradition of the *Ecce Homo* scene – with which Rembrandt represents the Pharisees in his *Ecce Homo* depiction.

This digression into Anabaptist theology was necessary to establish the plausibility of the case that Rembrandt was indeed engaged on a coherent group of prints. The other reason for this excursion was to underpin the role in this project, already suggested on other grounds, of Hendrick Uylenburgh – or one of his 'brethren'.

It is striking that two of Rembrandt's paintings of the same period, the Boston *Christ in the storm on the Sea of Galilee* of 1633 (fig. 19) and the Moscow *Incredulity of St Thomas* of 1634 (fig. 20), both centre on the theme of belief in Christ's divinity. As in the Haarlem drawing, both paintings depict the whole group of disciples, which in the iconographic tradition of the *Incredulity of St Thomas* is as unique as in the *Christ with his disciples in Gethsemane*. And *Christ in the storm* is rarely depicted anyway. This emphasis on showing the whole group of disciples – as it were in an 'anti-hierarchical' way – accords with the Anabaptist brethren's strong identification with Christ's disciples. It is therefore likely that these paintings should also be seen in a Mennonite context. The fact that these are individual works shows that the (planned) prints based on the grisailles discussed here could also be seen separately and not necessarily as parts of a single series.

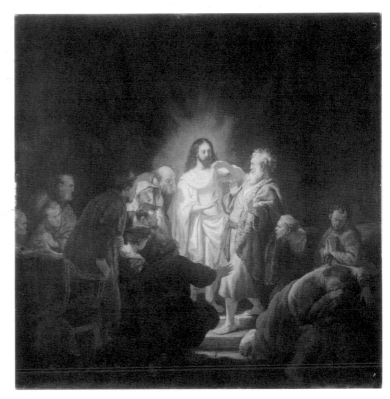

fig. 20 Rembrandt, *The incredulity of St Thomas*, 1634. Oil on panel, 53.1 × 50.5 cm. Moscow, Pushkin State Museum of Fine Arts

The two remaining oil-sketches *in 't graeuw* of the same period, the *Lamentation* in London (fig. 21) and the Glasgow *Entombment* (fig. 22), also show scenes from the Passion. Like the *Joseph telling his dreams*, the *St John the Baptist preaching* and the Haarlem drawing with *Christ with his disciples in Gethsemane*, no etchings resulted from them. Both grisailles are considerably smaller than the works discussed so far. Efforts to link them with the hypothetical suite of works would therefore seem to be rather forced, although the possibility should not be excluded.

The *Lamentation* in London had an extraordinarily complex genesis that has been described in detail elsewhere.[43] It is improbable that this small picture in its present state still displays its original format. The scale of the figures is identical to that in the *St John the Baptist preaching*, while the composition is peculiarly cramped in comparison with the latter. The irregularly cut and torn piece of paper with the core of the present composition was removed by Rembrandt from a larger sheet of paper, and subsequently stuck to a rectangular piece of canvas. At a much later date – around 1645 – that piece was attached to a panel of vertical format (fig. 21). The scene was then subsequently extended above and left by another, rather clumsy hand on this new support – presumably in Rembrandt's own studio.[44]

Thus, while the *St John the Baptist preaching* became larger, the core of the *Lamentation* was removed from a larger composition and reduced. For this reason, one should not entirely exclude the possibility that this grisaille was also made with a view to the series of works discussed here.

The fact that the most important elements of the Glasgow grisaille (fig. 22) were eventually worked into the considerably later *Entombment* in the painted *Passion series* (see fig. 8f) does not necessarily mean that the grisaille was made with that painting in mind. Having abandoned the plan, presumed above, to have the more ambitious graphic work executed by Van Vliet or someone like him, this grisaille may have been left unused until it was 'quarried' for elements of the *Entombment* from the painted *Passion series* and later for the *Birth of Christ* (fig. 8a), where we find the group of onlookers from the background of the grisaille in a modified form.

The hypothesis mooted here, of a group of monumental prints with, as it seems, Mennonite undertones, based on

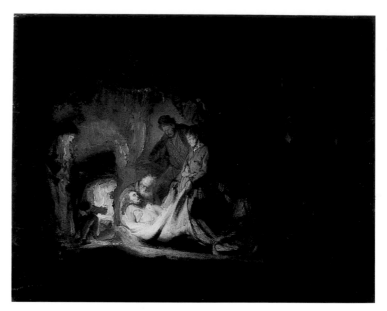

fig. 22 Rembrandt, *The entombment*, 1633–5. Oil on panel, 32.1 × 40.3 cm. Glasgow, Hunterian Art Gallery

Rembrandt's inventions and to be executed mainly by a professional printmaker, against the background of Uylenburgh's business and brethren, may have produced a trail that can be pursued further. In any case, the phenomenon of the group of oil-sketches *in 't graeuw* – and one related drawing – with scenes from the life of Christ, which originated during Rembrandt's first Amsterdam years might in this way be accounted for, even though they were not brought out in print. The exercise, at least, has I hope highlighted the phenomenon of series, and especially print series, in Rembrandt's *oeuvre*, with more emphasis than before.

The concord of the state

On the same occasion that Rembrandt showed his *excehomo in 't graaeuw* to the clerk inventorizing his possessions in 1656, the two men also listed a work with the title – no doubt again provided by Rembrandt – *De eendragt van 't lant* (The concord of the state).[45]

Since John Smith first pointed out in his 1836 *catalogue raisonné* of Rembrandt's paintings that this work may well be Rembrandt's large grisaille now in Rotterdam, this identification has never been challenged (fig. 23). This oil-sketch, detailed in some parts, remarkably cursorily executed in others, has been the topic of much debate as to its function and its exact meaning.[46] In a recent article, Kempers has amassed overwhelm-

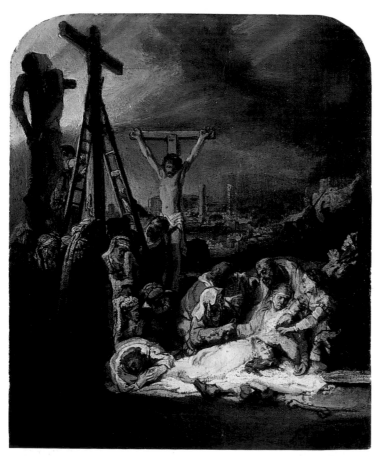

fig. 21 Rembrandt, *The lamentation*, 1634–5. Grisaille in oil on paper stuck on canvas stuck to panel, 31.9 × 26.7 cm. London, The National Gallery

ing evidence to demonstrate that the pictorial language and political symbols employed in it show a strong affinity with that of the political prints and pamphlets that had appeared during the Dutch-Spanish war.[47] The complicated political situation in the United Provinces between 1637 and 1641 was doubtless the background for the commission to provide this sketch, and Kempers convincingly shows that it must have been a member of the Orangist party, possibly Maurits Huygens, who provided the iconographic programme for the warning, embodied in the grisaille, to unite at that stage of the war (which had begun in 1568 and would end in 1648). The warning was especially aimed at the Amsterdam regents (symbolized by the group of horsemen in the right foreground) who, for commercial reasons, wanted to settle the conflict prematurely. The iconography of the grisaille is entirely consonant with the painting being a design for a print and not for any other purpose. This conclusion is supported by the fact that the great variety in the 'finish' of the sketch is comparable with that of the oil-sketch for the *Ecce Homo* and the other grisailles dealt with above. A possible objection to this suggestion is the unusually large size of such a preliminary design. The print, were it to reproduce the grisaille on the same scale, would have measured some 65 × 100 cm. Yet composite prints requiring two or more plates, printed on two or more sheets of paper which were then almost seamlessly glued together, were not exceptional in Rembrandt's day.[48]

Along the top and bottom of the panel, which measures 74.5 × 100 cm, strips of about 5 to 6 cm wide remained

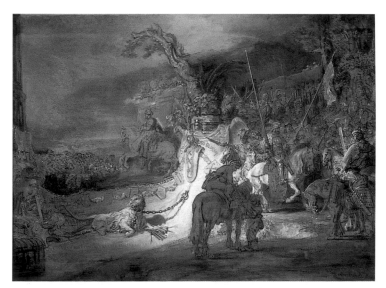

fig. 23 Rembrandt, *The concord of the state*, later 1630s. Oil on panel, 74.5 × 100 cm. Rotterdam, Museum Boijmans Van Beuningen

unpainted until Rembrandt extended the image to the edges at a later stage.[49] The fact that the design did not originally cover the entire surface of the panel will prove significant in the discussion to follow concerning the oil-sketch for the *Larger Coppenol* (see fig. 27).

The signature and date of 164– (the last digit is cut away) on the *Concord of the State* were added later by another hand. On stylistic grounds it is more likely that the painting originated in the late 1630s, which would certainly fit the political situation for which it was designed. On these grounds Kempers considers the year 1637 the most probable date of production.

Oil-sketches for etched portraits

In Rembrandt's time, in addition to painted portraits, there was a demand for portrait-prints. The advantage of such prints is obvious: they could be multiply printed and distributed on a fairly large scale. In the case of illustrious persons – *uomini illustri* – these prints were eagerly collected. They were sometimes conceived as series – a good example of such a series being Van Dyck's *Iconography*, referred to earlier (see note 10).

Rembrandt, too, produced etched portraits. Although there are several of famous men, such as the preachers Johannes Uyttenbogaert, Cornelis Claesz. Anslo and Jan Cornelisz. Sylvius, they were never brought out in a series. It can be assumed that, unlike Van Dyck and his *Iconography*, Rembrandt was not the one who initiated the making of these prints, but rather he was responding to occasional commissions.

Rembrandt made eighteen portrait etchings that should be considered 'official' portraits, to which may be reckoned another four remarkably thoroughly characterized, etched *Self-portraits* of 1631 (cat. 13), 1636 (B.19), 1639 (cat. 34) and 1648 (cat. 58).[50] The portraits of others were made between 1633 and 1665, but the periods from 1646 to 1648 and 1656 to 1658 may be considered the high points of Rembrandt's activity in this area, especially the last period mentioned, when he produced seven etched portraits.

In another essay in this catalogue (pp. 64–81), Martin Royalton-Kisch discusses the role played by preliminary drawings in the case of three of the eighteen portraits. Only in two of them, as far as we know, did Rembrandt employ 'cartoons', detailed drawings whose contours and modelling were indented through on to the etching ground, so that the scale of print and drawing correspond closely.

Similarly, there are remarkably few oil-sketches which correspond with etched portraits. The first of these is the roughly executed, small portrait of *Ephraïm Bueno*, presumably made in 1647, which must have been used in the production of the etching of this physician (figs 24–6 and cat. 55). The second is the small painting of the schoolmaster and calligrapher, *Lieven Willemsz. van Coppenol*, of *c.*1658, which served as a starting point for the so-called *Larger Coppenol* (figs 27–9 and cat. 89).

The fact that only in the case of five of the eighteen etched portraits have drawn or painted preparations been preserved does not mean that all the others were set on the plate without preliminary preparation, though there is every chance that the majority of them were drawn directly on the copper. Just as with many other etchings by Rembrandt (and likewise with the painted portraits) a light sketch applied directly to the definitive support would often have sufficed to determine the 'lay-out' of the print.

The portrait of Ephraïm Bueno

Oil-sketches made with a view to bringing out portraits as prints were not unusual in Holland. One thinks of the sketches made by Frans Hals of Samuel Ampzing, René Descartes and Hendrik Swalmius that were used by such engravers as Jan van de Velde II (1593–1641) and Jonas Suyderhoef (*c.*1613–86),[51] and of the sketch by Thomas de Keyser for the group portrait of *Cornelis Davelaar announcing the arrival of Maria de Medici*, engraved also by Suyderhoef.[52] As mentioned at the beginning of this essay, colour was used in these sketches, certainly as far as the flesh tones are concerned, in the same way as in those oil-sketches by Rembrandt that now need to be dealt with.

The first of these, the *Portrait of Ephraïm Bueno* (fig. 24 and cat. 55), is larger in scale than the etching (fig. 25). It is therefore already unlikely that there could have been any sort of mechanical transference – though in theory it is not impossible. As early as the late fifteenth and in the sixteenth century, there were already geometrical techniques in use for mechanically copying images in reduced or magnified form from one to another support.[53] This cannot be the case here, however, as Bueno's bearing is slightly different in the print – specifically the position of the head in relation to the trunk. The proportions of the arm compared with the head have also been altered, and with good reason, since in the sketch the arm is much too short. Yet

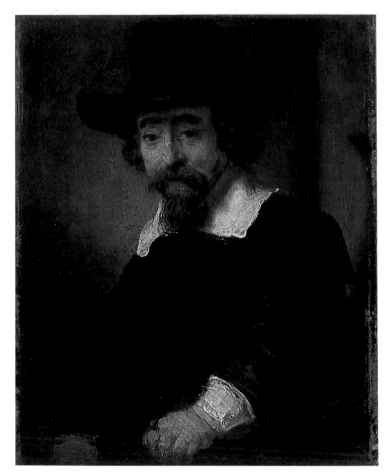

fig. 24 Rembrandt, *Portrait of Ephraïm Bueno*. Oil on panel, 19 × 15 cm. Amsterdam, Rijksmuseum (exh.)

the proportions within head and facial features are so strikingly similar between the sketch and the etching that one can well imagine that some form of mechanical reduction and transference may have been employed, at least for that part of the portrait. Certain solutions in the sketch, such as the articulation of the rear wall and shadow of the hat brim cast on the rear wall, are taken over in the etching in altered form and position. Thus the oil cannot be a free copy of the print, in the way that many copies in circulation after other etchings by Rembrandt are. In addition, the brushwork and paint consistency are familiar as characteristic of Rembrandt; and the type of changes in the hand and in the right side of the collar, which are revealed by the X-radiograph of the sketch, are also typical of him (fig. 26).

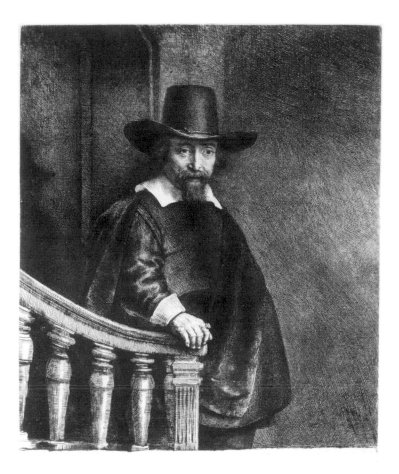

fig. 26 X-radiograph of fig. 24.

fig. 25 Rembrandt, *Portrait of Ephraïm Bueno*, 1647. Etching,
24.1 × 17.7 cm. Amsterdam, Rijksmuseum (B.278)

The larger Coppenol

Of all Rembrandt's portrait etchings, the so-called *Larger Coppenol* (fig. 28; cat. 89) is by far the biggest: 34 × 29 cm. It was long assumed to be self-evident that Rembrandt had made the portrait of *Lieven Willemsz. van Coppenol*, painted on panel (fig. 27), in preparation for this etching. As in the case of the *Ecce Homo* amply dealt with above, it is an exact mirror image of the print, and must have been transferred to the copper plate using some indirect tracing method.

In 1969, however, Hubert von Sonnenburg expressed doubts as to whether the painting had, after all, been made as a preparation for the etching, suggesting that it should rather be considered as a later, mirror-image copy of the print. In an article of 1976 he rejected the painting yet more firmly. Von Sonnenburg's thesis was partially based on what he

considered the – for Rembrandt – unacceptable quality of the painting, and of the head in particular. In addition, he pointed out that the X-radiograph showed, on all sides of the panel, unprecedented strips of X-ray absorbent paint of various widths that had been applied with broad brushstrokes. From this he concluded that the imitator had painted on a panel that had been used before.[54] With these arguments accepted without discussion, the painting virtually disappeared from the Rembrandt literature.[55]

The dendrochronological dating of the panel was the most important reason for the Rembrandt Research Project (which had not committed itself in print to a view as to its status) to investigate the New York sketch further in 1995. It had emerged that the last annual ring of the panel dated from 1634, and that the earliest possible date this support could have been painted on was 1651. This information did not confirm Von Sonnenburg's view that we are dealing with a later imitation; rather, the facts were consistent with the accepted dating of the print in, or shortly before, 1658. Furthermore, as with most of

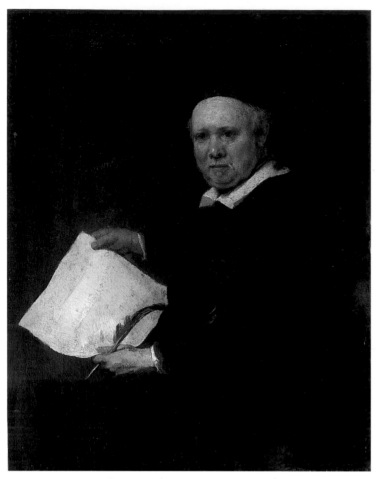

fig. 27 Rembrandt, *Portrait of Lieven Willemsz. van Coppenol*. Oil on panel, 36.8 × 29 cm. New York, The Metropolitan Museum of Art, Bequest of Mary Stillman Harkness, 1950 (50.145.33; exh.)

Rembrandt's panels, the wood appeared to be of Polish/Baltic origin.[56]

Analysis of the X-radiograph, moreover, revealed some ten *pentimenti*, for example in both thumbs, the cuffs and collar, in the feather and in one of the eyes. These *pentimenti*, taken together, excluded the possibility that the painting could be a copy. Similar changes are encountered in many of Rembrandt's paintings in comparable places and in a related way, as for example in the sketch for the *Portrait of Ephraïm Bueno* discussed above. The execution of the painting, as far as may be judged given its worn and partly overpainted condition, also indicates that it should be reattributed to Rembrandt. The brushwork, crisp and economic while at the same time loose, in details like the hands, the cuffs and collar and the feather, corresponds to Rembrandt's own manner in paintings with small-scale details, as in his small history paintings from the late 1640s and 1650s.

It is therefore almost certain that we are dealing here with a

sketch for the *Larger Coppenol* from Rembrandt's own hand. There are still several questions, however, that need to be addressed, the most important of which concern the obviously weak quality in the execution of certain parts, including the head. Another question is why a preparatory sketch, on the same scale – unlike the sketch and print of *Ephraïm Bueno*, should have been made specifically for this etching. The last question relates to the mysterious, light brushstrokes found in the X-radiograph and partly visible in the areas of wear.

When one analyses the state of the painting, there appear to be strong indications that the paint-surface has suffered so extensively from over-cleaning that it has been retouched – in actual fact, repainted – on a considerable scale, in particular in the head. With over-cleaned faces, certain details usually have to be reconstructed. In this case, it would seem an obvious assumption that in 'restoring' the face, and where necessary other parts of the painting, the etching – the *Larger Coppenol* – would have been used as the model. This would explain why the striking correspondence between the painting and the print, precisely in the head, coincides with such an un-Rembrandtesque execution in these very areas. The second question is why Rembrandt, in this particular case, made a full-scale oil-sketch for the etching, whereas in the case of the *Portrait of Ephraïm Bueno* he did not. In the first part of this essay, it was argued that full-size oil-sketches were usually made when the end-product was to be executed by another hand. The production of portrait prints, even if they were executed by Rembrandt himself, sometimes required such precise preparations that a 1:1 sketch would be necessary. With the etched portraits of *Cornelis Claesz. Anslo* and *Jan Six*, which were prepared with drawings that were subsequently traced through on to the plate (see pp. 64–9), there can be no doubt that these were executed by Rembrandt himself. The somewhat mechanical execution of the *Larger Coppenol* nevertheless does raise the question of whether another hand might have been involved in making this print.

The last, and the most intriguing question concerns the enigmatic brushstrokes along all four edges, visible on the X-radiograph and in areas where the surface has worn (fig. 29). For a possible explanation, one needs to turn to a peculiar phenomenon regarding Rembrandt's framing. In Rembrandt's drawings, one sometimes finds indications of framing which, naturally enough, do not coincide with the edge of the sheet. With paintings, one may reasonably assume that as a rule, the framing of the composition coincides with the limits of the support. Yet

there are exceptions to this rule, and the most interesting in the present context is the large grisaille of the *Concord of the state*, discussed above (fig. 23). The original format of this sketch, done on a panel measuring 74.5 × 100 cm, was about 65 cm high. Strips along both the top and bottom margins of the support were left unpainted. When the grisaille acquired another purpose, the composition was enlarged to the margins both above and below.[57] Did something similar happen with the oil-sketch for the *Larger Coppenol*? Was it originally not intended to fill the entire panel, just as Rembrandt's drawings on paper often were not meant to fill the entire sheet? And was it only subsequently in the course of its genesis that the enlargement not only filled the panel, but also required a further strip of wood to be added to the left side of the panel?

One can see, both on the X-radiograph and in the paint surface, that the original framing of the sketch was situated approximately 5 cm from the left edge, 4 cm from the bottom, 3 cm from the top and 1.5 cm from the right edge. The evidence is clearly visible in the altered direction of the brush-

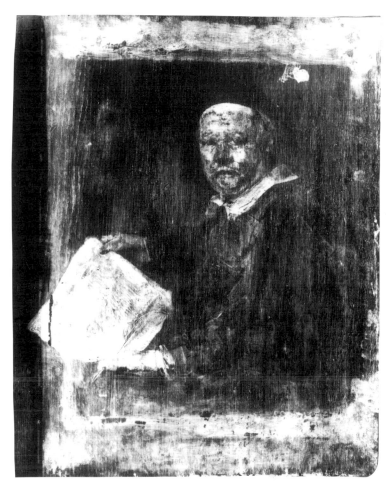

fig. 29 X-radiograph of fig. 27.

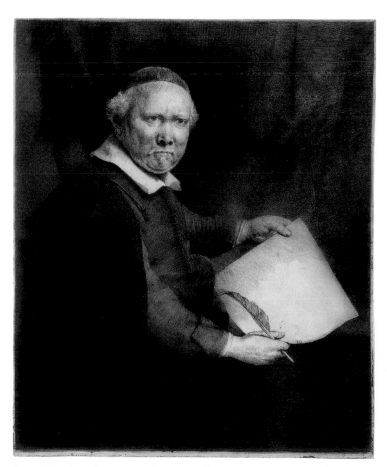

fig. 28 Rembrandt, *Portrait of Lieven Willemsz. van Coppenol (the larger Coppenol)*, c.1658. Etching, 34 × 29 cm. London, British Museum (B.283)

strokes in the piece of paper that Coppenol holds, showing that it was subsequently decided to enlarge the composition. This change in the brushwork runs along a vertical borderline on the main panel, through the piece of paper, around 5 cm from the present left-hand margin. Apparently, the composition in its original conception was considered unsatisfactory, and it was decided to incorporate the whole piece of paper that Coppenol is holding into the sketch. But this intervention meant that the framing of the composition had to be expanded, not only to the left but, for compositional reasons, above, below and on the right as well. The composition of the sketch was filled out to the edge of the panel, whilst, in order to include the tip of the sheet of paper, a 2.3 cm wide strip of wood had to be added to the panel. This, then, was how that image grew from which the tracing for the etching was subsequently taken. Such an expansion of a composition – with all the various consequences for the support – are common with Rubens. Although rare in the case of Rembrandt, they do occur, as for example in the enlargement

of the *St John the Baptist preaching*, discussed above (fig. 12), and the *Concord of the state* (fig. 23).[58]

The enigmatic brushstrokes applied to the margins of the sketch do not belong to the original composition. One is led to wonder whether the margins outside the first framing were perhaps originally painted dark to give the patron a clear picture of the print as initially intended. The light paint would then have been applied as a light ground for the enlargement of the oil-sketch. An investigation of paint samples taken from these areas might reveal whether this surmise is correct, as the dark layer should be visible in paint cross-sections.

Conclusion

One of the most striking aspects of Rembrandt's artistry is the enormous difference in scale between his works. Tiny etchings and drawings conjure up the image of Rembrandt working with minute precision to create these amazingly evocative miniature works of art. On the other side stands the Rembrandt who, with a broad sweep of his hand, could throw down only the barest, most general indications of forms on his canvases or panels. Houbraken writes that he had seen this range of scale within particular paintings 'in which some parts were worked up in great detail, while the remainder was smeared as if by a coarse tarbrush, without consideration to the drawing'.[59] Rembrandt's oil-sketches show a remarkably wide variation in the degree to which he worked up the details; the relation between the coarse and the minutely fine within each etching presents yet another story. It is this variation in execution and the great freedom to which this testifies which makes Rembrandt's oil-sketches such fascinating documents of his artistry. They also allow us a glimpse into Rembrandt's studio practice and, at the same time, illuminate aspects of his printmaking.

★ This article was written in the context of the Rembrandt Research Project. I want to express my gratitude to NWO (Netherlands Organisation for Scientific Research, Council for Humanities) and the University of Amsterdam for generously supporting this project. I thank Murray Pearson, who translated the article, Margaret Oomen and Martin Royalton-Kisch for their patience and co-operation during the growth and constant changes in the evolution of the text. During the writing of the article I received much inspiration, useful criticism or other help from the following colleagues: Sib de Boer, Michiel Franken, Egbert Haverkamp-Begemann, Erik Hinterding, Arie Lambo, Walter Liedtke, Ger Luijten, Mireille te Marvelde, Lideke Peese Binkhorst, Peter Schatborn, Dasha Shishkin, Guus Sluijter, Mieke Smits-Veldt, Hubert von Sonnenburg and Pieter Visser.

1 Hoogstraten 1678, p. 195. See also Wuestman 1998.

2 Ryckevorsel 1932; Tümpel 1968b; Broos 1977.

3 Amsterdam 1996, cats 1a–12.

4 For a survey of the history of the oil-sketch see for instance, Wescher 1960, R. Wittkower, in New York 1967, and Rotterdam-Braunschweig 1983–4.

5 Brinkman 1993.

6 For the different kinds of oil-sketch see Haverkamp Begemann 1954, pp. 2–21; idem, 1967, pp. 104–13, d'Hulst 1968, Bauer 1999, pp. 520–30.

7 Held 1980b and d'Hulst 1968.

8 *Corpus* V, Chapter III (forthcoming).

9 *Corpus Rubenianum* XXI, cats 58a, 60a, 62a, 72a, 81a and 85a.

10 Antwerp-Amsterdam 1999–2000, cats 5, 22, 23, 26, 27 and 37.

11 Strauss & Van der Meulen 1979, 1634/6; see also Benesch 913–14 and 1057. The suggestion that the oil-sketch with the *Bearded Man* might have been made for an album was first expressed in *Corpus* II, no. A74.

12 The sheet of paper is now stuck to canvas; in 1730 the grisaille was still kept in one of Valerius Röver's forty-two portfolios of drawings. See *Corpus* II, no. A89, p. 468.

13 The first unfinished state of the print is signed and dated below the clock: *Rembrandt f. 1635*. The second state is signed and dated in the bottom margin: *Rembrandt f. 1636 cum privile*.

14 Royalton-Kisch 1984, pp. 2–23.

15 See *Corpus* II, no. A89, p. 467; see also Royalton-Kisch 1988, pp. 206–7, fol. 33.

16 Strauss & Van der Meulen 1979, 1656/12, no. 121. Royalton-Kisch has expressed doubts as to whether the grisaille listed in the inventory is the same as the work discussed here, since the impression is given that the work in the inventory seems to have been hung like a painting, whereas the London grisaille was still treated as a drawing in the eighteenth century (see n. 12 and Royalton-Kisch 1994). On the other hand, it was not unusual to frame art works on paper such as prints and hang them like paintings.

17 See n. 1. Personal communication from Erik Hinterding. His view is based, among other things, on the extent to which traces of wear are evident in certain prints. This would indicate that at least 200 and probably many more impressions were put into circulation.

18 The hypothesis was briefly outlined in *Corpus* III, p. 79; see also Schwartz 1985, p. 112, caption to fig. 104.

19 Houbraken 1718–21, I, pp. 254–73.

20 White 1999, pp. 88–97.

21 Bredius 1909, pp. 238–40: 'dat hij oock eenige geslepen plaetten van Kattenburgh in handen hadt, om daer de passie op te maecken'. It should be mentioned in this connection that Rembrandt also sketched a series of four illustrations of the same size for Menasseh ben Israël's book, *Piedra gloriosa*, published in 1655 (see cat. 79). In addition, he worked on a sequence of etchings which, one suspects, may have formed part of a projected 'Drawing book' or 'Model book' – a series of examples for young artists to copy. Emmens 1979 refers to the fact that the French writer on art, d'Argenville, wrote in 1745 that Rembrandt had made such a 'Drawing book' (*son livre a dessiner est de dix à douze feuilles*). Emmens linked the two similarly sized etchings from 1646, B.193 and 196 (respectively 164 × 97 mm and 97 × 169 mm) with this book, but also the larger etching (19.6 × 12.6 cm) known as the *Walking-frame* of c.1646 (cat. 51). Emmens

was the first to see a reference to the learning process in this etching, which may well have served as the first page of the series.

22 Filedt Kok, Hinterding and Van der Waals 1994, pp. 351–78, especially pp. 368–70.

23 For a detailed discussion of the genesis and material history of the painting see *Corpus* III, no. A106. Since the panel on which the canvases were glued was made from the same tree as the panels of three paintings from Rembrandt's hand (Corpus III, nos A132 and 140, from 1639 and 1640 respectively, and Bredius 566 of 1644) there can be no doubt that the operation of enlarging the painting took place in Rembrandt's studio. The fact that the grisaille is not signed would seem to argue against any assumption that the enlargement was carried out with a view to selling the work.

24 Personal communication from Erik Hinterding, who explores this point in detail in his forthcoming doctoral dissertation.

25 This theory is discussed more extensively in *Corpus* II, pp. 56–60; for Rembrandt's entry in the Guild of St Luke, see Strauss & Van der Meulen 1979, 1634/9.

26 Hind 1931, p. 72, no. 1, repr. plate XLIII. Hind refers to another drawing in Hofstede de Groot's collection. Schwartz 1985, chapter 20 is an informative chapter on Hendrick Uylenburgh in which the author compiles a list of activities documented in connection with the firm of Hendrick, and later Gerrit Uylenburgh.

27 Sandrart 1925, p. 194.

28 E. van de Wetering, 'Problems of apprenticeship and studio collaboration', in *Corpus* I, pp. 45–90, especially p. 57.

29 This assumption played a crucial role in Josua Bruyn's chapter 'The documentary value of early graphic reproductions' in *Corpus* I, pp. 35–51, especially p. 40.

30 E. Hinterding, 'Rembrandt and Van Vliet: the watermarks', in Amsterdam 1996, pp. 24–6.

31 E. de Heer, 'Jan Gillisz van Vliet, "Plate cutter in Leyden"', in Amsterdam 1996, p. 6.

32 See ibid., p. 26.

33 Strauss & Van der Meulen 1979, 1656/12, no. 277.

34 It has long been known that Uylenburgh's Mennonite affiliation also had a bearing on Rembrandt's livelihood during the latter's stay with Uylenburgh, as the sitters of several portraits commissioned in this period were Mennonites. There is a remark in Baldinucci's text on Rembrandt (Baldinucci, 1686) that he too was a Mennonite. Visser 't Hooft 1956 convincingly argues that so much speaks against this suggestion that we can safely exclude the notion that Rembrandt was of the same persuasion as Uylenburgh.

35 Visser 1988, especially vol. I, p. 92.

36 Twisck 1632, *lemma* 'Joseph' (pp. 553–9), especially p. 553: 'hy hadde eenen droom dat sijn Broeders schooven, voor de sijne neyghden: hy hadde noch een droom, dat Son, Mane ende elf Sterren voor hem neyghden, waerom sijn Broeders hem haten'; and p. 555 ('Gheestelijcke verklaringhe ende leeringhe', 'Droomen'): 'Josephs droom, is niet alleen vleyschelijck in hem maer oock geestelijck in Christo den waren Joseph vervult: want die Scholen [het is niet uit te sluiten dat het woord Scholen een bij de druk ontstane verbastering van het woord schooven is dat, gezien de context, logischer zou zijn] der Jootsche broederen, en conden die verhooginge in Christo niet verstaen, verachte hem als hy van sijn heerlijckheyt ofte verhooginge sprac. Maer die schooven der gheloovigher Broederen, die de wille des Vaders doen, hebben hem ghelijck nae de opstandighe aenghebeden ende voor hun Heer ende Godt bekent.'

37 Schabaelje 1634, pp. 68–97, especially p. 68: 'Afbeeldinghen ende prophetien des ouden Testaments. Waer in alle de deelen des Levens ende der Passien onses heeren Jesu Christi worden aangewezen, ende in het leven der voorvaderen als in eenen spiegel gesien.'; and pp. 46–7: 'Van de gelyckformicheijt des levens die de voorvaderen met Christus hebben',

especially p. 49, vv. 1–51 'Van de gelyckformicheijt die Joseph met Christus heeft'.

38 Twisck 1632, p. 538.

39 Simons 1539, p. 46: 'want die [Christ and the Apostles] leren, dat dese nieuwe gheboorte geschiet doer Godes woort alst boven gesecht is, welcke woort niet den doven, simpelen unde onverstandighen kynderen . . .'

40 Plomp 1997, no. 323 does not mention the possibility of the drawing having been reduced in size. My reasons for concluding that this must have happened are the following:

1 The lower edge of the drawing cuts through the feet of the silhouetted disciple in the foreground in a way that is unusual for Rembrandt, which suggests that a strip is missing along that edge.

2 The lines and washes indicating the disciple to the extreme right are cut by the edge of the paper in a way which can only be accounted for if one assumes that a strip of paper has been cut off.

3 It is highly likely that this strip was of considerable width, since at least one disciple is missing who – given the composition – could only have been placed on that side. The signature written in deep black chalk and the wooden fence indicated in the upper right corner of the drawing with the same black chalk would seem to have been added after the drawing had been cut. When introducing these elements, the present border was taken into account. The nature of the chalk used here and the sharpness of line differ so markedly from the other materials in the drawing that it may be assumed that these elements were added later, by Rembrandt.

41 Ibid.

42 The way in which a shadowy figure has been added in light chalk on the darker washes in the upper left area of the composition may be seen as an indication that this figure was moved as an afterthought, possibly in connection with the reduction in size of the work.

43 *Corpus* III, no. A107; London, 1988, cat. 6.

44 *Corpus* V, Chapter III (forthcoming).

45 Strauss & Van der Meulen 1979, 1656 no. 106.

46 Smith 1836. For a review of the discussion relating to the *Concord of the state* see *Corpus* III, no. A135.

47 Kempers 2000, pp. 71–113.

48 For a discussion of such large, composite prints see Amsterdam 1996, under cat. 41.

49 See Hermesdorf, Van de Wetering & Giltaij 1986, pp. 35–49.

50 These self-portraits are mentioned here as they would have been called by Rembrandt's contemporaries: 'portraits of Rembrandt done by himself' – see E. van de Wetering 'The multiple functions of Rembrandt's self-portraits', in London-The Hague 1999–2000, p. 17.

51 Slive 1970–74, cats 47, 76, 175 and 126.

52 Jensen Adams 1985, cat. 77.

53 Dijkstra 1990.

54 Von Sonnenburg 1976, pp. 9–24, especially pp. 20–21. Von Sonnenburg had already expressed his doubts about the painting in Chicago 1973, pp. 83–101, especially p. 88.

55 See New York 1995, pp. 120–22.

56 The export of Baltic oak timber to Holland was brought to an end by the war between Sweden and Poland from 1655 to 1660, see *Corpus* III, p. 783 and Leiden 1983, p. 76.

57 Another example is the Florence half-length figure of *A youth in a cap and gorget* in *Corpus* III, no. B11.

58 Rembrandt's lost *Alexander the Great* painted for Don Antonio Ruffo around 1661/2 was also enlarged. Strauss & Van der Meulen 1979, 1661/5 and 1662/11.

59 Houbraken 1718–21, I, p. 259.

The role of drawings in Rembrandt's printmaking

Martin Royalton-Kisch

Rembrandt made no less than 300 etchings and most were created directly on the copper plates without recourse to preliminary drawings. Indeed many of the prints are unusual in themselves resembling drawings, including the *Three women's heads* and the landscape entitled *Six's bridge* (cats 29 and 49). Nevertheless, around twenty-eight preparatory sketches for the prints survive, and like the touched proofs and variant states of the etchings they offer a remarkably vivid glimpse of the artist at work, and reveal that some prints, quite as much as any of his oil paintings, were subjected to extensive revisions.[1]

Unusually for works by Rembrandt, the attributions of the drawings under consideration are rarely in doubt. Although notions of quality still play an important part, the drawings present objective criteria for accepting their autograph status. A few bear Rembrandt's signature, others clearly reveal the development of his compositional ideas and five of them, uniquely to this category of his work, were employed as cartoons: their outlines were pressed through with a stylus in order to transfer them to the copper plates, and the resulting indentations still remain visible.[2] By examining a few drawings in detail a picture emerges that clarifies our understanding of the roles played by the remainder in Rembrandt's working process. Their functions varied and this is reflected in their diverse techniques and styles. For instance, the two most significant sketches for the portrait of *Jan Six* (cat. 57) range from the energetic first design in pen and brown ink to the dryer, chalk cartoon, which is indented (figs 1–2). Yet the similarly indented chalk drawing for the *Diana at the bath* (fig. 3 and cat. 10) lies stylistically somewhere between the two. This essay attempts to explain why.

Despite their variations, the five indented drawings form a homogeneous group for the purposes of study.[3] In the *Diana at the bath* of around 1631, which is among the earliest, only the figure is indented (fig. 3). The background is summarily indicated in abstract scrawls, and the quiver of arrows is dashed in like an afterthought on top of some parallel shading. While the drawn figure exhibits all the immediacy of a study from life, in the etching she is more mechanically delineated, and her contours replicate the indented outlines. Conversely the background trees and scrub in the etching, for all the detail, bristle with life, as if observed directly from nature. A significant *pentimento* in the sketch occurs in the figure's left arm, which at first reached down for her drapery but was raised to the position that was finally adopted in the print.

These nuances of style articulate Rembrandt's working method: having drawn the figure from life, he blackened the *verso* of the sheet and indented the outlines which he then followed in the etching; but the background was created almost from scratch on the plate. That he should base a mythological goddess so closely on an unidealized study of the nude provoked strong criticism in the seventeenth century,[4] but was inherent in his approach to composition. His raw material, a drawing that could have served as the basis for any representation of a bathing nude (who reached for her drapery like a startled Susannah before the arm was adjusted), was placed in a landscape and provided with an emblem of hunting, and this alone transformed her into a goddess. The plate makes no further concessions to her mythological status.

Another indented drawing, the study in red chalk dated 1640 for the portrait of *Cornelis Claesz. Anslo* of 1641 (fig. 4 and cat. 45) likewise differs from the related etching. The print introduces a prominent nail in the wall above the sitter and a framed object to the right (perhaps indicated in the lower right corner of the drawing).[5] The *verso* was coated with a yellow-ochre preparation which may have assisted in the transfer of the design to the plate, and the drawing's function as a cartoon therefore seems straightforward. It even resembles the earlier *Diana at the bath* in its freedom of line and cursory indications in the background.

Yet unlike the *Diana* it may not have been drawn from life. This is because Rembrandt was at the same time painting a large portrait of *Anslo with his wife* (cat. 45, fig. c), which shows him in a comparable pose. Dated 1641, like the etching, Rembrandt prepared the figure of Anslo in a full-length pen study of 1640 (cat. 45, fig. b), the same year as the red chalk drawing. Apart

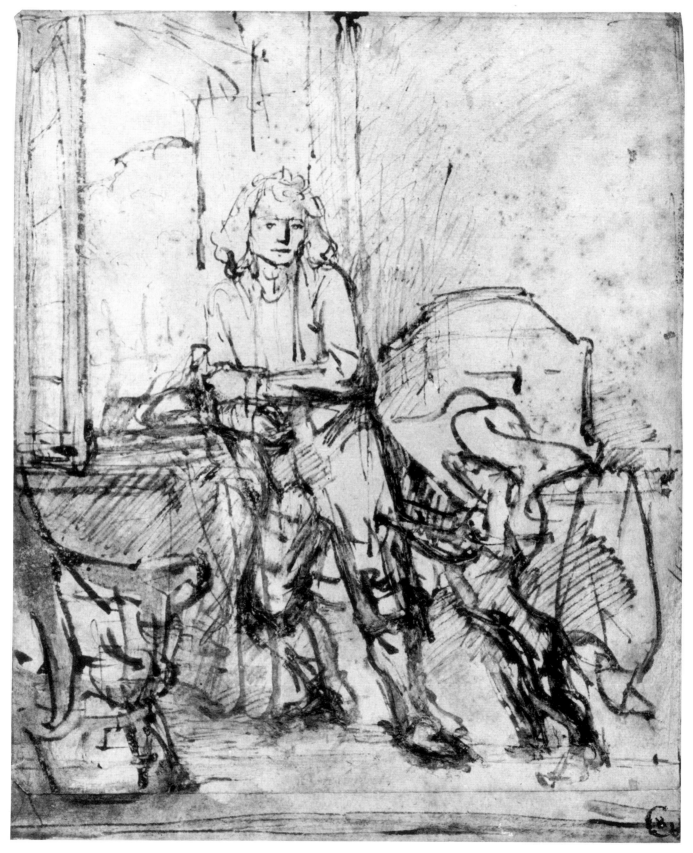

fig. 1 Rembrandt, *Jan Six*. Pen and brown ink with brown wash, corrected with white, 220 × 177 mm. Amsterdam, Six Collection (Benesch 767; exh.)

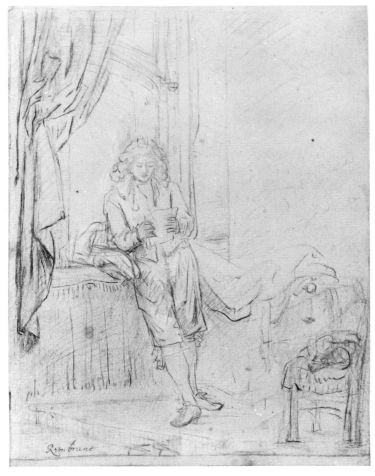

fig. 2 Rembrandt, *Jan Six*. Black chalk, outlines indented, 245 × 191 mm. Amsterdam, Six Collection (Benesch 768; exh.)

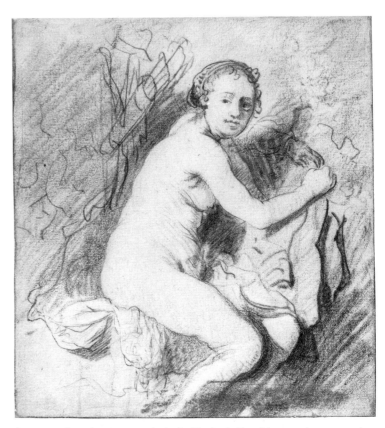

fig. 3 Rembrandt, *Diana at the bath*. Black chalk with some brown wash, outlines indented for transfer, 181 × 164 mm. London, British Museum (Benesch 21; exh.)

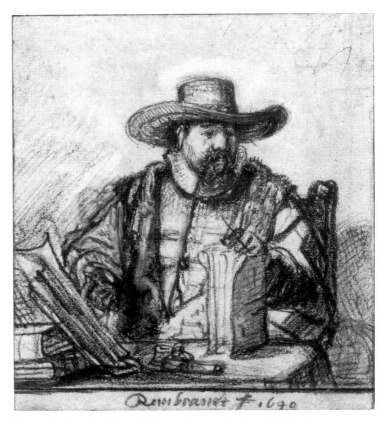

fig. 4 Rembrandt, *Cornelis Claesz. Anslo*, 1640. Red chalk with some red wash, heightened in oil, on pale yellow-brown paper, outlines indented, 157 × 144 mm. London, British Museum (Benesch 758; exh.)

from the different technique and the altered positions of the table and the sitter's arms, which now appear to move more freely, the two drawings are similar. There are few *pentimenti* in either, but as the indented sheet initially depicted Anslo's upper right arm in a slightly higher position, with a wavy upper outline which apparently followed the pen drawing, it probably depends on the latter. This would also explain the somewhat perfunctory modelling, for example of the lace collar; and although Rembrandt struggled in both sketches to define the outlines of Anslo's hat and right sleeve, the greater immediacy of the pen sketch also argues for its precedence. The indented drawing, unlike that for the *Diana at the bath*, was therefore probably not made from nature but based on the earlier sketch. This is reflected in its appearance, which even though it shares the *Diana*'s lively, preliminary style, falls short of its suggestive power. Also noteworthy is the fact that the Berlin painting (cat. 45, fig. c) does not slavishly copy the ink drawing either, but reworks the figure once more: Anslo's left hand now reaches further across his body, his head is turned towards us, and the sleeve of the gown on his right arm is lengthened. Thus

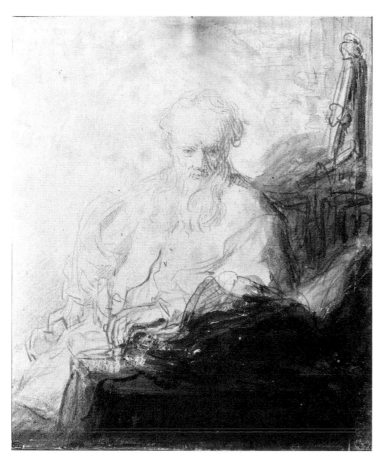

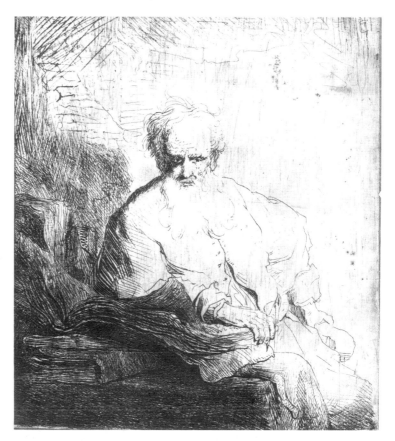

fig. 5 Rembrandt, *Study for St Paul in meditation*. Red chalk with grey wash, heightened with white, indented, 236 × 201 mm. Paris, Musée du Louvre (Benesch 15)

fig. 6 Rembrandt, *St Paul in meditation*. Etching, 238 × 200 mm. Paris, Musée du Petit Palais, collection Dutuit (B.149)

in four portraits of the same sitter – two drawings, an etching and a painting – made within two years and all depicting Anslo in a similar pose and action, Rembrandt came to four different solutions, a significant point to which we will return later.

Typically for an etching that was preceded by preliminary sketches, the *Anslo* is highly finished. Yet the etched portrait of *Jan Six* (cat. 57) is even more detailed. One of Rembrandt's most richly worked plates, it comes as no surprise to discover that it was preceded by three preparatory drawings (figs 1–2 and cat. 57, fig. b). The composition is an entirely novel approach to portraiture and could hardly be further removed from the then fashionable, aristocratic, Van Dyck mode. The related drawings suggest that the image was hard won.

The earliest composition drawing (fig. 1) energetically sets down the arrangement with the reed pen. Here Six's posture seems more self-conscious and ungainly. He leans stiffly at the window, seemingly unaware of the dog supporting itself against his left leg. There were to be numerous changes: in the etching the open window casement, freely sketched in perspectival recession to the left in the drawing, is swathed in heavy curtains, the chair is moved to the other side and the dog is removed

altogether. Six himself, despite his almost tousled, unkempt appearance (the sense of untidiness increased by the expressive and unruly sketching style), dominates the drawing, but was turned in the print into a more restrained figure, reflective in mood, absorbed in reading, and no longer looking at the viewer. The pen sketch has been enlarged with a strip of paper below, perhaps to simulate the final format more closely and to act as a kind of *modello* for the print. In its freedom of style the drawing contrasts sharply with the cartoon, but as we shall see it does resemble other bold, preliminary sketches of the same period, such as that for the *Jan Cornelisz. Sylvius* of 1646 (fig. 11).

The second study for the *Jan Six* (cat. 57, fig. b), a slight notation in the same black chalk medium as the cartoon, may have immediately preceded the latter. Concentrating on the figure of Six, it anticipates his final pose but shows him wearing a hat, an idea that proved to be short-lived. It was discarded at the cartoon stage (fig. 2), in which the major components of the composition are fixed. This sheet, as noted above, is more drily drawn than those indented for the *Diana át the bath* and the *Cornelis Claesz. Anslo*, and this must reflect the fact that

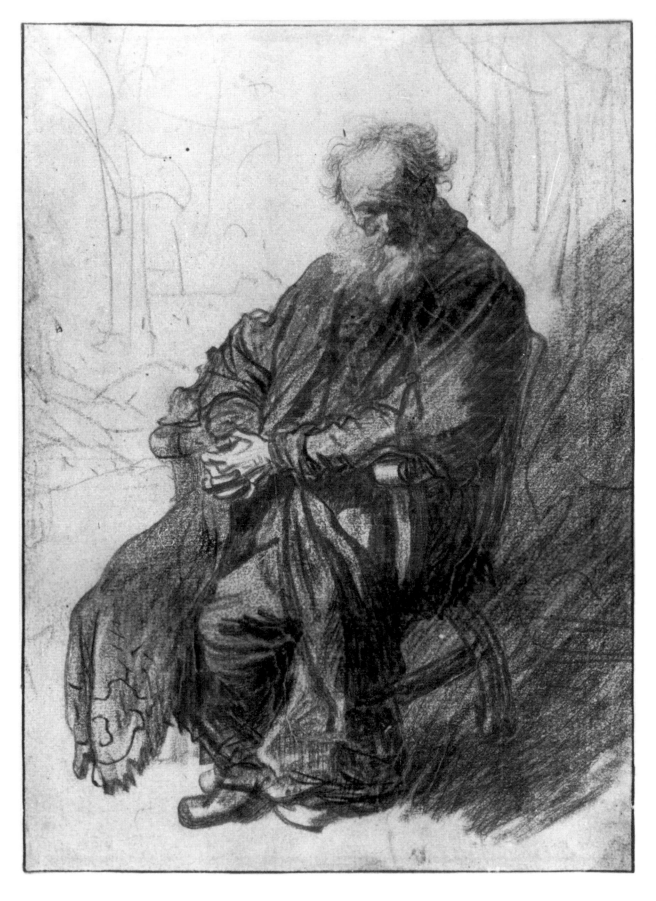

fig. 7 Rembrandt,
*Old man with clasped
hands.*
Red and black chalk,
on yellowish paper,
226 × 157 mm.
Berlin, Staatliche
Museen,
Kupferstichkabinett
(Benesch 41)

Rembrandt had already sketched out the design. But it is remarkable that in all three etchings resulting from the indented drawings we have studied, much was elaborated only on the plate itself. In the *Jan Six*, for example, *pentimenti* occur in the sitter's head and feet. Revisions of this sort are not rare in Rembrandt's etchings, and bolster our impression of him as an artist who was tireless in his search for the perfect composition, and who could expend as much effort on an etching as on an oil painting.

Two of the earliest indented drawings by Rembrandt are exceptional in being related to prints that were neither elaborate nor highly finished. The Louvre *St Paul* (fig. 5), only the lower part of which appears to have been indented, was used for the broadly etched plate of the saint made in around 1629 (fig. 6). Sections of the print, such as the saint's left arm, appear slackly drawn, perhaps betraying its dependence on the drawing. In style the latter approximates to the *Diana at the bath*, although the technique is more elaborate, with wash and white heightening. Also indented is the *Old man with clasped hands* of *c.*1631 in Berlin (fig. 7). Drawn in red chalk on yellowish paper, all the outlines have been pressed through, but curiously only the head was etched in a small plate of the same period (fig. 8). Rembrandt may have started with a larger plate and subsequently cut it down. But the drawing was one of several such studies of old men made at this time, including that of 1631 which was subsequently used in his representations of *Joseph telling his dreams* (see cat. 31).[6] The incorporation of a figure study into a historical composition was not an unusual practice for Rembrandt, and his chalk sketch of an *Old man with arms*

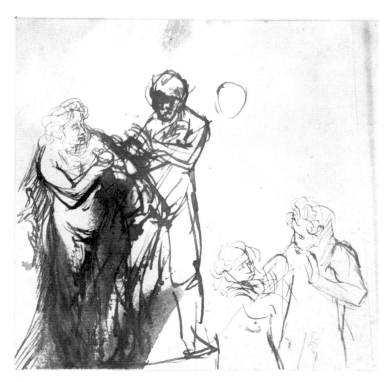

fig. 9 Rembrandt, *Study for Adam and Eve.* Pen and brown ink with brown wash, 115 × 115 mm. Leiden, Prentenkabinet der Rijksuniversiteit (Benesch 164; exh.)

outstretched may not originally have been intended for St Peter in the etching of *Peter and John at the gate of the temple* (see cat. 5, fig. 6).

The first truly preliminary sketches, as opposed to cartoons, that survive for a Rembrandt etching date from 1638, for the *Joseph telling his dreams* (cat. 31) mentioned above, and for the *Adam and Eve* (cat. 30). For the latter Rembrandt roughed out two concepts for the figures on a single sheet (fig. 9), providing a clear view of his search for an appropriate interaction between them – for the right psychology and movement, or, to quote the artist's own words, 'the most, and most natural emotion (or movement)'.[7] In the first version on the left of the sheet, Eve tentatively offers Adam the apple with her right hand. He shrinks back in alarm, raising both arms, turning his head to one side and transferring his weight away from Eve onto his left foot.

Rembrandt must have judged Adam's reaction too strong, and already in this first sketch he began to rethink the composition, as the *pentimenti* reveal. In the second trial on the right of the sheet, the figures' postures approximate to the etching: Eve holds the fruit in front of her chin and Adam cups one hand over it, as though uncertain whether to accept or reject it, while raising the other. This second gesture is clarified in

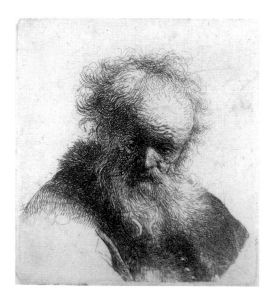

fig. 8
Rembrandt,
*Bust of an old man
with white beard.*
Etching,
71 × 64 mm.
Amsterdam,
Rijksmuseum
(B.291)

the etching, where he points heavenwards with his index finger as if to recall God's warning not to eat the fruit of the Tree of Knowledge.

The drawings are in reverse to the print, as are those for the 1646 etching of *Jan Cornelisz. Sylvius* (cat. 54). This was prepared on two separate sheets in sketches that fulfil a similar function to those for the *Adam and Eve*. Once more the first idea (fig. 10) differs markedly from the final result but maps out the essential features of the composition, showing Sylvius within a fictive oval frame with an area reserved for the text below, divided into two fields. In fact Rembrandt, on the lower right section of the drawing, drew eight parallel strokes, precisely the number of written lines that appears in the etching. Although the few strokes of hatching outside the oval may have inspired Rembrandt to enliven the action with the gesturing arm protruding from the frame, they were probably intended to convey the surface texture around the oval. In this first sketch,

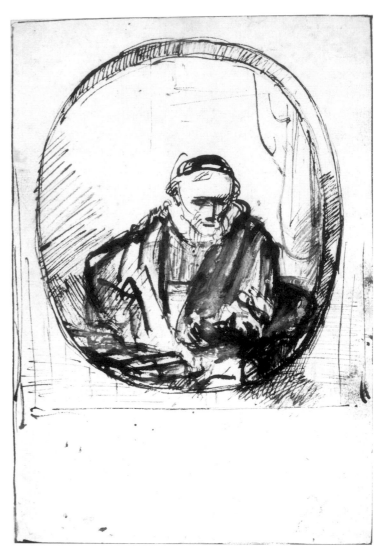

fig. 11 Rembrandt, *Study for Jan Cornelisz. Sylvius*. Pen and brown ink, touched with white, 285 × 195 mm. London, British Museum (Benesch 763; exh.)

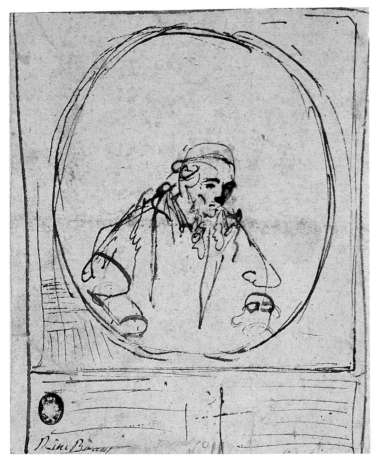

fig. 10 Rembrandt, *Study for Jan Cornelisz. Sylvius*. Pen and brown ink, 143 × 115 mm. Stockholm, Nationalmuseum (Benesch 762a; exh. Amsterdam)

Rembrandt seems to have been confronted with the difficulty of expressing the perspectival recession of the inside edge of the oval. In fact he never reached a fully logical solution and one would expect the rim of the frame to be visible beneath the book in the etching.

Again in reverse to the print – reversal itself being of necessity characteristic of many preparatory sketches for etchings – Rembrandt changed the posture of the figure in the second drawing (fig. 11): the right arm now presses down in a similar way to Cornelis Anslo's in the Louvre's drawing that detained us earlier (cat. 45, fig. b). The left hand is thrust forward, casting a shadow over the frame, an illusionistic device that is clarified and given yet greater prominence in the etching. The gesture

was probably inspired by the text of the Latin poem by Caspar Barlaeus which appears on the etching and refers to Sylvius' oratorical powers. The space on the drawing below the sitter again confirms that the poem's appearance on the print was foreseen from the start, and Rembrandt introduced several motifs and refinements: the recession of the oval is more fully defined and shaded to the right. In the etching, this shadow is recognizably cast by the sitter's head, while the five fingers of his nearer hand make individual shadows below. In addition, the drawing sketches the curtain behind him and Rembrandt indicates, with a vertical line, a division of the background that was elaborated in the architecture behind the sitter's head. The completed print is a highly detailed production, lacking the energy inherent in the working drawings. Yet Rembrandt continued to tinker with the design on the plate, developing both the shadows as we have seen and the motif of the book, probably a Bible, with Sylvius' fingers keeping several places open for ready reference.

The drawings we have examined so far, whether preliminary sketches or indented cartoons, conform to types that can be found in the work of many of Rembrandt's predecessors and contemporaries. But the function of his drawing for the *Artist drawing from the model* of around 1639 is less orthodox (fig. 12) and the etching (cat. 36) was never completed, although it exists in two states. In the first, the interior is brighter, with an unseen light source placed low so that the shadows, for example of the sculpted bust at the upper right, are thrown upwards. In the second state this area is worked over, reducing the contrast; and the sculpture itself, the drapery held by the nude figure and the upper part of the easel are elaborated. The press in the centre, perhaps a linen press, is covered with hatching in the second state, and below the canvas a dark area marks the edge of both the work on the easel and its right foot. Another minor, but highly significant adjustment occurs below the feet of the nude. The scratchy and tentative underdrawing provides the model with two alternative pairs of feet; and in the second state, Rembrandt introduced a flat surface below the lower pair, as if to confirm that he wanted to proceed with the longer legs.

The related drawing (fig. 12), which is in reverse, is curious for several reasons. Firstly, it differs in style from the other preliminary sketches we have encountered, lacking the characteristic *pentimenti* (compare fig. 11, for example). Secondly, it lacks most of the studio paraphernalia indicated in the foreground of the etching, including the chairs in the lower corners.

Thirdly, the design is complete, both in the overall shading and in the inclusion of the platform below the model's feet. In fact this is shown more clearly than in either state of the etching. If Rembrandt had produced this as a preliminary sketch, with rather definite outlines, why is the underdrawing so tentative in the etching?

The drawing is not indented for transfer to the copper plate – indeed all of Rembrandt's indented drawings were executed in chalk – and we are forced to conclude that it is not a preparatory drawing in the conventional sense, made before work on the plate had begun, but a project for its completion, executed only after the second state had been printed. The contrast in handling with the bold preparatory sketches of *Adam and Eve* or of *Jan Cornelisz. Sylvius*, which preceded work on the plate, could hardly be more stark. If this assessment is correct, then Rembrandt would have relied for his drawing on a counterproof of the second state of the etching, and in fact two of these survive, although none is recorded of the first state.[8] It would also refute the suggestion that the print was intentionally left

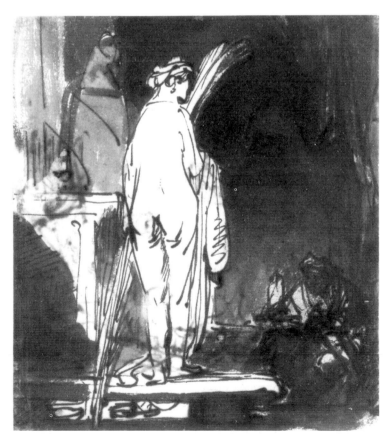

fig. 12 Rembrandt, *The artist drawing from the model*. Pen and brown ink with brown wash, touched with white, on paper washed brown, 188 × 164 mm. London, British Museum (Benesch 423; exh.)

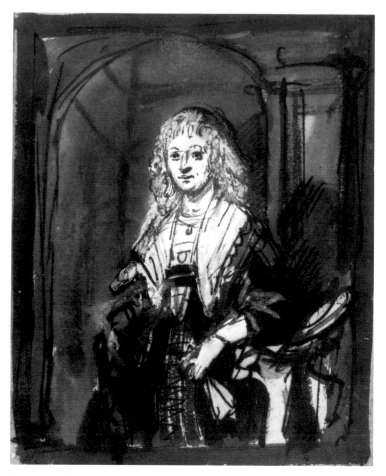

fig. 13 Rembrandt, *Study for the portrait of Maria Trip*. Pen and brown ink with brown wash, heightened with white, 160 × 129 mm. London, British Museum (Benesch 442; exh.)

he had decided to paint over a balustrade that ran across the whole width of the painting, as X-radiography has revealed. As the sketch differs little from the final result, and as it is rather neater than his other preparatory studies of this period, the hypothesis that he made the drawing only after work had reached an advanced stage on the panel is persuasive. In style it is inseparable from the sketch of the *Artist drawing from the model*, a style that reveals their intermediate, rather than preliminary, function in the working process.

Another study, for the etching of the *Great Jewish bride* of 1635 (fig. 14 and cat. 25), lends support to this thesis, although its genesis was more complicated. The first state of the print was probably begun directly on the copper plate from the model (in this case Rembrandt's wife Saskia, whom he had married in 1634). The first two states represent only her head and shoulders, and it was not until the third that the composition filled the plate. Rembrandt also modified the wall behind the figure, breaking up the corner with an inserted pilaster so as to allow the figure to stand out more effectively from the background. It was this completion of the figure in the third state, rather than its initial creation, that Rembrandt rehearsed in the sketch (fig. 14), as may be deduced from its style: where he was repeating the head, shoulders and flowing hair of the earlier states, the ink is paler than elsewhere and the style more rectilinear. These are characteristics that we encountered in the drawings of the *Artist and the model* and *Maria Trip* (figs 12–13). But the remainder of the figure is drawn more liquidly, with bold flourishes of the pen that resemble his strictly 'preliminary' drawing style.[11]

Somewhat different roles were played by two other drawings, the only ones known that are connected with his landscape etchings. The earlier of the two, now in Oxford (fig. 15), relates to the *Landscape with a milkman* (fig. 16). It may initially have belonged to an informal stock of landscape studies, before being adapted for the print – the added strip of paper on the right prefigures the format of the etching. The second drawing, now in Rotterdam (fig. 17), relates to the *Goldweigher's field* of 1651 (cat. 65) and may be from the same year. It shows the town of Haarlem from near Bloemendaal, but in the etching the viewpoint is slightly different, to judge from the relationship between the hills and the distant town, and in particular from the tower of the church at Bloemendaal, seen on the right of the print, where it pierces the horizon, whereas in the drawing it does not. In some respects, the print seems to be a carefully composed

unfinished, either to instruct Rembrandt's pupils in the elaboration of a composition, or to symbolize and emphasize the act of drawing within the allegory that makes up the composition.[9] While possible, the existence of two progressive states of the plate renders this highly speculative, as does the drawing, in which the design is finished. It may be that Rembrandt abandoned the composition for aesthetic or technical reasons. The awkwardness of the low light source and the reconciliation of the platform with the model's legs, which in the drawing he shortens (following the upper pair in the print), may possibly have contributed to the fact that the etching was never finished.

Viewed in this light the drawing is unusual for Rembrandt in the preparation of a print, but may be paralleled among his sketches for his paintings. The Rembrandt Research Project has discovered that he sometimes resorted to making a drawing only after he had begun some of his paintings. For example, his *Study for the portrait of Maria Trip* of 1639 (fig. 13)[10] was made only after

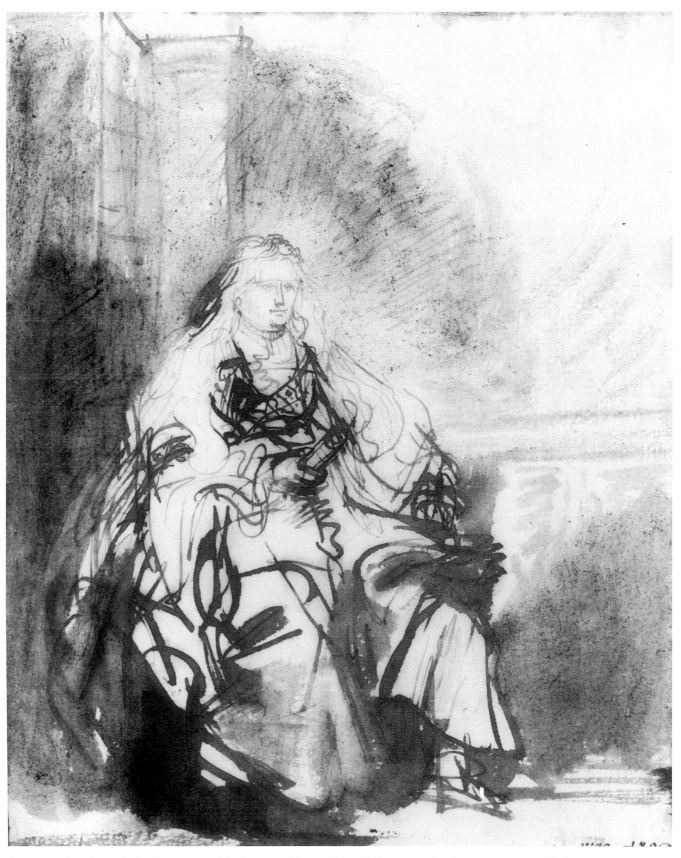

fig. 14 Rembrandt, *Study for the Great Jewish bride*. Pen and brown ink with brown wash, 240 × 190 mm. Stockholm, Nationalmuseum
(Benesch 292)

fig. 15 Rembrandt,
*Farm buildings beside
a road.*
Pen and brown ink
with brown wash,
113 × 247 mm.
Oxford, Ashmolean
Museum
(Benesch 1227)

(*below*)
fig. 16 Rembrandt,
*Landscape with
a milkman.*
Etching and
drypoint,
66 × 174 mm.
London, British
Museum (B.213)

version of the scene, rearranged and subtly idealized, with figures introduced into the fields in the middle ground, plying the common Haarlem trade of bleaching. The difficulty here is to decide whether the drawing was in any sense preparatory to the print; or whether the print was executed directly from nature, as the drawing seems to have been. In fact the print combines etching and drypoint, so that it would only have been technically possible for Rembrandt to draw the etched lines out of doors before submitting his plate to the acid back in his workshop; the drypoint lines must have been added later. Topographical considerations suggest that both views were indeed taken from nature.

The problem as to whether any of Rembrandt's landscape etchings were executed *en plein air* is worth a small digression from our topic. No written seventeenth-century text confirms that artists took etching plates out of doors. Yet in the eighteenth century, Edmé-François Gersaint wrote that Rembrandt 'avoit toujours des planches toutes prêtes au vernis'.[12] Gersaint was describing *Six's Bridge* (cat. 49), which he claims was made on the spot while a servant fetched some mustard from the local village. It is not difficult to imagine that Rembrandt was here drawing directly on to the copper from nature. The composition, unfinished and informal, closely resembles his drawings from nature; and the topography has been so precisely identified

fig. 17 Rembrandt,
View of the Saxenburg estate near Haarlem.
Pen and brown ink with brown wash and some white heightening,
89 × 152 mm.
Rotterdam, Museum Boijmans Van Beuningen
(Benesch 1259; exh.)

as showing the estate of Klein Kostverloren, with the church of Ouderkerk behind, as to reinforce this conclusion.

In addition, recent studies have affirmed that the *Clump of trees with a vista* (cat. 70) reveals that Rembrandt took plates with him on his sketching trips. In the first state, the outlines are set down in drypoint with exceptional immediacy and spontaneity. With its combination of free indications and precisely observed details, it encapsulates the qualities that typify an informal sketch from nature, one in which Rembrandt lingered over the central area and merely roughed out the remainder of the composition. In the second state, the foliage was completed and the plate cut horizontally at the base. But the parallel hatching in the second state is more uniform, less analytic, than in the first, reinforcing the notion that the plate was begun from nature and then completed in the studio. Together with the immediacy of prints like the *View of Amsterdam* of around 1641 (cat. 39) and of the pure drypoint *Landscape with a road beside a canal* (B.221),[13] we should be persuaded, like Gersaint, that Rembrandt did indeed sometimes use copper plates out of doors. Deviations in topographical accuracy should not deter us from this hypothesis, as Rembrandt always responded more to compositional imperatives than to exactitude. Nor do they preclude him from having embellished or elaborated his prints on the spot or after his return to the studio, as the relationship between his etching of the *Goldweigher's field* and the drawing in Rotterdam suggests:

the etching was probably begun from nature, although in completing it in the studio Rembrandt may well have referred to his sketchbooks.

Indeed most of Rembrandt's informal etched landscapes, as opposed to more elaborate compositions such as the *Three trees* (cat. 48), belong to the majority category of his etched work as a whole in having been executed straight on to the plate, without any preparation in drawings. As we have seen (with the *Diana at the bath*, and the portraits of *Anslo* and *Sylvius*), when he used preparatory drawings, the prints generally become highly finished and pictorial. This distinction, neatly encapsulated by the difference between, for example, *Six's Bridge* and the *Portrait of Jan Cornelisz. Sylvius*, furnishes us with two categories into which the vast majority of Rembrandt's etchings fit stylistically. The few exceptions, such as the *Peter and John at the gate of the temple* and the *St Paul*, both date from 1629, before Rembrandt had matured as a practitioner of etching.

It was perhaps in a similar manner to the landscape drawings now in Oxford and Rotterdam that Rembrandt's sketches of a *Pancake woman* and a *Sleeping dog* relate to his etchings of these subjects (see cats 28 and 37). On grounds of style both drawings appear to be contemporaneous with the prints, which date from 1635 and around 1639. Yet neither seems directly to prepare the prints.[14] The drawing of a *Pancake woman* is not in reverse to the etching and differs in all details. The most fully realized figure,

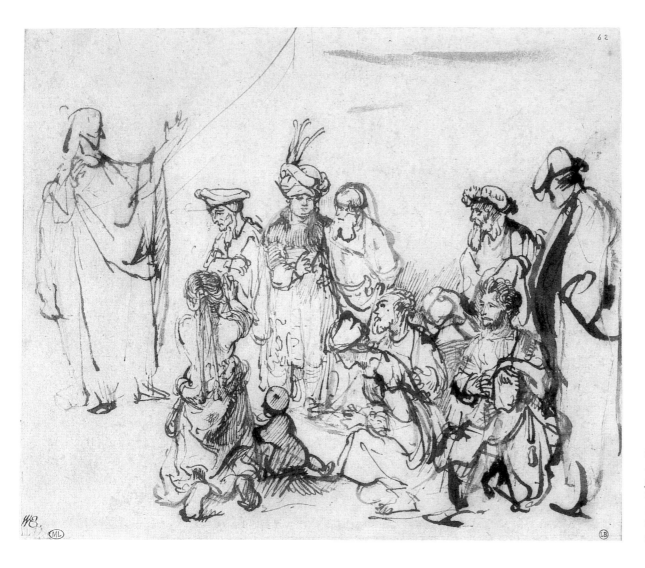

fig. 18 Rembrandt,
*Study for the Hundred
guilder print.*
Pen and brown ink,
198 × 230 mm.
Paris, Musée du Louvre
(Benesch 543)

fig. 19 Rembrandt,
The star of the kings.
Pen and brown ink with
brown wash,
204 × 323 mm.
London, British Museum
(Benesch 736)

fig. 20 Rembrandt, *Studies of sick woman for the Hundred guilder print.*
Pen and brown ink with brown wash, 101 × 122 mm. Amsterdam,
Rijksmuseum (Benesch 183; exh.)

a boy reaching into his pocket for change, was discarded alto-gether. On the other hand, the *Sleeping dog* is drawn in reverse to the print, in the iron-gall ink that is characteristic of the years 1638–9. Yet differences of scale and posture (note the positions of the rear leg), as well as the omission of the kennel and chain, imply that the etching was not derived from it. The detailed description of the animal's pelt in the print suggests that it was made directly from life, like the drawing, and probably at the same time

Both the high degree of finish and the compositional com-plexity of the *Hundred guilder print* (cat. 61) would lead us to expect Rembrandt to have made preparatory drawings for it, and six survive. The attribution of the earliest has recently become contentious (fig. 18),[15] yet its stylistic analogies with such works as the signed *Star of the kings* (fig. 19) argue for its authenticity. Whether in the manner of hatching shadows around the profiles, in the liquid but insistent outlines or the overall *chiaroscuro* effects, the draughtsman seems to be the same. A number of Rembrandt's drawings of the mid-1640s have similar, meandering outlines that trail almost as if he was reluctant to lift

fig. 21 Rembrandt,
Study for the Hundred guilder print.
Pen and brown ink with brown
wash, heightened with white,
139 × 185 mm. Berlin, Staatliche
Museen, Kupferstichkabinett
(Benesch 188; exh.)

his pen from the page. The figure of Christ is certainly tentative, but for this, too, there are many precedents in Rembrandt's work.

In the drawing, the light enters from the left, as can most clearly be observed in the figure of the kneeling woman. It was therefore probably a sketch for the group of figures to the spectator's left in the etching. This accords with the position of Christ and with the fact that the other drawings for the print are also in reverse to the etching. Although Rembrandt reworked the composition, moving the kneeling woman to the other side of Christ and changing most of the other figures entirely, this is characteristic of his working method when constructing a composition of such complexity.

In chronological order the next two studies were made specifically for the reclining woman near the centre of the print. The first sketches her twice (fig. 20), with her feet directed towards the spectator. Again this is far from the final result,[16]

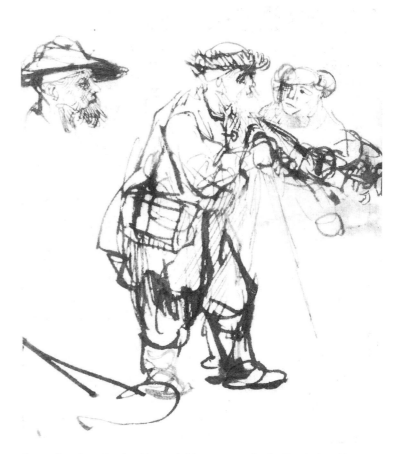

fig. 23 Rembrandt, *An old man led by a woman for the Hundred guilder print.* Pen and brown ink, 122 × 98 mm. Paris, Musée du Louvre (Benesch 185)

revealing that Rembrandt reworked individual details as much as the composition as a whole. This impression is reinforced by a second, slight sketch for the same figure (cat. 61, fig. e). Here the artist moves towards the final position adopted in the print, where she is turned to one side, but her gesture of prayer was later assigned to the figure immediately above her.

The three other surviving drawings for the *Hundred guilder print* consist of a further composition study and two for particular details. The composition drawing (fig. 21) shows the reclining sick woman in the pose finally adopted, with the praying figure above her. The design is close to the print and includes the pointing man behind her, the kneeling woman at the front (whose headdress was still to be revised), and, schematically indicated, the man between them supporting himself on crutches. Interestingly revealed by this and by the earlier composition drawing (fig. 18) is Rembrandt's focus on groups of figures within the composition: they articulate the artist's concern to bind the figures into dynamic units in a manner akin to those created by Raphael and other Renaissance masters. That

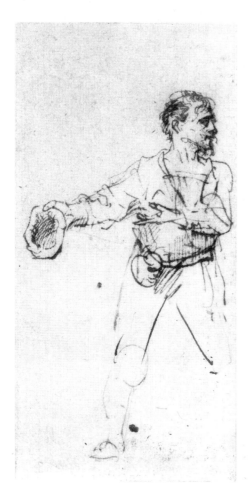

fig. 22 Rembrandt, *Standing man for the Hundred guilder print.* Pen and brown ink, 127 × 58 mm. London, Courtauld Institute, Count Antoine Seilern Collection (Benesch 184)

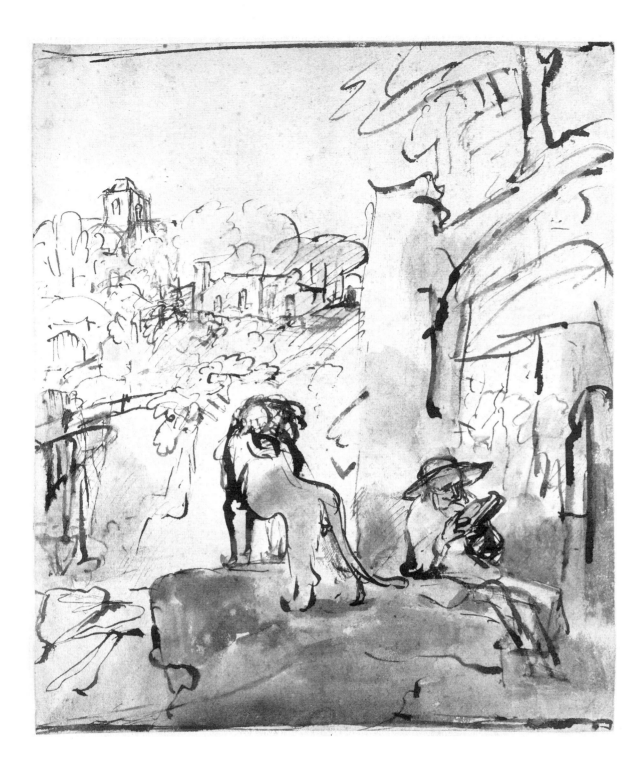

fig. 24 Rembrandt,
*St Jerome in an Italian
landscape*, pen and brown
ink with brown wash,
heightened with white,
252 × 208 mm.
Hamburg, Kunsthalle
(Benesch 886; exh.
London)

the etching has the poise of a *School of Athens* is a direct result of this labour.

The standing, pointing man was rehearsed in a drawing now in the Courtauld Institute (fig. 22). Here he holds a cap, later abandoned, and the drawing therefore probably preceded the composition sketch. Yet the cursory indications of his legs, which were to be hidden behind other figures, reveal that it was made specifically for the print. In style his head resembles that on the left of another related drawing, the *Blind old man led by a woman* (fig. 23) – the loop under the ear, marking the start of the

jawbone, is almost identical. The two figures in this second drawing appear in reverse towards the right in the print, with adjustments to their postures, so that the old man shuffles along more weakly, his head sunk and further arm lowered, as is anticipated in a *pentimento* in the drawing. The woman's head is turned to profile, so that she looks towards Christ, an alteration that helps to link the groups of figures entering from the right with the central area of the composition. The adjustment may seem subtle, but is in fact crucial to the dynamics of the design, and again reveals something of Rembrandt's perfectionism.

Together with the other five drawings for the print, it gives an indication of the extent of Rembrandt's deliberations in producing the *Hundred guilder print*, and the plate itself shows signs of revisions, for example near Christ's feet and among the upper figures on the left. Although impressions from Rembrandt's lifetime survive only in two states, with minimal differences between them, it seems likely, given that he worked on the plate over several years, that earlier trials were made, in states that no longer survive.

The drawings we have studied equip us well to analyse the study for the *St Jerome in an Italian landscape* of *c*.1653, an etching that was never fully finished (fig. 24 and cat. 72). Two aspects of the sketch are of particular interest. Firstly, it seems reasonable to deduce from its bold style that it is a preliminary sketch rather than a plan for the completion of the etching. Even allowing for its later date, it has none of the characteristics, such as the lack of *pentimenti* and the rigidness of line of the drawing for the Artist and his model (fig. 12), which was made only after the second state of the print as we have seen. Rembrandt's most comparable drawing is his first sketch for the *Jan Six* of 1647 (fig. 1), despite its having been made some

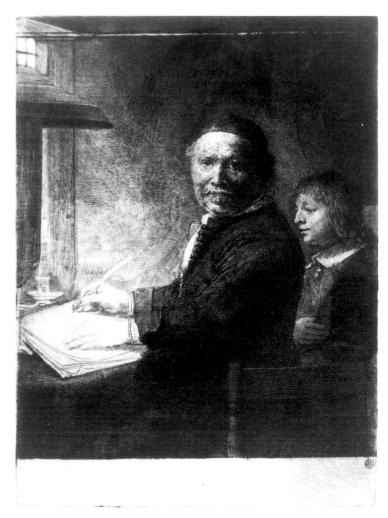

fig. 26 Rembrandt, *Lieven Willemsz. van Coppenol: the smaller plate*. Etching, drypoint and burin, 258 × 190 mm. London, British Museum (B.282)

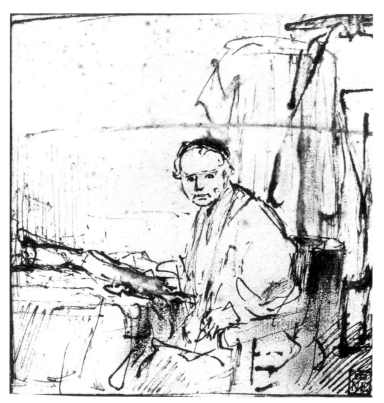

fig. 25 Rembrandt, *Study for the 'Smaller Coppenol'*. Pen and brown ink and brown wash, 161 × 150 mm. Budapest, Szépmûvészeti Múzeum (Benesch 766)

six years before. The close stylistic analogies result from their identical preliminary roles. Yet more interesting is the fact that the composition is shown complete in the drawing although the print itself was left unfinished, not only in the blank area below but also in the top of the tree in the upper left-hand corner. The modelling, apparently by burnishing the plate, of St Jerome's shelter also provides a curious effect. Yet despite these flaws, the etching was printed in considerable numbers in the 1650s, as is now known from the watermarks, so that its unfinished qualities must have been appreciated by contemporary taste much as they are today.

The last of Rembrandt's drawings connected with an etching is for the *Lieven Willemsz. van Coppenol* of around 1658, known as the *Smaller Coppenol* (figs 25–6) to differentiate it from cat. 89, the *Larger Coppenol*.[17] Unusually for a preliminary sketch, the

drawing is in the same direction as the etching; yet it is clearly not a derivation: Coppenol's pose is more relaxed and the youth is omitted, to mention only the most salient differences between them. These adjustments are characteristically far-reaching, and echo the move towards a more formal arrangement that marked the development of the *Jan Six*. In addition, the *Smaller Coppenol* went through half a dozen states, some of them introducing further radical changes, perhaps made on the road towards the yet more formal portrait of the same sitter in the *Larger Coppenol* (cat. 89).[18]

Even at this late date, Rembrandt's energy in searching for the best artistic solution apparently remained undiminished. All the drawings we have studied, despite their chronological and stylistic variety – a variety often dictated by their functions in the working process[19] – collectively present a clear image of the artist at work. Together with the evidence of Rembrandt's prints in their multiple states, quite apart from the study of his paintings and drawings, they confirm that his indefatigability was as much the key to his success as his innate and astonishing talent. As Constantijn Huygens, the Prince of Orange's secretary, wrote of the young Rembrandt and his associate Jan Lievens in 1628–9: 'I am forced to witness that I have not seen equal industry and application in any sort of man, whatever his pursuit or age.'[20]

1 The text of this essay is developed from Royalton-Kisch 1993b. The topic has been considered by both Schatborn 1986 and White 1999. While a few of the drawings related to Rembrandt's prints are attributionally contentious, most are not, and I accept the following twenty-eight, many of which are discussed in this catalogue and essay (in the order of Benesch's catalogue):12, 13, 15, 20, 21, 41 (57 is a touched proof), 161 *verso* (Benesch knew only the *recto*; see cat. 31), 164, 168, 183, 184, 185, 188, 292, 388, 423, 477, 482 *verso*, 543, 758, 749 *verso*, 762a, 763, 766, 767, 768, 886, 1227 (perhaps not made specifically for the related etching). See also cat. 77. There are also numerous touched proofs, some of them discussed in this catalogue, including Benesch 57 (see cat. 13).

2 The word 'cartoon' is generally applied to drawings related to paintings rather than prints, but their essential purpose is the same.

3 They are Benesch 15, Louvre (for *St Paul* B.149); Benesch 41, Berlin (the head used for the *Bust of an old man with flowing beard*, B.291); Benesch 21, British Museum (for the *Diana bathing*, B.201); Benesch 758, British Museum (for *Cornelis Claesz. Anslo*, B.271); and Benesch 768, Six collection, Amsterdam (for *Jan Six*, B.285). All are discussed in the present essay.

4 For the criticisms, see the catalogue entry (cat. 10).

5 For the iconographic significance of these motifs, see cat. 45.

6 On which see both the catalogue entry and the essay by Ernst van de Wetering, pp. 47ff.

7 'De meeste ende die naetuereelste beweechgelickheijt'; this from his third letter to Constantijn Huygens of 12 January 1639 (Strauss & Van der Meulen 1979, p. 161, no. 1639/2).

8 White & Boon record counterproofs of the second state only, in Cambridge and Vienna.

9 Emmens 1964, pp. 159–63.

10 The painting is in Amsterdam, Rijksmuseum, *Corpus* III, no. A31.

11 The print was until recently often thought to have been completed by a pupil – for a summary of opinions, see Royalton-Kisch 1993b, p. 192, n. 17.

12 Gersaint 1751, under no. 200. Boeck 1953 came to this conclusion in his analysis of left to right reversals in Rembrandt's etchings. White 1999, p. 212 tends to reject the notion for most plates, although recording that Schatborn, in Amsterdam 1983, p. 7, and Schneider 1990, p. 31, n. 4, respectively suggest that five or four etchings were made on the spot. The lack of documentary evidence is pointed out by Bevers in Berlin-Amsterdam-London 1991–2, under no. 20, with further literature, and in Amsterdam 1993, p. 86. In Amsterdam 1998, Bakker *et al.* seem to believe that all the etchings were dependent on drawings, but the idea that a print might be embroidered on the spot is not investigated.

13 In Amsterdam 1998, p. 340, this print is rightly associated with the drawing of the same view in reverse, Benesch 1248, but the drawing in fact shows the foliage in full leaf rather than in winter, so they must have been made at different times.

14 They are therefore omitted from the list of preparatory drawings at n.1 above.

15 It was already discussed as a problematic work by Lugt 1933, no. 1132, who however accepted it, as did Benesch, no. 743. It was later rejected by Sumowski IV, 1981, p. 1877, no. 7, by Schatborn in Amsterdam 1985, under no. 21, n.6, who tentatively suggested an attribution to Ferdinand Bol, and omitted by Starcky from the exhibition in Paris 1988–9; in reviewing the latter I attempted to reinstate it (Royalton-Kisch 1990, p. 134, and again in *idem*, 1993, p. 191, n. 12). Lugt records the belief of Vosmaer and others that the kneeling woman was derived from her counterpart in Raphael's *Transfiguration*, while Clark 1966, pp. 159–60, believed she was based on a figure in a drawing from the school of Paolo Uccello.

16 There is another sketch of her head on the *verso*, illustrated in Schatborn 1985, p. 49.

17 Benesch 766; he compared it with the first sketch of *Jan Six* (here fig. 1) and therefore dated it 'about 1646', claiming that it depicted the writing-master many years before the etching (which was then generally dated *c*.1653 rather than 1658 as now). Reviewing Benesch, both Rosenberg 1959, pp. 113–14, and Haverkamp Begemann 1961, p. 56, already redated the drawing to around 1658, the date proposed for the etching by Wijnman 1933. The style of the drawing marries well with the *Simeon in the temple* now in The Hague of 1661 (Benesch 1057) and with the preparatory sketch for the painting of the *Jewish bride* of around 1665.

18 Perhaps difficulties in satisfying the sitter led to Rembrandt's also making a preparatory painting (on which see further the essay by Ernst van de Wetering, p. 59ff). Erik Hinterding informs me that White & Boon's states V–VI may not be by Rembrandt.

19 Giltaij 1989 discusses the relationship between style and function in Rembrandt's drawings.

20 Strauss & Van der Meulen 1979, p. 72, from the Latin (given on p. 69): 'Testari cogor, non vidisse me parem diligentiam aut assiduitatem ullo in hominum genere, studio vel aetate.'

Note to the catalogue

The prints are arranged chronologically, with a few exceptions in order to group related works. They have been selected from the Rijksprentenkabinet, Rijksmuseum, Amsterdam and the Department of Prints and Drawings at the British Museum in London, with loans of related works by Rembrandt.

Whenever impressions of the same state and of similar character and quality are present in both collections, the Amsterdam impression is shown in the Rijksmuseum and the London one in the British Museum. An asterisk★ after the name of the institution indicates which impression is reproduced. Rather than listing the complete provenance of each impression, we have given between brackets (before the inventory number) the name of the last owner before it was acquired by the two museums – often the person who presented or bequeathed it. If an impression bears a collector's mark, their name and the number in Lugt's standard work are included.

Watermarks are identified with reference to Ash & Fletcher. If a watermark unknown to them occurs in an impression catalogued here, it is described, marked with an asterisk★ and reproduced. Wherever appropriate, the watermarks are discussed by Erik Hinterding in a brief analysis under the heading 'Watermarks' near the top of each entry.

Considering the vast literature on Rembrandt, our bibliography is a selective one, although we have of course tried to do justice to authors who have put forward new insights. All references are abbreviated, and are given in full in the Bibliography (pp. 371–83). The abbreviation 'exh.' in the captions to the illustrations shows which related drawings and oil-sketches are included in the exhibition (when followed by 'Amsterdam or 'London', the item will be shown in that location only). See further the list of lenders on p. 6.

Dimensions are given height before width; wherever possible the measurements are those of the platemark.

For technical terms (etching, drypoint, counterproof, etc.), readers are referred to Griffiths 1996.

Contributors

EH	Erik Hinterding	MS	Marijn Schapelhouman
GL	Ger Luijten	PS	Peter Schatborn
MRK	Martin Royalton-Kisch		

1

The rest on the flight into Egypt c.1626

Etching, 217 × 165 mm

Hind 307; White & Boon 59 (only state)

Amsterdam★ (Van Leyden RP-P-OB-120; watermark: none); London (1925-6-15-24; watermark: none)

SELECTED LITERATURE: Six 1909, pp. 69, 85; Burchard 1917, pp. 93–4; Münz 1952, II, pp. 90–91; Bauch 1960, pp. 106–7; Vienna 1970–71, pp. 16–17; Amsterdam 1988–9, pp. 118–27; Schatborn 1991, pp. 62–3; Berlin-Amsterdam-London 1991–2, p. 161; White 1999, pp. 20–22.

The rest on the flight into Egypt was a popular theme in art, and Rembrandt illustrated it on several occasions. The subject is based on the gospel of Pseudo-Matthew (xx–xxi), and is not described in the Bible. We see the Holy Family at the foot of a large tree in a landscape, with a tower on a hill in the distance. Mary holds the child on her lap and feeds him with a spoon, while Joseph, who is seated before a pot on a small fire, proffers a bowl of the food he has prepared. Beside him are a hat, a basket and a saw, the latter alluding to his occupation as a carpenter. An ass stands grazing behind him.

This is one of Rembrandt's very first prints and was executed when he was about twenty years old. The later Rembrandt is not yet discernible in the broad, rather uncontrolled style of etching. Doubts have therefore been expressed as to whether the print is indeed by his hand, but the traditional attribution is now accepted. In style the work is related to the earliest prints of Jan Lievens, with whom Rembrandt worked in close association

fig. a Jan Lievens, *St John the Evangelist on Patmos*, c.1626. Etching, 156 × 141 mm. Amsterdam, Rijksmuseum

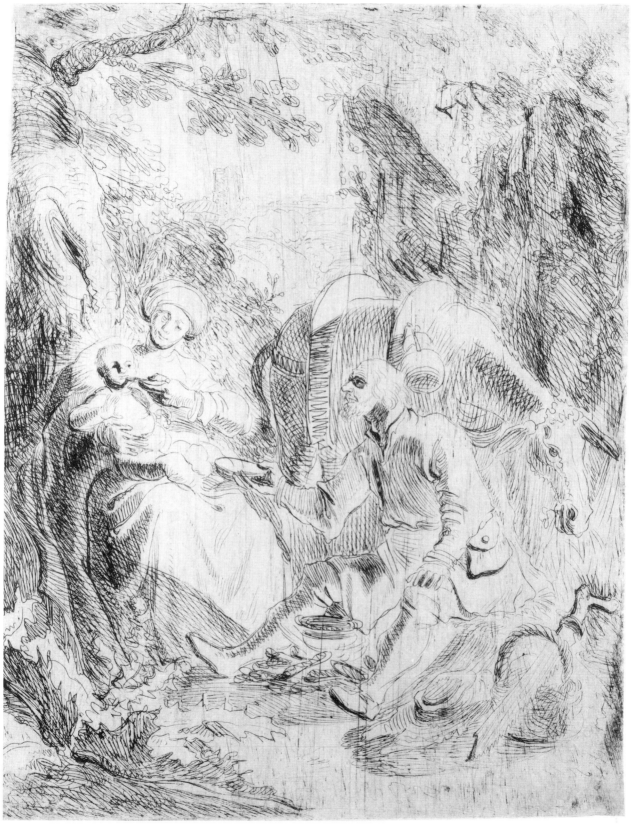

Amsterdam

in these years and possibly even shared a studio. The sketchy rendering of the foliage behind the figure in Lievens' *St John the Evangelist* (fig. a) of about 1626 is strikingly similar to Rembrandt's, while the same is true of the shading on the man's costume, which is frequently in the form of zigzag hatching. However, there are also distinct differences between the works of the two artists. For instance, Lievens' contour lines are more emphasized, and he uses shadow to model the figure and set it off against the background. Rembrandt, on the other hand, concentrates on the overall play of light and dark in the design rather than on the volume of the figures. As a result, the Holy Family tends to dissolve in the landscape and is difficult to distinguish from the background.

Early etchings such as this have prompted speculation as to which artists may originally have influenced Rembrandt's style. The names put forward, apart from Jan Lievens', include Rembrandt's teacher Pieter Lastman and various Dutch printmakers – Moses van Uyttenbroeck, Jan Pynas and Gerrit Pietersz Sweelinck. But perhaps we need to look further afield. We know, for example, that the beggars Rembrandt etched a short time later were stylistically influenced by the prints of the French artist, Jacques Callot, and that two etchings of lion hunts that Rembrandt made around 1629 (fig. b) were inspired by prints by the Italian Antonio Tempesta. The latter may also already have inspired the early *Rest on the flight into Egypt* of around 1626, as his version of the *Flight into Egypt* (fig. c) is similar not only in characterization, but also in the free manner of hatching and the representation of the leaves.

EH

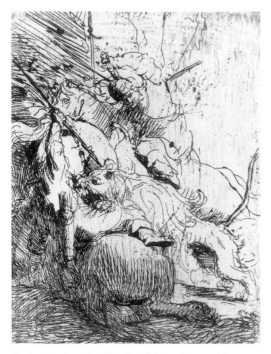

fig. b Rembrandt, *The Small Lion Hunt: with one Lion*, c.1629. Etching, 158 × 117 mm. Amsterdam, Rijksmuseum (B.116)

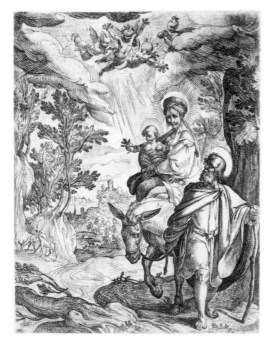

fig. c Antonio Tempesta, *The flight into Egypt*. Etching, 248 × 190 mm. Amsterdam, Rijksmuseum

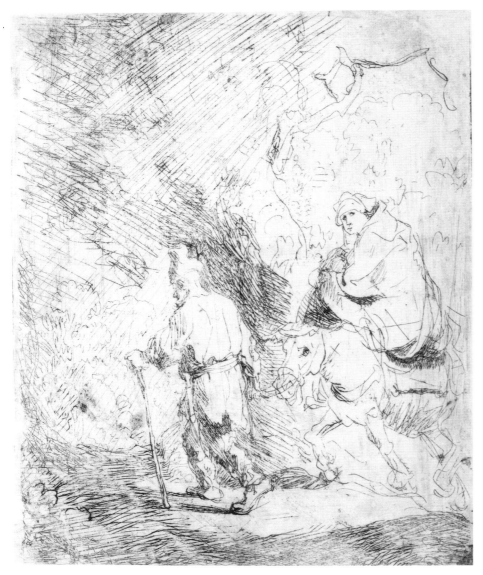

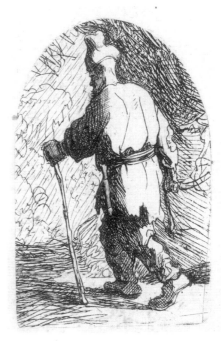

fig. a Rembrandt, *Joseph on the flight into Egypt*, *c*.1626. Etching, 79 × 51 mm. Amsterdam, Rijksmuseum (B.54 III)

I Amsterdam

2

The flight into Egypt: a sketch *c*.1626

Etching, 146 × 122 mm (first state); 79 × 51 mm (from second state)

Hind 17; White & Boon 54 I (of VI)

I Amsterdam★ (Van Leyden RP-P-OB-108; watermark: Basilisk [Ash & Fletcher 12, C´.d., illustrated only here])

Watermarks: the watermark in this impression is not found in other prints and cannot be dated.

SELECTED LITERATURE: De Vries 1883, p. 295; Six 1909, pp. 76, 85; Bauch 1960, pp. 123–5; Amsterdam 1988–9, p. 5; Chapman 1990, pp. 21–22; Schatborn 1991, pp. 62–3; London-The Hague 1999–2000, no. 2; White 1999, pp. 22–3.

In comparison with the *Rest on the flight into Egypt* (cat. 1) Rembrandt here takes the first steps on the way to a new style, which was to inform all his later work. Large areas of cross-hatching and continuous dark outlines are abandoned, while the figures and the foreground and background are set down more loosely and sketchily. Areas have been left open and dark accents and shadows have been placed so as to intensify the effect of the light. This drawing-like style was of course only possible because the artist could move the etching needle freely in the etching ground. Rembrandt is the first artist to have imbued the etching technique with the character of a drawing in such a thorough-going fashion.

The only two surviving impressions of this work were not particularly successful. Rembrandt made corrections in pen and ink on the second of them, now in Paris. Nevertheless he did not consider it worthwhile to improve the plate and decided to cut

the figure of Joseph and make a separate plate of it. Joseph thus lost his identity and became a man walking with a stick, although part of the donkey's head remains visible on the right (fig. a). Rembrandt worked up details of Joseph's beard in the third state, but the changes made from the fourth state onwards were not made by him.

Rembrandt turned the remaining upper right portion of the original plate and used it for a small *Self-portrait* next to Mary's head. In the first state her head can still be seen, upside down; the other visible lines are the remnants of the tree (fig. b). The virgin was removed in the third state and the plate was also reduced in size.[1]

The long series of self-portraits by Rembrandt started with the depiction of his own face in a number of historical paintings, known as the self-portraits *in assistenza*.[2] In these he appears as an onlooker or participant in a biblical or other historical scene. As in these paintings, the young Rembrandt in the present etching looks boyish, almost childlike. The gaze with which he regards himself appears concerned, but in fact essentially reveals the concentration with which he is recording his portrait on the etching plate.

PS

1 The shadow under the chin was darkened in the second state. The only example of this state is in Paris, Musée du Louvre, Cabinet des Arts Graphiques, coll. De Rothschild. There is also a second example of the self-portrait on which the Virgin's head can still be seen in the Rothschild collection, formerly in the Rijksprentenkabinet and auctioned on 2 May 1882 as a duplicate.
2 London-The Hague 1999–2000, p. 41 and the figures on pp. 88–9.

3

The artist's mother: head only, full face 1628

Etching, 85 × 72 mm (first state), 63 × 64 mm (second state); signed and dated in the second state at centre left: *RHL 1628* ('2' reversed)

Hind 2; White & Boon 352 I and II (of II)

I Amsterdam★ (Van Leyden RP-P-OB-747; with additions in black chalk; watermark: none)

II Amsterdam★ (De Bruijn RP-P-1961-1195; *verso* in brown ink: *P. mariette 1674*; watermark: fragment of fleur-de-lis with initials BA. [Ash & Fletcher 36, Initials BA.b.]); London (Cracherode 1973.U.737; watermark: none)

Watermarks: the Strasbourg lily in the Amsterdam impression of the second state is found in numerous other etchings, such as the small *Presentation in the temple* of 1630 (B.51) and the *Good Samaritan* of 1633 (B.90). The latest dated print with this watermark is the *Great Jewish bride* of 1635 (cat. 25), the year in which these impressions must have been made.

SELECTED LITERATURE: Münz 1953, pp. 141–90; Boon 1956, p. 48; White 1999, pp. 114–15.

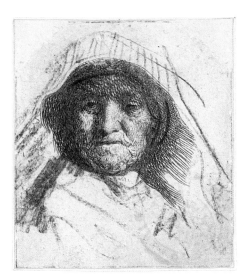

I Amsterdam

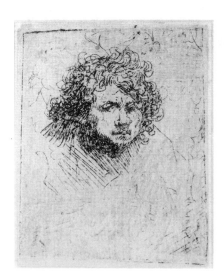

fig. b Rembrandt, *Self-portrait*, c.1626. Etching, 97 × 51 mm. Amsterdam, Rijksmuseum (B.5 I)

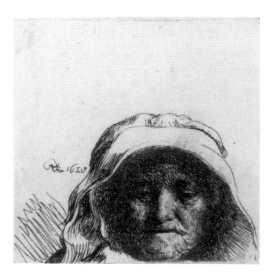

II Amsterdam

Apart from prints of biblical subjects and beggars, Rembrandt made numerous etched studies of the human face at the beginning of his career. Many of them were based on his own features, but he also portrayed people from his immediate surroundings. The woman in this etching of 1628 is almost certainly his mother, Neeltgen Willemsdr. van Zuytbroeck (*c*.1568–1640). She is not actually named on the print, but in 1679 the copper plate of another print (B.349; fig. a), which formed part of the estate of the Amsterdam print dealer Clement de Jonghe, was identified as 'Rembrandt's mother', and the resemblance between the two women is clear.[1]

There are two states of this early print. The first is only a drawing of the head: the shoulders and torso are not shown, but the shading to the right of the head suggests what he had in mind. The precise way it is rendered suggests that Rembrandt, seated opposite his mother, etched directly onto the plate. He modelled the face with a profusion of fine lines, evoking the feel of the wrinkled skin, and the shadow that the headdress casts is etched with meticulous care.

At this stage Rembrandt was apparently uncertain about how to complete the image. In the impression of the first state shown here, one of only two known, he drew the rest of the headdress in black chalk, and tentatively outlined the shoulders. He subsequently executed this version, but only in part. In the second state, which is also included, the headdress is completed, and Rembrandt may have etched the torso as well, but if that is indeed the case he must have been dissatisfied with the result because the plate was finally cut just beneath the woman's chin. Rembrandt also made some other, more minor changes to the face in this state. He added a few lines to soften the patch of light on the right cheek, and made the right eye slightly smaller so that the woman's gaze appears to be fixed on a lower point than in the first state.

A comparison between this print of 1628 and the *Rest on the flight into Egypt* (cat. 1) of about two years earlier reveals not only his talent, but also the tremendous technical and stylistic progress that he had made in this short time. Even so, the print is not entirely successful. The fact that the plate is cut directly under the woman's chin gives the impression that we are looking at no more than a fragment.

Nevertheless, the print was evidently in demand, as the copper plate is known to have been reprinted on at least two occasions. The watermark on the second state shown here can also be seen in specimens of the second and third states of the *Great Jewish bride* (cat. 25), and the impression must therefore have been made in

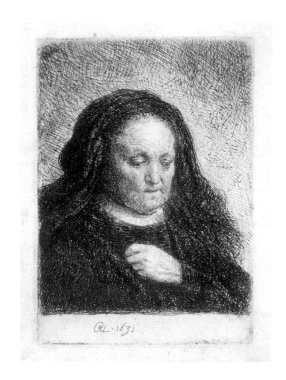

fig. a
Rembrandt,
Rembrandt's mother with her hand on her chest,
1631. Etching,
94 × 66 mm.
Amsterdam,
Rijksmuseum
(B.34a)

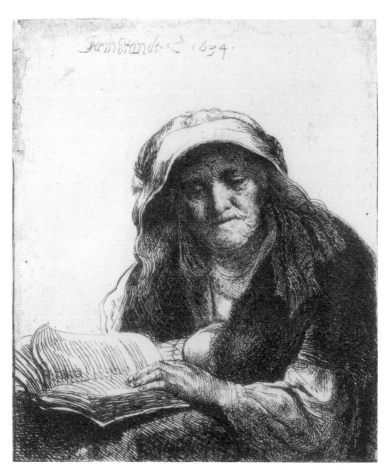

fig. b Eighteenth-century forgery combining Rembrandt, *Woman reading* (B. 345) and *Rembrandt's mother: head only* (B.352). Etching, 123 × 100 mm. Paris, Bibliothèque Nationale de France

around 1635. The plate was reprinted a short time later, but in this case on paper with the Arms of Württemberg watermark.[2] A forgery was made in the early eighteenth century (fig. b) by combining impressions of the present print with the *Woman reading* (B. 345).[3]

EH

1 For the inventory of Clement de Jonghe, which mentions Rembrandt's mother under no. 10, see De Hoop Scheffer & Boon 1971, pp. 1–17, and especially De Hoop Scheffer 1972, pp. 126–34.

2 Ash & Fletcher 9, B′.a.

3 The forgery was mentioned by Gersaint 1751, no. 315, and must therefore have been made before that date.

4

Self-portrait, bareheaded: bust, roughly etched, *c.*1629

Etching, 174 × 155 mm; signed and dated upper left in reverse: *RHL 1629*; both impressions touched with pen in dark grey ink

Hind 4; White & Boon 338 (only state)

Amsterdam★ (Van Leyden RP-P-OB-723; watermark: none); London (1848-9-11-19; verso, inscription in black chalk (or graphite), early seventeenth-century hand but almost certainly not Rembrandt's: *2 Wtenbogaert / 2 Ulespiegels / 2 [..] solemans [?] printen [?]*; watermark: none).

SELECTED LITERATURE: Boeck 1953, pp. 198–9; Chapman 1990, pp. 11, 22, 24, 34, 59; London-The Hague 1999, no. 11; Schatborn 1985, no. 1; White 1999, pp. 115–16.

Most of Rembrandt's early self-portraits are small or even very small. This is the first large etched self-portrait and it also has a certain status, as can be seen not just from its size, but from the monogram and date which appear prominently, in reverse, at the upper left. It resembles the signature on Rembrandt's paintings at this time. He probably intended to print an edition of this portrait but was evidently dissatisfied with the result and only two impressions are now known.

The portrait departs from virtually everything ever made as an etching up to this time. This is because Rembrandt used not only a fine etching needle but also a quill or reed pen which, if the artist presses hard, produces a double line. The lines are sometimes so broad that the ink did not adhere, and Rembrandt retouched them, as can be seen most clearly in the London impression. He also etched and inked the plate very heavily, creating dark passages and strong contrasts. Nor was the plate entirely pristine, as a small scene appears at the upper left which

may represent the *Supper at Emmaus*. It is most visible on the London impression (fig. a).

The present *Self-portrait* is an extreme example among Rembrandt's attempts to make etchings in the manner and style of drawings. The etching also closely resembles a drawn *Self-portrait* of the same period (fig. b). The drawing is not a true preliminary study, however, since it portrays Rembrandt as he saw himself, whereas the etching shows him as he wanted to be seen by others. On the print he has a lock of hair down to his shoulder on one side of his head, a style affected by the aristocracy but not by Rembrandt himself. The significance of this lock, which he added here and on other self-portraits, again points to the ambitions he had in making these portraits. He wears the same clothes as he does in the drawing – a white collar over a jacket with braiding, evoking associations with military uniforms.

PS

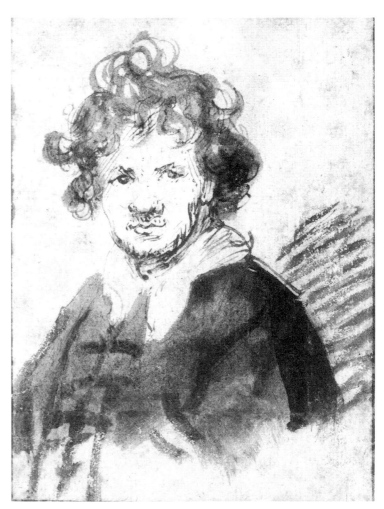

fig. b Rembrandt, *Self-portrait*, *c.*1629. Pen and brown ink with grey wash, 127 × 94 mm. Amsterdam, Rijksmuseum (Benesch 54)

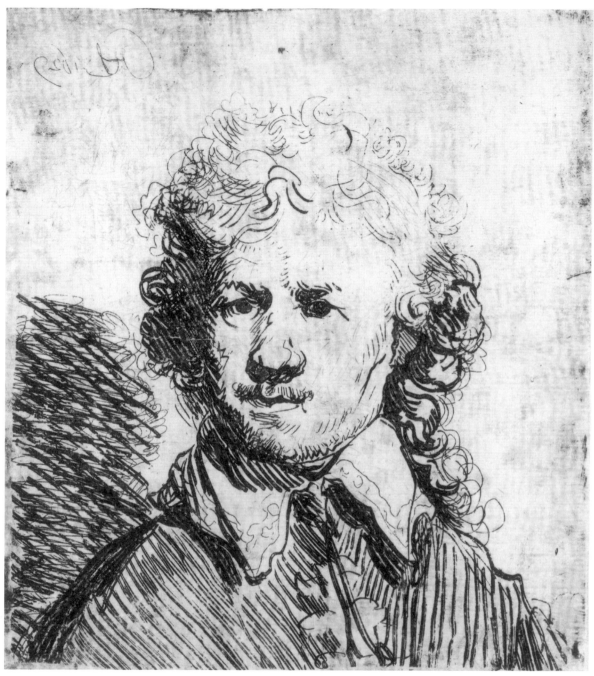

Amsterdam

fig. a Rembrandt, *Christ at Emmaus*(?), detail of cat. 4. London, British Museum

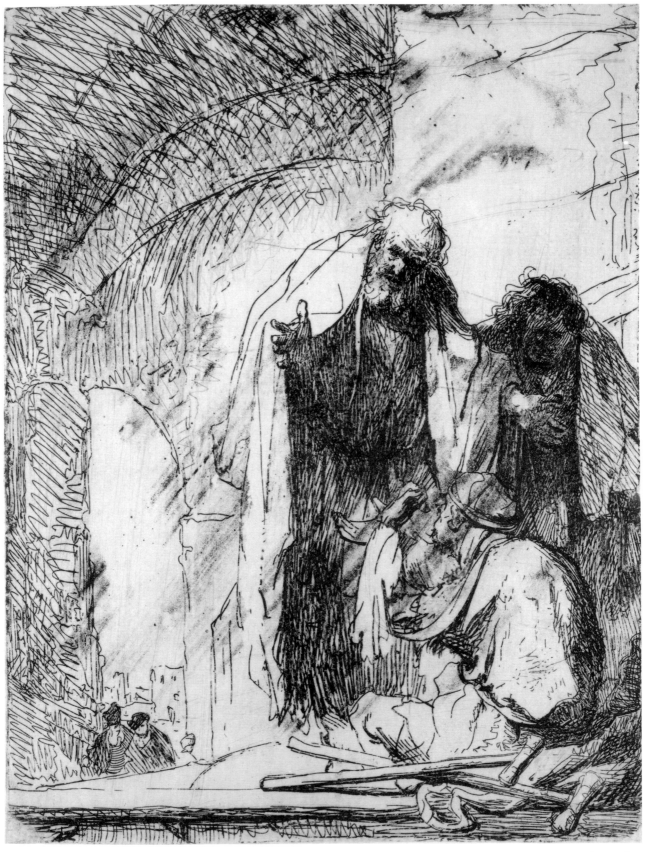

Amsterdam

5

Peter and John at the gate of the temple *c.*1629

Etching, 221 × 169 mm

Hind 5; White & Boon 95 (only state)

Amsterdam★ (Van Leyden RP-P-OB-178; lines retouched in parts with brush and grey ink; watermark: Countermark NA [Ash & Fletcher 26, NA.b.]); London (1848-9-11-50, lines retouched in parts with brush and grey ink; watermark: Countermark NA★)

Watermarks: the countermarks seen here are probably 'twinmarks' that come from the same stock of paper. They are not otherwise recorded in Rembrandt's etchings, but the rarity of the impressions in which they occur, suggests a date around 1629 (see pp. 27–28).

SELECTED LITERATURE: Bauch 1960, p. 127; Vienna 1970–71, no. 10; White 1999, pp. 23–5, 27, 28.

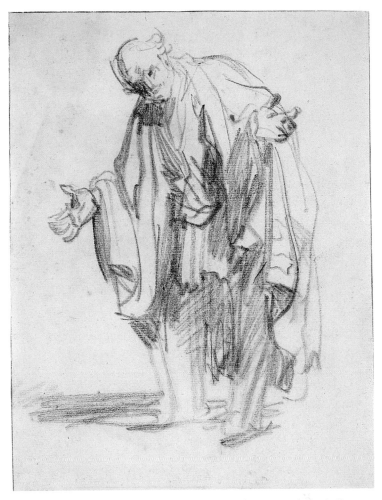

fig. b Rembrandt, *Old man with arms outstretched, c.*1629. Black chalk, 254 × 190 mm. Dresden, Kupferstich-Kabinett (Benesch 12; exh. Amsterdam)

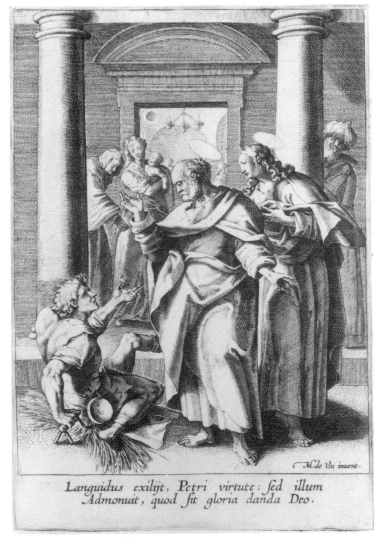

fig. a Anonymous artist after Maarten de Vos, *Peter and John at the gate of the temple, c.*1585. Engraving, 189 × 130 mm. Amsterdam, Rijksmuseum

Arriving at the temple gates, Peter and John encounter a beggar who has been lame since birth. Peter addresses the man, saying that he can give him neither silver nor gold, but heals him in the name of Christ (Acts 3:1–10). The encounter between the two apostles and the lame man is part of the standard repertoire of illustrations from the *Acts of the Apostles*, and several separate depictions of the text also exist.[1] The main ingredients are present in a widely disseminated engraving after a drawing by the Antwerp artist Maarten de Vos (1532–1603): the architectural surroundings, the two apostles – Peter greeting the beggar, arms outstretched, and several people who witness the scene as they visit the temple (fig. a).[2]

Rembrandt chose to represent the same moment: not the miracle itself but the action immediately preceding it, when Peter accosts the man. He based Peter's somewhat theatrical pose on a figure study, having manoeuvred a model into this position for

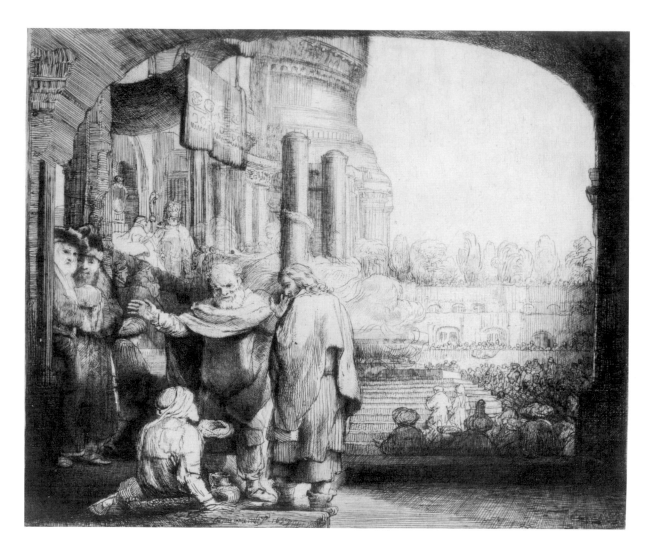

fig. c Rembrandt,
*Peter and John at the gate
of the temple*, 1659.
Etching, drypoint and
burin, 180 × 215 mm.
Amsterdam,
Rijksmuseum
(B.94 II)

the purpose (fig. b). He deliberately adopted a low viewpoint, sitting on a stool or on the ground to draw the model.[3] He may have made an equivalent study of the beggar, but the figure of John is worked up so little that he may have invented it on the copper plate. Yet his head vaguely recalls Rembrandt's etched self-portraits and studies of heads from the same period.[4]

As only four impressions of the print have survived, it is unlikely that a sizeable edition was produced. Nor is the print by any means a flawless work of art. Black streaks are visible all over the plate, probably caused by the disintegration of the etching ground. Rembrandt tried to remedy this by applying varnish with the brush in places, and various white strokes or stripes interrupt these splotches as a result. Where the hatching had failed to absorb any ink – in particular in the figure of John – three of the four impressions were retouched subsequently with the brush in grey ink.

Even leaving aside these technical flaws, the etching displays an unusually crude and scratchy execution, which greatly adds to its experimental appearance. Rembrandt had rarely adopted such a large size for his prints before, and did not adapt his mode of

hatching or the width of the lines. It is as if he wanted to see whether he could approximate the sketch-like qualities of his early chalk drawings in a print, an ambition impossible to realize fully, as an etching needle makes far thinner lines than crumbly chalk.

Rembrandt almost certainly reused the copper plate for another etching, though which one has yet to be determined. He may have cut or sawn the plate down, something he did quite frequently. Rembrandt was to return to this subject in another etching in 1659 (fig. c), changing the disposition of the three protagonists and the architecture. It is hard to believe that the artist did not have the thirty-year-old version to hand when he once again etched the bald, gesticulating Peter, the cloaked figure of John and the seated beggar gazing up at them.

GL

1 See Pigler 1974, I, pp. 386–8.

2 Hollstein, *Maarten de Vos*, 892.

3 Schatborn 1993, p. 161.

4 See also Bauch 1933, pp. 192–3.

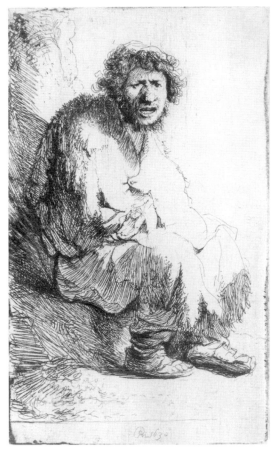

London

6

Beggar seated on a bank 1630

Etching, 116 × 70 mm; signed and dated lower centre: *RHL 1630*

Hind 11; White & Boon 174 (only state)

London★ (Cracherode 1973.U.742; watermark: none)

SELECTED LITERATURE: Chapman 1990, p. 33; Halewood 1993, p. 292; London–The Hague 1999–2000, no. 24.

Beggars and the disabled feature in Rembrandt's drawings and prints from the end of the 1620s. These subjects, which had been depicted since the Middle Ages, were usually intended to be satirical. As the seventeenth century progressed, portrayals of such street types became more detached and were valued principally for their picturesque qualities.[1] The clothes and, in particular, the beret worn by Rembrandt's beggar look old-fashioned; in later prints he would give his street figures a more contemporary air (as in cat. 35).

The beggar's features resemble Rembrandt's in his etched *Self-portrait, open-mouthed* (fig. a), which also dates from 1630. In both prints the forehead is creased in a frown and the mouth is open,

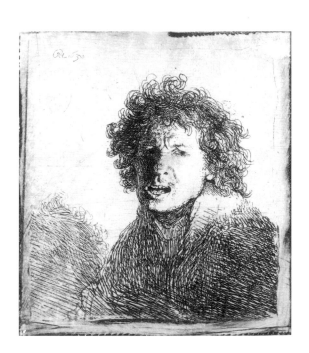

fig. a
Rembrandt,
*Self-portrait,
open-mouthed*,
1630.
Etching,
81 × 72 mm.
Amsterdam,
Rijksmuseum
(B.13 I)

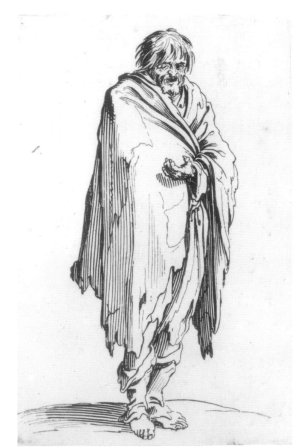

fig. b
Jacques Callot,
Standing beggar,
c.1620–23.
Etching,
137 × 82 mm.
Amsterdam,
Rijksmuseum

93

revealing a few teeth; there is a highlight on the tongue. Unlike the self-portrait, the beggar has a beard. A single button fastens his coat.

Rembrandt took as his model the series of prints of beggars by the French artist Jacques Callot (1592–1635).[3] The face with the open mouth and the gesture of the begging hand are found in a standing figure by Callot (fig. b).[5] The rocky bank on which Rembrandt's beggar sits is a motif that was probably derived from an engraving by Lucas van Leyden, in which a man and a woman sit together on a virtually bare rock, their poverty further illustrated by a leafless tree (fig. c).[5] However, they are by no means as poorly dressed as the figure in Rembrandt's print.

The etching gives the impression that Rembrandt wanted to make a portrait of himself as a beggar, but this is not so. In fact, he transferred the expression of despair that he had depicted in the *Self-portrait, open-mouthed* to the beggar.[6] In the 1634 etching of a *Man crying out 'tis vinnich kout'* (cat. 19) the head differs yet more from the likeness we know from Rembrandt's self-portraits.

There is an impression of an undescribed second state of the *Beggar seated on a bank* in which the lower margin of the plate has been cut off and the signature removed.[7]

PS

1 Stratton 1986, pp. 78–9.

2 B. 176 and 131.

3 Lieure 479–503, V, pp. 41–45; VI, figs 479–503.

4 Lieure 490, V, p. 43; VI, fig. 490.

5 The New Hollstein, *Lucas van Leyden*, 143.

6 On the identification of the figures see Washington-Boston 1983, no. 23.

7 Aachen, Suermondt-Ludwig-Museum. Aachen 1984, no. 2; the plate now measures 102 × 69 mm.

7

Self-portrait, frowning: bust 1630

Etching, 75 × 75 mm (first state); 72 × 60 mm (second state); in the first state only signed and dated upper left: *RHL 1630*

Hind 30; White & Boon 10 I and II (of III)

I Amsterdam★ (Van Leyden RP-P-OB-20; watermark: none)

SELECTED LITERATURE: Boeck 1953, p. 199; Chapman 1990, pp. 19, 21; Berlin-Amsterdam-London 1991–2, no. 2; London–The Hague 1999–2000, no. 21; White 1999, p. 117.

Like the *Self-portrait with beret, wide-eyed* (cat. 8) and two other self-portraits (cat. 6, fig. a and cat. 8, fig. a), the *Self-portrait, frowning* is one of the etchings in which Rembrandt used his own features to render emotions (see cat. 8). The artist has looked himself straight in the eye in the mirror with an angry stare: he

fig. c
Lucas van
Leyden,
Beggars,
c.1509.
Engraving,
108 × 77 mm.
Amsterdam,
Rijksmuseum

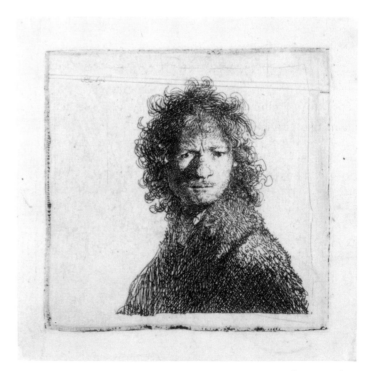

I Amsterdam

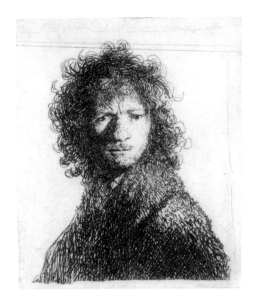

fig. a Rembrandt, *Self-portrait, frowning,* 1630. Etching, 72 × 60 mm. Amsterdam, Rijksmuseum (B.10 II)

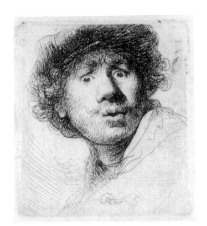

Amsterdam

recorded a tight-lipped mouth, a piercing gaze and a furrowed brow.

It is interesting to see the other means Rembrandt used to amplify the effect of anger. In the first state the head is to the right of centre. To increase the directness of the image, Rembrandt reduced the plate on the left-hand side, bringing the head into the centre in the second state (fig. a). In an impression of a previously unknown intermediate state of the print that survives in Berlin, Rembrandt has added a new outline around the left shoulder, mirroring the right.[1] He evidently felt that this was taking the symmetry too far, and the line was removed again in the next state. Rembrandt is not wearing a cap, and the hair bristling out from his head likewise heightens the intensity of the emotion. So, too, does the sharply delineated shadow of the nose cast on the left side of the face, which strengthens the power of the expression. A glimpse of a white shirt can be discerned under the plain coat with its fur collar.

PS

1 Berlin-Amsterdam-London 1991–2, p. 172, no. 2, fig. p. 173.

8

Self-portrait with beret, wide-eyed 1630

Etching, 51 × 46 mm; signed and dated in drypoint lower centre: *RHL 1630*

Hind 32, White & Boon 320 (only state)

Amsterdam★ (Van Leyden RP-P-OB-697; watermark: none); London (Cracherode 1973.U.769; watermark: none)

SELECTED LITERATURE. Benesch 1926, p. 6; Chapman 1990, pp. 19, 21; Berlin-Amsterdam-London 1991–2, pp. 170–72, no. 1; London-The Hague 1999–2000, no. 20; White 1999, p. 117.

The *Self-portrait with beret, wide-eyed* is one of a small group of etchings made in 1630 in which Rembrandt used his own likeness to depict various facial expressions. Three other etchings show Rembrandt frowning (cat. 7), laughing (fig. a) and open-mouthed (cat. 6, fig. a). These prints are not so much self-portraits as studies in expression, which could serve both Rembrandt himself and his pupils as models.

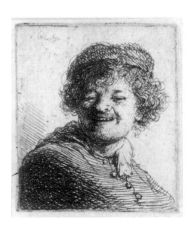

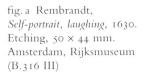

fig. a Rembrandt, *Self-portrait, laughing,* 1630. Etching, 50 × 44 mm. Amsterdam, Rijksmuseum (B.316 III)

It was important for a history painter to be able to render feelings and emotions in biblical, mythological and allegorical scenes. Samuel van Hoogstraten, a pupil of Rembrandt's in the 1640s and author of the *Inleyding tot de Hooge Schoole der Schilderkonst* of 1678, advised young artists: 'You will also find the same assistance in expressing passions by using what you have before you, chiefly by being at the same time actor and spectator in front of a mirror.'[1] Van Hoogstraten may well have been given this advice by his teacher, who demonstrated this approach in the four prints.

In the present *Self-portrait* the face occupies a large part of the small area of the picture. The way that the portrait is cut off at the upper edge and the fact that the face is rendered slightly from below reinforce the impression of surprise and amazement, as if the artist has tilted his head up and back in a swift gesture. A comparable expression can be seen on the face of the astonished figure on the right of the etching made in around 1632 of the *Raising of Lazarus* (cat. 17), although the mouth is slightly more open. The same sort of wonderment can also be seen in the print after a drawing by Rembrandt that Houbraken used in order to illustrate a passage on the life of the artist: in it one of the disciples at the Supper at Emmaus stares wide-eyed at Christ's disappearance.[2]

PS

1 Hoogstraten 1678, p. 110; 'Dezelve baet zalmen ook in 't uitbeelden van diens hartstochten, die gy voorhebt, bevinden, voornaemlijk voor een spiegel om tegelijk vertooner en aenschouwer te zijn'.

2 Houbraken 1718–21, I, p. 258.

9

Bald-headed man in profile to right; the artist's father? 1630

Etching, 118 × 97 mm (first and second states), 69 × 58 mm (third state); signed and dated in drypoint, lower left: *RL 1630*. Etched at lower centre in the second state: *RL 1630.*; at lower right in the third state: *RHL 1630*

Hind 23; White & Boon 292 I, II and III (of III)

I Amsterdam★ (Van Leyden RP-P-OB-589; watermark: fragment of Words★ [incorrectly described in Ash & Fletcher 38, F.a.])

I London★ (Cracherode 1973.U.761, with additions in brush and grey ink, and on the verso an impression of the first state of the *White negress*, B.357 [fig. b]; watermark: none)

II Amsterdam★ (Van Leyden RP-P-OB-590; watermark: none); London (1855-4-14-272; watermark: none)

III Amsterdam (Van Leyden RP-P-OB-591; watermark: none); London★ (1843-6-7-174; watermark: Basel crosier [Ash & Fletcher 11, A.b.])

Watermarks: the watermark fragment in the Amsterdam first state impression may be related to another fragment in a London impression of the first state of the *Self-portrait, frowning* (cat. 7) of 1630. The Basel Crozier in the third state also occurs in impressions of other prints, of which the *Angel appearing to the shepherds* (cat. 21) of 1634 has the latest date. Thus the third state impression in London (illustrated) must have been printed at around this time.

SELECTED LITERATURE: Hind 1905–6, pp. 427–9; Münz 1953, pp. 141–90; Boon 1956b, no. 12; Vienna 1970, no. 28; Amsterdam 1981, no. 2.

Rembrandt is known to have depicted not only his mother but also his father, the Leiden miller Harmen Gerritsz. van Rijn (*c.* 1568–1630). A painting was documented in Leiden in 1644 as a *Tronie* [i.e. character study of the head] *of an elderly man: portrait of Rembrandt's father*, while the inventory of the print publisher Clement de Jonghe of 1679 describes a copper plate as of *Rembrandt's father*.[1] It is difficult to say whether the subject of the etching shown here is indeed Harmen Gerritsz. van Rijn. Rembrandt depicted several elderly men repeatedly in his early work, but too little is known about them to draw any conclusions as to which was his father. One drawing of an elderly man bears the inscription *Harman. Gerrits. van de Rhijn* in a seventeenth-century hand (fig. a), possibly Rembrandt's, but the features bear little resemblance to those of any other figures that appear in Rembrandt's work. The man in this etching appears in several other prints and paintings, most of which were executed in or before 1630, the year that Harmen Gerritsz. died.

The print was completed in three states, a procedure that Rembrandt normally used for model studies of this kind. The rare first state shows only the head; the rest of the figure is outlined only very lightly. The head is rendered with an immediacy which

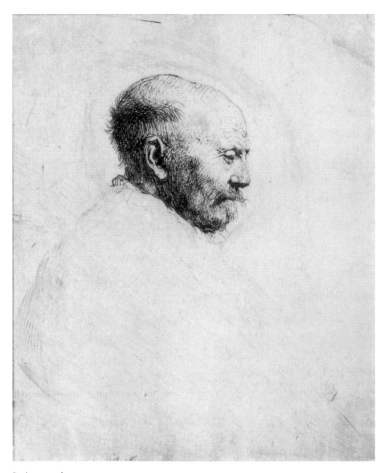

I Amsterdam

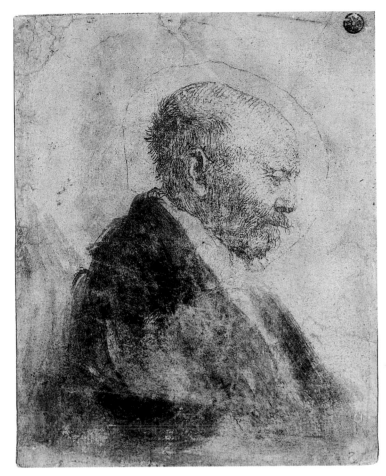

I London (touched)

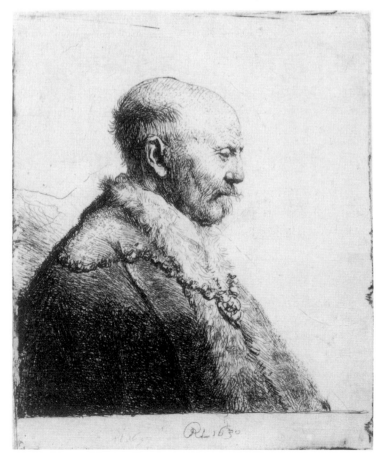

II Amsterdam

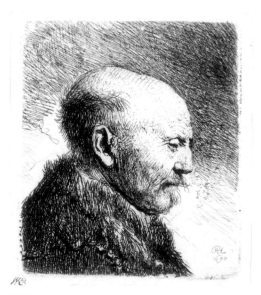

III London

97

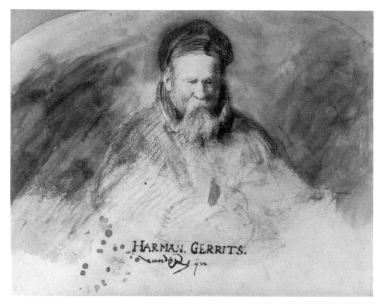

fig. a Rembrandt, *Rembrandt's father*, c.1630. Red and black chalk, with brown wash, 189 × 240 mm. Oxford, Ashmolean Museum (Benesch 56)

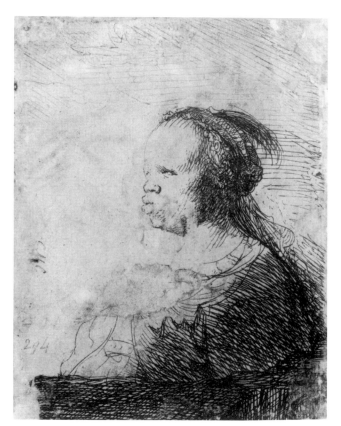

fig. b Rembrandt, *The white negress*, c.1630. Etching, 112 × 84 mm. London, British Museum (B.357)

leaves little doubt that Rembrandt etched it directly onto the copper plate from the model, who appears to look downwards, as if waiting patiently. We can also infer that the print was not based on a drawing from the fact that Rembrandt, on the second impression of the first state shown here, drew in the bust in brush in grey ink before completing the etching. This retouched proof reveals much about the process by which the print was made, but for Rembrandt it was probably nothing more than a trial sheet, to be discarded once it had served their purpose. So as not to waste paper he used the other side to print the first state of the *White negress* (fig. b). Though this proof of the *Bald-headed man* is usually described as a first state, it may in fact be earlier, as the faint lines indicating the body in the first state cannot be seen here, while part of the irregular circle around the head seems to have been erased before the 'first state' was printed.

The additions in brush and grey ink were executed in the second state, where we see the man in a white shirt and a fur-trimmed coat. Although the shoulders and torso in the touched proof are convincing, Rembrandt depicted them more broadly on the copper plate. As a result, the figure fits better in the picture-space; but the torso is too large in relation to the head. This might explain why Rembrandt reduced the plate in the third state (also shown here). Here he also strengthened the shading of the head, shirt and fur collar, and added a dark background.

EH

1 See Strauss & Van der Meulen 1979, 1644/1; De Hoop Scheffer & Boon 1971, pp. 1–17 (under no. 53) and De Hoop Scheffer 1972, pp. 126–34. Another painting of Rembrandt's father was mentioned in 1680 in the estate of Jan van de Capelle. See Hofstede de Groot 1906, no. 350.

10

Diana at the bath *c.*1631

Etching, 178 × 159 mm; signed lower right: *RHL. f.*

Hind 42; White & Boon 201 (only state)

Amsterdam★ (De Bruijn RP-P-1962-70; watermark: Pot [Ash & Fletcher 32, A.a.]); London (1829-4-15-17; watermark: Double-headed eagle [Ash & Fletcher 15, A.a.])

Watermarks: the Pot watermark in the Amsterdam impression is probably from French paper and is otherwise unrecorded in Rembrandt's etchings. The Eagle watermark on the British Museum's occurs in several prints of the early 1630s.

SELECTED LITERATURE: Royalton-Kisch 1992, no. 5; Royalton-Kisch 1993b, p. 174; Schatborn 1993, p. 164; Schatborn 1994, p. 21; White 1999, pp. 195–6.

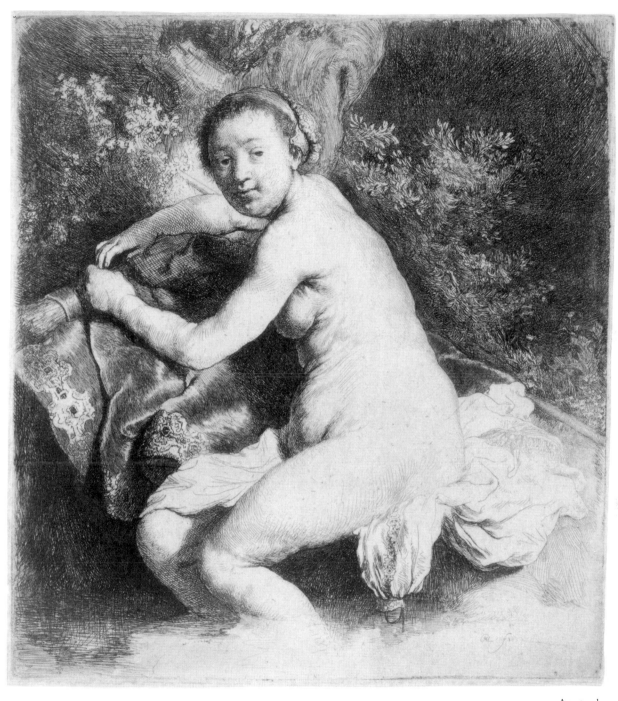

Amsterdam

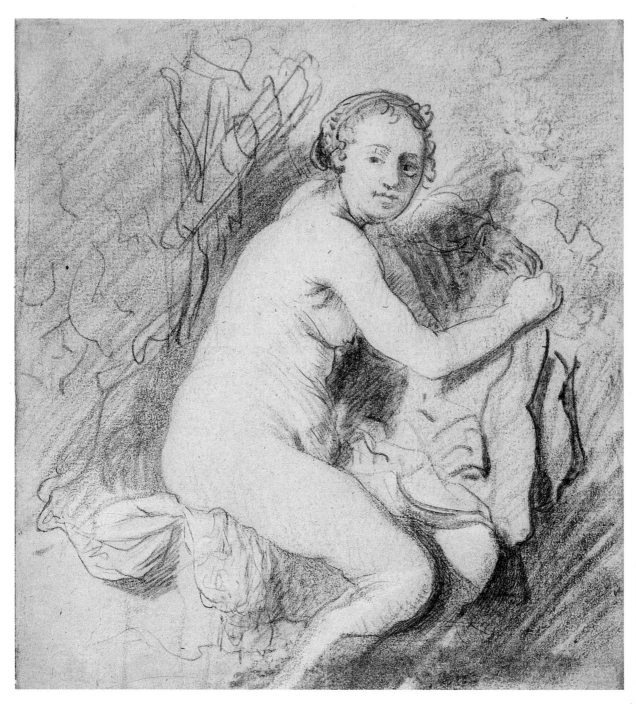

fig. a Rembrandt,
Diana at the bath.
Black chalk with some
brown wash, outlines
indented for transfer,
181 × 164 mm.
London, British
Museum
(Benesch 21; exh.)

Rembrandt first sketched the figure for his print of *Diana at the bath* in a drawing in black chalk (fig. a). This gives every appearance of having been made from life, as is suggested by the immediacy of the glance and the convincing description of the light raking across the body. On top of some generalized shading in the background Rembrandt finally dashed in the quiver and arrows, anticipating the subject-matter of the etching, but the woodland is indicated only summarily. His chief concern appears to have been to fix the figure's pose and the shadows immediately surrounding her, which are vigorously set down with a more temperate addition in brown wash (which has since faded to near-invisibility).

The outlines of the figure were pressed through onto the copper with a sharp point. No longer confronted by the model, the resulting, etched figure appears more mechanical, the expression more dimmed. The subtlety of modelling in the shadows is also undermined by the deep blacks down the front of the torso in the print. These and some other adjustments, such as the modelling of the nearer leg, and the lack of any embellishment to the model's face or other features, were perhaps intended to emphasize the 'realism' of the nude, thereby challenging the normative idealization of mythological goddesses in western art, an approach that had been taken for granted since the Renaissance. On the other hand the background vegetation,

though no less detailed, is etched in a lively manner, almost as if from nature, producing some of the most satisfactory passages in the print. The position of the quiver has been altered and the rich texture of the robe below the arms, with what appears to be an embroidered and jewelled pattern, is convincingly suggested. Elsewhere Rembrandt seems almost wilfully to have refrained from working up the details: for example, the drapery over the thigh appears flat, and the water in the central foreground is also barely elaborated. The patch of light above the further arm must have been left open – unfinished, even – in order to prevent the shaded side of the face from sinking into the background.

These uneven qualities, combined with the somewhat pale tonality of most surviving impressions from the lightly bitten plate, have led some commentators to suggest that it was executed with studio assistance.[1] Yet a more detailed and mechanical finish is characteristic of several prints for which preparatory drawings were made.[2] Also worthy of note is the *pentimento* in the drawing where the further arm of the figure, originally reaching down towards her drapery, is raised to comply with its position in the print: it would have been difficult for an assistant to produce the final arm on the basis of the sketch.

Rembrandt probably made the print in 1631, the year in which he moved definitively to Amsterdam. It was a period during which he began to display a greater interest in mythological subjects, perhaps prompted by his contact with courtly tastes through Constantijn Huygens, the secretary to the Prince of Orange in The Hague, in around 1628–9. Yet Rembrandt's approach to this kind of iconography was unconventional, and only the quiver suggests that the goddess Diana is represented. Along with its 'pair', the *Naked woman seated on a mound* (cat. 11), the etching may well have prompted the poet Andries Pels' (1631–81) attack on the artist:

'When he would paint a naked woman, as sometimes happened, he chose no Greek Venus as his model, but a washerwoman or peat-treader from a barn, naming his error truth to Nature, and everything else idle decoration. Flabby breasts, wrenched hands, yes even the marks of corset-lacings on the stomach and of the stockings around the legs, must all be followed, or nature was not satisfied.'[3]

The controversy rumbles on to this day, with some writers claiming that these nudes conform to an ideal, while others, somewhat more plausibly in our view, believe that they were intended to challenge Neo-Platonic, classicizing styles of representation.[4] Both prints attracted some early emulators: Jan van Neck (1636–1716) repeated the figure of Diana closely in his

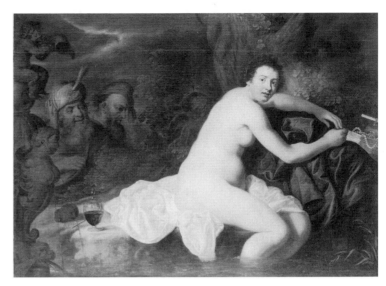

fig. b Jan van Neck, *Susannah and the elders*. Oil on canvas, 1230 × 1670 mm. Copenhagen, Statens Museum for Kunst

painting of *Susannah and the Elders* (fig. b),[5] and an etched copy of the head only, in reverse, has been attributed to Jan Lievens.[6] The pair, the *Naked woman seated on a mound*, was copied in an etching by Wenceslaus Hollar (1607–77) during his visit to Amsterdam in 1635 (see cat. 11, fig. d).[7]

MRK

1 E.g. Rovinski 1890, no. 201; Münz 1952, no. 134.

2 See further the Introduction, pp. 64–81.

3 Als hij een' naakte vrouw, gelijk 't somtijds gebeurde,
Zou schild'ren, tot modél geen Grieksche Venus keurde;
Maar eer een' waschter, of turftreedster uit een' schuur,
Zijn dwaaling noemende navolging van Natuur,
Al 't ander ydele verziering. Slappe borsten,
Verwrongen handen, ja de neepen van de worsten
Des rijglijfs in de buik, des kousebands om 't been,
't Moest al gevolgd zijn, of natuur was niet tevreen
Pels 1681, pp. 35–6. Without naming Rembrandt, Jan de Bisschop made similar comments about unspecified Dutch depictions of the nude ten years before, in his *Paradigmata,* The Hague 1671 (in the unpaginated dedication to Jan Six). Slive 1953, p. 83, already brought the *Naked woman seated on a mound* (cat. 11) into the discussion of Pels' remarks.

4 E.g. respectively Hollander 1975, pp. 108 and 160, and Clark 1966, p. 11.

5 Sumowski *Gemälde*, I, repr. p. 151; another painting, long attributed to Rembrandt himself, follows the composition yet more closely (ex-Warneck collection, Amsterdam, Bredius 461).

6 Rovinski 1890, no. 83.

7 Pennington, 603.

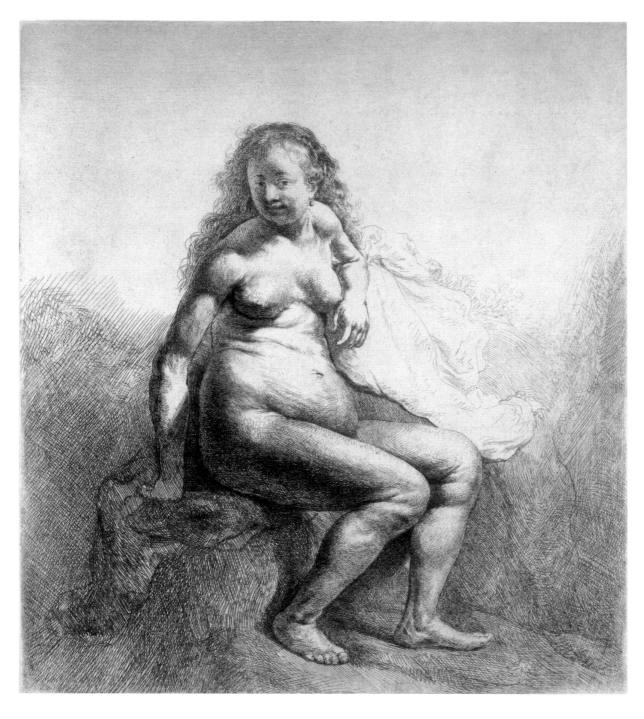

I Amsterdam

11

Naked woman seated on a mound *c*.1631

Etching, 177 × 160 mm; signed upper left: *RHL*

Hind 43; White & Boon 198 I and II (of II)

I Amsterdam★ (De Bruijn RP-P-1961-1108; ex. Von Lanna [L.2773] and P. Matthey [L.2100b]; watermark: Countermark NA [Ash & Fletcher 26, NA.c.])

II Amsterdam★ (De Bruijn RP-P-1961-1109; ex. M.J. Perry [L.1880]; watermark: none); London (1843-6-7-126; inscribed in margin lower right and again on *verso*: *198/190*; watermark: Double-headed eagle [Ash & Fletcher 15 A.a.])

Watermarks: the countermark in the first state is not otherwise recorded in Rembrandt's etchings, but closely related countermarks occur in a few prints dated around 1630 (see pp. 27–8). The double-headed eagle watermark has been found in several prints of the early 1630s.

SELECTED LITERATURE: Wurzbach 1876, p. 287; Slive 1953, p. 83; Reznicek 1977, pp. 91–9; Berlin-Amsterdam-London 1991–2, pp. 182–4; no. 6; Melbourne-Canberra 1997–8, no. 99; White 1999, pp. 193 and 195.

In style, scale and format the *Naked woman seated on a mound* is inseparable from the *Diana at the bath* (see cat. 10). They share the contrast between areas of methodical hatching or of detail (here especially in the figure) and less worked-up parts – as in the

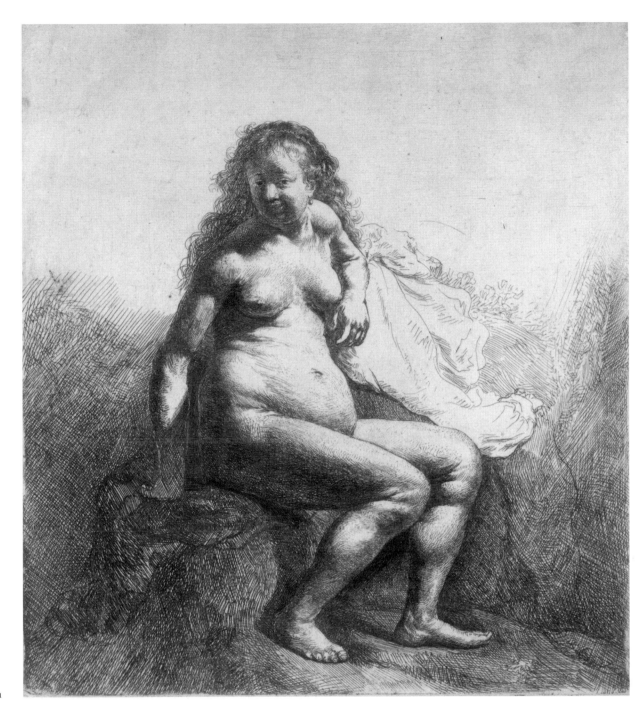

II Amsterdam

background, with its incipient tree-trunk rising on the right. Only in the more frequent use of a solid outline – kept to a minimum in the *Diana* – is there a significant difference of approach. If, as seems likely, the two prints were conceived as a pair, then Rembrandt may have intended the present work to depict another mythological figure, such as one of Diana's nymphs.[1] Of the latter, the most frequently represented in art is Callisto, the discovery of whose impregnation by Zeus led to her banishment and metamorphosis into a bear. The exceptionally distended stomach (even more than the *Diana*'s) might support such an identification, along with the indications of shrubbery,

the nymph's natural habitat, but it is characteristic of Rembrandt to supply insufficiently conclusive iconographic indications.[2]

Rembrandt's figure was apparently inspired by Annibale Carracci's etching of *Susannah and the elders* (fig. a). Yet in Rembrandt's own representation of Susannah in a painting of 1636, she seems less overtly rotund and her expression circumspect (fig. b).[3] The poses of both the *Naked woman* and, more especially, the *Diana* also bear some resemblance to a print of *Bathsheba combing her hair* by Willem Buytewech (fig. c). For type they have also been compared with works by Rubens and Jordaens; yet Rembrandt's vision remains unorthodox.[4]

fig. a Annibale
Carracci,
*Susannah and
the elders*.
Etching and
engraving,
351 × 310 mm.
London, British
Museum

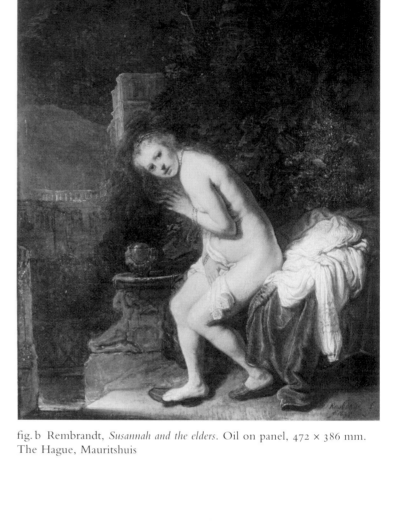

fig. b Rembrandt, *Susannah and the elders*. Oil on panel, 472 × 386 mm.
The Hague, Mauritshuis

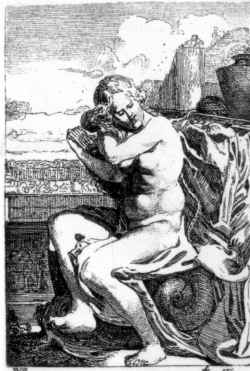

fig. c
Willem
Buytewech,
*Bathsheba combing
her hair*.
Etching,
155 × 104 mm.
Amsterdam,
Rijksmuseum

fig. d
Wenceslaus
Hollar,
*Naked woman
seated on a mound
(after Rembrandt)*.
Etching,
78 × 67 mm.
London, British
Museum

Reworking the plate in the second state, Rembrandt refined the lighting, allowing more to fall on the figure's thigh, stomach and right foot by burnishing lines away, while darkening her right shoulder, the shadows in the face and filling small areas left too pale behind her left calf and beneath both shoulders. The effect is somewhat less luminous.

One wonders what prompted Hollar to make the copy of the *Naked woman seated on a mound* (fig. d): a desire to emulate Rembrandt, or was it a trial for employment as a Rembrandt's reproductive engraver? If the latter, he was not successful: his only other print after Rembrandt is a copy, also made in 1635, of the etching of *Saskia with pearls in her hair* (B. 347).[5]

MRK

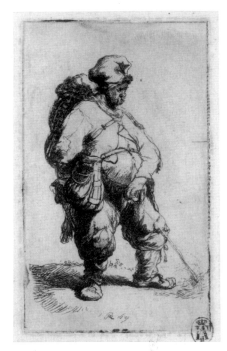

Amsterdam

1 That she might be a nymph associated with Diana was suggested in general terms by Welzel in Berlin-Amsterdam-London 1991–2, pp. 182–4, no. 6.

2 Similar logic could argue the reverse, or that both prints were intended to represent either Diana or Callisto: the *Diana at the bath* omits the goddess' crescent moon, and the quiver is equally appropriate to both.

3 *Corpus* A117; Bredius 505.

4 Reznicek 1977. Wurzbach 1876, believed that the print represented Saskia, but despite a general resemblance, even if Rembrandt knew her at this stage in his career she would probably not have posed nude for him.

5 Pennington 1650. Johannes van Vliet, who was employed by Rembrandt (see cats 22–4), also etched copies after Rembrandt's prints as well as his paintings (see Amsterdam 1996, p. 13, fig. 4, p. 52, figs 6–II.1 and 2).

12

Man making water 1631

Etching, 82 × 42 mm; signed and dated, lower centre: *RHL 1631*

Hind 45; White & Boon 190 (only state)

Amsterdam★ (De Bruijn RP-P-1961-1099; ex. Friedrich August [L.971]; watermark: none)

Woman making water and defecating 1631

Etching, 81 × 65 mm; signed left of centre in the lower margin: *RHL 1631*

Hind 46; White & Boon 191 (only state)

Amsterdam★ (De Bruijn RP-P-1961-1101; watermark: none)

SELECTED LITERATURE: Amsterdam 1999–2000, p. 108.

Rembrandt may well have intended these two etchings as companion-pieces; besides the obvious similarity of subject-matter they are virtually the same height and both date from 1631. Yet they cannot be viewed in isolation from the small prints of beggars and vagrants that Rembrandt produced in Leiden in

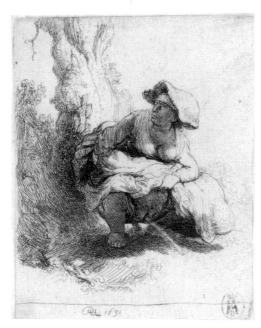

Amsterdam

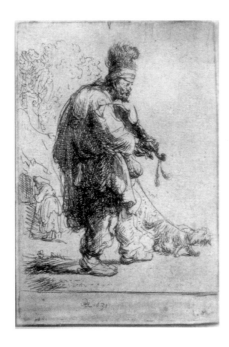

fig. a Rembrandt,
The blind fiddler, 1631.
Etching, 78 × 53 mm.
Amsterdam,
Rijksmuseum (B.138)

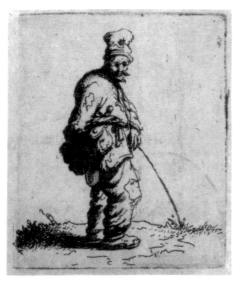

fig. b
Johannes van Vliet,
Man making water,
1632. Etching,
66 × 56 mm.
Amsterdam,
Rijksmuseum

1630–31 and that visibly derived inspiration from the prints of Jacques Callot.[1] Perhaps he was working on a series, like the French artist, as we can group at least six such etchings together, including the *Blind fiddler* (fig. a).[2] In 1632 Johannes van Vliet, a printmaker with whom Rembrandt collaborated for some time, made a series of etchings inspired by Rembrandt, depicting nine extremely similar street figures, including a *Man making water* (fig. b).[3]

Since the nineteenth century, many have found it hard to countenance that Rembrandt could have been responsible for such vulgarity.[4] Rovinski described the *Woman making water and defecating* as 'une horreur artistique'.[5] Charles Blanc was a rare apologist; he held that while Rembrandt was no libertine he had depicted every aspect of human nature in the manner of an uncompromising philosopher.[6] But even today, surveys of Rembrandt's prints usually omit all mention of these images. Although the faecal tradition in the visual arts is not extensive, there were other sixteenth- and seventeenth-century artists who did not flinch from portraying figures relieving themselves. Pieter Bruegel the Elder depicted literally the expression 'ergens schijt aan hebben' ([not] to give a shit about something) several times. Jan van de Velde dealt with the theme in a series of prints about the brevity of human life, and the Rubens imitator Theodoor van Thulden made an etching that shows a woman wiping her companion's backside (fig. c).[7] This latter scene is set in decidedly idyllic surroundings, as if the artist wanted to illustrate 'et in arcadia excrementum'.

In this sense the seventeenth century was more open-minded than was supposed in the nineteenth century, and caprice and farce were genres firmly anchored in humanist tradition.[8] Thus the *album amicorum* of Jacobus Heyblocq, teacher and later headmaster of the Latin school in Amsterdam, to which many prominent authors and artists – including Rembrandt – contributed, contains a witty drawing of a man relieving himself and inspecting the steaming result with interest (fig. d). Amusing images of this kind were known as *capricci*, and in 1617 Jacques Callot dedicated his series *Capricci di varie Figure* to none other than Lorenzo de' Medici of Florence; it includes an etching of a man who, like Rembrandt's female figure, is making water and producing faeces at the same time (fig. e).[9]

Rembrandt certainly knew this print, and it may well have given him the idea, but whether he would have needed it as an example is open to doubt. Even in these early etchings we are struck by Rembrandt's powers of observation, which give these

prints such immediacy and realism. Callot stylized his figures, but Rembrandt's straddle-legged man is clearly someone who likes his food and drink. This explains the powerful jet that splatters as it hits the ground. Equally lifelike is the female figure crouching beneath a tree, who looks over her shoulder to check that no one is watching. To show us what she has produced Rembrandt lit the scene from behind, and he reserved a line for the jet of urine. Carefully measured effects of this kind are characteristic of Rembrandt's skill. Combined with his compulsion for realism they have the power – even in our own times – to amaze and confound.

GL

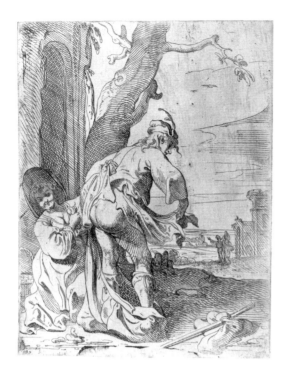

fig. c
Theodoor van
Thulden,
*Couple beneath a
tree.*
Etching,
184 × 133 mm.
Vienna,
Graphische
Sammlung
Albertina

1 See Nancy 1992, pp. 276–81, nos 317–42.

2 The height of a number of these etchings is virtually identical, though they differ in width: besides the three prints reproduced here, see also B.141, B.150 and B.164.

3 This series also has a title-page; see Hollstein 83–92 and Chris Schuckman in Amsterdam 1996, no. 55. Interestingly, it includes a turbaned figure with a sabre, much like Rembrandt's *Polander* of 1632 (B.141), and *Quack* of 1635 (B.129).

4 Sträter 1886, p. 259.

5 Rovinski 1890, p. XVIII.

6 Blanc, 1859–61, II, p. 11.

7 Bruegel's painting of *Netherlands proverbs* in Berlin includes an illustration of the expression 'de galg beschijten' (lit. 'to shit on the gallows'); there is another example in Amsterdam 1997, p. 46. For Jan van de Velde, see Hollstein 130; for Van Thulden, Hollstein 99. A peasant making water is the subject of an etching by Willem Basse, Hollstein 33; see Fuchs 1909, p. 185, fig. 150, which gives other examples of this iconography. Michel Weemans collected a quantity of (largely animal) excreta from Dutch printmaking in Nantes 1996.

8 For these concepts see Amsterdam 1997, pp. 23–4 with select bibliography; for the genre of the farce in the Netherlands see esp. Van Stipriaan 1996 and Verberckmoes 1998.

9 Nancy 1992, p. 237, no. 214; for the *Capricci*, see Daniel Ternois in ibid., pp. 233–4.

fig. d Anonymous artist, *Man relieving himself*. Black chalk, drawing in the *album amicorum* of Jacobus Heyblocq, 95 × 147 mm. The Hague, Koninklijke Bibliotheek

fig. e Jacques Callot, *Man making water and defecating*, 1617. Etching from the series *Capricci di varie figure*, 59 × 81 mm. Amsterdam, Rijksmuseum

13

Self-portrait in a soft hat and patterned cloak
1631

Etching with touches of drypoint, 148 × 130 mm; signed and dated, visible from V, upper left (see further below): *RHL (in monogram) 1631* and from X, upper right: *Rembrandt f.*

Hind 54; White & Boon 7 I, II, IV, VII and VIII (of XI)

I London★ (1848-9-11-7, cut; watermark: none)

II London★ (1842-8-6-134; touched in black chalk; ex. G. Hibbert [L.2849]; watermark: none)

IV Amsterdam★ (Van Leyden RP-P-OB-10; watermark: none)

IV Paris★ (touched in black chalk; watermark: none; exh. London)

VII London★ (1843-6-7-3; watermark: fragment of Single-headed eagle with Basel staff★)

VIII Amsterdam★ (Van Leyden RP-P-OB-12; watermark: none)

Watermarks: the watermark in VII above may be related to a fragmentary mark in the first state of *Christ disputing with the Doctors: small plate* (B.66) of 1630. A countermark NA in an impression of IX in Amsterdam (not shown) probably dates from *c*.1631. See further p. 26ff.

SELECTED LITERATURE: Münz 1952, no. 14; Campbell 1971, pp. 61–3; Broos 1981–2, pp. 246 and 251; Chapman 1990, pp. 59–62, figs 87–92; Royalton-Kisch 1992, no. 8a; Royalton-Kisch 1993, pp. 111–22; White 1999, pp. 117–21; London-The Hague 1999, no. 32.

This is Rembrandt's first etched *Self-portrait* proper, as opposed to the earlier character studies based on his own features (see cats 4, 7 and 8).[1] Made in the period that Rembrandt moved from Leiden to Amsterdam, it marks a significant departure in his self-presentation, depicting him as a member of the wealthy merchant class, with a touch of the courtier. This he may have judged appropriate for his patrons in the larger metropolis and in The Hague. Such an image also could have advertised his abilities as a

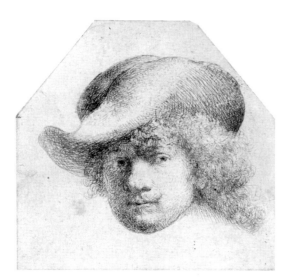

I London

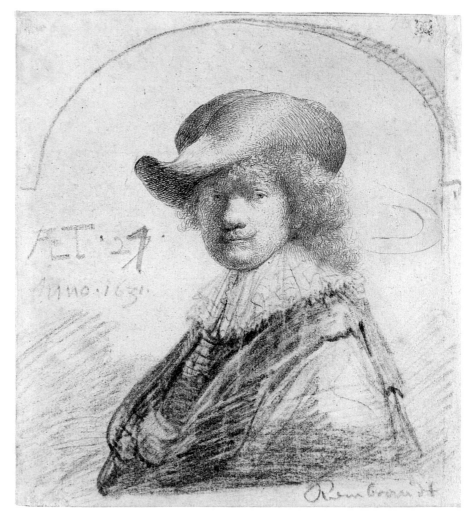

II London (touched)

portraitist, the area in which he specialized during his early Amsterdam years, and at the same time fostered the demand among collectors for his self-portraits.

Rembrandt at first etched only the head and hat, producing a delicate, lightly bitten plate that he found unsatisfactory in modelling and tonal balance.[2] At this stage he may also have monogrammed and dated it *1631* at the top left, although this area of the plate seems only to have been inked in surviving impressions from the fifth state. In the next three states (II–IV) he added minor refinements and corrections – emphasizing the contour of the hat and adding shade to the brim (state II), darkening the hair and, again, the brim (state III), and strengthening outlines, with some further shading in the fourth state. But it was only in the fifth state that he filled out the plate as a complete composition,

adding the body and richly textured cloak in a self-consciously elegant pose. Rembrandt was again dissatisfied, and the plate went through five or six further states (the last may be posthumous) as he wrestled to complete the image to his satisfaction: darkening the cloak by rebiting in the acid (state VI); adding the pattern to the cloak, with further retouching of the shadows (state VII); toning down the background, while simultaneously erasing an incipient balustrade that he had introduced at the lower right in the sixth state (state VIII); darkening a passage below the sleeve that was printing too pale (state IX); picking out the pattern of the lace collar and adding his fuller signature, *Rembrandt f.*, a form he employed only from 1633 (state X); and finally burnishing out the background to approximate it to its appearance in the fifth state, a change perhaps executed by a later hand (state XI).

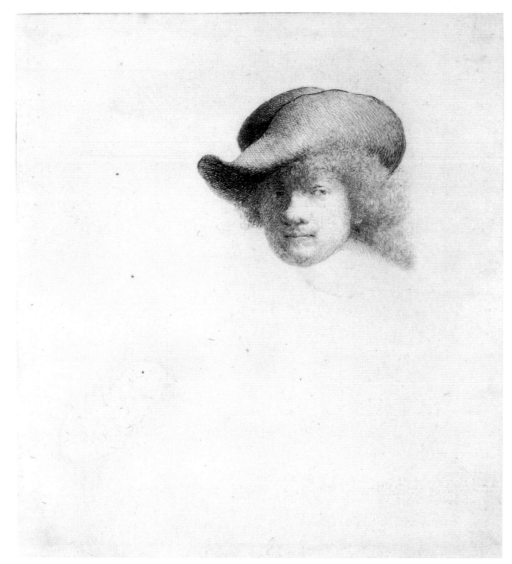

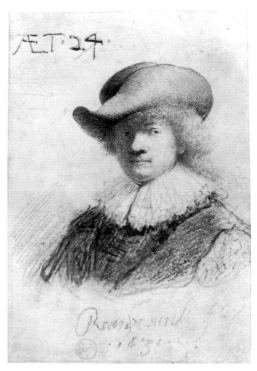

IV Amsterdam

IV Paris (touched; exh. London)

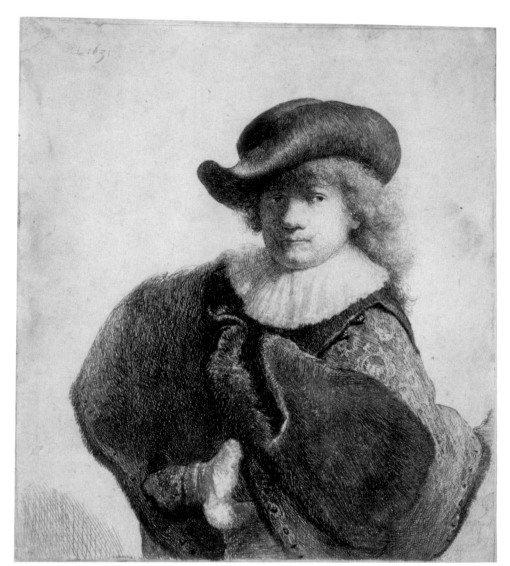

VII London

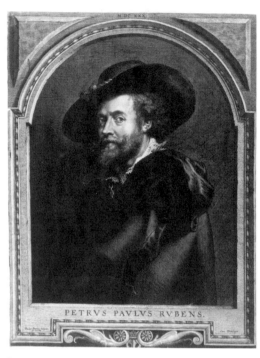

fig. a Paulus Pontius after Rubens, *Peter Paul Rubens*, 1630. Engraving, 368 × 277 mm. London, British Museum

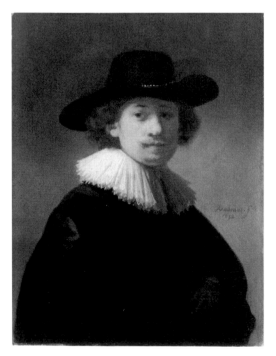

fig. b Rembrandt, *Self-portrait*, 1632. Oil on panel, 218 × 163 mm. Private collection

These mostly finicky alterations, the majority of which required immersing the plate in the acid at some risk to the image as a whole, exemplify the artist's perfectionism when producing an image for publication.

For inspiration Rembrandt appears to have turned to an engraving of 1630 by Paulus Pontius after a *Self-portrait* by Peter Paul Rubens (fig. a). To what extent Rembrandt intended to emulate his older Antwerp colleague is uncertain, but in the early 1630s Rembrandt's self-portraits, the engraved reproductions of his paintings (see cats 22–4) and his more ambitious productions as a history painter combine to suggest that he aimed, at least for a time, both to elevate his social status and broaden his fame. That Pontius' print influenced Rembrandt's thinking is all the more apparent in the British Museum's unique impression of the second state of the etching (included here), in which not only is the artist's body drawn in, but placed beneath a comparable arch. In another 'head only' impression, but of the fourth state (also

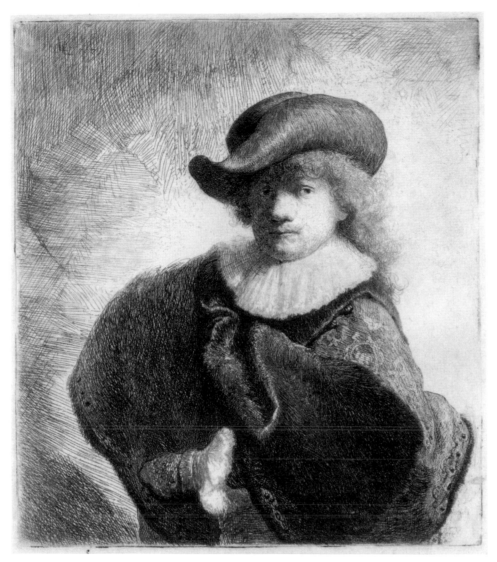

VIII Amsterdam

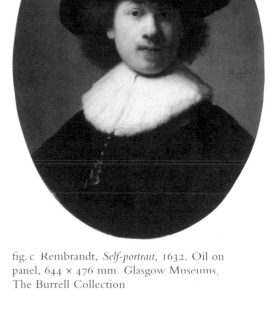

fig. c Rembrandt, *Self-portrait*, 1632. Oil on panel, 644 × 476 mm. Glasgow Museums, The Burrell Collection

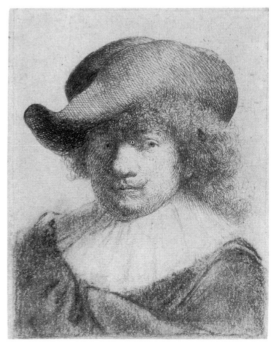

fig. d Rembrandt, *Self-portrait in a soft hat.* Etching, touched in black chalk, 88 × 68 mm. London, British Museum (B.7 III)

shown), Rembrandt again completed the image in black chalk to bust length, but turned the body more towards the spectator.

Quite what role these touched impressions played in the development of the plate is uncertain. Of interest here is the fact that although he dated them both 1631, which agrees with the monogram and year that are visible in the etching from the fifth state, he also signed the two touched impressions with his name in full – *Rembrandt* – the form of signature he employed only from 1633. Furthermore, he altered his age on these two impressions, given first as twenty-seven (his age in 1633–4) to twenty-four, his age until his birthday on 15 July 1631. Thus he must have drawn on these proofs of the unfinished plate in 1633–4. The issue is further complicated by the fact that the touched impressions of the second and fourth states resemble, respectively, the *Self-portrait* painting of Rembrandt in a private collection (fig. b), and another in Glasgow (fig. c), both of which are dated 1632. Whether the touched impressions played a part in developing the

subsequent states of the print, or in preparing the two paintings, is uncertain. Insofar as the paper is datable, all states appear to have originated in *c.*1630–31; yet the style of the work in black chalk is closest to Rembrandt's in around 1634; and the format adopted in the British Museum's reworked proof, with the arch, very like a drawn *Portrait of a man* that Rembrandt produced in 1634 (Benesch 433). It therefore seems logical to suppose that the artist only added the passages in black chalk in 1633–4, after the paintings and the print had been completed. In another touched proof of this kind (fig. d) Rembrandt seems simply to have followed the completed etching.[3]

MRK

1 Previously called the *Self-portrait with a soft hat and* embroidered *cloak*, Marieke de Winkel noted that the pattern is not in fact embroidered (see London-The Hague 1999–2000, p. 251, n. 120).

2 The early states resemble those of Van Dyck's etched *Self-portrait* (Mauquoy-Hendricx 4, i; see Antwerp-Amsterdam 1999 no. 5), which probably dates from 1630–31.

3 Münz 1952, no. 14, believed that the later development of the print was the work of Johannes van Vliet. Before all the evidence of paper and watermarks was available, I wrote in critical terms of Chapman *loc. cit.*, in which she stated that the proofs were probably only retouched after the print was finished, but I was wrong (Royalton-Kisch 1991). For the reasons for accepting the touched impression of III in the British Museum, which is rubbed, see Royalton-Kisch 1993: it came from Zoomer's collection, which probably included Rembrandt's own archive of impressions, along with the other touched proofs in London and Paris (both shown here).

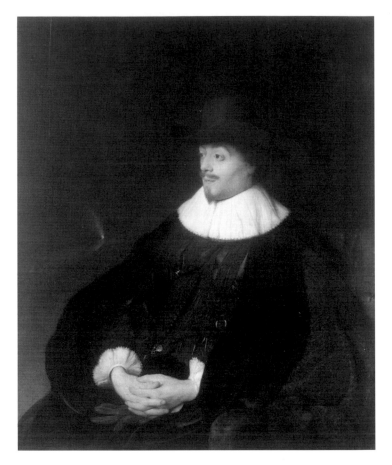

14

*The artist's mother seated at a table c.*1631

Etching and burin, 149 × 131 mm; signed lower left: *RHL. f.*

Hind 52; White & Boon 343 I (of III)

I Amsterdam★ (Van Leyden RP-P-OB-730; watermark: fragment of an unidentified coat of arms★)

Watermarks: the mark in the first state otherwise appears only in a first state of the *Old man with beard, fur cap and velvet cloak* (B.262; see cat. 15).

SELECTED LITERATURE: Van Schendel 1963, pp. 5–10; Berlin-Amsterdam-London 1991–2, pp. 177–9, no. 4; White 1999, p. 121.

As in the etching of 1628 (cat. 3), Rembrandt here depicted his mother again, but this time not just her head but in three-quarter length. Wearing a fur-trimmed coat and a black headscarf, she is seated in an armchair at a table, with her hands resting in her lap. Her pose is similar to that in which Jan Lievens portrayed Constantijn Huygens in around 1628–9 (fig. a), and as Rembrandt was already working with Lievens by that time, he may have had that composition in mind.[1] It was probably not intended to be a

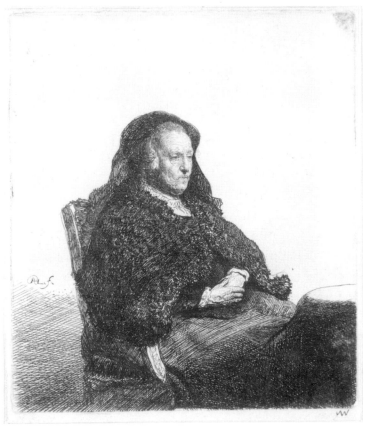

(*left, top*)
fig. a Jan Lievens,
*Portrait of Constantijn
Huygens*, c.1628–9.
Panel, 990 × 840 mm.
Amsterdam,
Rijksmuseum

(*left, bottom*)
fig. b Rembrandt,
*The artist's mother seated
at a table*, c.1631.
Etching, 149 × 131 mm.
Amsterdam,
Rijksmuseum (B.343 II)

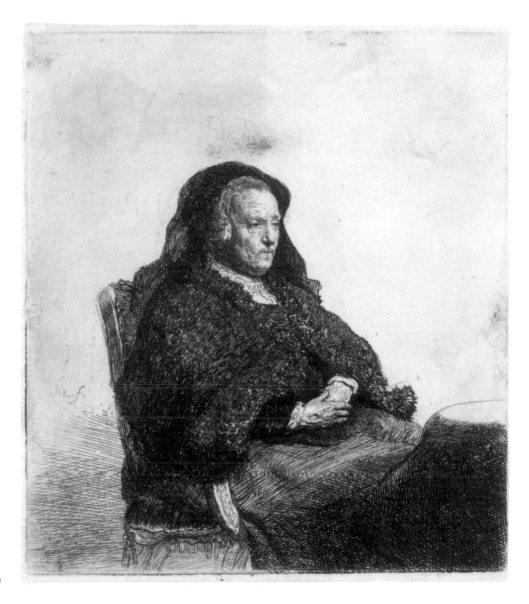

I Amsterdam

formal portrait of his mother, and looks more like an elaborate study after a model.

A close look at the print reveals how Rembrandt went about his work. The headscarf is bitten more deeply and appears darker than the head, and was clearly added subsequently. Rembrandt must have started with the head and completed the rest of the figure afterwards. Moreover, the closely observed details in the face suggest that he worked directly from the model onto the plate, as he did in the etching of 1628. At this stage he also defined the contours of the figure in fine outlines, as he was to do in the first state of the *Angel appearing to the shepherds* (cat. 21). Traces of these lines can be seen on the right beside the hands, just above the coat and in several sections under the coat.[2]

Rembrandt then covered the plate with varnish again, and after drawing the scarf, coat, skirt and the chair he bit the plate in acid. He also added the small table on the right. The outlines of the skirt can just be discerned underneath, indicating that it was drawn first. When Rembrandt finally saw an impression from the copper plate (the first state as shown here), he must have realized that this last addition disturbed the balance. He restored this in the second state by adding numerous lines to strengthen the shadows under and to the left of the chair (fig. b). Instead of etching the plate again at some risk to the image as a whole, the ever practical Rembrandt used a burin to engrave these lines directly on the plate.

The print must have been a success: it was reprinted several times in the 1630s, and editions are also known from the 1640s

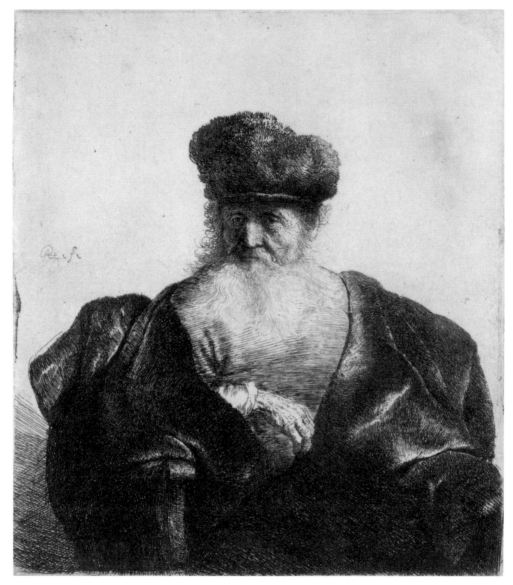

II Amsterdam

and later.[3] The third state of the etching – at which point the plate was cut into an oval – was probably made only in the eighteenth century.

EH

1 For the portrait by Jan Lievens, see also Braunschweig 1979, no. 17.

2 The traces under the coat are visible only through a magnifying glass.

3 See, for example, Ash & Fletcher 12, C´.a. and C´.b. (c.1632), Ash & Fletcher 11, A.a. (c.1634).

15

Old man with beard, fur cap and velvet cloak c.1632

Etching and burin, 149 × 130 mm; signed centre left: *RHL. f.*

Hind 92; White & Boon 262 II (of III)

II Amsterdam★ (De Bruijn RP-P-1962-94; watermark: Basilisk [Ash & Fletcher 12, C´.b.])

Watermarks: this Basilisk mark is found in impressions of a great many prints, including *Christ disputing with the doctors* of 1630 (B.66), and the *Raising of Lazarus: larger plate* of some two years later (cat. 17). The watermark can be dated to around 1632.

SELECTED LITERATURE: Middleton 1878, no. 90; Münz 1952, no. 42.

In Charles Henry Middleton's catalogue of Rembrandt's etchings of 1878, he observed that this print seemed to be the pendant of the *Artist's mother seated at a table* (cat. 14). He based this assumption on their similarities in size, technique and signature, and speculated that the man might be Rembrandt's father, adding, however, that the costume was more reminiscent of a rabbi than a 'quiet burgher'. The etching is usually dated around 1632, but as we now know that the artist's father died in 1630, the face we see is probably not his (unless of course it was a posthumous portrait). The same model appears in several other prints and paintings but has not been firmly identified.[1] Even so, there is much to be said for Middleton's idea that the etching is a counterpart to *The artist's mother seated at a table*, and the watermarks corroborate this theory. Impressions of the extremely rare first state of the *Old man with a beard* bear a watermark that appears in just one other print, the only known first state impression of the *Artist's mother*.[2] We can conclude from this that the earliest specimens of both etchings were printed at around the same time.

There are also striking similarities in the way the prints were executed. The man's beard beneath the mouth is less heavily etched than the face itself. There are a few fine lines in the face, indicating that the image we see now conceals an earlier, more

lightly bitten version. Here, too, Rembrandt probably started with the head, although in this case the headdress was envisaged right from the start, as no trace of the man's head can be seen under the fur cap.

Continuing with the rest of the figure, Rembrandt focused mainly on the fabric and texture of the coat, and achieved a more convincing result than in the *Self-portrait in a soft-brimmed hat and patterned cloak* (cat. 13), which he had etched slightly earlier. He captured the feel of the velvet and the folds of the heavy coat, using a combination of cross-hatching and parallel lines, and highlights with little or no shadow. At this stage, even after Rembrandt had bitten the plate in acid, the man's chest was probably still almost white. The lines around and under the beard were not etched, but engraved with the burin, which suggests that, like the additions to the *Artist's mother* (cat. 14), they were applied at the end.

Though there are only minor differences between the first and second states of the print, they nevertheless reflect Rembrandt's perfectionist approach to his work. A narrow strip of white under the man's hand in the first state is covered in the second state with horizontal lines applied with the burin.[3]

EH

1 Cf. B. 260 (1631), B.291 (c.1631), B.309 (1630), B.312 (c.1631), B.315 (1631), B.325 (1630).

2 See the watermark in cat. 14.

3 The plate was coarsely reworked in the third state, not by Rembrandt himself.

16

Sheet of studies c.1631–2

Etching, 101 × 114 mm

Hind 90; White & Boon 363 I (of II)

I Amsterdam★ (Van Leyden RP-P-OB-764; watermark: Strasbourg lily with initial L★); London (1848-9-11-187; watermark: Strasbourg lily with initial L)

SELECTED LITERATURE: Chapman 1990, p. 33; Berlin-Amsterdam-London 1991–2, pp. 180–81; no. 5; London-The Hague 1999–2000, no. 31.

Especially in his early years as an etcher, Rembrandt appears to have scratched his designs into the etching ground on his copper plates very freely, almost as if working on a sketch-book, and only later to have singled out motifs he thought worth distributing in a fair-sized edition.

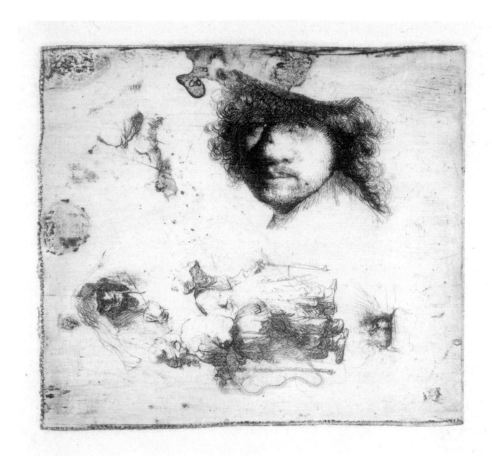

1 Amsterdam

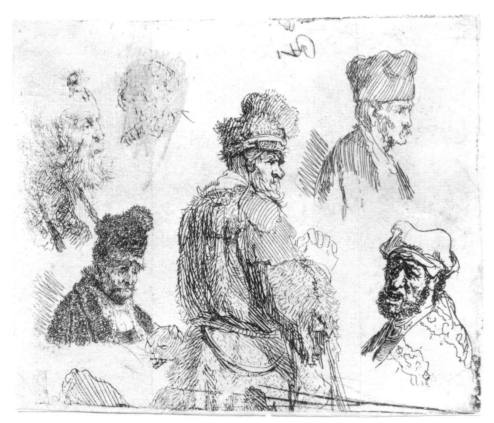

fig. a Rembrandt,
Sheet of studies of men's heads,
*c.*1631. Etching, 98 × 124 mm.
Vienna, Graphische Sammlung
Albertina (B.366 I)

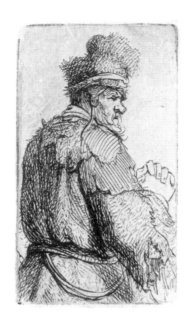

fig. b Rembrandt, *Old man, seen from behind*, c.1631. Etching, 72 × 42 mm. Amsterdam, Rijksmuseum (B.143 II)

fig. c Rembrandt, *Old man in fur coat and high cap*, c.1631. Etching, 36 × 28 mm. Amsterdam, Rijksmuseum (B.333 II)

fig. d Rembrandt, *Study sheet with part of a self-portrait*, c.1645. Etching, 78 × 69 mm. Amsterdam, Rijksmuseum (B.372)

In the 1620s and early 1630s he produced a wealth of small etchings – some very small indeed – that one can scarcely imagine having started life as individual compositions. One rare impression exists of a plate that – judging by the hatching at lower left – may have already been cut smaller when it was first placed on the press (fig. a) and was sawn down again into five small plates (figs b–c).[1] There are other prints by Rembrandt with a fairly random *mise-en-cuivre*, sometimes either because the images had been detached from a larger whole, or because they were still awaiting such liberation. To Rembrandt, working freely on a larger plate may have been a way of attaining the sketch-like result that he, more than anyone else, sought to achieve in these prints.

The structure of the picture plane in this *Sheet of studies* also appears rather arbitrary. Rembrandt rotated the plate by 90 degrees three times to find space for the various motifs. Furthermore, he combined two different approaches to technique: he left the small figures and head studies rudimentary and etched them only lightly, while the self-portrait, which called for verisimilitude and precision, was bitten more deeply to increase the contrast in the dark areas. Rembrandt probably started off with the beggars and scribbles before adding his own head. That he intended to plant a beret or hat in the curly hair seems unlikely. It would have been more logical to start with the headgear, as he did elsewhere (fig. d). He did not, in any case – despite repeated assumptions to the contrary – reserve space for it. The strikingly even contours are rather the result of the use of a brush with stopping-out varnish in the upper zone to cover some unintentional smudges, including traces of an etching made on the other side of the design.[2] The head is curiously placed in the composition (and would be even more so with a hat), grazing the upper edge. It appears that here too the decision of where to cut the plate was only made later. The traces of a file that serve as framing lines are still irregular, and combined with the ink blotches they give the print a lively and painterly appearance that has particular appeal for modern tastes.[3]

The notion that Rembrandt may have deliberately left the technical flaws intact and combined his own portrait with images of beggars to express his 'fear of failure in life' would appear an overly speculative reading of the motifs scattered about the plate.[4] In this first, unpolished state the etching is very rare: only three impressions have been preserved, two of which are on paper bearing the Strasbourg lily watermark with the initial L. The only other documentation for this in Rembrandt's work is in a fine

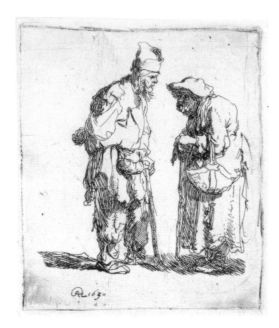

fig. e
Rembrandt,
Beggar couple,
1630. Etching,
78 × 66 mm.
Amsterdam,
Rijksmuseum
(B.164)

impression of the first state of the *Portrait of Cornelis Claesz Anslo* from 1641 (cat. 45), suggesting that it was years after the plate was cut that the first known impressions – and then only a few – were pulled from it. The unintentional traces of biting were subsequently obliterated, after which the plate was cut by a centimetre in width. Whether Rembrandt himself did this is uncertain. The few watermarks found in the second state indicate paper dating from the late seventeenth and eighteenth centuries. It is highly questionable whether any commercial edition was distributed on Rembrandt's initiative; the artist may well have regarded this etching, that we esteem so highly today, as a mere experiment.

It is not possible to determine exactly when the print was made. The dating is based on comparison of the self-portrait with other self-portraits and resemblances between the two beggars and dated etchings. The cleverly composed couple appear to have been done somewhat later than the figures in a separate etching of 1630 (fig. e). The play of light on the old woman also testifies to somewhat more skill in draughtsmanship.[5]

GL

1 See White 1999, pp. 173–4.

2 With thanks to Ad Stijnman for his technical comments on this print.

3 That Rembrandt would have made deliberate use of imperfections such as blotches and rough contours is highly improbable (see Holm Bevers, in Berlin-Amsterdam-London 1991–2, p. 180).

4 Chapman 1990, p. 33.

5 Erwin Mitsch, in Vienna 1970–71, no. 50.

17

The raising of Lazarus: larger plate *c.*1632

Etching and burin, 366 × 258 mm; signed to Christ's right on the rock: *RHL van Ryn f.*

Hind 96; White & Boon 73 III and VIII (of X) [II and V (of VII)]

III [II] London★ (1848-9-11-35; touched with graphite; watermark: Strasbourg bend★)

VIII [V] London★ (Cracherode 1973.U.823; watermark: Strasbourg bend★)

Watermarks: the watermarks are what are known as 'twin marks', meaning that they come from the same stack of paper. They are not found in other prints, but occur in White & Boon's first, third and eighth states of the *Raising of Lazarus* (first, second and fifth states in the new numbering). This confirms that these and the intervening states must have been created shortly after one another.

SELECTED LITERATURE: Mariette 1857, p. 351; Seymour Haden 1877, pp. 34–5; Benesch 1926, p. 8; Graffon 1950, pp. 43–5; Slatkes 1973, pp. 251–2; Guratzsch 1980, pp. 144–57; Held 1980, pp. 161–4; Schatborn 1986, pp. 36–7; Chapman 1990, p. 19; Rand 1991; Berlin-Amsterdam-London 1991–2, pp. 185–8, no. 7; Royalton-Kisch 1992, no. 6a; Royalton-Kisch 1992b, pp. 336–7; Lambert & Séveno 1997, pp. 37–41; White 1999, pp. 27–31.

In the late 1620s Rembrandt made several rather experimental-looking, sizeable etchings on biblical subjects, like the *Rest on the flight into Egypt* (cat. 1) and *Peter and John at the gate of the temple* (cat. 5), only to continue to develop his skills in this genre solely in small prints. It was not until around 1632 that he again worked on a large scale with the *Raising of Lazarus*. This highly detailed print is based on a painting of the same subject that he made in around 1630–31, probably in a spirit of creative competition with Jan Lievens (fig. a). Lievens also painted a version of the raising of Lazarus in 1631, and made a large print of it (figs b–c).[1]

Rembrandt's etching illustrates the moment described in the Bible when Jesus, standing by the grave, 'cried with a loud voice: "Lazarus, come forth". The dead man came out, his hands and feet swathed in linen bands, his face wrapped in a cloth' (John 11: 43–4). The focus is mainly on the reactions of the bystanders. Although Jesus is rendered as a towering figure with his arm raised in summons, his face is all but invisible as he is standing with his back half turned to the viewer. The faces and the wild gestures of the other people present, among them Lazarus's sisters Mary and Martha, are plain to see, however, and clearly register their astonishment at the miracle that is taking place. The drama is heightened still further by the deployment of the *chiaroscuro* in the etching. With an elaborate web of lightly and more heavily bitten lines, Rembrandt succeeded in evoking a wide range of

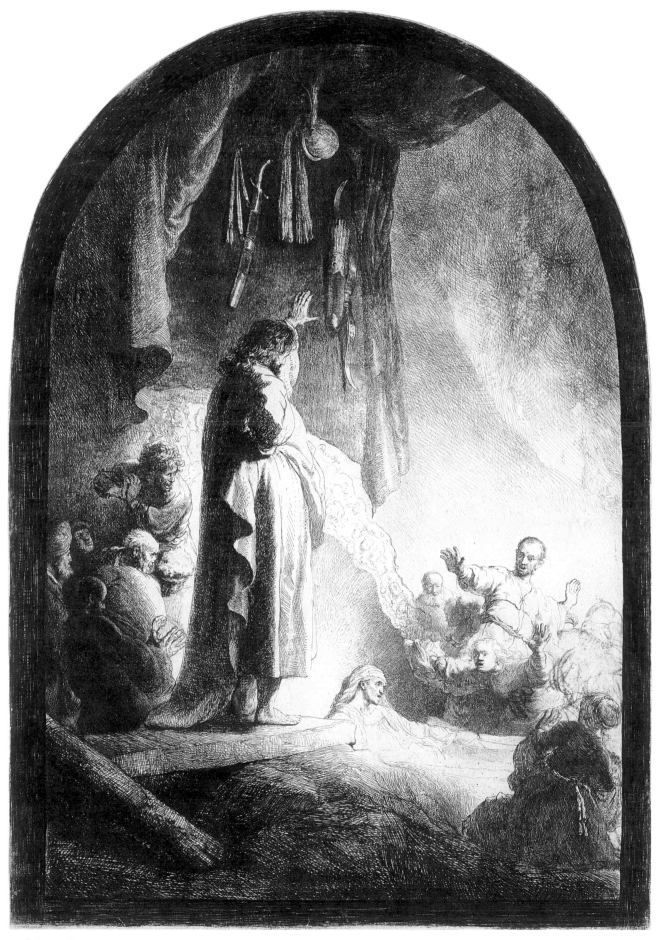

III [II] London

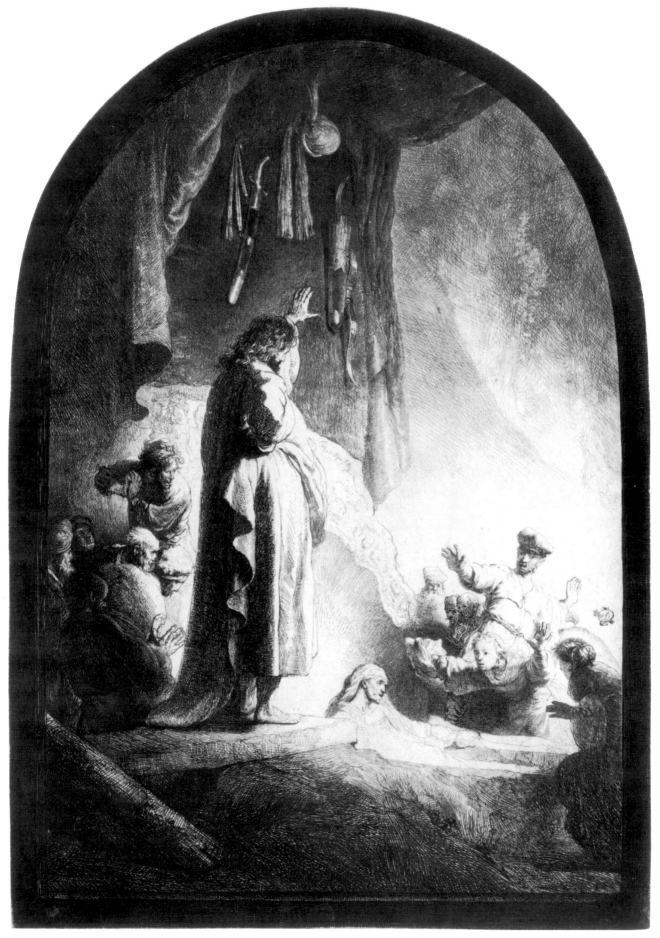

VIII [V] London

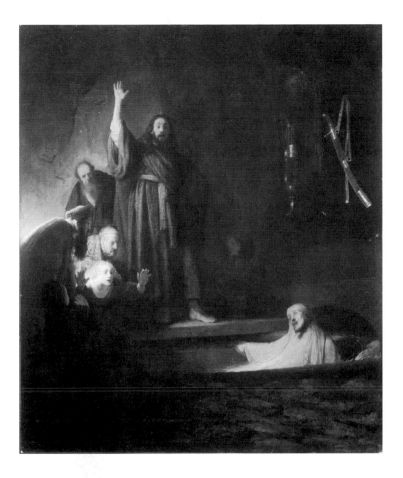

grey and black tones, placing Lazarus and the group around him in full light, with the surrounding passages gradually darkening into deep obscurity.

The etching is similar in many ways to Rembrandt's painting of the same subject, despite several differences. The depiction of Lazarus is the same in both works, for example, and the woman with her arms outspread at the graveside appears in an identical pose (fig. a). The most obvious difference is in the position of Christ. In the painting he stands behind the grave and is shown from the front. The fact that the etching and the painting were created in close association with each other recently emerged from an X-radiograph of the panel, which revealed that Rembrandt had significantly reworked the composition and that it had originally resembled the etching more closely. Lazarus's head in the painting was nearer the centre, as in the etching, and the woman with outstretched arms was holding a cloth. Nevertheless, the suggestion that the etching is a representation of an earlier version of the painting[2] is debatable, since it also shows signs of reworking. The man with the turban and long

(*left*) fig. a Rembrandt, *The raising of Lazarus*, *c*.1630–31. Panel, 962 × 815 mm. Los Angeles, Los Angeles County Museum of Art

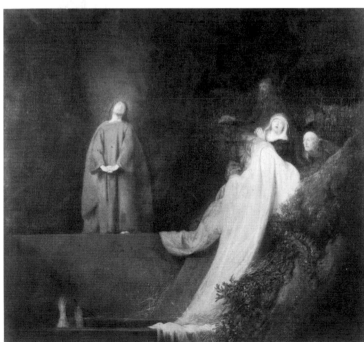

fig. b Jan Lievens, *The raising of Lazarus*, 1631. Canvas, 1030 × 1120 mm. Brighton, Royal Pavilion Art Gallery and Museum

(*right*) fig. c Jan Lievens, *The raising of Lazarus*. Etching, 360 × 312 mm. Amsterdam, Rijksmuseum

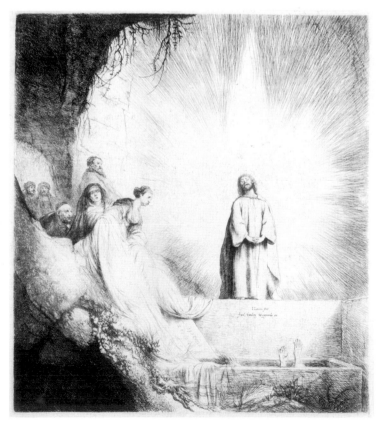

fig. d
Rembrandt,
detail of the
verso of III

18

The rat-catcher 1632

Etching and burin, 140 × 125 mm

At lower right: *RHL 1632* (the last two figures in reverse image)

Hind 97; White & Boon 121 I and III (of III)

I London★ (1847-11-20-5; watermark: none)

III Amsterdam★ (De Bruijn RP-P-1962-59; watermark: Countermark HN [Ash & Fletcher 26, HN.a.]; London (Cracherode 1973.U.826; watermark: Arms of Burgundy and Austria [Ash & Fletcher 5, A.a.])

Watermarks: the watermark and countermarks in these impressions of the third state are from the same paper. It was employed for a large group of different prints all dating 1632 or earlier.

SELECTED LITERATURE: D'Argenville 1745, p. 28; Coppier 1917, p. 31; Lawrence-New Haven-Austin 1983–4, no. 13; White 1999, pp. 174–5, 188.

Having drawn and etched several individual studies of people of the streets, in about 1632 Rembrandt started combining them in narrative scenes. He already had experience of juxtaposing figures to make compositions in his paintings. Even so, *The rat-catcher*, one of his earliest genre prints, does not yet display much boldness in this respect. The protagonists have remained separate individuals: the man leaning on the lower section of his front door, a ratsbane pedlar with all the standard accoutrements, a pole surmounted by a cage containing live rats, with a few poisoned specimens dangling round about (figs a–b), and a diminutive assistant carrying a box of the pedlar's wares, consisting of portions of rat poison.[1] Rembrandt barely ventured to make the figures overlap, which would have given the group greater cohesiveness. The boy has been placed exactly in between the two adults, and the silhouette of his head does not touch any

beard at the far left of the painting was originally depicted in the etching, but on the extreme right. However, he had to make way for the man with the outstretched arms, visible in the third state shown here.

There are five states altogether, but the changes in the later states were minor (see pp. 31–2).[3] The most significant change was to Martha, the woman in the lower right corner. Initially she was shown shrinking back, but in the third state Rembrandt made her lean forward so as to bring her into closer association with the other figures. He prepared for this ingeniously by drawing what he had in mind in graphite on the impression of the second state included here. He had probably placed a piece of paper, coated with black chalk, under the impression, so that the lines on the front were traced onto the *verso* of the impression (fig. d). He then made the changes to the copper plate using this 'carbon' copy to guide him.[4]

EH

1 See Braunschweig 1979, no. 26 and no. 102, with further literature references. See also Royalton-Kisch 1992, no. 15 for a drawing which until recently muddied the waters in the debate about the creation of the works by Rembrandt and Lievens.

2 See Bruyn in *Corpus*, no. A30, and especially pp. 301–4.

3 White and Boon describe eight states, but closer examination reveals that there are only five. See pp. 31–2.

4 See Schatborn 1986, pp. 36–8 and Royalton-Kisch 1992, no. 6a.

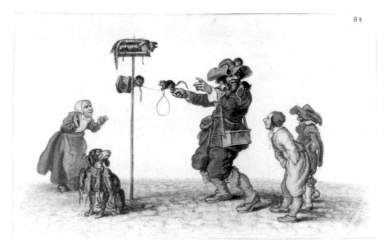

fig. a Adriaen van de Venne, *Rat-catcher*, c.1625. Drawing, 97 × 153 mm. London, British Museum

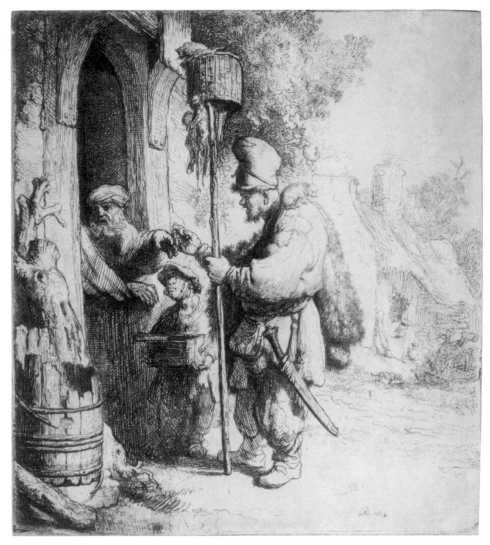

I London

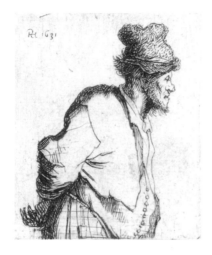

fig. c Rembrandt, *Man with hands behind his back*, 1631. Etching and burin, 59 × 48 mm. Amsterdam, Rijksmuseum (B.135 II)

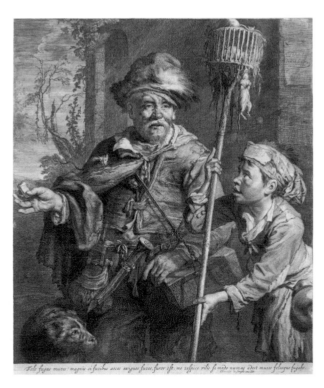

Fele fugat mures! magnus is faccbus acris exigua fuxa.furor oft. me respicis vile si modo navius dret mures felesque fugabi

other element. The only point of contact is between the men's gnarled hands.

The hunchbacked pedlar must have been taken from Rembrandt's stock of figure-studies. A year earlier he had made a simple etching of a comparable man with hunched shoulders and the same wispy beard (fig. c), and the beggar with a stick in the *Sheet of studies with self-portrait* (cat. 16) is also somewhat similar. The man in the house recalls the bearded *tronies* (character heads) with extravagant caps or exotic turbans that Rembrandt painted in the same period. The boy's head, which is disturbingly large for his body, is wound about with a strip of material that keeps a bandage in place around the jaws. Perhaps his employer was a jack-of-many-trades and this an allusion to the latter's gifts as a tooth-puller, a profession much practised on the side in the seventeenth century.[2] The quantity of fur slung over his right shoulder evidently indicates another branch of his business.

fig. b Cornelis Visscher, *Rat-catcher*, 1655. Etching and engraving, 377 × 318 mm. Amsterdam, Rijksmuseum

123

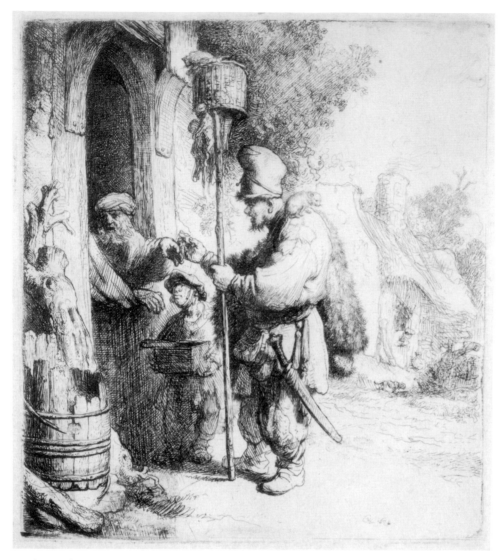

III Amsterdam

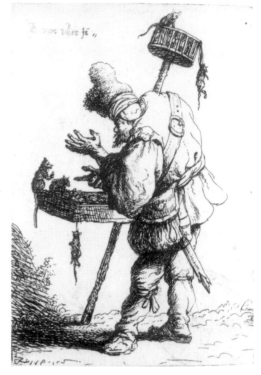

fig. e Johannes van Vliet, *The rat-catcher*, 1632. Etching and burin, 94 × 64 mm. Amsterdam, Rijksmuseum

fig. d Rembrandt, *Two farmsteads*. Silverpoint on prepared vellum, 80 × 134 mm. Rotterdam, Museum Boijmans Van Beuningen (Benesch 341)

Rembrandt did not neglect the surroundings. A tree trunk and a broken barrel serve as a *repoussoir*, though the entrance to the house is depicted, the rest is largely overgrown and obscured. The landscape with the farmhouse in the distance is etched more lightly, creating an effect of depth. Few landscapes by Rembrandt from the 1630s are known. Stylistically this type of scene is close to an early sketch that he executed in silverpoint on a prepared piece of vellum (fig. d).[3]

In the first state, only two impressions of which are recorded, the right side of the box of poison is not yet shaded. This was Rembrandt's first addition, after which one or more impressions were made (only one is known); he then used a burin to add diagonal hatching to the foliage above the pedlar's head, which accentuated this element more strongly in the final image.

Exactly how this print is to be interpreted is unclear. Was Rembrandt echoing long-standing prejudices about the riff-raff that knocked on people's doors peddling their dubious wares, or is this a picture of an innocent transaction to the parties' mutual advantage?[4] It is hard to make out whether the man standing in the doorway is rejecting the proffered goods or turning away after his purchase because he cannot bear the sight of the two figures and the smell of their merchandise and reeking advertisements.[5] These puzzling elements have done nothing to impede the print's success, it should be said. *The rat-catcher* was copied on a large scale even in the seventeenth century, and numerous versions of it were in circulation.[6] The man of the same trade that Johannes van Vliet included in his series of idlers, published the same year, is clearly derived from Rembrandt's example (fig. e).[7]

GL

1 For the drawing by Adriaen van de Venne, see Royalton-Kisch 1988, pp. 306–7; for Cornelis Visscher's print and other images, see De Jongh in Amsterdam 1997, pp. 318–20.

2 See De Jongh & Luijten 1997, no. 43 with select bibliography.

3 See Giltaij 1988, p. 56 and Van de Wetering 1997, pp. 47–8.

4 For the iconography of beggars, see Sudeck 1931 and Amsterdam 1997, pp. 111–14 and 276–80, esp. p. 279 on prevailing views of beggars and charity in this period. Stratton 1986 believes that Rembrandt gradually became more compassionate towards beggars and reflected this in his art; see also Held 1991.

5 See Donahue Kuretsky 1997, p. 69.

6 White & Boon, pp. 63–4 record eleven copies.

7 Hollstein 80; see also Chris Schuckman, in Amsterdam 1996, pp. 124–5, no. 56h.

19

Man crying out ''Tis bitterly cold' 1634

Etching, 112 × 43 mm; signed and dated upper right: *Rembrand f.1634*

Hind 114; White & Boon 177 (only state)

Amsterdam★ (Van Leyden RP-P-OB-417; watermark: none); London (Cracherode 1973.U.845; watermark: none)

Man replying 'Not at all' 1634

Etching, 112 × 39 mm; at upper right: *Rembran f 163*[4]

Hind 115; White & Boon 178 (only state)

Amsterdam★ (Van Leyden RP-P-OB-418; watermark: none); London (Cracherode 1973.U.846; watermark: none)

SELECTED LITERATURE: Held 1991, pp. 159–60; White 1999, pp. 175–6.

Rembrandt possessed a large collection of prints that stimulated his creativity in various ways, regardless of whether they were by great or minor masters; nor would he neglect a print on account of its age. These two etchings, for instance, are based on engravings by the German *Kleinmeister* Sebald Beham, which were almost a hundred years old when they attracted Rembrandt's attention (figs a–b).[1] 'Es ist kalt weter' ('Cold weather today'), Beham has the pitchfork-wielding peasant declare, as he peers heavenward, at which his laconic companion retorts 'Das schadet nit' ('No matter').

The captions in Rembrandt's prints are virtually identical, although in this case the reply roundly refutes the concise weather report of the shivering complainer. The main difference is in their presentation. Beham's figures have vacant expressions, while Rembrandt took the opportunity to depict two opposing moods, 'het lachen en 't krijten' ('laughing and wailing') – which according to the art theoretician Karel van Mander, writing in 1604, was a tall order for painters, whom he often found deficient in this regard.[2]

Rembrandt studied emotions by holding up a mirror to his own face and recording his expressions in drawings and prints (cat. 6).[3] In this case he himself acted as the model for the miserable man gazing at us; but that he set out to convey a particular view of himself, as is sometimes suggested today, is questionable.[4] Given the moods Rembrandt expressed through these figures, the iconography of these prints resembles that of Heraclitus and Democritus, the weeping and laughing philosophers, a well-known theme in the seventeenth century.[5] They too were sometimes conveyed with the barest of indications (fig. c).[6]

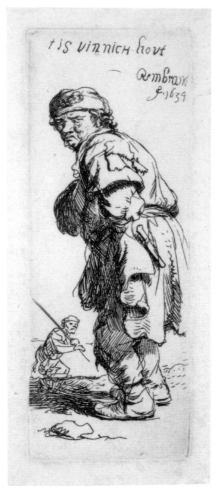

Amsterdam

Amsterdam

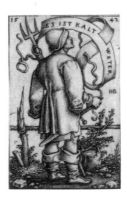
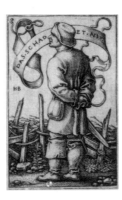

fig. a Sebald Beham, *Farmer crying 'Es ist kalt weter'*, 1542. Engraving, 45 × 30 mm. Amsterdam, Rijksmuseum

fig. b Sebald Beham, *Farmer replying 'Das schadet nit'*, 1542. Engraving, 45 × 30 mm. Amsterdam, Rijksmuseum, Rijksprentenkabinet

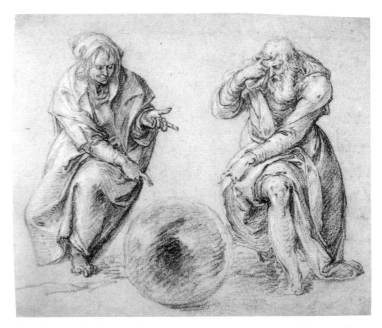

fig. c Jacques de Gheyn, *Heraclitus and Democritus, c.*1603. Black chalk on grey paper, heightened with white, 237 × 280 mm. Amsterdam, Stichting P. and N. de Boer

The two etchings show the suppleness that Rembrandt sought to achieve in his works on paper in about 1635 (see also cat. 28). Hatching has been added unceremoniously; light and dark are indicated in the patched cloaks and trousers of both men, who appear to be standing on the bank of a frozen stretch of water. The small figures in the distance are on the ice, one of them evidently wearing skates: his pose – hands grasping a stick resting on his shoulder – is the same as that of the skater that Rembrandt portrayed in another, small print (fig. d).

While Beham's *Wetterbauern* face each other, Rembrandt's duo turn their backs on one another. There is no doubt that this was quite deliberate, and it has an undeniable impact, particularly since both independently seek eye contact with the viewer. The horizon is exactly the same height in the two prints, and as one would expect, the two plates were placed on the press together. This can be inferred from an impression on a single sheet of paper, from which the two men had yet to be separated (fig. e).[7]

The figures have traditionally been seen as peasants, following Beham's prototypes, although their clothing provides no clue as to their trade. The gloomy man who has covered up his hands away from the cold is wearing something in front of his belly, possibly a pedlar's pack with string or thread and ribbons dangling from it. Given their dishevelled attire the two men look more as if they belonged to the motley crowd that slept in the streets in the seventeenth century, scraping an existence from begging and dubious modes of trade, and to whom cold temperatures posed a real threat. Their deceitful natures are emphasized in an early title of the prints, 'The two rascals'.[8]

GL

1 Bartsch 188–9; see Zschelletzschky 1975, p. 304 and Goddard in Lawrence-New Haven-Minneapolis-Los Angeles 1988–9, no. 56a.

2 Van Mander 1604, *Grondt*, fol. 25r; see also Blankert 1967, pp. 63–6.

3 London-The Hague 1999–2000, p. 21.

4 Held 1991, p. 160.

5 For this iconography, see Blankert 1967; Held 1991, p. 160 pointed out the resemblance.

6 The drawing reproduced is discussed by Van Regteren Altena 1983, I, pp. 84–5, II, no. 136 and in Rotterdam-Washington 1985–6, no. 38.

7 This paper bears a single-headed eagle watermark (Ash & Fletcher 16, B.a.), which is also found in various other impressions (see Laurentius 1996, pp. 82–3).

8 See the sale catalogue of coll. Amadé de Burgy, Amsterdam, 16 June 1755, nos 478–9: 'De Twé Schurkjes'.

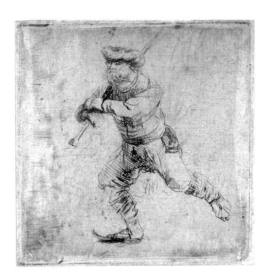

fig. d Rembrandt, *Skater*, c.1639. Etching and drypoint, 61 × 59 mm. London, British Museum (B.156)

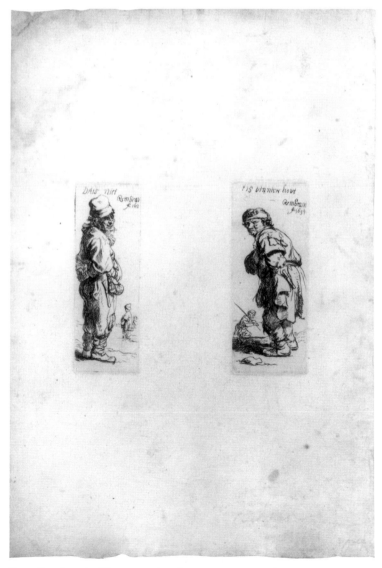

fig. e Rembrandt, The two prints from cat. 19 printed on a single half sheet of paper. Paris, Collection Frits Lugt, Institut Néerlandais

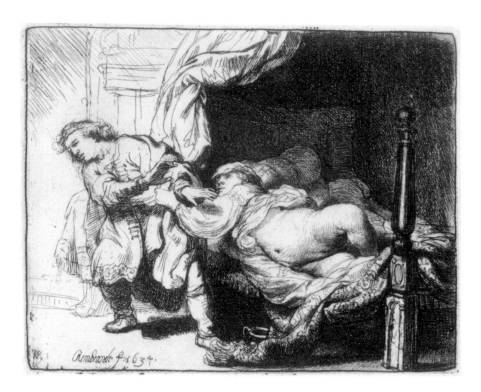

fig. a Antonio Tempesta, *Joseph and Potiphar's wife*. Etching, 58 × 67 mm. Amsterdam, Rijksmuseum

I Amsterdam

20

Joseph and Potiphar's wife 1634

Etching, 90 × 115 mm; signed and dated lower left: *Rembrandt. f. 1634.*

Hind 118; White & Boon 39 I (of II)

I Amsterdam (Van Leyden RP-P-OB-78; watermark: Arms of Württemberg [Ash & Fletcher 9, A.c.])

Watermarks: the watermark found in this impression is also found in other impressions of the first state, and in other prints, like the *Man replying 'Not at all'* (cat. 19).

SELECTED LITERATURE: Landsberger 1946, pp. 124–5; Boeck 1953, pp. 206–7; Smith 1987, pp. 505–6; Amsterdam 1991–1, pp. 188–9, no. 8; White 1999, p. 32.

Seldom has the story of Potiphar's wife, who tries in vain to seduce the slave Joseph, been depicted as boldly as in Rembrandt's 1634 etching. The story is related in Genesis in the barest outline: Joseph, sold into bondage by his brothers to the Ishmaelites, becomes a slave of Potiphar, the Egyptian captain of Pharaoh's guard. He soon gains his master's favour. But Potiphar's wife lusts after the handsome young man: 'And it came to pass about this time, that Joseph went into the house to do his business; and there was none of the men of the house there within. And she caught him by his garment, saying, Lie with me: and he left his garment in her hand, and fled, and got him out' (Genesis 39: 11–12).

Rembrandt based the composition of his etching on a small print by Antonio Tempesta (1555–1630; fig. a).[1] In both prints Joseph walks away towards the left, and Rembrandt has also

followed his example in the pose of the young man's legs and the positioning of the bed in the pictorial space. But there the resemblance ends. In the final analysis, Tempesta's etching is a more wooden creation, his Joseph is a muscular adolescent in whom the advances of Potiphar's wife arouse nothing more than faintly glazed bewilderment. Rembrandt, on the other hand, has infused the scene with powerful psychological depth. Joseph reels from the woman in a highly suggestive gesture of physical revulsion. In her desire and shameless nakedness, Potiphar's wife is a near-pitiful figure. It seems as if Rembrandt wanted to use even the *chiaroscuro* to stress the contrast between good and evil, as the chaste Joseph is seen in the full light – he seems even to radiate light – while Potiphar's wife lies in the sultry semi-obscurity of the bed-curtains.[2]

Two fairly similar states of this print are known. The second is distinguishable only by the addition of some hatching in the upright of the bed and in one of the pillows.

In the sale of the works of art from the estate of Pieter de Haan (1767) the copper plate of 'Joseph and Potiphar's Wife, with 2 impressions' was purchased for seven guilders by the art dealer Fouquet. The plate has been preserved and is now in a private collection.[3]

MS

1 Bartsch 71.
2 Berlin-Amsterdam-London 1991–2, p. 188.
3 Hinterding 1993–4, p. 290.

21

The angel appearing to the shepherds 1634

Etching, drypoint and burin, 262 × 218 mm; from the second state signed and dated: *Rembrandt. F 1634*

Hind 120; White & Boon 44 I and III (of III)

I London★ (Cracherode 1973.U.850; with touches of brownish wash in the sky above the landscape; watermark: Basel staff with letters AV★ [comparable to Ash & Fletcher 11, C.a.])

III Amsterdam★ (De Bruijn RP-P-1962-19; watermark: Strasbourg lily [Ash & Fletcher 36, D.a.]); London (Cracherode 1973.U.852; watermark: Basel crozier [Ash & Fletcher 11, A.b.])

Watermarks: the Strasbourg lily in the first state is possibly a twin-mark to Ash and Fletcher 11, C.a., which occurs only in impressions of the second and third of the *Good Samaritan* (B.90) of 1633. The Strasbourg lily in the Amsterdam impression has been found in a few other impressions of this print, perhaps the earliest of the third state. The Basel crozier in the London impression occurs in a large group of different prints, such as *Beggar in a high cap, standing and leaning on a stick* (B.162) of *c.*1629, the *Man making water* (B.190) of 1631, and the *Woman reading* (B.345) of 1634. The latter date must be when this group of impressions was printed. See further below.

SELECTED LITERATURE: Boston-St Louis 1980–81, no. 80; Berlin-Amsterdam-London 1991–2, pp. 190–91, no. 9, White 1999, pp. 32–7.

The *Angel appearing to the shepherds* is Rembrandt's first etched nocturne, and this drove him to wrest new possibilities for rich tonal contrasts from the copper plate. These were to have far-reaching consequences for his later work, especially in the 1640s, when he frequently combined etching, drypoint and engraved lines to create velvety blacks that resemble the medium of mezzotint, which he himself did not employ. The composition, which melodramatically describes the fear engendered in the shepherds by the apparition of the angel, has a bold, Baroque sweep, derived in part from the unusually small figure scale.

The first state produces a startling effect, with the central band of darkness worked over to a high degree of finish, while the remainder of the plate, including all the main figures, is lightly and freely sketched. The only comparable plate in this respect is the first state of the *Christ before Pilate* of 1635–6 (cat. 24), prepared in the *grisaille* of 1634, the same year as the present etching. The later print was largely the work of Johannes van Vliet, and the idea that the *Angel appearing to the shepherds* was also the result of a collaboration is worthy of consideration. In style it offers few grounds to support such an attribution, not least because in the first state, the figures are already sketched in, unlike those in the first state of the *Christ before Pilate*. But the question also arises because of the watermarks: an impression of the second state in

Amsterdam[1] has the mark (Monogram 4HP) that occurs in the *Christ before Pilate* and the *Descent from the cross* (cats 22–4), both produced with the help of Van Vliet, in whose prints this watermark is common.[2] The mark is otherwise unknown in Rembrandt's. Yet even if Van Vliet did assist in the execution and printing of the plate, it is clear that his contribution was extremely limited, and the completion of the image in the second and third states must be largely or even entirely Rembrandt's own work.[3] Most of it was finished in the second state, but in the third he added shade to the upper branches of the dying tree in the centre, the figure immediately below (and the ground around him), to the two more distant cows on the right and to the wings and drapery of the angel. These alterations ensure that the brightest light is reserved for the sky.

When Rembrandt's prints are highly finished, as here, they often depend on a painted or drawn prototype.[4] While none is now known for the present composition, it is worth pointing out the resemblance with the style of the (more lightly etched) *Good Samaritan* of the previous year, which almost certainly was based on a now lost painting;[5] and that the angel raises his left arm in blessing, although it should traditionally be the right, perhaps reversing the original design.[6]

<div align="right">MRK</div>

1 RP-P-OB-84.

2 See Hinterding in Amsterdam 1996, pp. 25–6 and 35.

3 The additions to the angel in the final state are anticipated in an impression of the second which has been touched in black chalk, now in the British Museum (1848-9-11-24). But the retouches (apart from a few crude lines in the angel's lower drapery, which do not seem to be autograph) are so smudged that it is difficult to judge their authenticity (and may have led to the statement in Berlin-Amsterdam-London 1991–2, pp. 190–91, no. 9, that the second state showed signs of a sulphur tint; the Amsterdam impression of the third state [illustrated] is also washed in grey ink). The landscape seems to have been worked on as well, perhaps with the brush in grey wash.

4 See the Introduction, pp. 64–81.

5 See *Corpus* I, no. C48. It is worth remarking the similarity between the landscape in cat. 21 and that in the *grisaille of St John the Baptist preaching* in Berlin (see p. 48, fig. 12).

6 Several writers have tackled Rembrandt's apparent lack of respect for left and right, but fail to take sufficient account of this possibility (Graffon 1950, Boeck 1953, Zwaan 1965, Held 1980). The painted version of the *Good Samaritan* is in reverse to the etching (see previous note). The copper plate for cat. 21 is in an American private collection (Hinterding 1993–4, p. 44, repr. p. 47).

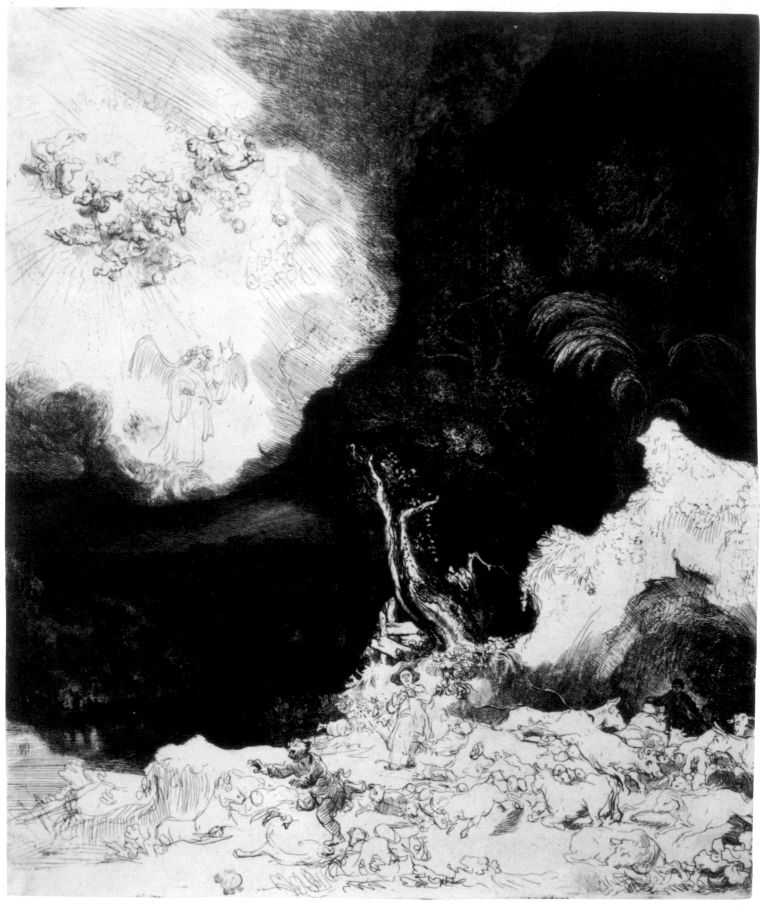

I London

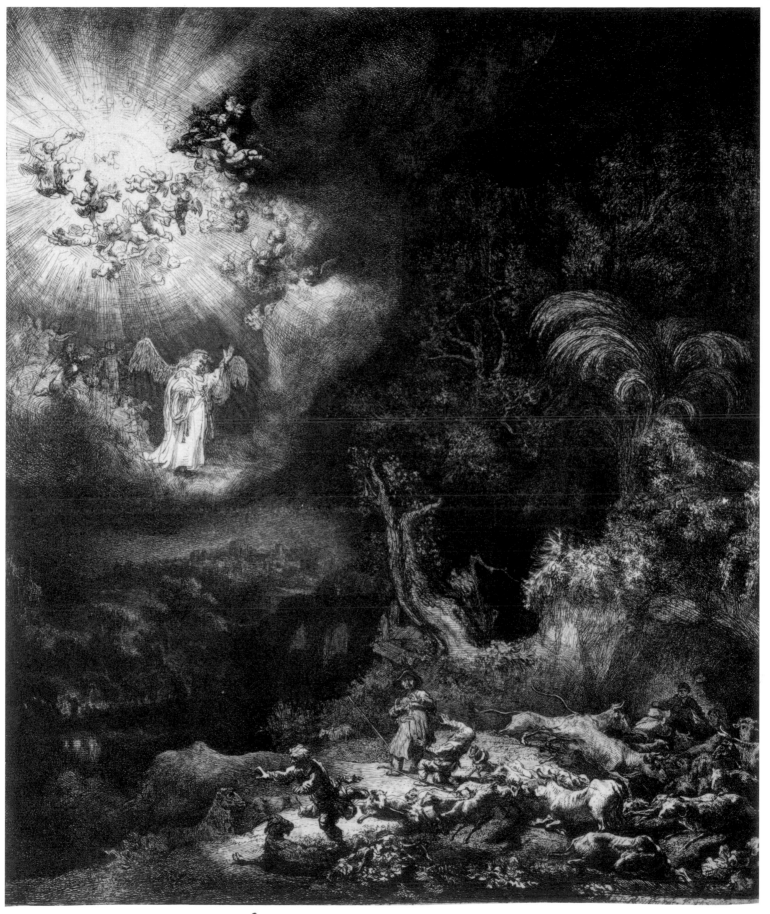

22

The descent from the cross (first plate) 1633

Etching, 518 × 402 mm; inscribed lower centre: *Rembrandt . Ft . 1633.*

Hind 102; White & Boon 81 (only state)

Amsterdam★ (Van Leyden RP-P-C8-619: watermark: Monogram 4HP with countermark R [Ash & Fletcher 24, A.a])

Watermarks: the watermark is one that frequently appears in prints by Johannes van Vliet in these years, and is highly unusual in Rembrandt's (see further under cat. 21).

SELECTED LITERATURE: Royalton-Kisch 1984, pp. 3–23; *idem.* 1994, pp. 3–13; *idem.* 1995, pp. 216–18; Amsterdam 1996, no. 17; White 1999, pp. 16–17.

This and the following plate (cat. 23) reproduce, with variations, Rembrandt's painting which was executed for the Stadholder, Prince Frederik Hendrik of Orange, in 1632–3 (fig. a).[1] The painting was influenced by Peter Paul Rubens' celebrated altar-piece in Antwerp Cathedral, of 1611–14, which would have been known to Rembrandt through the engraved reproduction by Lucas Vorsterman (fig. b).

Only four impressions from the first plate are known.[2] The extraordinary appearance of the image is due to the disintegration of the etching ground, which allowed acid to attack most of the surface of the plate. On the other hand a few white patches (e.g. in the arms of the figure at the top of the cross and in the left hand of the nearest figure) reveal that the ground was there impervious, even where lines drawn with the etching needle must have revealed the plate. Presumably the etching ground was too liquid and closed over the lines in these areas.

Although the product of a ghastly accident that ruined many hours of work, to a modern eye, trained in abstraction, the print retains its fascination. As we attempt to fathom the image, our sight is constantly thrown back and forth by wilful highlights and

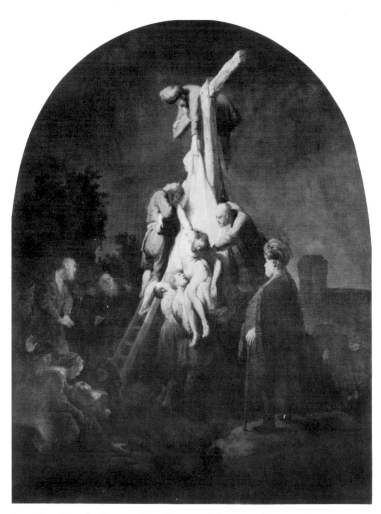

fig. a Rembrandt, *Descent from the cross*. Oil on panel, 896 × 650 mm. Munich, Alte Pinakothek

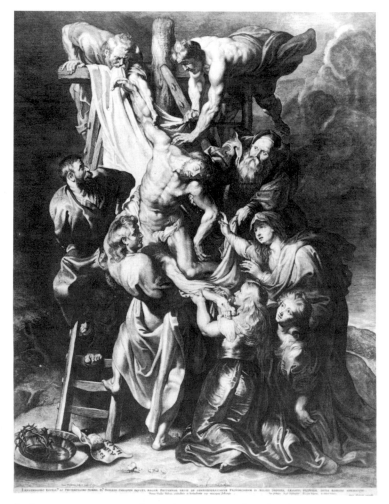

fig. b Lucas Vorsterman after Rubens, *Descent from the cross*. Engraving, 585 × 435 mm. London, British Museum

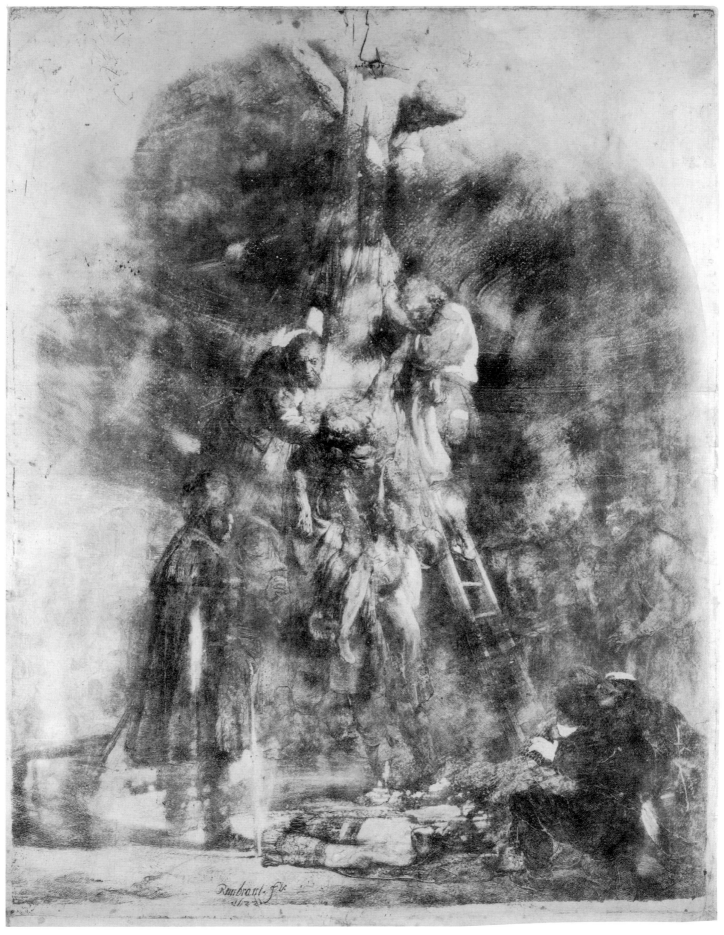

Amsterdam

inappropriate shadows. The smoked background eddies around the central group of figures, producing a darkly threatening atmosphere that might have benefited the technically successful second plate (cat. 23).

Despite the 'signatures' on both plates, that on the first being entirely untypical of Rembrandt's orthography in 1633, there are many reasons for supposing that they are largely or even entirely the work of Jan (Johannes) van Vliet (between 1600 and 1610–c.1668). The quality of the drawing is at times inordinately coarse, even in the heads of the most significant figures. In the second plate we can also observe the *moiré* technique, whereby engraved cross-hatching is so regimented that the intersections of lines produces an extra trail. This is foreign to Rembrandt's technique, yet typical of professional reproductive engravers, including Van Vliet, who may have mastered it on a visit to Antwerp in 1632.[3] The style of the signature in the failed plate also marries with his rather crude lettering. The arched format of the painting was followed here, albeit with less room between the nearer arm of the cross and the top of the composition. In the second plate (cat. 23) the composition was altered to a rectangle.

MRK

1 *Corpus* II, no. A65.

2 In Amsterdam (shown here), London (retouched by a later hand in grey wash), Paris (Bibliothèque Nationale de France) and Vienna (Albertina).

3 See Royalton-Kisch 1984, p. 21, and the illustration in Amsterdam 1996, p. 12, fig. 2.

23

The descent from the cross (second plate) 1633

Etching and burin, 530 × 410 mm; signed and dated lower centre: *Rembrandt . F. cum pryvl⁰ . 1633*. In the third state the plate has the publisher's inscription: *Amstelodami Hendrickus Ulenburgensis Excudebat*. In the fourth state this is altered to *Amstelodami Justus Danckers Excudebat*, which is erased in the fifth.

Hind 103; White & Boon 81 (II) II (of V)

II Amsterdam (Van Leyden RP-P-OB-621; watermark: Strasbourg lily [Ash & Fletcher 36, C.c]); London★ (Cracherode 1973.U.934; watermark: Strasbourg lily [Ash & Fletcher 36, C.b])[1]

Watermarks: there is no reason to doubt that the impressions were taken around 1633, although these watermarks also occur in second state of the *Ecce Homo* (cat. 24) of 1636, and in the *Death of the Virgin* (B.99) of 1639. This large-format paper seems to have been in use for a number of years.

SELECTED LITERATURE: see cat. 22.

After the failure of the first plate (cat. 22), Rembrandt and Johannes van Vliet produced this second version of the *Descent from the cross*, eliminating the arched format of the painting in order to conform to the rectangular shape of the copper plate. The second plate also differs from the first in a number of details: the right background, where there are signs of burnishing and revision, presents a solid corner tower;[2] the foot of the ladder on the left side is omitted, and shafts of light are introduced from above. The group of figures spreading the pall-cloth in the foreground differs from the painting in both prints, and it is thought that this may reflect a subsequently abandoned stage in the development of the oil.[3] The latter also reduces the scale of the apostle standing on the ladder and holding Christ's forearm, a figure generally regarded as a self-portrait of the artist (despite an uncanny resemblance to Ludwig van Beethoven); and the head of the man on the other ladder is turned towards Christ in the oil.

In spite of the complexity of the design, most of the changes of state in this plate merely record alterations in the publisher's address (enumerated above), apart from the addition of some shading in the second state to the legs of the figures receiving Christ's body.

The etching is often rightly regarded as a pendant to the slightly later *Christ before Pilate* (cat. 24), which presents yet more evidence that Rembrandt employed a reproductive engraver, making only a limited contribution to the plate himself. Van de Wetering argues that these etchings formed part of a sequence of prints that was planned while Rembrandt worked for Hendrick Vylenburgh in the first half of the 1630s.[4]

The copper plate itself is now in a private collection in America.[5]

MRK

1 E. Hinterding considers the watermarks on the Amsterdam and London impressions to be twin marks, i.e. on the same paper.

2 Also characteristic of Van Vliet is the method of adding tone immediately above the tower, with scratchy vertical lines crossed by short flicks to produce a somewhat indeterminate shadow. This is seen in the background of Van Vliet's print of an *Old woman reading* after Rembrandt, Hollstein 18.

3 *Corpus* III, p. 282.

4 See pp. 36–63.

5 Hinterding 1993–4, pp. 46–9, with reproduction.

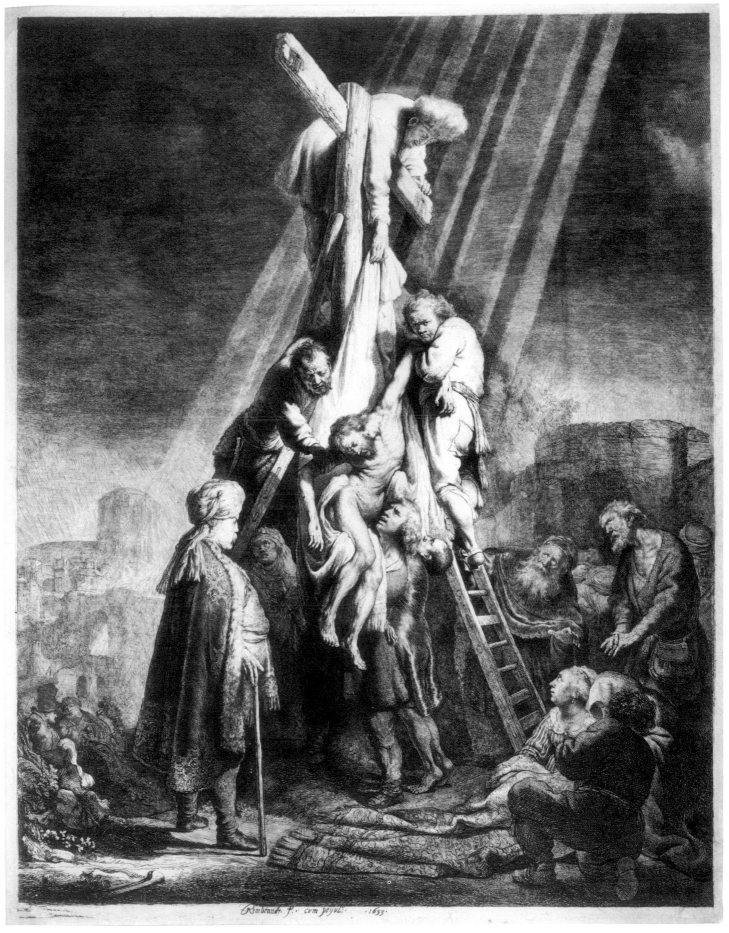

Rembrandt f. cvm prvvl. 1633.

II London

24

Christ before Pilate: large plate 1635–6

Etching and burin, 549 × 447 mm; signed and dated under the clock in I: *Rembrandt f. 1635*; from III signed and dated in lower margin in drypoint: *Rembrandt f. 1636 cum privile.*

Hind 143; White & Boon 77, I and III (of V)

I Amsterdam (Van Leyden RP-P-OB-613; watermark: Monogram 4HP, with countermark R [Ash & Fletcher 24, A.a]); London★ (Cracherode 1973.U.936; ex. J. Barnard [L.219]; watermark: as I Amsterdam)

I London★ (Cracherode 1973.U.937; touched in brown oil paint; watermark: 4HP with countermark R [Ash & Fletcher 24, A.a])

III Amsterdam (Van Leyden RP-P-OB-614; watermark: none); London★ (Cracherode 1973.U.938; watermark: Strasbourg lily, type not in Ash & Fletcher★)

Watermarks: the watermark in the first state, also seen in cat. 22, is characteristic of works by Van Vliet of the same period, and highly unusual for Rembrandt.

SELECTED LITERATURE: Royalton-Kisch 1984; *idem.* 1994; *idem.* 1995; Amsterdam 1996, nos 16 a–b; White 1999, pp. 17–18.

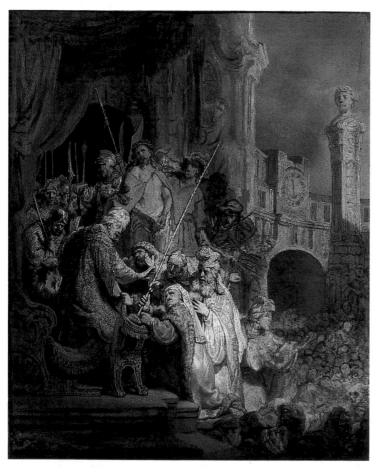

fig. a Rembrandt, *Christ before Pilate*, 1634. Oil on paper stuck down on canvas, 545 × 445 mm. London, National Gallery

In spite of the signature, the etching, like those of the *Descent from the cross* of 1633 (cats 22–3), is a reproductive print after Rembrandt, although in the present case he also worked on the plate himself. For the most part, however, he turned again to Johannes van Vliet.

Several factors make this clear. Firstly, the technique of finishing much of the plate without any indication of the central group of figures, as seen in the first state shown here, is characteristic of reproductive engravings and foreign to Rembrandt's own practice. Only in the *Angel appearing to the shepherds* (cat. 21), is the plate left partially unfinished in this way, although there, significantly, the figures are already sketched in outline. Secondly, there exists a detailed, full-size oil-sketch on paper by Rembrandt himself, dated 1634, the outlines of which are indented for the print (fig. a). This is highly unorthodox for a print executed by the artist himself; he would have no need of such an elaborate preparation. The oil, which resembles the *modelli* produced by Rubens for reproductive engravings after his paintings, is executed with so few *pentimenti*, or alterations, that it may even copy a now lost prototype, perhaps an oil-painting.[1] This becomes all the more probable when it is compared with Rembrandt's other indented sheets, such as those for the *Diana at the bath* and the portraits of *Cornelis Claesz. Anslo* and *Jan Six*, which although far less complicated compositionally exhibit many *pentimenti* (cats 45 and 57).

Thirdly, the printmaker misunderstood parts of the oil. The (untouched) impressions of the first state reveal that the form of the canopy and the details of the crowd immediately below the monument were too sketchily presented for the engraver to follow. To clarify his intentions Rembrandt added some indications on the impression now in the British Museum, included here: he cut back the canopy, made the arch higher, obliterated the background figures, darkened those in the lower left foreground and added emphasis to some architectural outlines. In the following states these areas are corrected, often precisely as anticipated by Rembrandt's indications, and Van Vliet completed the central group of figures. However, some extensive additions made in the second and third states, either in drypoint or with the burin (but never etched), are consistent with Rembrandt's own style. He not only added his own signature in drypoint, but also used the same tool to enhance various details: the head of the bald man at the lower left in the first state, when compared with his reincarnation in the second (complete with cap), points up the superior quality of these interventions (figs b and c). Pilate's left

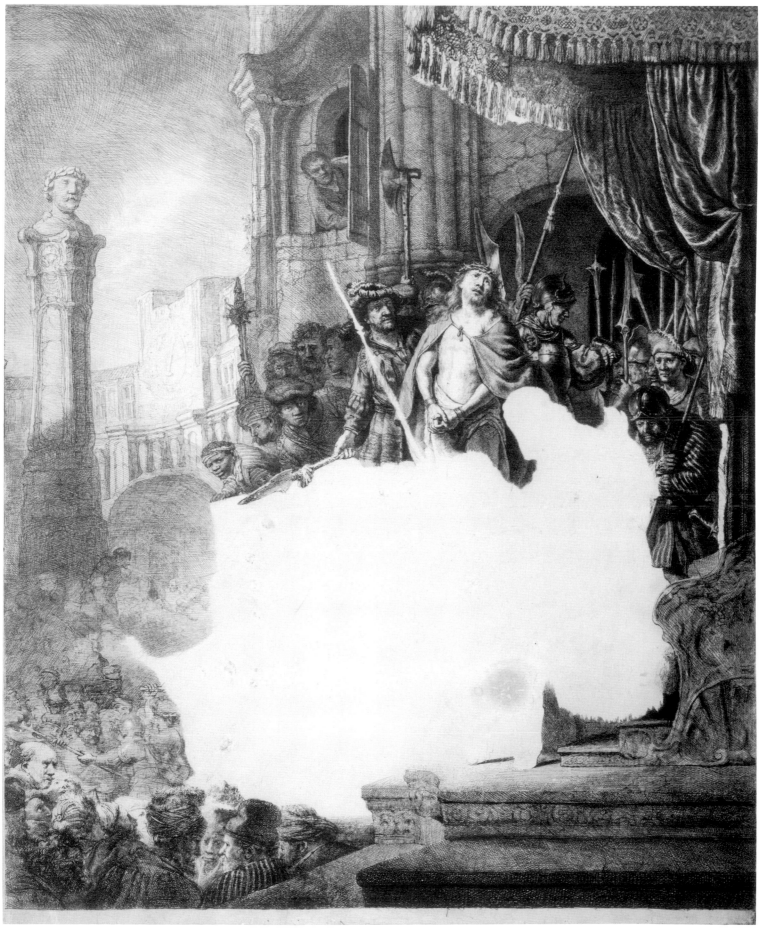

I London

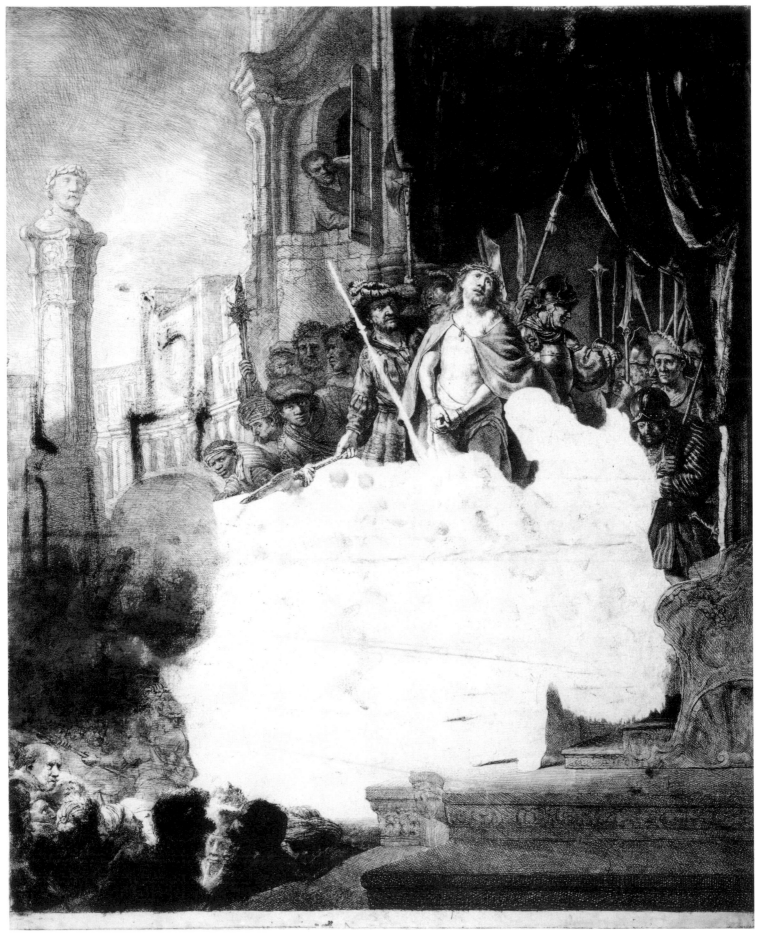

I London (touched)

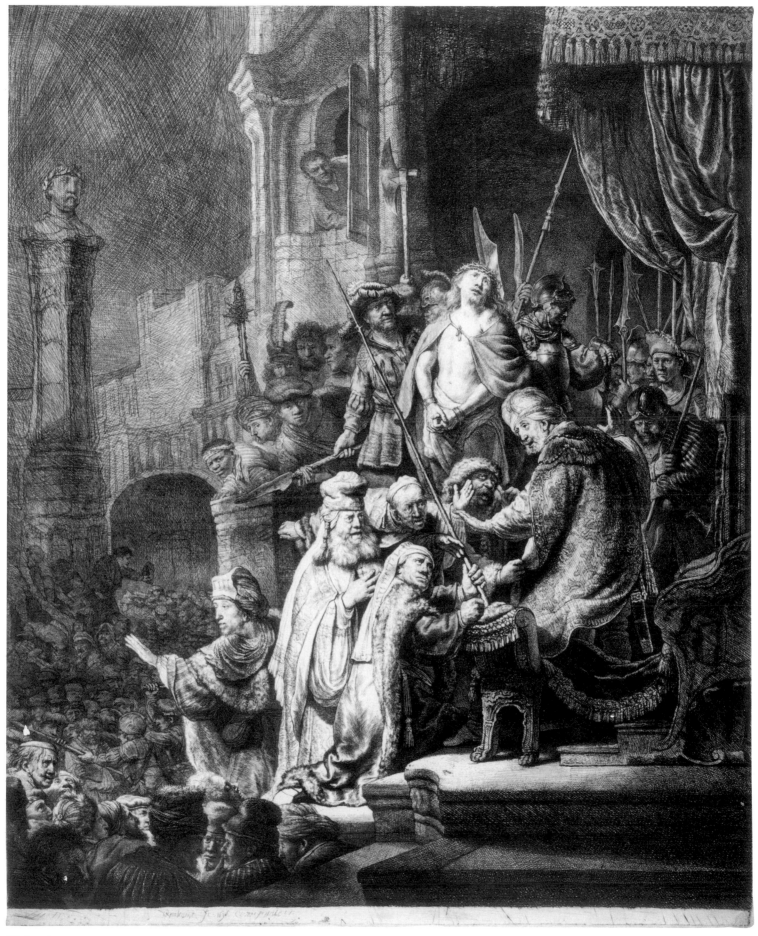

III London

fig. b Detail of I
London.

fig. c Detail of III
London.

hand, the cap of the pharisee by Christ's knees, and the reworked strip of drapery above Pilate's chair also benefited from refinements in drypoint. On the left, much was improved and reinvented, often using the burin in a free style that departs radically from the character of the work in the first state, for example in the bold darkening of the sky, the bust of Caesar, and the clarified forms of the architecture. Many figures in the farther part of the crowd are similarly redefined, and sometimes invented from scratch, including the soldier holding the crowd back and the youths climbing the monument, who were not fully anticipated in the *grisaille*.[2]

The plate was almost certainly part of a planned series of reproductive prints after Rembrandt of the 1630s, including its pendant, the *Descent from the Cross* (see cats 22–3), but the project was abandoned after Rembrandt left Hendrick Vylenburgh's studio in the mid 1630s.[3]

MRK

1 Royalton-Kisch 1994. The National Gallery sketch is *Corpus* II, no. A89.

2 One figure seated behind Pilate's lower back in the *grisaille* (looking somewhat like a self-portrait) was not transferred to the print.

3 See the essay by van de Wetering, pp. 36–63.

25

The great Jewish bride 1635

Etching with some drypoint and burin, 219 × 168 mm; from the third state signed and dated lower left: *R 1635* [reversed]

Hind 127; White & Boon 340 II and IV (of V)

II Amsterdam★ (Van Leyden RP-P-OB-724; watermark: fragment of Strasbourg lily with initials BA [Ash & Fletcher 36, initials BA.b.]); London (Cracherode 1973.U.868; watermark: Strasbourg lily with initials BA [Ash & Fletcher 36, initials BA.b.])

IV Amsterdam★ (Van Leyden RP-P-OB-726; watermark: Single-headed eagle [Ash & Fletcher 17, B´.a.])

Watermarks: both watermarks can be dated 1635.

SELECTED LITERATURE: Landsberger 1946, pp. 74–8; Kahr 1966, pp. 228–44; Royalton-Kisch 1993b, pp. 186–8; White 1999, pp. 125–8.

Despite its title and the elaborate, fantastical costume, the *Great Jewish bride* of 1635 can be counted among Rembrandt's most directly descriptive portraits of his first wife, Saskia Uylenburgh (1612–42), whom he married in the previous year. It may be compared with a number of etchings he made of her in the following two years, including the *Studies of the head of Saskia and others* of 1636 and the *Three heads of women, one lightly etched* of

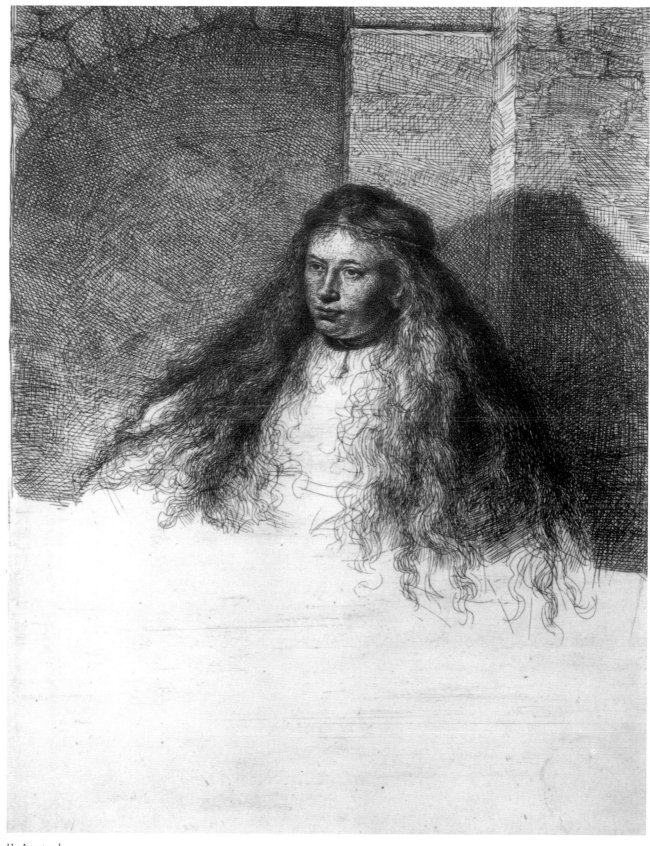

II Amsterdam

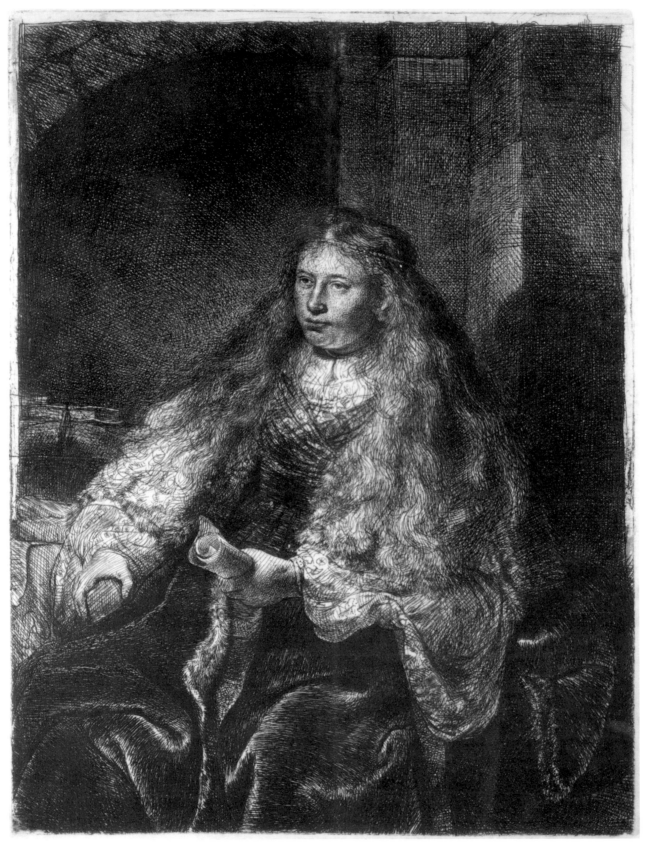

IV Amsterdam

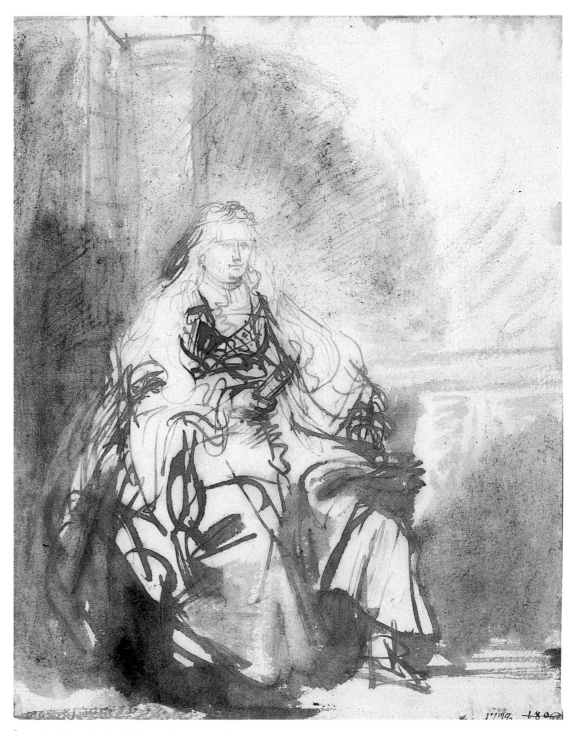

fig a Rembrandt, *Study for the Great Jewish bride*. Pen and brown ink with brown wash, 240 × 190 mm. Stockholm, Nationalmuseum (Benesch 292)

*c.*1637 (B.365 and cat. 29). Also worthy of comparison for its iconography is the *Study of Saskia as St Catherine (the 'little Jewish bride')* of 1638 (B.342), which casts Saskia in another role.

The question arises as to whether, in the *Great Jewish bride*, Rembrandt had a specific iconography in mind. Various suggestions have been made, the most persuasive of which holds that Saskia here modelled for Esther, shown (from the third state) clasping the decree to slay the Jews, and clad in her 'royal apparel' before approaching Ahasuerus in order to expose Haman's treacherous intentions towards the Jewish people (*Esther* IV, 8 and V, 1).[1] This biblical episode precedes the *Triumph of Mordechai*, represented by Rembrandt in around 1641 (cat. 44).

Rembrandt seems to have begun the plate by working informally from life, doubtless lengthening Saskia's hair in anticipation of the final design. The second state, shown here, adds little to the first, reducing a few highlights on the forehead, nose and chin. Before embarking on further work, Rembrandt made a rough, boldly executed drawing which anticipates his style of the 1640s (fig. a). This was a rehearsal for the completion of the composition in the third state, and interestingly the ink is paler and the style more rectilinear in the sections of the drawing that Rembrandt was copying from the second state; for the rest a far darker and freer line prevails.[2] After the third state there were further refinements, some of them (more hair on the forehead, shadows over the breast and nearer sleeve) sketched in black chalk on a third-state impression in Amsterdam.[3] Shading was then added to the figure's sleeves and hands in the fourth state, which is extremely rare – only the Amsterdam impression and one other, in Berlin, are recorded. Yet the more common fifth state merely adds definition to the stonework at the upper right corner, as sketched out on the touched impression of the third in Amsterdam.

The watermarks suggest that all five states were created in a short period, revealing – along with the drawing and the touched proof – the exceptional lengths to which Rembrandt was prepared to go in order to perfect the result, which has always been counted among the artist's most desirable prints.

MRK

1 Kahr 1966. Rembrandt's painting in Ottawa of *c.*1632–3 may represent the same subject (*Corpus* II, no. A64), as also his drawing of a *Young woman seated in an armchair* in the British Museum (Benesch 1174, as suggested by Royalton-Kisch 1992, no. 59).

2 See further the Introduction, pp. 72–3.

3 De Bruijn RP-P-1962-112.

26

The Remonstrant preacher Johannes Uytenbogaert 1635

Etching and engraving, 250 × 187 mm (first state), 224 × 187 mm (from the third state [octagonal]); signed and dated in the upper section of the oval, in drypoint: *Rembrandt ft 1635*; inscribed under the oval: *Qúem pia mirari plebes, qúem castra solebant, / damnare et mores aula coacta súos. / Jactatús múltum, nec tantum fractús ab annis / WTENBOGARDUS sic túús, Haga, redit. / HGrotius.* (The [worldly] court was forced to condemn the man so admired by the pious, the soldiers and the court itself, and denounce his convictions. The Hague, after much wandering your fellow townsman Uytenbogaert returns, withered, not by the years alone. Hugo de Groot.)

Hind 128; White & Boon 279 I, II and IV (of VI)

I Amsterdam★ (Van Leyden RP-P-OB-560; watermark: Double-headed eagle [Ash & Fletcher 15, C.c.]); London (1842-8-6-149; watermark: Double-headed eagle [Ash & Fletcher 15, C.c.])

II London★ (1855-4-14-271; reworked in black chalk; watermark: none)

IV Amsterdam★ (Van Leyden RP-P-OB-561; watermark: Double-headed eagle [Ash & Fletcher 15, C.a.); London (1848-9-11-145; watermark: none)

Watermarks: the Double-headed eagle of the type found in the first state occurs only in these two impressions. The type the fourth state also occurs in impressions of the *Persian* of 1632 (B.152) and the *Great Jewish bride* of 1635 (cat. 25). The latest dated print in which it occurs is the *Abraham casting out Hagar and Ishmael* of 1637 (B. 30), and all impressions with the watermark in this form must have been made at around that time.

SELECTED LITERATURE: Mariette 1857, p. 358; Amsterdam 1986, pp. 24–7; White 1999, pp. 128–30.

The man portrayed is the preacher Johannes Uytenbogaert or Wtenbogaert (1557–1644), a distinguished and highly influential figure in his day. Shown at the age of seventy-eight, he was formerly Frederik Hendrik of Orange's tutor, and minister at the court of Prince Maurits. He became a leading spokesman for (and later the leader of) the Remonstrants, a liberal movement in the Calvinist Church in opposition to the Counter-Remonstrants. An outspoken champion of religious tolerance, Uytenbogaert played a prominent role in the controversy between the two factions over the question of divine predestination. This theological dispute flared into a nationwide political struggle, reaching such proportions that Uytenbogaert was forced to flee the country in 1618, after which he was officially banished. He returned in secret in 1626 once the situation had calmed down, and moved back into his old home in The Hague in 1629.[1]

The caption to the print, written by Hugo de Groot – himself a Remonstrant and still in exile in 1635 – alludes not only to these events but was also clearly intended to draw attention to Uytenbogaert's return to The Hague. The portrait must have

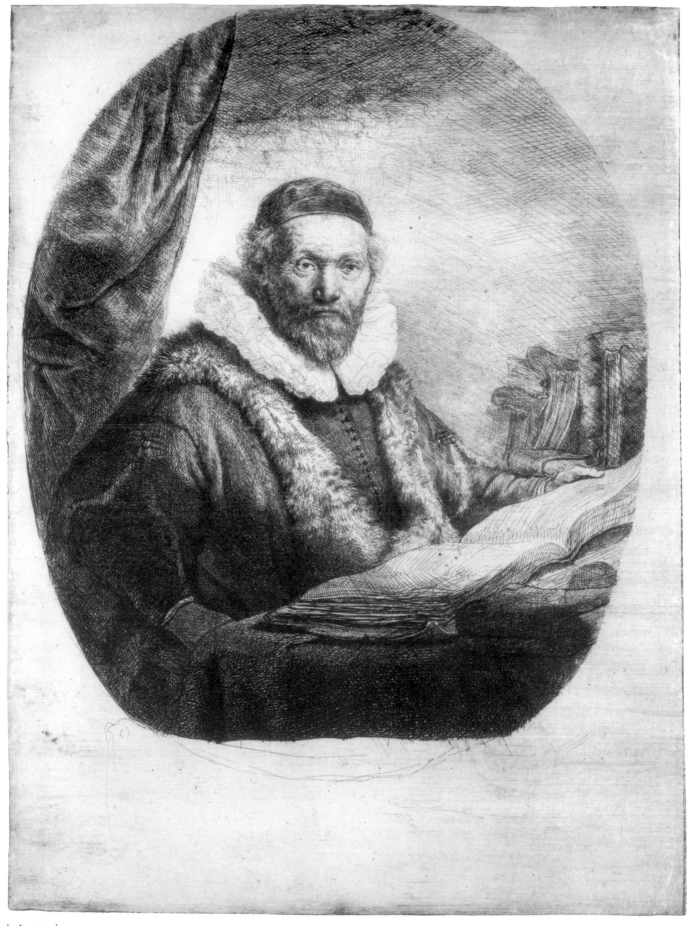

I Amsterdam

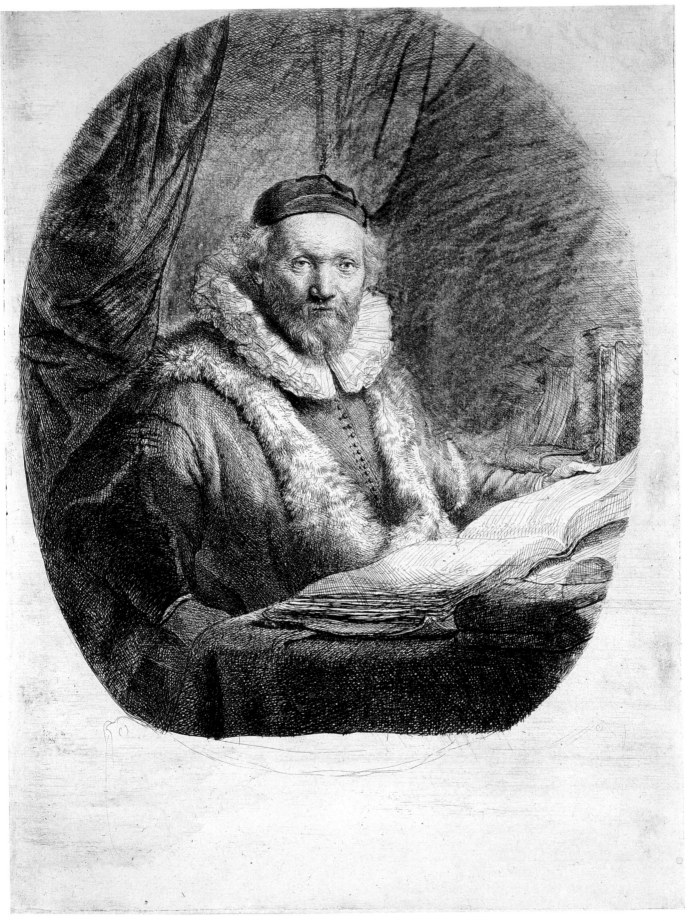

II London (touched)

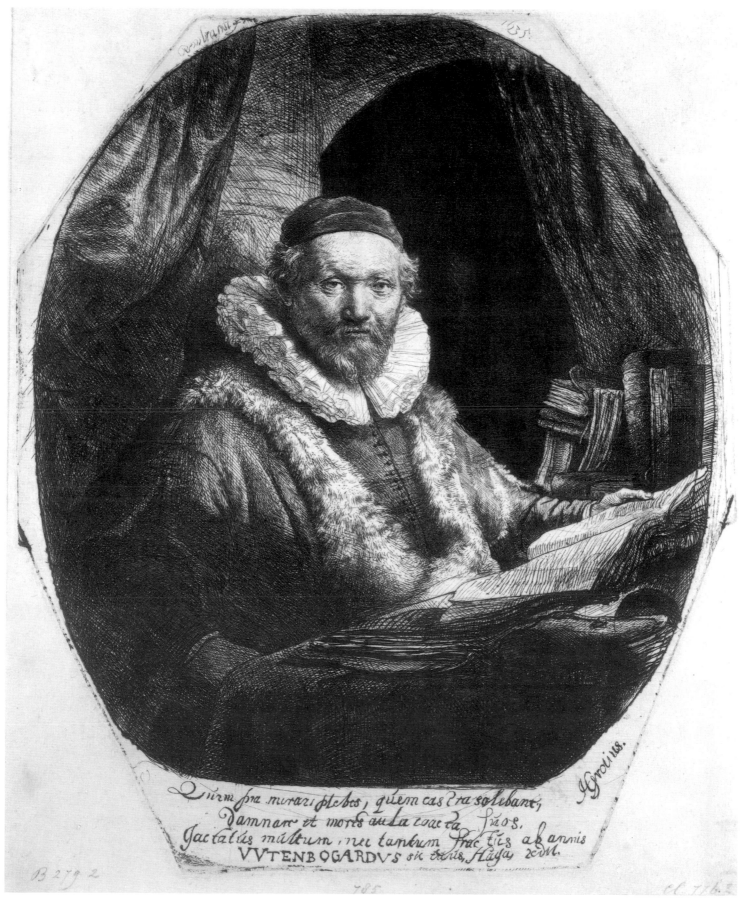

IV Amsterdam

been ordered with a view to distributing the prints among friends and admirers of the elderly clergyman. Uytenbogaert may even have commissioned it himself, but this is not necessarily the case. Rembrandt had painted his portrait two years earlier, and we know that this was at the request of the Remonstrant merchant, Abraham Antonisz. Recht (fig. a). On that occasion Uytenbogaert posed for Rembrandt, but it is uncertain whether he did so for the etching, as the two versions of the man's face are remarkably similar, down to the wisps of hair straying from under his cap.

Rembrandt must have based the head on a now lost drawing, but it is clear from the various states that he was not entirely sure at the start how he intended to proceed. The first state, included here, is unfinished. Uytenbogaert is portrayed with a varied network of etched lines, and we see him sitting at a table, glancing up from the open book in front of him. The row of books at his side are lightly bitten, as is the curtain on the left of the print. The background, however, is barely worked out, and only the bricks

which are vaguely discernible above the man's head give an idea of what Rembrandt had in mind. It is also clear that the portrait was intended to be oval.

In the second state, Rembrandt made a few changes to heighten the contrasts on the head, the cap and the collar, but left the background unaltered. He was nevertheless seeking a different solution for this section, as he darkened the background with black chalk on the impression of this state shown here, and added a second curtain. However, the changes he ultimately made were slightly different. In the third state he placed a column behind Uytenbogaert and added a dark arch which was partly concealed on the left by a draped curtain. To keep the contrasts in balance Rembrandt heightened the shading in various passages, on the books on the table, for instance, and on Uytenbogaert's right arm, which is consequently less distinct than it had been. The text was also added in this state, and the plate cut to an octagon.[2]

The only change in the fourth state, which is also shown here, is the darkening of the curtain on the right. This completed the etching, and nothing further was done in the fifth state, except that the edges of the plate were cleaned up.

EH

1 For Uytenbogaert's biography and a brief account of the dispute between the Remonstrants and Counter-Remonstrants, see Kloek 1992, pp. 346–52.

2 Most descriptions of this state mention that the framing line around the oval is not closed. Recently, however, it was discovered that the only known impression of this state, the sheet in St Petersburg, was cut around the oval, and that a small section of the framing line was inadvertently removed in the process.

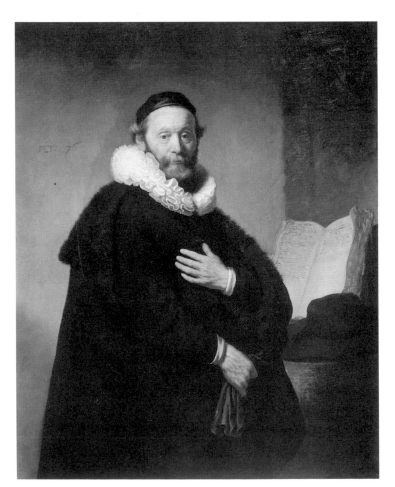

fig. a Rembrandt, *Johannes Uytenbogaert*, 1633. Canvas, 1300 × 1010 mm. Amsterdam, Rijksmuseum

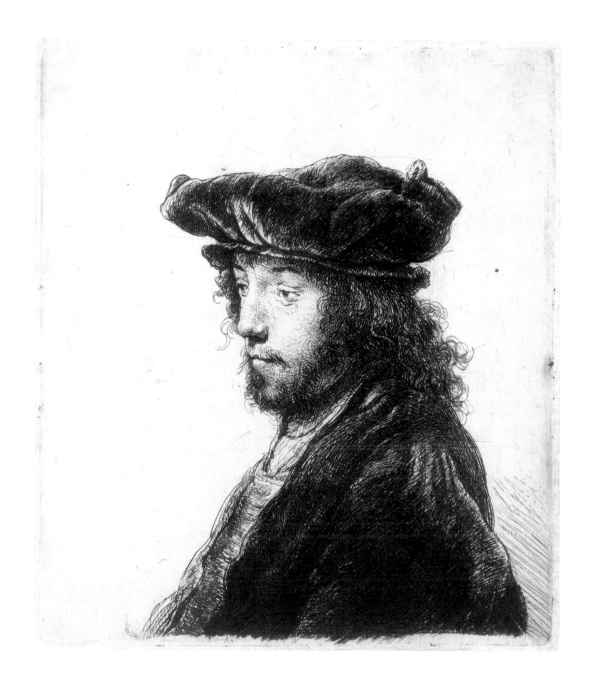

I London

27

The fourth oriental head c.1635

Etching, 158 × 135 mm; signed centre left: *Rt*

Hind 134; White & Boon 289 I and II (of II)

I London★ (1851-5-30-8; watermark: none)

II Amsterdam★ (De Bruijn RP-P-1961-1165; watermark: Strasbourg lily with the initials BA [Ash & Fletcher 36, Initials BA.a.]); London (Cracherode 1973.U.874; watermark: none)

Watermarks: this type of the Strasbourg lily is found in numerous other etchings, such as the small *Presentation in the Temple* of 1630 (B. 51) and the *Good Samaritan* of 1633 (B. 90), but the latest, dated print is the *Great Jewish bride*, likewise of 1635 (cat. 25), and that is the year in which these impressions must have been made.

SELECTED LITERATURE: De Piles 1699, pp. 433–4; Vosmaer 1868, p. 96; Seymour Haden 1877, p. 39; Six 1909, p. 100; Broos 1981–82, pp. 250–51; Broos 1985, nos 6–7; Paris 1986, no. 29; Amsterdam 1988–9, pp. 50–51; Schatborn 1991, pp. 76–7; Gutbrod 1996, pp. 288–91.

The print, which shows the bust of a young man in a velvet beret belongs to a loose series of four etchings, traditionally known as 'the four oriental heads' (B.286–289). They are freely interpreted copies, made in 1635, after prints by Jan Lievens. Three of the latter belong to a series of seven *tronies*, or study heads, that Lievens had executed around 1631,[1] and the fourth is an independent print made in the same year (fig. a). Without mentioning whose prints he had used as models, Rembrandt noted in the plates of three of the etchings that he had 'retouched' the motif, which could mean either 'worked up' or 'improved' (fig. b). This

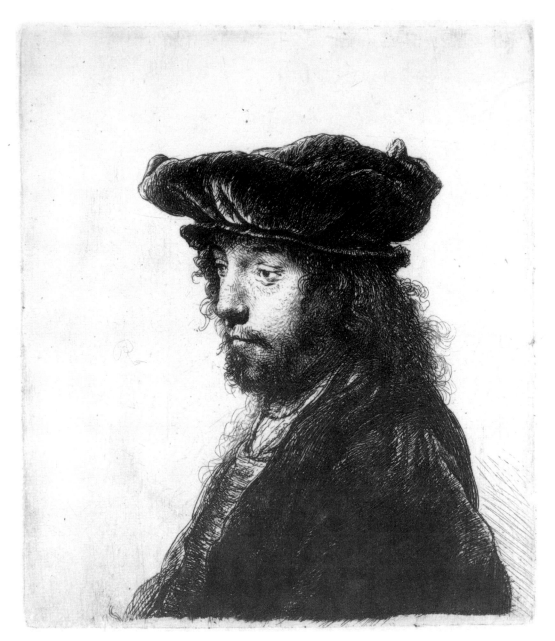

II Amsterdam

fig. a Rembrandt's signature and inscription on the *Second oriental head*, 1635. Amsterdam, Rijksmuseum (B.287)

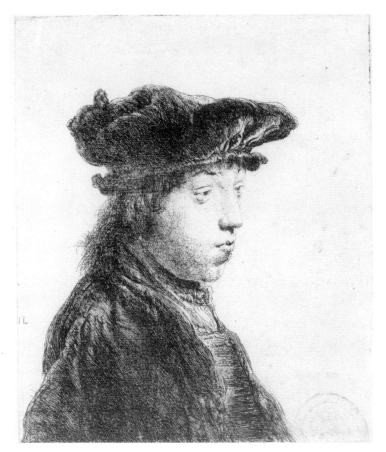

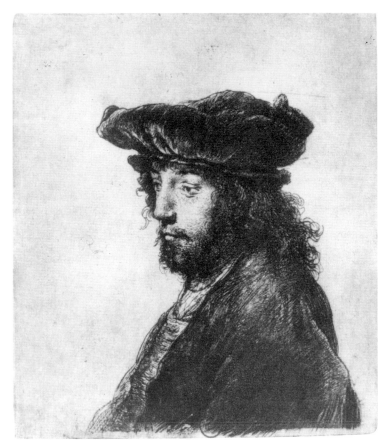

fig. b Jan Lievens, *Bust of a young man in a velvet beret, c.*1631–2. Etching, 150 × 126 mm. Amsterdam, Rijksmuseum

fig. c Rembrandt, *Fourth oriental head, c.*1635. Etching, 158 × 135 mm. Paris, Bibliothèque Nationale (B.289, undescribed first state)

inscription does not appear on the present print, but it has nevertheless affected the interpretation of the etching. The same note appears on several paintings listed in Rembrandt's inventory of 1656,[2] and as a result the four oriental heads were long believed to have been executed by a pupil, and improved by Rembrandt. In the prints, however, it is impossible to distinguish between the styles of the pupil and master, and today the heads are attributed entirely to Rembrandt. He probably transferred the contour lines from Lievens' prints onto a new etching plate and subsequently elaborated the image.

Although Rembrandt's version of the young man in a velvet beret is similar to the original by Lievens (fig. a), there are marked differences. For instance, he used small lines rather than dots for the shading on the face, and concealed the plump cheeks of Lievens' model under a beard and moustache. He also ingeniously added a lock of dark hair behind the man's profile, which makes the face more expressive. In addition, Rembrandt enhanced the sense of depth by introducing a small patch of shadow in the lower right-hand corner.

Two states of the etching have been known for some time, but an undescribed first state recently came to light. The figure in this unique impression is almost finished, but it is still closer to the Lievens in that the shading on the right has not been added. The lines on the shoulder above the seam of the sleeve were not bitten successfully, leading to a few grey patches in that area (fig. b). In the second state Rembrandt added a few lines to camouflage this irregularity, and made the folds of the coat more distinct. He also introduced the shadow on the right behind the figure (see the first state shown here). In the third state, he made a number of minor changes, adding a few hairs under the man's nose and others straying down by his chest. He also drew several lines of shadow around the eyes to bring out the contrast between light and dark on the face (the second of the states included here).

EH

1 Hollstein nos 35, 36, 39 and 44. There is often confusion between this series and two series of smaller heads by Lievens, which were published as *Variae Effigies a Joanne Livio Lugd. Bat.* and *Diverse tronikens geëtst van J.L.* See Amsterdam 1988–9, p. 6.

2 See Strauss & Van der Meulen 1979, 1656/12, nos 25, 27, 33, 120, 123, 295 (?) 301 (?). See also *Corpus* III, p. 112, fig. 10: 'altered and overpainted' 1636.

28

The pancake woman 1635

Etching, 177 × 109 mm; signed and dated in the margin, lower centre: *Rembrandt f. 1635*

Hind 141; White & Boon 124 I and II (of III)

I Amsterdam★ (Van Leyden RP-P-OB-212; watermark: none); London (1848-9-11-62; watermark: none)

II Amsterdam★ (De Bruijn RP-P-1961-1056; watermark: none); London (Cracherode 1973.U.880; watermark: none)

SELECTED LITERATURE: Boston-St Louis 1980–81, no. 72; Robinson 1980, pp. 165–6; Berlin-Amsterdam-London 1991-2, pp. 192–4, no. 10; White 1999, pp. 176–7.

Three pancakes are spread out in the flat-bottomed pan, and judging by the impatience with which the assembled youth are clamouring for them, the cook will have to keep her fire ablaze for some time yet. Rembrandt did not depart from traditional images of pancake-making: since Pieter Bruegel the Elder the emphasis had been on the enthusiasm with which children, in particular, devoured the delicacies (figs a–b). Rembrandt presents us with a scene from everyday life, including keenly observed details such as the child on the right that gazes thoughtfully into the frying pan, the plump toddler in the foreground holding its portion out of reach of an importunate dog, and the lad behind the pancake woman who shows some coins in the hope of gaining preferential treatment.

The cautious composition that characterized a narrative picture such as *The rat-catcher* (cat. 18) has vanished without a trace, producing a far livelier scene. The loose technique is also a contributory factor here: the image has been created from a combination of scratches and smooth hatching that recall drawings from the same period, one of which also depicts a *Pancake woman* with her clientele (fig. c).[1] The drawing conveys the way the culinary aromas work on the appetite in an original manner: one boy digs deep into his pocket to fish out a coin, while two others behind him indulge in horseplay on their way to the stall. Rembrandt must have regarded the etching as a means of disseminating drawn studies of this kind, albeit in a somewhat more elaborated form.

Especially in the first state of this print, which appears to have survived in only two impressions, the figures were all treated even-handedly. In the second state, produced for the market, the woman received extra attention. Her clothes and bonnet were furnished with hatching and the contours of her face accentuated.

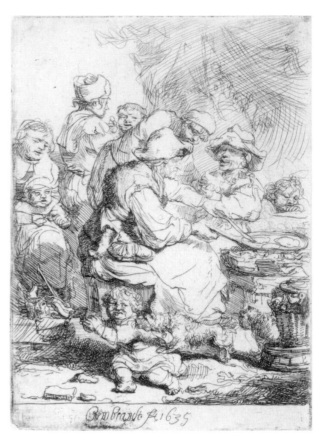

I Amsterdam

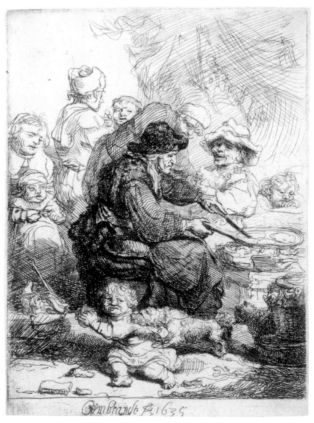

II Amsterdam

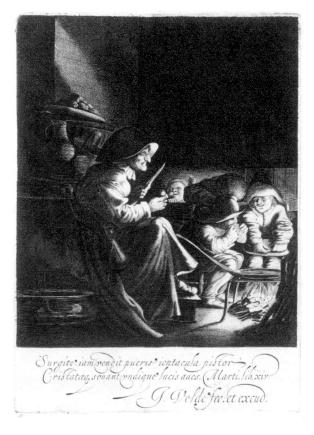

Surgite iam vendit pueris ientacula pistor
Cristataeq, sonant undique lucis aues. Marti. lib. xiv
J. Velde fec. et excud.

fig. c Rembrandt, *Pancake woman*. Pen and brown ink, 108 × 144 mm. Amsterdam, Rijksmuseum (Benesch 409, cat.)

fig. a Jan van de Velde II, *Pancake woman*. Engraving, 184 × 129 mm. Amsterdam, Rijksmuseum

fig. b Theodoor Matham after Adriaen Brouwer, *Pancake woman*. Etching, diameter 180 mm. Amsterdam, Rijksmuseum

In consequence, she became more emphatically the focus of the composition. In other parts too, parallel lines were added and shadows deepened, making the image easier to read.

Rembrandt's choice of motif may have been influenced by an existing print of the subject, an engraving by Jan van de Velde II, inspired by Willem Buytewech, which excels in its rendering of nocturnal light effects (fig. a).[2] Rembrandt himself owned a painting, 'A Piece by Ad. Brouwer, depicting a pastry cook' and an etching exists that was made in Haarlem after a painting by the same artist showing a woman making pancakes (fig. b).[3]

Both Brouwer and Jan van de Velde set their scenes in domestic interiors. Rembrandt, on the other hand, showed the woman cooking on a makeshift outdoor stove in the manner of today's roast chestnut vendors.[4] Around the mid-seventeenth century the same motif was depicted in paintings by artists such as Gerard Dou and Gabriel Metsu.[5] These show us how such stalls were set up and help us to interpret the free configuration of lines in the background of Rembrandt's etching, beneath which some scrawls can be made out. The paintings reveal that pancake

fig. d Attributed to Aert de Gelder, *Pancake woman*. Brush and brown ink, 148 × 170 mm. Paris, Musée du Louvre

makers, like the pedlars of other wares, sometimes constructed simple shelters by hanging a piece of tarpaulin in a tree or draping it across some posts. A drawing of a *Pancake baker* by one of Rembrandt's pupils, most probably Aert de Gelder, shows a construction of this kind (fig. d).[6] The flapping, indeterminate shape in Rembrandt's print may be such a tent.

GL

1 Schatborn 1985, pp. 16–17, no. 6.

2 Hollstein 48; see Clifford Ackley in Boston-St Louis 1980–81, no. 61. There is a similar drawing by Buytewech in Leipzig, see Paris-Rotterdam 1974–5, no. 37.

3 For Theodoor Matham's print (Hollstein 34), see Scholz 1985, pp. 126–7, no. 39; for Brouwer's painting, see Trautscholdt 1961.

4 The construction of such an oven is clearly visible in Gerard Dou's *Quack* in the Museum Boijmans Van Beuningen in Rotterdam, in which a pancake baker occupies a prominent place; see Lammertse 1998, no. 19.

5 Gerard Dou's painting is in Florence, Uffizi; see Martin 1913, p. 136 (with ill.). For the paintings by Metsu, see Robinson 1974, p. 147, figs 79–79a, and Cologne-Rotterdam 1970, no. 30.

6 See Peter Schatborn, in Dordrecht-Cologne 1998–9, p. 257, no. 63.

29
Three women's heads *c.*1637

Etching, 127 × 103 mm; signed, top, in the second state only: *Rembrandt*

Hind 153; White & Boon 367 I and III (of III)

I Amsterdam★ (Van Leyden RP-P-OB-769; watermark: fragment of Strasbourg lily with initials PD★)

III Amsterdam★ (Van Leyden RP-P-OB-770; watermark: none)

Watermarks: the watermark in the first state also occurs in the impression of the first state in London, but does not occur in other etchings by Rembrandt.

SELECTED LITERATURE: Berlin-Amsterdam-London 1991–2, pp. 198–9, no. 12; White 1999, pp. 131–2.

Saskia Uylenburgh, who became Rembrandt's wife on 22 June 1634, sat for him on many occasions. Of unusual intimacy and restraint is the drawing made, according to Rembrandt's own inscription, on 8 June 1633, a few days after the couple had pledged their troth (fig. a). She wears a wide straw hat and holds a flower in one hand, while the fingers of the other support her head.[1]

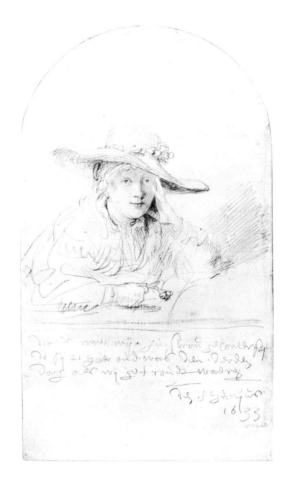

fig. a Rembrandt, *Portrait of Saskia Uylenburgh*, 1633. Silverpoint on prepared vellum, 185 × 107 mm. Staatliche Museen zu Berlin, Kupferstich-kabinett (Benesch 427)

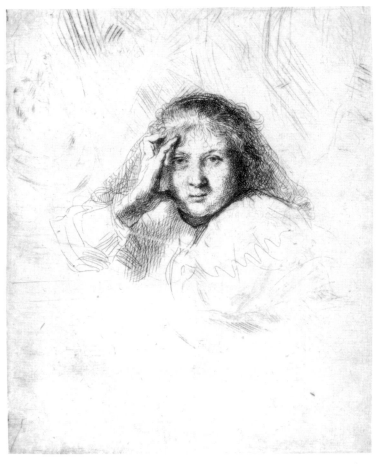

I Amsterdam

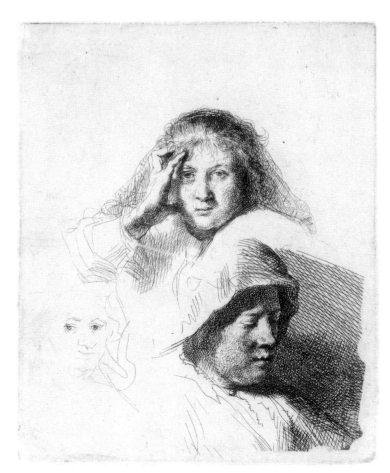

III Amsterdam

In the present etching Saskia looks past the viewer with the same slightly fixed gaze as in the drawing. Yet, in the words of Christopher White, 'the mood has changed from the happy, care-free air to a more introspective, brooding look. The fingers say it all: in the drawing straight, resting lightly on the cheek, in the etching, bent and taut'.[2]

The print was probably produced several years later, in 1636 or 1637, when Rembrandt etched a few comparable sheets of studies in which several heads are assembled. A similar intention evidently underlay this print too, as after pulling a few impressions of the plate with only Saskia's head, placed at the centre, he added two more heads, one of which consists of only a few thin lines. Without a doubt these too render his wife's features, and she was also the model for a similar etching (fig. b).

Prints of this kind were not intended as portraits. They belong to a tradition of model sheet series, printed and distributed on a large scale as soon as printmaking was an established medium.[3] In these series, women wearing a variety of headgear are a regular feature (fig. c). Presumably Rembrandt wanted to create studies

that would be far removed from the rigid, monotonously drawn prints that were all too common, and to preserve the immediacy of drawn sketches. On further inspection, we see that Saskia constantly changed her clothes, did her hair differently or discarded a veil for a heavier shawl, enhancing the visual richness of the heads.

The variety in the angles of the heads is characteristic of such images, and motifs in different degrees of elaboration also crop up in drawn sketches by numerous artists from the late Middle Ages onwards. In the Netherlands, besides Rembrandt, drawings of this kind by Hendrick Goltzius and Jacques de Gheyn have been preserved (fig. d).[4] Rembrandt must have made these prints for the market, which is corroborated by the watermarks on the paper and by the large number of early impressions that have survived. One edition demonstrably came off the press between 1635 and 1640; another appeared along with a frenzy of reissues of his work around 1652.[5]

The upper part of the Amsterdam impression of the first state has some prominent scratches. These are not traces of scouring

but signs of earlier use: probably an image with widely spaced hatching lines had been bitten into the plate before (*cf.* e.g. cat. 5) and then burnished out, but not thoroughly enough to remove it entirely. In the second state Rembrandt's name was added amid the scratches, but it did not remain there for long. It vanished with the polishing of the plate when the artist had a larger edition printed.

The copper plate does not appear to have survived Rembrandt by very long. Clement de Jonghe's 1679 inventory lists a plate entitled 'Three little *tronies*', but whether it was a reference to this image is very much open to doubt.[6] In any event the plate did not, like many by Rembrandt, survive to this day.[7]

GL

1 The drawing is discussed by Peter Schatborn in Berlin-Amsterdam-London 1991–2, pp. 29–31, no. 3.

2 White 1999, p. 131.

3 For a survey, see Bolten 1985; a number of examples of similar sheets are in Antwerp-Amsterdam 1999–2000, pp. 350–56.

4 The drawing illustrated here is discussed in Reznicek 1961, under no. 420; for De Gheyn, see Van Regteren Altena 1983.

5 The earliest impressions are printed on paper with the watermark the Arms of Baden Hochberg (Ash & Fletcher 2, A´.a.); later on paper with a Strasbourg lily was used (Ash & Fletcher 36 E´.a.).

6 De Hoop Scheffer & Boon 1971, p. 10.

7 Hinterding 1993–4.

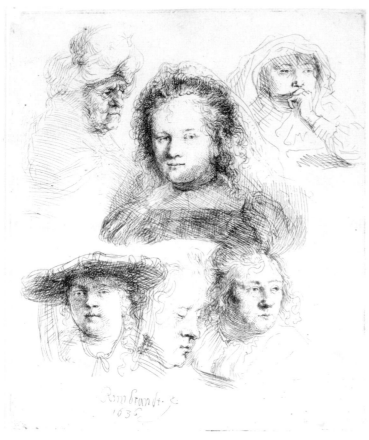

fig. b Rembrandt, *Sheet of studies with Saskia and the head of an old man*, 1636. Etching, 151 × 126 mm. Amsterdam, Rijksmuseum (B.365)

fig. c Heinrich Vogtherr, Sheet with women's heads, from *Kunstbüchlein*, Strasbourg 1572. Woodcut, 193 × 138 mm. Amsterdam, Rijksmuseum

fig. d Hendrick Goltzius, *Sheet of studies with woman's head and hand*. Red and black chalk, 1240 × 890 mm. Amsterdam, Amsterdams Historisch Museum, coll. C. J. Fodor

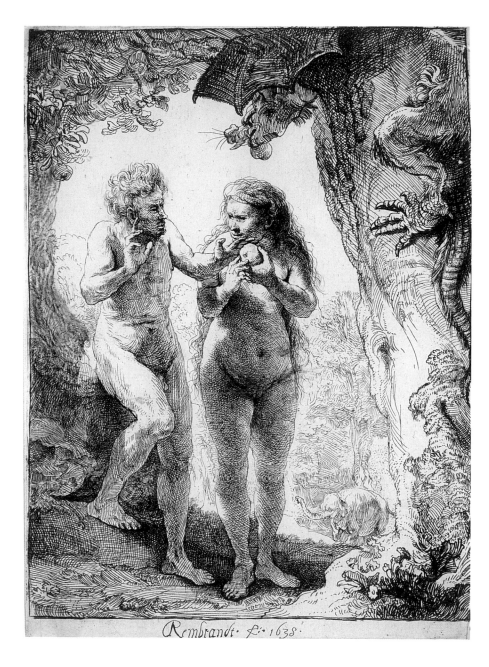

I London (touched)

30
Adam and Eve 1638

Etching, 162 × 116 mm; signed and dated lower-centre margin: *Rembrandt.f. 1638*

Hind 159; White & Boon 28 I and II (of II)

I London★ (1852-12-11-42; touched in black chalk, grey wash and pen and brown ink; watermark: Strasbourg lily★)[1]

II Amsterdam (RP-P-1961-992; ex. G. Hibbert [L.2849]; watermark: none); London★ (Cracherode F.4-40; with Dighton's mark [L.727]; watermark: none)

Watermarks: the Strasbourg lily watermark sometimes occurs in the second

state, as well as in the *Diana at the bath* (cat. 10), the third state of the *Self-portrait with plumed cap lowered sabre* (B.23), and the first state of the 1633 *Portrait of Jan Cornelisz. Sylvius, preacher* (B.233).

SELECTED LITERATURE: Berlin 1970, no. 1; Slatkes 1980, pp. 7–13; Paris 1986, no. 57; Berlin-Amsterdam-London 1991–2, pp. 195–7, no. 11; Roscam Abbing 1994, pp. 15–23; White 1999, pp. 38–41.

In terms of creating spatial recession in the landscape and an immediate sense of atmosphere, the etching of *Adam and Eve* marks a significant development for Rembrandt. For the first time he suggests an airy landscape background, in which an elephant trumpets its bulk through a sunny Eden.[2] The figures are lit

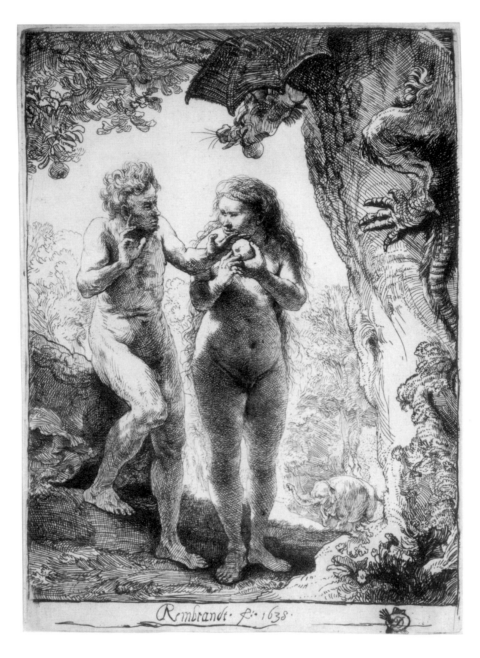

11 London

mostly from behind, so that Rembrandt depicts their forms largely in terms of light reflected from the foreground, producing an unorthodox and yet astonishingly convincing effect.

The only difference between the two states is the addition of a firm outline to clarify the bank behind Adam. The touched first state from the British Museum (the only other recorded impression of this state, in Vienna, is not touched) suggests that he considered enclosing the figures in a kind of arbour instead. This impression also has some extra hatching in pen and brown ink around Adam's left foot. The additions in grey wash, to the foliage at the top left, Adam's head, and the touch on Eve's, are probably posthumous.[3]

As in the earlier etching of *Diana at the bath* (cat. 10), Rembrandt abstains from the customary idealization of these figures and presents Adam and Eve as past the first flush of youth. For this the print was singled out for criticism by the classicist painter and biographer, Arnold Houbraken.[4] Nor, as they discuss the implications of the fruit, do they radiate a keen intelligence. In the preparatory sketch (fig. a), Rembrandt at first toyed with a more melodramatic solution on the left of the sheet, with Adam shrinking back in horror from the proffered fruit.[5] The figures were sketched again on the same sheet, much as they appear, in reverse, in the print, with a more subtle portrayal of the psychology of the moment. The dragon-like 'serpent' is based on

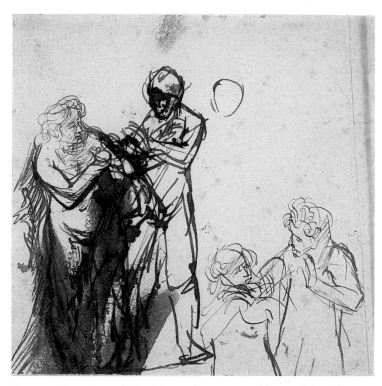

fig. a Rembrandt, *Study for Adam and Eve*. Pen and brown ink with brown wash, 115 × 115 mm. Leiden, Prentenkabinet der Rijksuniversiteit (Benesch 164; exh.)

the beast in Albrecht Dürer's engraving of *Christ in limbo*; Rembrandt acquired a large group of the German master's prints in 1638, the year of this etching.[6]

<div align="right">MRK</div>

1 Ash & Fletcher 36, E′.c. is a twin to the present watermark.

2 In 1637 Rembrandt had made studies of an elephant in black chalk (Benesch 457–60, see Slatkes 1980, though the example in the British Museum may date from later – see Royalton-Kisch 1992, no. 18). His landscape style remains rather consistent in his etchings between the *Adam and Eve* of 1638 and the mid- to later 1640s (cf. the *Boathouse* of 1645, B.231, and the *Cottage with a white paling* of 1648, B.232).

3 The pen and brown ink lines may have been acted upon, as hatching appears very faintly indeed immediately under Adam's foot in another impression of the second state in the British Museum (1843-6-7-16), producing a new state. But these lines probably wore away very quickly.

4 Roscam Abbing 1994.

5 Noted by Bevers in Berlin-Amsterdam-London 1991–2, p. 195, no. 11. See further the Introduction, pp. 69–70.

6 The Dürer is B.16, from the 1512 *Engraved Passion*. For the documents, see Strauss & Van der Meulen 1979, no. 1638/2. Rembrandt purchased the prints on 9 February 1638 at the estate sale of Gommer Spranger.

31

Joseph telling his dreams 1638

Etching, 110 × 83 mm; signed and dated lower left: *Rembrandt f. 1638*

Hind 160; White & Boon 37 II and III (of III)

II London★ (Slade 1868-8-22-660; ex. J. Barnard [L.1419]; watermark: fragment, Arms of Baden Hochberg★)

III London★ (Cracherode 1973.U.895; watermark: none)

Watermarks: the watermark fragment in the second state has not been found in other prints.

SELECTED LITERATURE: Berlin 1970, no. 14; *Corpus* II, no. A66; Giltaij 1988, no. 13; Berlin-Amsterdam-London 1991–2, pp. 26–8, no. 2; White 1999, p. 18 and p. 263, n. 47.

Joseph was the son of Jacob and Rachel, the story of whose life was regarded as prefiguring that of Christ. The seventeen-year-old's interpretation of his own dream, in which his brothers' sheaves of corn bowed down to his own sheaf, increased his unpopularity among them (Genesis 37). When he again dreamt that 'the sun and moon and eleven stars made obeisance to me' – the dream being interpreted here – they finally decided to do away with him.

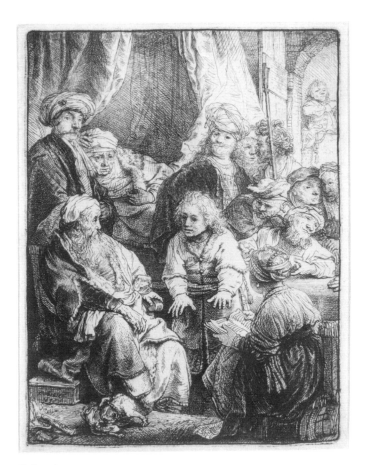

II London

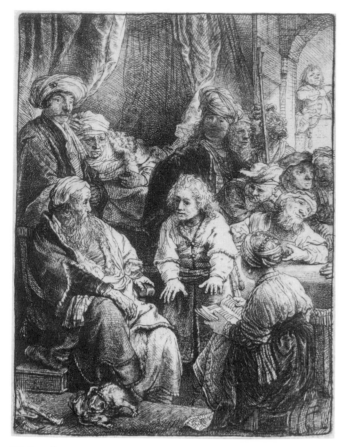

III London

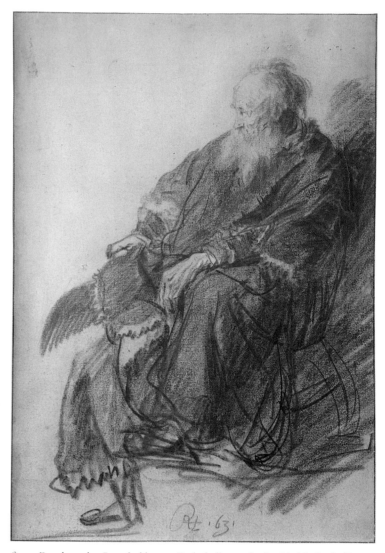

fig. a Rembrandt, *Seated old man*. Red chalk touched with black chalk on paper prepared pale yellow, 233 × 160 mm. Private collection (Benesch 20)

The genesis of the etching is unusual. In 1631 Rembrandt drew in red chalk a *Seated old man* (fig. a).[1] This belongs to a group of independent studies of elderly men that do not appear to have been made with any particular painting or print in mind. While making the drawing, he lowered the position of the subject's right leg, leaving part of the first version hanging in the air. Two to three years later, the figure was adapted with minor alterations in detail (and giving the impression of a higher viewpoint) as Jacob in Rembrandt's *grisaille* of *Joseph telling his dreams* (fig. b).[2] This anticipates the present etching in several respects, but on a much larger scale. Joseph and Jacob face each other in profile, dividing the composition into two distinct halves.

The *grisaille*, like that of *Christ before Pilate* (see cat. 24, fig. a), may have been intended as the model for a reproductive engraving, but it was never executed.[3] But in 1638, Rembrandt himself made the present etching in which he reconfigured the composition, placing Joseph in the centre of a circle of figures. The moment of alteration is documented by a drawing of the same year, one of the slightest to have survived from his hand (fig. c).[4] In red chalk he schematically roughed out the five fore-ground figures much as they appear, in reverse, in the print: Joseph is turned towards the spectator, holding his hands at waist level, Jacob remains on the right, while a new protagonist is introduced in the left foreground, seen from behind and turned towards Joseph. Beyond to the left Rembrandt repeated the man leaning on a table from the *grisaille* version.

The seated figure on the left of the rough sketch (fig. c), and the oriental standing immediately behind Joseph, were both studied in another drawing, executed in iron-gall ink (fig. d), one of a number in this medium that relate to works of 1638–9.[5] While the woman was used in the print without any significant change, the oriental's nearer arm was raised to form a 'backcloth' for Joseph's head. In recasting the design Rembrandt added a vista through an arch to a man (rending his clothes?) in another room, and the sleeping dog, first seen in the foreground of the *grisaille*, now cleans itself.[6] (see cat. 37, fig. e)

The drawings and sketches reveal that Rembrandt had pondered the subject for five years before publishing the etching in 1638. The resulting print was not radically altered in the three

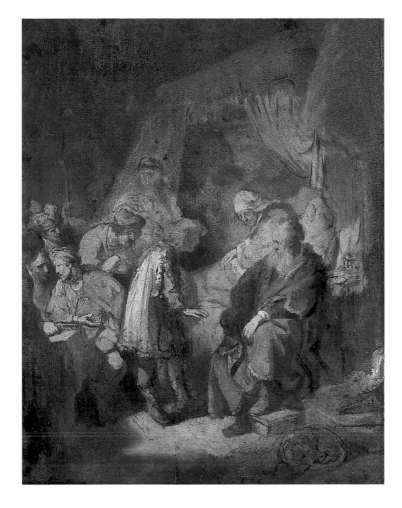

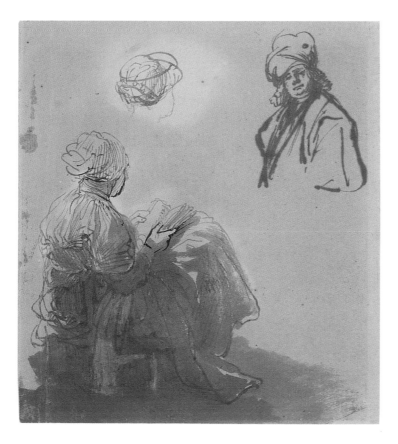

(*above left*) fig. b Rembrandt, *Joseph telling his dreams*. Grisaille on paper stuck on card, 558 × 387 mm. Amsterdam, Rijksmuseum (exh.)

(*above*) fig. c Rembrandt, *Joseph telling his dreams*. Red chalk, 180 × 125 mm. Rotterdam, Museum Boijmans Van Beuningen (Benesch 161 *verso*; exh.)

(*left*) fig. d Rembrandt, *Studies of a woman reading and an oriental*. Pen and brown ink with brown wash, touched with white, on paper prepared in brown, 139 × 125 mm. Private collection (exh. Amsterdam)

states: the second eliminates some hatching between the foreground woman's cheek and Joseph's arm; in the third, probably of c.1640,[7] shading was added to the foreground (including Joseph's legs) as well as to the figures behind Joseph, so that the latter stands out even more prominently. Yet Rembrandt's iconography is characteristically unusual in that it includes women in a subject normally described as an all-male event: the one in the foreground studied in the drawing, and another, bedridden woman in the background.[8]

The copper plate is in an American private collection.[9]

MRK

1 Benesch 20; Berlin-Amsterdam-London 1991–2, pp. 26–8, no. 2.

2 *Corpus* II, no. A66, where dated to 1633. The work is signed and dated, but the last digit is unclear. Schatborn, in Berlin-Amsterdam-London 1991–2, p. 28, argues that the drawing may have been retouched by Rembrandt before being incorporated into the composition, and perhaps again before the etching was made.

3 As argued by *Corpus* II, no. A66. In the present catalogue Van de Wetering argues that the *grisailles* formed part of a planned series (see pp. 36–63).

4 The drawing was discovered on the *verso* of Benesch 161, a drawing of *Ruth and Naomi* executed in iron-gall ink and published by Giltaij, *loc. cit.* (see further n. 5).

5 The other datable iron-gall ink drawings include the *recto* of Benesch 161 (of which fig. c is the *verso*), the study for the 1639 painting of *Maria Trip* (Benesch 442), that for the 1639 etching *The Artist drawing from a model* Benesch 423, both in the British Museum, and the dated sketch of 1639 after Raphael's *Portrait of Castiglione* in Vienna (Benesch 451; see cat. 34, fig. b).

6 The drawing of a *Sleeping dog* in Boston (Benesch 455; here cat. 37, fig. c) has been related to the *grisaille* but is certainly later, of *c.*1638–9 (and in iron-gall ink – see previous note).

7 Datable through the Basilisk watermark on the Amsterdam impression (Ash & Fletcher 12, A´.a.).

8 Attempts have been made to identify the elderly woman in bed as Rachel, Joseph's mother, or as Leah, Jacob's first wife (for a summary see *Corpus*, II, p. 296, where the foreground woman is connected with Dinah, Jacob's only daughter).

9 Hinterding 1993–4, pp. 42–3.

32

The death of the Virgin 1639

Etching and drypoint, 409 × 315 mm; signed and dated lower left: *Rembrandt f. 1639.*

Hind 161; White & Boon 99 I (of III)

I Amsterdam★ (Van Leyden, RP-P-OB-23; watermark: Strasbourg lily [Ash & Fletcher 36, K.a.])

I London (Cracherode 1973.U.898; watermark: Strasbourg lily [Ash & Fletcher 36, K.a.])

Watermarks: the Strasbourg lily found here occurs in all the documented impressions of the first state, but not in the second state nor in any other print.

SELECTED LITERATURE: Brom 1926, pp. 112–16; Graffon 1950, pp. 70–75; Campbell 1980, pp. 2–33; Berlin-Amsterdam-London 1991–2, pp. 203–5, no. 14.

Rembrandt's print *oeuvre* contains several examples with what one might call a distinctly Roman Catholic theme, among them two representations of *St Jerome* (cats 59 and 72), a *St Francis in prayer* (cat. 85), the *Death of the Virgin* and the *Madonna in the clouds* (cat. 43). Yet the frequent assertion that Rembrandt produced these etchings for Catholic clients would appear questionable, certainly in the case of the *Death of the Virgin*. Rembrandt here took several highly idiosyncratic liberties with the traditional

iconography that his clientèle might well have taken amiss. On the other hand it is hard to imagine that he could have produced such a large, ambitious print, that required a considerable investment of time and material, solely for his own pleasure.

Since the late Middle Ages, the literary source most frequently consulted for images of the death of the Virgin Mary has been Jacobus de Voragine's *Golden Legend*.[1] It tells of an angel appearing to Mary to announce that her death is nigh. At Mary's request the apostles, who are preaching the Gospel in every corner of the known world, are miraculously transported to Mount Zion to attend her at her deathbed. It has sometimes been claimed that Rembrandt had no knowledge of the text of the *Golden Legend* and based his version entirely on visual sources. Yet his combination of two different moments from the story, the angel's appearance to Mary and the hour of her death, suggests that he was.[2]

Whatever the case may be, it is certain that Rembrandt derived inspiration from two earlier works of art: the *Death of the Virgin* by Albrecht Dürer, a woodcut from his series of the *Life of the Virgin*,[3] and a stained-glass window after a design by Dirck Pietersz. Crabeth.[4] Rembrandt owned an impression of the woodcut, while the window was available for his daily inspection in the Oude Kerk (Old Church) in Amsterdam. In his etching he studied Dürer through the lens of Crabeth, as it were: certain compositional elements, such as the placing of the canopy bed and the striking figure seen from the back who is studying Holy Scripture – possibly a personification of the Church – seem to have been borrowed directly from Crabeth. The print also

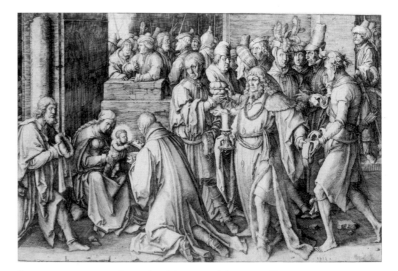

fig. a Lucas van Leyden, *The Adoration of the Magi.* Engraving. Amsterdam, Rijksmuseum

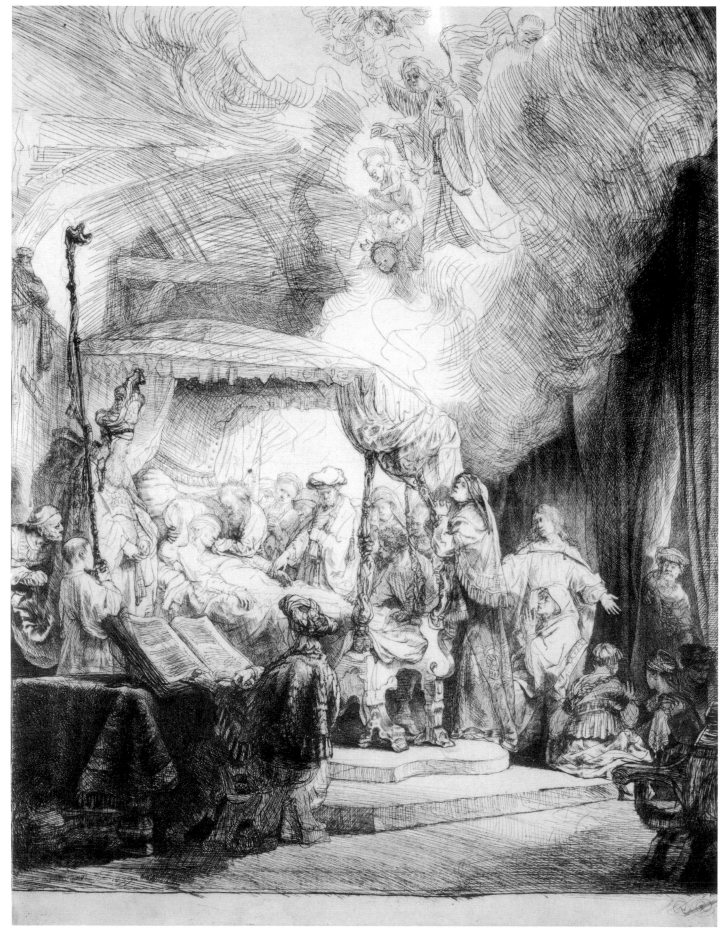

I Amsterdam

contains a quotation, as we often find in Rembrandt, from Lucas van Leyden, namely in the long-haired young man standing a little towards the back, who appears to have just entered. This figure, possibly representing St John the Evangelist, is very similar in appearance and gesture to the third of the wise men in Lucas's engraving, the *Adoration of the Magi* of 1513 (fig. a).[5]

Rembrandt departs from the *Golden Legend* account by having the Virgin surrounded not by the full complement of apostles but by a company consisting of both men and women. Pieter Bruegel the Elder had taken the same liberty almost a hundred years earlier.[6] In one detail Rembrandt's reading is unlike all previous ones: his Mary is no blissfully smiling, youthful apparition, but a sick old woman. The earnest-faced physician taking her pulse is likewise wholly original. Given the artist's highly personal interpretation of the subject, it is not surprising that the eighteenth-century French collector and author, Dezallier d'Argenville, believed that the print depicted the death of St Anne.[7]

The print exists in three states. In the second, Rembrandt elaborated the armchair in the right foreground in drypoint. In good impressions of the third state, thin, broken lines are visible in numerous parts of the shaded areas, a consequence of the fact that the plate was worked with a mezzotint rocker in the eighteenth century.[8] The Amsterdam collector Pieter de Haan still owned the copper plate in 1767: at his sale, 'The death of the Virgin, with 15 impressions' was purchased by the publisher and art dealer Fouquet for 30 guilders, but the plate does not appear to have been preserved.[9]

MS

1 Benz 1969, pp. 583–609.

2 Bartsch 93; Hollstein (German) 205.

3 Campbell 1980, pp. 4–5.

4 Crabeth's *vidimus* for the pane is in the Rijksprentenkabinet; Boon 1978, I, pp. 59–60, no. 161, II, repr. p. 69.

5 The New Hollstein, *Lucas van Leyden*, 37.

6 Van Bastelaer 1908, p. 43, no. 116.

7 Dezallier d'Argenville 1745, II, p. 28.

8 With thanks to Erik Hinterding and Ad Stijnman, ICN, Amsterdam.

9 Campbell 1980, pp. 10–12 and fig. 7, suggested that Rembrandt had set about depicting the *Death of the Virgin* once before, but abandoned the attempt early on, interpreting the overcast skies of the *Three trees* as including the apparition of the angel and parts of a curtain (see cat. 48, n. 7).

33

Death appearing to a wedded couple 1639

Etching and drypoint, 109 × 79 mm; signed lower left: *Rembrandt.f 1639*

Hind 165; White & Boon 109 (only state)

Amsterdam★ (Van Leyden RP-P-OB-191; watermark: none); London (Cracherode 1973.U.906; watermark: none)

SELECTED LITERATURE: Paris 1969–70, no. 54; Vienna 1970–71, no. 114.

The transience of life was a major theme for writers and artists in the sixteenth and seventeenth centuries, and in the lives of medieval men and women, too, death and mortality were a tangible presence. To illustrate the inevitability of death, the Middle Ages had developed the *danse macabre*, a succession of scenes in which people from all walks of life and of every age are taken unawares by Death and enjoined to follow him.[1] The scenes decorated public buildings and the façades of houses. In 1611 a *danse macabre* was painted on the inside walls of a covered wooden footbridge in Lucerne, giving everyone who crossed the water a chilling brush with death.[2]

The *danse macabre* was especially popular in German-speaking territories, but thanks to the new scope afforded by printmaking it spread and was widely emulated. The superb series of woodcuts after drawings by Hans Holbein the Younger, in particular, was a standard feature of print collections and libraries.[3] The enormous creativity of Holbein's designs attracted the attention of other artists. Rubens made drawings after the woodcuts as part of his training, and Rembrandt, who collected Holbein's prints, took inspiration from them when making his image of *Death appearing to a wedded couple*.[4] He dressed the figures in old-fashioned clothes that recalled Holbein's world, and the almost playful yet poignant atmosphere is also akin to his model. Rembrandt appears to have based himself particularly on the woodcut entitled *Die Edelfrau* (the noblewoman), in which a couple, their hands entwined with similar grace, march behind drumming Death (fig. a).

The etching, which was executed largely in drypoint, is extremely light in tone and lacking in contrast, even in the few good impressions that exist. The drawing is so loose that many details are hard to identify. Is Death swathed in bandages? And what is the framed object on top of the tomb? It most resembles a mirror, that, while not out of place in this context, is a peculiar attribute for a grave. This framed space is surprisingly empty; perhaps Rembrandt had intended to add a caption.

The skeleton with its hourglass and scythe emerges from

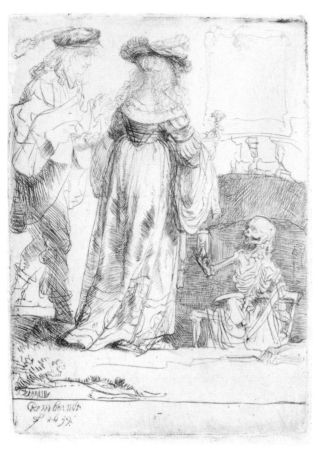

Amsterdam

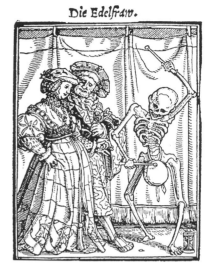

fig. a
Hans Holbein the Younger,
Die Edelfrau, 1538.
Woodcut, 65 × 49 mm.
Amsterdam, Rijksmuseum

fig. b
Hans Holbein the Younger,
Gebeyn aller Menschen, 1538.
Woodcut, 66 × 49 mm.
Amsterdam, Rijksmuseum

a grave with its bent stick-legs and hails the mortals. This is an original addition, although a woodcut in Holbein's *danse macabre*, entitled *Gebeyn aller Menschen*, depicts him in roughly the same manner, sounding a trumpet (fig. b). This may have planted the idea in Rembrandt's mind. Death usually conceals his presence from the protagonists, remaining visible only to the viewer. This applies especially to images of young couples and Death that represent them independently from the *danse macabre*.[5] Thus Death stands behind a tree with his hourglass in an engraving by Albrecht Dürer, poised to confound the young lovers.[6]

Rembrandt may have worked directly on the plate, apparently without a detailed preliminary drawing, although he would doubtless have used existing studies. The profile of the man with a gigantic feather piercing his beret corresponds to a quite distinctive head in a sheet of studies he produced in the mid-1630s: the two men have identical hairstyles, a pointed chin and a nose that is virtually an extension of the forehead (fig. c).[7] So different is this nose from Rembrandt's own, oversized one that the print cannot possibly be a self-portrait, as was once suggested.[8] That Saskia may have been the model for the young woman is

fig. c Rembrandt,
Study of a head,
detail from a model
sheet.
Pen and brown ink.
Birmingham,
Barber Institute
of Fine Arts
(Benesch 340)

fig. d Rembrandt, *Saskia in sumptuous dress*, between 1634 and 1642. Panel, 995 × 788 mm. Kassel, Gemäldegalerie

fig. e Gillis van Breen after Karel van Mander, *Allegory of the brevity of human life*, c.1599. Engraving, 193 × 126 mm. Vienna, Graphische Sammlung Albertina

quite possible. She was decked out equally sumptuously in a painting by the artist, the most important difference being that her hair was there more tightly combed (fig. d). In the painting, as in the etching, she has a flower in her hand, entirely in line with the iconography of the brevity of human life (fig. e).[9]

GL

1 For the *danse macabre*, see e.g. Wentzlaff-Eggebert 1975 and Hoffman 1990.

2 The Spreuerbrücke displaying these paintings perished in a fire several years ago; they are reproduced in Hilber 1937. See also Meadow 1992.

3 Hoffman 1990.

4 For Rubens' copies, see Van Regteren Altena 1977; they have since been acquired by the Stedelijk Prentenkabinet in Antwerp, see Antwerp 2000. The 1656 inventory of Rembrandt's property lists 'Een papiere kas vol printen van Hubse Marten, Holbeen, Hans Broesmer en Isarel van Ments' (i.e. Martin Schongauer, Hans Holbein, Hans Brosamer and Israel von Meckenem); see Strauss & Van der Meulen 1979, 1656/12, no. 237.

5 Michigan 1975–6.

6 For Dürer's engraving (B.94), see Panofsky 1955, p. 69 and Meadow 1992.

7 For this drawing, see Peter Schatborn, in Berlin-Amsterdam-London 1991–2, pp. 44–5, no. 8.

8 Rovinski 1890, under no. 109.

9 The New Hollstein, *Karel van Mander*, 94.

34

Self-portrait leaning on a stone sill 1639

Etching, 205 × 164 mm; signed and dated, top left: *Rembrandt f 1639*

Hind 168; White & Boon 21 I and II (of II)

I London★ (1868-8-8-3177; touched in black chalk; ex. Aylesford [L.58]; watermark: Strasbourg lily with initials HP [Ash & Fletcher 36, initials HP.b.])

II Amsterdam★ (Van Leyden RP-P-OB-38; watermark: foolscap, with five-pointed collar [Ash & Fletcher 19, E.a.]); London (Slade 1868-8-22-656; watermark: none)

Watermarks: the Strasbourg lily watermark appears in all impressions of the first state but not in the second, nor in other prints. The foolscap watermark is the earliest of those found in the second state; those with a basilisk were, however, probably printed in the early 1640s. A countermark in this print suggests a date in the 1650s.

SELECTED LITERATURE: Boston-St Louis 1980-81; Chapman 1990, pp. 69–78; Berlin-Amsterdam-London 1991–2, pp. 200–202, no. 13; Melbourne-Canberra 1997–8, no. 103; London-The Hague 1999–2000, no. 53; White 1999, pp. 132–6.

In this, Rembrandt's most detailed etched self-portrait, he is dressed in Renaissance costume. He drew inspiration from Titian's painting, the so-called *Portrait of Ariosto*, which in Rembrandt's day was in the Amsterdam collection of Alfonso Lopez (fig. a). From this he derived the wall and the idea of a rich

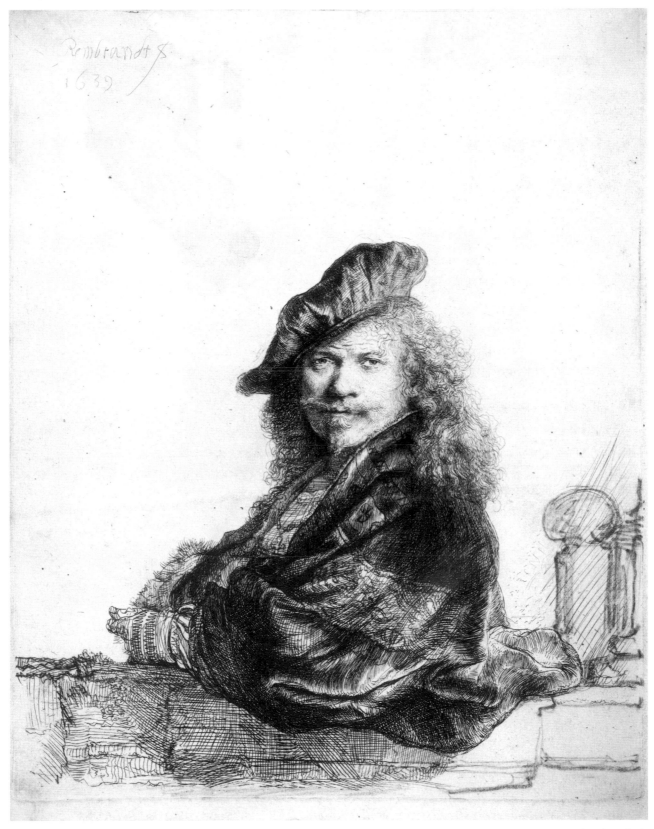

I London (touched)

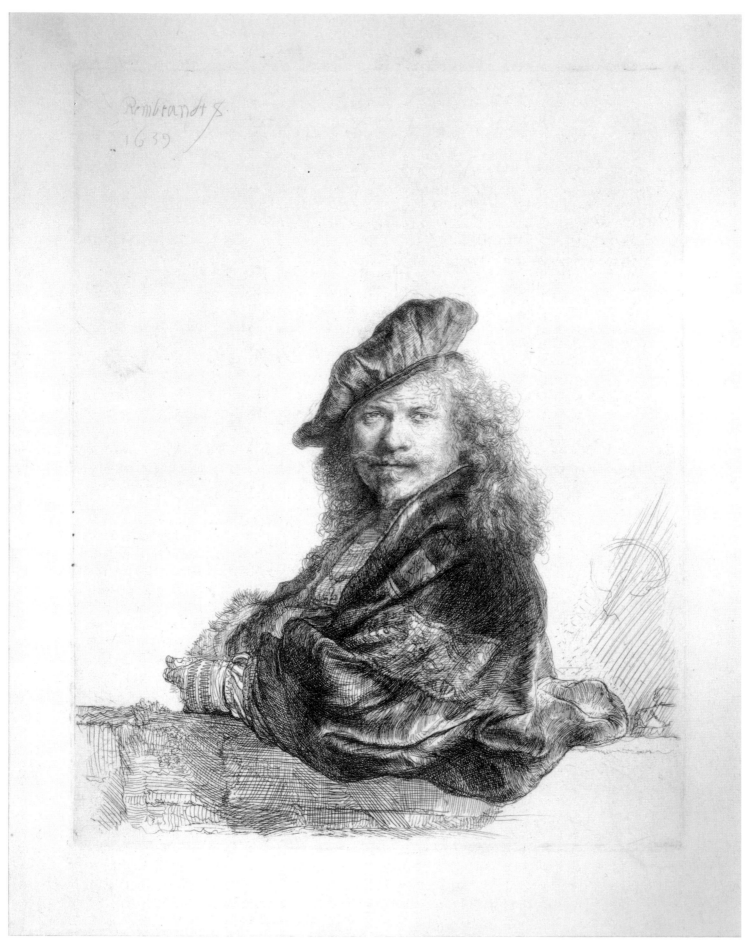

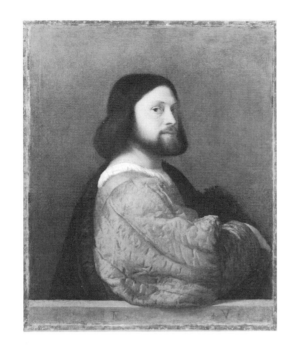

fig. a Titian,
Portrait of a man
('Ariosto').
Oil on canvas,
812 × 663 mm.
London,
National Gallery

sleeve, itself emblematic of the wealth and status of the wearer,[1] protruding towards the spectator. But in 1639 he also saw Raphael's portrait of *Baldassare Castiglione*, now in the Louvre, when it was auctioned in Amsterdam and purchased by Lopez for 3,500 guilders. This enormous sum was recorded by Rembrandt himself in a drawing (fig. b), a rapid sketch of the painting that alters, among other things, the angle of Castiglione's hat. The Raphael, seen through the lens of the drawing, provided Rembrandt with the angle of his beret and the upturned collar of his costume in the present etching, and the design was elaborated in a painted *Self-portrait* of the following year (fig. c). Noticeable in the latter is his shorter hair, which is lengthened in many of the fantasy self-portraits,[2] as well as many other alterations of detail.

The background of the print is left unclear. The moss-encrusted stone wall is unelaborated at the lower right, and the significance of the baluster-shape at the extreme right, which the artist seems to have cancelled, is uncertain. In several impressions, these areas were worked up in black chalk by Rembrandt himself, as in the British Museum's (somewhat stained) first state included here. Blocks of stone are picked out in the wall, and the baluster is reinstated. This latter motif occurs frequently in seventeenth-century portraits with a garden setting as an emblem of the sitter's aspiration to noble ideals and virtue.[3] In neither of the Italian paintings that inspired him, nor in his own painted *Self-portrait* of 1640 (fig. c), is an outdoor setting suggested, although the description of moss on the wall in the print could indicate that Rembrandt had such a background in mind.[4] He also retouched

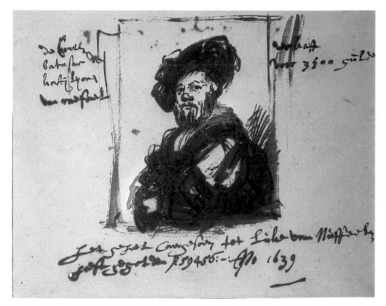

fig. b Rembrandt after Raphael, *Baldassare Castiglione*, 1639.
Pen and brown ink, touched with white, on paper prepared in brown,
163 × 207 mm. Vienna, Graphische Sammlung Albertina (Benesch 451)

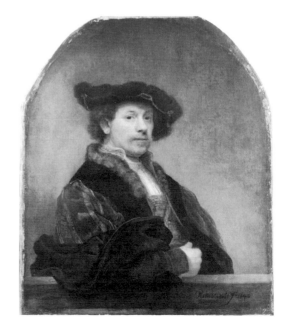

fig. c Rembrandt,
Self-portrait.
Oil on canvas,
930 × 800 mm.
London, National
Gallery

the beret in black chalk, as here, in several first state impressions, and in the second state he clarified the outline on the right and worked over the lower band.

Were it not for the historical anachronism, it would be tempting to describe the resulting portrait as Romantic. Rembrandt depicts himself fictionally, in the nostalgic garb of his Renaissance heroes – not just those from Italy, but with reminiscences of northern European self-portraits by artists such as Albrecht Dürer and Lucas van Leyden.[5] He rehearsed this approach several times in the 1630s, as in the etched *Self-portrait in a velvet cap with plume* of the previous year (B.20). Part of his intention was presumably to produce an image that was a worthy emulation and even improvement on its artistic ancestors, especially those in Lopez's collection that were widely known in Amsterdam.[6]

<div align="right">MRK</div>

1 Richly decorated sleeves in art (from Pollaiuolo to Rossetti) have been the subject of two separate articles (Duits 1997 and De Jongh 1997).

2 For the painting see *Corpus* III, no. A139. De Jongh 1969, believed that Rembrandt only sketched the Raphael after completing the etching, but this has not met with general agreement. For the hair *cf.* B.20 of 1638. Rembrandt introduces a suggestion of wildness by lengthening his hair, normally trimmed at the level of his ear. An exception is the long hair in the 1631 *Self-portrait in a soft hat and patterned cloak*, here cat. 13, and Rembrandt may then have worn his hair longer. In the present work, as in B.20, one senses that the hair was lengthened below the ear almost as an afterthought (as noted for the latter print by Dickey 1994, p. 164, n. 62).

3 De Jongh 1995. An impression in Melbourne (186e/1) is also touched in the hand. See Gregory & Zdanowicz 1988, no. 10, fig. 47, and Melbourne-Canberra, 1997–8, no. 103.

4 Schatborn, in London-The Hague 1999–2000, p. 172, believes that the lines to the left of the baluster may indicate leaves; and that the crumbling wall might be a *vanitas* symbol.

5 See De Winkel in London-The Hague 1999–2000, p. 68.

6 Welzel in Berlin-Amsterdam-London 1991–2, p. 202. In 1657 a painted self-portrait by Rembrandt was described as *Rembrandts contrefeytsel antycks* (Rembrandt likeness *à l'antique*), meaning in 'old' or 'historical' rather than 'antique' costume, as pointed out in *Corpus* III, p. 380.

35

Jan Uytenbogaert, 'The Goldweigher' 1639

Etching and drypoint, 250 × 204 mm; signed in the margin lower left: *Rembrandt f. 1639*

Hind 167; White & Boon 281 I and II (of II)

I Amsterdam★ (De Bruijn RP-P-1962-108; watermark: Strasbourg lily [Ash & Fletcher 36, C.d.])

II Amsterdam★ (De Bruijn RP-P-1962-109; watermark: Strasbourg bend [Ash & Fletcher 35, C.a.])

Watermarks: the Strasbourg lily in the first state is found in several other impressions of the same state, in early impressions of the second, and in a reprint of the fourth state of *Christ before Pilate* (cat. 24). It therefore has to be dated to 1639. The Strasbourg bend in the second state is also found in a good, strongly contrasted impression of the *Three trees* (cat. 48) of 1643, and this impression must have been printed at around that time or very shortly afterwards.

SELECTED LITERATURE: Mariette 1857, pp. 358–9; Seymour Haden 1877, p. 41; Benesch 1926, p. 7; Rifkin 1972, p. 124; Strauss 1984, pp. 24–35; Amsterdam 1986, pp. 35–6; Dickey 1994, pp. 239–52; Ackley 1995, pp. 25–7; White 1999, pp. 136–7.

The tax collector Johannes (Jan) Uytenbogaert (or Wtenbogaert; 1608–80), was a second cousin of the renowned Remonstrant preacher (cat. 26). He was probably a long-standing acquaintance of Rembrandt's. Born and raised in Amsterdam, he studied law in Leiden from 1626 to 1632. Rembrandt was also living and working in Leiden during this period, and it is quite conceivable that the initial contacts between them date from this time.[1] Upon completing his studies Uytenbogaert returned to Amsterdam, where in 1638 he succeeded his uncle Pieter Reael in the important post of 'Collector of national taxes'.

Uytenbogaert was very interested in art. He amassed a considerable collection, predominantly of drawings and prints, while his house in Amsterdam and his country estate Kommerrust near Naarden acted as a focus for painters and poets. If he did not already know Rembrandt from his Leiden days, he must have come across him through this activity. We know that in 1637 they were both present at the sale of the art dealer Jan Basse's estate, and that they bought a great many prints there. However, the first documentary evidence of a meeting dates from 1639, when Rembrandt bought a house in the Breestraat – now the Rembrandt House. In order to make the down payment on the house, Rembrandt was in urgent need of the money he was owed for two paintings in the Passion series commissioned by the Stadholder, Prince Frederik Hendrik of Orange (see cats 22–3). Payment was not forthcoming, however, and Uytenbogaert offered to intercede on Rembrandt's behalf. His intervention appears to have been effective,[2] and Rembrandt may well have etched this portrait as a mark of gratitude for his assistance; yet the fact that the copper plate was still in the possession of Uytenbogaert's descendants in 1760 might suggest that this was a commissioned work, so that the plate would have remained the sitter's own property.[3]

The tax collector is shown sitting at a table, with a book supported on a slope, below a set of scales. He hands a bag of money, which he has evidently just weighed and recorded, to a

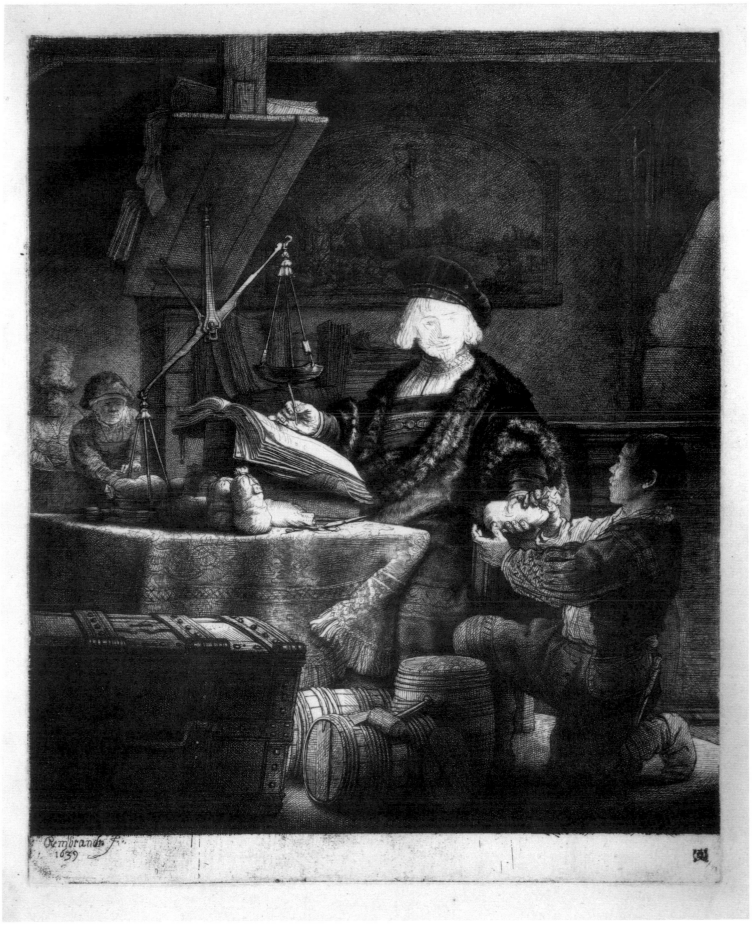

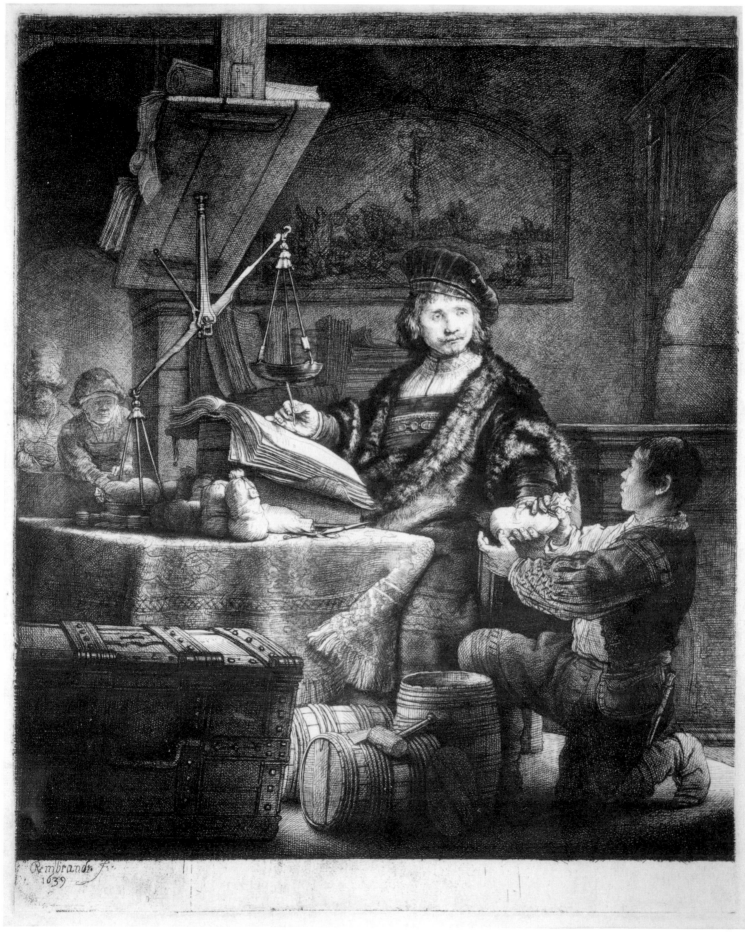

kneeling servant. In the doorway on the left stand a man and a woman, bringing further bags of money. The scene recalls sixteenth-century paintings of moneychangers and jewellers, such as those by Quinten Massys and Marinus van Reymerswaele, and this impression is reinforced by the sixteenth-century style of the sitter's costume. It is therefore not surprising that in the eighteenth century the print came to be known as '*The Goldweigher*'. It may well have been made in consultation with Uytenbogaert, who was a great admirer of the art of that period. Be that as it may, Rembrandt's approach provides a light-hearted commentary on the post of tax-collector to which Uytenbogaert had recently been appointed. The etching gave rise to several copies and variations by later artists, one of which, remarkably enough, confused Rembrandt with Adriaen van Ostade (fig. a).[4]

The meticulous way Rembrandt worked out the print is reminiscent of earlier etchings like the *Great Jewish bride* (cat. 25) and the portrait of the preacher *Johannes Uytenbogaert* (cat. 26), both of 1635. A new feature of this work, however, is the extensive use he made of drypoint – not, as before, to make the final corrections, but specifically to suggest the velvety quality of the fur coat. The two known states also reveal that the composition was built up in a manner that seems to be unique in Rembrandt's etchings: it was actually completed in the first state except for Uytenbogaert's face, which was left blank, as can be seen from the impression shown. Evidently Rembrandt did not have a likeness he could use. He used black chalk to draw in the face on a counterproof of the first state, possibly with the sitter in front of him (fig. b), after which he finished the print using the burin and drypoint, as seen in the second state, which is also included here.

EH

1 In 1626 Uytenbogaert lived in the household of the rector of the university in Leiden. The rector's wife, Machtelt Jans van der Pluym, was related to Rembrandt's family. See Dudok van Heel 1978, p. 169.

2 For further biographical details, see above all Dudok van Heel 1978, pp. 146–69.

3 See also cat. 57. For the copper plate, see Dudok van Heel 1978, p. 167. Soon after 1760 the plate was purchased and worked up by William Baillie. The plate was auctioned in New York in 1946 and is now in the Israel Museum in Jerusalem. See auction cat. Parke-Bernet Galleries Inc., New York, 4 April 1946, p. 70, no. 106, and Hinterding 1993–4, pp. 271–2.

4 The anonymous artist based his adaptation on the copy by Jan van der Bruggen after Rembrandt. See Strauss 1984, p. 30.

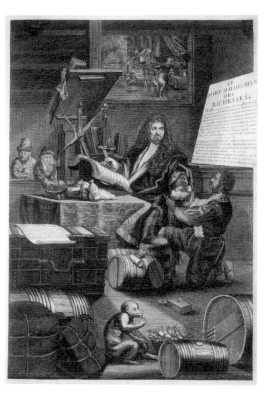

fig. a Anonymous, published by Pierre Landry, *Le sort malheureux des richesses*. Engraving, 713 × 487 mm. Amsterdam, Rijksmuseum

fig. b Rembrandt, *Joannes Vytenbogaert*, 'The Goldweigher', 1639. Counterproof, touched with black chalk. Baltimore, Baltimore Museum of Art; The Garret Collection (B.281 I)

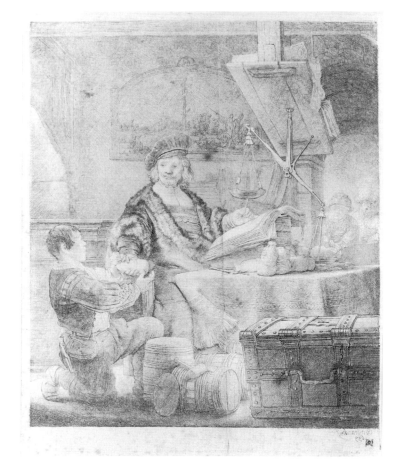

36

The artist drawing from the model c.1639

Etching, drypoint and burin, 232 × 184 mm

Hind 231; White & Boon 192 I and II (of II)

I London★ (1895-12-14-111, retouched with black chalk; watermark: none)

II Amsterdam (De Bruijn RP-P-1962-66; watermark: fragment of a Basel crozier★); London★ (Cracherode 1973.U.995; watermark: none)

Watermarks: this type of Basel Crozier watermark is not found in other prints and cannot be dated with precision. However, the high quality of the Amsterdam impression of the second state suggests that this is early.

SELECTED LITERATURE: Yver 1756, no. 184; Seymour Haden 1877, pp. 41–2; Saxl 1910, pp. 41–8; Hofstede de Groot 1912, pp. 70–74; Emmens 1979, pp. 220–29; Schatborn 1986, pp. 18–19; Chapman 1990, pp. 85–6; Berlin-Amsterdam-London 1991–2, pp. 206–8, no. 15; Royalton-Kisch 1992, no. 27; Royalton-Kisch 1993b, pp. 181–3; White 1999, pp. 180–82.

This unfinished print, which Rembrandt executed in around 1639, shows an artist seated on a chair, surrounded by his studio equipment. He is drawing a nude female model who stands on a platform holding a large palm leaf. There is a painting on an easel behind them, and a sculpted bust on the mantelpiece on the right. A shield, a sword, a quiver and a plumed beret hang on the wall on the left. Though all these details are clear enough, questions as

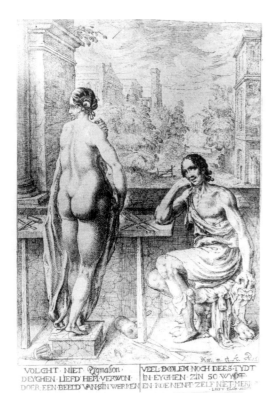

fig. a
Feddes van Harlingen, *Pygmalion*, 1615. Etching, 223 × 156 mm. (Photo: Warburg Institute)

to the meaning of the representation and why it was left unfinished have puzzled scholars through the years. In the eighteenth century the print was described simply as 'the half finished standing nude'; the traditional explanation for its incomplete state is that Rembrandt died before he managed to finish it.[1] In 1756, however, Yver noted in a supplement to Gersaint's catalogue that the etching was known in Holland as 'the statue of Pygmalion'. Pygmalion was a sculptor in ancient times, who fell in love with an ivory statue he had made. He asked Venus to bring the woman to life, and his wish was granted.[2]

As if to confirm the identification, Rembrandt's composition bears a striking resemblance to Feddes van Harlingen's portrayal of this subject of 1615 (fig. a). The name of Pygmalion continued to be associated with Rembrandt's etching from the late eighteenth century on, even though it was recognized that it showed the artist drawing from a model rather than an enamoured sculptor. Today it is generally assumed to be an allegorical motif, a homage to the art of drawing and designing.

The copper plate has survived, proving that the composition was never completed (cat. b). It has been suggested that Rembrandt deliberately left it unfinished as a means of illustrating his technique, and that it was especially intended for the instruction of his pupils.[3] However, the watermarks and the process by which it came into being argue against this hypothesis. In the rare first state shown here, Rembrandt merely sketched the scene in drypoint, and started to work on the darkest sections first, rather as he had done in the *Angel appearing to the shepherds* (cat. 21). He was evidently undecided about the length of the model's legs, as he rendered her ankles twice. In the second state, also shown here, he defined her position more clearly by placing her on a small bench, but he also made a number of further changes. The background is darker, and there are new lines on the upper section of the easel. Rembrandt also erased the linen press which stood between the artist and the model in the first state.

At this point Rembrandt made a drawing, presumably after a counterproof of the second state, to prepare for the next stage of the project (fig. c).[4] In this study the scene is completed. We see the nude standing on a platform, and both her position and the length of her legs are rendered with far greater precision than in the etching. Rembrandt also dispensed with some of the studio equipment.

The question as to why Rembrandt failed to complete the plate remains unanswered. Though it is true that the composition was not yet perfect, its shortcomings were not such as to warrant his

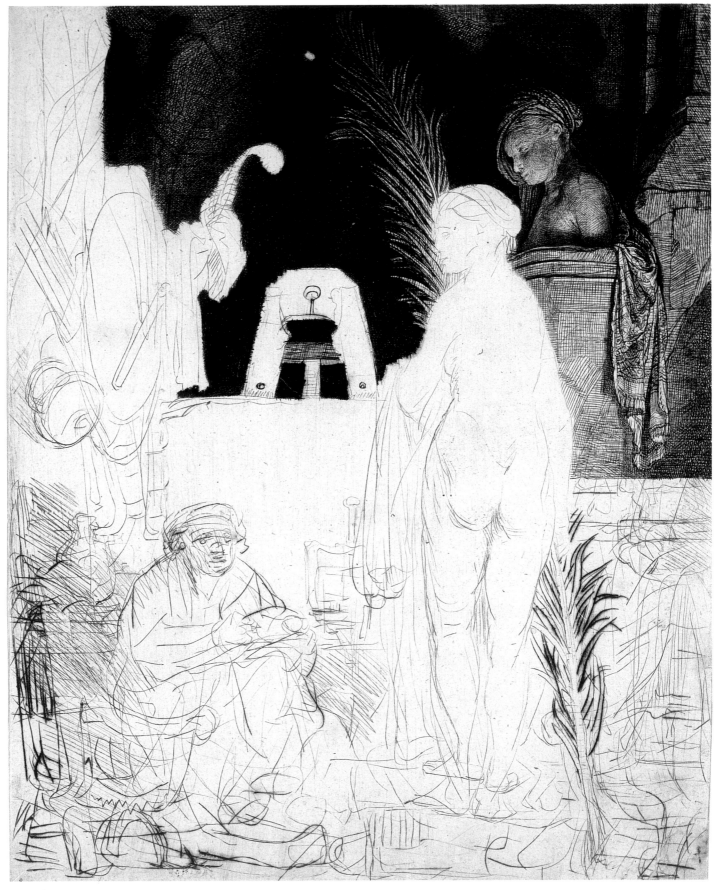

I London

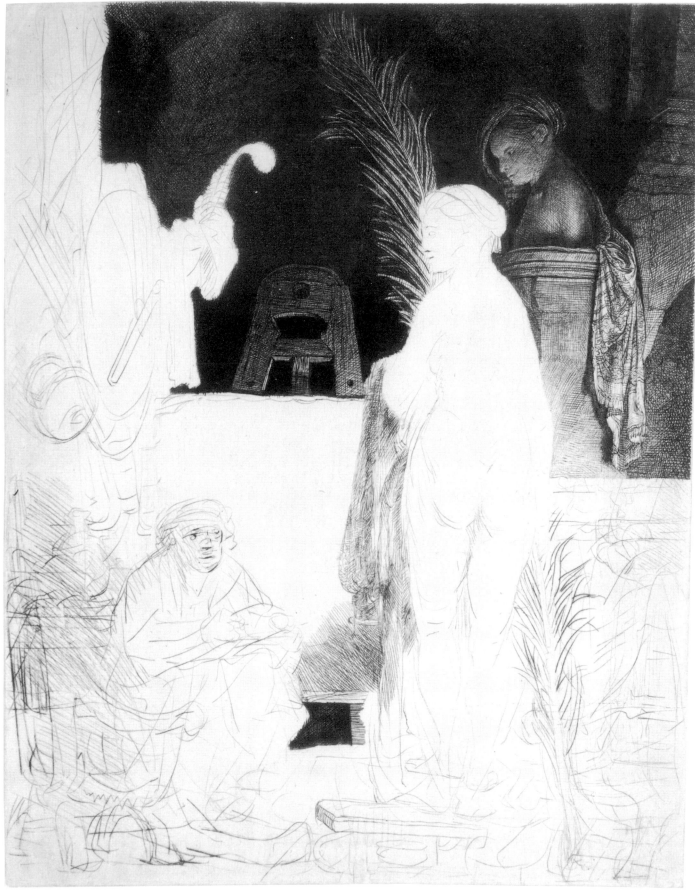

II London

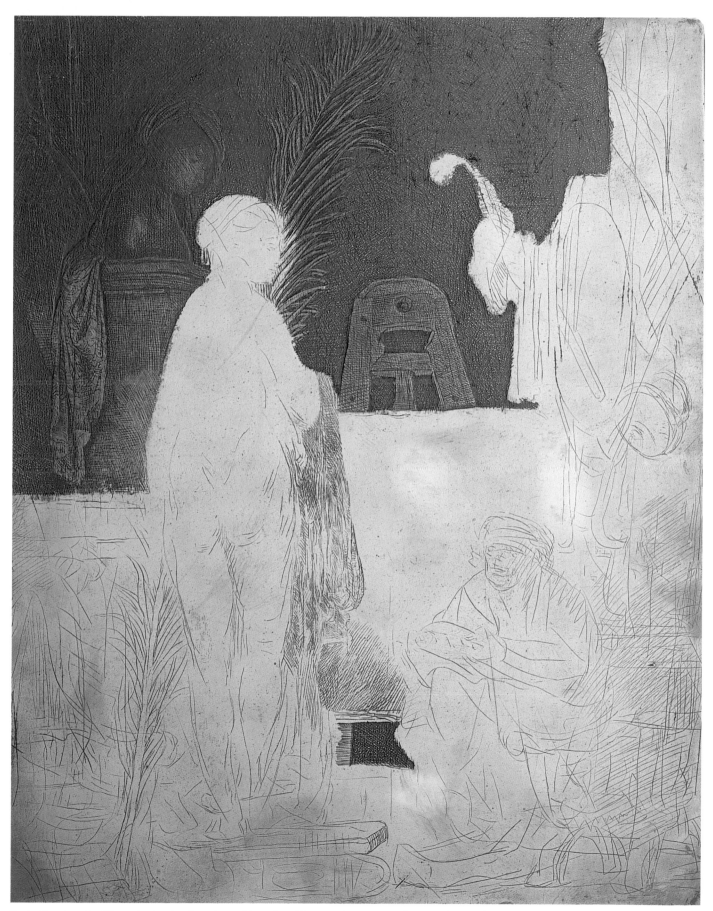

fig. b Rembrandt, *The artist drawing from the model*, c.1639. Copper plate, 235 × 185 mm. Amsterdam, Museum het Rembrandthuis (exh.)

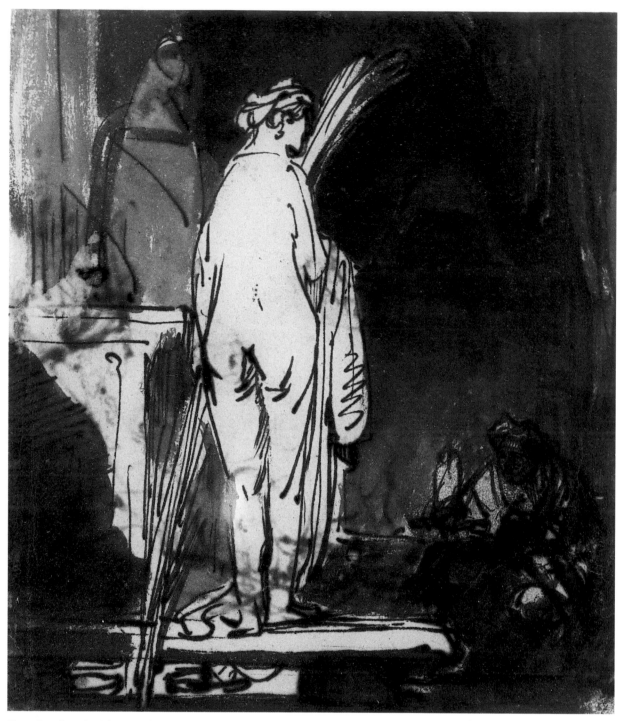

fig. c Rembrandt, *The artist drawing from the model*, c.1639. Pen and brown iron-gall ink, on paper washed brown, 188 × 164 mm. London, British Museum (Benesch 423; exh.)

abandoning the plate as a failure. Yet this seems to be what happened. The second state was printed several times around 1640 on paper with a Basilisk watermark, but thereafter the plate was apparently left to gather dust for over a decade.[5] New impressions were made around 1652 on paper with a fleur-de-lis watermark;[6] most of these still look remarkably fresh, with the drypoint burr still clearly visible.

EH

1 See Van Gelder & Van Gelder-Schrijver 1938, p. 12; Gersaint 1751, no. 184; sale catalogue Amadé de Burgy, Amsterdam, 16 June 1755, no. 363.

2 Ovid, X, pp. 231–2.

3 Emmens 1979, pp. 220–29.

4 Royalton-Kisch 1992, no. 27.

5 Ash & Fletcher 12, A´.a.

6 Ash & Fletcher 36, E´.a.

37

Sleeping dog c.1640

Etching and drypoint, 64 × 105 mm (first state); 47 × 90 mm (second state); 39 × 81 mm (third state)

Hind 174; White & Boon 158 I, II and III (of III)

I London★ (1842-8-6-144; watermark: Basel crozier★)

II London★ (Cracherode 1973.U.919; watermark: none)

III Amsterdam★ (Van Leyden RP-P-OB-240; watermark: none)

Watermarks: the watermark in the impression of the first state in London has not been found to date in other prints by Rembrandt.

SELECTED LITERATURE: Paris 1969–70, no. 51; Vienna 1970–71, no. 125; White 1999, p. 179.

The visual arts are teeming with dogs, and prints are no exception. Although often a mere element of staffage in a narrative scene, as mundane a creature as a dog could still catch a connoisseur's eye. The Italian artist and biographer Giorgio Vasari wrote of the engraving *St Eustace* by Albrecht Dürer, 'this print is miraculous, most of all for the beauty of several dogs in a variety

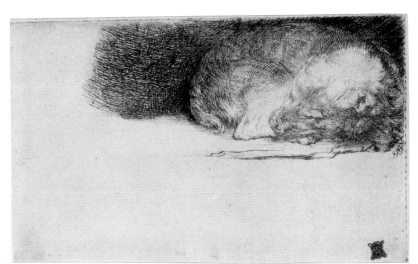

I London

II London

III Amsterdam

of poses, which could not possibly be finer'.[1] Others too were struck by this superior quality, and in the course of the sixteenth century Dürer's dogs were singled out for copying in two engravings.[2]

These prints have the appearance of model sheets, many of which existed in the sixteenth century, made for the use of artists and craftsmen. Dogs had served as separate motifs since the fifteenth century, when the Master of the Amsterdam Cabinet made a drypoint of a *Dog scratching*.[3] Later on, Agostino Carracci (fig. a) and Hendrick Goltzius gave dogs a place in their print oeuvre.[4] The latter had understood that sleeping animals can lie obligingly still, and made several drawn studies after a dog both dozing and awakening, a pointer from his own household (fig. b).[5]

In about 1640 Rembrandt chose exactly the same position but a more oblique viewpoint for his small etching of a dog. Scarcely using contours at all, he depicted the curled-up creature with short lines and strokes in different directions. The three-dimensionality is enhanced by the artist's use of the white of the paper in the legs and head and by the pitch-darkness around the dog in the upper right corner, conveyed using drypoint. The elongated shape in the foreground is probably a tether.

Rembrandt's print is related to a drawing executed in pen and dark brown ink in which he added washes over and around the dog's body (fig. c). It shows the animal chained in a type of kennel with an open upper hatch. Rembrandt omitted the cramped shelter in his etching, using the corner of the image as a

fig. b Hendrick Goltzius, *Sleeping dog*. Metalpoint on ivory-coloured prepared paper, 59 × 88 mm. Berlin, Staatliche Museen, Kupferstichkabinett

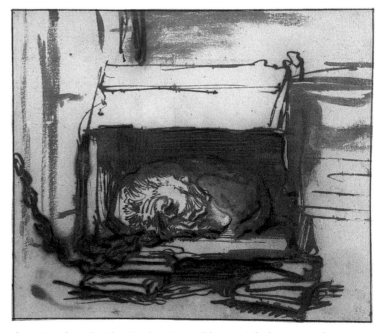

fig. c Rembrandt, *Sleeping dog*. Pen and brown ink, brown wash, 130 × 153 mm. Boston, Mass., Museum of Fine Arts (Benesch 455; exh.)

fig. a Agostino Carracci, *Dog*, c.1585. Engraving, 156 × 122 mm. London, British Museum

fig. d Rembrandt, *Joseph telling his dreams*, detail. *Grisaille* oil on paper. Amsterdam, Rijksmuseum

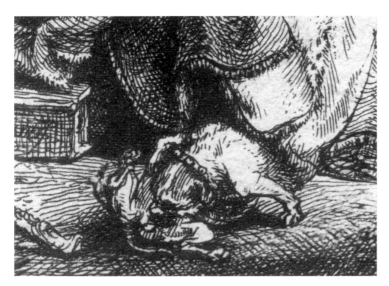

fig. e Rembrandt, *Joseph telling his dreams*, detail, enlarged. Etching. Amsterdam, Rijksmuseum (B.37)

boundary instead. This creates the impression, reinforced by the dark portions behind and to the left which resemble the drawing, that the animal is in a kennel or box.

Initially a few proofs were pulled from the copper plate, two-thirds of which was left blank. Then the plate was cut, which meant that the dog was confined within the pictorial plane, as was certainly intended. To enhance this effect, almost another centimetre was removed from the side and the top, after which an edition was printed. Given the delicacy of the etching, the edition must have been small, which is corroborated by the fact that few impressions are known.

Rembrandt had depicted a comparable dog before, among the staffage in his *grisaille* of *Joseph telling his dreams* (see cat. 31, fig. b); and he transferred the creature to the right foreground with a few brushstrokes (fig. d).[6] In the far smaller etching of the same subject made a year later (cat. 31), the dog nonchalantly cleans itself (fig. e).

GL

1 Vasari 1878–85, V, pp. 408–9: 'la quale carta è mirabile, e massimamente per la bellezza d'alcuni cani in varie attitudine, che non possono essere più belli.'

2 In Virgin Solis's workshop and by Johannes Wierix; see Nuremberg 1978, nos 80–81.

3 J. P. Filedt Kok in Amsterdam 1985, no. 78.

4 For Carracci's engraving (Bartsch 259) see DeGrazia Bohlin 1979, pp. 186–7, no. 95; for Goltzius, see G. Luijten in Amsterdam 1993–4, no. 51.

5 Reznicek 1961, no. 413.

6 See Van de Wetering 1997, pp. 72–3, and his essay in the present catalogue, pp. 47–8.

38

Sheet of studies with figures and Saskia in bed
c. 1639

Etching, 138 × 150 mm

Hind 163; White & Boon 369 (only state)

Amsterdam★ (Van Leyden RP-P-OB-773; watermark: none)

SELECTED LITERATURE: Boston-St Louis 1980–81, no. 106; White 1999, pp. 178–9.

The motifs on this sheet, which the viewer must turn by 90 degrees to see each individual figure properly, are a mixture of ageing ragged beggar types, three of which are executed on the same scale, and studies full of emotional intensity depicting a young woman in bed. There is no reason to think that Rembrandt had anything particular in mind with this anomalous juxtaposition; the etching belongs to a small group of printed model sheets (*cf.* cats 16 and 29). Also included in outline is the head of a man with a double chin and a curious hat; conveyed with only a few lines, it has the air of a portrait. Could this be the actor Willem Ruyter, who often sat for Rembrandt?[1]

It has already been noted that Rembrandt occasionally used his etching plates like a sketchbook, and some of his motifs from life occur almost identically in drawn and printed form. This applies to the bust of the old man at lower left, whom the artist also portrayed in a drawing, though slightly more in profile (fig. a), suggesting that he had both paper and a prepared copper plate to hand when the model stood before him. In both cases Rembrandt

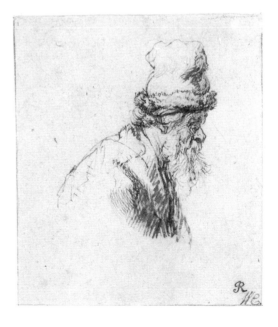

fig. a
Rembrandt,
*Bearded old man
wearing a high cap,*
*c.*1639.
Pen and brown
ink, 93 × 77 mm.
New York,
Pierpont Morgan
Library
(Benesch 331)

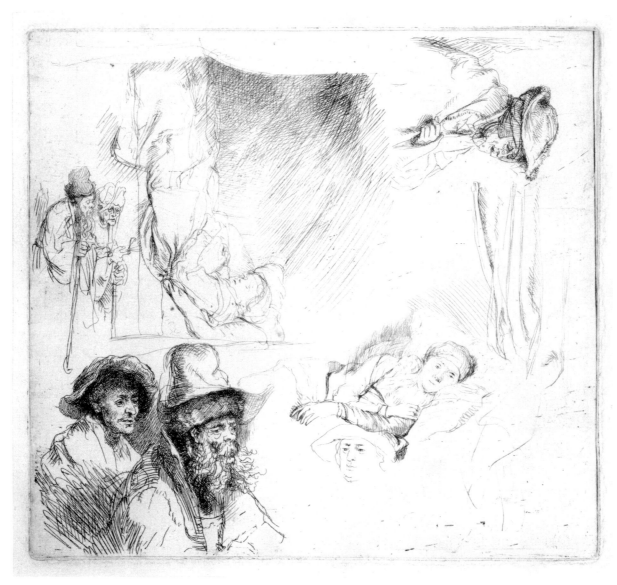

Amsterdam

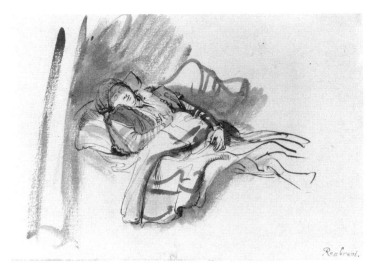

fig. b Rembrandt, *Saskia in bed*, *c*.1639. Pen and brown ink, brown wash, 137 × 203 mm. Oxford, Ashmolean Museum (Benesch 281A)

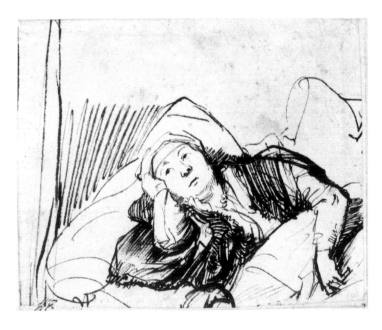

fig. c Rembrandt, *Saskia in bed*, *c*.1639. Pen and brown ink, 84 × 104 mm. London, British Museum (Benesch 286)

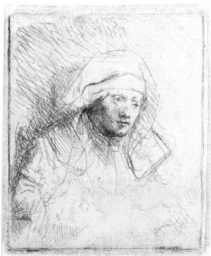

fig. d Rembrandt, *Sick woman (Saskia)*. Etching and drypoint, 61 × 51 mm. Amsterdam, Rijksmuseum (B.359)

emphasized the capricious shape of the beard with hairs sticking out from the contours.[2]

Several drawn examples exist of the bedridden woman, too, here depicted twice, once asleep and once staring listlessly before her (see figs b–c).[3] She is rightly identified as Rembrandt's wife Saskia, who had four confinements in her brief life (tuberculosis claimed her before the age of thirty) although the artist may also have depicted her in the final months of her life. She looks very weak in the etching, alternately asleep and sunk into the pillows with lacklustre eyes, but this does not necessarily imply that she is dying, despite past assumptions to this effect.[4]

The drawings have since been tentatively dated between 1635, when Rumbartus van Rijn was born, and 14 June 1642, the date of Saskia's death, but this allows perhaps an unduly generous margin. On stylistic grounds the drawings would appear to have originated in about 1639. If we adhere to the same date for the etching, it would be closer in time to the other printed model sheets. This would also help to explain the striking resemblance between the pose of the slumbering Saskia and the languishing Virgin Mary in the *Death of the Virgin* of 1639 (cat. 32).[5]

Rembrandt elected to show his wife in her surroundings. Thus in one case we see the mattress on which she lies and a little of the inside of her box bed, and in the other we see a turned-back curtain. Saskia's vacant gaze, suggesting ineluctable submission to her frail state of health, is conveyed more compellingly still in a small etching that shows her in close-up (fig. d). Rarely has a print been as personal and intimate as in this rendering of fragility.

GL

1 For Ruyter's physical features, see Schatborn & De Winkel 1996.

2 White 1999, p. 178, in which this comparison is drawn.

3 For the drawing in Oxford, see Ben Broos in Melbourne-Canberra 1997–8, no. 82; for the sheet in London, see Royalton-Kisch 1992, no. 19.

4 For images of Saskia in bed, see Peter Schatborn in Berlin-Amsterdam-London 1991–2, pp. 78–80 and 80, n. 3.

5 For this relationship, see Barbara Welzel in Berlin-Amsterdam-London 1991–2, p. 204.

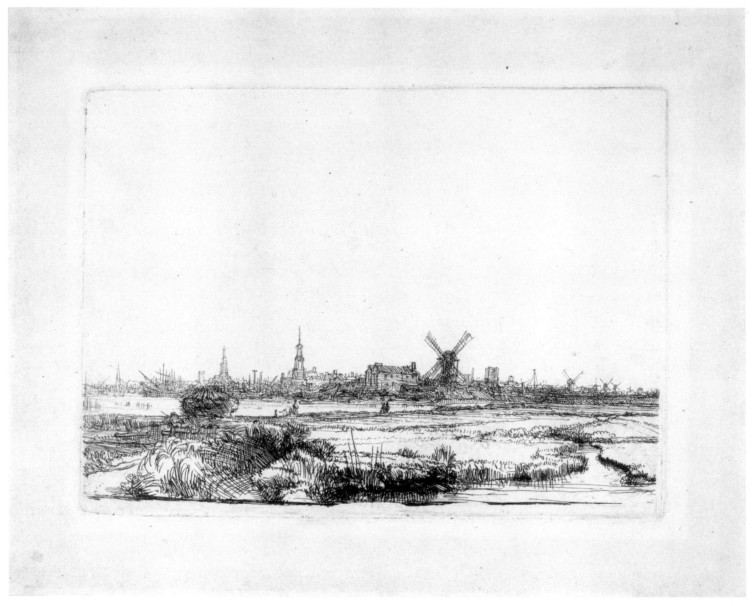

London

39

View of Amsterdam *c*.1641

Etching, 112 × 153 mm.

Hind 176; White & Boon 210 (only state)

Amsterdam (Van Leyden RP-P-OB-271; watermarks: none); London★ (Slade 1868-8-22-676; watermark: Strasbourg lily with initials LC [Ash & Fletcher 36, initials LC.a.])

Watermarks: although the London impression is good, the watermark indicates that it was printed in around 1645, and it also occurs in early impressions of *Cottages beside a canal* (B.228) and *Cottages and farm buildings with a man sketching* (B.219), both datable around that year.

SELECTED LITERATURE: Lugt 1920, pp. 131–3; Schneider 1990, no. 74; Amsterdam 1993, no. 33; Amsterdam 1998, pp. 210–12; White 1999, pp. 215–16.

The etching shows in reverse the profile of Amsterdam from the north east. Looking north west across the city, it depicts to the right the windmills on the walled fortifications, the largest and nearest of which stood on the outermost bulwark on the River IJ, the so-called 'Rijzenhoofd'. The stump of a tower to the right of this is roughly in the position of the Zuiderkerk (South Church), perhaps showing it before the completion of the spire.[1] To the left of the Rijzenhoofd, on Rapenburg Island, are the warehouses and

shipyards of the Dutch East India Company (the Verenigde Oostindische Compagnie), the Montelbaanstoren, the Oude Kerk (Old Church), perhaps also (as a stump) the Westerkerk (West Church) and in the far distance the Herring Packers Tower (Haringpakkerstoren). The representation is not painstakingly accurate and substitutes the formality of a precise topographical view with an atmospheric approach that embraces such details as the haphazard scrub in the foreground marshland. Rembrandt probably tinkered with the view as he drew on the plate, out of doors, seated on the Kadijk, the dyke that ran up the north-eastern edge of the city.[2]

The style is indistinguishable from that of the two horizontal etchings of 1641, the *Landscape with a cottage and large tree* and the *Landscape with a cottage and haybarn* (B.226 and B.225; cat. 40 and fig. a), both dated 1641.[3]

<div style="text-align: right">MRK</div>

1 As suggested in Amsterdam 1993, no. 33.

2 On Rembrandt executing plates out of doors, see the Introduction, pp. 74–5.

3 The etching has until now been dated *c*.1640, but the present writer produced a false 'panorama', joining the three prints together (the *View of Amsterdam* in the centre, with B.226 to the left and B.225 to the right), to prove this point in a lecture in 1992, and mentioned it to Theo Laurentius, who reported it with additional observations in Laurentius 1996, p. 84. The ensemble of prints works surprisingly convincingly as a single panorama. Laurentius suggests that the panorama was intentional, and that the *Windmill* (B.233) was an alternative, earlier idea for the position on the left of B.210.

40

Landscape with a cottage and large tree 1641

Etching, 127 × 320 mm; signed and dated towards lower right: *Rembrandt f 1641*

Hind 178; White & Boon 226 (only state; new state I of II, see n. 2 below)

Amsterdam★ (De Bruijn RP-P-1961-1125; ex. A. Sträter [L.787] and R. P. Goldschmidt [L.2926]; watermark: Strasbourg lily, type not in Ash & Fletcher★); London (Cracherode 1973.U.923; with Dighton's mark [L.727]; watermark: fragment of Strasbourg lily [Ash & Fletcher 36, D.b.])

Watermarks: the watermarks show that the London impression is not especially early, those from 1641 having either the type of Strasbourg lily found in the Amsterdam impression, or a Basilisk (Ash & Fletcher 12, A´.a.).

SELECTED LITERATURE: Schneider 1990, no. 5; White 1999, pp. 216–18.

This view of a picturesque, tumbledown cottage, like that of the companion plate, the *Landscape with a cottage and haybarn* (fig. a), is an imaginary distillation or *capriccio* of the countryside around Amsterdam.[1] However, a drawing in the Louvre of around 1639, of a *Cottage with a cart and road* (fig. b), which may well have been made out of doors, seems to have provided the starting-point for the left half of the composition.

Like its companion, and like the *Windmill* (cat. 41), the etching bears the date 1641, the earliest to be found on Rembrandt's landscape prints. Yet the plate is executed with supreme assurance. In a detailed image Rembrandt successfully suggests a rich variety of

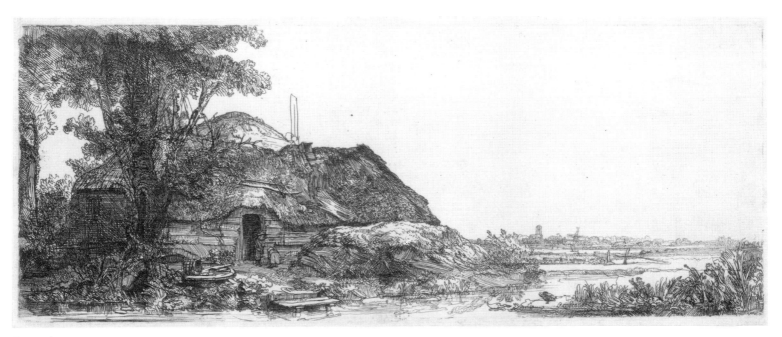

Amsterdam

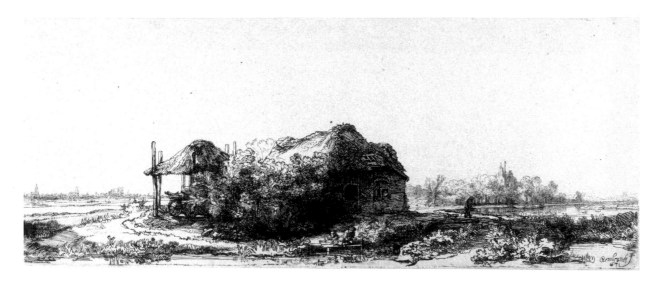

fig. a Rembrandt,
Landscape with a cottage and haybarn.
Etching, 1641,
129 × 321 mm.
London, British
Museum (B.225)

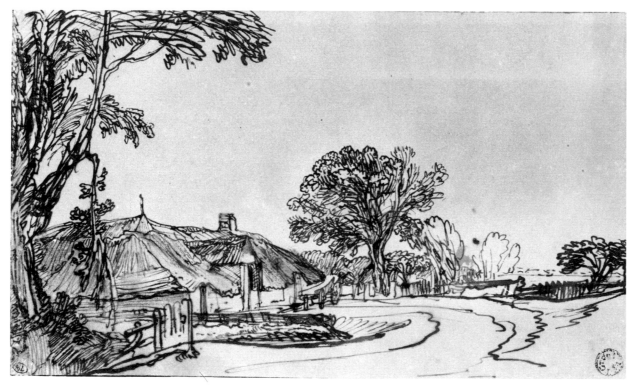

fig. b Rembrandt,
Cottages with a cart.
Pen and brown ink,
141 × 237 mm.
Paris, Musée du
Louvre (Benesch 797)

textures, including thatch, foliage and water, elaborating them to a high degree of finish. Particular subtlety has been derived from immersing the plate more than once in the acid to etch the lines more deeply in the foreground than the distance, where the forms dissolve in the atmosphere. Only by introducing drypoint were his later landscapes to develop radically from these first plates.[2]

Rembrandt's characteristic inclusion of incidental detail, for example the children by the door, the abandoned milk pail and yoke lying on the old cartwheel, and the disrepair of the thatch, have led to the suggestion that the plate has some allegorical meaning.[3] While the all-pervasive themes of *vanitas* that lie behind so many seventeenth-century images may well have informed Rembrandt's thinking, it is difficult to go further than this in analyzing his intentions. He was probably preoccupied above all by questions of representational skill and compositional harmony, the qualities that still attract interest in his work.

MRK

1 Six 1909, p. 96, noted that the view in B.225 unrealistically combined a view of Kostverloren with a profile of Amsterdam, although the city would have lain behind him.

2 A new state of the early 1650s, in which the present plate was enriched with a tonal technique akin to a sulphur tint, darkening the shadows in the tall tree to the left, was described by Schneider, *loc. cit.*, but is not present in Amsterdam or London. The earliest impressions do not have the tint.

3 Schneider, *loc. cit.*

41

The windmill 1641

Etching, 145 × 208 mm; signed and dated lower right: *Rembrandt f 1641*

Hind 179; White & Boon 233 (only state)

London★ (Slade 1868-8-22-687; watermark: none)

SELECTED LITERATURE: Schneider 1990, no. 4; Amsterdam 1998, pp. 194–5.

The print shows the so-called Little Stink Mill on the De Passeerde bulwark at the southern extremity of the wall that ran down the west side of Amsterdam. Looking back along the wall in a northerly direction, Rembrandt would have seen the windmill on his right (this is reversed in the printing process), with

cottages beyond it, all standing just within the earthen city wall that encloses the bulwark. In the distance two figures stand on the next bulwark to the north, where stood another, larger windmill, known as the Large Stink Mill. Both were tower mills owned by the Leathermakers' Guild and were active softening tanned leather by treating it with cod liver oil – hence the names attached to them.

The windmill is depicted in great detail. The tower mill type allowed the cap and sails to turn independently of the main body, a more efficient method of keeping the sails to the wind than the traditional post mill, the whole structure of which rotated. Rembrandt describes the wooden platform around the body of the windmill and the three long tailpoles attached to the cap. The latter converge near the wheel that helped to keep the mill turned

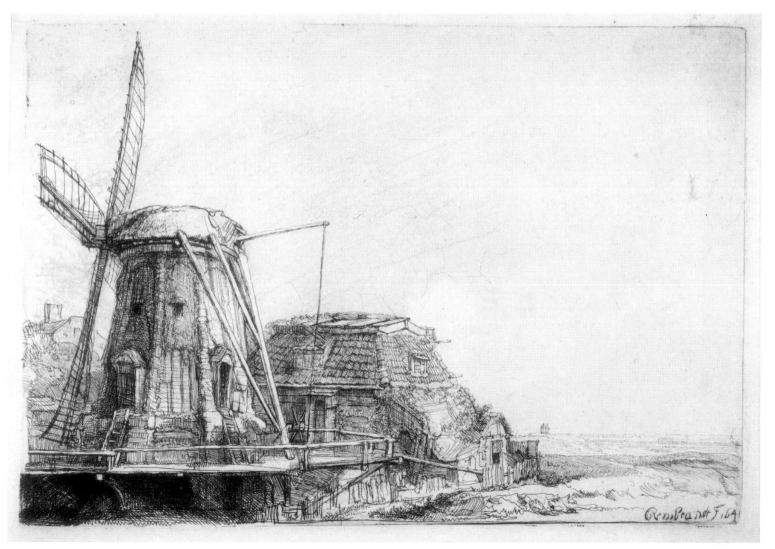

London

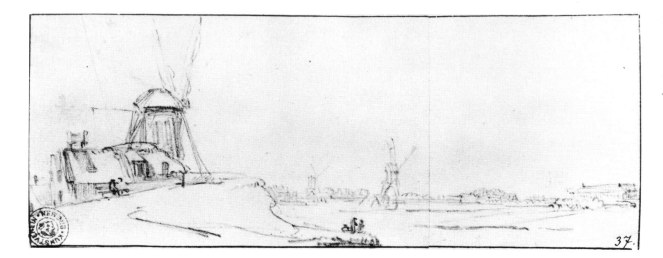

fig. a Rembrandt, *The Bulwark 'De Passeerde' with the 'Little Stink Mill'.* Black chalk on two joined sheets, 85 × 231 mm. Formerly Bremen, Kunsthalle (Benesch 810)

to the wind. The rope descending from the horizontal post behind the cap operated a brake on the mill's main axis. Below the cap, the main body of the structure would have been made of brick with a wooden cladding, into which the doors are set. These could be reached only by ladders, and Rembrandt has included a figure with a sack over his shoulder about to mount (or descending from) one of these. The sails of the mill are furled and in fact face away from the prevailing westerly winds.

The exceptionally detailed description suggests that Rembrandt worked on the plate on site. The nearby cottage is represented with equal exactitude. Rembrandt's *plein-air* drawings, including the drawing he made of the same windmill, but seen from the north (fig. a),[1] are normally far less precise, and would not have supplied sufficient visual information to produce the print.[2]

The etching needle seems to have been particularly thin, and the resulting line permits the introduction of more detail than appears in Rembrandt's later, more economically etched landscapes. Also noticeable in most impressions (though more strongly in early ones) is the layer of grey tone around the mill, and there is also some craquelure in the centre of the plate. The diagonal striations suggest that some acid may have been brushed directly on to the plate. The result is not entirely successful, and the process only rarely recurs in Rembrandt's work.[3]

The etching also prompts us to ask why he should choose to focus on a windmill and why, of all the mills in Amsterdam, Rembrandt chose to represent the Little Stink Mill, one of the least prepossessing and which stood almost as far from his home in the Breestraat as it was possible for him to travel without leaving the city? His choice of motif is certainly idiosyncratic, and perhaps the traditional view of Rembrandt as a rebel against ideal beauty is nearer the mark than is sometimes currently allowed.

MRK

1 As noted in Amsterdam 1998, pp. 191–2. The details of the topography and the mill are taken from this publication. As noted in the Introduction, there is no written record of artists etching out of doors in the seventeenth century.

2 It is argued that Rembrandt sometimes sketched from nature on to his etching plates in the Introduction, pp. 74–5.

3 An identical effect occurs in the failed, first plate of the *Descent from the cross* (cat. 22), which implies that it was not intentional. White & Boon suggest that the craquelure is due to the cracking of the etching ground, and that the tone could be the result of using a sulphur tint (an idea favoured by Schneider 1990, who thought it might be intended to evoke the wind), or to imperfect burnishing of the plate. A similar effect is also seen, for example, in the *Cottage beside a canal: view of Diemen* (B.228, identified as of Ouderkerk in Amsterdam 1998, p. 302).

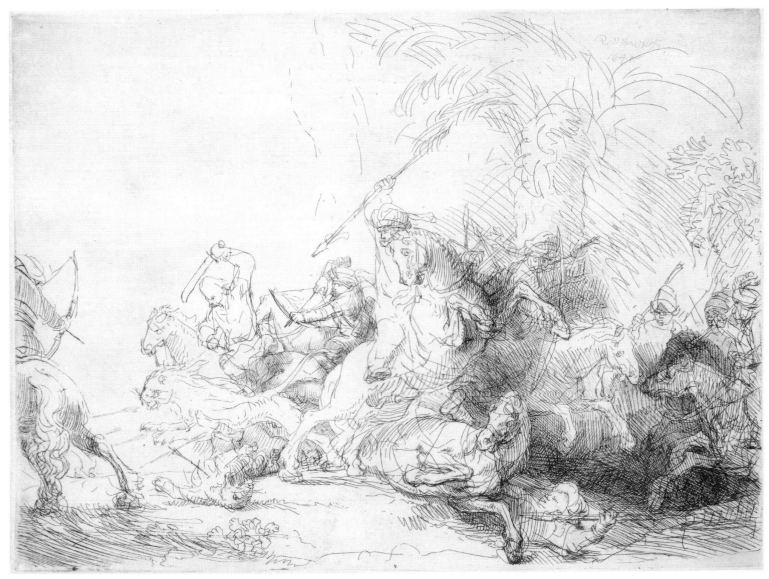

II Amsterdam

42

The large lion hunt 1641

Etching, drypoint and burin, 224 × 300 mm; signed and dated upper right (in drypoint): *Rembrandt f 1641*

Hind 181; White & Boon 114 II (of II)

II Amsterdam★ (Van Leyden RP-P-OB-200; watermark: none); London (1851-5-30-2; watermark: Basilisk [Ash & Fletcher 12, A´.a.])

Watermarks: the Basilisk seen here is particularly characteristic of early impressions of prints made around 1641, including the *Cottage with a haybarn* (cat. 40, fig. a) and the *Madonna in the clouds* (cat. 43).

SELECTED LITERATURE: Munich 1982, pp. 101–3.

It is a continuous source of amazement that Rembrandt should have despatched his unusually freely executed *Large lion hunt* into the world as a finished product, complete with signature and date. It is a large print for Rembrandt, making its sketch-like qualities even more conspicuous, and the artist must have been confident that there was a market for this type of *infinito*. Some connoisseurs and art lovers will certainly have appreciated the virtuosity displayed here: to render such a whirling spectacle on the plate in one fell swoop testifies to immense audacity and self-confidence.

Rembrandt's prime aim was to suggest swift movement and to depict the lion-hunters' strength and heroism. He showed blithe disregard for anatomical anomalies, as in the horses, the raised arm of the mounted swordsman or the foreshortened leg of the

spear-hurling central figure. Where is the body of the man who has crashed to the ground with his mount? Faces and horses' heads are rendered schematically. At the centre of the scene a horseman aims an arrow at the scrawny lion that speeds away, its tail flying aloft; another hunter plucks a fresh arrow from his quiver. It is impossible to ascertain who despatched the arrows in the left foreground that have missed their target and hover forever in the air. Precision was not the artist's goal; what mattered was evoking the spectacle.

Rembrandt had chosen the motif of the struggle between man and beast some ten years earlier, for two far smaller etched lion hunts (fig. a).[1] The comparison reveals the enormous strides he had made as a printmaker in the interim, above all technically. One of the earlier prints displays a rearing horse that bears a striking resemblance to the animal at the centre of the *Large lion hunt*. Rembrandt probably owned a cast of a small sculpture, such as those made by Adriaen de Vries, and used it as a model.[2] Objects of this kind were common in artists' circles, and Hercules Segers made an etching of one as an independent image (fig. b).[3]

fig. b
Hercules Segers,
Rearing horse.
Etching on grey
prepared linen,
105 × 75 mm.
Amsterdam,
Rijksmuseum

fig. c Antonio Tempesta, *Lion hunt*, 1624. Etching, 187 × 280 mm. Amsterdam, Rijksmuseum

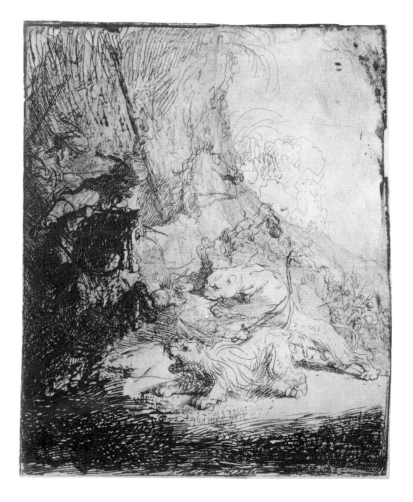

fig. a Rembrandt, *The small lion hunt*, c.1632. Etching, 154 × 121 mm. London, British Museum (B.115)

fig. d Johannes Collaert after Johannes Stradanus, *Deer hunt*. Engraving, 194 × 260 mm. Amsterdam, Rijksmuseum

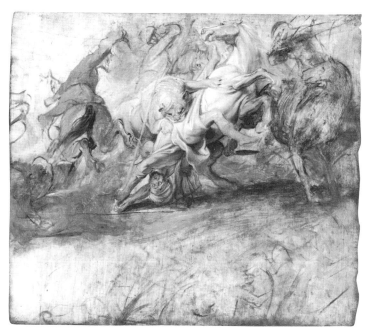

fig. e Peter Paul Rubens, *Lion hunt*. Oil sketch on panel, 44 × 50 cm. Munich, Alte Pinakothek

A rearing horse whose rider has tumbled into the jaws of a raging lion is also the central feature of the print from which Rembrandt took his inspiration for the *Large lion hunt*, an etching by Antonio Tempesta (fig. c).[4] We know that Rembrandt collected much of the Italian's substantial print *oeuvre* and used it more than once (see cats 1 and 20). The large palm tree echoes Tempesta's etching, and Rembrandt paraphrases other elements too. A shrewd addition was the mounted figure, cut off at the left edge, who forms a compositional counterpoint in the image, which has a strong dynamic thrust to the left. At first sight it looks like an invention typical of Rembrandt, but in fact he borrowed it from an engraving after Johannes Stradanus, the king of printed hunting-scenes (fig. d).[5]

Whatever else these masters may have had to offer, they had none of the light tone and sketch-like qualities that give Rembrandt's etching such unique appeal. These he would have encountered, up to a point, in images of an entirely different type by Italian etchers such as Guido Reni and his imitator Simone Cantarini. Rembrandt was once thought to have based himself on engravings of hunts after Rubens, but it was probably the Antwerp artist's oil-sketches that particularly fascinated him. The *Large lion hunt* is in fact the equivalent in print of a free sketch of this kind (fig. e).[6] It is above all this etching's bravura that is more akin to Rubens' masterful sketches than anything else, justifying the surmise that the painted 'lion fight by Rembrandt' listed in the 1656 inventory, which is no longer known, may have been an oil-sketch in Rubens' manner.[7]

Rembrandt left his print as a sketch – 'légèrement griffonné', as later French connoisseurs would say.[8] In the second state he merely darkened the horse on the right that is partly concealed behind another, which had initially displayed rather a ragged profile.

GL

1 One is reproduced here, the other is B.116; see Munich 1982, p. 102 and White 1999, p. 171.

2 Amsterdam-Stockholm-Los Angeles 1998–2000, no. 21.

3 Haverkamp Begemann 1973, no. 52.

4 Beets 1915, p. 2.

5 For the series from which this engraving derives, see Baroni Vannucci 1997, pp. 371–89, with illustrations. The print reproduced here is no. 37.

6 For the sketch reproduced, see K. Renger in Munich 1997–8.

7 Strauss & Van der Meulen 1979, 1656/12, no. 21: 'leeuwengevecht van Rembrand'.

8 De Claussin 1824, p. 78, no. 116.

9 The impression of the rare first state from the Fitzwilliam Museum in Cambridge is reproduced in White & Boon II, p. 109.

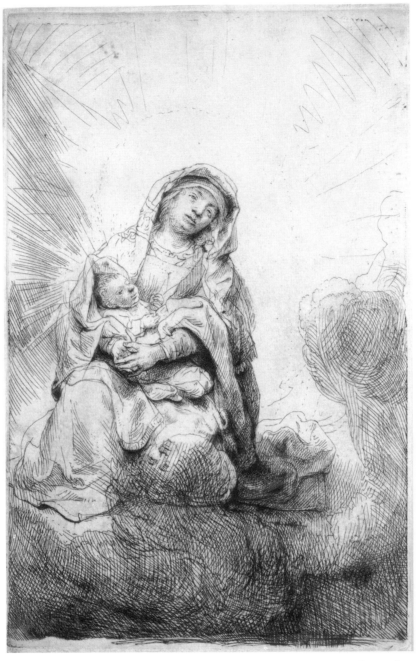

Amsterdam

43

The Madonna in the clouds 1641

Etching and drypoint, 168 × 106 mm

At lower centre (in the dark clouds): *Rembrandt f. 1641*

Hind 186; White & Boon 61 (only state)

Amsterdam★ (De Bruijn RP-P-1962-37; watermark: Basilisk [Ash & Fletcher 12, A´.a.])

Watermarks: see cat. 42.

SELECTED LITERATURE: Clark 1966, pp. 27–8; Amsterdam 1985, pp. 70–71, no. 59.

Rembrandt made a false start when he embarked on this print, and an upside-down face is visible in Mary's left knee. Evidently the artist soon realized that the head was too small and poorly positioned in the picture plane. Without erasing the traces of his initial design he turned the plate 180 degrees and started afresh.

Rembrandt may have drawn inspiration for the print – one of the least known in his *oeuvre* – from several sources, including Dürer's *Madonna on the crescent moon* on the title-page of his *Life of the Virgin,* a small print of the same subject by Jan van de Velde after a design by Willem Buytewech, and Federico Barocci's *Madonna and child* (fig. a), all of which have been suggested.[1] On closer inspection, it would not be an overstatement to describe Rembrandt's print as a free copy after Barocci.[2] The two are nearly the same size, and Rembrandt's seated Virgin Mary is almost an exact repetition of the Italian master's (albeit in reverse). It is striking that Rembrandt faithfully adopted the uncommon motif of the Virgin Mary's folded hands. He also appears to have followed Barocci in the distribution of the light and dark, and in the etching technique – with simple cross-hatching in the shaded areas. Nevertheless, the two prints are very different in tone: Barocci's Madonna is a young, sweetly smiling girl with an idealized, symmetrical doll's face. The Christ child is a burly infant that gazes directly at the viewer and makes a gesture of blessing. In contrast, Rembrandt's Virgin seems scarcely aware of the child's presence. She stares past the viewer into the distance; whether or not intentionally, her expression recalls numerous images of the Mater Dolorosa from the Italian Baroque. His Christ is also less robust, a sickly baby that turns away from the viewer, wholly unconscious of his divinity. When set beside Barocci's sprightly counter-reformation icon, Rembrandt's Madonna seems laden with unfathomable emotional ambiguity. It is safe to assume that Rembrandt owned an impression of Barocci's print, as his 1656 inventory lists a

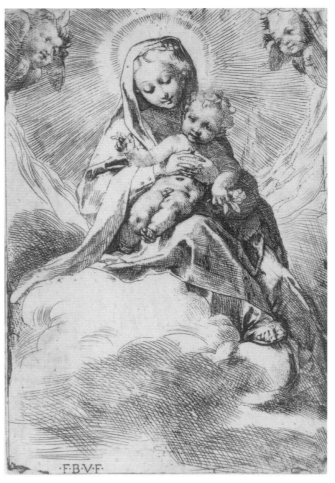

fig. a Federico Barocci, *Madonna and child*. Etching, 153 × 305 mm. Amsterdam, Rijksmuseum

'Ditto [book] with copper prints by Vanni and others including Barocci'.[3]

No other states are known of Rembrandt's print. Early impressions exhibit a fine *chiaroscuro*. The etching plate was preserved well into the eighteenth century, and is mentioned as late as Pieter de Haan's sale catalogue of 1767: 'No. 18, Mary with the Infant Jesus on the clouds, with 31 impressions'.[4] The '31 impressions' were probably recent specimens; in any case several rather grey impressions exist of the print, obviously pulled from a worn plate, on eighteenth-century paper, but it is not known what happened to the plate after 1767.

MS

1 Broos 1977, pp. 75–6.

2 Bartsch 2; Amsterdam 1985, p. 70, no. 58, repr.

3 'Een dito [boeck] met kopere printen van Vani en anderen als meede barotius' (Strauss & Van der Meulen 1979, pp. 368–9).

4 'No 18 Maria met het Kindje Jezus op de Wolken, met 31 drukken.'

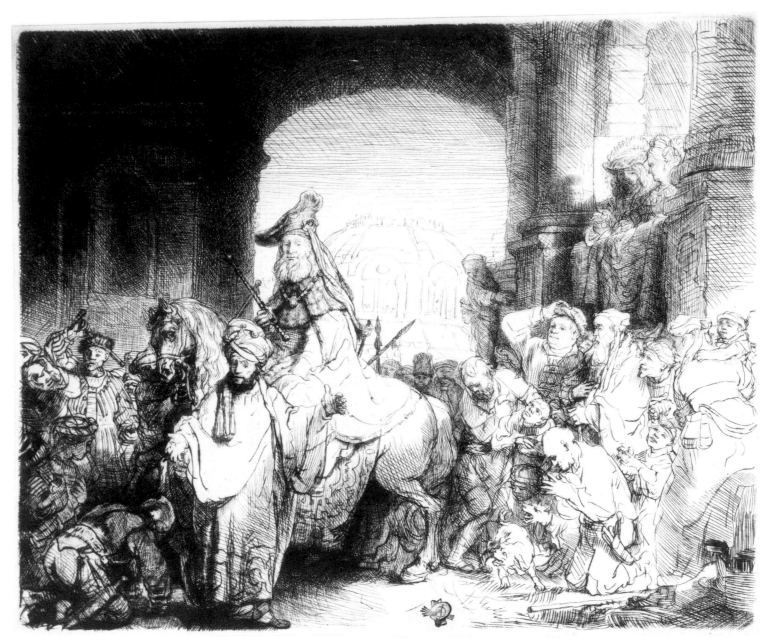

London

44

The triumph of Mordecai *c.*1641

Etching and drypoint, 174 × 215 mm

Hind 172; White & Boon 40 (only state)

Amsterdam (De Bruijn, RP-P-1962-16; watermark: none)

London★ (Cracherode 1973.U.915; watermark: none)

SELECTED LITERATURE: Landsberger 1946, p. 116; Boeck 1953, p. 200; Forssman 1976, pp. 297–311; Wheelock 1983, pp. 291–6; Amsterdam 1991, p. 119; Perlove 1993, pp. 38–60; White 1999, pp. 45–7.

Dutch artists of the sixteenth and seventeenth centuries were particularly fond of the Old Testament *Book of Esther,* and drew inspiration from two episodes in particular. The first is the moment at which King Ahasuerus (Xerxes I) is informed by his consort, the Jewish Esther, of the heinous intentions of his favourite, Haman. Driven by blind hatred of Esther's stepfather Mordecai, Haman plans to massacre all the Jews in the empire. In the other popular episode, Ahasuerus vents his rage on Haman during a banquet prepared by Esther. Both scenes provided ample opportunity to depict violent emotions and forceful gestures.

The *Triumph of Mordecai* is an entirely different kind of subject. Here, the emotions lie beneath the surface, and the two protagonists are only partly aware of their fates. Mordecai, in kingly attire and mounted on a horse from the royal stables, is as yet ignorant of the full consequences of his changed fortunes. He does not yet know that the king has had the chronicles of the land recited to him throughout a sleepless night and thus learnt that Mordecai once foiled an attempt on his life. Similarly, Haman has not yet taken in the degree of his fall from grace, and has yet fully to grasp that his life will end on the gallows that he himself had erected for Mordecai (Esther 6:10–11).

Although the subject was not especially popular, Rembrandt could nonetheless turn to two illustrious examples: Lucas van Leyden's engraving of 1515 (fig. a),[1] and a painting of 1624 by his own teacher, Pieter Lastman (fig. b).[2] In Lucas' engraving, the picture almost recalls a triumphal procession from classical Rome: the throng moves from left to right in a two-dimensional, frieze-like composition. Mordecai is almost mobbed by a vast crowd paying tribute to him, while Haman walks beside the horse. Lastman based his composition on Lucas van Leyden's engraving, but the multitude is reduced to a few soldiers, a handful of children and a company observing the event from a balcony. By depicting Mordecai from a three-quarter angle while adopting a frontal perspective for Haman, Lastman added depth to his

painting. Rembrandt clearly set out to mould these two examples into a single entity. In the multiplicity of figures he followed Lucas. He also honoured the older master, as on other occasions, by inserting an oblique quotation: the rather rustic-looking, corpulent man about to doff his cap, in the crowd of onlookers towards the right, is a paraphrase of the man on the extreme right in Lucas' print. The group including Mordecai and Haman and the circular building in the background are borrowed directly from Lastman. By placing Haman prominently in the foreground, Rembrandt ensures that the viewer's initial gaze is inexorably drawn towards him; and his idea of having Ahasuerus and

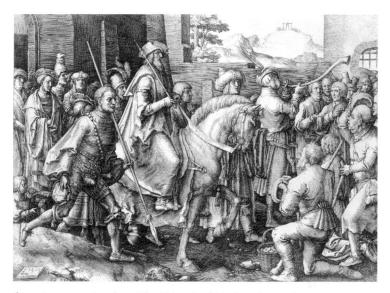

fig. a Lucas van Leyden, *The Triumph of Mordecai.* Engraving, 210 × 289 mm. Amsterdam, Rijksmuseum

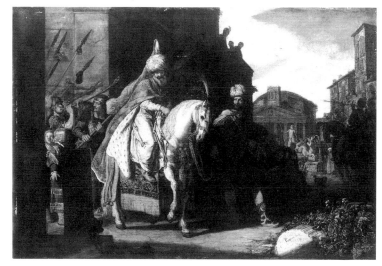

fig. b Pieter Lastman, *The Triumph of Mordecai.* Panel, 520 × 715 mm. Amsterdam, Museum het Rembrandthuis (on loan from the Institut Collectie Nederland, Amsterdam)

Esther watch the events unfolding from a balcony is entirely original.

In spite of its modest dimensions, the *Triumph of Mordecai* exploits the scope of printmaking to an astonishing degree. It is as if Rembrandt wanted to exhibit the entire spectrum of his technique, from the airiest etched lines in the crowd on the right to the inkiest blacks in the drypoint areas around the superb figure kneeling in the left foreground.

No other states are known and the copper plate has disappeared. But Rembrandt's composition was copied, among others, by Melchior Küsel in popularized form in a seventeenth-century German biblical print in his *Icones Biblicae Veteris et Novi Testamenti* (Augsburg 1679),[3] but his well-intentioned copy conveys little of the power of Rembrandt's etching.

MS

1 The New Hollstein, *Lucas van Leyden*, 31.

2 Amsterdam 1991, pp. 118–19, no. 17.

3 Hollstein (German) 1036–1286; a facsimile edition was published in 1968 (Küsel 1968).

45

Cornelis Claesz. Anslo 1641

Etching and drypoint, 188 × 158 mm; signed and dated, right: *Rembrandt f 1641*

Hind 187; White & Boon 271 I (of II)

I London★ (1842-8-6-147; inscribed in brown ink in margin below: *Ansloos*; watermark: none)

SELECTED LITERATURE: Emmens 1956, pp. 133–65 (reprinted 1981, pp. 61–97), Frerichs 1969, pp. 206–11; Busch 1971, pp. 196–9; *Corpus* III, under no. A145; Berlin-Amsterdam-London 1991–2, pp. 209–11, no. 16; Royalton-Kisch 1992, no. 32; Royalton-Kisch 1993b, pp. 175–6; Dickey 1994, pp. 312–75; White 1999, pp. 137–8.

Cornelis Claesz. Anslo (1592–1646) was a wealthy cloth-merchant, theologian, and Mennonite (*Doopsgezind*) minister and teacher, famed for his oratory. In 1611 he married Aeltje Gerritsdr. Schouten (d. 1657) and in 1615/16 he founded the Anslohofje almshouse for old women in Amsterdam (now the Claes Claesz. Hofje Foundation). In 1617 he became a preacher to the Waterland congregation in Amsterdam, a group that had broken with the stricter followers of Menno Simons and based themselves at a chapel on the River Singel, the Grote Spijker (the large warehouse), and he published various theological writings.[1]

The print is among Rembrandt's more highly finished etch-

ings. At times the extensive cross-hatching and parallel shading threaten to produce monotony, leading one commen-tator to attribute the plate to Rembrandt's pupil, Ferdinand Bol.[2] But the image is enlivened by Rembrandt's description of such minutiae as the buttons and fur, and these details could not be granted more attention than areas that were more central to the portrait. Like the *Diana at the bath* and *Jan Six* (cats 10 and 57), the etching was prepared in a broadly handled cartoon, the outlines of which were indented to transfer the design to the copper plate (fig. a).[3] Its *verso* was coated in an ochre medium, possibly containing wax, but whether this played a part in the transfer is uncertain.

Although the drawing fixed the portrait, Rembrandt character-istically introduced various refinements. Thus in the print, the hat is made taller (in the drawing a correction in white heightening had reduced its height); to the right a framed object is placed against the wall, and a conspicuous *trompe-l'oeil* nail protrudes from the cracked plaster above.[4] The somewhat amorphous shapes at the lower right of the drawing may have been a trial for the framed item. The nail, on the other hand, appears only in the print, and contrary to earlier opinion is probably a simple pun on the word 'spijker', which could refer either to a 'warehouse' or a 'nail', and as we have seen this was the name of the building where Anslo's congregation convened. This realization, combined with the compiler's doubts that the framed object is a painting placed face to the wall (as is usually supposed) somewhat undermines various recent surmises that these motifs are an allegory concerning the primacy of the word over visual images in the dissemination of Protestantism.[5] This would not have carried significance only for the Mennonites. More probably the framed object is a wooden tablet of some kind, perhaps intended for a list of names (Rembrandt has placed his own there) and the mouldings on the top of the frame show that it is not placed face to the wall.[6]

Anslo's gesture and keen glance imply that he is speaking, and in a contemporary poem, Joost van den Vondel challenges the artist to convey the oratorical powers, and indeed the very voice, that were so characteristic of the sitter:

Aÿ, Rembrant, mael Cornelis Stem.
Het Zichtbre deel is 't minst van hem:
'tonsichbre kent men slechts door dooren.
wien Anslo zien wil, moet hem hooren

(O, Rembrandt, paint Cornelis' voice. The visible part is the least of him; the invisible is known only through the ears; he who would see Anslo must hear him).

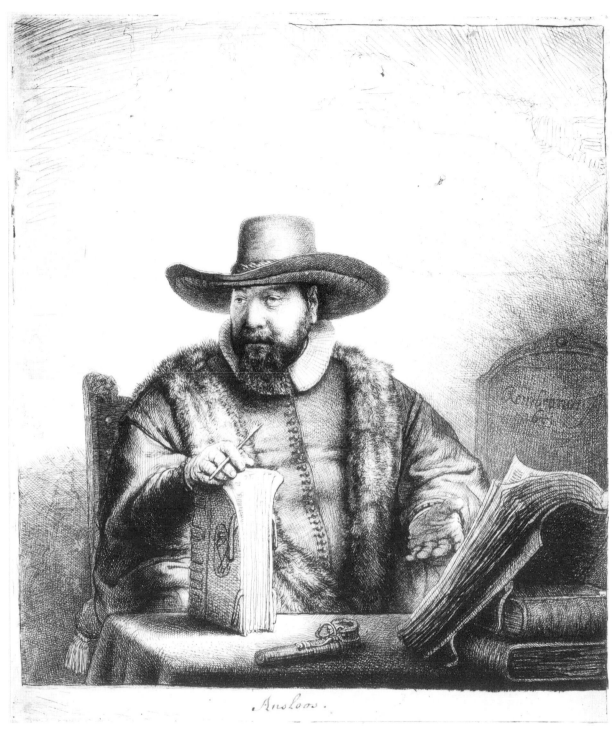

Ansloo.

I London

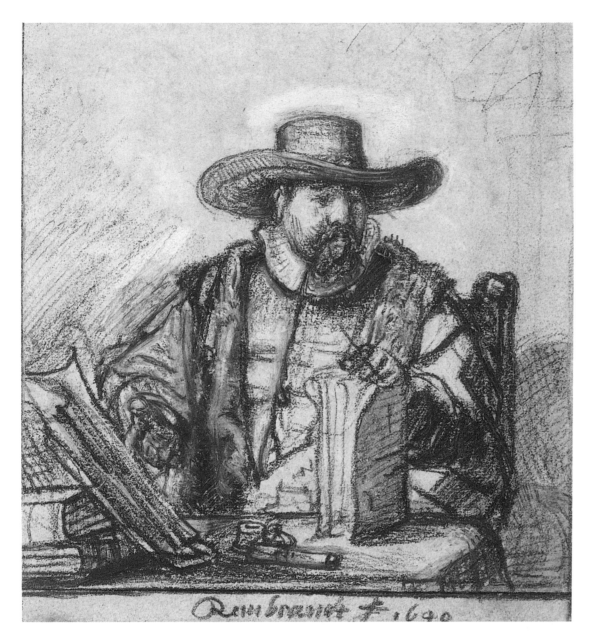

fig. a Rembrandt,
Cornelis Claesz. Anslo, 1640.
Red chalk with some red wash,
heightened in oil, on pale yellow-
brown paper, outlines indented,
157 × 144 mm.
London, British Museum
(Benesch 758; exh.)

Modern commentators have been greatly exercised by this challenge to the artist and have debated whether Rembrandt knew Van den Vondel's lines before he designed the etching, or *vice versa*. But secure answers remain elusive. There is no evidence that Vondel's poem existed earlier than its first publication in 1644, three years later than the etching.[7] Furthermore, in a second drawing of Anslo made in 1640 (fig. b), Rembrandt tilted the torso and freed the gesture of the left hand as if to enhance the impression of a 'speaking' likeness, and he continued these adjustments in his painted *Portrait of Anslo and his wife* (fig. c), which is dated 1641, like the etching.[8] Whether these adjustments constituted a response to the poem is far from certain.

In this context it should be noted that in Cesare Ripa's *Iconologia* of 1611, a handbook for artists, *Eloquence* is described as holding a book in her right hand, the left being raised with an extended index finger, rather as in Rembrandt's depictions of Anslo.[9] In all of the latter, books are prominent. In the print, the one towards which Anslo gestures is probably a Bible; the other, which he holds pen in hand, may refer to his own theological writings together with the inkwell and penholder lying on the table. The converse idea that Van den Vondel based his lines on Rembrandt's images of Anslo is perhaps more plausible.[10] In awarding precedence to the voice (which, incidentally, Vondel makes no attempt to describe) and the verbal over the visual

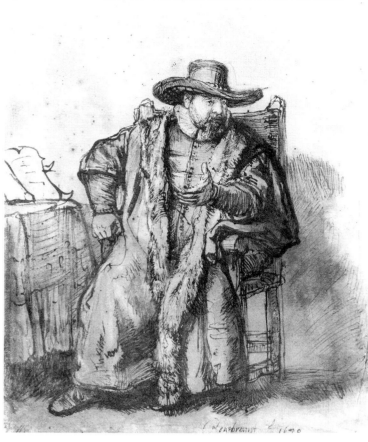

fig. b Rembrandt, *Cornelis Claesz. Anslo*, 1640. Pen and brown ink with grey and brown wash, corrected with white, 246 × 201. Paris, Musée du Louvre, coll. E. de Rothschild (Benesch 759)

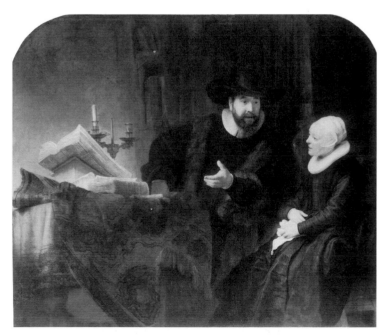

fig. c Rembrandt, *Cornelis Claesz Anslo with his wife, Aeltje Gerritsdr. Schouten*, 1641. Oil on canvas, 1760 × 2100 mm. Berlin, Gemäldegalerie (photo: Jörg P. Anders)

image of the sitter, he followed a literary tradition.[11] It has also been argued that the white strip at the lower edge in the first state proves that Rembrandt was aware that the poem was to be associated with his print; yet they occur in other prints by him, sometimes blank, sometimes containing his signature. On an impression of the *Anslo* in the Bibliothèque Nationale in Paris, Rembrandt himself wrote an autograph signature, rather as in the preparatory drawing, while in the same place on the British Museum's proof shown here there is a seventeenth-century inscription: *Ansloos*. These factors somewhat undermine the idea that the quatrain was intended for the copper plate;[12] and in any event the white strip was worked over in the second state, in which Rembrandt also added some drypoint in the shadows by the fur.

The questions as to whether the red chalk drawing was executed before or after that in Paris, and whether they were both drawn from life, have given rise to some debate.[13] The way the sitter's right arm in the London sketch initially followed the same lines as the Paris sheet offers some support for the precedence of the latter. The indication of the pen in the left hand in the indented drawing anticipates the reversal of hands in the print[14] and suggests that it was not drawn from life. But in all four depictions of Anslo, Rembrandt exhibits his constitutional incapacity for mere repetition.

MRK

1 *Corpus* III, p. 410; Dickey 1994, p. 323.

2 Van Dyke 1927, pp. 30–31.

3 Benesch 758; Royalton-Kisch 1992, no. 32. See further pp. 64–7.

4 The print is larger (188 × 158 mm) than the drawing, which may have been cut, as proposed by White 1969, p. 124. A touched impression, not recorded by White & Boon 1969, was in the S. Woodburn sale, Christie's, 9th day, 26 June 1854, no. 2253: *Reinier Anslo – the etching, touched upon with bistre and red, by the master*, bt Cheney, £7–7–0.

5 As suggested by Busch 1971, pp. 196–9. See Welzel in Berlin-Amsterdam-London 1991–2, p. 209 for an excellent summary of the relationship between the print and the religious context of its iconography, themes elaborated by Dickey, 1994. The latter informs me (14 November 1999) that the idea of the pun occurred to Egbert Haverkamp-Begemann in conversation with her. It also appears on a label in the Rembrandthuis (as E. de Heer tells me); otherwise I am unaware of any mention that the nail (spijker) might allude to the Waterlanders' chapel in Amsterdam. Dickey also rightly points to the existence of the (much less distinct) nails on the wall behind Jan Asselijn (see cat. 56, first state).

6 The object on the right seems to me more probably to be a framed religious tablet of some kind rather than a painting, not least because of what appears to be a hole at the top of the frame for hanging it. I am grateful to Reinier Baarsen and Wouter Kloek for their comments. The former believes that its rounded top shows that the object was likely to have been made of wood and possibly contained a list of names. C. W. Fock, contacted through E. de Heer, stated that she knows of no similar seventeenth-century frame for a painting or mirror.

7 First published in Vondel 1644, p. 136. Other poems, by Caspar Barlaeus and an anonymous author, were produced in response to the image in Rembrandt's lifetime and appear on Salomon Savery's copy of the etching (see Dickey 1994, pp. 373–5)

8 Bredius 409, *Corpus* A143.

9 Ripa 1611, p. 139, as remarked by Royalton-Kisch 1992, p. 91, n. 5.

10 Hofstede de Groot 1906, p. 130, thought that the poem probably referred to the print or the Berlin painting, as suggested by Unger in his edition of Vondel.

11 See Scholte 1946, and Emmens 1981, III, pp. 89ff. Busch 1971, partly negates the latter's arguments. Haak 1969, p. 170 believed that the poet's lines were not a criticism but merely follow a *topos* that a man is remembered for his deeds; and pointed out that the word *mael* can be used for etchings as well as paintings, so that the poem could refer to the print. Schwartz 1985, pp. 217–19, *Corpus* III, pp. 413–14 and Frerichs 1969, pp. 206–11, also enter into these questions. It is worth noting that in an inscription on Antonij van Zijlvelt's print of *Claas van Daalen* (Wurzbach 5), Vondel describes the sitter's profession of surgeon and concludes: 'that describes him better than any copperplate' ('Dat beelt hem beter uit dan alle kopre platen').

12 Supported by Scholte and Emmens (see previous note), but refuted by *Corpus* III, 1989, p. 413. Compare also the portrait of *Jan Cornelisz. Sylvius* and the related drawings (here cat. 54), in which the inscriptions were clearly anticipated. On an impression of the second state in the British Museum (Slade 1868-8-22-694), the poem was added in the empty margin *below* the plate-mark in pen and ink by a calligrapher, probably Willem van der Laegh between the years 1641 and 1660 (see *Corpus* III, p. 411, fig. 11). The handwriting was identified by A. R. A. Croiset van Uchelen of the Amsterdam University Library. The Arms of Amsterdam watermark on this impression (a variant of Ash & Fletcher 1, F.a.) suggests a date *c*.1660 (information from Erik Hinterding).

13 See Sumowski 1957–8, p. 236 and Schatborn 1986, pp. 8–9.

14 Boeck 1953, pp. 193–4.

46

The flute-player 1642

Etching and drypoint, 116 × 143 mm; from the second state signed and dated below, right of centre: *Rembrandt.f 1642* [2 in reverse]

Hind 200; White & Boon 188 I and II (of IV)

I London★ (Cracherode 1973.U.956; watermark: Basel crozier [Ash & Fletcher 11, B´.a.])

II Amsterdam★ (De Bruyn RP-P-1961-1096; watermark: Basel crozier [Ash & Fletcher 11, B´.a.]); London (Cracherode 1973.U.958; watermark: Basel crozier [Ash & Fletcher 11, B´.b.])

Watermarks: the Basel crozier B´.a. is characteristic of the first three states of this print; it also occurs in the rare first state of the *Three oriental figures* (B.118) and the first state of the *Portrait of Cornelis Claesz. Anslo* (cat. 45), both of 1641.

SELECTED LITERATURE: Emmens 1979, pp. 190–200; McNeil Kettering 1977; Berlin-Amsterdam-London 1991–2, pp. 212–14, no. 17; White 1999, pp. 182–4.

Shepherds do more than their fair share of walking, but their lives also provide ample opportunity for relaxation. While a flock of sheep quench their thirst at a brook, a shepherd and shepherdess are seen taking things easy, sheltered by an overgrown rise in the landscape. A staff stands to one side and the man has placed his hat on the ground. He is sprawled out forwards, while she sits a little higher up, wreathing a garland. Her legs are slightly parted and the shepherd is stealing a glance under her skirts. Not a note sounds from the flute in his hands.

Like many of his contemporaries Rembrandt was drawn to the pastoral idiom.[1] This is clear from several of his paintings with figures decked out in shepherds' garb as well as from a number of prints. His 1656 inventory includes a reference to 'a shepherd's path' (*Een hardersdriffie*) by the artist himself, probably a landscape with a shepherd and his flock.[2] Rembrandt encountered the genre in Pieter Lastman's studio in Amsterdam, where he worked for six months in 1624 to complete his training before setting up as an independent artist. In that same year a painting was made in Lastman's studio that contains many of the ingredients of Rembrandt's *Flute-player* (fig. a). Other paintings by Lastman with pastoral themes include one showing a man and a woman having an intimate rollick.[3] That Rembrandt's etching has been called 'the least idyllic pastoral depiction by a seventeenth-century artist' is probably because it does not make the self-consciously posed impression that characterizes images like Lastman's.[4] Moreover, Lastman's figures, like those of Abraham Bloemaert, for instance, are decorative dolls, while the features of Rembrandt's protagonist, modelled on a shepherd in a print after Titian (fig. b), are more realistic. The artist has immersed himself in the amorous situation and has played a transparent game with ancient ambiguities and innuendos surrounding the flute and garland.[5] Rembrandt would often be more directly to the point where others were wedded to suggestion (cats 52–3). In another pastoral scene, a young man impelled by Eros and led by his eager lover, finds the goal of his attentions while an older shepherd sleeps nearby (fig. c).

In circles of print lovers and collectors the *Flute-player* was long known as *Eulenspiegel* ('Owl-glass') after the protagonist of the popular folk-tale. The print was given this title almost immediately it was made in an inscription with a list of three Rembrandt etchings on the back of a *Self-portrait* (see cat. 4). This is not hard to understand, and it is certainly not solely attributable to the tame owl on the shepherd's shoulder. The name of this notorious trickster was proverbial from the sixteenth century onwards and used to denote someone with a wily nature. The expression 'to play Eulenspiegel's flute' meant to talk rubbish or to take some-

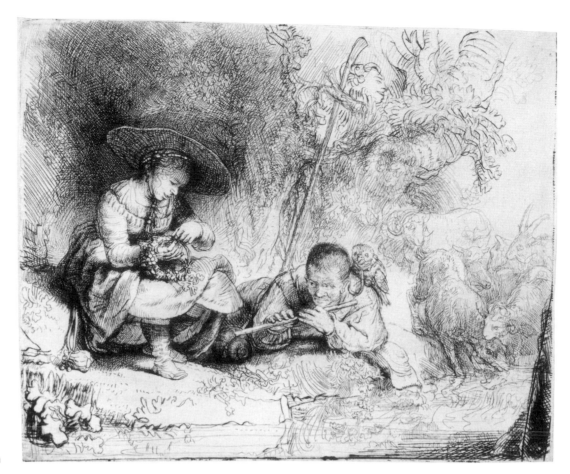

I London

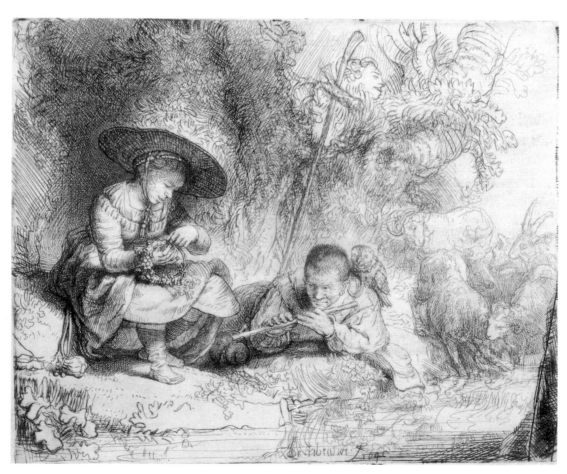

II Amsterdam

one for a ride, and Rembrandt's resourceful shepherd evidently conjured up such associations at the time.[6] More ominously, it is also quite possible that the shepherd was endowed with an owl as a symbol of wickedness.[7]

The composition must have been delineated on the plate in full in a single session, after which Rembrandt deepened lines with drypoint and added accents and contrasts in the various sections. At this point a small number of impressions was pulled. Immediately above the shepherdess a darkly hatched area is visible, creating the impression that her hat is weighed down. Rembrandt removed it in the second state (fig. d), which also displays minor discrepancies elsewhere: the upper left corner is rather more densely hatched, twigs with foliage have appeared in the tree on the right, and here and there extra lines have been added, for instance to the underside of the woman's hat and to the part of her skirt that hangs over her left knee. On the impression of the first state shown here, some wash has been added at this point with a brush. Another impression of this state displays an extra stroke near the flute-player's elbow, where an area was burnished away in the second state.[8] So Rembrandt must have regarded the first state as experimental, as is also clear from the fact that he did not add his signature and the date until after the reworking. On second thoughts he was evidently still dissatisfied with the area above the shepherdess's hat, where in the third state he made further adjustments in drypoint.

The first three states were printed on paper with the same watermark, from which it may be inferred that they succeeded one another fairly rapidly and that Rembrandt was working methodically towards an edition. Before long a fourth state was prepared.[9] By then the drypoint effects had suffered and the plate needed reworking. On the left, the image was now filled with hatching right up to the edge of the plate. Also at this stage, the woman's head among the foliage was removed. Rembrandt may have left her there by way of caprice from an earlier etching that was never completed, although in the second state he made corrections to her curls. The sketch-like style makes it hard to read her expression, but a smile visibly plays around her lips. Perhaps Rembrandt intended to suggest the presence of another couple, but at all events the *mise-en-scène* lacked clarity and Rembrandt decided to remove her from the stage. Such changes are par for the course when artists work fast and spontaneously while continuing to respond to what has come into existence under their hands.

GL

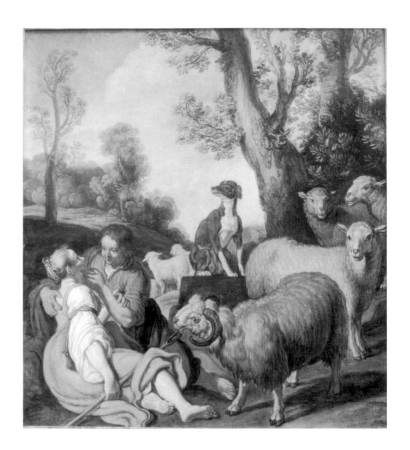

(*above*) fig. a Pieter Lastman, *Shepherd and shepherdess*, 1624. Panel, 53 × 47 cm. Gdánsk, Muzeum Naradowe

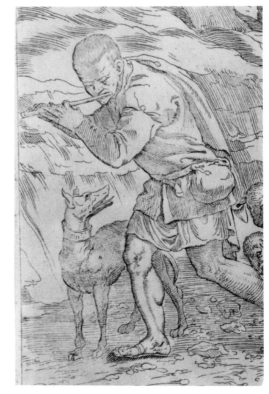

fig. b Anonymous artist after Titian, *Shepherd playing the flute*. Woodcut (detail). Amsterdam, Rijksmuseum

fig. c Rembrandt, *Sleeping shepherd*. Etching, 78 × 57 mm. Amsterdam, Rijksmuseum (B.189)

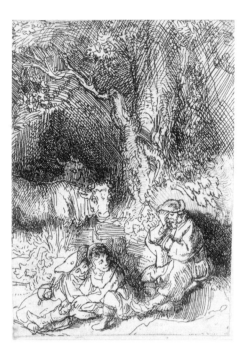

fig. d Rembrandt, detail of II Amsterdam

1 McNeil Kettering 1983 and Utrecht-Frankfurt-Luxembourg 1993–4.

2 Strauss & Van der Meulen 1979, 1656/12, no. 60.

3 See Utrecht-Frankfurt-Luxemburg 1993–4, p. 54, fig. 37 and cat. 34.

4 McNeil Kettering 1977, p. 21.

5 For a detailed discussion see McNeil Kettering 1977.

6 *Woordenboek der Nederlandsche Taal* XVII–3, cols 73–5; it was obviously never Rembrandt's intention to depict Till Eulenspiegel himself (see Enklaar 1941, p. 21).

7 For the iconography of the owl, see Vandenbroeck 1985.

8 In Berlin; see Bevers in Berlin-Amsterdam-London 1991–2, p. 214 and fig. 17b.

9 The fourth state already occurs on paper bearing the watermark of a Fool's cap with five-pointed collar (Ash & Fletcher 19, A.a.), which is characteristic of the regular edition of the *Three trees* dating from 1643 (cat. 48).

47

The sow 1643

Etching and drypoint, 145 × 184 mm; signed and dated, lower right: *Rembrandt f 1643*

Hind 204; White & Boon 157 I (of II)

I Amsterdam★ (Van Leyden RP-P-OB-238; watermark: Countermark M [Ash & Fletcher 26, M´.a.]); London (1845-2-5-3; watermark: Dutch lion★)

Watermarks: both watermarks occur exclusively in impressions of this print; the Dutch lion also occurs in an impression of the second state in London.

SELECTED LITERATURE: Boston-St Louis 1980–81, no. 72; Berlin-Amsterdam-London 1991–2, pp. 192–4, no. 10; White 1999, pp. 184–5.

Though not a specialist in animal pieces, Rembrandt painted a number of creatures, sometimes as independent motifs. The inventory of his possessions lists 'a little painting of hares', 'two greyhounds from life' and 'a little painting of a pig', all by the artist himself.[1] Given the epithet 'little', the paintings may have been oil sketches, but they are no longer known. The inventory also lists 'a [book] full of drawings by Rembrandt consisting of animals depicted from life'.[2] Several of these studies, now dispersed, have survived, a few of which show pigs gobbling their swill or stretching out on the ground (fig. a).[3]

This etching should rightly be called *The sow*, as the creature is shown in so much detail that its nipples are visible. The prominent animal clearly forms the main subject of the print, but the composition takes on the air of a narrative, if not one with a specific meaning, from the cursorily sketched figures in the background. In that sense it prefigures the *Walking-frame* of a few years later (cat. 51).[4]

To judge from the spatial structure, it is doubtful whether the artist recorded the entire scene on the spot. Rembrandt was certainly no sufferer of *horror vacui*, as is clear here too from the large area left blank. The pig, its legs bound and tied to a post, may have been based on a study, though it could have been drawn directly on the plate.[5] Yet the woman with the toddler, the two excited boys and the standing man appear to have been added later. They may be based on drawings, although Rembrandt was practised enough to invent them from scratch (that the man, a shadowy apparition with uncommonly short legs, was drawn from life, seems improbable). Although rather infelicitously jammed into the picture, the man is the key to understanding exactly what is going on. A basket hangs from his arm, and in his hands he has an axe and a curved yoke, or cambrel. He is a pig

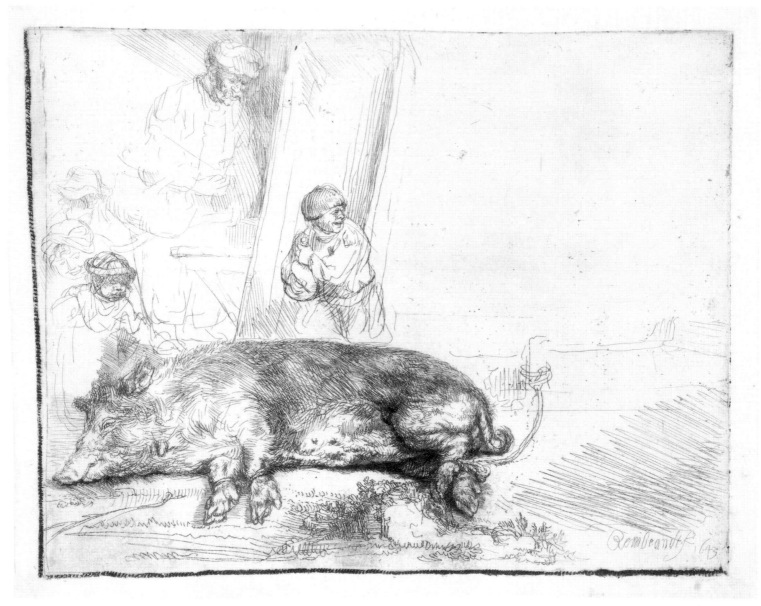

I Amsterdam

fig. a Rembrandt,
Two pigs.
Pen and brown ink,
corrected in white,
125 × 183 mm.
Paris, Musée du Louvre
(Benesch 777; exh.
Amsterdam)

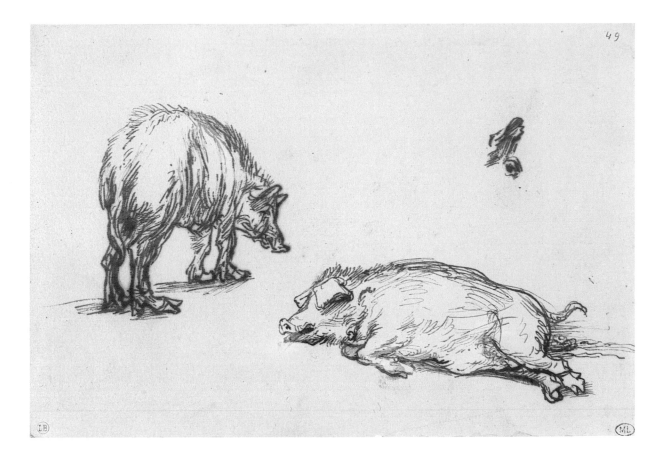

butcher, and it seems that the animal will soon be meeting its end. The children are waiting to watch the spectacle. In the seventeenth century (and long afterwards in the countryside), people often bought pigs to fatten at home before slaughtering them once winter drew near. Butchers used to travel around to perform this bloody task at people's houses. We can gain a clear impression of how this was done from a painting of 1648 by Rembrandt's pupil, Jan Victors (1620–76 or later; see fig. b). There, the work is nearing completion: the butcher, equipped with the same type of axe and with a basket slung over his shoulder, is at the centre, with a ladder on the right along with the cambrel from which to hang the animal's carcass. The pickling barrel at left contains some of the meat, and the boy on his knees clutches a leg. The two children on the right are playing with the pig's bladder, poking a straw into it and inflating it.

It is typical of Rembrandt to have chosen a different moment from that represented in such scenes, which often figure in series of the Twelve Months, in breviaries, almanacs and in painted genre pieces. These invariably show the cavernous carcass on the ladder which, combined with the image of children inflating the bladder, alludes to the brevity of life (fig. c).[6] Rembrandt

evidently wanted to give his etching similar undertones by placing the pig's bladder in the hands of the little boy looking over his shoulder with a broad grin on his face.[7] He presses it against his body, letting a little air escape to create a sound like someone breaking wind.

Rembrandt rendered the scene with mercurial vigour. The broad zigzag hatching at the lower right was executed in a single, unbroken movement, and the grass in the foreground was equally nimbly delineated. In early impressions, such as the one in Amsterdam, rough traces of filing are discernible at the left and near the lower edge, which have retained ink. When the plate began to wear, various accents were introduced in drypoint. Thus the sow's skin was darkened considerably and emphasis added to the little child's hat, and to the jacket, face and hair of the boy with the bladder (fig. d).[8] Curiously enough, only a handful of impressions of the second state are known, so that the plate may not have been printed very often after these modifications were made.

GL

fig. b Jan Victors, *The pig butcher*. Canvas, 795 × 995 mm. Amsterdam, Rijksmuseum

(*above*) fig. c
Michiel van Musscher,
Pig's carcass on ladder.
Canvas, 620 × 538 mm.
Amsterdam, Amsterdams
Historisch Museum

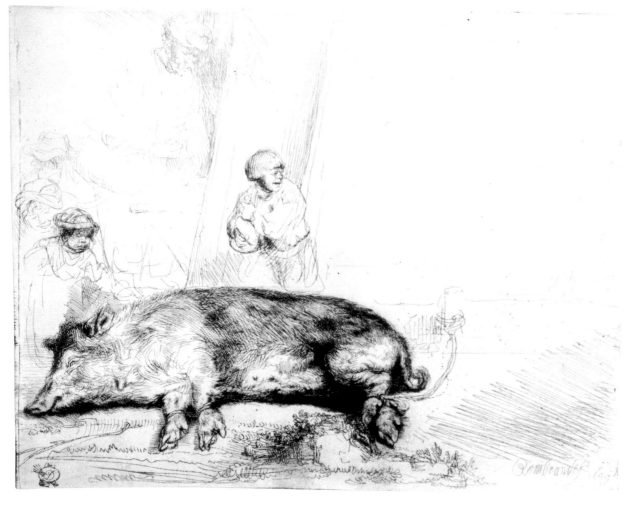

fig. d Rembrandt,
The sow, 1643.
Etching and drypoint,
second state,
145 × 184 mm.
London, British Museum
(B.157 II)

1 Strauss & Van der Meulen 1979, 1656/12, nos 15, 36 and 16 respectively: 'Een schilderijtie van haesen', 'Twee hasewinden nae 't leven' and 'Een schilderijtie van een varcken'.

2 Ibid., no. 249: 'Een [boeck] vol teeckeninge van Rembrandt bestaende in beesten nae 't leven.' For these drawings see Schatborn 1977.

3 For the drawing depicted, see Starcky 1988–9, no. 25 and Royalton-Kisch 1992, nos 23–4.

4 Dickey 1986.

5 See also Schatborn 1977, p. 10.

6 See the lengthy discussion in Amsterdam 1976, pp. 116–19, no. 24 and Salman 1997, p. 12, fig. 2. It seems that later generations were not always happy to be confronted with gaping carcasses: when the Amsterdams Historisch Museum purchased the painting by Michiel van Musscher (here fig. c) in 1981, the carcass had been painted over, only to be revealed during restoration (with thanks to Norbert Middelkoop).

7 Also noted in Schatborn 1977, p. 10.

8 See White 1999, p. 85.

48

The three trees 1643

Etching, with drypoint and burin, 213 × 279 mm; signed and dated lower edge, towards the left: *Rembrandt f 1643*

Hind 205; White & Boon 212 (only state).

Amsterdam (Van Leyden RP-P-OB-444; watermark: Foolscap with five-pointed collar [Ash & Fletcher 19, A.a.]); London★ (Cracherode 1973.U.967, with Dighton's mark [L.727]; ex. JVD [L.1551 *verso*, anonymous]; watermark: Foolscap with five-pointed collar [Ash & Fletcher 19, A.a.])

Watermarks: the watermark indicates that both impressions belong to the first edition of this print, of 1643.

SELECTED LITERATURE: Campbell 1980, pp. 2–33; Boston-St Louis 1980–81, no. 133; Ziemba 1987, pp. 123–5; Werbke 1989, pp. 225–30; Schneider 1990, no. 75; Kirsch 1991, pp. 436–8; Berlin-Amsterdam-London 1991–2, pp. 218–20, no. 19; Cohn 1992, pp. 386–7; Nevitt 1997, pp. 162–91; White 1999, pp. 219–22.

Few landscape prints in the history of art rival the evocative power of Rembrandt's *Three trees*. In layer upon layer of tone, Rembrandt graduated distance and atmosphere with breathtaking subtlety, using etched lines of varying density which show that the plate was immersed more than once in the acid bath. As well as the engraver's burin and the drypoint needle, other tonal processes may have been used in the densely worked foreground, and a ruler for the diagonals in the sky.[1] In the absence of any known impressions of earlier states, Rembrandt's working procedure is impossible to unravel, but it seems probable that he prepared the composition with drawings, as they survive for several of his most detailed etchings.[2] The studied balance of the design, more artificial than in most of his etched views, recalls the contemporary idylls of Claude Lorrain (1600/5–82) that were based on the *campagna* near Rome. Rembrandt substitutes the environs of Amsterdam for Claude's Arcadia, suggesting (not accurately) the northern metropolis on the horizon, dwarfed by the cloud formations above.

The shifting meteorological melodrama must also ultimately depend on first-hand observation, and is an unusual feature, as the skies in Rembrandt's landscape etchings are usually blank, as also in his drawings. In the *Les Méteores* section of the *Discours sur la méthode* by René Descartes, first published in 1637, a comparable atmosphere is described by the philosopher and illustrated in a diagrammatic engraving by Rembrandt's fellow-Leiden artist, Frans van Schooten (fig. a). Dark streaks for the sunlight, rising vapours, and traversing cloud are there analysed in a formal arrangement that has echoes in the composition by Rembrandt, whose patron Constantijn Huygens assisted enthusiastically in the production of this illustration.[3]

The three sturdy trees, of uncertain species,[4] are starkly silhouetted against a clear patch of sky, and seem reminiscent of the three crosses at the crucifixion of Christ as darkness fell (compare the *Three crosses*, cat. 73).[5] Yet the human life depicted in the print continues undisturbed: the fisherman on the left and his female companion, the lovers obscured in the undergrowth at the lower right,[6] the diminutive cattle-farmer in the field, with a group of figures at a similar distance in the centre, the waggon on the dyke behind the trees, near where an artist is seated sketching, looking out beyond the edge of the print – none of them responds to the climatic drama unfolding around them. Other details, such as the bird leaving the tree and the distant flock above, serve to heighten the poetic mood.

Modern interpretations of the *Three trees*, which often focus on the pair of lovers, cannot convince in the absence of any known programme for the print.[7] They generally either describe commonly shared psychological projections tempered by contemporary source material, including emblematic engravings that juxtapose fishermen and lovers in an erotic context, or relate the image to Calvinist theology and Spinoza's pantheism. Monuments to the suggestive power of Rembrandt's art and to the intellectual creativity of its interpreters, these theories remain ultimately unprovable.[8] That man is dominated by the overwhelming force of nature seems clear, and the apparent durability of the trees kindles familiar *vanitas* associations. Ephemeral, shifting conditions are caught for timeless contemplation. *Vanitas vanitatum, omnia vanitas?* The poignant,

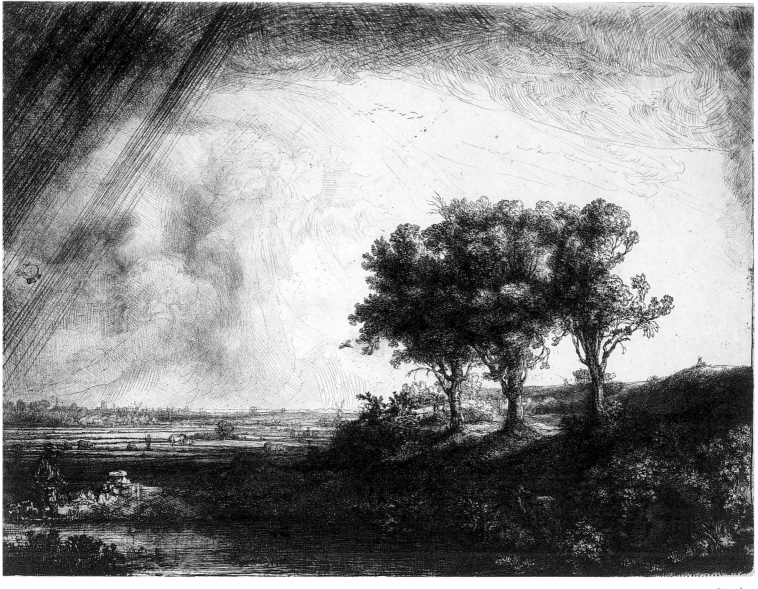

London

melancholic characteristics of the print are enhanced by the knowledge that Rembrandt's wife Saskia died in the year before it was made.[9] But we can never know his intentions for sure. We can only affirm that his image, like so many he created, acts as a powerful catalyst for profound meditations.

MRK

1 The use of sulphur tinting was recently re-emphasized by Schneider, *op. cit.* Similar effects might be produced by burnishing as noted by other writers, including White & Boon. The direct application of acid to the flat surface of the plate, followed by burnishing, could also produce comparable results. For a summary see White 1999, p. 269, n. 52. See also under no. 41.

2 See further the introduction, pp. 64–81.

3 See further Royalton-Kisch 1999, pp. 253–5. The analogy with the *Three Trees* is not mentioned in that text, but was examined in the lectures on which it is based. Similar diagonal lines were commonly used in seventeenth-century printmaking in order to represent shafts of sunlight or rain.

4 As is clear from correspondence I undertook with various botanical authorities in 1992. I am especially grateful to Maurice Hinterding, formerly of the Hortus Botanicus in Amsterdam, who believes the trees are elms,

fig. a Frans van Schooten, *Formation of clouds, after Descartes*, 1637. Engraving. Private collection

rather than willows, as was previously sometimes thought. But experts from the Natural History Museum in London and the Royal Botanical Garden in Edinburgh suggested birch and oak trees respectively. Campbell 1980, p. 32, n. 19, records that Alan Mitchell of the Forestry Commission (UK) could not specify which trees were represented, and thought beech trees a possibility, and willows unlikely on such a high eminence.

5 An idea suggested by the compiler to Christopher Brown and used by him in London 1986, p. 226. It is rejected by Nevitt 1997, p. 165.

6 Discussed especially by Nevitt, *op. cit.*, but see further below.

7 Campbell, *op. cit.*, suggested that half way up the left side, at 90 degrees , the remnants of a bed canopy underlies the cloud forms, probably from a discarded version of the *Death of the Virgin*. The shorter diagonals in the sky (immediately to the right of the longer ones) remain difficult to interpret.

8 Several writers have discussed whether the storm clouds are gathering or receding. If the sea is beyond the dyke and to the west, then the prevailing westerly winds would suggest that the storm is receding; but whether Rembrandt was thinking so prosaically we cannot know.

9 Eisler 1918, pp. 152–4, was among those to relate the print to the death of Saskia.

49

Six's Bridge 1645

Etching, 129 × 224 mm; signed and dated lower right: *Rembrandt f 1645*

Hind 209; White & Boon 208 I (of III)

I London★ (1847-11-20-3; watermarks: countermark IB [Ash & Fletcher 26, LB.c.])

Watermarks: the countermark has only been found in one other print, an impression of the first state of the *Boat house* (B.231), dated 1645.

SELECTED LITERATURE: Lugt 1915, pp. 113–17; Kannegieter 1925, p. 71; Schneider 1990, no. 76; Berlin-Amsterdam-London 1991–2, pp. 221–3, no. 20; Amsterdam 1998, pp. 298–9; White 1999, p. 224.

The earliest known title of the etching is 'Six's Bridge', recorded in the 1731 inventory of the collection of Valerius Röver of Amsterdam.[1] Edmé-François Gersaint (*c.*1696–1750) stated in his posthumously published catalogue of Rembrandt's prints that it was made by the artist when with (*avec*) Jan Six, and the supposition grew that he meant that it was made on Six's own country estate.[2] Subsequently, the correct identification of the distant church seen between the nearer trees as that of Ouderkerk showed that the view was taken on the Klein-Kostverloren estate on the west bank of the River Amstel, a little north of Ouderkerk. When the print was made in 1645, the estate belonged to Albert Coenraedz. Burgh, a man who, like Six, was to be Burgomaster of Amsterdam.[3] It later belonged to Burgh's son-in-law Dirck Tulp, son of Dr Nicolaes Tulp (of *Anatomy lesson* fame); and Dirck's half-sister married Jan Six in 1654. At all events

Rembrandt made other prints and drawings in the vicinity, as did other artists of his era.[4]

The immediacy of atmosphere and the informal, yet topographically plausible composition give the print the character of a page from a landscape sketchbook, as if Rembrandt executed it on the spot, out of doors.[5] For the most part he seems to have completed it in a single operation, although in later states he shaded the hats worn by the two men on the bridge, that of the nearer man in the second state, the other, very delicately, in the third and final state (see fig. a). The spontaneous style may have inspired the story, first related by Gersaint, that the etching was made after a wager by Six that Rembrandt could not make a print in the time it took a servant to fetch a pot of mustard from the nearest village.

MRK

1 'Six Bruggetje' – better translated as 'Six's little bridge'. See Van Gelder & Van Gelder-Schrijver 1938.

2 Gersaint 1751, no. 200. Gersaint had spent considerable time in Holland. Six only acquired his estate at Hillegom in 1651 (Elias 1963, p. 585). For this reference I am grateful to S. A. C. Dudok van Heel, who suggests that Röver's title may well preserve an authentic tradition of some kind.

3 Lugt, *loc. cit.*, who pointed out that the bridge was at the so-called *verlaat* or sluice at the edge of a polder near the estate (a suggestion supported in Amsterdam 1998, p. 299). Kannegieter, *op. cit.*, believed that the view was of the east rather than the west bank of the Amstel between Amsterdam and Ouderkerk.

4 Summarized in Amsterdam 1998, pp. 298–9.

5 See further the Introduction, pp. 74–5. Gersaint, *loc. cit.*, specifically states that this was the case and that Rembrandt *avoit toujours des planches toutes prêtes au vernis*.

fig. a III, detail. London, British Museum

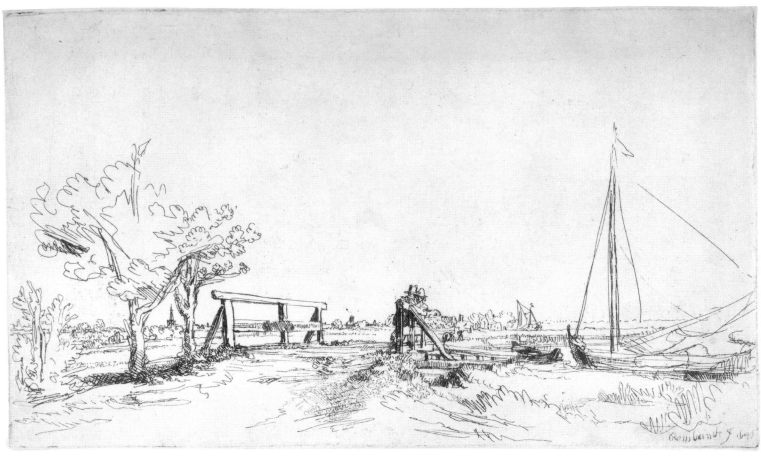

50

The Omval 1645

Etching and drypoint, 184 × 225 mm; signed and dated lower right: *Rembrant 1645*

Hind 210; White & Boon 209 I and II (of II)

I Amsterdam★ (Van Leyden RP-P-OB-269; watermark: (Double)-headed eagle [Ash & Fletcher 15, C.b.])

II London★ (Slade 1868-8-22-675; with the trial lines at upper right scraped out; ex. W. Esdaile [L.2617] and J. J. de Claussin [L.485]; watermark: none)

Watermarks: the same watermark has been found in one other impression of the first state and in an impression of the second state.

SELECTED LITERATURE: Lugt 1920, pp. 89–94; Schneider 1990, no. 54; Nevitt 1997, pp. 170–91; Amsterdam 1998, pp. 265–70; Melbourne-Canberra 1997–8, no. 107; White 1999, pp. 224–8, figs 306–8.

The area of Amsterdam still known as the Omval (the Ruin; a ruin formerly stood on the site) was in the seventeenth century a small spit of land at the head of a canal which entered the east bank of the River Amstel south east of the city. Like the ruins of Kostverloren manor further south, this was an area often represented by Rembrandt and his contemporaries.[1]

The etching mirrors the real situation (in reverse) to a considerable extent and shows on the extreme right, as a dark hole (somewhat resembling a bridge), the opening of the irrigation pipe where it discharged water pumped from the nearby polder into the Amstel. One of the windmills producing this flow is shown in the far distance, near the banks of the canal that ran south east from this point. The second, larger windmill stood on the Omval itself, near some shipyards, and several boats are shown moored or hauled up on the banks. In the centre, further boats partly obscure the inn behind, which was also known as the Omval. This may have been the destination of the covered ferry that enters the scene on the right.

The foreground figures, the standing man in the centre and, in the shadow of the tree, the lover placing a garland on the head of his beloved, appear to be unconnected with each other. Indeed the pastoral group of lovers marries somewhat uneasily, both iconographically and perspectivally, with the rest of the scene, which reflects the real situation closely. It has been suggested that Rembrandt intended to recast the traditional image of pastoral lovers, usually represented in an idyllic (and Italianate) landscape, and place them instead in a real, recognizable and urban setting.

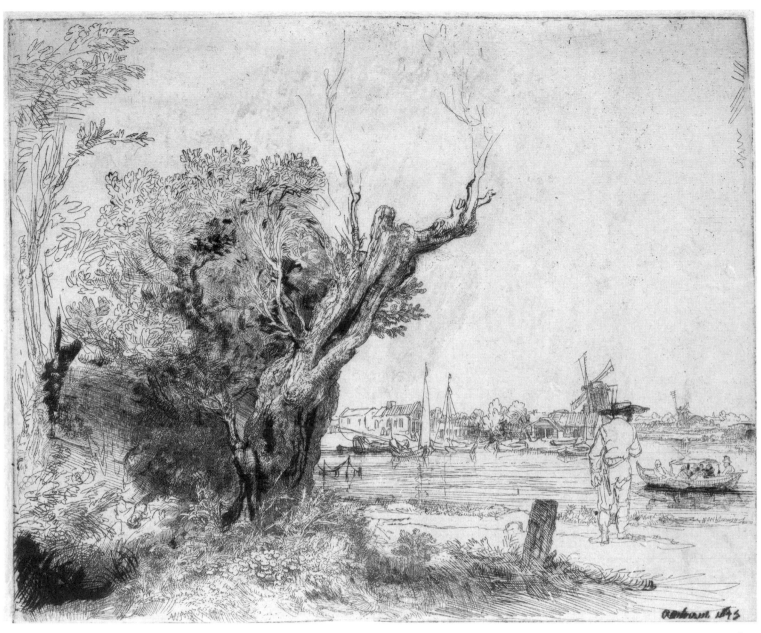

I Amsterdam

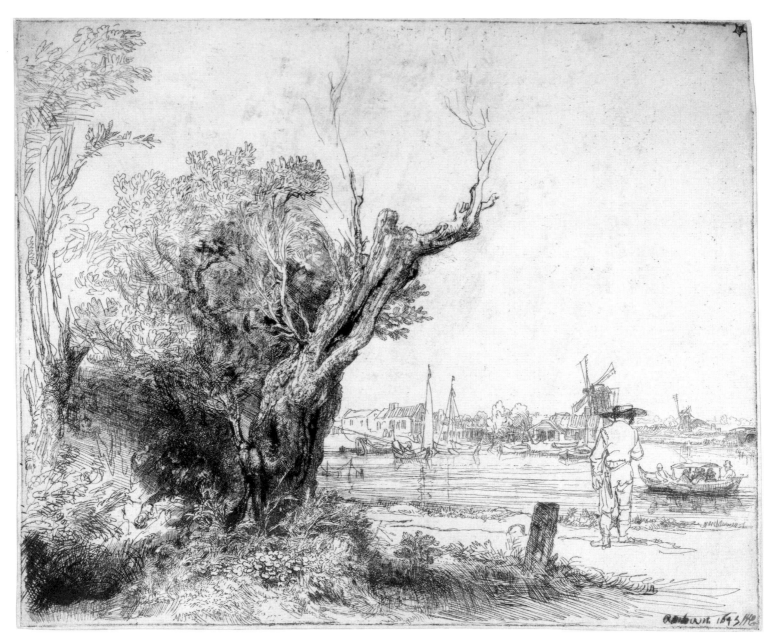

II London

They may be compared with those in the *Three trees* (cat. 48), and the depiction of young pairs embracing in landscapes was commonplace.[2] The gnarled old tree is reminiscent of contemporary *vanitas* imagery, but Rembrandt's intentions remain obscure. To judge from its upper branches, the print was left unfinished in any conventional sense, despite the fact that Rembrandt not only enriched the texture of the work with drypoint additions – among the earliest in his *oeuvre* to print with such abstract force (the effect wears away during the second state) – but also signed and dated the plate in the same medium. In his later landscapes the two techniques are integrated more harmoniously.

MRK

1 Amsterdam 1998, reproduces three drawings of the Omval by or attributed to Rembrandt (Benesch 1321, 1322 and a slight sketch sold at Christie's, Amsterdam, 15 Nov. 1983, lot 39), as well as drawings by Jan van Kessel and Philips Koninck, mentioning others (on p. 270) by Johannes Leupenius and Jacob Esselens. The site is now dominated by the execrable 135-metre 'Rembrandt Tower'.

2 Nevitt *op. cit.*, p. 171, rightly draws particular attention to Pieter Lastman's *Pastoral landscape* (private collection), an Italianate idyll in which the lovers are prominent. *Cf.* also the drawing of a *Landscape with lovers* by Paulus van Vianen in the Rijksmuseum (Boon 1978, no. 467).

51

Male nude, seated and standing ('The walking frame') *c*.1646

Etching, 194 × 128 mm

Hind 222; White & Boon 194 I (of III)

I Amsterdam★ (Van Leyden RP-P-OB-427; watermark: none); London (Cracherode 1973.U.983; watermark: Strasbourg lily [Ash & Fletcher 36, G.c.])

Watermark: this type of Strasbourg lily occurs frequently in the first state, but not in the second. It is also found in several other prints, of which the *Self-portrait, etching at a window* of 1648 (cat. 58) is the latest with a date. These impressions were therefore probably printed at around this time.

SELECTED LITERATURE: Boeck 1953, p. 191; Emmens 1979, pp. 209–20; Amsterdam 1984–5, nos 20–23; Dickey 1986, pp. 253–62; Berlin-Amsterdam-London 1991–2, pp. 224–6, no. 21; Bruyn 1991–2, pp. 80–81; Royalton-Kisch 1992, no. 87; White 1999, pp. 199–201.

Early in his career Rembrandt took the female nude as a subject, as in the *Diana at the bath* and the *Naked woman seated on a mound* (cats 10–11) of around 1631, and again in the *Artist drawing from a model* (cat. 36) of around 1639. However, it was not until 1646 that he etched three studies of male nudes. The *Seated male nude*

(B.193) and *Seated male nude, one leg extended* (B.196) each depict a single model, while the print shown here portrays the same young man twice. It also differs from the other two in including a genre scene of a woman teaching a child to walk in a baby walker in the background. Because of this motif the etching acquired the subtitle of 'The walking frame' as early as the eighteenth century, but the fact that the scene bears a thematic relationship to the model in the foreground went unremarked for many years. In the seventeenth century, teaching a child to walk in a baby walker was a common metaphor for 'learning' or 'practising' in general. Its illustration behind two studies from life must undoubtedly be read as an exhortation to young artists – they can only master their art by constant practice.[1]

We know that Rembrandt and his pupils drew from life and 'The walking frame' must have been made during one or more of such sessions. This can be deduced from the fact that the standing model in the etching also appears in three drawings by pupils, all shown here, in which he is seen from slightly different angles. This group of works gives us a unique glimpse of Rembrandt's studio – it not only provides documentary evidence of the instruction of his pupils, it also actually allows us to reconstruct the positions of the people who were there. The pupil whose drawing is now in Vienna was furthest to the left (fig. a). To his right sat Rembrandt, who almost certainly drew directly on to the copper plate (fig. b). Next to him was Samuel van Hoogstraten (fig. c), and finally, on the far right, the pupil who made the drawing now in London (fig. d).

Rembrandt probably drew the seated young man on to the copper plate first and then added the standing figure. The fact that he also worked directly on the plate when he drew the seated model is suggested by a number of corrections. The right forearm was originally thinner and Rembrandt added a strip along its lower edge. The more lightly hatched area along the underside of the young man's right thigh should perhaps also be interpreted in the same way. It is not clear whether this figure had already been bitten in acid before the standing young man made his appearance on the plate. Both nudes have lines that are more deeply etched and therefore look blacker than the others, which indicates that neither was completed in a single session.

It is nonetheless difficult to determine more precisely how Rembrandt set about his work, as the composition was completed in the first state. It is remarkable that the seated young man, in particular, displays various technical shortcomings. The top edge of his loincloth has vanished, and there are other places

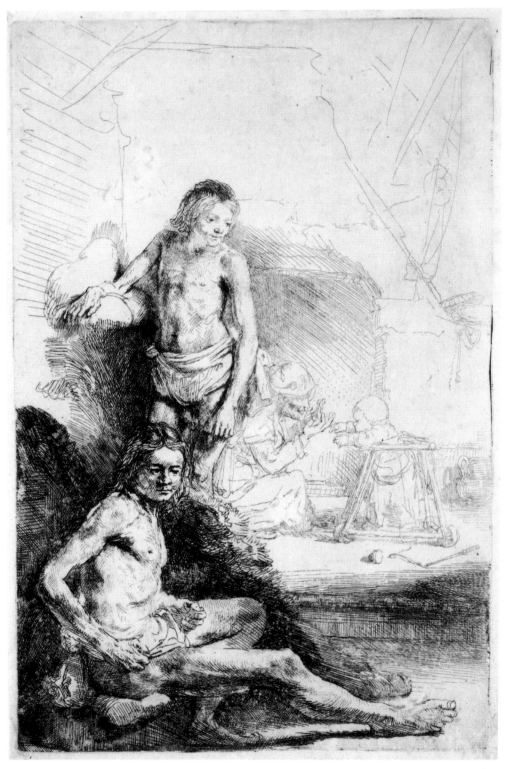

I Amsterdam

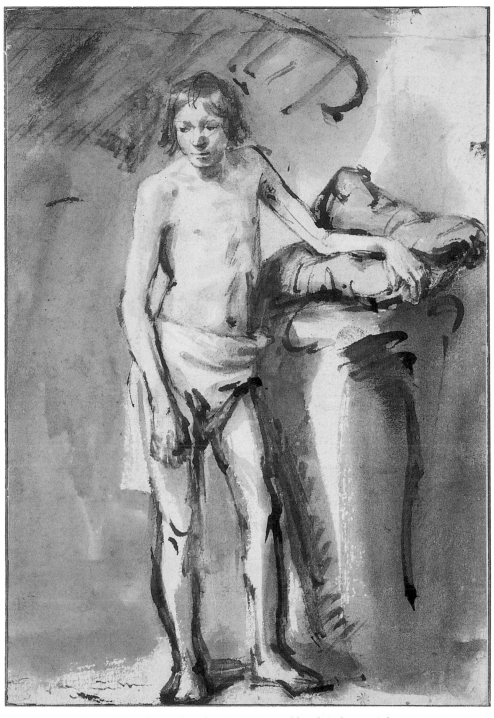

fig. a Rembrandt pupil, *Standing male nude*, c.1646. Pen and brush in brown ink, 198 × 133 mm. Vienna, Graphische Sammlung Albertina (Benesch 709; exh.)

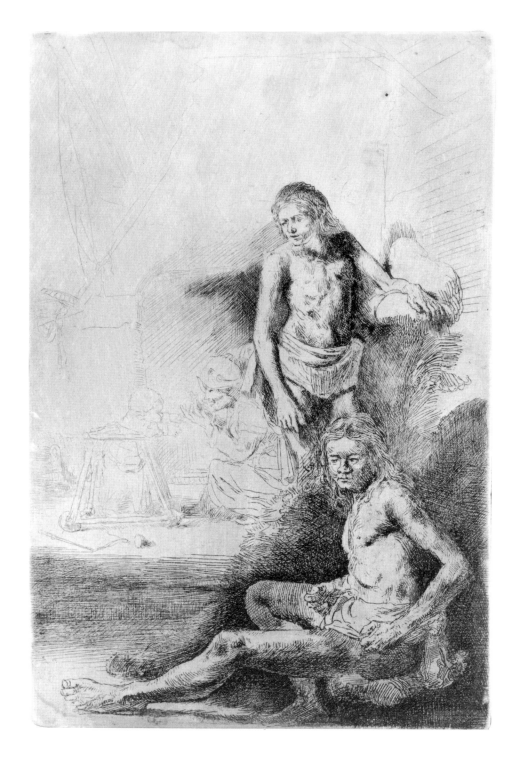

fig. b Rembrandt,
Male nude, seated and standing
['The walking frame'].
Copper plate, 198 × 129 mm.
USA, private collection (B.194)

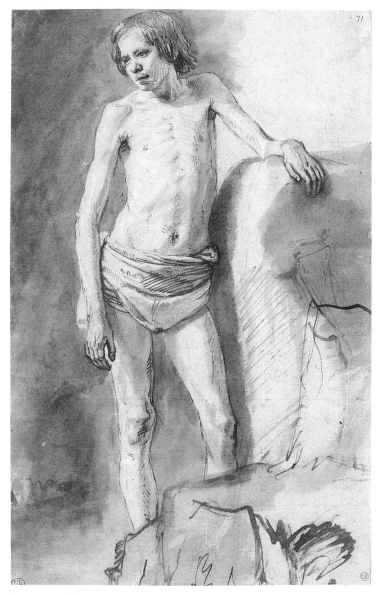

fig. c Samuel van Hoogstraten, *Standing male nude*, *c*.1646. Pen and brown ink, brown wash, with white body colour, 247 × 155 mm. Paris, Musée du Louvre (Benesch A55; exh. London)

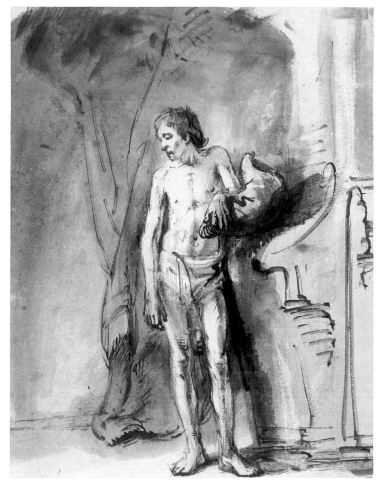

fig. d Rembrandt pupil, retouched by Rembrandt, *Standing male nude*, *c*.1646. Pen and brown ink, brown and grey wash, touched with red chalk and heightened in white; over black chalk, 252 × 193 mm. London, British Museum (Benesch 710; exh.)

where the lines are not bitten, leaving odd white patches. These imperfections were removed in the second and third states, but it is by no means certain that we should see Rembrandt's hand in them, firstly because the first state was evidently printed in a significant quantity: we know of at least twenty-six impressions; and secondly (and more importantly) because there are several known examples of the second and third states with watermarks that are not found in any good impressions of contemporary prints. These later states should therefore be dated to the late seventeenth or the eighteenth century.

EH

1 See Emmens 1979, pp. 209–20.

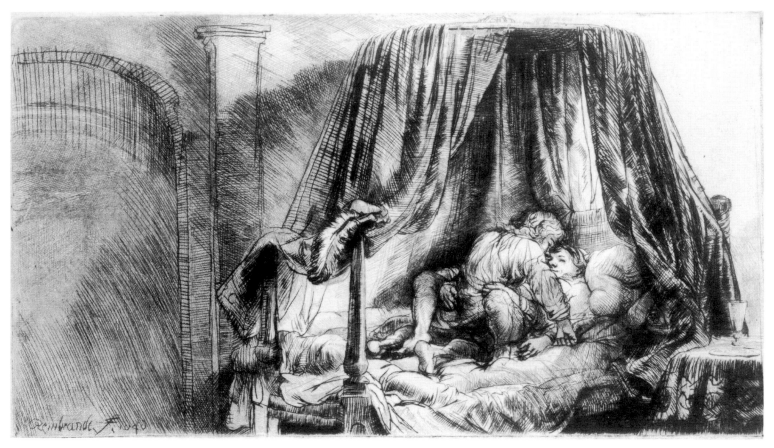

III Amsterdam

52

The French bed ('Le lit à la française') 1646

Etching, drypoint and burin, 125 × 224 mm; at lower left, *Rembrandt.f. 1646* (both sixes in reverse)

Hind 223; White & Boon 186 III (of V)

III Amsterdam★ (Van Leyden RP-P-OB-633; watermark: none)

SELECTED LITERATURE: Busch 1983; Amsterdam 1997, pp. 281–5; White 1999, pp. 186–7.

Given what we know about seventeenth-century morality, with its narrow-mindedness in matters of sexuality and eroticism, we are bound to wonder whether certain risqué works of art could circulate at the time. In 1647, one year after this etching was made, someone in Antwerp evidently took umbrage at certain prints with erotic themes that were available in the city. An astonishing twenty-two artists, including Jacob Jordaens, Jan Bruegel and Jan de Heem, testified that 'volumes of prints by Carracci, Rosso and De Jode are sold and traded every day showing the fornication of the gods and suchlike, and these picture-books are commonly purchased by print-lovers, indeed similar picture-

fig. a Agostino Carracci, *Satyr and nymph.* Engraving, 150 × 102 mm. Amsterdam, Rijksmuseum

fig. b Drawn copy of Marcantonio Raimondi after Giulio Romano, *Couple making love* (1524). Pen and brown ink, 135 × 186 mm. Paris. Bibliothèque Nationale de France (Ae 52 Réserve libre no. 3976)

fig. c Crispijn de Passe, *Night*. Engraving, 188 × 218 mm. Amsterdam, Rijksmuseum

books by Raphael of Urbino and Marco da Ferrara are also sold and traded as well as new ones made in Paris by Peter van Mol which are more scandalous still'.[1] It seems that respectable painters and plate-cutters wanted to emphasize their familiarity with such prints and to stress that they were standard collector's items – proof once again that the issue of who finds what offensive is timeless.[2]

Rembrandt's print collection also included a book with pictures of fornication (*boelering*) by Raphael, Rosso, Annibale Carracci and Giulio Bonasone.[3] 'Boelering' initially meant love-making, without any negative connotations, but by the seventeenth century it was equated with lewd acts between men and women.[4] Many of the prints that were alluded to in the Antwerp testimony and noted as in Rembrandt's album, including Agostino Carracci's *Lascivie* (*c*.1590–95), are known.[5] Some are highly explicit (fig. a), as is Marcantonio Raimondi's renowned series of positions *I modi* made in 1524 (fig. b). True, the Pope banned this series and it was taken out of circulation, but it lived on in imitations, including woodcuts furnished with salacious sonnets by Pietro Aretino.[6]

It is not impossible that Rembrandt's *French bed* was intended as a riposte to such expressions of undisguised classicizing lust, with the athletic gymnastics of the Roman school being replaced with a *mise en scène* far closer to reality. It is typical of his artistic approach to see a challenge in taking subjects with a certain tradition in art and giving them a twist of his own. In the final analysis, the visual ingredients of prints such as Raimondi's and Rembrandt's etching are not so very different.

On the other hand, countless images exist, many of them produced in northern Europe, with the sultry atmosphere that precedes the moment that Rembrandt has depicted with such immediacy. Particularly numerous are prints showing the *Children of Venus*, or allegorical representations of *Touch* from series depicting the senses, *Night* from the times of the day, *Luxuria* (Lust) from series of personifications of the Seven Deadly Sins, images showing the consequences of excessive drinking, racy biblical bed-scenes or pictures with a small, *piquant* image just visible in the background. Some of these, such as Crispijn de Passe's depiction of *Night*, contain all the elements found in Rembrandt's etching (fig. c).[7] A woman, a prostitute judging by her coiffure, invites a man who is lingering over a glass at the table, his head resting on his hand, to accompany her to the bed in a corner of the room. She has already picked up his plumed cap. Whether they are also to enjoy the privacy of a French bed,

a seventeenth-century name for a curtained bed which became the euphemistic title of Rembrandt's 'boelering', it is impossible to tell.[8] In a sense Rembrandt's *French bed* is the next moment in a story such as that related by De Passe, and carries on where others – with a few exceptions (fig. d) – break off their narrative.

Because of the many thematic contexts in which expressions of lust turn up in the seventeenth century, it is understandable that some writers have attempted to construe the picture as an allusion to the Prodigal Son in the brothel. That Rembrandt intended to depict this moment in the parable cannot be proven, but certain renderings of the story show a very similar scene albeit in the background (fig. e). In the sixteenth and seventeenth centuries, endeavours were made to enhance the parable's topicality by dressing the protagonists in contemporary apparel, and in 1630 a play appeared entitled *Present-day Prodigal Son*.[9] A fixed attribute of most images with this theme is a beret sporting a large plume, an ambiguous accessory, which Rembrandt certainly would not have draped so ostentatiously over the bedpost without good reason.[10]

Inserting drawing-like, drypoint accents, Rembrandt took great pains over the beret and feather. The velvety effects of this technique dominate the print, which – partly for this reason – is extremely rare. At the proof stage, there was an unworked strip along the top of the copper plate, about two and a half centimetres high. Having removed it, Rembrandt turned his

fig. e Abraham Bosse, *The Prodigal Son in the brothel*. Etching and engraving, 262 × 327 mm. Amsterdam, Rijksmuseum

attention to details, albeit selectively. He burnished the plate in the man's right sleeve and inserted new lines there in drypoint, yet he did not deprive the woman of either of her two left arms. In the fourth state the tablecloth acquired some diagonal hatching. From then on, impressions appear increasingly worn. Following Rembrandt's death, when the plate had suffered too much to produce a clear impression, a five-centimetre strip was cut off along the left side, eliminating the passageway that had given the room a palatial ambience.

GL

1 They bore witness that: 'hier dagelycx vercocht ende verhandelt worden de boecxkens van printen van Carats, van Rous ende van De Jode inhoudende boeleringen van de goden ende diergelijcke, ende dat deselve print-boecxkens onder de liefhebbers gemeyn syn, jae dat oick vercocht ende verhandelt worden diergelycke printboecxkens van Rafaël Urbino ende Marco de Ferrara ende de nieuwe gemaeckt tot Parys by Peter van Mol dewelcke veel schandeleuser syn ...' (Duverger V, pp. 399–400).

2 The artists' biographer Arnold Houbraken, following in the train of Florent Le Comte, would describe many of these images as *geil en onbeschoft* (lascivious and boorish); see Houbraken 1718–21, III, pp. 203–5.

3 Strauss & Van der Meulen 1979, 1656/12, no. 232.

4 *Woordenboek der Nederlandsche Taal* III–1, cols 142–3.

5 See DeGrazia Bohlin 1979, pp. 289–305.

6 Lawner 1988 and Talvacchia 1999. A great deal of material related to this series is collected in Dunand & Lemarchand 1977.

7 See Franken 1197; Hollstein XVI, pp. 79–80, nos 295–89 ad.

8 For 'un lit à la Françoise', see *Woordenboek der Nederlandsche Taal* VIII–1, col. 1231.

9 See Amsterdam 1997, pp. 118–23, no. 19, esp. p. 120.

10 Ibid., p. 284, with a quotation from Roemer Visscher's *'t Lof van de mutse*.

fig. d Anonymous, French or Flemish, *Two couples making love*. Engraving, 80 × 91 mm. Paris, Bibliothèque Nationale de France

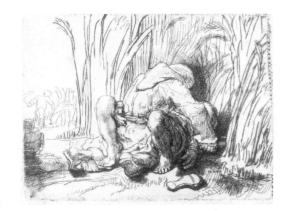

London

53

The monk in the cornfield *c.*1646

Etching and drypoint, 47 × 66 mm.

Hind 224; White & Boon 187 (only state)

Amsterdam (De Bruijn RP-P-1961-1094; watermark: none); London★ (1848-9-11-95; watermark: none)

SELECTED LITERATURE: Rifkin 1972, p. 124; Amsterdam 1999–2000, p. 136; White 1999, p. 186.

The *sujets libres* in Rembrandt's print oeuvre include the *Monk in the cornfield*, which shows in miniature a deed as old as humanity. Like the other prints in this group (including cat. 52), the etching is extremely rare, and given the fineness of the lines and the use of drypoint, not many impressions can have been produced.

The scene is a cornfield at the height of summer. The crops are so tall that the sexual act can take place unobserved. In the distance a man wields a scythe. Although Rembrandt is known for his sweeping brushstrokes, here he displays an astonishing amount of detail in just a few square centimetres. The figures have been conveyed with immense care. The monk is not supporting himself with flat hands, but has clenched fists, his toes dig into the ground and his sandals come loose from his heels. The woman beneath him is barefoot. She puts her right arm around him encouragingly while her other arm extends slackly on the ground. The tonsured monk wears a hooded habit; his leather or vellum-covered pocket Bible or Prayer Book, removed from its place under his girdle, lies to one side. At left stands a jug that identifies the woman as a milkmaid.

Rembrandt often took inspiration from an existing print, and in the case of the *Monk in the cornfield* this was an engraving by Heinrich Aldegrever (fig. a), which several other artists also copied.[1] It shows a monk and a nun being interrupted in their

open-air sexual activities by a *Landsknecht* with a sword. The tone is admonitory, and the devil is ensconced in the tree above them. Aldegrever, an adherent of the Reformation, takes a swipe at the Catholic clergy by highlighting their carnal sins, a hot topic in his day that attracted the righteous indignation of many a pamphleteer.[2]

Rembrandt's interpretation is not entirely free of satire, but it is more good-natured in tone. He seems to be drawing on the medieval tradition that represented monks and priests as extremely potent. Especially in the genre of farce this image recurs again and again, and one of the examples in Jan van Stijevoort's sixteenth-century *Refereynenbundel* is the poem *The monk and his temptress*.[3] One standard episode features a husband away from home and a monk or curate paying a call to keep the man's wife company; the husband then reappears just when matters have taken a particularly friendly turn. Even before 1500, woodcuts were printed showing the furious husband taking revenge on the cleric, and not infrequently on his adulterous wife too, transforming the marital bed into a bloodbath.[4]

Rembrandt opted for eroticism *en plein-air* and set the intimate encounter in the countryside, as did other artists who showed their figures enjoying earthly pleasures while reclining on the

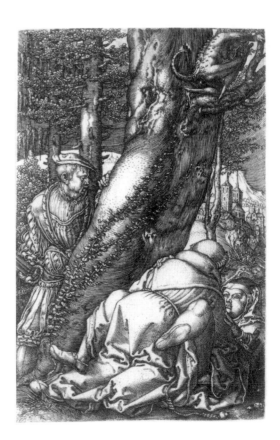

fig. a Heinrich Aldegrever, *The monk and the nun with the devil in the tree.* Engraving, 117 × 74 mm. Amsterdam, Rijksmuseum

earth's surface. The very few who dared to go as far as Rembrandt in depicting the subject produced works exhibiting the total lack of artistic quality that is the hallmark of all early pornography (fig. b). In the sixteenth century in particular, the lovers had generally retired into the corn in the background of a painting of a peasant wedding or *kermis*. The painting by the Brunswick Monogrammist, which has at its centre a passionate couple who have secluded themselves from the fairground crowds (fig. c) and Albrecht Altdorfer's matchless drawing *Lovers in the cornfield* (fig. d) are exceptions to the rule.[5] It is usually peasants who are depicted giving their lust free rein, and Rembrandt too confirmed the milkmaid's great reputation in the erotic sphere in his surprising *pas de deux*.[6]

Until the late seventeenth century, the monk who had accepted the rule of chastity but nonetheless took certain liberties in relation to the female sex was a common character in Netherlandish art. Most are mischievous, comic figures who answer to the cliché of the rotund Catholic cleric (fig. e).[7] They never have the magnificence of Rembrandt's faceless monk, who seems to be totally absorbed in his pleasure.

GL

fig. b Anonymous French or Flemish, *Couple lovemaking in the meadow.* Engraving, 76 × 90 mm. Paris, Bibliothèque Nationale de France

1 The New Hollstein (German), *Heinrich Aldegrever*, 30. Aside from a variant by Aldegrever himself (ibid., 29), there are two copies, one with a text, wrongly reproduced as by Aldegrever in Amsterdam 1999–2000, p. 146.

2 For the interpretation of Aldegrever's engraving, see Janey L. Levy in Lawrence-New Haven-Minneapolis-Los Angeles 1988–9, pp. 186–8.

3 For such farces, see Van Altena 1997, based on Noomen & Van den Boogaard 1983–99. The 1524 poem by Van Stijevoort is included in Van Straten 1992, pp. 73–5.

4 Fuchs 1909, p. 125, fig. 108.

5 For the painting, see Becker 1994 and Müller 1997; for Altdorfer's drawing, see Hans Mielke in Berlin-Regensburg 1988, no. 28.

6 Amsterdam 1997, pp. 260–63, no. 52.

7 See Paul Dirkse in Utrecht 1981, pp. 43–7. Cornelis Dusart's mezzotint is one of a series of six; see Hollstein 57–62. Jacob Gole (*c*.1660–1737) also produced prints of monks, some more satirical than others (see, e.g., Hollstein 185–6, both after Cornelis Dusart).

fig. c Brunswick Monogrammist, *Couple in the cornfield*. Panel, 203 × 281 mm. Brunswick, Herzog Anton Ulrich-Museum

fig. d Albrecht Altdorfer, *Couple in the cornfield*, 1508. Pen and black ink, 221 × 149 mm. Basel, Kunstmuseum, Kupferstichkabinett

fig. e Cornelis Dusart, *The groping monk*. Mezzotint, 187 × 147 mm. Amsterdam, Rijksmuseum

54

Jan Cornelisz. Sylvius, preacher 1646

Etching, drypoint, burin and tone, 278 × 188 mm; signed and dated upper centre: *Rembrandt 1646* (for the further inscriptions, see below)

Hind 225; White & Boon 280 I (of II)

I London★ (Cracherode 1973.U.984; with Dighton's mark [L.727]; watermark: Strasbourg bend [Ash & Fletcher 35, A.a.])

Watermarks: the watermark in the first state also occurs in impressions of the second state, and in a variety of other prints. It can be dated around 1646.

SELECTED LITERATURE: Münz 1952, no. 68; Haak 1969, p. 193; Boston-St Louis 1980–81, no. 97; Paris 1986, no. 68; Berlin-Amsterdam-London 1991–2, pp. 227–30, no. 22; Royalton-Kisch 1992, no. 46; Royalton-Kisch 1993b, pp. 178–80; White 1999, pp. 141–4.

Jan Cornelisz. Sylvius (1563/4–1638) was a cousin by marriage of Saskia Uylenburgh (1612–42), whom Rembrandt married in 1634. In 1635 and 1638 Sylvius officiated at the baptisms of their children, Rumbartus and Cornelia (who both died in infancy). Having served as a minister for the Dutch Reformed Church in several Frisian communities, he was called to Sloten near Amsterdam and the Gasthuiskerk in the city itself in 1610, and after 1622 was employed at the Oude Kerk. He died in 1638.

Rembrandt etched a portrait of him in 1633 (fig. a), the year of his betrothal to Saskia, a print that has never been counted among his most successful productions.[1] But the reasons for making a new plate of the sitter eight years after he had died remain obscure.[2] Like the portraits of *Cornelis Claesz. Anslo* and *Jan Six* (cats 45 and 57), it is a highly detailed print, and was prepared in a quick draught (fig. b) as well as a full-size drawing (fig. c). Both sketches were preliminary ideas and not made from life; nor were the outlines of either indented for transference to the plate. Indeed, the sitter's pose was there altered again so as to reach out of the fictive oval frame.

The first sketch (fig. b) already anticipates the general layout of the design and marks out the lines of poetry in two columns below. The second, more vigorous drawing (fig. c) turns the sitter outwards and thrusts his hand forward, casting a shadow on the outer frame. This conceit was probably developed from earlier figures by Rembrandt, including Frans Banning Cocq in the *Night Watch* and his several portrayals of *Cornelis Claesz. Anslo* (see cat. 45), and is employed to dramatic, illusionistic effect in the etching of Sylvius. In two representations of Anslo (there figs b and c), the second arm is crooked and pressing down as shown here (fig. c). Also visible are the background curtain and a vertical

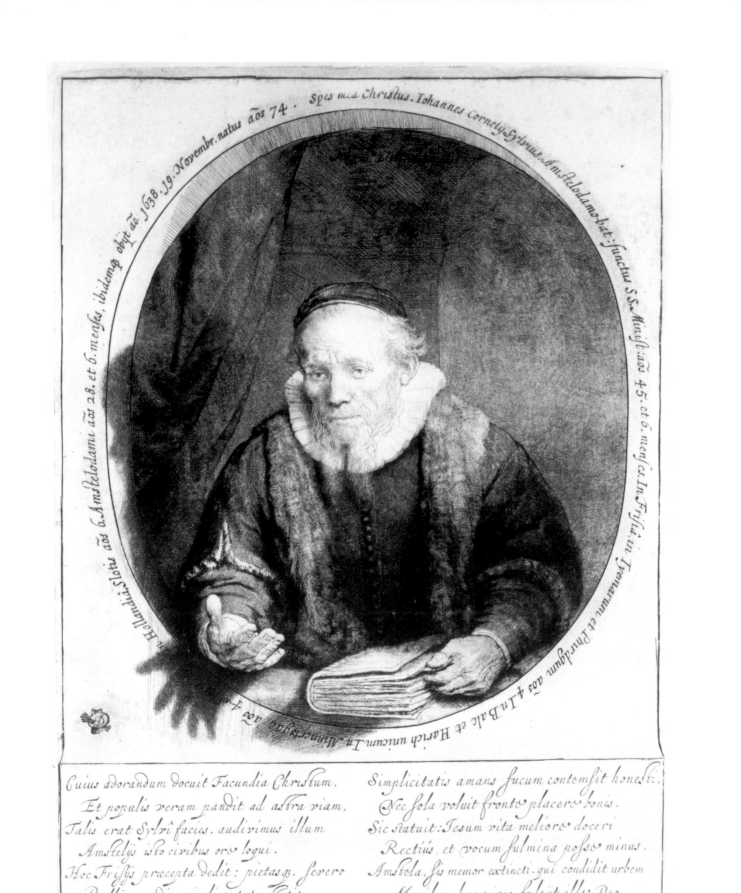

Spes mea Christus. Iohannes Cornely Sylvius Amstelodamo bat: functus SS. Ministerio 45. et 6. menses. In Frisiâ, in Frenetum et Phrisdum aos 41. In Bal et Harch unicum. In Minnerspie aos 4...

Cuius adorandum docuit Facundia Christum.
 Et populis veram pandit ad astra viam,
Talis erat Sylvi facies. audivimus illum
 Amstelys isto civibus ore loqui.
Hoc Frisys præcepta dedit; pietasq; severo
 Relligiog; diu vindice tuta stetit.
Præluxit, veneranda suis virtutibus, ætas.
 Erudytg; ipsos sossa senecta viros.

Simplicitatis amans fucum contemsit honesti.
 Nec sola voluit fronte placere bonis.
Sic statuit: Iesum vita meliore doceri
 Rectius, et vocum fulmina posse minus.
Amstela, sis memor extincti. qui condidit urbem
 Moribus, hanc ipso fulsyt ille Deo.
 C. Barlæus.
Haud amplius deprædico illius dotes,
 Quas æmulor, frustraque persequor versu.
 P. S

I London

line that marks the point where the architecture was to abut the figure in the etching.[3]

The sitter's oratorical powers are referred to in the poem below by Caspar Barlaeus: 'His eloquence taught of Christ who must be adored and has opened for men the true way to the stars, such was the face of Sylvius. We have heard him speak to the citizens of Amsterdam with this same aspect. He gave precepts to the Frisians, both piety and religion have remained long secure through his stern championship. He stood out in his lifetime, venerated for his own virtues. And in his worn old age he continued to instruct his fellow men. A lover of honest simplicity he spurned outward appearances. Nor did he wish to please good men by appearances alone. Thus he decided: that Jesus can be taught more properly through leading a better life than by thundering speech. O Amsterdam, be mindful of this man now deceased, who shaped your city with his character and made it glorious in God's sight.' This is followed by two additional (and feeble) lines by Petrus Scriverius: 'I cannot advertise this man's gifts better. My attempt to emulate them in pursuing verse is in

fig. b Rembrandt, *Study for Jan Cornelisz. Sylvius*. Pen and brown ink, 143 × 115 mm. Stockholm, Nationalmuseum (Benesch 762a; exh. Amsterdam)

vain.' The inscription around the oval reads: 'My hope is Christ. Johannes Cornelisz. Sylvius, Amsterdammer, filled the function of preaching the holy word for 45 years and 6 months. In Friesland in Tyemarum (Tzummarum) and Pherdgum (Firdgum) four years; in Balk and Haring one year; in Minnertsga four years; in Sloten, Holland, six years; in Amsterdam 28 years and 6 months. He died there on 19 November 1638, 74 years of age.'[4]

The etching is known in just two states, with only the minor infilling of an unintentional highlight by Sylvius' right eye to differentiate them. This obscures the complexity of its development. The plate is heavily worked up in both etching and drypoint, and enriched with a subtle tone process that is most clearly visible in the face. Although similar to the nineteenth-century technique of sulphur tinting, Rembrandt's own method may have been different.[5] The plate must also have been proofed as it was sent to a specialist letterer. The result as printed has the aspect of a memorial, and the elaborate technique produces rich tonal and textural effects.

fig. a Rembrandt, *Jan Cornelisz. Sylvius*. Etching, 1633, 166 × 141 mm. London, British Museum (B.266 II)

fig. c Rembrandt,
*Study for Jan
Cornelisz. Sylvius.*
Pen and brown
ink, touched
with white,
285 × 195mm.
London, British
Museum (Benesch
763; exh.)

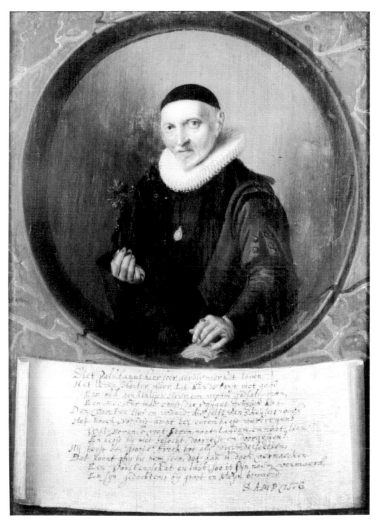

fig. d Hendrick Pot, *Bernardus Paludanus*. Oil on panel, 265 × 190 mm. Haarlem, Frans Halsmuseum

Some precursors of Rembrandt's striking design have been enumerated, in particular works by Gerrit Pietersz. Sweelinck and Frans Hals.[6] Also worthy of inclusion in the discussion is Hendrick Pot's *Portrait of Bernardus Paludanus* of 1629, with its accompanying poem below by Samuel Ampzing (fig. d).[7]

MRK

1 Münz 1952 thought it had been produced with studio assistance.

2 Ekkart, in Amsterdam 1986, suggested that Rembrandt may have wished to reaffirm his links with Saskia's family at this time; but the portrait is especially elaborate and with its poem suggests that another reason prompted it. It may have been commissioned.

3 The drawings are discussed further in the Introduction, pp. 70–71. Another (Benesch 762, Washington) is sometimes connected with the etching, but the relationship is questionable (see Royalton-Kisch 1992, p. 117, n. 4).

4 My thanks to Antony Griffiths for improving the translation.

5 Compare the remarks under cat. 48.

6 See Münz 1952, no. 68 and Boston-St Louis 1980–81, p. 150. The works concerned are reproduced in Slive 1970–74, I, fig. 9 and II, pls 14, 60, 81, 82 and 210. Welzel, in Berlin-Amsterdam-London 1991–2, p. 230, also rightly points to Jan van de Velde's engraving after Hals' portrait of *Petrus Scriverius* (Hollstein 407), although the scale is very different. See also Van de Velde's print after Hals' portrait of *Johannes Acronius* (Hollstein 384).

7 Discussed in Amsterdam 1992, no. 23.

55

The Jewish physician Ephraïm Bueno 1647

Etching, drypoint and burin, 241 × 177 mm; signed and dated lower right: *Rembrandt f. 1647*

Hind 226; White & Boon 278 I (of II)

I Amsterdam (Van Leyden RP-P-OB-558; watermark: none); London★ (1847-11-20-7; watermark: Basilisk [Ash & Fletcher 12, A′.a.])

Watermark: the Basilisk seen here is especially common in early impressions of prints of around 1641, including the *Cottage with a haybarn* (cat. 40) and the *Virgin and child in the clouds* (cat. 43). The same paper must still have been available in 1647 because of this impression of *Ephraïm Bueno*, and it is also often found in the second state of this etching.

SELECTED LITERATURE: Mariette 1857, p. 355; Six 1921, pp. 36–7, no. 236; Landsberger 1946, pp. 47–9; Amsterdam 1986, pp. 49–52; Dickey 1994, pp. 32–6; White 1999, pp. 144–6.

The physician and writer Ephraïm Hezekiah Bueno (1599–1665), also known by the Latinized name Bonus, came from a Portuguese Jewish family that had already produced a number of renowned doctors. In 1625, for instance, his father was called to Prince Maurits's sickbed because of his reputation as a physician. Bueno wrote poems in Spanish, made translations, and was also an important backer of the Jewish printing-house run by Samuel Menasseh ben Israel, as well as being one of its customers.

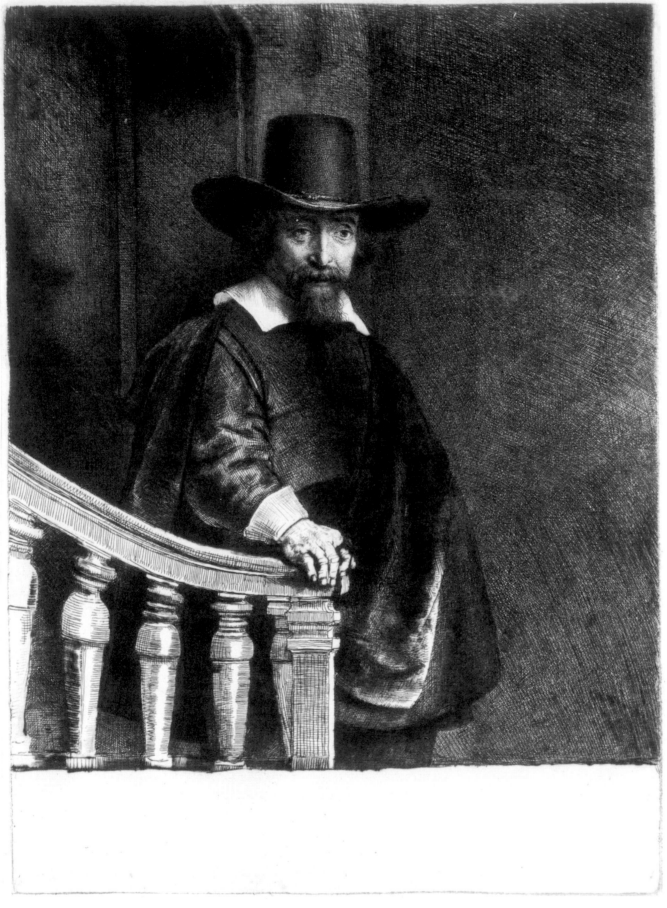

I London

228

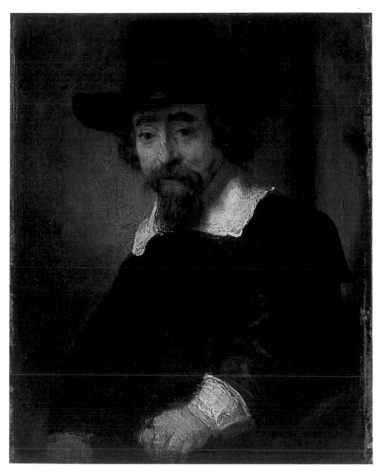

fig. a Rembrandt, *Ephraïm Bueno*, *c*.1647. Oil on panel, 190 × 150 mm. Amsterdam, Rijksmuseum (exh.)

Menasseh ben Israel lived across the road from Rembrandt in the Jodenbreestraat and may have been portrayed by him as early as 1636 (B.269).[1] It was probably he who brought about the meeting between Bueno and Rembrandt.

Bueno is shown standing, like *Jan Asselijn* and *Jan Six* in Rembrandt's portraits of them made in the same year (cats 56–7).[2] He lingers at the bottom of a staircase with his hand on the banister and wears a dark suit, with sharply contrasting white collar and cuff, a cape cast loosely over his shoulders, and a hat with a broad brim. A wide strip under the portrait was left blank for a text, but none was ever added.

This portrait is exceptional among Rembrandt's etched works because it was not executed directly on the plate or with the aid of drawings, but was based on a preliminary study painted on a panel about the same size as the print and included here (fig. a). It shows Bueno in the same pose, albeit only half-length. His body has been laid down with broad brushstrokes, while much more attention has been devoted to the face with its heavy eyebrows. The subtle play of light on the face and around the eyes is striking, and Rembrandt has transferred this faithfully to the etching. The composition of the print has been enlarged slightly all round, so that more of the figure can be seen in the picture space and the banister is clearly visible. The dark tones of the background were achieved with lively etched lines, strengthened with the burin towards the upper left, and the velvety black of Bueno's clothes was enhanced through the use of drypoint.

It is often remarked that while Rembrandt may have used the small oil sketch as his starting point for the etching, he introduced a significant change. In the study Bueno looks directly at us, but his gaze has shifted in the print. This gives him a slightly distant, even melancholy expression. The question is whether this was intentional. On close examination, Bueno appears to be squinting slightly: he looks straight at us with his left eye, as he does in the painted sketch, but not with the other. Rembrandt was evidently not concerned about this – there are two known states of the etching, but the alterations do not involve the eyes.

The extremely rare first state shown here can be regarded as a trial, because the banister is clearly indicated but not finished, and Bueno's cloak has almost white highlights. In the second state Rembrandt darkened these passages to increase the tonal harmony. Finally, he removed the heavy burr from the ring on Bueno's right hand, so that it can be seen more clearly (fig. b). It is curious that it was precisely this last, tiny change that was to be remarked upon early. In 1731 the Delft collector Valerius Röver

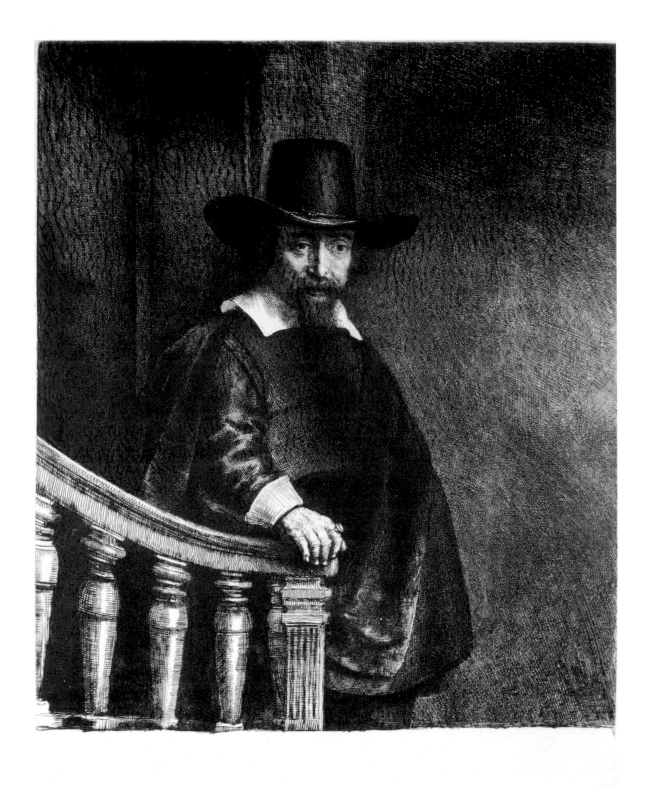

fig. b Rembrandt, *Ephraïm Bueno*, 1647. Etching, drypoint and burin, 241 × 177 mm. Amsterdam, Rijksmuseum (B.278 II)

described the impressions he owned as '2 of the portrait of the Jewish Doctor with the white ring and the black ring on the finger, the latter is also very rare'.[3]

EH

1 The identification of this latter portrait was recently called into question. See Dudok van Heel 1993, pp. 22–9.

2 The fact that this is a portrait of Bueno is confirmed, as it is in the case of Jan Asselijn (cat. 56), by an inscription on an impression that is now in Florence (Uffizi, inv. no. 6176). This once belonged to Pierre Mariette II, who wrote on it, in addition to his name and the year 1684, the words *Buono, docteur juif* (in pen and brown ink).

3 See Van Gelder & Van Gelder-Schrijver 1938, p. 11.

56

Jan Asselijn, painter (known as 'Crabbetje') *c.*1647

Etching, drypoint and burin, 216 × 170 mm; signed and dated lower right corner: *Rembr[andt] f 16* (the last two digits are missing)

Hind 227; White & Boon 277 I and II (of III)

I Amsterdam★ (Van Leyden RP-P-OB-553; on Japanese paper; *recto* inscribed in pen in brown ink: *Crabbetje alias Asselin a Painter.*)

I Amsterdam★ (De Bruijn RP-P-1962-105; on cartridge paper [according to White & Boon, on Indian paper])

II Amsterdam★ (De Bruijn RP-P-1961-1152; inscribed in pen and brown ink: *Asselijn alias krabbetie*, and lower right: *Rembrandt* and: *N°. 177*; watermark: Post horn [Ash & Fletcher 31, B.a.]); London (1982.U.2717; watermark: none)

Watermarks: the Post horn does not appear in other etchings by Rembrandt, which makes it impossible to date the impression.

SELECTED LITERATURE: Mariette 1857, pp. 354–5; Benesch 1926, p. 9; Benesch 1927, p. 22; Boston-New York 1969, no. 1; Amsterdam 1986, pp. 45–8; Chapman 1990, p. 83; Dickey 1994, pp. 39–46; White 1999, pp. 152–3.

This etching has always been known as a portrait of the landscape painter Jan Asselijn (*c.*1614–1652). The earliest confirmation dates from 1668, when the Parisian art dealer Pierre Mariette wrote *Crabbeten Penter* on an impression.[1] Asselijn's left hand was deformed, and during his stay in Rome fellow-members of the Dutch painters' association, 'De Bentvueghels', nicknamed him 'krabbetje' – Dutch for 'little crab'. It is difficult to say how old he was when the portrait was made, and his date of birth is unknown. He was probably born in Dieppe in northern France, and moved to Amsterdam in 1620. A few cavalry battles are known from his early *oeuvre*, in the style of Esaias van de Velde, but after his departure for Italy in around 1636 he concentrated on painting Italianate landscapes which met with great success. In

1647 he returned to Amsterdam, where he died, still rather young, in 1652.[2]

There are three states of the portrait that Rembrandt etched shortly after Asselijn's return to Holland, even though the representation was virtually finished in the first state. Asselijn is shown standing and looking out at the observer, confidently resting his good hand on the table and discreetly tucking the other into his side. He cuts a dashing figure in an elegant, loosely draped coat, with lace cuffs, gloves and a sweeping hat. The only allusion to his occupation are the painter's attributes displayed around him; and he stands in front of a painter's easel, which supports one of his Italianate landscapes. Books, a palette and a few paintbrushes lie on the table. The attributes were simply etched, but the figure was first drawn with the etching needle and then worked up in drypoint and possibly with the burin. This enabled Rembrandt to achieve an unusual tonal effect.

The plate is Rembrandt's first portrait of a fellow-artist, and it may be no coincidence that he here experimented with different papers, using Japanese, cartridge and possibly even Indian paper. The deep yellow of the Japanese paper tones down the contrast, and Rembrandt applied surface tone to reduce it even further, as in the first impression shown here. The first state on cartridge paper, also shown, looks different: the coarse, pale-yellow paper enlivens the portrait, and as this sheet was printed with little surface tone, it is brighter and the details are sharper.

The easel and painting were erased in the second state (also illustrated), but traces of them are still visible around the figure. Though the alteration does not improve the spatial effect, the figure of Asselijn is more compelling without the easel towering above him. It is not known when this change was made. At least eighteen impressions of the first state are known, so it is by no means rare, and the second state may date from considerably later, and possibly be the work of another hand. The inscription by Pierre Mariette on an impression of the second state indicates that the state must in any event date from before 1668.

The traces of the easel in the background of the scene were finally removed in the third state, but it is doubtful whether this was done during Rembrandt's lifetime. There are numerous impressions of this state on watermarked paper, but all appear to be posthumous prints, and none of these watermarks are found on good, contemporary impressions.

EH

1 Washington, National Gallery of Art, inv. no. 1943.3.7158 (second state).

2 For Asselijn's biography, see Steland 1989, p. 11.

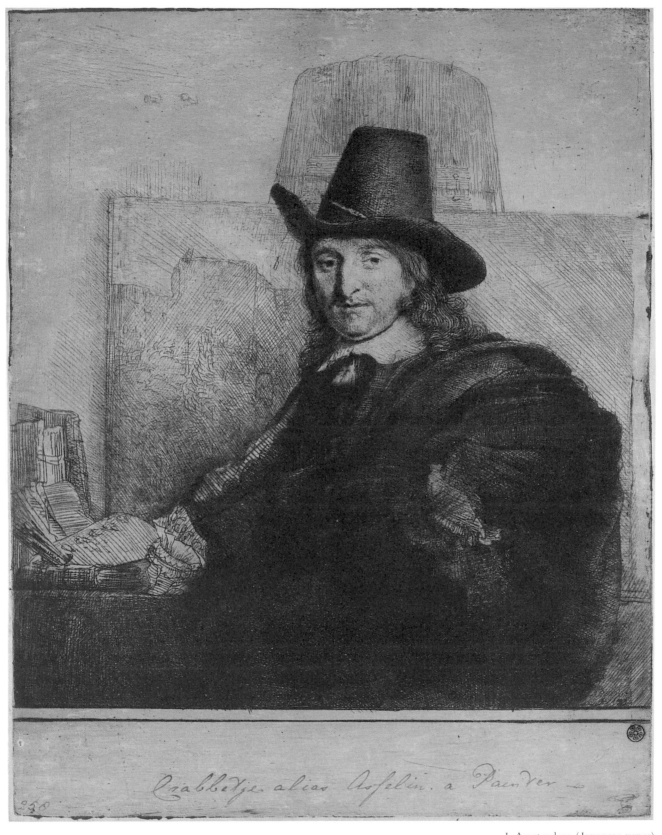

I Amsterdam (Japanese paper)

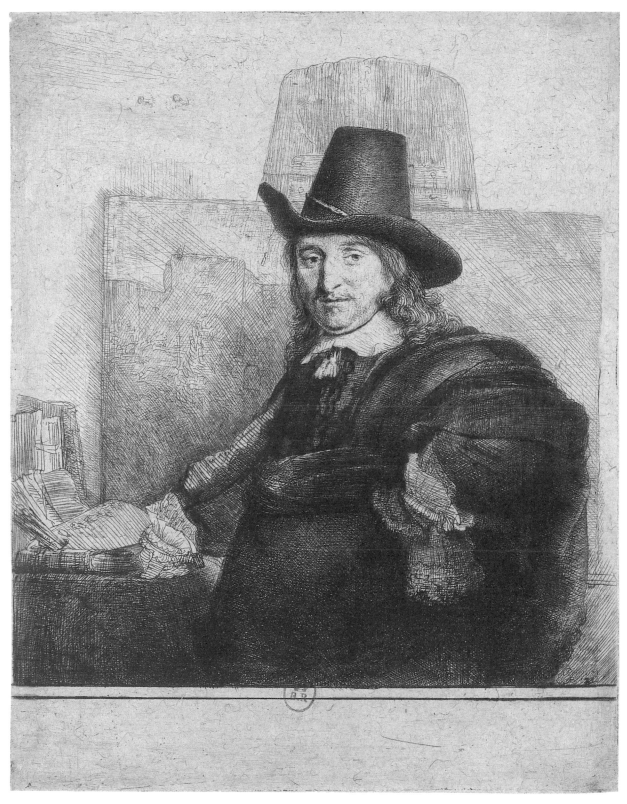

I Amsterdam (cartridge paper)

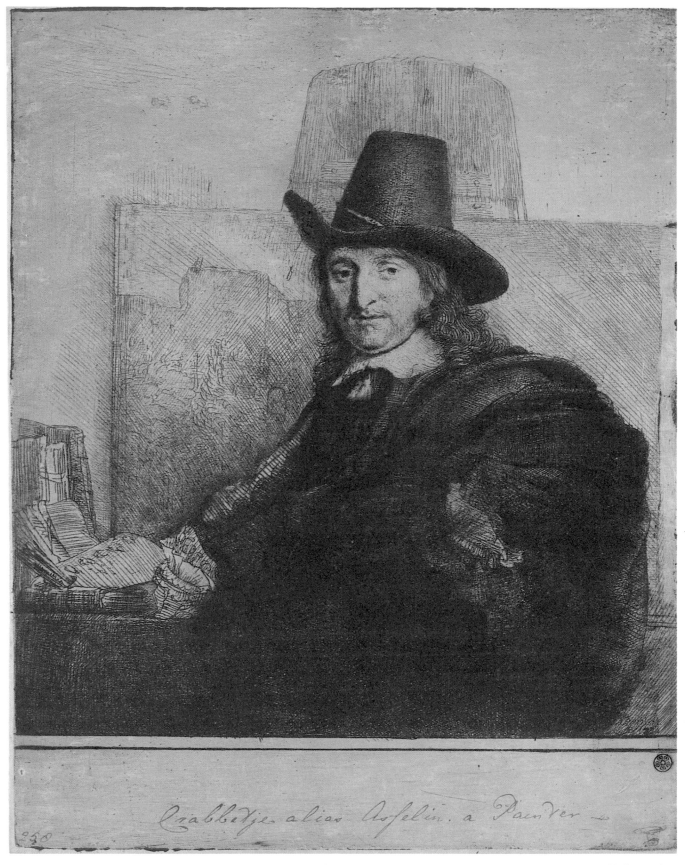

Crabbetje alias Asselin. a Paender

57

Jan Six 1647

Etching, drypoint and burin, 244 × 191 mm; from II signed and dated in lower margin: *Rembrandt f. 1647* [the '6' and '4' reversed until corrected in IV]; from IV also inscribed: *IAN SIX AE: 29*

Hind 228; White & Boon 285 I, II and IV (of IV)

I Amsterdam★ (Van Leyden RP-P-OB-578, on Japanese paper)

II Amsterdam★ (De Bruijn RP-P-1962-III, on Japanese paper)

IV Amsterdam (De Bruijn RP-P-1961-1160; watermark: countermark VA [Ash & Fletcher 26, VA´.a]); London★ (Cracherode 1973.U.987; watermark: Strasbourg lily [Ash & Fletcher 36, D´a.])

Watermarks: the watermark and countermark in the Amsterdam and London impressions of the fourth state listed above are from the same paper. It was also employed for the first state of the *Hundred Guilder Print* (cat. 61) and the fourth state of the *Marriage of Jason and Creusa* of 1648 (B.112). These impressions are therefore likely to date from *c*.1647–8.

SELECTED LITERATURE: Boston-New York 1969, no. 2; Paris 1986, no. 70; Berlin-Amsterdam-London 1991–2, pp. 231–3, no. 23; Royalton-Kisch 1993b, p. 176; White 1999, pp. 146–50.

Rembrandt's etched portrait of *Jan Six* has attained almost mythical status. Already in the eighteenth century, when its pictorial finish was wholly in accord with prevailing taste, its rarity and desirability gave rise to special comment. Gersaint in 1751 stated that it was 'aujourd'hui d'une rareté infini […] le plus cher morceau de ce Maître […] une des plus belles choses que Rembrandt ait fait',[1] and its allure was combined with legends concerning the artist's friendship with the sitter, whose family owned one of the most complete collections of Rembrandt's etchings ever assembled.[2]

Technically and stylistically the fastidious style of the print is surprising in the context of Rembrandt's work as a painter and draughtsman in the later 1640s, when economy of means and an increasingly bold impasto became the hallmarks of much of his output. Harking back to such plates as the *Angel appearing to the shepherds* of 1634 (cat. 21), the *Goldweigher* of 1639 (cat. 167) and the *St Jerome in a dark chamber* of 1642 (B.105), Rembrandt here achieves a new refinement in the production of a rich, velvety, background tone, etching and scratching layer upon layer of cross hatching on to the plate. Unable, as in his paintings, to employ a rough surface texture to increase the illusion of space,[3] he deployed these layers – glazes, almost – of tone to create a tangible sense of an interior atmosphere gradually absorbing and arresting the light that penetrates it. The effect resembles the subtlest of mezzotints, especially in impressions on Japanese paper, like those included here of the first two states. Light glances off reflective surfaces, while elsewhere it almost suffocates, as it does among the heavy drapes and in the folds of the hat hanging in the corner. Such a convincing illusion must have astonished Rembrandt's contemporaries.

Equally novel is Rembrandt's placement of the figure, with an unrestricted light from the open window falling *à contre jour* over Six's shoulders, his face illuminated only indirectly by refraction. No precedent has been found for Rembrandt's composition in a formal portrait – one might rather say informal, as Six is represented in a casual state at home, somewhat in the manner later taken up, among others, by German Romantic painters in Rome. Six's erudition and status are implied by the books, one of which he of course reads, by the ceremonial sword on the table, and the painting. This last, largely covered by a curtain, appears to depict an Old Testament subject.[4] The window curtains frame the figure and mask the light from the hat, dagger and stick beyond him, which make their presence felt dimly.

This radical solution was not easily reached and the plate itself reveals *pentimenti* in the head and nearer foot. Rembrandt also prepared the composition with drawings, as he so often did those etchings that are highly wrought.[5] In the earliest, broad, reed-pen sketch, the sitter's unbuttoned informality appeared more extreme (fig. a). Here Six leans, almost slouches, at the window, like some student in digs, apparently oblivious to a pet dog leaping up against him on its hind legs. A chair in the foreground, a table, and perhaps a cage or casket on a ledge are the only possessions indicated. The drawing may have served as a *modello*, as the artist went to the trouble of increasing its height by adding a slip of paper below, as if better to approximate to the final proportions of the plate.

Such a novel iconography may have disconcerted Jan Six (1618–1700), who although a rich man of leisure after inheriting at his mother's death in 1645, remained a prominent figure in Amsterdam society, becoming the town's burgomaster in 1691. The subsequent alterations to the design add austerity and social tone to his surroundings, imbuing the sitter with a more scholarly, reflective air. The figure was tentatively rehearsed in black chalk (fig. b) on the *verso* of a memento of a *Beggar family*. The drawing introduced the motif of Six reading, but wearing a hat, a motif that was later abandoned. Again using black chalk, the composition was then outlined on a larger sheet (fig. c), the contours of which were indented to transfer them on to the copper.

Much of the detail was worked up only on the plate itself,

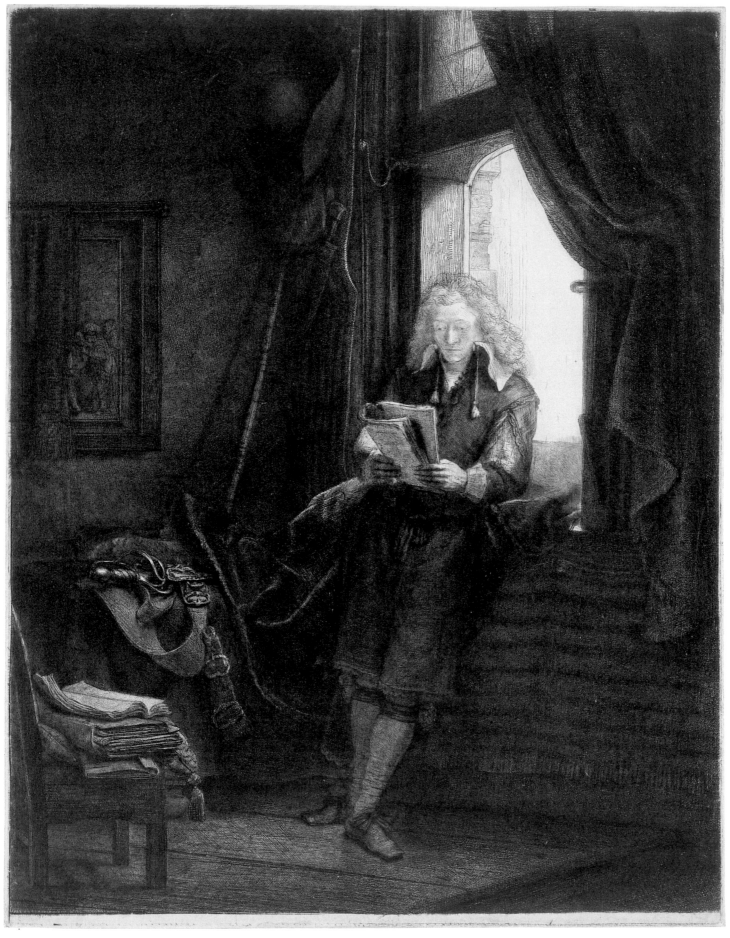

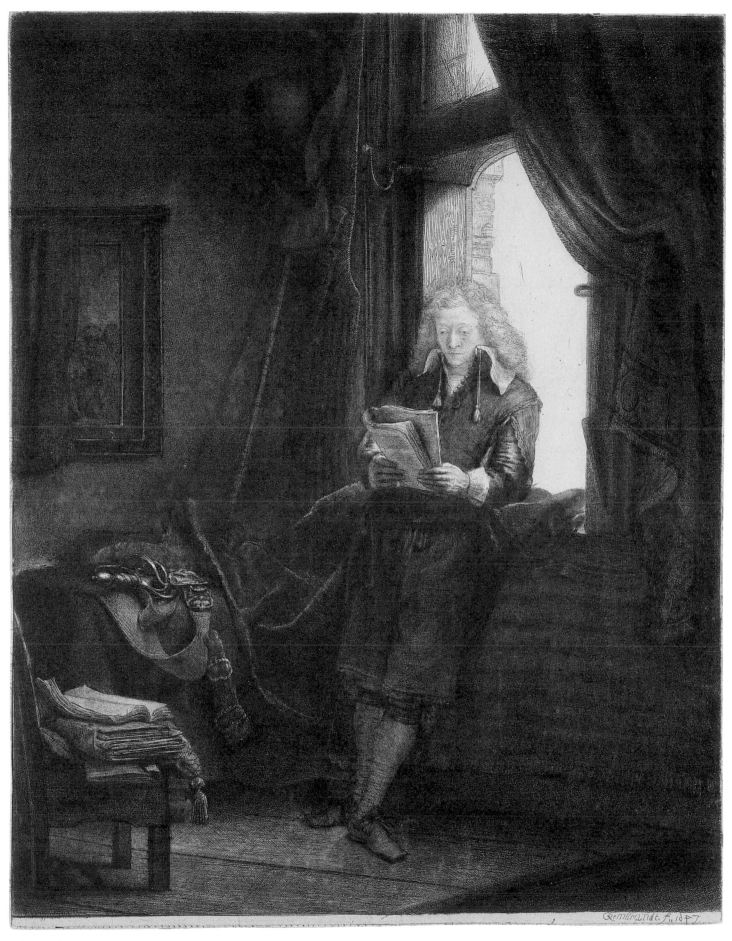

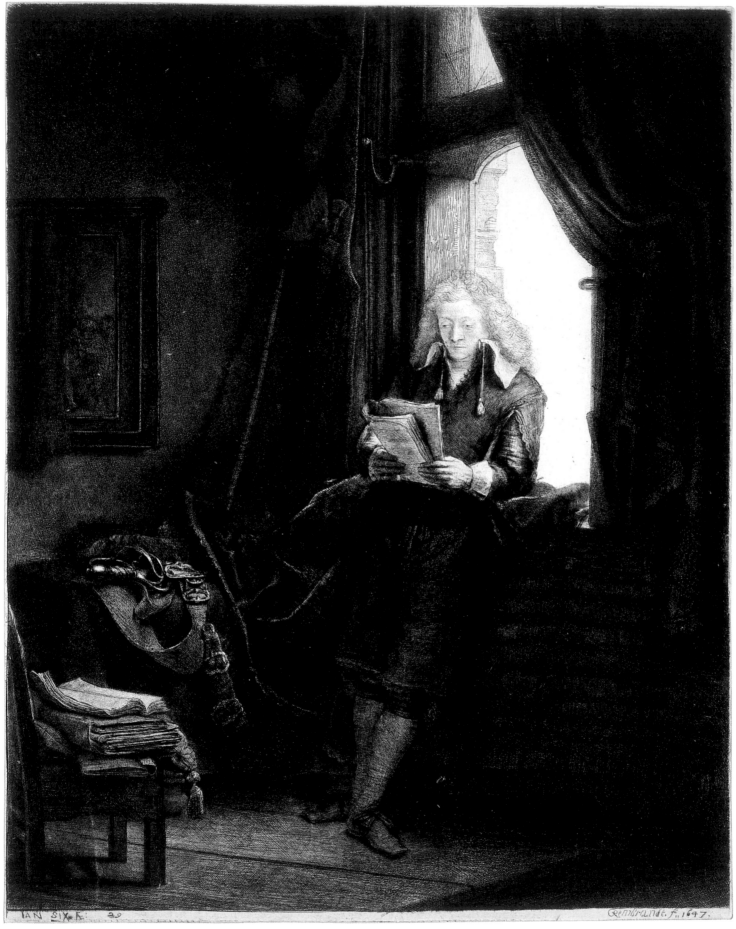

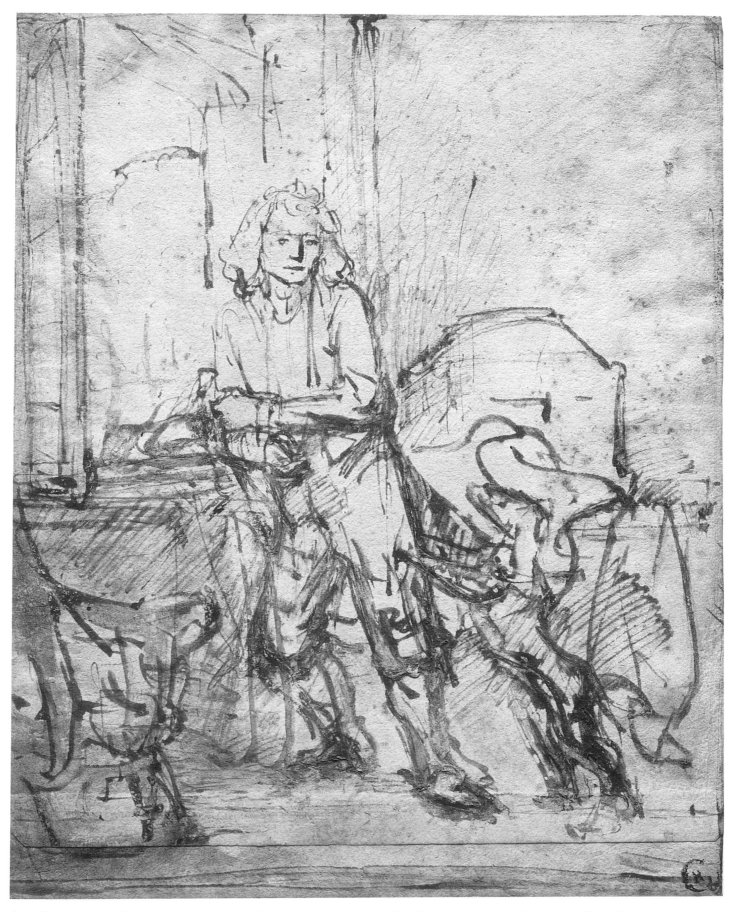

fig. a Rembrandt, *Jan Six*. Pen and brown ink with brown wash, corrected with white, 220 × 177 mm. Amsterdam, Six Collection
(Benesch 767; exh.)

which still survives in good condition (fig. d), retaining a sense of the sweat expended over its surface. Once the rare first state impressions were pulled, there were few alterations to come in the three further states. If anything Rembrandt must have felt that he had produced too dark an overall tone. He burnished out the ledge (if that is what it is) near Six's arm and allowed more light into the room from the upper window, increasing the illumination to the face and clothing. This effect was emphasized by darkening the jambs of the windows to produce contrast; and certain lines were so delicate that they must have worn away after a few impressions – for example on the face, yet the retouching here was confined to accenting the eyes and nostrils. Once done, the resulting third state was printed in significant, if not generous, numbers. The final, fourth state, as rare as the third, merely corrected the two reversed digits of the date and added the further inscription: *IAN SIX AE:29.*

Such is the exactness of observation, with a multiplicity of details that were never adumbrated in the drawings (note the grain of the floorboards and the peg holding up the window!), that one suspects that Rembrandt may have worked directly on the plate from life, as he must have done before most of his sitters.[6] But here this seems especially to apply to the background as well. In 1660 a poem by Jacob Lescaille was published in praise of the print, saying that it shows the sitter 'standing in his Library in the exercise of wise knowledge'.[7] Jan Six was then living at the Blauwe Arent (Blue Eagle) at no. 103 Kloveniersburgwal, the interior of which the print must represent.[8] He was a man of letters, a wealthy merchant and a patron of Rembrandt, with whom his contacts can be securely documented from the year of the etching of 1647 until that of his painted portrait of 1654 (see cat. 66, fig. a).[9] In 1648 Rembrandt illustrated Six's tragedy, *Medea*, with a frontispiece depicting the *Marriage of Jason and Creusa* (B.112). Four years later their friendship produced the two sketches drawn by Rembrandt in Six's *album amicorum 'Pandora'*, both dated 1652,[10] when the artist also sold him three paintings.[11] In 1653 Six joined the ranks of Rembrandt's creditors when he lent the painter the considerable sum of one thousand guilders,[12] and in 1654 he married the daughter of Nicolaes Tulp, represented in Rembrandt's famous *Anatomy lesson of Dr Tulp* of 1632.[13]

MRK

fig. b Rembrandt, *Jan Six*. Black chalk, 131 × 96 mm. Amsterdam Historisch Museum (Benesch 749 *verso*; exh. London)

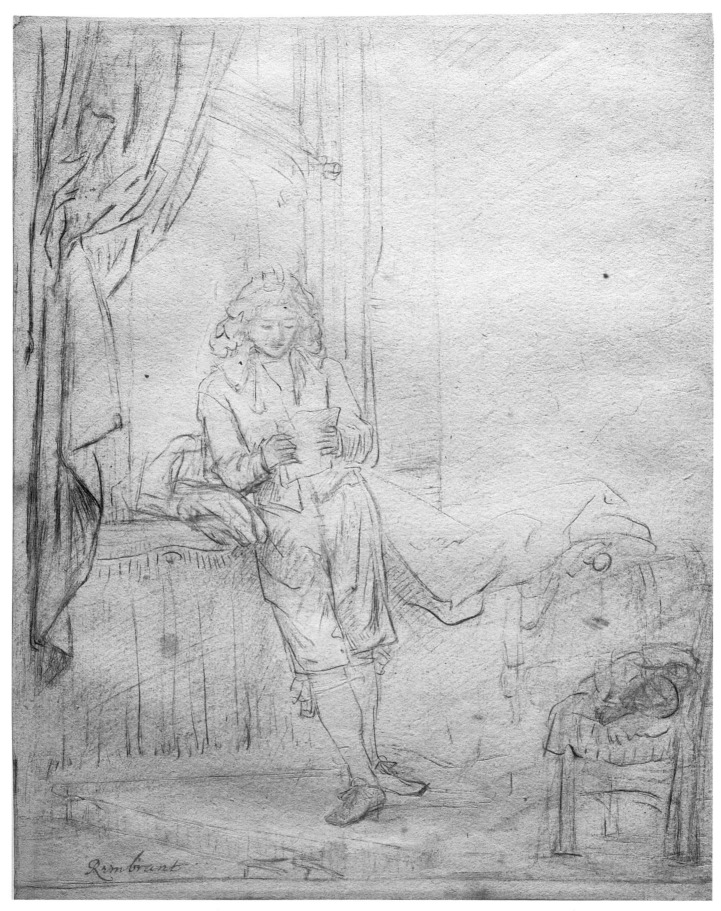

fig. c Rembrandt, *Jan Six*. Black chalk, outlines indented, 245 × 191 mm. Amsterdam, Six Collection (Benesch 768; exh.)

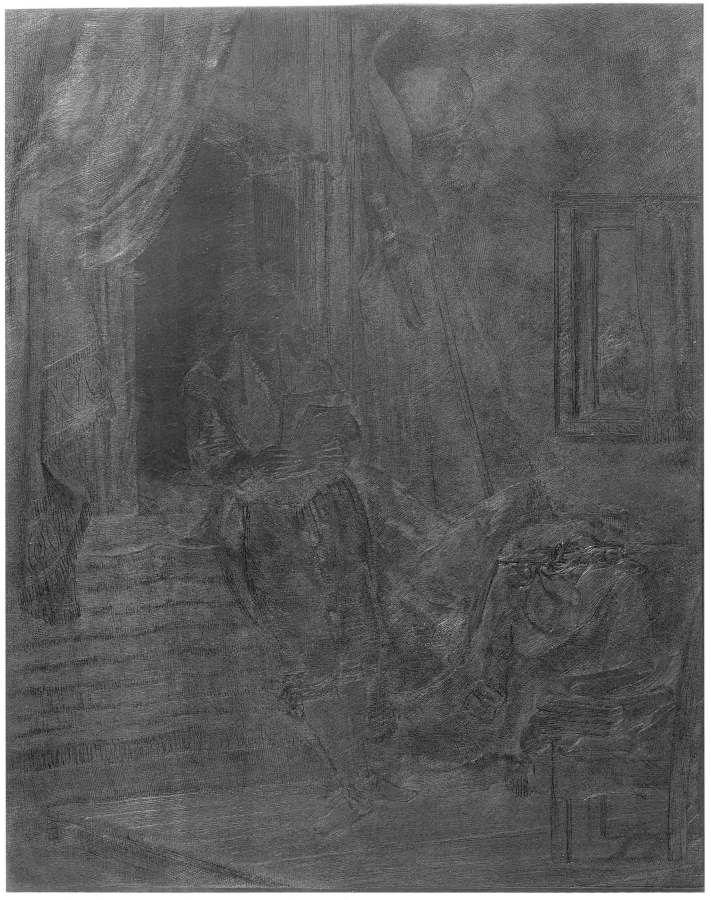

fig. d Rembrandt, *Jan Six*. Copper plate, 248 × 196 mm. Amsterdam, Six Collection (exh.)

1 Gersaint 1751, no. 265.

2 The collection is first recorded as belonging to Jan Six's nephew, Willem Six. Purchased by Jacob Houbraken in 1734, much of it finally came via the Baron van Leyden collection to the Printroom of the Rijksmuseum. (See Duchesne 1826, Lugt, *Suppl.*, 1539 a–b and Boon 1956).

3 See Van de Wetering 1997, pp. 183–8.

4 It seems to be in Rembrandt's style. De Bussierre, in Paris 1986, p. 144, refers to Lastman's *Paul and Barnabus at Lystra*.

5 See further the Introduction, pp. 64–81, for a further discussion of this phenomenon, and pp. 67–9 on the drawings related to this print.

6 Indeed eight years later, in 1655, Rembrandt was asked to complete a 'portrait of Otto van Kattenburgh, which the aforesaid van Rijn will etch from life, to be of the quality of the portrait of Mr Jan Six, for the sum of 400 guilders' ('een conterfeytsel van Otto van Kattenburch, twelck de voorsz. van Rijn sal naer 't leven etsen, van deucht als het conterfeytsel van d'Heer Jan Six, ter somme van f 400.0'). See Strauss & Van der Meulen 1979, no. 1655/8. In the case of portraits the phrase *naer het leven* ('from life'), should usually be taken literally.

7 Strauss & Van der Meulen 1979, 1660/24: 'Op d'Afbeelding van den Ed. Heer Joan Six, Commissaris der Zeezaeken, &c. Door R. van Rijn kunstigh in koper gedaen, daer zijn E. in zijn Boekkamer staat in 't oeffenen der wijze wetenschappen.'

8 Elias 1963, p. 585 (my thanks to S. A. C. Dudok van Heel).

9 Bredius 276, Six Collection, Amsterdam. The notion of a connection between Six and Rembrandt at the time of the etching, *Six's bridge*, of 1645 (cat. 49) should not be too readily dismissed.

10 Benesch 913–14.

11 Strauss & Van der Meulen 1979, no. 1652/7 and 1658/18 (in 1658 these sales were cancelled).

12 *Idem.*, no. 1657/3 (in 1657 the debt was transferred to Lodewijk van Ludick). For a discussion of their connections, see Bille 1967. For more on the portrait's iconography, see Smith 1988.

13 *Corpus* II, no. A51. Among the Rembrandt etchings in the Edward Rudge sale (Christie's, 16 December 1924) was an impression of the *Self-portrait, etching at a window* (cat. 58) that was inscribed: *Six 1649*.

58

Self-portrait, etching at a window 1648

Etching, drypoint and burin, 160 × 130 mm; from the second state signed and dated upper left in drypoint: *Rembrandt. f 1648*

Hind 229; White & Boon 22 I, II and IV (of V)

I Amsterdam★ (Van Leyden RP-P-OB-39, on Chinese paper)

II Amsterdam (De Bruijn RP-P-1962-9; watermark: fragment of Strasbourg lily★); London★ (Cracherode 1973.U-988, on Japanese paper)

IV London★ (Cracherode 1973.U-991, on Japanese paper)

Watermarks: the watermark in the second state is probably a fragment of Ash & Fletcher 36, D´.a.. This is also found, among other prints, in the first and second states of the *Hundred Guilder Print* (cat. 61) and the third and fourth states of *Medea, or the marriage of Jason and Creusa* (B.112) of 1648. It can therefore be dated to 1648.

SELECTED LITERATURE: Mariette 1857, pp. 356–7; Van Gelder 1943, pp. 34–5; Boston-New York 1969, no. 3; Chapman 1990, pp. 81–4, 86–8; Berlin-Amsterdam-London 1991–2, no. 25; London-The Hague 1999–2000, no. 62; White 1999, pp. 150–52.

This is the first portrait print that Rembrandt made of himself after the ambitious *Self-portrait leaning on a stone sill* of 1639 (cat. 34), and there is a world of difference between the two. In the earlier work, following the example of Titian and Raphael, Rembrandt had opted for the pose of the proud courtier who, clad in an elegant beret and an opulent sixteenth-century costume, gazes out self-confidently at the viewer. In this portrait made in 1648 he has depicted himself without pretence, working by an open window. He wears a hat with a narrow brim and a shirt under an ordinary coat, probably his working clothes. Similar garb can be seen in the self-portrait drawing of around 1650, to which an inscription was later added: *drawn by Rembrant van Rhijn after himself, as he was attired in his studio* (fig. a).[1]

In the print Rembrandt appears to fix us with a penetrating gaze, but in fact we are seeing him intently studying his own reflection in a mirror in order to capture it on the copper plate: he sits at a table, etching. He holds the etching needle in his right hand, and the copper plate, unseen by the viewer, lies on a folded cloth in front of him supported on two thick books. The hand in which he holds the etching needle likewise confirms that he was working at a mirror. In the latter he would have seen himself reflected as left-handed, and drew himself thus; as a result of the reversal that takes place during the printing process, he appears right-handed again in impressions from the plate.[2]

Rembrandt depicts himself without any adornment, and yet the print is an impressive example of his skill. The image appears

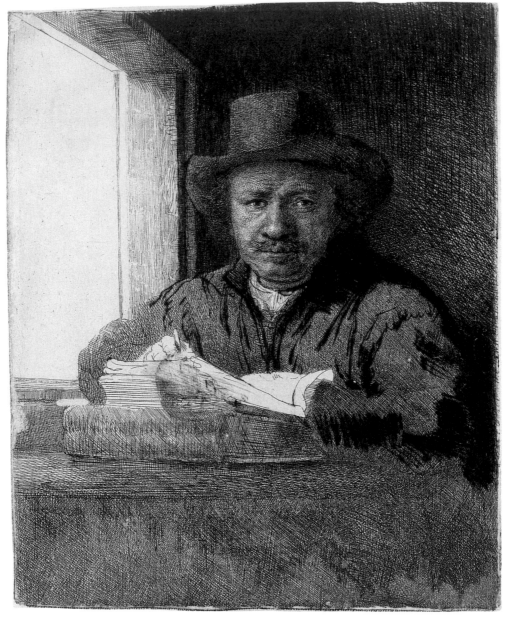

I Amsterdam

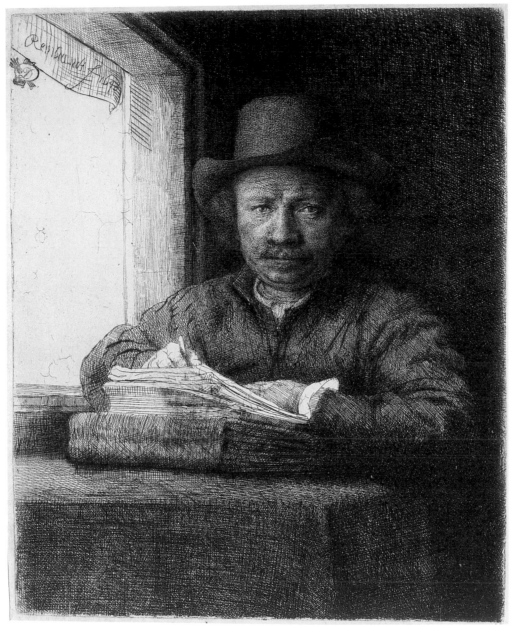

II London

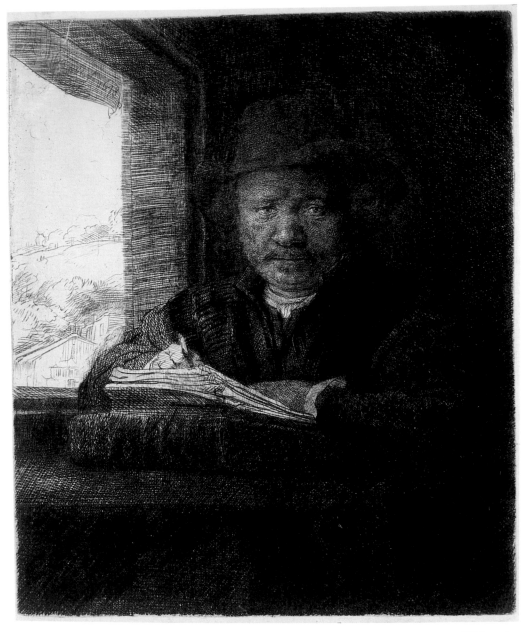

IV London

to be built up not so much of lines as of a range of shades of grey. He had tried the same complicated technique a year earlier in the portraits of *Ephraïm Bueno* (cat. 55) and the *Jan Six* (cat. 57), but in contrast to those prints, it is possible in the self-portrait to reconstruct the way he set to work. In the undated first state we can see that the portrait was originally drawn on the plate with a dense web of etched lines, after which the contrasts were strengthened with drypoint to intensify the forms. The Amsterdam impression shown here is printed on thin Chinese paper, and the etched lines are sharp and clear, while the lines of the drypoint stand out precisely because of their velvety quality.[3] In the second state Rembrandt modelled the work still further by indicating the folds of the coat, reinforcing the shadows on the books and on the tablecloth, and making the background darker. In this state he also signed and dated the plate. He subsequently toned down the highlights on the hands and cuffs by lightly hatching them, and in the fourth state new lines are added that significantly darken the whole composition, while a landscape becomes visible through the open window. In comparison with the earlier states these later changes were executed rather roughly. Doubts as to whether Rembrandt was responsible for this state have consequently been expressed. Good impressions of the fourth state are often found with a Strasbourg lily watermark, which is not found in prints with later dates but does occur in the first state of *The walking frame* (cat. 51) of around 1646.[4] This suggests that the fourth state of this self-portrait was indeed made in or shortly after 1648.

EH

1 This drawing is usually dated between 1652 and 1660, but Ben Broos recently suggested a date of around 1648–50; he is supported in this by Peter Schatborn (*c*.1650). See Melbourne-Canberra 1997–8, no. 85, and London-The Hague 1999–2000, no. 63.

2 Rembrandt was indeed right-handed. See for example Royalton-Kisch 1992, no. 6a.

3 Christopher White suggests that the mark which can be seen on the book is probably an earlier version of Rembrandt's right elbow. See White 1999, p. 151.

4 Ash & Fletcher 36, G.c. They point out that a nearly identical variant has been recorded in various dictionaries of watermarks, where it is always dated around 1646.

fig. a Rembrandt, *Self-portrait in studio attire*, *c*.1650. Pen and brown ink, 203 × 134 mm. Amsterdam, Museum het Rembrandthuis (Benesch 1171)

59

St Jerome beside a pollard willow 1648

Etching and drypoint, 180 × 133 mm; signed and dated below, left of centre, in drypoint, from second state: *Rembrandt f. 1648*

Hind 232; White & Boon 103 I and II counterproof (of II)

I Amsterdam (Van Leyden RP-P-OB-168; watermark: Foolscap, five-pointed collar [Ash & Fletcher 19, M.a.]); London★ (Cracherode 1973.U.996; watermark: Foolscap with five-pointed collar [Ash & Fletcher 19, M.a.])

II counterproof Amsterdam★ (Van Leyden RP-P-OB-12430; watermark: Countermark WK [Ash & Fletcher 26, WK´.a.])

Watermarks: the watermark in the first state also occurs in the impression of the first state of the *Medea* (B.112) of 1648. The countermark in the counterproof of the second state is found in a large group of prints and can be dated *c*.1652.

SELECTED LITERATURE: Donahue Kuretsky 1974; Dickey 1986, pp. 253–62; Ziemba 1987, p. 122; Berlin-Amsterdam-London 1991–2, pp. 234–5, no. 24.

'A tree study with Saint Jerome thrown in' is how A. M. Hind once described this stunning print.[1] Witty as this description may be, it probably misses the point and certainly fails to do justice to

the iconographic tradition to which this St Jerome belongs. Whether Rembrandt's impressive tree trunk is indeed a 'study' in the sense of a study from life is arguable. A drawing of a pollard willow in Turin was previously thought to be the preliminary study for the print.[2] Aside from the fact that the attribution of this drawing has now been called into question, it cannot have been the direct model for the etching since it differs in numerous respects. We certainly cannot rule out the possibility that Rembrandt simply 'made up' his pollarded willow, perhaps with Jacques de Gheyn II's visionary tree studies in his mind's eye

(fig. a).[3] And St Jerome was definitely not 'thrown in', but is part of a coherent triangular composition. The only element that seems to fit slightly less smoothly into the overall scene is the melancholy lion, which looks out at the viewer from behind the tree with a somewhat bewildered expression.

St Jerome was a popular subject from the fifteenth century onwards, and was often depicted seated in a landscape, near a dead tree. The majority of these works portrayed the saint as a penitent, half naked and chastising himself with his eyes fixed on the cross. There were various reasons why this saint, in particular,

II (counterproof)
Amsterdam

was shown with a tree. To begin with, there was the imaginative etymology of the name given by Jacobus de Voragine in his *Legenda Aurea*, the most popular hagiography from about 1470 onwards: Hieronymus – the Latin version of Jerome's name – was supposedly derived from *gerar*, holy, and *nemus*, wood.[4] The dead tree could also be interpreted as the 'Tree of Life' in the Garden of Eden, which became the 'Tree of Death' after the Fall. According to legend, Christ's cross was hewn from the wood of this tree. It thus also came to symbolize redemption through faith; and Jerome himself referred to this symbolism in his writings.[5] The willow in Rembrandt's etching is not completely dead, however, and a branch above Jerome's head still bears leaves. The tree can consequently also be seen as a symbol of the Resurrection.

Rembrandt will certainly have been familiar with a number of the early sixteenth-century prints depicting St Jerome, among them those by Dürer and Lucas van Leyden. Rembrandt's saint sits working at a primitive writing-table, which is nailed to the tree. A similar contraption can be seen in a print by Marcantonio Raimondi, maybe after Titian (fig. b).[6] In one

fig. a Jacques de Gheyn II, *Study of a tree*.
Pen and brown ink, black chalk, on buff paper,
363 × 250 mm. Amsterdam, Rijksmuseum

fig. b Marcantonio Raimondi after Titian (?), *St Jerome and the Small Lion*.
Engraving, 144 × 189 mm. Paris, Bibliothèque Nationale de France

respect Rembrandt's print differs from all these earlier works, as his saint is a bespectacled scholar, who would appear to be at home among the books in his library, but Rembrandt does include the attributes of the penitent Jerome, a skull and crucifix. The little bird on the massive trunk of the willow is typical of the artist's attention to the smallest details: despite its minuscule dimensions it is immediately recognizable as a woodpecker. The heavy trunk of the willow has been executed in pure etching, and Rembrandt employed drypoint to draw Jerome immersed in his studies as well as the lion and the leaves on the branch above the saint's head.

There are two known states of *St Jerome beside a pollard willow*, but they differ only in the addition, in the second state, of pupils in the lion's eyes and some scratches in the foreground. Rembrandt also appended his signature and the date 1648 to the second state, which suggests that he definitely intended to print an edition for sale of this apparently so-informal-looking print. Impressions of both states have a sprinkling of black dots along the left and right margins; this probably results from flaws in the etching ground, allowing the acid to attack the copper plate.

The function of the Amsterdam counterproof of the second state, shown here, is unclear. It may be that Rembrandt wanted to do some more work on the print, but there is no indication that this was in fact the case.

MS

1 Hind 1932, p. 106.

2 Turin, Biblioteca Reale; Benesch 852a.

3 On the *verso* of the sheet, which is discussed in Amsterdam 1993–4, pp. 644–5, no. 317.

4 Donahue Kuretsky 1974, p. 574.

5 Ibid., p. 573.

6 Bartsch 102.

60

Beggars receiving alms at the door 1648

Etching, drypoint and burin, 166 × 129 mm; signed and dated, lower right: *Rembrandt.f. 1648*.

Hind 233; White & Boon 176 I (of III)

I Amsterdam★ (De Bruijn RP-P-1962-65; watermark: unidentified fragment of a fool's cap★)

SELECTED LITERATURE: Berlin-Amsterdam-London 1991–2, pp. 239–41, no. 26; Amsterdam 1997, no. 56; White 1999, pp. 188–9.

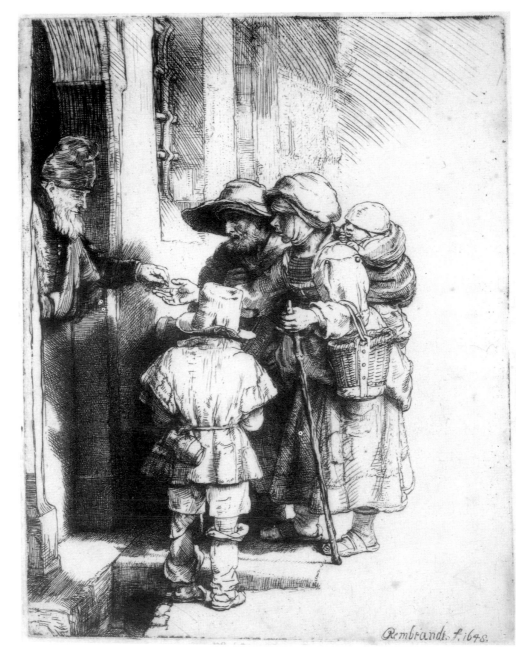

I Amsterdam

Rembrandt's interest in beggars as a pictorial motif was sustained at least into the 1650s. Aside from the many drawn studies, sketches made in the street and informal etchings, *Beggars receiving alms at the door*, dated 1648, is his most complete and monumental depiction in the mendicant genre. A man and a woman stand before a house with a boy and an infant. The house-dweller, a bearded man wearing a house-cap, appears over the hatch of a divided door and places a coin in the woman's outstretched hand. The beggar's unfocused gaze may indicate blindness; he is playing a tune on the hurdy-gurdy, his right hand enclosing the knob of the handle.[1]

The scene has been composed with great care, certainly in comparison with a similar etching such as the *Rat-catcher* of 1632

(cat. 18). There is nothing to distract us from the central action – the giving and receiving – around which the figures are grouped in a circle. Details of the appearance of the figures have been observed with great precision: the fists of the baby, whose little bonnet is sagging over its eyes, the profile and white beard of the man in the door, and then there is the standing youth, a rear view unparalleled in the history of printmaking. The way in which the contours are delineated against a densely hatched section behind, the few lines that are needed to indicate shapes, the shrewd use of light effects and perfect rendering of textures are signs of an artist whose skills are fully matured. The print shows that Rembrandt, a sketcher *par excellence*, was also capable of stopping at exactly the right moment when elaborating a print. The white of the paper,

251

fig. a
Gerard van Groeningen,
Sixty years from the series
The Ages of Man.
Etching and burin,
201 × 240 mm.
Amsterdam, Rijksmuseum

which lends some of his earlier etchings a slightly sinister air (see e.g. cat. 47) is suggestive here, bathing the image in light from the left and enhancing the work's eloquence.

The jet black is so crucial to the print's effect that it is conceivable that after a few impressions more hatching had to be added or parts darkened with drypoint. Interventions of this kind are hard to read from later but still fresh impressions, and the watermarks show that the plate was printed several times without alteration. Three states with minor discrepancies have been distinguished: in the second state a gossamer-thin web with cross-hatching was added to the doorpost. As in the case of other prints that were already complete in the first state, it is unclear whether Rembrandt himself was responsible for these tiny changes.[2]

There has been much speculation as to what Rembrandt wanted to convey with his images of beggars, and with the *Beggars receiving alms at the door* in particular.[3] That the print heralds a new phase in attitudes to poverty and attests to Rembrandt's sense of humanity is improbable.[4] In the sixteenth and seventeenth

centuries, a distinction was drawn between honourable and dishonourable poverty. The latter was self-inflicted and was seen as morally repugnant. The Church thundered on about charity, but not so much out of compassion for the unfortunate as out of concern for the givers' own souls: 'He who scorns God's poor here on earth will receive his retribution in the hereafter' was the admonition printed on a widely disseminated illustration of the parable of Dives and Lazarus. And the print *Sixty years* in a series depicting the Ages of Man, which includes a scene almost identical to *Beggars at the door*, bears the caption: *Par oeuvres sainctes cherchons paradis* (Through good deeds we seek paradise'; see fig. a).[5] Rather than a personal reflection on the theme of poverty and begging, Rembrandt's etching is more likely to have been one of the many general emblems of charity produced in this period.

Besides this, the print cannot be seen in isolation from one of the icons of early printmaking, the print nicknamed *Eulenspiegel* by Lucas van Leyden (fig. b).[6] This engraving was already extremely rare in the seventeenth century, and Rembrandt him-

self is known to have paid out a small fortune for an impression at an auction in 1642.[7] It is entirely conceivable that this print inspired him to produce his contemporary, but very similar portrait of a family of beggars.

GL

1 The fact that the man is playing a hurdy-gurdy was first noted by Jones Hellerstedt 1981.

2 For a list of the differences, see White & Boon I, p. 86.

3 See Stratton 1986, Held 1991, Holm Bevers in Berlin-Amsterdam-London 1991–2, pp. 239–40, Amsterdam 1997, pp. 278–80, and Spaans 1997, pp. 80–81.

4 Sudeck 1931, p. 90.

5 For the examples mentioned, see Amsterdam 1997, pp. 277–8; for Gerard van Groeningen's series see New Hollstein, *Gerard van Groeningen*, nos 14–23.

6 New Hollstein, *Lucas van Leyden*, no. 159; for the iconography and the derivation of Lucas van Leyden's motif from an illustration from Sebastian Brant's *Ship of Fools*, see Silver 1976.

7 Cornelis & Filedt Kok 1998, pp. 43–4, with quotations by Samuel van Hoogstraten and Ernst Brinck, burgomaster of Harderwijk, on Rembrandt's purchase of the engraving for the staggering sum of 179 guilders.

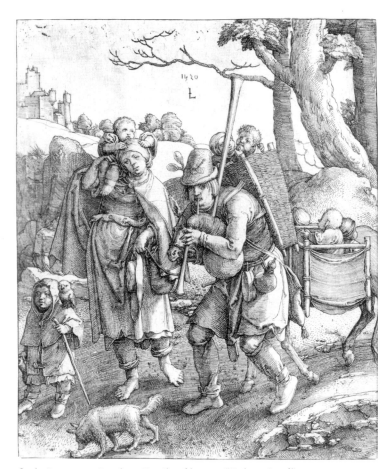

fig. b Lucas van Leyden, *Family of beggars* ('Eulenspiegel'), 1520. Etching and burin, 178 × 144 mm. Amsterdam, Rijksmuseum

61

Christ healing the sick: the hundred guilder print
*c.*1648

Etching with drypoint and burin, 278 × 388 mm

Hind 236; White & Boon 74 I (of II)

I Amsterdam★ (Van Leyden RP-P-OB-601, on Japanese paper; inscribed *recto* in graphite(?): *deze is alder eerste en dus raarste druk van deze plaat, met het wijnigze* [wijnigste?] *wit om het hoofi van Jezus*; on *verso*, in pen and brown ink: *Ici-dessous est ecrit en Pierre noire /'Vereering van mijn speciaele / vriend Rembrand, tegens de / Pest van M. Antony.// Rembrand Amoureux d'une / Estampe de M.A. savoir la / Peste, que son ami J. Pz. Zoomer, avoir de fort belle / Impression, & ne pouvant / l'Engager à la lui vendre, / Lui fit present, pour l'avoir / de Cette Estampe-ci, plus- / rares & plus Curieux Encore / que l'Estampe l'on Nome [?] / de* <u>Hondert Guldens Print</u> *, par / les Addition dans le Clair obscur / qu'il y a dans Celle-ci, / don't il n'y a eu, suivant le raport / qui m'en a Ete fait, que tres peu d'Impressions, don't / Aucune n'a jamais été vendûe / dutemps de Rembrand, mais / distribuées entres ses amis.* Also a vague, partly illegible Dutch text in black chalk, recorded in the above inscription in pen; London (Cracherode 1973.U.1022; on Japanese paper)

Watermarks: in Amsterdam an impression of the first state has the same watermark (Ash & Fletcher 26, countermark VA´.a.) that appears on an impression of the second state in Boston, and again on the fourth states of the portrait of *Jan Six* of 1647 (cat. 57) and of the *Marriage of Jason and Creusa* of 1648 (B.112), confirming that the print was first printed in these years.

SELECTED LITERATURE: Boon 1964, pp. 85–90; Boston-St Louis 1980–81, no. 98; Schatborn 1985, no. 21; Paris 1986, no. 80; Berlin-Amsterdam-London 1991–2, pp. 242–5, no. 27; Royalton-Kisch 1993b, pp. 180–81; Melbourne-Canberra 1997–8, no. 111; White 1999, pp. 54–64.

The *Hundred guilder print* has since its creation been admired as Rembrandt's most ambitious, complex and highly worked composition as a printmaker. Gersaint referred to it in 1751 as 'Rembrandt's most capital performance', and later in the eighteenth century, in a spirit of homage, the worn-out plate was reworked and finally cut into segments by Captain William Baillie (1723/4–1810).[1]

That it is known in only two seventeenth-century states, with the minor difference between them of additional shading over the neck of the donkey on the right and on the far wall of the archway, belies the exceptional effort that the plate represents in terms of imaginative power, technical brilliance and pictorial finish. Rembrandt applies every tool at his command and in a variety of styles, from the freely outlined Pharisees in debate on the left, flooded in light, to the precise rendering of the textures that apparel the figures who enter from the right. All the groups are subjugated to the overriding *chiaroscuro*, which ranges from the deep blacks into which Christ's halo melts away, to the areas

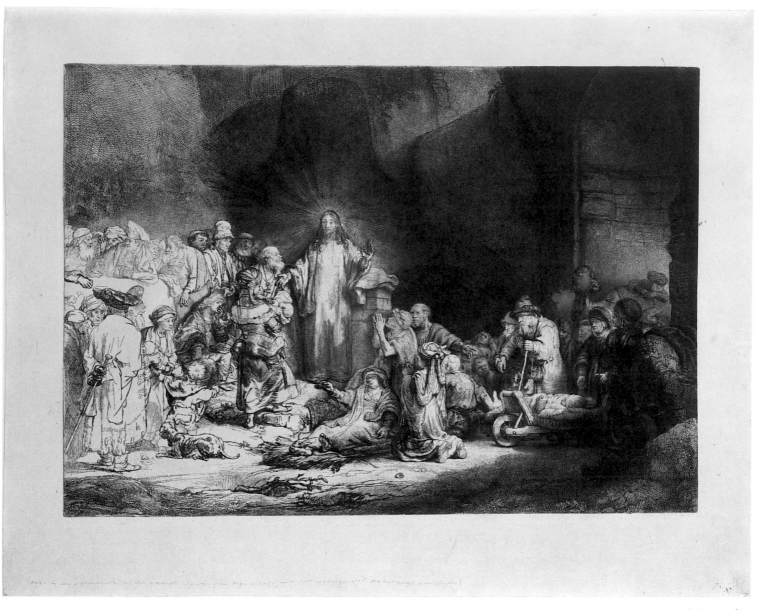

I Amsterdam

left white which suggest a sudden source of startling illumination (which is more muted in impressions on Japanese paper like those shown here). The play of shadows is nowhere made more manifest than by the dark silhouette cast on Christ's robe by the central figure with praying hands. Yet at times, as in the more mechanically shaded section at the upper left, and the white robe of the man seen from behind near the left edge (whose hat and hands are more highly worked), the etching, which was never signed by the artist, seems somewhat unresolved. The disparate styles and degrees of detail, especially the alterations and additions in drypoint that appear to have been made as work progressed on the plate,[2] have led to the suggestion that the etching was executed over a considerable period of time. This may well have

been the case, although the variety also serves to enhance the visual interest. In addition, Rembrandt's use of oriental papers in many impressions, like that illustrated here, has the effect of suffusing the scene in a dense, almost dusty atmosphere, reminiscent of that occupied by the civic guard in the *Night watch*, which was completed in 1642. Indeed, the *Hundred guilder print* rivals that painting in its degree of ambition and complexity.

Many aspects of the print, both compositional and stylistic, are comparable to etched works by Rembrandt of the first half of the 1640s: the *Beheading of the Baptist* of 1640 (B.92), the *Triumph of Mordecai* (cat. 44), in which the foreground figure seems to anticipate that of Christ in the present work, and, for the rich background textures, such prints as the *St Jerome in a dark chamber*

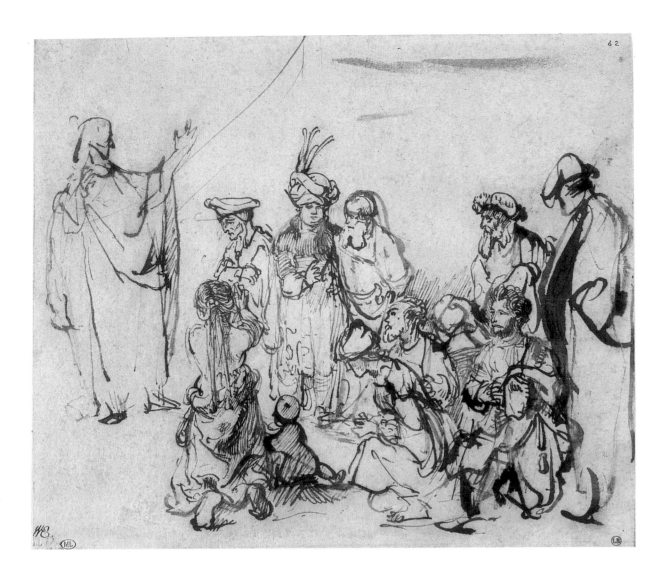

fig. a Rembrandt,
*Study for the Hundred
guilder print.*
Pen and brown ink,
198 × 230 mm.
Paris, Musée du Louvre
(Benesch 543; exh.
London)

(*below*) detail of cat. 61

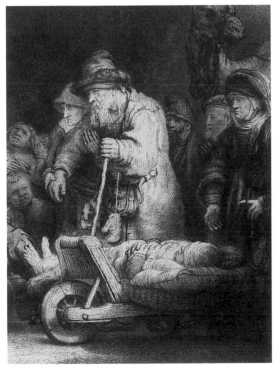

(B.105) and the *Student at a table by candlelight* (B.148). Yet the watermarks suggest that the known impressions were pulled only from around 1647–8 (see further above). Presumably many passages, and perhaps especially those containing drypoint, were added only after the middle of the decade. It is difficult with Rembrandt to draw general conclusions from this about his normal *modus operandi*, but he may sometimes have mulled over his more complex designs, whether painted or etched, for a considerable period before they were finally allowed out of the studio.

The title, the *Hundred guilder print*, may have originated early. In a letter from Jan Meyssens of Antwerp to Charles Vanden Bosch, Bishop of Bruges, dated 9 February 1654, he states: 'Also here is the rarest [i.e. finest] print published by Rembrandt, in which Christ is healing the sick, and I know that in Holland [it] has been sold various times for 100 guilders and more; and it is as large as this sheet of paper [on which the letter is written], very fine and lovely, but ought to cost 30 guilders. It is very beautiful and pure.'[3] This letter speaks volumes concerning Rembrandt's

fig. b Rembrandt,
*Study for the Hundred
guilder print.*
Pen and brown ink
with brown wash,
heightened with white,
139 × 185 mm.
Berlin, Staatliche
Museen,
Kupferstichkabinett
(Benesch 188; exh.)

fig. d Rembrandt, *Studies of sick woman for the
Hundred guilder print.* Pen and brown ink with
brown wash, 101 × 122 mm. Amsterdam,
Rijksmuseum (Benesch 183; exh.)

fig. c Rembrandt, *Standing man for the Hundred guilder print.* Pen and brown ink, 127 × 58 mm. London, Courtauld Institute, Seilern Collection (Benesch 184)

fig. e Rembrandt, *Sketch of sick woman in the Hundred guilder print*; Pen and brown ink, 80 × 109 mm. Private collection (Benesch 388)

fame, and the interest engendered by this print among his contemporaries (even among Roman Catholic Bishops). The composition in fact represents several episodes related in chapter 19 of the gospel of St Matthew. The text describes how Christ was followed by multitudes as he travelled out of Galilee to the coasts of Judaea beyond Jordan, where he healed the sick among them; and the Pharisees, seen here on the left, attempted to argue with him concerning the legality of divorce. Of central importance are the lines devoted to Christ as a healer of children: 'Then were there brought unto him little children, that he should put his hands on them, and pray. And the disciples rebuked them; but Jesus said: Suffer little children, and forbid them not, to come unto me; for of such is the kingdom of heaven'.[4] The print shows two mothers with their young offspring approaching Christ from the left, the first restrained by the bearded St Peter. But Christ welcomes them openly. Seated between the mothers with their young offspring is a contemplative figure, probably the rich young man described in verses 16–24, who hesitated to relinquish his wealth and follow Christ. After the man's departure, Christ stated that 'It is easier for a camel to go through the eye of a needle than for a rich man to enter into the kingdom of God', and the camel on the right may allude to this passage.

The complexity of the composition led Rembrandt to sketch it out in preparatory drawings, a few of which survive, although the authenticity of the earliest (fig. a) is disputed. This sheet, which includes a tentative rendering of Christ, differs in all but the most general sense from the final design. In style it is characteristic of Rembrandt's most freely penned studies of the mid-1640s,[5] and as the light comes from the left it may be an abandoned idea for the figures to the left of Christ (his right) in the etching. The second composition drawing (fig. b) contains the germ of the arrangement of the figures on Christ's other side. Despite its cursory style it may have been preceded by the sketch of a *Man gesturing* (fig. c) who appears again (minus his cap) in the centre of the Berlin sheet (fig. b), and by two separate drawings for the *Sick woman* at Christ's feet, where her pose is less close to the final version (figs d–e). Clearly this figure, perhaps inspired by Rembrandt's drawings of Saskia in bed, was radically rethought. A further drawing sketches a *Blind old man led by a woman* (fig. f), a motif that was adopted with adjustments to their postures: in the print the old man shuffles along more weakly, his head sunk and further arm lowered (the latter change already indicated in the drawing), while the woman changes the direction of her glance to face the figure of Christ.[6] In style all the drawings are compatible

with Rembrandt's work of the mid-1640s. The alterations that Rembrandt finally introduced reorganize and simplify the dynamics of the figure groups so that they achieve an almost Raphaelesque refinement, always subservient to the focal point of Christ, from whom radial lines of force extend to bind the composition as a whole.

MRK

1 For a recent discussion see Hinterding 1993–4, pp. 25–6. On Baillie's motives for reworking the plate (which was done on subscription) see Stogdon 1996.

2 White 1999, pp. 54–64 enumerates several such *pentimenti*, e.g. in Christ's feet, head and hands, behind the figures to the left, and in the shadows behind Christ. There is also a touched impression of the first state in the British Museum, with additions made with the tip of the brush in grey wash (Cracherode 1973.U.1023) but the rework is not attributable to Rembrandt himself.

3 Van den Bussche 1880, pp. 358–89. 'Vooder is alhier de raerste print van Rembrant dier wtgaet, daer Criistus de melatsche geneest, ende jck wete als datse jn Hollant diversche keeren vercoght syn 100 gul. ende meer; ende is soo groot als dit blad pampier, seer fray ende ardich, maer sy souden moeten 30 guldens costen, is seer schoon ende suyver.' I am grateful to Ger Luijten for this important reference. The same high price was mentioned in 1711 by Von Uffenbach (1753, III, p. 581), publishing his record of 1 March 1711 when he noted that the print was lacking from the collection of David Bremer. Gersaint 1751, p. 50, recorded that Rembrandt exchanged an impression with a dealer from Rome for one hundred guilders' worth of prints by Marcantonio Raimondi, a version of the story recorded on the *verso* of the Amsterdam impression.

4 Verses 13–14. The interpretation of the etching as representing the whole of Matthew 19 is supported by a poem by Rembrandt's contemporary H. F. Waterloos, written on an impression in Paris (see recently Berlin-Amsterdam-London 1991–2, p. 242).

5 See further the Introduction, pp. 77–80. The most telling comparison is perhaps with the signed drawing of the *Star of the Kings* in the British Museum (Benesch 736); note also its compatibility with the other drawings related to the etching (here figs b–f).

6 Another drawing, of a standing *Mother and child* (Benesch 1071) has also been associated with the etching but the connection is not persuasive. The Louvre drawing of an *Old man led by a woman* (fig. f) may also be compared with the sketches of a similar motif, but showing the old man led towards the spectator, in Stockholm and Rotterdam (Benesch 189–90).

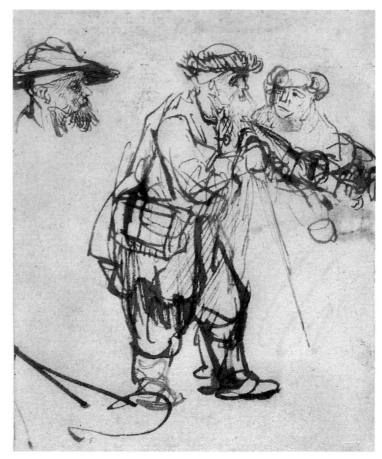

fig. f Rembrandt, *An old man led by a woman: study for the Hundred guilder print*. Pen and brown ink, 122 × 98 mm. Paris, Musée du Louvre (Benesch 185; exh. London)

62

The shell 1650

Etching, drypoint and burin, 97 × 132 mm; signed, lower left: *Rembrandt. f. 1650*

Hind 248; White & Boon 159 I and II (of III)

I Amsterdam★ (Van Leyden RP-P-OB-241; watermark: none)

II Amsterdam★ (Van Leyden RP-P-OB-242; watermark: none); London (1868-8-22-672; watermark: none)

SELECTED LITERATURE: Hoff 1975, pp. 16–19; Berlin-Amsterdam-London 1991–2, pp. 248–50, no. 29; White 1999, pp. 189–90.

It is clear that Rembrandt was often struck by other artists' prints and saw a challenge in trying to equal or surpass an admired work in an etching of his own. Something of the kind must have prompted this portrayal of the marbled cone shell, *Conus marmoreus*; otherwise it would be hard to explain why he should

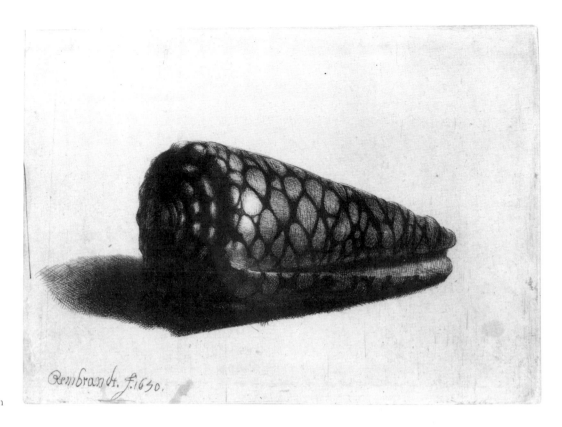

I Amsterdam

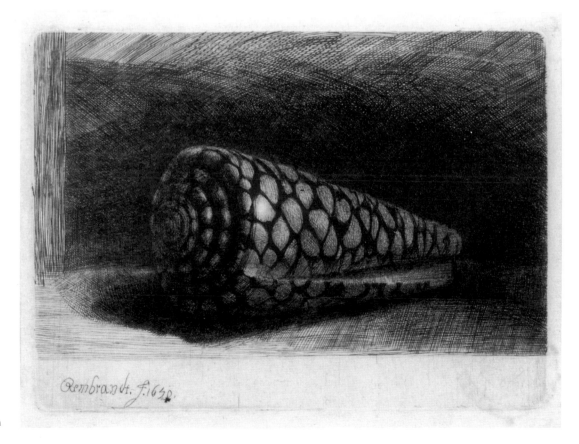

II Amsterdam

suddenly have chosen a still-life motif of this kind, unique in his print oeuvre.

Paintings of snails and other shells, sometimes depicted in bewildering profusion, had existed in the Netherlands since the early seventeenth century.[1] But Rembrandt's imagination was doubtless fired by the unusual etched series of shells by Wenceslaus Hollar (1607–77). In this series of thirty-eight sheets, the minutely observed objects of *virtu* are all rendered against a white background.[2] The *Conus marmoreus* itself does not occur in Hollar's series, and the shell that most closely resembles it is the *Conus imperialis* (fig. a). Rembrandt's etching was once mistakenly thought to be a free imitation of this print.[3] However, he collected shells, as did many of his contemporaries, and he probably had an example of this species among the 'large quantity of conches and marine inhabitants' in his cabinet.[4]

What both Hollar and Rembrandt overlooked was that asymmetrical snail shells of this kind, seen from below, always coil in a clockwise direction, culminating in a protruding lip at the opening through which the snail can crawl out.[5] The shell depicted by Rembrandt, who knowingly placed his signature and date on the plate in reverse so that they would appear the right way round after printing, nevertheless displays an anticlockwise twist, which never occurs in nature (fig. b). In paintings made from life (fig. c) and certainly in drawings aspiring to scientific accuracy, artists took pains to get the direction right. One watercolour by Bartholomeus Assteyn (1607–67 or later) includes the name by which the marbled cone shell was called at the time:

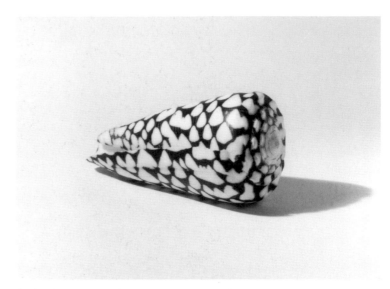

fig. b Photograph of the marbled cone snail (*Conus marmoreus*). Private collection

fig a Wenceslaus Hollar, *Conus imperialis*. Etching, 98 × 136 mm. Amsterdam, Rijksmuseum

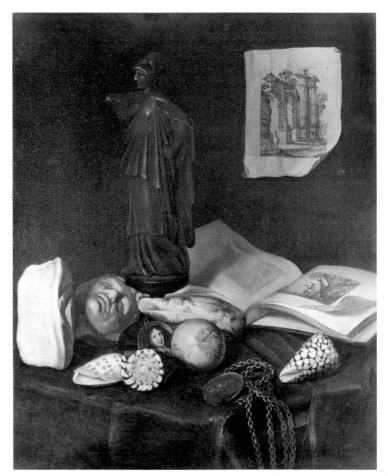

fig. c Sebastian Stoskopff, *Still life with art objects and shells*. Canvas, 49 × 39 cm. Princeton, The Art Museum, Princeton University

fig. d
Bartolomeus
Assteyn,
*Herts Horen En
Geel Belleken*
('Stag's horn
and yellow
bell').
Black chalk and
watercolour,
314 × 203 mm,
Paris, Fondation
Custodia, coll.
F. Lugt

the indentations and details of the base no longer came out well as the plate became worn, in the third state the twisted extremity was reworked with the burin and drypoint until the tip became clearly visible again.[8]

Shells such as the *Conus marmoreus* were rare in the seventeenth century. They were transported to Europe on ships returning from the East and incorporated into collections of art and natural objects.[9] Painters with a programmatic bent loved to depict them as symbols of the dichotomy characterizing the world of phenomena. Thus Sebastian Stoskopff made a painting in which prints, sculptures, a miniature portrait and a medal represented the *artificialia* made by human hands, with shells representing *naturalia* (fig. c); as Philibert van Borselen put it in 1614, they were 'Not fashioned or shaped by an artful hand / but as Nature's

fig. e
Jakob Demus,
Two shells,
1990.
Drypoint,
130 × 140 mm.
Private
collection

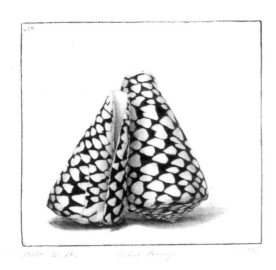

Herts Horen (stag's horn; see fig. d).[6] It is curious that Rembrandt failed to notice the shell's essential feature, especially since he was so intent on conveying the details of the reddish-brown and white tinted surface so precisely – and exactly life-sized. Unlike Hollar, Rembrandt tried to position the shell in space by having it cast a shadow, even in the first state. However beautiful the print undoubtedly is in this early form – five impressions of which are known – Rembrandt must have envisaged a far darker image from the outset. A slightly jarring note in the first state is the upper contour, which continues along the white areas of the shell where it should have been interrupted against the white background. Furthermore, the artist applied unduly dense hatching to sections that are in reality pure white. Because of this, the shell is far too dark in the first state, particularly with its bright illumination, and even has a slightly strange air about it. Only once the surroundings have been abundantly filled with lines do the highlights on the left – betraying the maker's primary calling as a painter – and the grey in places where the shell is actually as white as snow make sense. The atmosphere generated by t he elaboration of the plate gives the print a certain tension and even a slightly meditative ambience. Hercules Segers achieves a comparable effect with his etching of a *Still life with books*.[7] Since

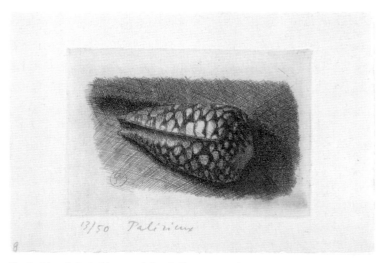

fig. f Gérard de Palézieux, *The shell*, 1968. Etching, 94 × 141 mm. Amsterdam, Museum Het Rembrandthuis

boon despatched to Man'.[10] It is therefore easy to imagine that Rembrandt wanted his intricate etching to demonstrate that an artist has the special gift of pitting himself against nature, an idea that had preoccupied poets and artists since the Renaissance.[11]

His man-made shell had enormous appeal to later painters and printmakers. Early etched copies exist, one of which is so faithful to its model that it was often taken for the original.[12] The inspiration that Rembrandt had drawn from Hollar communicated itself through his own work to generations of printmakers right down to the late twentieth century. Some copied the virginal first state, while others favoured the worked-up second state (figs e–f). In our time, of course, no master would want to be seen making a direct copy after Rembrandt. The new prints are therefore variations on a theme, but they illustrate strikingly how a single work of art – even centuries later – can give birth to others.

GL

1 See Sam Segal in Delft-Cambridge-Fort Worth 1988–9, pp. 77–92.

2 Although the prints are rare, the Rijksmuseum has thirty-seven of the thirty-eight; see *Bulletin van het Rijksmuseum* 40 (1992), pp. 102–3. For the series, see R. T. Godfrey in New Haven 1994, pp. 19–20 and 128–9, no. 93.

3 Ibid., no. 94.

4 Rembrandt had a *groote quantiteit hoorens* [en] *seegewassen* (Strauss & Van der Meulen 1979, 1656/12, no. 179; on Rembrandt's collections, see also Scheller 1969).

5 H. E. Coomans in Amsterdam 1992, pp. 202–3 and *Catalogue*, pp. 46–7, no. 63.

6 For Stoskopff's painting, see Strasbourg-Aachen 1997, pp. 199–200, no. 39. With thanks to Hans Buijs of the Fondation Custodia, Paris, for the information he supplied about the drawing reproduced in fig. d.

7 Haverkamp Begemann 1973, no. 54.

8 See White 1999, p. 189, fig. 261 for a detail of the part that is worked.

9 See Copenhagen 1983–4.

10 '[ze zijn] door geener handen konste/ Geplaesterd noch gevormt, maer wt s'Naturen gonste/ Den menschen toegeschickt' See Scheller 1969, pp. 119–21 with on p. 120 the quotation from Philibert van Borselen's *Strande oft Ghedichte van de schelpen, kinckhornen, ende andere wondere Zee-schepselen*.

11 Taylor 1964.

12 See Minder 1997, pp. 180–81, no. 105.

63

Landscape with three gabled cottages 1650

Etching and drypoint, 161 × 202 mm; signed and dated lower left: *Rembrandt f 1650*

Hind 246; White & Boon 217 I and III (of III)

I London★ (1847-11-20-6; watermark: none)

III Amsterdam★ (Van Leyden RP-P-OB-275; watermark: none); London (Cracherode 1973.U.1033; watermark: Strasbourg lily with letters PR [Ash & Fletcher 36, E´.a.])

III counterproof London★ (1848-9-11-107; ex. E. Astley [L.2775] and Aylesford [L.58]; watermark: Strasbourg lily with letters PR [Ash & Fletcher 36, E´.a.])

Watermarks: the watermark seen in the two London impressions of the third state is usually dated to 1652 or slightly later. This must be the date of these impressions.

SELECTED LITERATURE: Boston-New York 1969, no. 6; Paris 1986, no. 147; Berlin-Amsterdam-London 1991–2, pp. 256–7, no. 32; Schneider 1990, no. 20; Amsterdam 1993, no. 35; Amsterdam 1998, p. 334.

The view is related to that shown in a drawing Rembrandt made, probably on the spot, of *Cottages on the Schinkelweg, looking towards the Overtoom* (fig. a).[1] The Overtoom was a roller-bridge on the Schinkel canal, a few kilometres to the south west of Amsterdam in the direction of Sloten. Despite the change in viewpoint (which has prompted the suggestion that Rembrandt may have made another drawing of the view, now lost), we recognize the longhouse with two doors at the side and a tall chimney, as well as the foreground tree and the stump nearby, and the more distant buildings near the water beyond.[2] The drawing allows us to observe how Rembrandt could enrich a prosaic view by adjustments of scale and position, or 'artist's licence'.

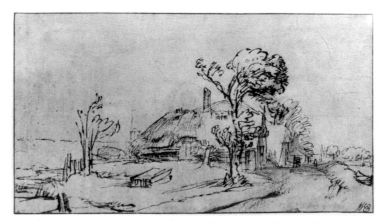

fig. a Rembrandt, *Cottages on the Schinkelweg*. Pen and brown ink with brown wash on paper prepared brown, 94 × 172 mm. Berlin, Staatliche Museen, Kupferstichkabinett (Benesch 835)

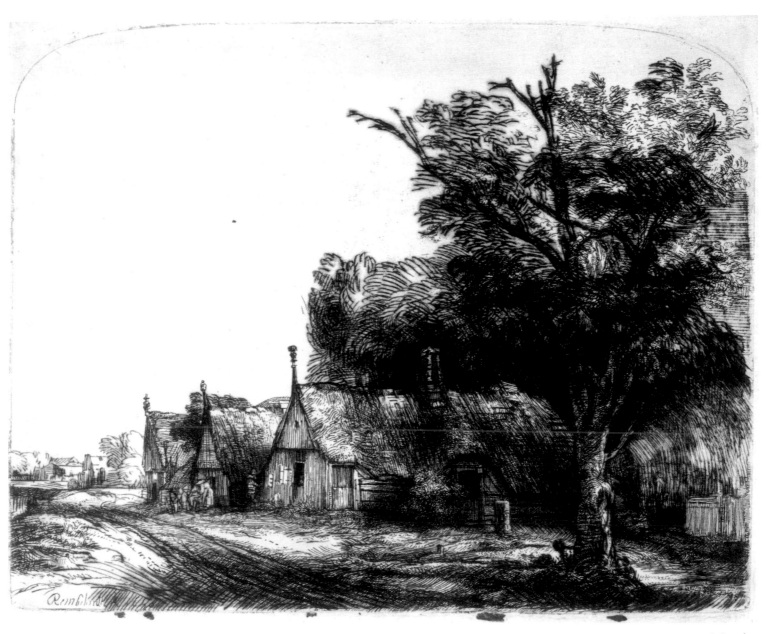

I London

The print is remarkable for the richness of the drypoint burr, which in early impressions prints a furry black, to abstract effect. It was vigorously scored over the etched lines, which are more delicate (and in the foliage in the centre, Rembrandt burnished them, leaving only faint traces). In the second and third states Rembrandt darkened further areas, especially in and around the foreground cottage, probably in an attempt to integrate the tonal balance of the composition. Even before these additions, the print suggested the recession towards the distant houses remarkably convincingly, but in later states the play of light and atmosphere is extraordinarily subtle, with sunlight playing on the distant buildings while the foreground seems partially overcast. Few of these qualities are present in the drawing (fig. a), which probably belonged to a stock of informal sketches that were retained and sometimes used at the starting-point for independent compositions.

The lack of burr in the counterproof of the third state shown here produces a dry effect. That a counterproof was printed suggests that Rembrandt may have contemplated further additions, which in the event were never carried out.

MRK

1 The similarity was noted by Haverkamp Begemann 1961, p. 57. For a detailed discussion of the topography, see Amsterdam 1998, p. 334.

2 Amsterdam 1998, p. 334 notes the similarity of the view to another drawing in Berlin (Benesch 1293), and suggests that yet another sketch, now lost, may have depicted the same houses from an angle closer to that of the etching. *Cf.* also the earlier drawing in Stockholm (Benesch 795) which shows a comparable motif.

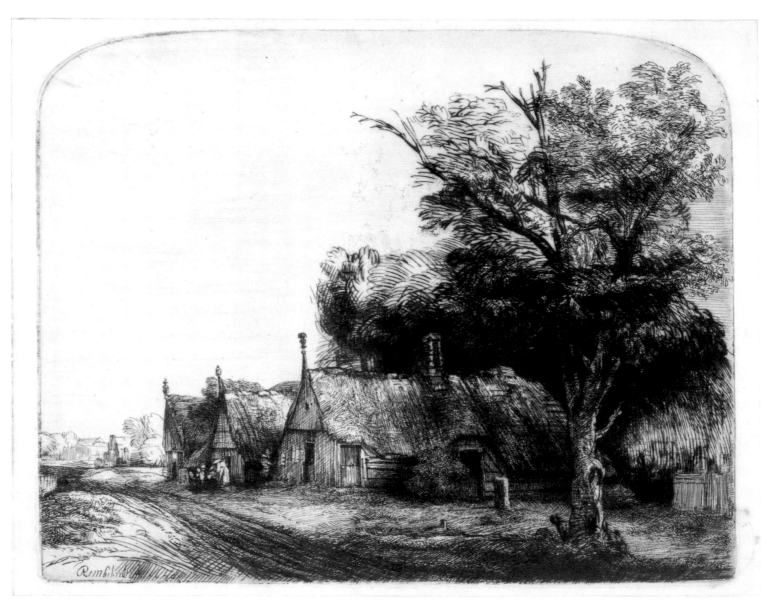

III Amsterdam

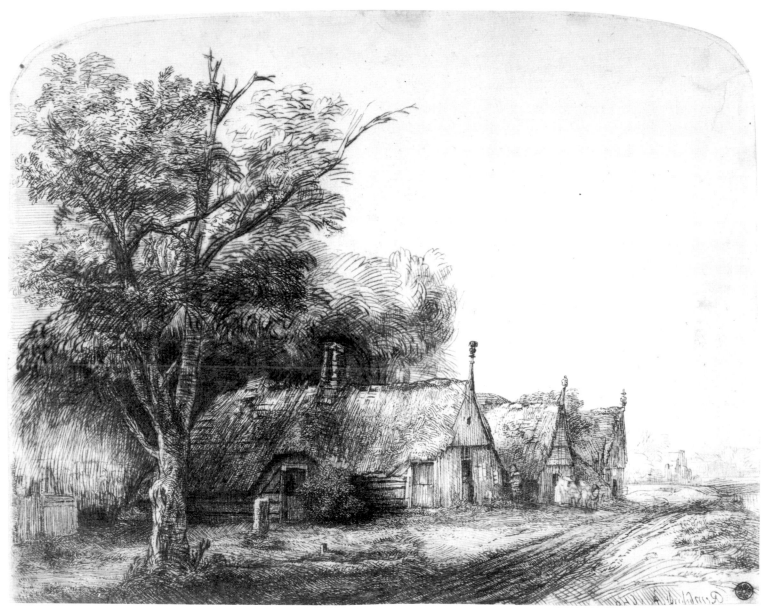

III London (counterproof)

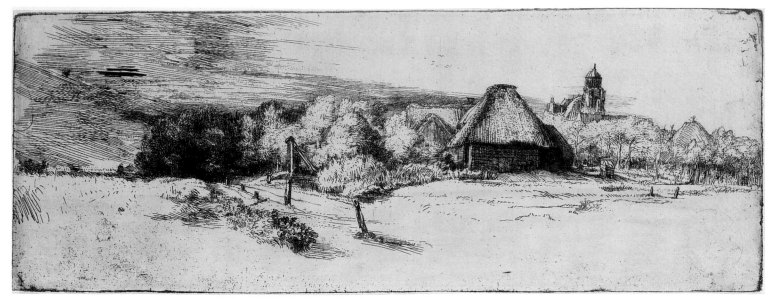

I Amsterdam

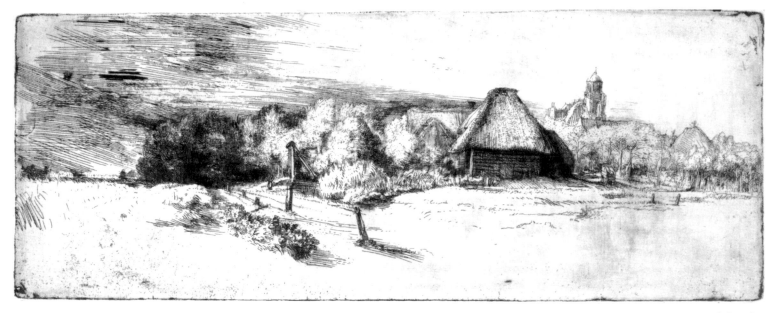

I London

fig. a Rembrandt,
*Landscape with the house
with the small tower.*
Pen and brown ink with
brown wash,
97 × 217 mm.
Los Angeles, J. Paul Getty
Museum (Benesch 1267)

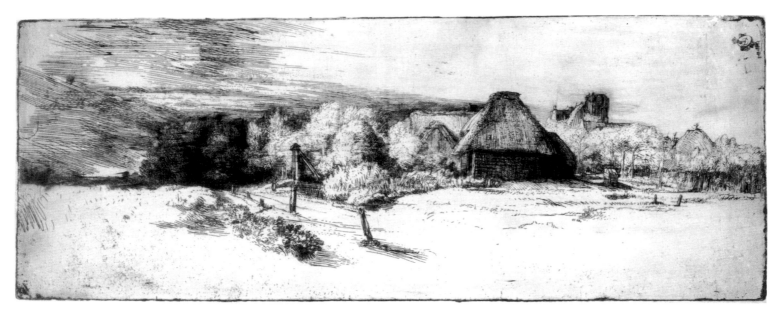

III London

64

Landscape with trees, farm buildings and a tower
*c.*1651

Etching and drypoint, 123 × 319 mm

Hind 244; White & Boon 223 I and III (of IV)

I Amsterdam★ (Van Leyden RP-P-OB-456; on Japanese paper)

I London★ (1848-9-11-111; watermark: fragment of Foolscap with five-pointed collar [Ash & Fletcher 19, K.a.])

III London★ (Cracherode 1973.U.1029; with Dighton's mark [L.727]; watermark: none)

Watermarks: the watermark in the first state also occurs in impressions of the second, and in a large group of other etchings, including the *Good Samaritan* (B.90) of 1633, *Six's bridge* (cat. 49) of 1645 and the *Landscape with three gabled cottages* (cat. 63) of 1650. They must have been printed around 1651.

SELECTED LITERATURE: Lugt 1920, p. 112; Regteren-Altena 1954, pp. 1–17; Boston-New York 1969, no. 5; Schneider 1990, no. 82; Berlin-Amsterdam-London 1991–2, pp. 261–3, no. 34; Amsterdam 1998, pp. 314–19; White 1999, pp. 238–9.

The composition gives in reverse an actual view: on leaving De Overtoom to the south west of Amsterdam, Rembrandt must have taken the road south towards Amstelveen. After approximately one kilometre, he stopped on the right hand side of the road and, still looking south, saw the barn and farmhouse a little further along on the other side of the road, with beyond it a second farm and the so called 'House with the small tower' ('Huis met het toorentje'). All this is of course reversed in the print, but the accuracy of much of the depiction and the immediacy of the sense of mood suggest that the etching may have been drawn at least partly on the spot, rather than only on the basis of drawings. The sun appears to have been low in the western sky, so that the

trees and bushes in the centre are in sharp *chiaroscuro* in the late afternoon light. Surface tone (ink left on the flat surface of the copper plate before printing) serves to intensify this effect on some impressions, including those from the British Museum.

In later states Rembrandt, as well as burnishing out the black blobs in the sky (second state), clarified the light in the third state by adding shading to the roof of the barn, in the sky to the left and, in drypoint, on the trees nearby. The changes throw this section of the landscape into dramatic shadow. More surprisingly, in the third state he also burnished out the upper section and cupola of the tower. His reasons for doing this are obscure, but it would certainly have rendered the view less recognizable. This is odd, given that the house belonged to the Receiver-General, Jan Uytenbogaert, portrayed by Rembrandt in a print of 1639 (cat. 35).[1]

The etching is datable to around 1651 on stylistic grounds. In the same period, Rembrandt drew the *Huis met het toorentje* from the further bank of the River Schinkel to the west (fig. a). The barn and longhouse in the foreground of the print are there on the extreme left.[2] The drawing may have served as the starting-point for two other prints by Rembrandt, the *Canal with an angler and two swans* and the *Canal with a large boat and bridge* (B.235–6),[3] to which he added mountains and towers so that the landscapes are less naturalistic.

MRK

1 White 1999, p. 239, suggests that the alteration makes the print 'more harmoniously balanced'.

2 The buildings survived until 1915 (see Amsterdam 1998, *loc. cit.*, with photograph repr. p. 316, fig. 4).

3 Also noticed in Amsterdam 1998, *loc. cit.*

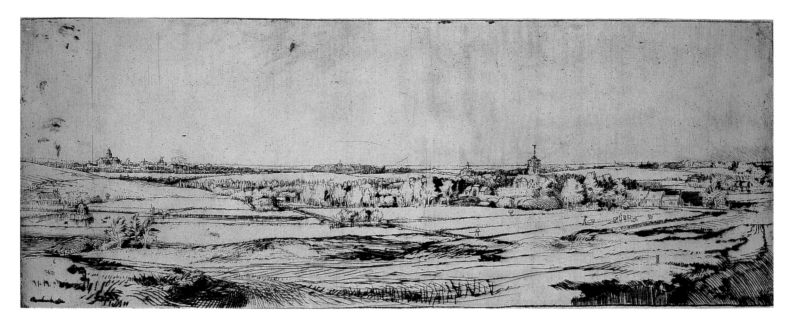

London

65

The goldweigher's field 1651

Etching and drypoint, 120 × 319 mm; signed and dated lower left:
Rembrandt 1651

Hind 249; White & Boon 234 only state

Amsterdam (De Bruijn RP-P-1962-91; ex. Rijksmuseum [L.240]; water-
mark: Strasbourg lily with initials 4WR [Ash & Fletcher 36, initials
4WR.e.]); London★ (Cracherode 1973.U.1037; watermark: Strasbourg lily
with initials 4WR [Ash & Fletcher 36, initials 4WR.e.])

Watermarks: these identical watermarks are only found in the earliest
impressions of this print, and do not occur in other prints.

SELECTED LITERATURE: Valentiner 1951, pp. 341–7; Van Regteren Altena
1954, pp. 1–17; Boston-New York 1969, no. 7; Boston-St Louis 1980–81,
no. 158; Stone-Ferrier 1985, pp. 418–36; Paris 1986, no. 149; Giltaij 1988,
no. 21; Schneider 1990, no. 84; Berlin-Amsterdam-London 1991–2,
pp. 245–7, no. 28; Laurentius 1996, p. 49; Melbourne-Canberra 1997–8,
no. 113; Amsterdam 1998, pp. 374–9; White 1999, pp. 239–42.

More than most of Rembrandt's landscape etchings, the
Goldweigher's field resembles the style of his drawings. Rather than
his habitual trails of etched lines, he employed short ticks and
stabs of the etching and drypoint needles, retaining the character
of some of his informal sketches made from nature in pen and
brown ink. His precision is astonishing, as is also his use of the
blank page to suggest not only distance and atmosphere, but also
details such as the house and trees to the right, while delicately
touching in the shadows around them. The economy of tech-
nique is remarkable, whether in the wide expanses of receding
terrain or the staffage, including the bleachers in the fields on the

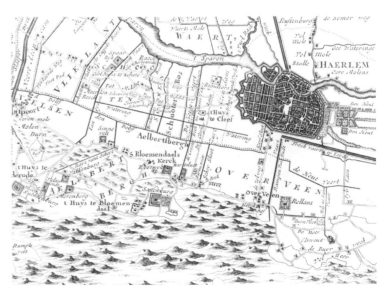

fig. a Nicolaas Visscher (publisher), *New Map of the District of
Kennemerland, c.*1726. Haarlem, Rijksarchief in Noord-Holland

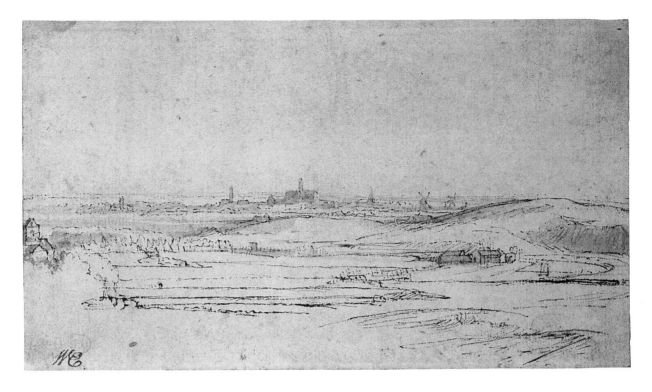

fig. b Rembrandt,
*View of the Saxenburg
estate near Haarlem.*
Pen and brown ink
with brown wash
and some white
heightening,
89 × 152 mm.
Rotterdam, Museum
Boijmans Van
Beuningen (Benesch
1259; exh.)

right. In some impressions the drypoint burr prints so darkly that it somewhat undermines the intended effect. Rembrandt also experimented with plate tone (as in the British Museum impression) and Japanese paper to vary the mood and tonality of the print.

The representation is accurate enough to have prompted (again) the idea that the plate was worked on out of doors, on the spot (see the map, fig. a).[1] Rembrandt was up on one of the dunes to the west of Haarlem.[2] Looking east, he saw to his left (reversed and thus to the right in the print) the Saxenburg estate, a classical country house capped by a tall tower and with a gate house in front. The foreground fields, which also belonged to the estate, are traversed by two almost parallel roads leading to Haarlem. Behind the bleachers to the right we see a group of houses, while above the gate-house the diminutive spire of the church of Bloemendaal pricks the horizon. Just to the left of centre stands another classical structure on the edge of the Saxenburg estate, near the road to Haarlem, the town on the horizon to the left. Its main church of St Bavo, along with the tall tower of the Bakenesser church and a high windmill on the town walls are all recorded on the plate, reinforcing the sense that it was begun *in situ*.[3] Below the town, near the foreground, lies a pond with, in the centre, a domed construction, perhaps a duck-house, with a farm just beyond it at the edge of the print.

In pen and brown ink with wash, Rembrandt drew the scene

another time from slightly further north (fig. b), thereby reducing the distance between the city and the tower of Saxenburg and reversing the positions of the construction in the pond and the farm behind it. The drawing should be placed in the same period as the etching, with which it shares congruities of style, but whether it played a direct preparatory rôle is uncertain. The print was started as a pure etching and subsequently elaborated in drypoint, which must have been added after the plate had been immersed in the acid bath.[4] Thus a possible reconstruction of Rembrandt's working method would be that he made the drawing (and perhaps some others, now lost) and the purely etched parts of the print on an excursion to the area in 1651 (the date on the etching); and that on his return to the printing press, having bitten the plate with acid and perhaps pulled a few proofs (and even a counterproof) in an earlier state that has not survived, he added the work in drypoint, retouching various details in the process and balancing the composition as a whole. Otherwise we would have to assume that the entire print was made on the basis of the drawings; given its precision, and the incidental details (note the ducks on the pond, the two figures at its further edge, one of them holding a pole, and the equally minute figures in the foreground, in front of the building in the water) this seems less probable.

Followers of Rembrandt depicted the same area at least three times: a drawing by Ferdinand Bol (fig. c), which shows the

fig. c Ferdinand Bol,
View near Bloemendaal.
Black chalk with grey
and brown wash,
147 × 292 mm.
Paris, Institut
Néerlandais, coll. Frits
Lugt

water-bound pavilion in the centre and two diminutive figures
(who may be artists);[5] a watercolour, usually dated a decade later
than Rembrandt's etching, by Gerbrand van den Eeckhout
(fig. d);[6] and a painting and a drawing that are both usually attrib-
uted to Philips Koninck (figs e–f).[7] One possible reason for their,
or at least Rembrandt's, choosing the motif may have been the
latter's connection with Christoffel Thijsz, the owner of the
Saxenburg estate. Thijsz was never fully repaid by Rembrandt for
credit given on the large house in the Breestraat in Amsterdam
that the artist acquired in 1639 (now the Museum het
Rembrandthuis). In the 1650s, Rembrandt's financial crisis
worsened, leading to his making over many of his belongings to
the court of insolvency in 1656, when an inventory of his posses-
sions was made, prior to their dispersal at auction sales that were
completed in 1658 – the year in which Thijsz died. But although
the theory that Rembrandt made the view of Thijsz' estate in
order to placate his creditor is a tempting one, we cannot know
this for certain.[8]

The traditional title, the *Goldweigher's field*, used in 1751 by
Gersaint, is misleading. Either Gersaint associated the wrong
print with a title he had heard (which might have been meant
to describe cat. 64, which indeed shows the estate of Jan
Uytenbogaert, the subject of Rembrandt's print, the *Goldweigher*,
cat. 35); or he was erroneously led to believe that Uytenbogaert
owned the estate depicted in the present work.

MRK

fig. d Gerbrand van den Eeckhout, *View towards Haarlem.*
Watercolour over black chalk, 139 × 185 mm. Berlin, Staatliche Museen,
Kupferstichkabinett

fig. e Philips Koninck, *Landscape with the Saxenburg estate*. Oil on panel, 220 × 295 mm. Private collection

fig. f attributed to Philips Koninck, *View near the Saxenburg estate*. Pen and brown ink with watercolour, 166 × 275 mm. Dresden, Staatliche Kunstsammlungen, Kupferstich-Kabinett

1 See the Introduction, pp. 74–5, and e.g. cats 41, n. 1, and cat. 49.

2 The notes on the topography here are taken from Amsterdam 1998, pp. 374–9. As there noted, Van Regteren Altena, *loc. cit.*, believed that Rembrandt's vantage point was the high dune called the *Kopje van Bloemendaal*, but the artist must have been about 400 metres further north.

3 Bevers (in Berlin-Amsterdam-London 1991–2, p. 246, n. 7) suggested that a wide-angle lens may have been used, giving rise to the optical effect of the etching (supported in Amsterdam 1998, p. 376). While not impossible, a similar result may have been reached by compressing a wide view (involving turning the head) on to the plate, using only the natural lens of the eye. The 'panoramic' format has been compared (e.g. by Zdomowicz in Melbourne-Canberra 1997–8, under no. 113) to the *View of Amersfoort* by Hercules Segers (Havercamp Begemann 1973, p. 56, no. 30).

4 Laurentius 1996, p. 49, suggests that the burr was reworked in *c.*1680 in the impression illustrated and others, but the watermark evidence now available shows that this was not the case.

5 As suggested by Bakker, in Amsterdam 1998, p. 378.

6 Sumowski 686.

7 Sumowski, *Gemälde* 1042; Sumowski 2285[XX] (as attributed to Roelant Roghman).

8 A drawing in the British Museum is inscribed with Thijsz's name on the *verso*, in a note by Rembrandt in which he seems to be preparing for a meeting with his creditors (Benesch 1169; see Royalton-Kisch 1992, no. 60). Thijsz's rôle as Rembrandt's creditor was connected with the etching by Valentiner 1951 (who was the first to publish the painting) and Van Regteren Altena 1954 (the latter supposing that the etching concerned was B.223, here cat. 64). Both these authors thought the Koninck painting was by Rembrandt, and Van Regteren Altena identified the figure with dogs in the foreground as Thijsz himself.

66

Clement de Jonghe 1651

Etching, drypoint and burin, 207 × 161 mm; signed and dated, lower right: *Rembrandt f. 1651*

Hind 251; White & Boon 272 I, II, and IV (of VI)

I Amsterdam★ (Van Leyden RP-P-OB-525; watermark: Countermark RC [Ash & Fletcher 26, A.a.]); London (Cracherode 1973.U.1042; on Japanese paper)

II Amsterdam (Van Leyden RP-P-OB-526; watermark: Paschal Lamb [Ash & Fletcher 29, A.a.]); London★ (1843-6-7-158; watermark: Paschal Lamb [Ash & Fletcher 29, A.a.])

IV Amsterdam (Van Leyden RP-P-OB-528; watermark: none); London★ (Cracherode 1973.U.1044; watermark: none)

Watermarks: as the Paschal Lamb watermark and the Countermark RC belong together, the first and second states are printed on the same paper. The same watermark occurs in impressions of the *Goldweigher's field* of 1651 (cat. 65). Several copies of the third state (not exhibited) are printed on a different type of Paschal Lamb paper. Unlike the first three states, impressions of the fourth state occur with a variety of watermarks, indicating that the plate was reprinted several times in that state.

SELECTED LITERATURE: Seymour Haden 1877, pp. 17 and 47–8; Boston-New York 1969, pp. 55–61, no. 8; Amsterdam 1986, pp. 58–61; Berlin-Amsterdam-London 1991–2, pp. 251–3, no. 30; New York 1995, II, pp. 213–16, no. 92; White 1999, pp. 153–5.

The sitter's pose in this etching is strikingly informal, and the fact that he is wearing a hat, a loose-fitting cloak and gloves suggests that he was passing by and plumped himself down for a few minutes to sit for Rembrandt. Because of these characteristics, the portrait can be regarded as more or less the equivalent in print form of the *Portrait of Jan Six* painted three years later (fig. a); even the open, limpid style of etching – suggestive rather than descriptive – greatly resembles the wide brushstrokes with which Rembrandt depicted his friend Six. That the sitter is shown from a frontal perspective is unusual for Rembrandt, who generally preferred a three-quarter view. The chair stands at the exact centre of the image, but as the man leans slightly to the left, the composition does not seem austere.

Going by the theory that it was mainly artists and art lovers who appreciated this kind of informality in pose and execution, it seems logical to assume that the sitter belonged to one of these two groups. He was long believed to be Clement de Jonghe (1624/5–77), the Amsterdam print and map dealer who, probably during Rembrandt's lifetime, acquired seventy-four of the master's copper plates. This identity has recently been

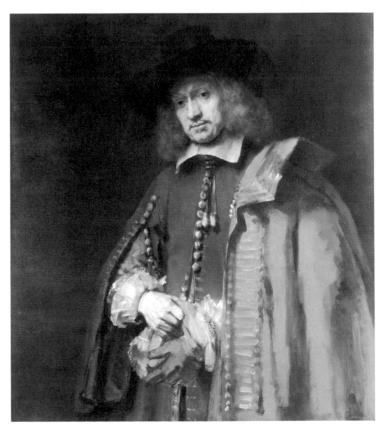

fig. a Rembrandt, *Jan Six*, 1654. Canvas, 112 × 102 cm. Amsterdam, Six Collection

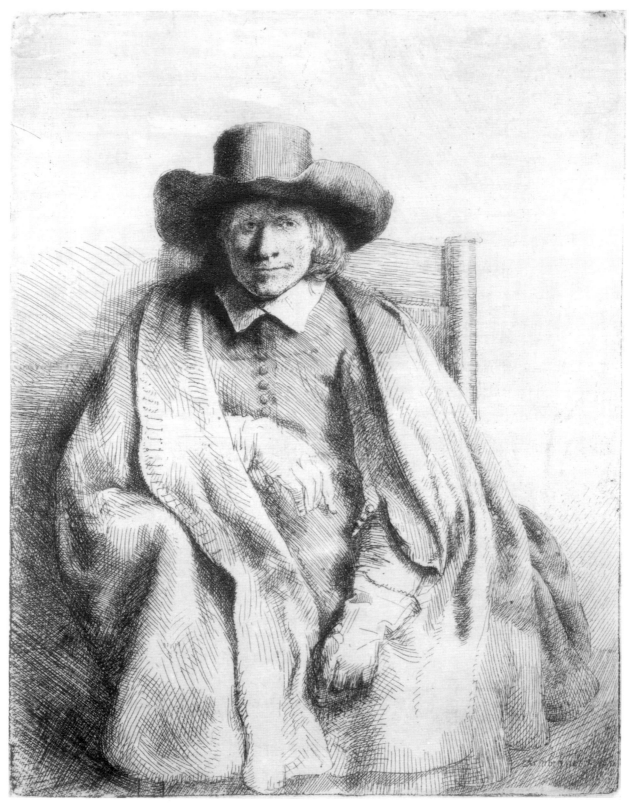

I Amsterdam

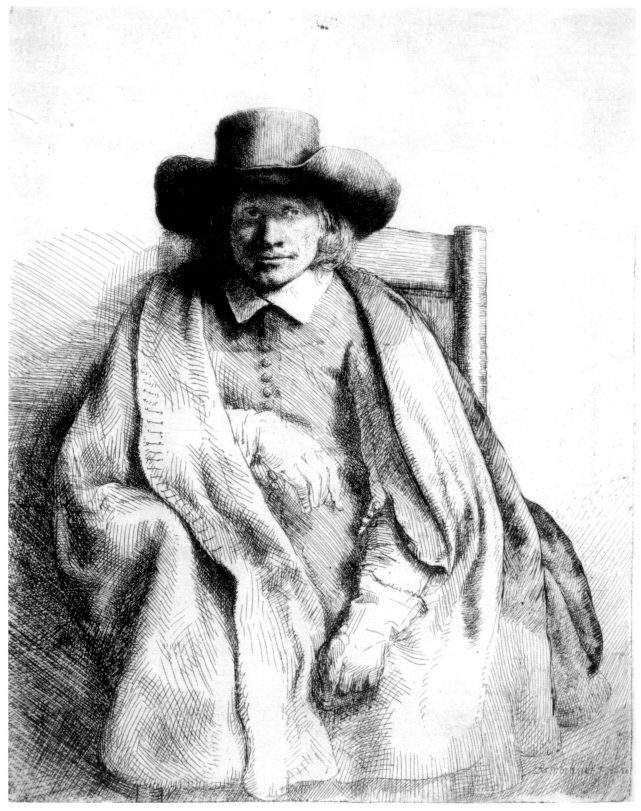

II London

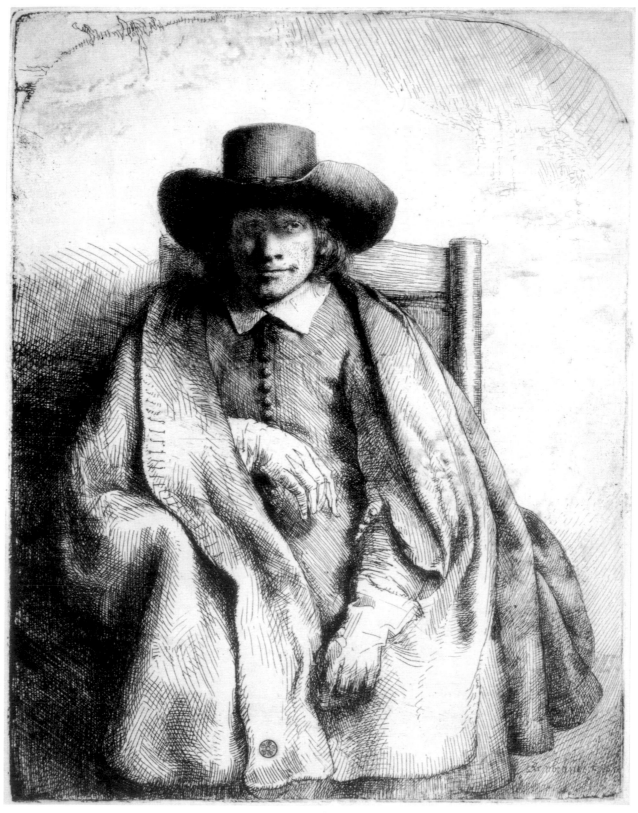

IV London

275

questioned, albeit on uncertain grounds.[1] One fairly subjective argument is that the sitter must be older than twenty-six, De Jonghe's age in 1651. Another is that he does not resemble the dealer as depicted in the vignette advertising De Jonghe's shop, which was made in or around 1655, probably by Rembrandt's pupil Gerbrand van den Eeckhout (1621–74; see fig. b). However, it is reasonable to question whether the schematic figures reproduced in that little piece were meant in any sense as portraits. The original identification was based on a few old inscriptions on impressions and on the 'memorial' that the Delft collector Valerius Röver compiled in 1731 of the prints that he owned by Rembrandt.[2] That the etching was linked to De Jonghe far earlier, while Rembrandt was still alive, is evident from a inscription dated 1668 by the Parisian print publisher and dealer Pierre Mariette (1634–1716) on the back of an impression: *Clement de Johnge marchand de tailles douces a Amsterdam* (fig. c).[3]

The etching went through six states. The changes relate not so much to the print's general appearance but more to details, though they altered De Jonghe's expression. Rembrandt paid particular attention to the illumination of the face around the eyes. While in the first state the face is still hatched transparently, in the second state the shadow cast over it by the wide-brimmed hat is more marked; the modelling is tauter; and in good, early impressions the white of the eyes is bright and clear. Drypoint accents were added to the chin and around the mouth, and the hair becomes fuller on the right. The right eye has also been slightly enlarged. As a result, the somewhat dreamy expression of the first state is expunged. In the third state, in which the eye is reduced again, a rather frozen smile appears. Elements outside the face that were reworked early on included the outer fold of the cloak on the right and the chair, where a gaping hole was closed at shoulder level.[4] In the third state a rather rudimentary arch was drawn loosely in drypoint, relieving the emptiness of the background.

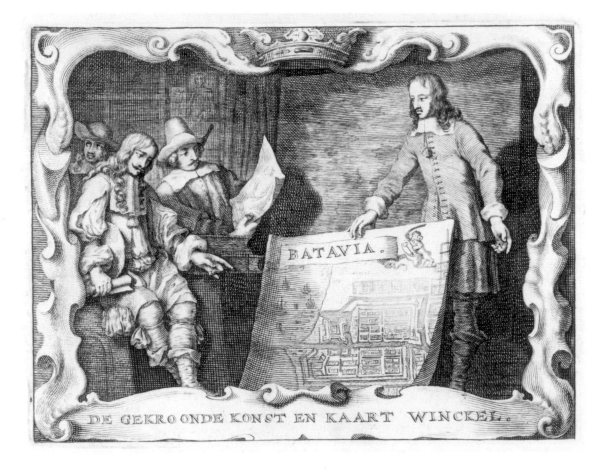

fig. b Gerbrandt van den Eeckhout, advertisement for Clement de Jonghe's print shop, *c*.1655. Engraving, 112 × 145 mm. Amsterdam, Rijksmuseum

fig. c Back of an impression of the third state of Rembrandt's *Portrait of Clement de Jonghe*. New York, Pierpont Morgan Library

From the watermarks in the paper of the first three states we may infer that they were probably made in rapid succession. Even so, Rembrandt was not working in a deliberate manner towards this third state, as more than thirty impressions of the first state are known, some of them printed on Japanese paper, and one on cartridge paper. Thus he definitely did not regard this state as a series of trial proofs. In part the later changes were probably needed to maintain the image's legibility, particularly since the print has so many drypoint areas.

In the fourth state the plate was retouched in several places: the hatching, especially to the sitter's left, was enhanced extensively and a bold *chiaroscuro* comes to dominate the overall picture. The fiddly changes to the arch at the top, although certainly Rembrandt's own work, are hardly typical of him. This fourth state occurs on paper with a variety of watermarks, some of which can be dated in the 1690s. This indicates that Rembrandt made the changes to the plate up to and including this state, while subsequent alterations were by another hand. Although many have thought that the retouches in the fifth state, in all their clumsiness – especially around the eyes – were Rembrandt's, the evidence of the watermarks rules this out.[5]

The inventory drawn up after Clement de Jonghe's death does not mention a copper plate with his portrait. If it was commissioned by the sitter, it is possible that the plate was not regarded as part of his business capital.[6] Like the Rembrandt plates from De Jonghe's inventory, this one too ended up in the possession of the merchant Pieter de Haan (1723–66). After that it followed the same course as Rembrandt's other copper plates, until it was acquired in 1993 by the Amsterdams Historisch Museum.[7]

GL

1 See Voûte 1987, pp. 21–7.

2 Van Gelder & Van Gelder-Schrijver 1938.

3 With thanks to Erik Hinterding, who tracked down this note. At the top of the sheet appears the inscription: *P. mariette 1670.*

4 For a detailed description of several differences, see White & Boon, I, p. 125.

5 White believed that the changes that led to the fifth state were Rembrandt's (White 1999, pp. 154–5). Unfortunately, the reproductions of the fourth and fifth state became interchanged in his book (figs 204–5). Hind had previously assumed that Rembrandt's interventions ended with the fourth state. See also Stephanie S. Dickey in New York 1995, II, p. 214, where she also attributes the changes in the fifth state to Rembrandt.

6 Hinterding 1993–4, p. 261, n. 43.

7 Ibid., p. 300.

67

The adoration of the shepherds *c.*1652

Etching, drypoint and burin, 148 × 198 mm

Hind 255; White & Boon 46 II (of VIII)

II Amsterdam★ (RP-P-1992-14; watermark: none)

SELECTED LITERATURE: Boston-New York 1969, pp. 62–9, no. 9; Filedt Kok 1992; White 1999, pp. 74–7.

Time and time again, in depicting subjects with a long tradition in art, Rembrandt set himself apart by exploring in depth the reality of the event. And although later generations were often to criticize him for a lack of decorum, it was precisely the textual pointers with implications for the accurate setting of a scene that really mattered to him.[1] Not for Rembrandt the improvised lying-

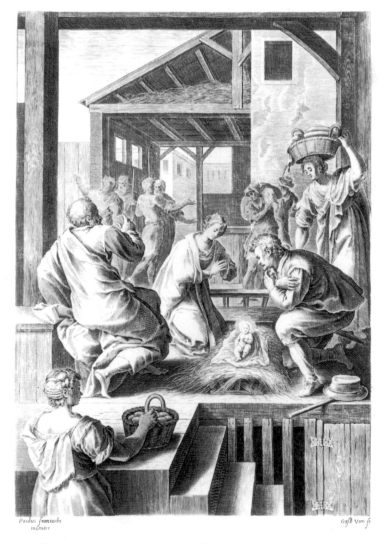

fig. a Gijsbert van Veen after Pauwels Franck, *Adoration of the shepherds.* Engraving, 315 × 215 mm. Vienna, Graphische Sammlung Albertina

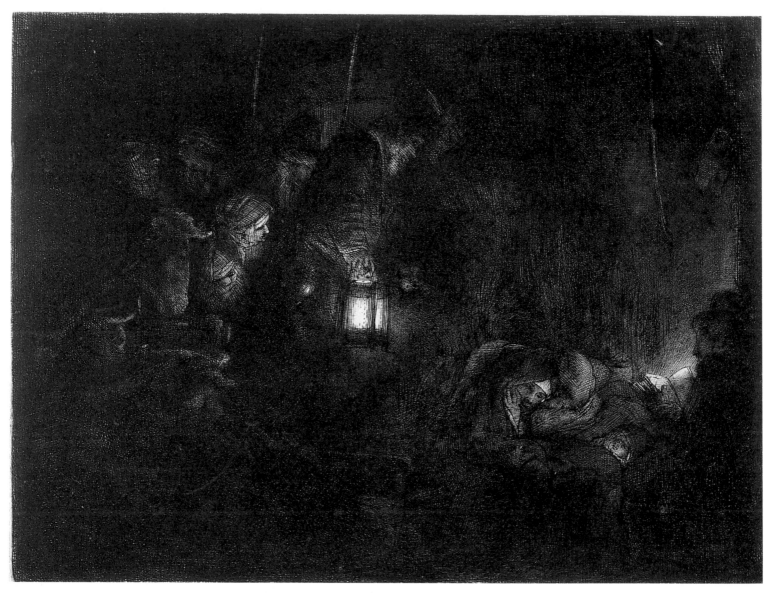

II Amsterdam

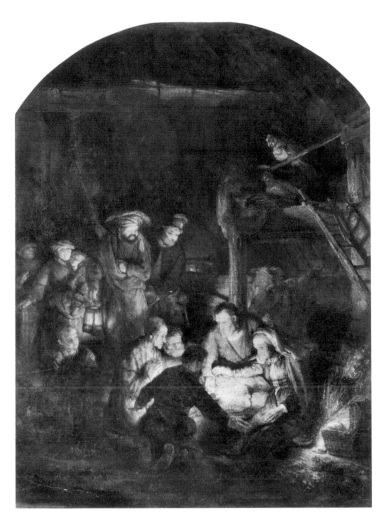

fig. b Rembrandt, *Adoration of the shepherds*. Canvas, 970 × 713 mm. Munich, Alte Pinakothek

fig. c Rembrandt, first state of cat. 67. Amsterdam, Rijksmuseum

in visit in broad daylight, set in a hastily knocked up stage setting with obscure characters, as the *Adoration of the shepherds* was usually visualized in his time (fig. a).[2] Rembrandt asked himself what it would really be like if, in the small hours of a bitterly cold night, a group of shepherds was to enter a scarcely-lit stable where a man and a woman were sheltering with a newborn baby.

He painted the subject, not afraid to make a real night scene of it, with all the technical difficulties entailed in rendering light effects in complete darkness so that they look natural. Painted in 1646, it formed was part of the series of scenes from the life of Christ commissioned by the stadholder Frederik Hendrik (fig. b); another, studio version on canvas was produced in the same year.[3] Rembrandt revisited the subject in a sketch-like etching with open hatching (B.45), one of a number of stylistically related prints from around 1654, and also in the work shown here, which is elaborated to a greater degree and, in the reading of the scene, is closer to the paintings. This nocturne occupies a special place in Rembrandt's graphic oeuvre, not least because in the eight – perhaps nine – states in which it is known he plays a highly experimental game with light and dark,[4] whether by using surface tone, by reworking elements or by scraping away burr or burnishing particular areas and drawing something new in their place. It is only in the British Museum and in the Rijksprentenkabinet that the subtle transformation of the print from start to finish can be experienced in full; we have selected a

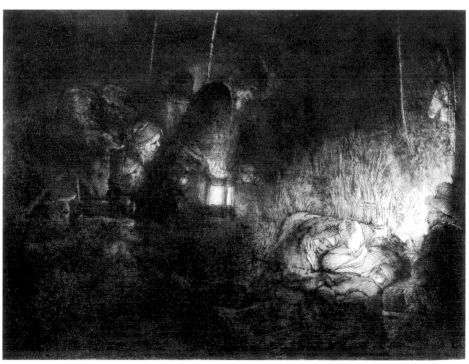

brilliant impression of the second state from this abundance. Whereas in the first state Rembrandt had tried the effect of highlighting the Holy Family in the darkness (fig. c), here the light has been reduced overall, and the little that remains comes from the lantern carried by one of the shepherds and from the candle, hidden from our view, by which Joseph, on the right, sits reading. This means that the spotlight falls in a very concentrated way on the newborn child and his mother who, exhausted by the birth, shelters under a blanket that leaves only her face exposed. Her gaze is fixed on her son in the manger and she holds the blanket away from her face with one hand. The huddled shepherds are rendered with the utmost economy, and the cattle on the left are little more than horns and ears just catching the light. The direction of the movement in the composition is strongly left to right, and Rembrandt contained this by planting three vertical stakes prominently in the scene.

There are only three known impressions of the second state, and the first, third and fourth states (with minor adjustments each time) are also extremely rare. It was evidently not until the fifth state that an edition of any magnitude was printed. An impression of the fifth state in the Hermitage in St Petersburg is printed on paper with a watermark (a Double-headed eagle) that also occurs in three impressions of the first state of the *Portrait of Jan Lutma* of 1656 (cat. 83), in that of *Abraham Francen* of *c*.1657 (cat. 84) and also in the first state of *Christ and the woman from Samaria* (B.70) of 1657.[5] It is therefore quite possible that the print should be dated closer to 1657 than 1652, which until now has been fairly generally accepted as the year in which it was made.[6] The way it was produced, with the many changes and second thoughts, resembles Rembrandt's approach in the *Portrait of Abraham Francen* (cat. 84). In prints dating from 1652 Rembrandt usually made more impressions of early states, often on Japanese paper, or achieved his goal more directly by completing the composition on the plate straight away.

In the seventeenth century night pieces like the *Adoration of the shepherds* were regarded by print collectors as a separate category and sometimes kept together in a special album. In 1699, when Florent Le Comte published his guide to the ideal print collection, he suggested an album devoted to *Nuits et pièces noires* by Rembrandt, Hendrik Goudt, Johannes van Vliet and Jan van de Velde.[7] One can readily imagine that this *pièce très noire* by Rembrandt – particularly on Japanese paper – would have been one of the crowning glories of such an album.

GL

1 For a more general discussion of Rembrandt's approach to biblical and other literary subjects, see Tümpel 1968.

2 For the reproduced engraving, see Hollstein 5.

3 The latter is now thought to be a 'satellite' variant produced by a studio hand (lecture by E. van de Wetering, The Hague, 7 December 1999).

4 For an accurate description of a number of the most striking differences between the states, see Filedt Kok 1992. On p. 170, n. 7 he refers to the existence of an impression in Washington that shows a stage between the fifth and sixth states; see the illustration in Boston-New York 1969, pp. 65–6.

5 Ash & Fletcher 15, D.a.

6 Münz 1952, no. 237 also suggested the same date (1656–7) without having the information about the watermarks.

7 William W. Robinson in Boston-St. Louis 1980–81, pp. xlv–vi.

68

Christ preaching ('La petite Tombe') *c*.1652

Etching and drypoint, 155 × 207 mm

Hind 256; White & Boon 67 only state

Amsterdam* (Van Leyden RP-P-OB-130; on Japanese paper); London (Cracherode 1973.U.1063; on Japanese paper)

Amsterdam (De Bruijn RP-P-1962–35; on Chinese paper; ex. P. Mariette 1674 [L.1789]); London* (Cracherode 1973.U.1064; ex. E. Astley [L.2775] and with Dighton's mark [L.727]; watermark: Foolscap with five-pointed collar*)

Watermarks: this particular foolscap mark has only been found in other impressions of the same print, all of them early and with rich burr.

SELECTED LITERATURE: Boston-New York 1969, no. 10; Berlin 1970, no. 86; White 1999, pp. 66–9.

In 1652 Rembrandt made a sketch based on Raphael's fresco of *Parnassus* in the *album amicorum* of his friend Jan Six (see p. 19, fig. 13; Benesch 913). The influence of Raphael's design also extended to the present etching, which is usually dated to the same year (although it could be from a little later).[1] The composition is more classically balanced than the *Hundred guilder print* of about four years before, which depicts a similar subject (cat. 61).[2] Yet a less formal accent is struck by the child doodling on the ground with its finger, and by the pair of feet on the verge of exclusion at the lower right corner. In style Rembrandt pares his technique to essential outlines and multiple series of parallel hatchings that never rival the earlier work in density. Yet in going over the etched plate in drypoint he enriched the details and produced effects of great subtlety, comparable to his additions in brush and wash to his pen drawings. The drypoint burr prints with considerable abstract force in early impressions, particularly in those on oriental papers as seen here. Less absorbent than

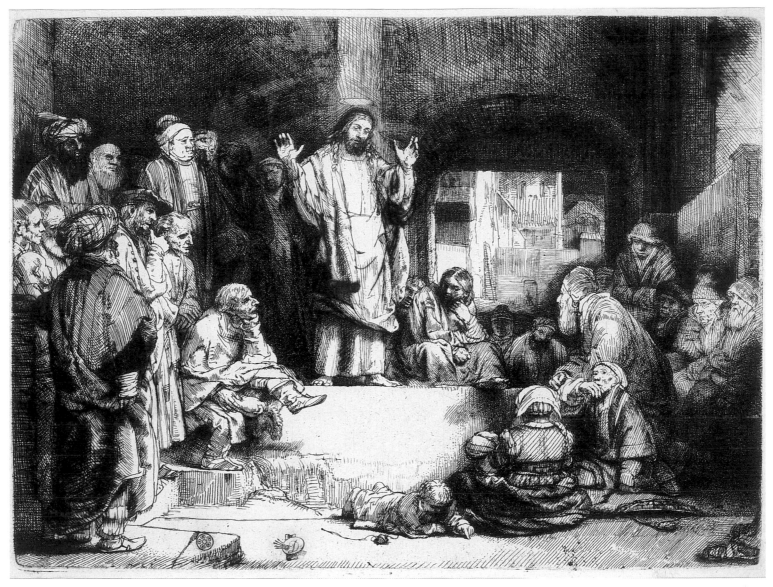

Amsterdam (Japanese paper)

European varieties of the period, it forces more ink to remain on the surface. In the sleeve of the man observed from behind on the left, the burr was so rich that Rembrandt apparently burnished it away.[3]

The name of the print, 'La petite Tombe', was used by Gersaint,[4] who based it on an earlier usage, which in fact referred to Nicolaes de La Tombe, who may have commissioned it. The 1679 inventory of Clement de Jonghe calls it *Latombisch plaatjen*, (La Tombe's little plate), and similar titles were employed by Arnold Houbraken in 1718, in the collector Valerius Röver's inventory of 1731, and in the Van Huls and De Burgy sale catalogues of 1735 and 1755.[5] Jacob, Nicolaes and Pieter de La Tombe are all mentioned in documents relating to Rembrandt between 1650 and 1658.[6]

MRK

1 As Erik Hinterding informed me on the basis of watermarks.

2 The figure of Christ has also been related to another fresco by Raphael in the Stanza della segnatura in the Vatican, the *Disputà* (see White 1999, p. 66).

3 Those without burr in this area are called 'white sleeve' impressions (*met het witte mouwtje*).

4 Gersaint 1751, no. 66.

5 Houbraken II, 1718, pp. 27–8; Röver calls it 'La tombes printje' as does the Van Huls catalogue, The Hague, 26 September 1735, lot 1046. De Burgy's catalogue, Amsterdam, 16 June 1755, lot 361, calls it *Christus, predikende aan de Schaare: of het zogenaamde la Tombes Prentje* (Christ preaching to the crowd, or the so-called la Tombe's little print); information collated by Erik Hinterding (see Hinterding 1993–4, p. 16, n. 45, with further literature).

6 See Strauss & Van der Meulen 1979, pp. 281–2, 353, 359 and 428. Pieter was the joint owner of two of the paintings inventoried among Rembrandt's belongings in 1656 and subsequently sold. De Hoop Scheffer & Boon 1971 discuss the De Jonghe inventory, as also De Hoop Scheffer 1972. In De La Tombe's will of 1671 he left two portraits of himself by Rembrandt, one painted when he was young, the other when old. According to Yver 1756, the name derived from Nicolaes de La Tombe (see also Van Eeghen 1956, pp. 43–9).

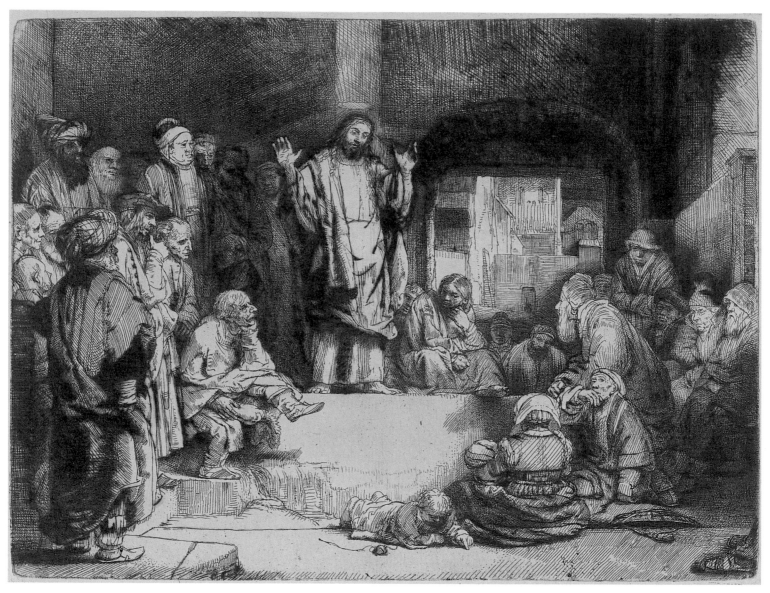

London (European paper)

69

A scholar in his study ('Faust') *c.*1652

Etching, drypoint and burin, 210 × 160 mm; inscribed in the centre of the circle in the window: *INRI.* ; and around it in the inner ring: + *ADAM* + *TE* + *DAGERAM* ; and in the outer ring: + *AMRTET* + *ALGAR* + *ALGASTNA* ++

Hind 260; White & Boon 270 I (of III [IV])

I Amsterdam★ (De Bruijn RP-P-1962-122; on Japanese paper); London (Cracherode 1973.U.1070; on Japanese paper)

SELECTED LITERATURE: Mariette 1857, p. 354; Leendertz 1921, pp. 132–41; Leendertz 1923–4, pp. 14–18; Benesch 1926, p. 9; Bojanowski 1938; Bojanowski 1940; Von Kieser 1940; Scholte 1941; Van Regteren Altena 1948–9, p. 11; Rehorst 1950; Rotermund 1957; Lehmann & Ettlinger 1958; Behling 1964; Boston-New York 1969, no. 11; Van de Waal 1974, pp. 133–81; Carstensen & Henningen 1988; Köhler 1982, pp. 10–12; Berlin-Amsterdam-London 1991–2, pp. 258–60, no. 33; Grothues 1992; Carstensen 1993, pp. 61–123; De Vries 1998.

This etching, which dates from around 1652, is one of Rembrandt's most puzzling prints. It depicts a man, pen in hand, leaning on a table with a writing-slope, papers and books on it. These attributes and the astrolabe in the lower right corner suggest that he is a scholar. His gaze is fixed on an apparition, partly surrounded by clouds, which looms up in front of the leaded panes of the window. By no means all the details of this apparition are visible, but the hands are clearly discernible. The left one holds a foreshortened mirror, while the right points to it. The form is further concealed by a circle of radiating light that encloses a series of letters. Only the *INRI* in the centre of this circle can immediately be identified, as being the abbreviation of the inscription placed over Christ's head during the crucifixion.

The question as to what precisely is depicted here still exercises experts and scholars after more than 300 years, and the interpretations are varied. In Clement de Jonghe's inventory of 1679, the subject is concisely described as the *Practising Alchemist*, but in 1731 Valerius Röver referred to the print as *Doctor Faustus*, and it has been known by this title ever since.[1] Early in the twentieth century, Leendertz believed that he was able to substantiate the validity of this traditional title. He pointed to the fact that a Dutch version of Christopher Marlowe's *Tragical History of Doctor Faustus* was staged in Amsterdam in about 1650, and argued that Rembrandt's etching represents the moment when a good angel, in the shape of a shimmering apparition, warns Faust not to enter into a pact with the devil.[2] Others sought the solution elsewhere, and several later studies concentrated primarily on solving the riddle of the letters in the circle, which are – rightly – described

as a Jewish mystical text, a cabalistic anagram.[3] The most influential theory was that advanced by Van de Waal, who interpreted the traditional title of the print in an unexpected way. He argued that the etching does not depict Faust, but that it is the portrait of the founder of the Socinian sect, Faustus Socinus; the apparition in the window supposedly represents Socinus' complex of ideas.[4]

An entirely different reading of the work, and one that certainly merits consideration, was suggested by Lyckle de Vries. Drawing to some extent on earlier studies, he describes the print as an allegory of faith, illustrating a text from the Bible. In Paul's first letter to the Corinthians, the apostle likens the limitations of human knowledge, as opposed to perfect, divine knowledge, to looking in a mirror at puzzling reflections – through a glass darkly (I Corinthians 13, v. 12). De Vries believes that the circle with Christ's monogram and the mysterious text symbolizes the divine knowledge, which humans can see at best as if in a mirror, in other words indirectly and distorted, and even then cannot comprehend. In this interpretation, the cabalistic anagram has no function other than to be indecipherable. We thus see a scholar – a seeker after truth and representative of the faithful in general – who is being reminded by the apparition that human knowledge or wisdom is limited, and that it is only through Christ that we can partake of perfect knowledge in the hereafter.[5]

Rembrandt devoted considerable attention to the execution of the print, creating a contrast between the dense, closely hatched background and the sketchy foreground, a characteristic also of the *St Jerome reading in an Italian landscape* (cat. 72). The print is usually described in three states,[6] although it was actually finished in the first state, thirty-nine impressions of which are known. The earliest are often printed either on Japanese paper or greyish cartridge paper, but also occur on western paper. Later impressions of the first state reveal that the copper plate was considerably worn: they look bare and grey and the drypoint burr has disappeared altogether. This suggests that the changes in the second and third states were made in order to give the plate a new lease of life,[7] but from the watermarks it can be deduced that it was almost certainly not Rembrandt who made the changes. Late impressions of the first state are found on paper with the Seven Provinces watermark.[8] This paper was used for a large group of etchings, and the latest dated print in which it is found is the *Portrait of Jan Antonides van der Linden* (B.264) of 1665, and then in a worn impression of the fifth state that unarguably dates from after Rembrandt's death.[9]

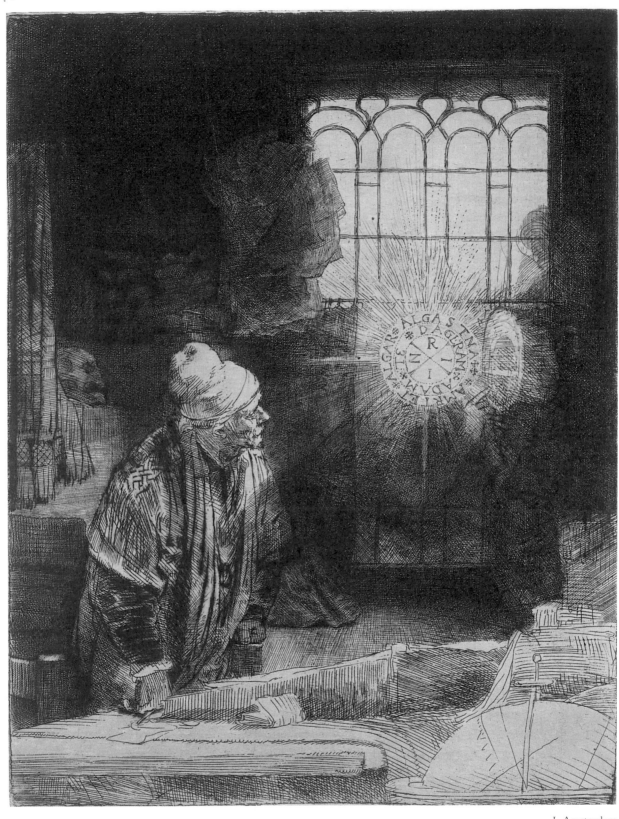

I Amsterdam

That the second state is posthumous is also argued by the nature of the differences between the states, and by the technique used to implement them: close examination reveals that the drypoint areas on the shoulder, sleeve and folds of the coat were not restored in drypoint, as there is no visible burr; but a similar effect has been achieved by placing numerous parallel lines very close together.[10] This method does not appear in any early impressions or early states of Rembrandt's etchings.

Several impressions of the second state are printed on Japanese paper, and there are even some on Indian paper.[11] It is known that, in an attempt to follow Rembrandt's example, impressions were taken from his copper plates on thin, oriental paper. The example of *Faust* serves to confirm yet again that the mere fact that impressions are on Japanese or Indian paper by no means guarantees that Rembrandt was responsible for them.

EH

1 See De Hoop Scheffer & Boon 1971, p. 8, no. 33 and Van Gelder & Van Gelder-Schrijver 1938, p. 19.

2 See Leendertz 1921, especially p. 140.

3 The last study in this series is Grothues 1992.

4 Van de Waal 1974, pp. 133–81.

5 De Vries 1998.

6 In Boston–New York 1969, p. 74, there is a description of an intermediate state between the second and third states.

7 The second state differs from the first in the addition of fine parallel lines on the stack of books to the right of the scene, and in the shadows added to Faust's shoulder, neck and the folds of his coat. In the third state new parallel lines have been added to the pile of books on the right, and the shadow on the lapel of Faust's coat has been extended.

8 Several different Seven Provinces watermarks occur in Rembrandt's prints, but this is the specific variant Ash & Fletcher 34, A´.a.

9 Impression in the National Gallery of Victoria, Melbourne, which has been retouched with brush and grey ink. See Gregory & Zdanowicz 1988, p. 124, no. 35. I am grateful to Irena Zdanowicz for the description of the quality of this impression that she sent me.

10 This is clearly visible in the somewhat worn impressions of the second state, like that in Boston.

11 See White & Boon I, p. 123.

70

Clump of trees with a vista 1652

Drypoint, 156 × 211 mm (I) and 124 × 211 mm (II); from the second state signed and dated lower right: *Rembrandt f 1652.*

Hind 263; White & Boon 222 I and II (of II)

I Amsterdam★ (Van Leyden RP-P-OB-454; watermark: none)

II Amsterdam★ (De Bruijn RP-P-1962-83; watermark: countermark HW [Ash & Fletcher 26, HW.a.]); London (Cracherode 1973.U.1141; ex M. Folkes [L.1034], and with Dighton's mark [L.727]; watermark: Pascal lamb [Ash & Fletcher 29, E.a.])

Watermarks: the watermark and countermark in the second state impressions are probably from the same paper: all the finest impressions have one or the other.

SELECTED LITERATURE: Lugt 1920, pp. 120–22; De Hoop Scheffer 1976, pp. 13–18; Giltaij 1988, p. 86; Schneider 1990, pp. 128–34; Melbourne-Canberra 1997–8, no. 114; White 1999, pp. 242–5.

The first state shown here gives a vivid sense of the artist at work. The outlines are set down in drypoint with such immediacy and spontaneity that it is generally assumed that the plate was worked on out of doors. Certainly this state encapsulates all the qualities of an informal sketch from nature, in which Rembrandt lingered over the central area and merely roughed out the remainder of the composition. The impression from the Rijksmuseum is slightly elaborated, in that during printing a film of ink (or plate tone) was left on the surface and wiped so as to suggest the atmos-

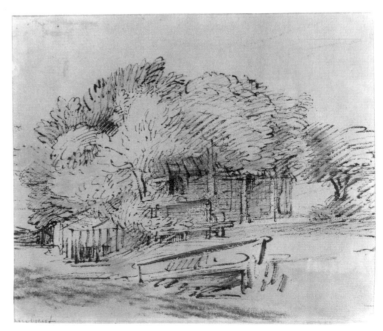

fig. a Rembrandt, *Farmhouse beneath trees*. Pen and brown ink with grey wash, 157 × 181 mm. Cambridge, Fitzwilliam Museum (Benesch 1274)

I Amsterdam

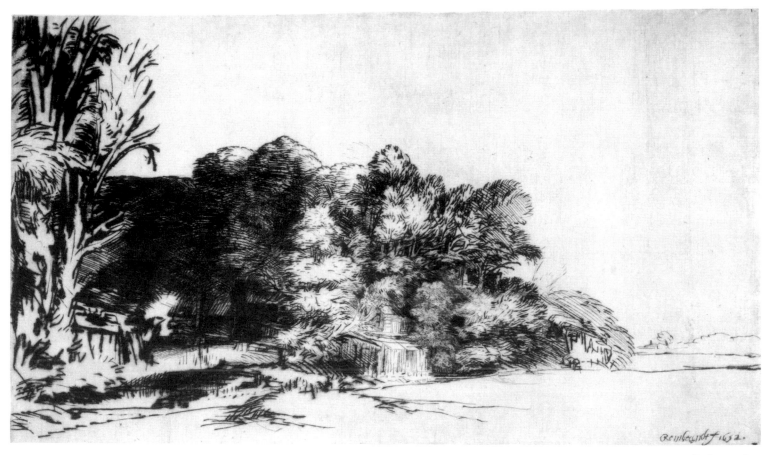

II Amsterdam

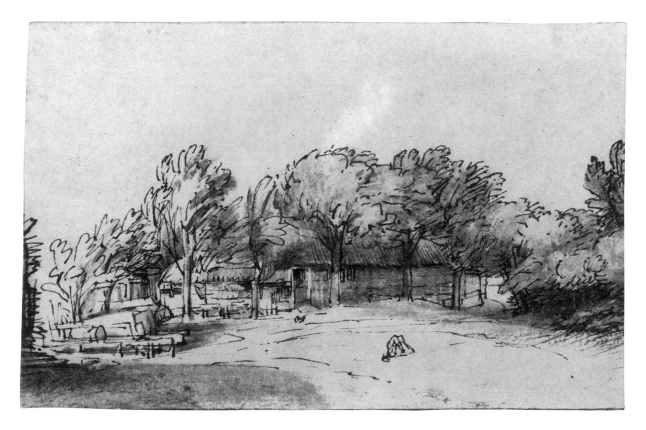

fig. b Rembrandt,
Farmhouse beneath trees.
Pen and brown ink with
brown wash,
102 × 161 mm.
Rotterdam, Museum
Boijmans Van Beuningen
(Benesch 1272)

fig. c Rembrandt, *Clump of trees by a farmhouse*. Pen and brown ink, 92 × 170 mm. Berlin, Staatliche Museen, Kupferstichkabinett (Benesch 1273, *recto*)

fig. d Follower of Rembrandt, *Evening landscape with trees near farmhouse*. Oil on panel, 255 × 395 mm. Formerly Montreal, Museum of Fine Arts

fig. e attributed to
Jacob Koninck,
Farmhouse beneath trees.
Pen and brown ink
with brown wash,
heightened with white,
147 × 187 mm.
Paris, Institut Néerlandais,
coll. F. Lugt

phere. This is enhanced by scratches on the plate, and the effect resembles that of the brown toned papers that Rembrandt sometimes used for landscape drawings.[1]

In the second state the plate was cut horizontally below, the foliage completed and the signature added. The parallel hatching, more uniform than the shading in the first state, reinforces the impression that the plate was begun from nature, while the work in the second state was executed in the studio. Using the same instrument throughout, the drypoint needle, he produced in this, probably his last landscape print, one of the great masterpieces of the medium.

Rembrandt made three drawings of the same farmhouse, but none appears to have served as a preliminary study for the print. That in the Fitzwilliam Museum in Cambridge, probably done from nature, comes closest to the print both in spirit and in the viewpoint from which it was taken (fig. a). A second drawing clarifies the relationship between the row of trees and the farmhouse behind, but renders the foreground shed or boathouse imprecisely (fig. b). The third sheet, like the first state of the

drypoint, examines the foliage with lively precision (fig. c).[2] The disparate handling of these drawings may be due to their having been executed at various times, although to judge from the style they probably all date from around 1648–52. A painting, formerly at Montreal, which although signed and dated *Rembrandt f. 1654* is probably the work of a follower, and a drawing attributed to Jacob Koninck, show that Rembrandt's pupils were also attracted, or taken, to the same spot (figs d–e).[3]

MRK

1 An impression with no plate tone in the British Museum (1973.U.1140, not included here) exhibits a crisper *chiaroscuro* and exposes the details of the foliage and hut in the centre more clearly.

2 We see little reason to follow Scharborn, 1990, p. 32 (as concurred with by Schneider, *op. cit.*), in doubting the attribution of the Berlin sheet although agree that it was not a study for the etching (*cf.* such drawings as the ex-Chatsworth *View on the road to Sloten* now in the J. Paul Getty Museum, Benesch 1253, the site as described in Amsterdam 1998, p. 345).

3 For the painting (Bredius 453), which is from the same vantage point as fig. e, see Schneider 1990a, cat. R10; for the Lugt drawing, see Sumowski 1353[XX] and Van Berge-Gerbaud 1997–8, no. 74. A drawing in the Amsterdam Museum in Oxford, attributed to Pieter de With, also shows the farmhouse (Sumowski 2449[XX]).

I Amsterdam

71

The Flight into Egypt: altered from the plate by Hercules Segers *c*.1653

Etching, drypoint and burin 212 × 284 mm

Hind 266; White & Boon 56 I, II, V (of VII)

I Amsterdam★ (Van Leyden RP-P-OB-796)

II London★ (1848-9-11-31; on vellum)

V Amsterdam★ (Van Leyden RP-P-OB-115; watermark: Strasbourg lily [Ash & Fletcher 36, C.e.])

Watermarks: the Strasbourg lily in the fifth state occurs in one impression of the fourth, suggesting that these states were made shortly after each other. The first state in Paris (Rothschild Collection) occurs with a foolscap that is nearly identical to one found in the London impression of *Christ preaching* (cat. 68), and therefore may have been made by Rembrandt.

SELECTED LITERATURE: Collins 1952, p. 98; Haverkamp-Begemann 1973, pp. 55–7 and 65, no. 1; Rowlands 1979, pp. 20–21 and 33–4, no. 48; Boston-St Louis 1980–81, pp. 237–9, no. 164; White 1999, pp. 245–9.

It was not unusual in the seventeenth century to give existing copper plates a new lease of life by burnishing away parts of the image and replacing them with other scenes. To mention but one example, the publisher Claes Jansz. Visscher took several landscapes with small biblical figures that had been engraved by Jan van Londerseel (1578–1624/5) after designs by David Vinckboons (1576–1632) and replaced the original figures with others in order to market the series again.[1]

Once in his lifetime Rembrandt intervened in this way on someone else's copper plate. At some point he came into the possession of Hercules Segers' plate of *Tobias and the angel*, a free imitation of a print by Hendrick Goudt, the *Big Tobias*, as it was known.[2] By burnishing parts of the plate, he obliterated the large figures of Tobias and the angel and replaced them with the Holy Family on a considerably smaller scale in a *Flight into Egypt*, against a background of a clump of tall trees. The impression of

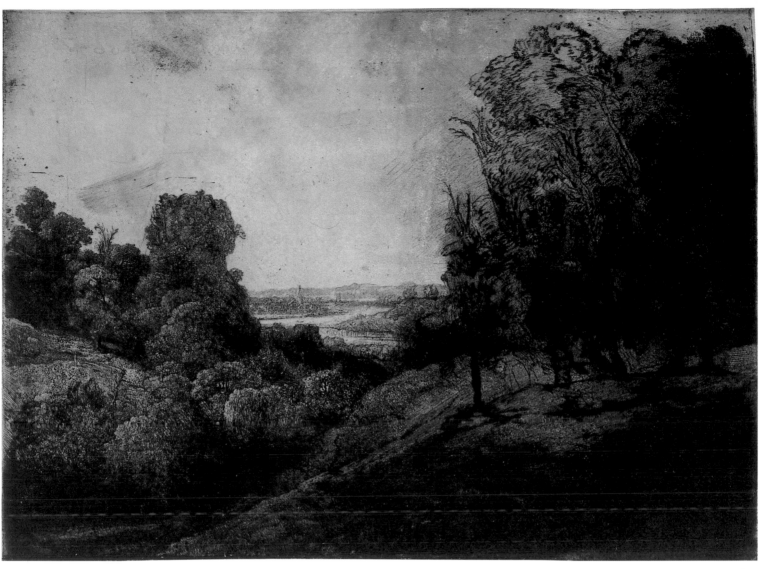

II London

the second state shown here shows the group containing the Virgin Mary seated on a scrawny donkey and clad in a cloak that completely conceals the Christ Child, with Joseph walking beside the animal.[3] Rembrandt failed to obliterate the figures of Tobias and the angel completely, however: one of the angel's huge swan wings is still visible in the trees, and in the donkey's back legs we can still make out the celestial being's left foot.

The sheer number of states of the *Flight into Egypt* – seven in total – shows that Rembrandt was not exactly pleased with the work's progress. He repeatedly made small changes, some in pure etching technique and others in drypoint or burin. The most dramatic change to the landscape was the addition of the trees on the right, but in the right foreground too Rembrandt covered Segers' peculiar, rather cabbage-like, plants with deeply etched lines. At the extreme left he added a row of short parallel lines of hatching, probably intending to give the print's left margin a

more restful and less ragged appearance. He also changed various details on the horizon, adding a tiny tower in the distance in the fifth state, but removing it again in the sixth. He was evidently also dissatisfied with the group showing Joseph and Mary and the donkey. In the fourth state he worked Joseph's face with a burnishing tool, so that it lights up in its dark surroundings, while in the fifth state it is darker again and in the sixth state the entire group was made lighter by more burnishing. Meanwhile the copper plate started to show signs of wear. It therefore seems highly likely that Rembrandt had to stop work on this print before achieving a result that satisfied him.

MS

1 Schapelhouman 1987, p. 152.

2 Haverkamp-Begemann 1973, p. 65, no. 1.

3 Some years earlier, in 1651, Rembrandt had depicted an almost identical group in a small etching (B.53).

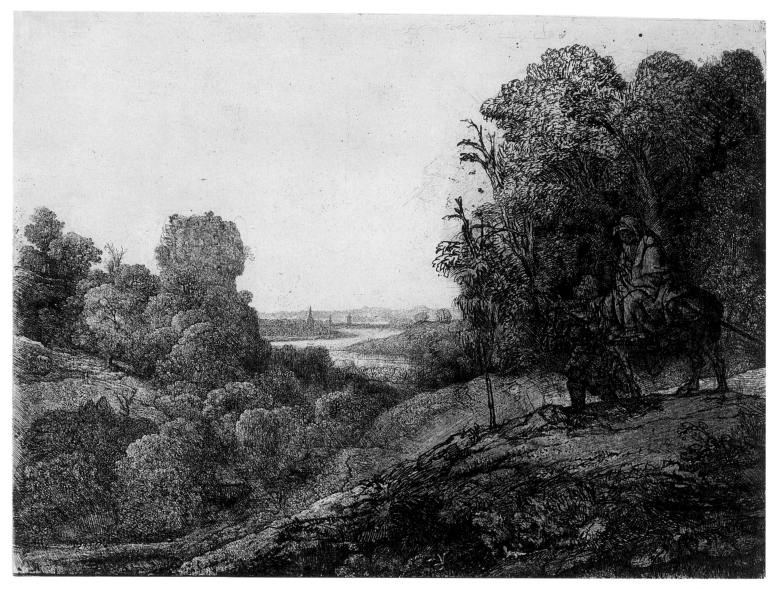

71 V Amsterdam

72

St Jerome reading in an Italian landscape c.1653

Etching, drypoint, burin, 259 × 210 mm

Hind 267; White & Boon 104 I and II (of II)

I London* (Cracherode 1973 U.1151; on Japanese paper; inscribed *recto*, in the lower margin, in pen and brown ink: *Hier zit Jeronimús als leevendich begraven/ ontziet noch leeuw, noch beer, noch naare wildernis,/ Maar zoeckt, dus leezende, de hemellijke gaaven/ terwijl de weerelt draaft na 't geen vergangklijck is./* Here sits Jerome as if buried alive/oblivious to lion, and bear, and frightening wilderness/But seeking as he reads the divine gift/ while the world strives for what is transitory])

II Amsterdam* (Van Leyden RP-P-OB-184; on oatmeal paper, watermark: none)

SELECTED LITERATURE: Springer 1908, pp. 799–800; Boston-New York 1969, pp. 81–5, no. 12; Donahue Kuretsky 1974; Boston-St Louis 1980–81, no. 166; Scallen 1990, pp. 262–84; Schneider 1990, pp. 168–70, no. 43; Berlin-Amsterdam-London 1991–2, pp. 254–5, no. 31; Scallen 1992; Royalton-Kisch 1993b, pp. 183–6.

We shall never know why Rembrandt was so fascinated by the character of St Jerome; in his etchings alone he chose to depict this Church father no fewer than seven times. The array begins in his Leiden years, around 1629, with the large, but only partly successful print of a penitent Jerome[1] and ends in the first half of the 1650s with the masterly *St Jerome reading in an Italian landscape*.

Whereas the attributes of the penitent – skull and crucifix – were still in evidence in *St Jerome beside a pollard willow* (cat. 59), there is no reference to guilt or awareness of sin in the present work. This last Jerome is a contented old man, totally absorbed in his reading. Although the broad-brimmed hat he wears was probably intended as a reference to the saint's cardinal's hat, it looks more like a bucolic sun hat. In one respect – the depiction of the lion – the *St Jerome in an Italian landscape* is more successful than the *St Jerome beside a pollard willow*. Here Rembrandt renders a truly convincing predator, alert and surveying the hilly landscape. This landscape reflects Rembrandt's love of sixteenth-century Venetian art, and for it he probably drew on an engraving by Cornelis Cort after Titian,[2] while the buildings in the background are very similar to those in an engraving by Giulio and Domenico Campagnola.[3]

The eighteenth-century French cataloguer of Rembrandt's etchings, Edmé-François Gersaint, wrote: 'It is greatly to be regretted that the whole of this Piece is not finished. [...] The Disposition of the Subject is rich, and that Part which is finished is in an admirable Taste.'[4] For a long time, following Gersaint's lead, critics continued to lament the supposedly unfinished state of the print. In the second half of the nineteenth century, changing conceptions of aesthetics saw this – partial – denunciation turn into admiration: it then became precisely the 'unfinished' character of the etching that was highly valued.[5] Rembrandt's preliminary study for the print also suggests that the work is indeed unfinished (fig. a).[6] The drawing reveals that he originally intended to submerge the whole foreground, and hence the saint too, in shadow. He obviously changed his mind while he was working on the print, with the result that the foreground is now bathed in sunlight. Finished or not (like the tree at the upper left corner), the print revels in a lively interplay of light and dark. As Rembrandt had done ten years before in the *Triumph of Mordecai* (cat. 44), he has exploited all the possibilities of the technique to the utmost, from the finest etched line in the figure of the seated Jerome to the softest, downiest black in the drypoint passages of the lion's mane. It was precisely this aspect of Rembrandt's graphic art that his contemporaries and near-contemporaries appreciated most – witness for example a passage in Filippo Baldinucci's (1625–97) description of the graphic work of 'Reimbrond Vanrein'.[7] It was the critics of the next generation, such as Arnold Houbraken (1660–1719), who were the first to be disconcerted by the real or supposed unfinished nature of some of Rembrandt's prints.

There are two states of this *St Jerome*, but the changes in the second state are minor: some slight strengthening of the outlines of the bridge supports to the right in the background. The fact that Rembrandt made so few alterations in the second state supports the conjecture that he considered the print – including the light foreground and the sketchily drawn Jerome – to be adequately finished. In addition to a fairly large number of early impressions on Japanese paper, there are also some on coarse buff oatmeal paper, like that of the second state included here.

The copper plate passed into the hands of the publisher Clement de Jonghe – probably during Rembrandt's lifetime. The inventory of De Jonghe's estate lists the plate of *Jerome with the lion*; it would seem self-evident that this refers to the late Jerome, and not to the small print of 1634 (B.100) with the rather odd-looking, shaggy beast in the foreground. There are moreover impressions of the late *St Jerome* printed on the same paper as prints by Jan Harmensz Muller that bear Clement de Jonghe's address.[8] These later examples are of good quality, although they appear rather sparser than Rembrandt's own early impressions with their warm black drypoint passages.

MS

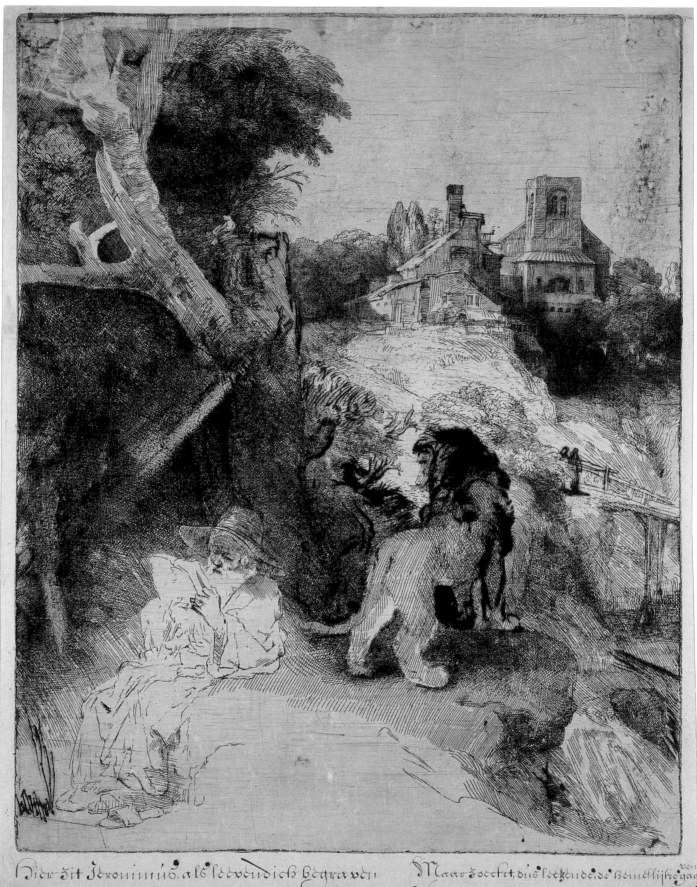

Hier zit Jeronimus, als leevendich begraven
ontziet noch leeüw, noch beer, noch naare wildernis.
Maar zoeckt, dus leezende de Hemelijsche gaven
terwijl de weerelt draaf, by naet geen vergelijck

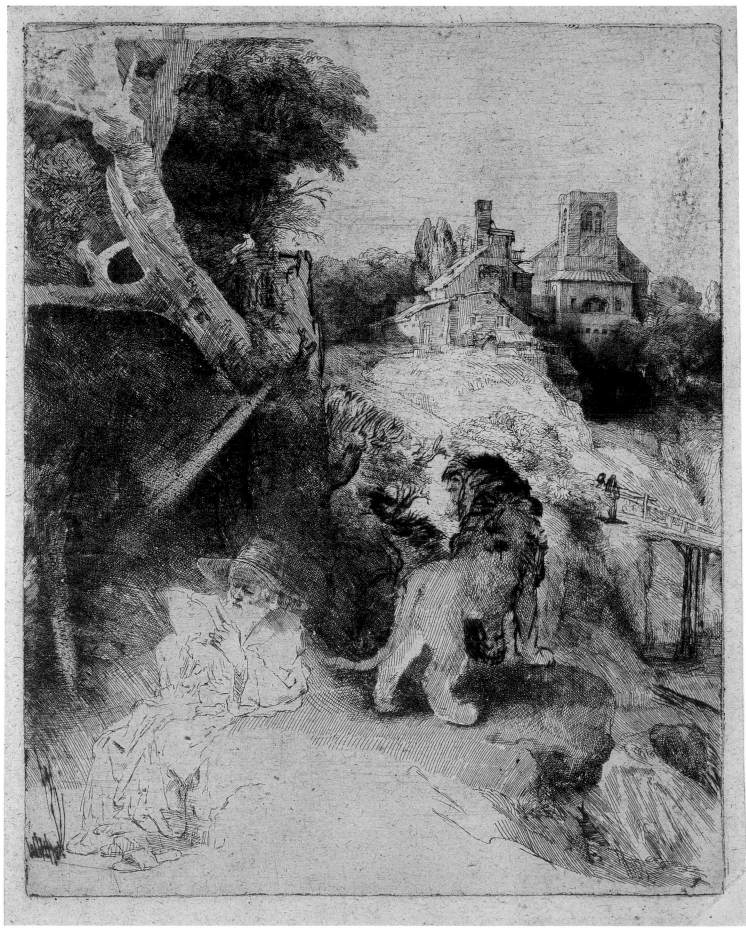

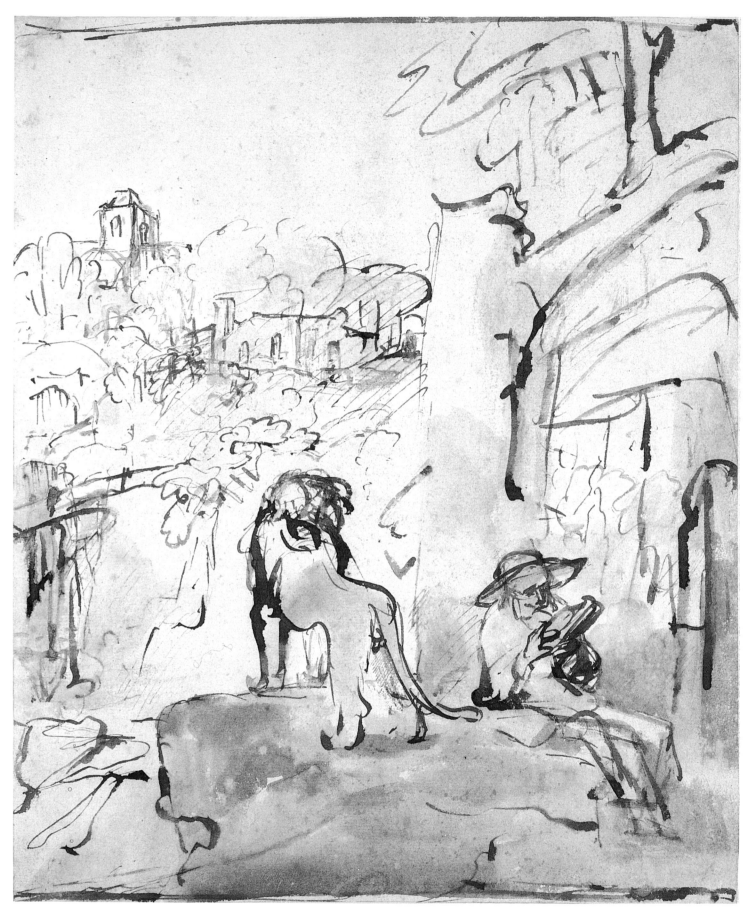

fig. a Rembrandt, *Saint Jerome reading in an Italian landscape*. Pen and brown ink with brown wash, heightened in white, 252 × 208 mm. Hamburg, Kunsthalle (Benesch 886; exh. London)

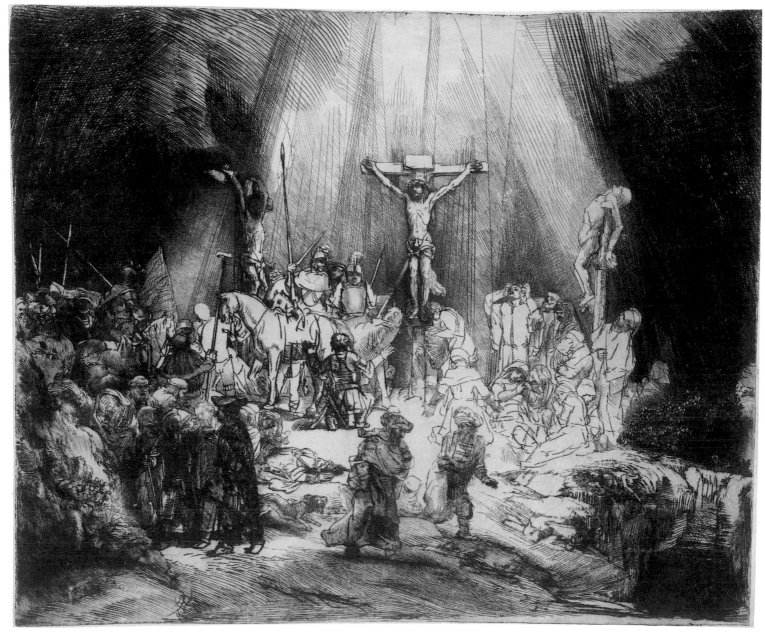

I Amsterdam

1 B.106.

2 The New Hollstein, *Cornelis Cort*, 120; Meijer 1991, p. 63, no. 25.

3 B.9 (as Domenico Campagnola); Schneider 1990, p. 170, fig. 1.

4 The quote is taken from the English edition of Gersaint's catalogue, published in London in 1752 (Gersaint 1752, p. 59).

5 For the history of the evaluation of the print: Scallen 1992.

6 Hamburg, Kunsthalle, Kupferstichkabinett, inv.no. 22414; Schneider 1990, no. 42. See further the Introduction, pp. 79–80.

7 Quoted in Scallen 1992, p. 3.

8 Hinterding 1993–4, pp. 260–61.

73

The three crosses 1653

Drypoint and burin, 385 × 450 mm; below, left of centre (from the third state onwards): *Rembrandt. f. 1653.*

Hind 270; White & Boon 78 I, III and IV (of V)

I Amsterdam★ (De Bruijn RP-P-1961-1196a; on vellum); London (1842-8-6-139; on vellum; inscribed by Rembrandt on the *verso: deesen is een / de eerste / van de leverancij 1653.*[this is one, the first, of the edition, 1653.)

III Amsterdam (De Bruijn RP-P-1962-39; watermark: Strasbourg bend [Ash & Fletcher 35, D´.a.]); London★ (Cracherode 1973 U.941; watermark: Strasbourg bend [Ash & Fletcher 35, D´.a.])

IV London★ (1848-9-11-40; watermark: none)

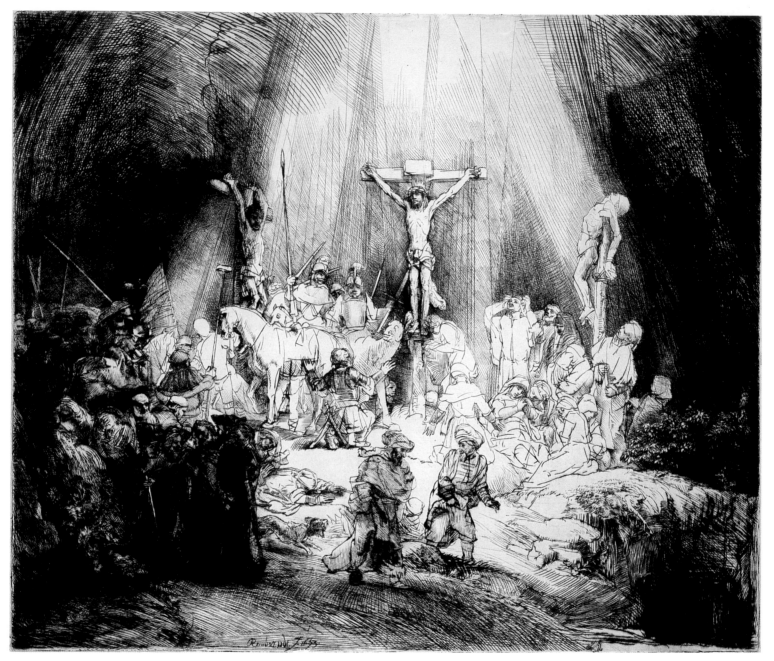

III London

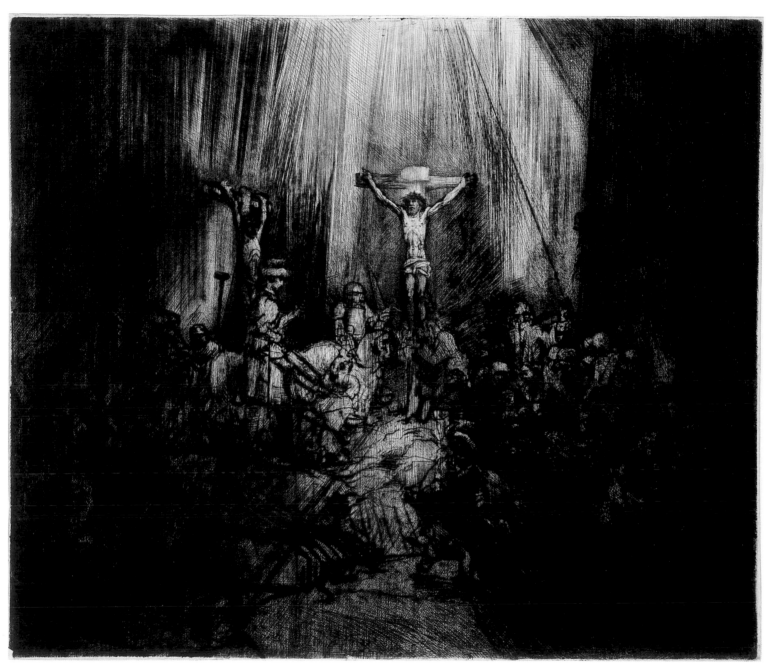

IV London

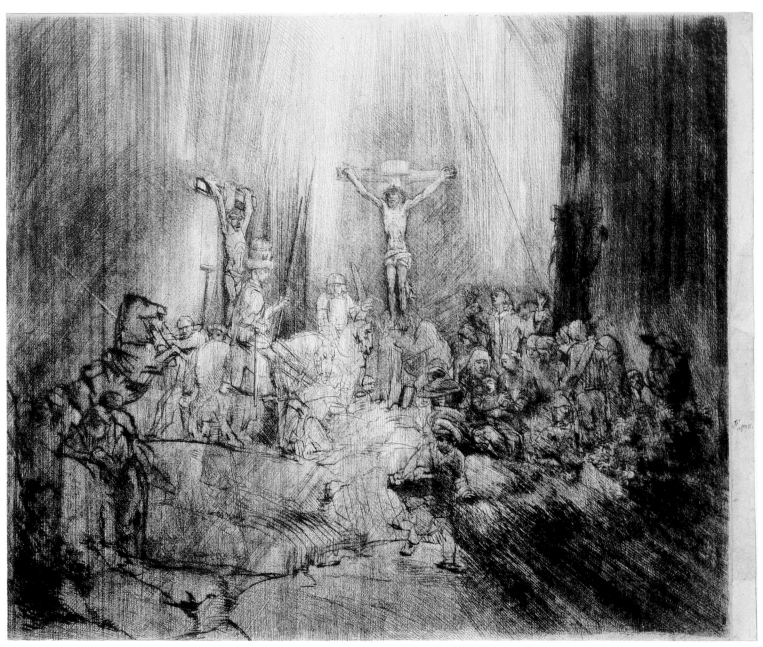

IV London (maculature)

fig. a
Giovanni Battista
Fontana,
Crucifixion.
Engraving,
377 × 452 mm.
Amsterdam,
Rijksmuseum

IV London* (Cracherode 1973.U.943, counterproof and on *verso* a maculature; watermark: none)

Watermarks: the Strasbourg bend occurs in all known impressions of the first three states of the *Three crosses* printed on western paper, and is also found in impressions of the fourth state. It is clear from this that these states were created in fairly rapid succession. The watermark also occurs in good impressions of *Faust* (cat. 69) of around 1652, the *St Jerome reading in an Italian landscape* (cat. 72) of around 1653, and in reprints of the *Death of the Virgin* (cat. 32) of 1639.

SELECTED LITERATURE: Vries 1883, p. 295; Boon 1956b, pp. 49–50; Frey 1956, pp. 208–32; Boston-New York 1969, no. 13; Boston-St Louis 1980–81, nos 169–70; Deutsch-Carroll 1981, pp. 605–10; Köhler 1982, p. 10; Berlin-Amsterdam-London 1991–2, no. 35; Noszlopy 1994; White 1999, pp. 77–88.

There were a few times when Rembrandt felt the urge to make a print with the impact of a painting, and the *Three crosses* of 1653 belongs unequivocally to this category. Its rich, pictorial effects can best be appreciated if the work is seen from a distance, preferably hanging on a wall.[1] The crucifixion is a subject that was often tackled on a large scale in graphic art, and Rembrandt used existing examples in developing his composition (see figs a–b). He shows us the moment of Christ's death on the cross, described as follows, for example, in St Luke's gospel (23: 44–8): 'By now it was about midday and a darkness fell over the whole land, which lasted until three in the afternoon; the sun's light failed. And the curtain of the temple was torn in two. Then Jesus gave a loud cry and said, "Father, into thy hands I commit my spirit"; and with these words he died. The centurion saw it all and gave praise to God. "Beyond all doubt," he said, "this man was innocent."' The scene is populated by numerous figures, but a full light is reserved only for those close to Christ, the remainder being shrouded in darkness. On the left are Roman soldiers, with the centurion kneeling penitently before Christ, his arms outstretched. Christ's followers are assembled on the right, with the grief-stricken Mary prominent among them.

This monumental etching is generally regarded as one of the

fig. b Master of the Die, *Conversion of the Centurion*, 1532. Engraving, 216 × 155 mm. London, British Museum

expensive than paper – twelve sheets cost as much as a whole ream of paper (500 sheets) – and this alone gave these impressions an exclusive status, although Rembrandt will also have been interested in the properties of the material. The capacity of vellum to absorb printing ink is much lower than that of paper, so that more ink remains on the surface; and it tends to run. Drypoint lines are already blurred, and on the impression shown here one can see clearly the extraordinary results that it can produce.

The second state differs from the first by only one minor correction,[3] and Rembrandt continued to devote the same care to the impressions as he did to those of the first state, though only two of the nine known examples were printed on vellum. Nevertheless they reveal that the burr of the drypoint had already begun to wear, and that the passages on the left and right, in particular, had become rather paler and clearer. As a result, Christ and the figures immediately surrounding the cross are less emphatically the illuminated heart of the composition. Rembrandt rectified this in the third state. Using drypoint and burin, he strengthened the existing shadows on the left and right, and also darkened the foreground with additional lines. In this state he signed the plate *Rembrandt.f.1653.*, which indicates that he regarded the print as finished. There are seventeen known impressions of this state, two of them on vellum. In the earliest impressions, like the one shown here, Rembrandt experimented with surface tone, but the later ones were generally printed with a faint, even surface tone, or with no tone at all. These later impressions are often greyish and dry because of the unmistakable progressive wear of the drypoint burr.

Although Rembrandt considered the print to be finished in the third state, he nonetheless returned to the plate once more and made such drastic changes that it was thought in the eighteenth century that this was a different matrix altogether.[4] In an entirely new version of the subject, Rembrandt replaced numerous bystanders with new figures, while he darkened the areas on either side of the cross with drypoint and burin – to such an extent that in some impressions, like the one shown here, the figures are barely visible.

An earlier author remarked on the striking similarity between the headdress and pose of the rider whom Rembrandt added in this state – modelled after a medallion by Antonio Pisanello (fig. c) – and the figure of Claudius Civilis in Rembrandt's painting of the *Conspiracy of Claudius Civilis*, which dates from around 1661.[5] It was therefore concluded that the fourth state of

high points of Rembrandt's later graphic oeuvre, in part because of its composition, but chiefly because it was executed in drypoint alone. This means that as well as being a spectacular print, it must also have been very expensive. The large plates dating from the early 1630s – the *Descent from the cross* (cat. 23) and *Christ before Pilate* (cat. 24) – were heavily etched and strengthened with the burin, which indicates that they were intended to be printed in large numbers.[2] In contrast, only about fifty impressions of a drypoint print can be pulled before the delicate burr that gives the lines their characteristic velvety effect has disappeared. Rembrandt consequently devoted exceptional care to impressions of the *Three crosses*, experimenting with various surface tone effects and inking some more heavily than others. He also printed no fewer than fourteen of the nineteen known impressions of the first state on vellum. Vellum was much more

the *Three crosses* may have been made only in around 1661. This also accords with the style of the fourth state, which unlike the first three, was executed in spare, angular lines that accord with Rembrandt's drawings of around 1660. The hypothesis that Rembrandt left the plate untouched for years before executing the fourth state therefore gained general acceptance.[6]

The revised plate was also printed in a different way from the first three states. For instance, Rembrandt hardly experimented with surface tone, although in early impressions he did introduce some variety by inking the plate more heavily or more lightly; and none of the fifty-two catalogued examples are on vellum, although there are four on Japanese paper. But the theory that the fourth state dates only from around 1661 is not supported by the watermarks. On the contrary, impressions are found on paper with the Strasbourg bend watermark (Ash & Fletcher 35, D´.a), which appears in all the known impressions of the first three states on western paper. This not only suggests that Rembrandt bought a stack of paper specifically for this large print, but also that the first three states were not unduly separated in date. However, crucially, the same watermark also occurs in impressions of the fourth state, thus proving that the radical reworking was also undertaken not long after the completion of the third state. It is difficult to pinpoint exactly when the fourth state was made, but it was almost certainly prior to 1655, the year in which

Rembrandt made the *Christ presented to the people* (cat. 78). Although virtually the same size as the *Three crosses*, all the known impressions have other watermarks, which suggests that the stack of paper that Rembrandt had bought for the *Three crosses* had been used up by then.[7]

It has long been acknowledged that, artistic considerations aside, Rembrandt also had practical reasons for reworking the plate.[8] He had pulled at least forty-three impressions of the first three states, and the burr had virtually disappeared from large areas of the plate. For a print executed predominantly in drypoint this is an appreciable number, but for a large and hence expensive plate like the *Three crosses* it is certainly not many, perhaps not even enough to cover the production costs. The fact that the fourth state was made not around 1661 but almost immediately after the first three supports the contention, more strongly than has previously been thought, that the reworking should be seen first and foremost as an ingenious solution to the problem of making more impressions from a rather worn plate.

The way in which Rembrandt set about his task seems to reflect this. Although it is generally assumed that he largely burnished away the first version of the *Three crosses* before embarking on the new composition,[9] a close examination of the maculature of the fourth state shown here reveals that Rembrandt mainly removed only the burr from the lines, leaving the first version essentially intact.[10] This makes it clear that the dense web of drypoint and burin lines with which Rembrandt covered the whole plate in the fourth state,[11] served a dual purpose: it lent the scene a melodramatic, oppressive air, but it also concealed the remnants of the earlier work as far as possible. The style of the figures also has to be viewed in this light: in contrast to those in the first three states, they are much less strongly modelled, while at the same time the outlines have become heavier. This lends them a certain massiveness that contributes significantly to the impressive character of the composition, but also diverts our attention away from the remains of the previous version, which can still easily be identified in several places.

It was only through this drastic reworking that Rembrandt was able to pull at least the ninety-five impressions we know from the plate, a number much higher than the drypoint technique would normally permit. The fact that so many impressions are still extant is evidence of the esteem in which this extraordinary work of art has always been held and of the care with which the impressions have consequently been preserved.[12]

fig. c Antonio Pisano, called Pisanello, *Medal of Gian Francesco Gonzaga*, c. 1440. Bronze, diameter 85 mm. The Hague, Koninklijk Penningkabinet

EH

1 On the back of an impression of the fourth state in a Dutch private collection there are markings that were almost certainly caused because the impression has at some time been stuck down on linen.

2 See Royalton-Kisch 1984, pp. 3–6.

3 In this state the only change is the definition added to the face of the man at the far right edge.

4 See Gersaint 1751, p. 68 (the comments by Helle and Glomy); Daulby 1796, p. 57.

5 See Musper 1935, p. 137.

6 See, for example, Frey 1956, pp. 208–32.

7 Another argument against a dating of about 1661 for the fourth state is the fact that Rembrandt petitioned for a *cessio bonorum* (bankruptcy) in 1656. The chance that after the sale of his possessions, he still had the same paper on which he had printed the first three states is remote.

8 See for example Stechow 1950, pp. 252–5, especially p. 254; Rosenberg 1968, p. 212; White 1999, p. 83; Holm Bevers in Berlin-Amsterdam-London 1991–2, p. 266.

9 See White 1999, pp. 83–4.

10 Without burr, and consequently by no means prominent, the signature can still be seen in the fourth state. See Berlin-Amsterdam-London 1991–2, p. 269, n. 13.

11 The unusually regular pattern of these lines and the fact that most of them are absolutely straight leaves us in no doubt that Rembrandt made repeated use of a ruler or similar instrument to draw them.

12 There is also a fifth state of this print, but it differs from the fourth only in the addition of the address of the Amsterdam 'plate printer' Frans Carelse (1631/2–83).

74

The circumcision in the stable 1654

Etching, 94 × 144 mm; signed and dated upper left: *Rembrandt f. 1654* [the 'd' in reverse] and centre left: *Rembrandt f. 1654*

Hind 274; White & Boon 47 I (of II; see further below)

Ia Amsterdam★ (Van Leyden RP-P-OB-299; watermark: fragment of Paschal lamb [Ash & Fletcher 29, C´.a.]); Ib London (Cracherode 1973.U.1075; watermark: none)

Watermarks: the watermark in the Amsterdam impression has hitherto otherwise only been found in an impression of the *Adoration of the shepherds* (B.45) also of 1654. In White & Boon's second state (which now becomes the third – see further below), all the watermarks so far recorded are posthumous.

SELECTED LITERATURE: Boston-New York 1969, no. 16; Berlin 1970, no. 46; Robinson 1980, pp. 166–7; Paris 1986, no. 117; White 1999, p. 89.

In 1654 Rembrandt etched a set of six plates depicting scenes from the infancy and childhood of Christ, subjects well suited to his talent for biblical illustration. The others were the *Adoration of the shepherds* (B.45), the *Flight into Egypt* (B.55), the *Virgin and child with the cat* (B.63), the *Christ disputing with the doctors* (B.64) and the *Christ between his parents returning from the temple* (B.60). In style and format they are all comparable, though the strong shadow

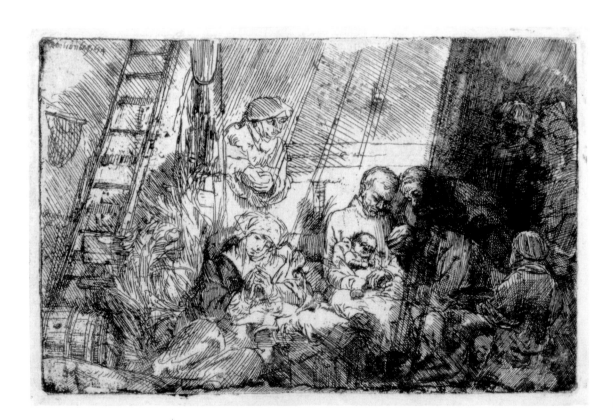

Ia Amsterdam

down the right side of the present print is exceptional, and reminiscent of the dramatic *chiaroscuro* of the drypoint of the *Three crosses* of the preceding year (cat. 73). The fall of light was of particular concern to Rembrandt, who seems to have burnished an oblique line in the plate in the area of densest shadow towards the upper right corner. White & Boon's second state, which is probably posthumous, adds shade in the unbitten patch of the plate at the top edge above the child (similar *lacunae* were treated in the same way before printing the first known state), and to the light area that appears at the top left corner.

While compiling the present catalogue a new state was observed, prior to the old first state, in that Rembrandt adjusted the right shoulder of the figure standing in the shadow to the right, who turns his head to talk to his neighbour (see fig. a). In the earliest impressions the shoulder is rounded and the shade to the left of him darker. This is seen in the Amsterdam impression. Rembrandt then burnished the shadows, which he must have deemed too dark, and straightened the shoulder line of this figure in an attempt – not altogether successful – to prevent the man immediately in front of him from sinking into the shadows. The dots at the top centre are also burnished. These minor refinements are characteristic of Rembrandt's perfectionism.

The iconography is unusual. The circumcision of Christ is generally depicted as taking place not in the stable but in the temple, as Rembrandt himself represented it in an etching of *c.*1630 (B.48), in a drawing now in Berlin (Benesch 574) and in a lost painting made for the stadholder Frederik Hendrik in 1646.[1] But in a Rembrandt school painting dated 1661 in Washington it is again shown in the stable (Bredius 596). Antoine Wierix (1555/9–1604) depicted the scene in the stable in the late sixteenth century,[2] and theological commentators had found good reasons for placing it there: young mothers were forbidden

fig. a detail of Ib London

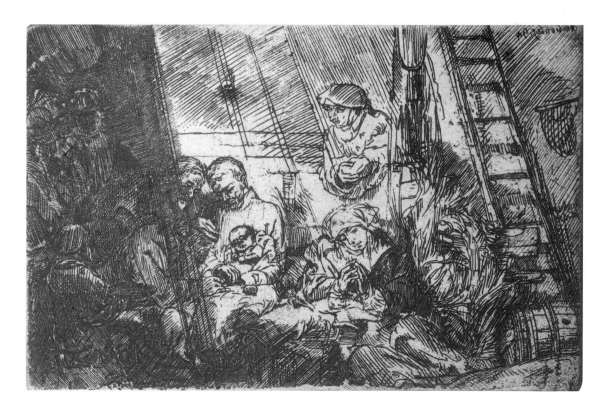

fig. b Rembrandt,
Circumcision in the stable, 1654.
Copper plate, 97 × 147 mm.
Amsterdam, Rijksmuseum (exh.)

by the Law of Moses to enter the temple until forty days after giving birth.[3] The setting allowed Rembrandt to allude, in the ladder propped against a post, to the Crucifixion, thereby juxtaposing Christ's first and last pain.[4]

The plate for the print survives and is included here (fig. b).

MRK

1 A copy is repr. in Gerson 1968, p. 92, fig. a.
2 Mauquoy-Hendricx, *Wierix*, 254.
3 Aurenhammer 1959, I, p. 356 (as quoted in Berlin 1970, no. 46).
4 Robinson, *loc. cit.*.

75

The descent from the cross by torchlight 1654

Etching and drypoint, 210 × 161 mm; signed and dated in the foreground, on the shroud: *Rembrandt. f 1654* (the 'a' reversed)

Hind 280; White & Boon 83 (only state)

Amsterdam (Van Leyden RP-P-OB-147; on Japanese paper); London★ (Cracherode 1973.U.1085; on Japanese paper)

Amsterdam (De Bruijn RP-P-1962-45; watermark: none); London★ (Cracherode 1973.U.1084; watermark: none)

SELECTED LITERATURE: Berlin-Amsterdam-London 1991–2, pp. 272–3, no. 37.

'When evening fell, there came a man of Arimathaea, Joseph by name, who was a man of means and had himself become a disciple of Jesus. He approached Pilate and asked for the body of Jesus; and Pilate gave orders that he should have it. Joseph took the body, wrapped it in a clean linen sheet, and laid it in his own unused tomb, which he had cut out of the rock; he then rolled a large stone against the entrance, and went away. Mary Magdalene was there, and the other Mary, sitting opposite the grave.' (Matthew 27: 57–61).

The *Descent from the cross by torchlight* is among the most melodramatic of Rembrandt's prints. The drama derives to a significant extent from the highly original composition: only a small part of the cross can be seen, and the main action takes place not in the centre of the picture but in the upper left corner. The foreground is dominated by a bier, over which the shroud is draped, creating a sombre white accent in the inky black gloom of the night. On the right, in the foreground, his face in shadow, kneels Joseph of Arimathaea, who has just laid the cloth over the bier. The viewer's eye is drawn inexorably from the scene in the foreground, which points ahead towards the entombment that is to

come, to the principal action, which has the emotional intensity of a late medieval 'Andachtsbild' or meditative picture. Because there is only one source of light – the torch held aloft by one of the men – the attention is focused on the grisly detail of the nail through Christ's right foot. The figure of the man seen from behind is superbly rendered: we can clearly see that at this moment he alone has to bear the full weight of the dead body, and one can almost feel the tension in his calf muscles. Further to the right, one of the men raises his arm to receive the corpse, and his outstretched hand catches the torchlight.

There is only one known state of this print. This might lead us to suppose that Rembrandt completed this etching in a single operation, spontaneously and with immense urgency. A striking aspect is that Rembrandt used the drypoint needle only sporadically, whereas one might expect him to have used this technique more extensively to suggest the velvety blackness of the night. However, he rendered the large dark passages by means of a dense web of deeply bitten, cross-hatched, etched lines. Traces of burr from the drypoint can be seen – and then only in the earliest impressions – in the drapery that hangs over the cross, in the face and torso of the man descending the ladder, by the shoulder of the man seen from behind, in Christ's face and in the shroud spread over the bier in the foreground. There are a number of good early impressions of the print on thin Japanese paper, which Rembrandt employed increasingly from the early 1650s for early impressions.

In 1679 the copper plate of the *Descent from the cross by torchlight* was in the estate of the Amsterdam print dealer Clement de Jonghe.[1] At the sale of Pieter de Haan's estate in 1767, the art dealer Fouquet paid nine guilders and ten stivers for 'A Descent from the Cross, with 14 prints'.[2] As always in the De Haan sale, the impressions that were sold with the copper plate must have been of recent date. There are indeed eighteenth-century impressions of this print, which are still of reasonable quality but in which it can clearly be seen that the drypoint burr has completely worn away. They consequently lack the brooding, ominous tension of early impressions.

MS

1 Hinterding 1993–4, p. 310. The copper plate is now in the Pierpont Morgan Library in New York, ibid, p. 294.
2 'Een Aflatung van het Kruis, met 14 drukken'.

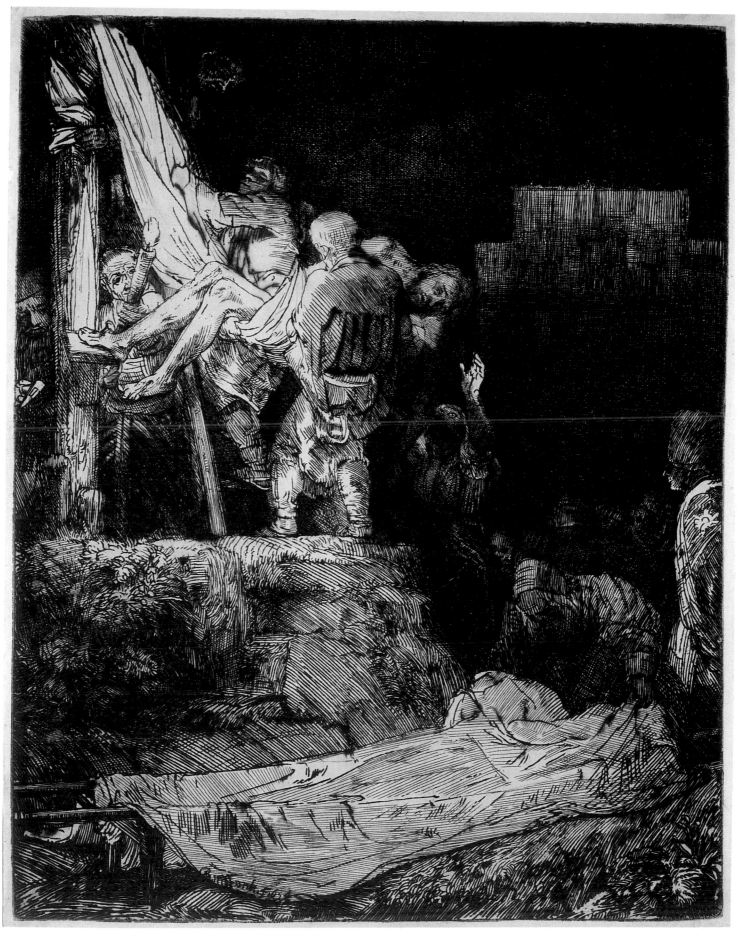

London (Japanese paper)

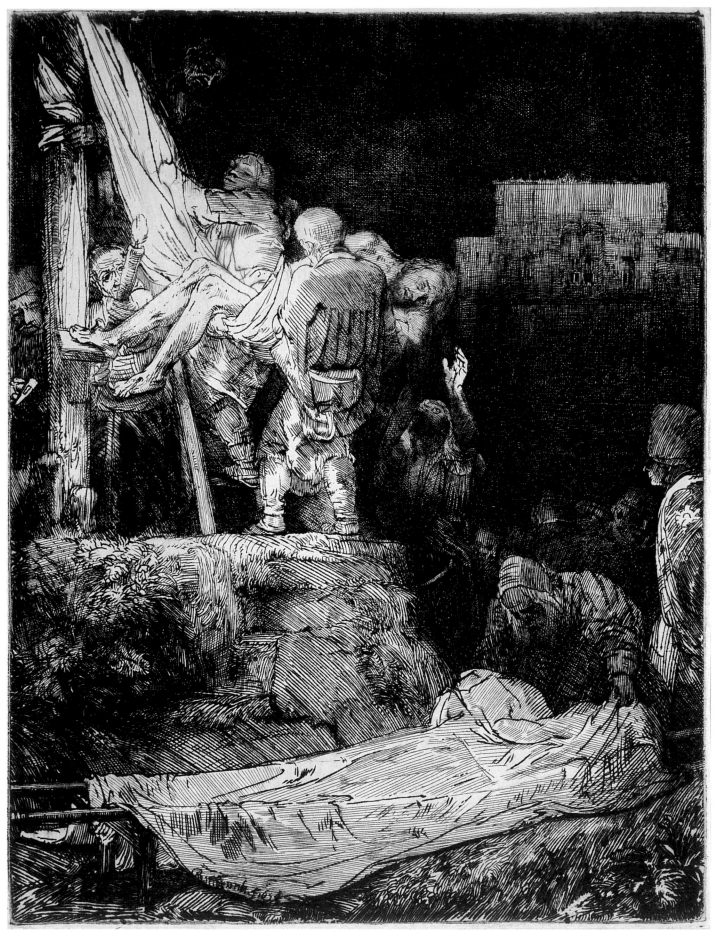

75 London (European paper)

fig. a Rembrandt after an
artist from the school of
Raphael,
The Entombment.
Pen and brush in brown,
corrections in white body
colour, 180 × 283 mm.
Haarlem, Teylers Museum
(Benesch 1208)

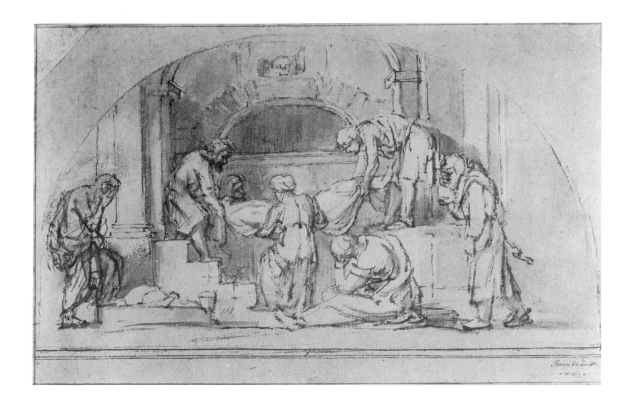

76

The entombment *c.*1654

Etching, drypoint and burin, 211 × 161 mm

Hind 281; White & Boon 86 I, II and IV (of IV)

I Amsterdam* (Van Leyden RP-P-OB- 151; on Chinese paper); London
(Cracherode 1973.U.1086; on Japanese paper)

II Amsterdam (Van Leyden RP-P-OB- 152; on vellum); London*
(1848-8-6-140; watermark: none)

IV London* (Cracherode 1973.U.1087; watermark: none)

SELECTED LITERATURE: Boston-St Louis 1980–81, pp. 242–3, no. 167;
Boston-New York 1969, pp. 123–5, no. 18; Lambert & Séveno 1997, p. 41;
White 1999, pp. 90–95.

Earlier in this book it was suggested that in his first few years
in Amsterdam Rembrandt probably toyed with the idea of
marketing a series of prints depicting scenes from the life of
Christ.[1] We cannot rule out the possibility that he resurrected the
plan in the 1650s and again considered producing such a series.
The *Presentation in the temple* (B.50), *Descent from the cross by torch-
light* (cat. 75) and the *Entombment* and *Christ at Emmaus* (B.87) are
all virtually the same size and could well have been intended for a
cycle that was never completed.

 Rembrandt broadly based the composition of his print on
that of a drawing from the school of Raphael, which in all like-
lihood he had in his own collection, as a copy he made of it has
survived (fig. a).[2] In the 1650s Rembrandt's graphic art became
increasingly experimental. Not only did he print his impressions

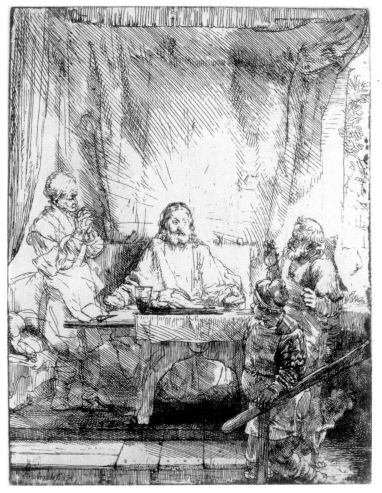

fig. b Rembrandt, *Christ at Emmaus*. Etching and drypoint,
211 × 160 mm. Amsterdam, Rijksmuseum (B.87)

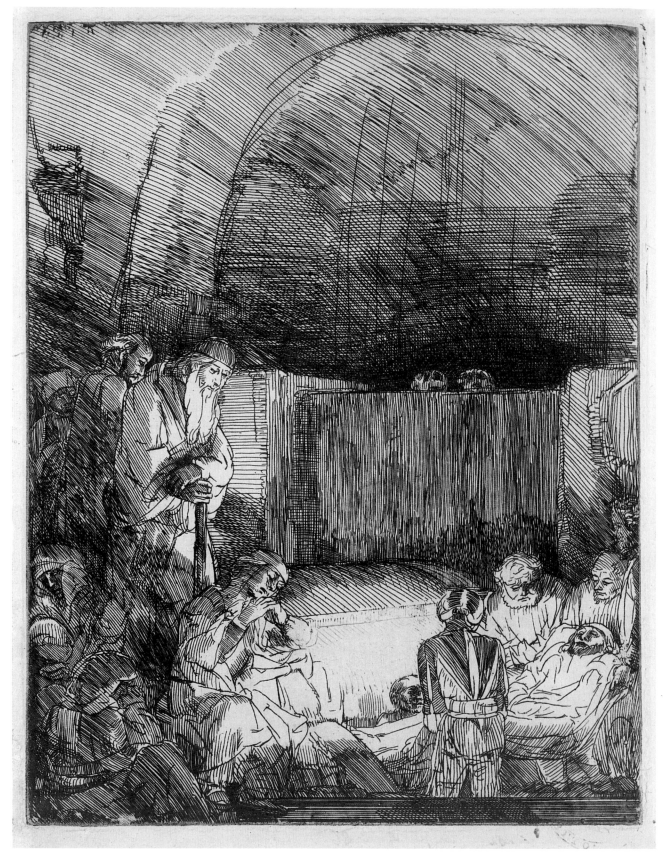

I Amsterdam

II London

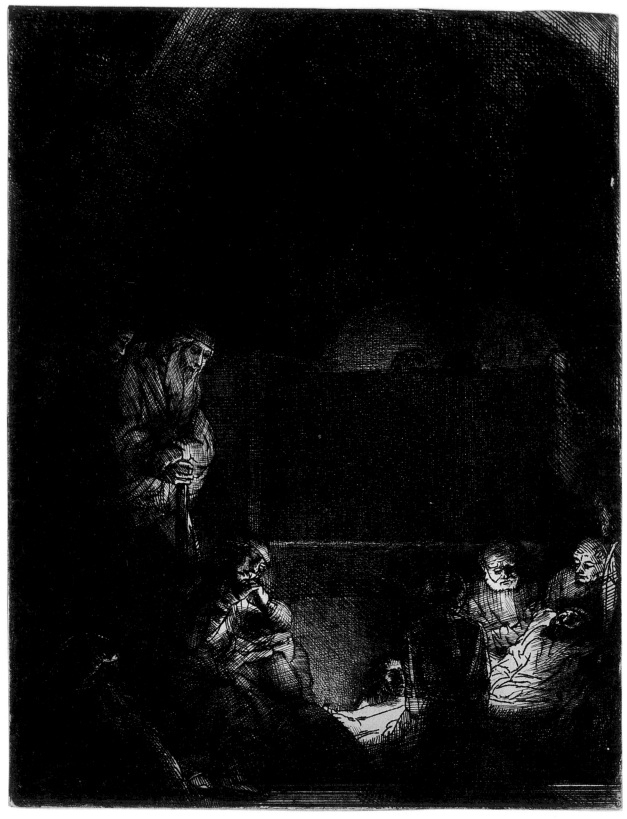

IV London

on the most diverse types of paper – from the thinnest Japanese paper to coarse buff oatmeal paper – and sometimes even on vellum, but he also tried increasingly to affect the look of an impression radically by using surface tone in all sorts of gradations. In the whole of Rembrandt's graphic *oeuvre* there is no print that better exemplifies this urge to experiment than the present *Entombment*: 'This Print is more remarkable than any other for the Variety of its Impressions,' as Gersaint wrote around the middle of the eighteenth century.[3]

The first state was executed in etching alone. Rembrandt sets the scene in a huge vaulted space that is more suggested than depicted. There is no evident source of light, which emanates from the grave, a deep sarcophagus into which the body will shortly be lowered. The whole composition is deceptively simple, and the figures are almost dashed off in swift, spontaneous lines. Shadow and volume are created by means of simple parallel lines of hatching, with cross-hatching only in the darkest areas. In this state the print is stylistically close to *Christ at Emmaus* (fig. b).

The second state differs dramatically from the first. Rembrandt filled the whole of the background with a dense web of hatching, so that the entire space is shrouded in an ominous gloom in which the figures seem to move like ghostly apparitions. The existence of the high vaulted ceiling can now only be guessed at. This was all done in a mixture of etching and drypoint, with the lines of the burin detectable here and there. Impressions of this second state can differ tremendously from each other. That in Amsterdam on vellum, shown here, is printed with heavy surface tone, making it almost impossible to distinguish the figures on the left. Rembrandt wiped some of the ink off the plate in places, so that a flickering light appears to fall on Christ's feet and shins, part of his torso and the faces of the two men on the right.

On another impression of what likewise seems to be a second state, we can with some difficulty make out the shapes of two arched windows. Here again it looks exactly as though Rembrandt has, as it were, 'drawn' the windows on the copper plate in the manner of a monotype, by wiping away the ink in some places and adding more elsewhere before pulling the impression.[4]

In the third state Rembrandt tried to bring more definition to the architecture by burnishing away parts of the dark background; and the differences between the third and fourth states are extremely minor. There are also impressions of the two latter states that differ widely because of the inking and wiping of the plate. This shows signs of wear in some impressions of the fourth

state, and it is possible that they were not made by Rembrandt himself. Yet the very fact that so many different impressions exist on a variety of papers and even on vellum is clear evidence that in Rembrandt's day there was a market for such individualistic examples of graphic art, far removed from those cut by the average professional engraver.

MS

1 See Ernst van de Wetering's essay, pp. 39–56.

2 Haarlem, Teylers Museum; Plomp 1997, pp. 307–8, no. 332.

3 Gersaint 1752, p. 51.

4 See also Sue Welsh Reed in New York-Boston 1980–81, pp. 65–7, nos 1–4. White 1969, p. 84, first compared the effects to monotype.

77
Abraham's sacrifice 1655

Etching and drypoint, 156 × 131 mm; signed and dated lower right: *Rembrandt f 1655*

Hind 283; White & Boon 35 (only state)

Amsterdam★ (Van Leyden RP-P-OB-63; on Japanese paper); London (Cracherode 1973.U.1091; on Japanese paper)

SELECTED LITERATURE: Landsberger 1946, p.158; Boeck 1953, p. 218; Rosenberg 1968, p. 176; Berlin 1970, no. 9; Held 1980, p. 161; Boston-New York 1969, no. 20; Smith 1985, pp. 290–302; Berlin-Amsterdam-London 1991–2, no. 39; White 1999, pp. 104–5.

Abraham's sacrifice is typical of the etchings produced by Rembrandt in the 1650s, above all in the reticent modelling of the figures and the parallel hatching in various parts of the plate (*cf.* cats 74–6). The almost iconic clarity of the gestures is also characteristic of these years. The face of Abraham, among the most expressive of Rembrandt's old men, forms the focal point of the composition and is judged to reveal his changing emotional state as the angel relieves him of the task of sacrificing his son Isaac, as God had directed (Genesis XXII: 1–19). The three central figures, illuminated brightly and blocked out as if sculpted in marble,[1] stand out dramatically from the darker background, with its indications of vertiginous terrain. Abraham's servant and packmule appear at the lower right, with two figures visible on a road with trees beyond.

To the left, Isaac's discarded clothes and a turban emerge from the blackest passage in the background, with shafts of light emanating from the miraculous illumination above the firmly outlined angel's wings. There are signs that Rembrandt may have burnished the top of the plate; and he also employed series of

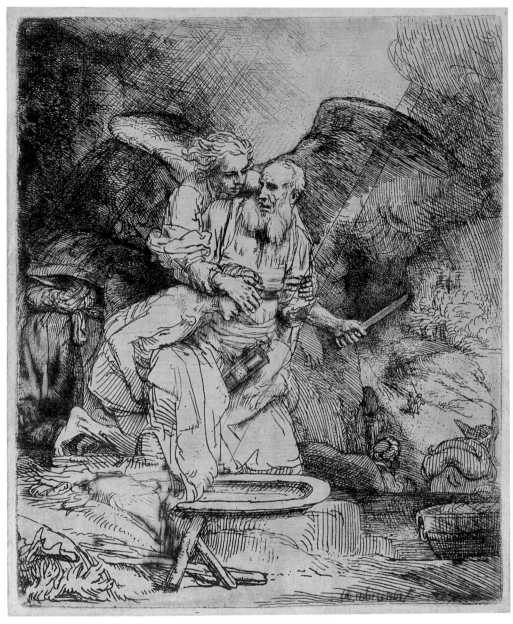

Amsterdam

dotted lines to achieve the effect he desired (at times they resemble the regular marks of a mezzotint rocker). The effectiveness of the image is enhanced in early impressions on Japanese paper, like those shown here, which are enriched by the tonality of the paper and the areas with strong drypoint burr.

Rembrandt produced a more melodramatic painting of the subject, inspired by his master Pieter Lastman, in 1635 (fig. a).[2] The etching retains general elements of the earlier composition despite the subtler characterizations. Probably in the later 1650s or the 1660s, nearer the time of the print, a pupil made a related painting, now in a private collection. This shows the composition in reverse, and probably depends on a pen sketch that has been attributed to Rembrandt himself (fig. b).[3] In the print, Abraham holds the knife in his left hand, and the idea that it

fig. b Rembrandt?, *Abraham's sacrifice*. Pen and brown ink, touched with white, 165 × 145 mm. Compiègne, Musée Vivenel

depends on a prototype, whether painted or drawn, is worthy of consideration.

In the following year Rembrandt etched the subject of *Abraham entertaining the angels* (B.29) on the same scale, perhaps intending to link them as a pair. Ten years before, in 1645, he had etched the episode immediately preceding that represented in the present work in his *Abraham and Isaac* (B.34), but although on the same scale, the earlier composition has an arched top.

MRK

1 As noted by White 1999, p. 105.

2 *Corpus* III, A108. There is a related sketch in the British Museum (Benesch 90, discussed by Royalton-Kisch 1992, no. 13) and a pupil's painting, retouched by Rembrandt, now in the Alte Pinakothek, Munich, inv. 438 (see Sumowski, *Gemälde*, II, 1983, no. 611, repr. and *Corpus* III, pp. 108–12, figs 6–10).

3 See Bruyn 1990, attributing both works to a pupil of Rembrandt, possibly his son Titus van Rijn; Jaffé 1994 published both as by Rembrandt himself. I have not seen the drawing, but feel slightly uncertain of the attribution on the basis of photographs.

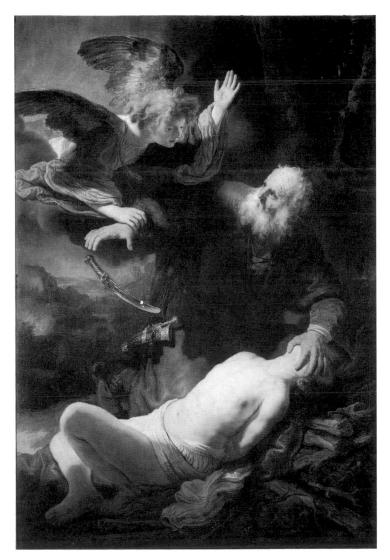

fig. a Rembrandt, *Abraham's sacrifice*. Oil on canvas, 1935 × 1328 mm. St Petersburg, Hermitage

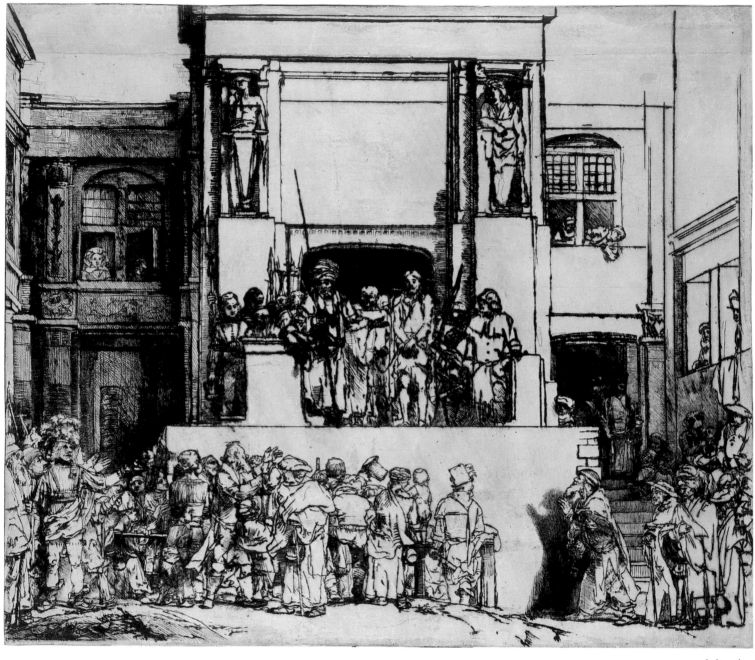

I London

78

Christ presented to the people 1655

Drypoint, 383 × 455 mm; from the fourth state onwards 358 × 455 mm; signed and dated upper right, under the window, from the seventh state onwards: *Rembrandt f 1655*.

Hind 271; White & Boon 76 I, IV, VI, VII and VIII (of VIII)

I London★ (1848-9-11-38; on Japanese paper)

IV London★ (Cracherode 1982.U.2759; on Japanese paper)

VI London★ (1845-7-24-17; on Japanese paper)

VII Amsterdam★ (Van Leyden RP-P-OB-611; on Japanese paper)

VIII Amsterdam (De Bruijn RP-P-1962-121; on Japanese paper);

London★ (Cracherode 1973.U.1022; watermark: Arms of Bern [Ash & Fletcher 3, A´.b.])

Watermarks: the Arms of Bern watermark seen here occurs in various impressions of the eighth state of *Christ presented to the people* but not in the earlier states, nor is it found in other prints.

SELECTED LITERATURE: Boston–New York 1969, no. 14; Winternitz 1969; Van de Waal 1974, pp. 182–200; Lindenborg 1976; Deutsch-Carroll 1981, pp. 587–605; Berlin–Amsterdam–London 1991–2, pp. 274–7, no. 38; Eeles 1998; Eeles 2000; White 1999, pp. 97–104.

Two years after Rembrandt made the *Three crosses* (cat. 73), he took an earlier event in the Passion as the subject for a print that he executed on the same large scale: the moment when Pontius

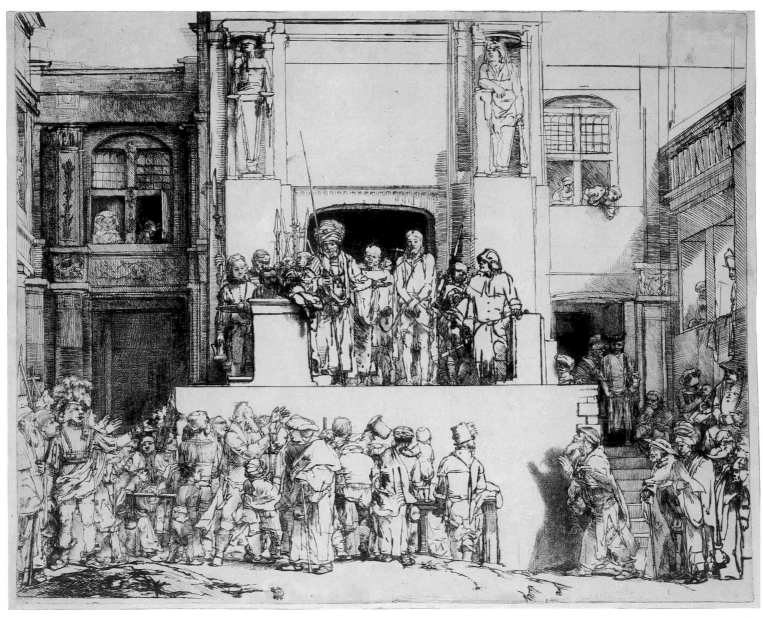

IV London

Pilate asks the people whether he should release Barrabas or Christ (Matthew 27: 21–3). The print shows the Roman governor on a dais and surrounded by soldiers, with a crowd gathered in front. He points to the bound Christ at his side, and between them can be seen the decidedly unpleasant features of the gaoler. On the far left of the platform stands a boy holding a jug of water and a large bowl in which Pilate will shortly (and literally) 'wash his hands' of the affair.

The overall composition was inspired by Lucas van Leyden's large engraving of the same subject, dating from 1510 (fig. a), and this choice was no coincidence. Since the sixteenth century, this artist had enjoyed a reputation as a virtually incomparable engraver, and Rembrandt's great admiration for his work is widely documented.[1] The similarities between his version and

Lucas' are particularly evident if Rembrandt's work is viewed in reverse – in other words as it appeared on the copper plate (fig. b). At the same time it is obvious that he gave it his own highly individual slant. For instance, Rembrandt stages the event in a small, enclosed courtyard. The statues above the central gateway would have been recognized by his contemporaries as the types of image that were to be found in Dutch courts of justice, for example in the new Amsterdam Town Hall, and this brings something of a topical flavour to the biblical scene.

Like the *Three crosses*, the print was executed entirely in drypoint, and in the first three states the dimensions of the plate are virtually identical. It is therefore likely that Rembrandt regarded the two works as pendants, as is often supposed, and perhaps even as part of a proposed series of Passion prints.[2] *Christ presented to the*

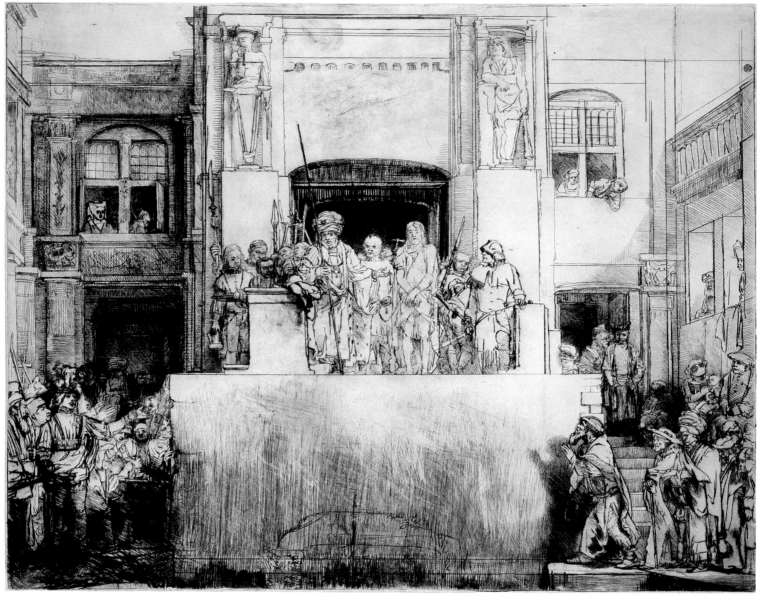

VI London

people was not signed until the seventh state, when it was dated 1655, but taking the 'pendant theory' further, it has even been suggested that Rembrandt had already made the first states of this print in 1653, when he was working on the *Three crosses*.[3] But this hypothesis is not borne out by the watermarks, although it must be noted here that impressions on western paper with a water-mark are only found in the fourth, fifth and eighth states of *Christ presented to the people*. Various marks appear, but none of them is found in impressions of the *Three crosses*, and this argues against dating it at around the same time as the latter.[4] This notwithstanding, closer examination of the way in which *Christ presented to the people* was produced reveals remarkable parallels with the earlier print, and also makes it clear that, as in the *Three crosses*, the development of the image through various

states cannot be divorced from the gradual wear sustained by the plate.

In the first state, the strongly symmetrical composition was virtually complete, and only the architecture in the upper right corner seems not to have been fully elaborated.[5] Rembrandt did not touch this passage in the two subsequent states, in which he made minor corrections elsewhere in order to point up the central group, with Christ and Pilate on the platform, more effectively. Strictly speaking, therefore, the first three states can be regarded as proofs, although the care that was taken in their printing suggests that they were intended for sale. Rembrandt was less exuberant in his experimentation with surface tone than in the *Three crosses*, but of the twenty known impressions, thirteen, including that shown here, are on Japanese paper, five are on

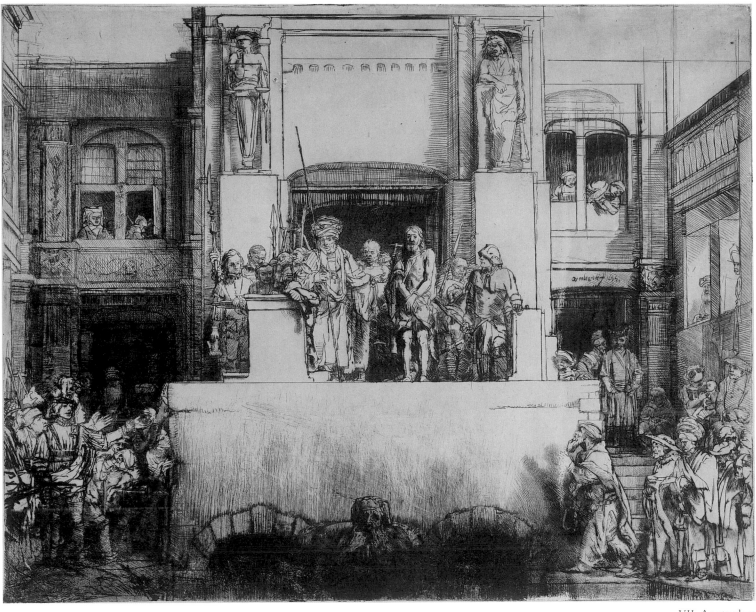

Chinese paper and one is on vellum. Only a maculature of the third state, made to clean the plate, was printed on western paper, which was less expensive and more absorbent.[6]

It is not until the fourth state that the work appears to be more or less finished. The architecture in the upper right corner has now been more fully worked out and shadows have been added, and Rembrandt has made corrections elsewhere. He also reduced the size of the copper plate by cutting away a strip (2½ cm wide) from the top edge. The reason for this was purely practical: the plate was slightly too large for the Oriental paper that Rembrandt had in stock, so that he had to make the sheets larger by sticking an extra strip along the top. Almost all the impressions of the first three states have such a strip.

Twelve impressions of the fourth state are known, of which six are on vellum, three are on Japanese paper and one is on Chinese paper. At this stage Rembrandt probably had a much larger edition in mind, but because of the signs of wear beginning to appear on the plate he was compelled to make a minor repair: in the fifth state he re-hatched the space behind the window upper right in drypoint, so that it is again just as dark as it was in the first states. He then pulled at least thirty-nine impressions which, unlike the previous ones, were printed mainly on western paper, although we also know of six on vellum and one on Japanese paper. This is consequently the most frequently found state of the present print.

By the later impressions of the fifth state, little remained of the sumptuous burr that makes the early states so attractive, and this is hardly surprising. Rembrandt had by now pulled at least seventy-one impressions from the plate, and for a print executed entirely

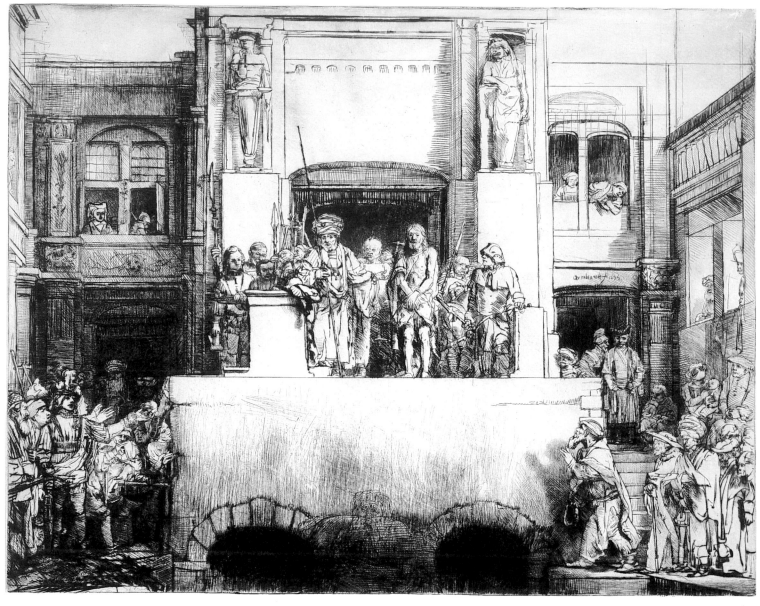

in drypoint, this is more than is often considered possible today.[7] The significant wear that can be detected in the impressions makes it clear that, if Rembrandt wanted to print more, he would need to rework the plate drastically first. Where, faced with precisely the same problem in the *Three crosses*, he had decided to execute a new version on the plate, in the case of *Christ presented to the people* he elected to rework only part of the composition. In the extremely rare sixth state Rembrandt removed the crowd from in front of the platform,[8] and in the seventh state this passage is replaced by two large arches, flanking a bearded, melancholy-looking figure, reminiscent of a river god. In the rest of the composition he essentially concentrated on camouflaging the wear by strengthening the existing lines in drypoint and re-hatching various areas. Finally, he signed and dated the plate 1655.

Although dictated by necessity, the changes that Rembrandt made focus the attention more directly on the events taking place on the dais. In the first version the viewer still had a crowd separating him from the main action. Yet the 'river god' that finally occupies the foreground seems somewhat out of keeping, and its significance has never been satisfactorily explained.[9] Rembrandt was in any event not happy with it; after only a few impressions of the seventh state, he concealed this figure under an area of dark shadow in the eighth and last state. Rembrandt printed the impressions of the sixth and seventh states with surface tone on Japanese paper. Most of the 30 known impressions of the eighth state do not have surface tone and are printed, almost without exception, on western paper. Impressions of this state occur with various watermarks, which suggests that the plate was reprinted

fig. a
Lucas van Leyden,
*Christ shown to the
people*, 1510.
Engraving,
285 × 452 mm.
Amsterdam,
Rijksmuseum

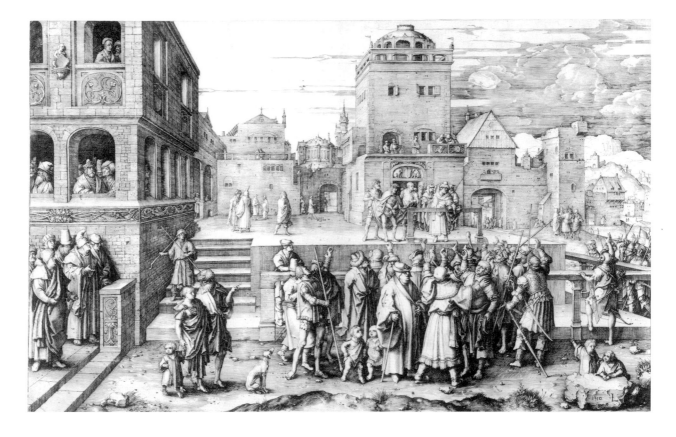

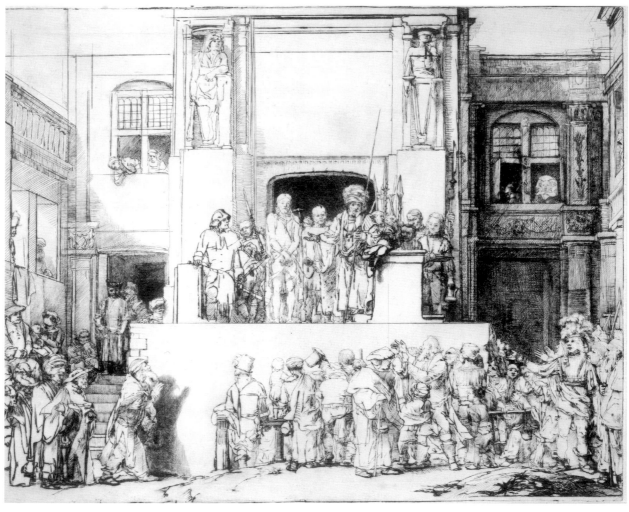

fig. b Cat. 78,
reversed

several times in this condition – in small numbers we may assume.

After *Christ presented to the people* and the *Three crosses*, Rembrandt did not embark on any other Passion scenes of this size. Although his last print dates from 1665, we know that he did have plans for such works shortly before his death in 1669. He actually had *some polished plates ... upon which to make the passion.*[10] They belonged to the Amsterdam art dealer Dirck van Kattenburgh. This may be the same man who was one of the earliest owners of a magnificent impression of the seventh state of *Christ presented to the people* on Japanese paper, inscribed 'katten-burgh' by Rembrandt himself in red chalk.[11] It is tempting to link the possession of this superb impression with the inspiration to produce a complete series.

EH

1 See Strauss & Van der Meulen 1979, 1638/2, 1642/10, 1656/12 (nos 57, 193, 198), and 1668/5. Also Hofstede de Groot 1906, nos 319, 326.

2 See Holm Bevers in Berlin-Amsterdam-London 1991–2, p. 266.

3 See Seymour Haden 1877, pp. 17–18 and 48–9; Hind, p. 111; and Filedt Kok 1972, p. 70.

4 See Ash & Fletcher 1998, p. 230.

5 As in the *Three crosses* (cat. 73) it is clear in *Christ presented to the people* that Rembrandt used a ruler to draw the perfectly straight lines of the buildings.

6 There are eight known impressions of the first state, five of the second and seven of the third (see Eeles 1998). The maculature is in the Albertina in Vienna.

7 See cat. 73.

8 There are two known impressions of the sixth state.

9 After Gersaint (1751), this figure was usually referred to as 'the mask' (*mascaron*), and later often as 'a river god'. For a concise summary of the existing interpretations see White 1999, p. 267, n. 43.

10 '...eenige geslepen plaetten ... om daer de passie op te maecken'. See Bredius 1909, pp. 238–40.

11 The impression is in the Lugt Collection, Paris (inv. no. 2086).

79

Four illustrations to a Spanish book 1655

Etching with engraving and drypoint, 280 × 160 mm (undivided plate); signed and date from the second state: *Rembrandt f 1655*.

Hind 284; White & Boon 36 III (of III)

III Amsterdam★ (Van Leyden RP-P-OB-66; on Japanese paper; cut horizontally across centre); London (Cracherode 1973.U.1092; watermark: Fleur-de-lys [Ash & Fletcher 18.C.a])

Amsterdam, Museum het Rembrandthuis★: the book in which the plate used: Samuel Manasseh Ben Israel, *Piedro gloriosa de la estatua de Nebuchadnesar*, Amsterdam 1655.

Watermarks: the same mark appears in an impression of the second state in Amsterdam, and on a first state impression of the *Virgin and child with the cat* of 1654 (B.63), also in Amsterdam (RP-P-1962-33).

SELECTED LITERATURE: Landsberger 1946, pp. 96–102; Van de Waal 1954–5; Fontaine Verwey 1956; Dubiez 1959; Held 1980, p. 162; Carstensen 1993, pp. 52–9; White 1999, p. 19.

The plate was composed to produce four illustrations to a book by Samuel Manasseh Ben Israel (1604–57), *Piedra gloriosa de la*

(*above*)
Amsterdam:
Museum het
Rembrandthuis

fig. a *The image
seen by
Nebuchadnezzar*,
second state.
London, British
Museum

estatua de Nebuchadnesar, published in Amsterdam in 1655. The four subjects were first etched on a single plate, that was subsequently cut into four for use by the publisher. They depict (a) *The image seen by Nebuchadnezzar*; (b) *Jacob's ladder*; (c) *David and Goliath*; (d) *Daniel's vision of the four beasts*. The book itself is an unorthodox, not to say fantastic discourse which unites these subjects from the Book of Daniel by claiming that the stone that destroyed the statue, the stone on which Jacob rested as he slept, and the stone employed by David to kill Goliath were one and the same; and that it symbolized the Messiah. This thesis was thematically linked to Daniel's vision of the four beasts and the Messiah. Like many of his co-religionists, Ben Israel, a rabbi and friend of Rembrandt, opposite whom he lived in the Breestraat in Amsterdam, held that the Messiah was soon to appear.[1]

Whether the book was often printed with Rembrandt's plates is uncertain, and only five such copies are now recorded.[2] Others contain cruder reworkings of Rembrandt's designs with some iconographic adjustments, such as the omission of any figural representation of the Almighty in the *Vision of Daniel*, possibly in response to the constraints of the first commandment. The new plates were probably by Salomo d'Italia, who engraved a portrait of the author.[3] The circumstances of Rembrandt's commission are also uncertain; but the suggestion that he made the plate out of friendship for the author is plausible, as his services would otherwise have been beyond the rabbi's financial reach.[4] Rembrandt's use of etching and drypoint, albeit strengthened with the burin, was unorthodox for a book illustration, for which the hardier media of engraving or woodcut were generally preferred in order to produce sufficient impressions for a book-edition.

Rembrandt tinkered with his first results before the plate was divided. The most significant change was made to the *Image seen by Nebuchadnezzar*, to which Rembrandt, among other alterations, added the background niche and reduced the breaks in the statue to just one, at the ankles – in the first two states the legs are broken in several places, to somewhat comic effect and in conflict with the biblical account, which states that the feet of the statue were smitten by the stone (fig. a).[5] The state shown here, the third, is after this adjustment. Once the plate was cut into four, a few other proofs were pulled of each illustration and further alterations made, the most noticeable being to the *Jacob's dream*, in which the ladder was lengthened, and once again to the *Image seen by Nebuchadnezzar*, to which the names of the nations were added: *Babel*, *Medi*, *Persi*, *Graeci*, *Mahometani* and *Romani*.

MRK

1 Van de Waal, *loc. cit.*

2 As well as the copy from the Rembrandthuis exhibited, others are in the Petit Palais in Paris, the University Libraries in Amsterdam and Leiden, the Institut Néerlandais in Paris (collection F. Lugt) and another that was recorded in the Fairfax Murray collection (as noted by White & Boon). The illustrations appear opposite pp. 5, 81, 160 and 186.

3 Landsberger 1946, pp. 96–102. Until recently, Rembrandt was thought to have portrayed the author in B.269, but the identification was probably erroneous (see most recently Dudok van Heel 1993).

4 Carstensen *op. cit.*, points out that the 400 guilders Rembrandt was promised for an etching of Otto van Kattenburg (see Strauss & Van der Meulen, 1979, p. 334) was more than double the rabbi's annual salary.

5 Van de Waal, *op. cit.*, following Benesch, 1943, p. 25, believed the illustrations were based on those by William Rogers in Hugh Broughton's *A concent of scripture*, London, 1590; Münz suggested another possible precursor in engravings for the Bible by Matthaeus Merian (Münz 1952, II, p. 89, repr.).

80
The goldsmith 1655

Etching and drypoint, 77 × 56 mm; signed and dated, lower left: *Rembrandt f. 1655*

Hind 285; White & Boon 123 I (of II)

I London★ (Cracherode 1973.U.1101; on Japanese paper)

SELECTED LITERATURE: Van de Waal 1974, pp. 233–46; Boston-St Louis 1980–81, no. 134; Lawrence-New Haven-Austin 1983–4, no. 5; Bangs 1985; White 1999, pp. 191–2.

During Rembrandt's frenzied production of etchings in the mid-1650s, several prints came into being that, in theme and execution, occupy a somewhat isolated position in his *oeuvre*. Besides dramatically illuminated biblical scenes, experimental in technique, and realistic portraits that are essentially continuations of themes that had long fascinated him as a printmaker, there is this miniature-like rendering of an artist in his workshop. The print is entitled 'The goldsmith', after the eighteenth-century French title, 'L'orfèvre', but whether this accurately conveys his profession is uncertain, as he appears rather to be a sculptor in metal. His statuette, a personification of Charity, is finished. He holds it tenderly while hammering it to a pedestal decorated with scrolls.

As with other etchings, Rembrandt may have been inspired by an older print. Here a likely candidate is the *Smith* by Dirck Vellert (*c*.1511–*c*.1547), an etching in which the hammering protagonist is depicted on exactly the same scale as in Rembrandt's work (fig. a).[1] Both the angle of the head and the rendering of details are similar. While sketch-like qualities generally predominate in Rembrandt's etchings, here he has taken the trouble

to cover the image with hatching in the manner of printmakers in the time of Lucas van Leyden. Furthermore, the tongs, for instance, not only appear in the same place in the composition as in Vellert, but are also depicted in the same way, in white against a dark background.

However, the figures are not doing the same kind of work. In the older print, the man hammers out a circular plate on an anvil in the open air. Beginning a new creation, his hammer poised high in the air, he is utterly absorbed in what he is doing. In the Rembrandt we witness the artist putting the final touches to his work; the chosen vantage-point gives us the impression that we are observing him at his work-bench through a window. Despite the difficulties in interpreting the expression on a face that measures no more than one square centimetre, some commentators have suggested that the sculptor seems distracted, and is pondering the fact that he will soon have to part with his creation.[2]

It has sometimes been asserted – quite categorically – that a statuette of this kind, about forty centimetres high and executed, perhaps, in bronze, could not have existed in the seventeenth century; and on the basis of this assumption, an ingenious if far-fetched biblical interpretation has been suggested.[3] Although no other examples are known today, so many similar images of allegorical representations of Charity are known from Rembrandt's day in a variety of materials, that it would actually be more surprising if such a piece had not existed, perhaps as one of the virtues crowning a gravestone, or above the entrance to a charitable institution.[4] Even the rather massive base is not fanciful

if the work was destined for a pediment (fig. b).[5] Rembrandt may even have owned such a statuette: in 1656, a year after the print was completed, the inventory of his possessions speaks, 'on the back shelf' of his art collection, of a sculpture representing 'antique love'.[6]

Of the first state, a whole series of impressions was printed on Japanese paper, the yellowish hues of which impart a glow to the fire blazing in the hearth at left. The second state, which merely has a little more hatching, occurs only on Western paper.[7] The copper plate has been preserved, and it shows that the contours are deeply bitten; but after Rembrandt's death it was not heavily reworked.[8] In contrast to many of the other plates, it does not occur in the 1679 inventory of Clement de Jonghe's property; yet posthumous impressions exist, made in the late eighteenth century. The testimony of the print connoisseur Adam von Bartsch reveals that people had no scruples about laying Rembrandt's copper plates on the press for the umpteenth time: 'Cette petite estampe, appellée le petit Orfèvre, a été très rare pendant bien du tems, parce qu'on ne savoit pas, où étoit la planche; mais comme elle a été depuis retrouvée, les épreuves tombent aujourd'hui plus facilement sous la main'.[9]

GL.

(below) fig. b Hans Lourens Schuyneman, *Charity*, c.1615. Stone sculpture above the entrance to Bolsward town hall

fig. a Dirck Vellert, *The smith*. Etching, 61 × 41 mm. London, British Museum

I London

1 The resemblance was noted by Linda Stone Ferrier in Lawrence-New Haven-Austin 1983–4, p. 53.

2 See Van de Waal 1974, p. 236; K. G. Boon also devoted a brief discussion to this element of the print in a handwritten contribution to an album for D. de Hoop Scheffer on her departure from the Rijksprentenkabinet in 1980.

3 See Van de Waal 1974, pp. 235–6 who believes that the Old Testament figure Micah (Judges 17:1–7) is depicted.

4 Various examples in stone and marble can be found in Neurdenburg 1948, p. 106, fig. 76, p. 141, fig. 111 and p. 154, fig. 123. For a similar, wooden statuette, attributed to Jan Hardewel of Amsterdam, see Carasso-Kok 1975, p. 114.

5 For the ensemble from which fig. 2 derives, see Neurdenburg 1948, pp. 153–6 and fig. 124.

6 '[O]p de agterste richel' of Rembrandt's collection was 'een beelt sijnde de antieckse liefde'; Strauss & Van de Meulen 1979, 1656/12, no. 180.

7 White & Boon, I, p. 64.

8 Hinterding 1993–4, p. 296; it is in the Albertina in Vienna.

9 Bartsch 1797, p. 120 (this small print, called the *Little goldsmith*, was for a long time very rare, because no one knew where the plate was; but as it has since been found, impressions come to hand more easily today).

Exceptionally, these two prints, one obviously made very soon after the other, are executed entirely in drypoint, worked up with the burin, and there are no etched lines in them at all. Deep black dominates both portraits, relieved by a starched collar and white cuffs. The Haringhs may well have posed in the same room, sitting by a window whose small panes admitted very little light, though the chairs are different. Rembrandt placed the two men at exactly the same height in the plane of the picture, and the prints differ in size by no more than a millimetre or two.

The problem with such heavily worked plates is that it is impossible to pull very many impressions from them before much of the velvety effect is lost and they become patchy. Inking calls for particular skill in this case, and balanced early impressions are consequently rare. Those on Japanese paper vary and have an unusual sheen, particularly when they have been printed with a great deal of surface tone. Needless to say, these were extremely

81

Thomas Jacobsz. Haringh *c.*1655

Drypoint and burin, 195 × 149 mm

Hind 287; White & Boon 274 II (of II)

II Amsterdam (De Bruijn RP-P-1962-102; on Japanese paper); London★ (Cracherode 1973.U.1103; on Japanese paper)

SELECTED LITERATURE: Amsterdam 1986, pp. 62–4, no. 45; Dickey 1994, pp. 22–3; White 1999, pp. 157–9.

Thomas Jacobsz. Haringh (*c.*1586/7–1660) was about seventy years old when he sat for this portrait. He was the Concierge of Amsterdam Town Hall and, in this capacity, was head of the messengers and responsible for the everyday running of town hall affairs. He was also charged with the sales under duress in the city, which means that he coordinated the forced sale of Rembrandt's possessions from the autumn of 1656 to December 1658, and acted as the auctioneer. Before this Rembrandt tried to stave off his impending insolvency by himself organizing a voluntary sale, which started in the Keizerskroon inn in the Kalverstraat on 25 December 1655 and continued into January of the following year. This brought him into contact with Thomas Jacobsz's second cousin Pieter Haringh (1609–85), who was Messenger of the Amsterdam orphans' court and acted as auctioneer in all sales not ordered by the court. Rembrandt etched his features as well at this time (fig. a). To distinguish the two portraits they are traditionally referred to as 'Old Haringh' and 'Young Haringh'.[1]

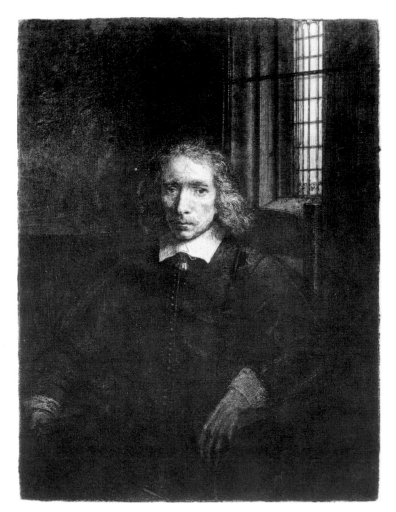

fig. a Rembrandt, *Pieter Haringh*, 1655. Drypoint and burin, 195 × 146 mm. Amsterdam, Rijksmuseum (B.275 I)

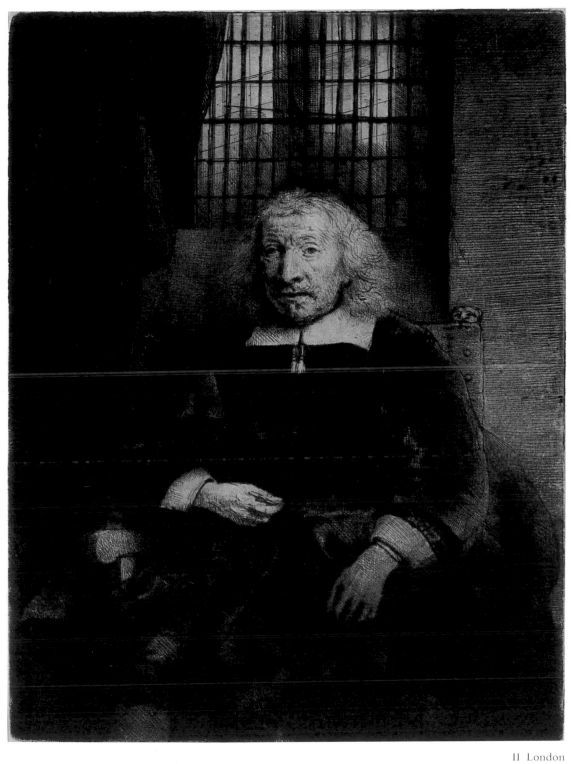

II London

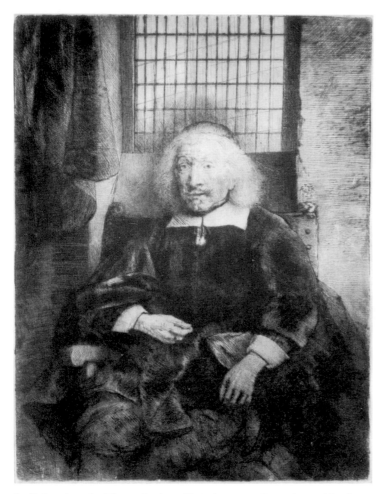

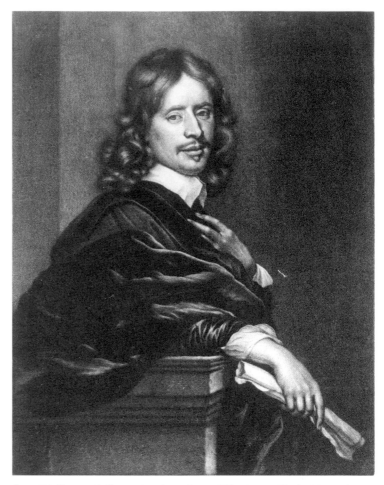

fig. b Rembrandt, *Thomas Jacobsz. Haringh*, c.1655. Drypoint and burin, 195 × 149 mm. Vienna, Graphische Sammlung Albertina (B.274 I)

fig. c Wallerant Vaillant after Gerard van Zijl, *Govert Flinck*. Mezzotint, 227 × 178 mm. Amsterdam, Rijksmuseum

sought after by connoisseurs. Pierre-Jean Mariette (1694–1774) reported, for example, that he had seen two impressions belonging to the Parisian collector Pierre Crozat, 'une où la main et la manchette gauches étoient plus claires et l'autre où elles estoient plus ombrées'.[2]

There are two states of the *Portrait of Thomas Jacobsz. Haringh*, the first of which, known only in a single impression, can be regarded as a proof (fig. b). In it Haringh has a rather foolish, almost senile expression, his hair is stiff and pure white and there are no locks to be seen. The curtain on the left displays residual forms that disrupt the balance and cause an unwanted scattering of the light. In the second state, the sitter has acquired dignity and the curtain has been made larger, resulting in a uniform tone.

It is hard to imagine that a print which so strives after effect could have come about without consultation with the sitter who had commissioned it. We know from Thomas Haringh's will that he was a connoisseur of graphic art;[3] and it is striking that the two members of the same family, who played such prominent roles in sorting out Rembrandt's financial problems, should have ordered their portraits from him. In Pieter's case there is evidence that the

copper plate remained in the family: the inventory compiled by his son Jacob in 1707 lists 'some prints being the portrait of my father' and 'a copper plate being the portrait of my father'.[4]

Rembrandt's richly black Haringh portraits anticipate the technical developments which, soon after, were to make the mezzotint possible. He lived to see the introduction of the technique in Amsterdam by Wallerant Vaillant of Lille (1623–77), who had encountered it around 1658 in Frankfurt.[5] By roughening a copper plate and then, starting from a completely black surface, building up an image by scraping and polishing, it was possible to achieve tonal effects that Rembrandt created by stippling and cutting (fig. 3).[6] But as far as we know he never used the new technique.

GL

1 For the identification of the two Haringhs, see Van Bemmelen 1929, pp. 59–77; Oldewelt 1930, pp. 175–8; Van Eeghen 1969; and for a description of their professions Van Eeghen 1969b, pp. 74–88.

2 '...one in which the left hand and cuff are lighter, and the other in which they are darker.' Mariette 1857, p. 356.

3 R. Ekkart in Amsterdam 1986, p. 62.

4 Van Eeghen 1969; 'enige printen sijnde het pourtrait van mijn vaeder' and 'een kooper plaatje sijnde het pourtrait van mijn vaeder'.

5 See Wuestman 1995, pp. 66–71.

6 For the mezzotint by Vaillant illustrated here, see Hollstein 174.

82

Arnout Tholinx *c*.1656

Etching, drypoint and burin, 198 × 149 mm

Hind 289; White & Boon 284 I (of II)

I London★ (Cracherode 1973.U.1109; watermark: Strasbourg lily★)

Watermarks: this type of Strasbourg lily also occurs in the impression of the first state in the Pierpont Morgan Library in New York, but is not found anywhere else.

SELECTED LITERATURE: Van Tol 1983; Amsterdam 1986, pp. 74–5, no. 56; White 1999, pp. 159–62.

This etching has always been noted for its rarity, which indicates that few impressions were ever made.[1] The abundant drypoint passages mean that the plate could not take a large number of impressions without appreciable loss of quality. The plate would also have been the property of the sitter, so that it would not have been available to pull through the press *ad infinitum*.

The sitter, who has kept his hat on while reading, is Arnout Tholinx (1607–79), a physician who had stepped down from his post as Inspector of the Amsterdam Collegium Medicum, the Company of Physicians, some years before the print was made, and had his own flourishing medical practice. In 1648 he married Catharina Tulp, the oldest daughter of the renowned physician Nicolaes Tulp, the central figure in Rembrandt's celebrated painting of an *Anatomy lesson* of 1632. When Jan Six married Catharina's sister Margaretha in 1654, he became Arnout Tholinx's brother-in-law.[2] Tholinx consequently moved in circles where people appreciated Rembrandt and his work, and this could explain why at some time around 1656, in the period when Rembrandt was in financial difficulty, he commissioned both a portrait in oils and a portrait print from him.

The painting shows Tholinx half length *en face*, with no other details (fig. a). At the age of forty-nine his hair was already quite white, as we can also see in the etching, in which his square-cut beard juts over his black, tightly buttoned jacket. He looks up from his reading in the volume on the table, a pair of pince-nez in his hand. So as not to smear the lenses, he holds the glasses by the nosepiece; the case is on the table in front of him. We cannot see what sort of book he is studying. Rembrandt's eye for detail

extends to the several pages curling up at the place where the grave doctor has been interrupted. If the book was incorporated in the composition to stress his learning, the bottles on the floor behind the chair refer to his profession. The margin below was left blank. It is possible that an ode to the sitter or some brief information about his life was to have been added here, but no text was ever cut in the plate. If the print was intended primarily for Tholinx himself to give to people, he could have written in this space by hand.

The impression of the first state exhibited here has an abundance of drypoint effects, so many in fact that they overshoot the mark and have the effect of spots, or create ambiguity. What are the horizontal streaks in the back of the chair? Creases in the leather? Obviously the accents on the coat suggest texture, but on the left side it looks as if black ink has been poured over his shoulder; and he appears to have applied mascara to his eyelids. In the best impressions of the second state, in which there are also a few very minor changes, this superfluity has been repressed to the

fig. a Rembrandt, *Arnout Tholinx*, 1656. Canvas, 76 × 63 cm. Paris, Musée Jacquemart-André

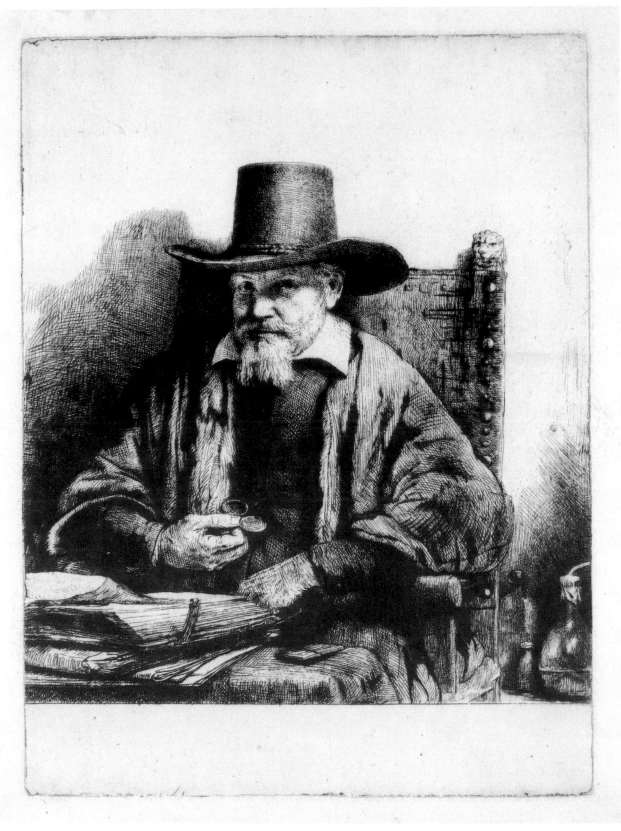

I London

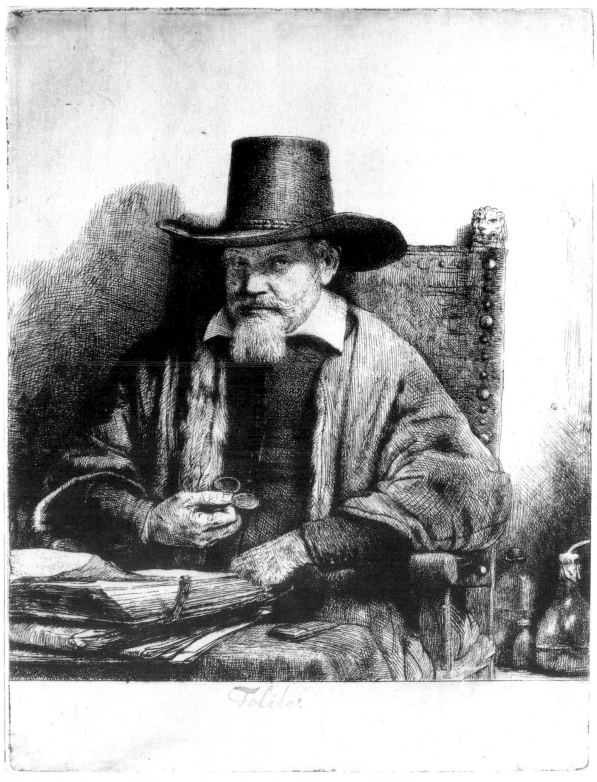

fig. b Rembrandt, *Arnout Tholinx*, second state. Amsterdam, Rijksmuseum (B.284 II)

benefit of the legibility of particular areas: now the bottles are the understated still life that Rembrandt must have had in mind and we are able to see just how phenomenal his ability was in allowing the viewer to perceive the space between the foreshortened arm of the chair and the folds of the coat (fig. b). In the first state the ink in this area reads only as ink.

The *Portrait of Arnout Tholinx* is an incomparable work of art and one can understand collectors' eagerness to acquire examples of it. While Rembrandt's etched likeness of Jan Six was the *non plus ultra* for a connoisseur, an impression of Tholinx was almost as desirable.[3] Since they were simply not to be had, people started to make and sell etched copies. At least six etchers embarked on this venture, with very varied results.[4]

<div style="text-align: right">GL</div>

1 See for example the reference in Valerius Röver's *memorie* of 1731, p. 12: 'het zeer raare portret van Van Thol met de overdruk' ('the very rare portrait of Van Thol with the counterproof'); Van Gelder & Van Gelder-Schrijver 1938, p. 11.

2 For the identification of the portrait and a profile of Tholinx, see Tol 1983.

3 Boon 1956, p. 50, n. 1.

4 For a list of these copies, see White & Boon I, p. 135.

83

Jan Lutma 1656

Etching and drypoint (with burin in the second state), 196 × 150 mm; in the second state, signed and dated upper centre in drypoint: *Rembrandt f. 1656* and engraved right of centre (not by Rembrandt): *Joannes Lutma Aurifex Natus Groningae*

Hind 290; White & Boon 276 I and II (of III)

I Amsterdam★ (Van Leyden RP-P-OB-550; watermark: none); London (1910-2-12-403; watermark: Arms of Amsterdam★)

I counterproof Amsterdam★ (Van Leyden RP-P-OB-549; touched in brush and grey wash; watermark: none)

II Amsterdam (Van Leyden RP-P-OB-548; watermark: none); London★ (Slade 1868-8-22-696; watermark: none)

Watermark: the Arms of Amsterdam seen in the first state is otherwise only found in a good impression with light burr of *Abraham entertaining the angels* (B.29) of 1656.

SELECTED LITERATURE: Boston-New York 1969, no. 22; Von Graevenitz 1973, pp. 190–92; Boston-St. Louis 1980–81, no. 137; Amsterdam 1986, pp. 68–73, no. 50; White 1999, pp. 159–60.

Although Jan Lutma (*c.*1584–1669) was already an elderly man when he was portrayed by Rembrandt in this etching, he was probably still working as a silversmith. Yet despite the presence of a hammer and a pot containing punches, he is not working here

but posing. He holds one of his creations – an object with a turned stem, possibly a candlestick – in his right hand, and beside him on the table is a chased silver drinking bowl. At least one example of this type of dish has survived (fig. a).[1] Rembrandt and Lutma may well have discussed the selection of these attributes. In a painted portrait of around 1643 by Jacob Backer (1608–51), when Lutma was far from being the old man whom Rembrandt portrayed, he sits, hammer in hand, showing off one of the great salts he had made for the City of Amsterdam (fig. b).[2]

Lutma was born in Emden in East Friesland. After spending five years in Paris, he settled in Amsterdam in 1621, where he built up a reputation as a master silversmith and received a series of official commissions. His work has an affinity with that of the Van Vianens, who shared his consummate mastery of chasing. As he grew older he began to experience problems with his eyes. Yet in 1656 he declared that he had been cured of his blindness. The fact that he is portrayed in Rembrandt's etching of that year with an absent look and half-closed eyes undoubtedly has to do with this handicap; and in the portrait print that his son Jan, leaning heavily on Rembrandt's example, made of him shortly afterwards, he is holding a pair of spectacles.[3]

Rembrandt used a fine needle to draw the silversmith and the furniture and attributes around him into the etching ground. He did this in a homogeneous manner so that most of the lines are equally thin, even those used to build up the shadow on the wall in the background. He created forms by intensifying the hatching and varying the direction of the lines, while the contrasts are strengthened with drypoint, as can clearly be seen in the folds of

fig. a Jan Lutma, Drinking bowl, 1641. Silver, chased, 79 × 150 × 203 mm. Amsterdam, Rijksmuseum

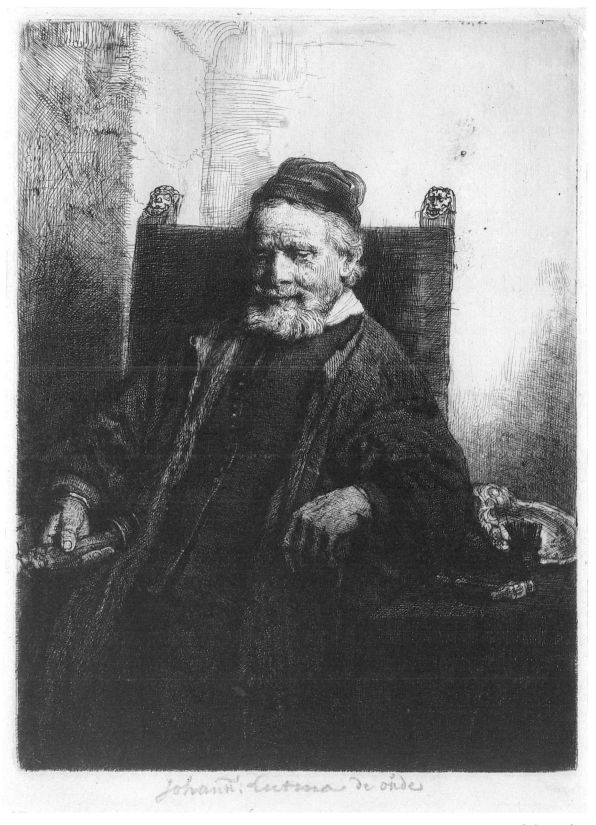

Johannes Lutma de oude

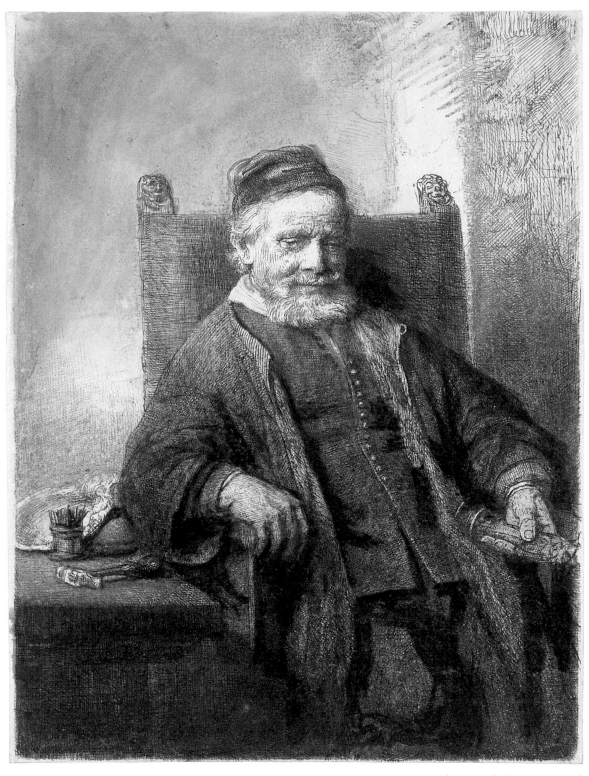

I Amsterdam (touched counterproof)

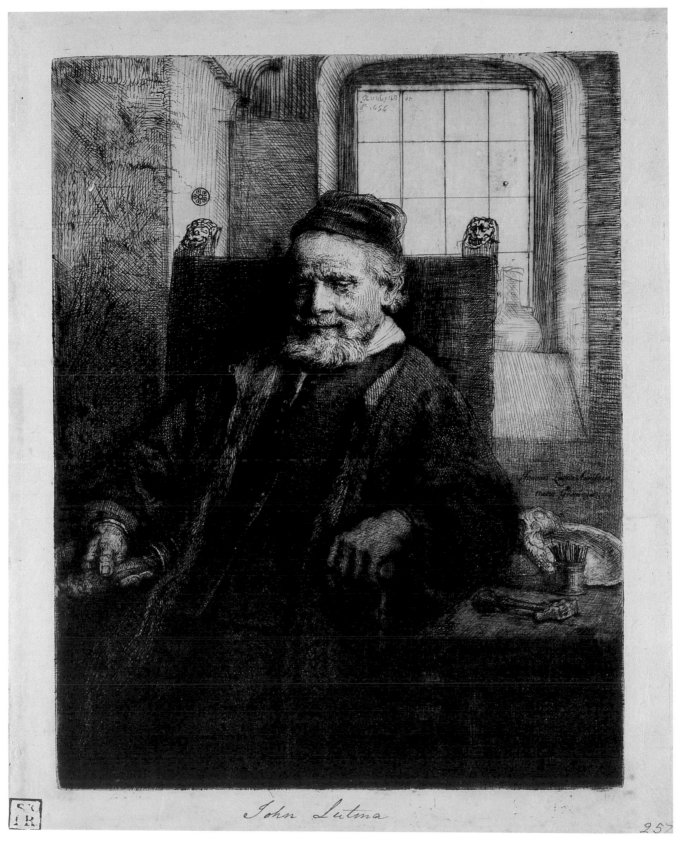

John Lutma

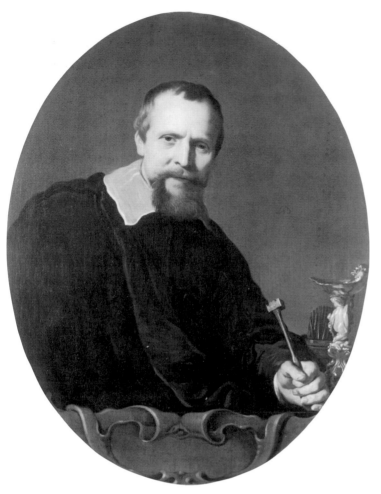

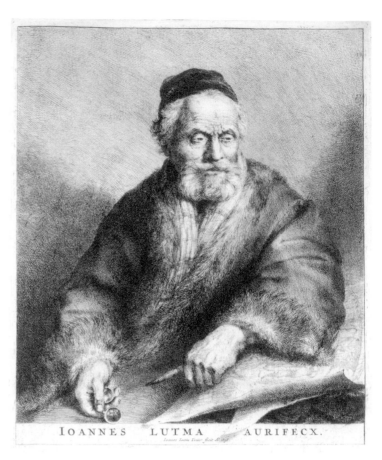

fig. b Jacob Backer, *Jan Lutma*, c.1643. Oil on panel, 91 × 71 cm. Amsterdam, Rijksmuseum

fig. c Jan Lutma the Younger, *Jan Lutma*, 1656, etching and punch, 239 × 203 mm. Amsterdam, Rijksmuseum

the coat. The resulting, rich tonal effects can best be admired in early impressions. The details are all enhanced to a similar degree apart from the two carved lion's heads on the chair, which are looser in form, and this gives these lively sentinels the look of grimacing little monsters. Rembrandt was a master in the suggestion of spatial values, and emphasized that the chair is standing freely in the room by leaving a light streak next to it, as well as its shadow on the left.

It would seem that there was a single moment when Rembrandt returned to the plate to work on it again. The first state was not a proof because a considerable number of impressions were printed. We know of thirty-four, either on European paper with different watermarks, or on cartridge paper or various types of oriental paper. The plate must have been put on the press at intervals. Late impressions of this state look slightly grey and insubstantial. In the second state Rembrandt installed a window in the room, behind Lutma, and added shadows on the wall. Using the most delicate of lines he drew a bulbous glass bottle on the window-sill. His signature and the date appear in the upper left pane. This major reworking has meant that, to this day,

impressions are described as 'Lutma without' or 'Lutma with' the window.

Rembrandt roughed out the broad outlines of these changes on the counterproof included here. The double reverse effect of printing a counterproof means that the image is seen in the same direction as on the plate, and this makes it much easier to see where the plate requires further work. He washed the background using grey ink and a brush and tried out shading to transform the wall into a recess. At that point he had evidently not thought about adding the window. We are left to wonder whether it was Lutma, the probable owner of the plate, who asked for the window to be included, or whether it was Rembrandt's own idea.

Various other changes were made to the plate in a later state, but although it was thought for a long time that Rembrandt was responsible for them, this is doubtful. They are primarily additional hatching, some in drypoint, in places where repeated printing had made repairs necessary, and areas of shadow had lost all texture. A note written on an old mount of an impression of this third state in the Teylers Museum in Haarlem claims that this

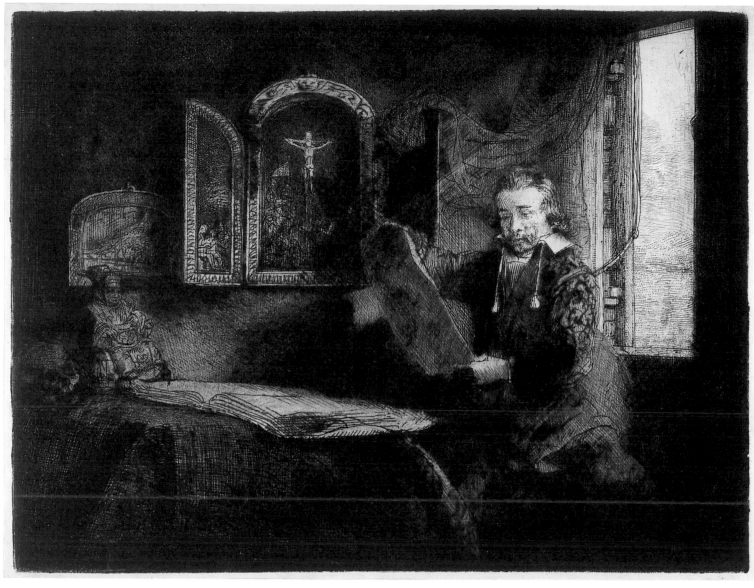

I London

reworking was done by a certain Plonski.[4] This could contain a kernel of truth. The Polish etcher Michael Plonski (1778–1812) obtained the copper plate at some time prior to 1810, and could do with it as he pleased.[5] He took it to Paris where he sold it to Henri-Louis Basan (died before 1819). The plate was thus added to the stock of Rembrandt plates that this publishing dynasty already owned.[6]

GL

1 See De Lorm 1999, pp. 42–3, no. 11.

2 Von Graevenitz 1973, pp. 190–92.

3 Hollstein 5; see Amsterdam 1986, no. 54.

4 With thanks to Marjolein Menalda of the Teylers Museum who, upon checking the inscription, found that the mount has meanwhile been replaced and the old one has disappeared.

5 See Josi 1810, p. 45.

6 See Erik Hinterding's comments on this in Minder 1997, p. 213, n. 9.

84

Abraham Francen, apothecary c.1657

Etching, drypoint and burin, 158 × 208 mm

Hind 291; White & Boon B 273 I, II, V, VII (of X)

I London★ (Cracherode 1973.U.1114, on Japanese paper)

II Amsterdam★ (Van Leyden RP-P-OB-531, on Japanese paper)

V Amsterdam★ (Van Leyden RP-P-OB-534; watermark: none)

VII Amsterdam (De Bruijn RP-P-1961-1151, on Japanese paper); London★ (1848-9-11-142; watermark: none)

SELECTED LITERATURE: Gersaint 1751, pp. 199–200; Six 1908, pp. 53–64; De Bruijn 1926, pp. 39–44; Cayeux 1965, p. 64; Van Eeghen 1969c, pp. 169–176; Boon 1970, pp. 89–91; Amsterdam 1986, no. 57; Dickey 1994, p. 22; Amsterdam 1999–2000, p. 142; White 1999, pp. 162–5.

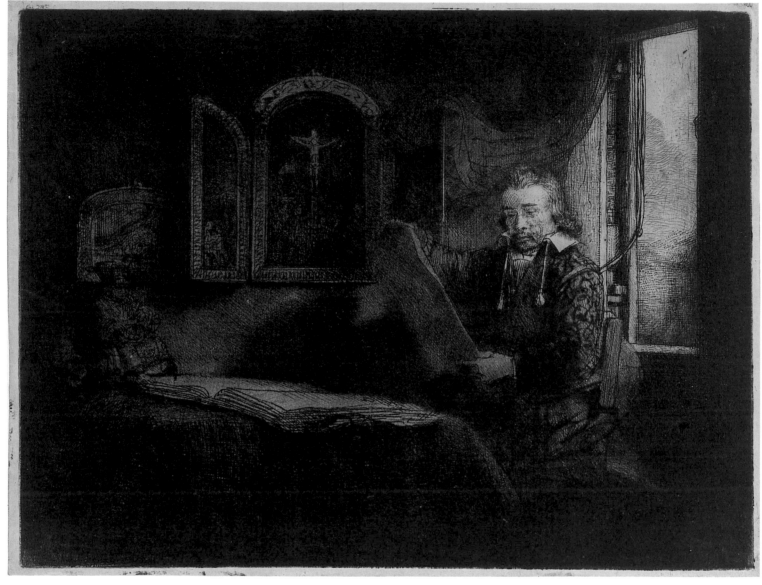

II Amsterdam

Abraham Francen (1612– after 1678) was an Amsterdam apothecary and a passionate collector of art. He was born in the Jordaan, a neighbourhood in the centre of town, and remained there all his life. He lived at various addresses, however, which can be taken to indicate that he was not particularly well-to-do. The eighteenth-century art dealer Edmé Gersaint remarked on Francen's meagre resources, and mentions that he was known to tighten his belt in order to indulge his love of prints.

Francen must have met Rembrandt through his interest in art: the two men were in any event close friends. Francen testified for Rembrandt on several occasions in the 1650s and 1660s, and offered support throughout his financial difficulties. He also

endorsed Titus' application to be declared of age in the eyes of the law, and assumed guardianship of Cornelia, the daughter of Rembrandt and Hendrickje Stoffels.

Viewed against this background, the portrait of Francen may have been made as a token of friendship rather than as an official commission. The meticulous detailing recalls the portraits of *Jan Six* (cat. 57) and *Thomas Haringh* (cat. 81), but in this case Rembrandt appears to have set to work without a clear-cut plan, as the plate went through at least five states. The composition was more or less completed in the first state, an example of which is shown. Rembrandt seems to be giving us a glimpse of his friend's art cabinet. We see Francen in front of an open window,

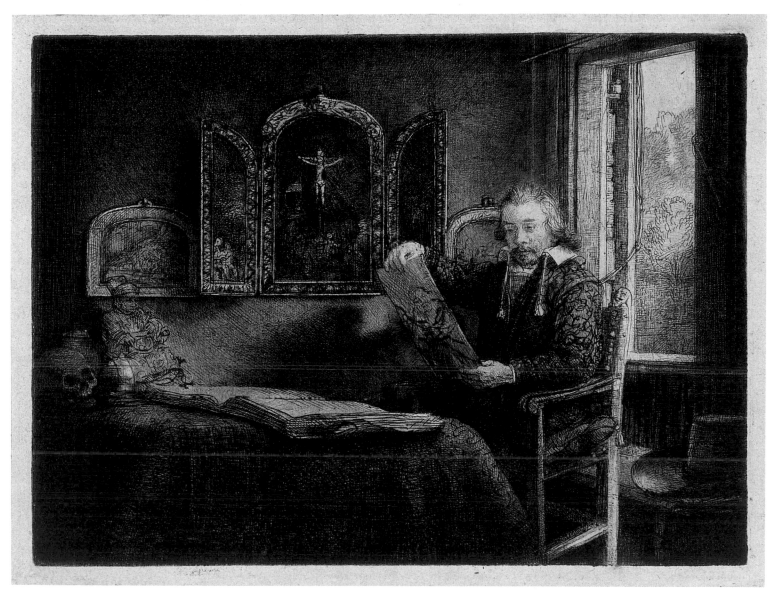

V Amsterdam

examining a print or drawing. An open album, a Taoist sculpture,[1] a skull and a pot are set out on the table before him. A triptych hangs on the wall, with a painting on either side. The scene is remarkably informal. The curtain at the window, for instance, has been casually tossed over the wing of the triptych to allow light to enter the room, and Francen himself has settled into a stool, but looks as if he had barely had time to compose himself. The daylight pouring into the otherwise gloomy study is evocative of a sunny summer's day, an effect heightened by the fact that the impression shown is printed with pale tone on yellowish Japanese paper.

But Rembrandt was not entirely satisfied with the result, as he made various alterations in the following four states, mainly to Francen's pose. In the second state, as seen here, he put Francen on a chair and brought him closer to the table by extending the tabletop. He also erased the ray of light and further darkened the room by printing the plate on Japanese paper with yet more surface tone than the first state: only Francen's face and the window are printed without tone and therefore seem brightly illuminated. Rembrandt subsequently replaced the chair, which was not in perspective, and removed the curtain behind the figure. He also reduced the size of the sheet that Francen is examining, so that more of his upper hand is visible at the top. In the fifth state, also included here, Rembrandt focused mainly on

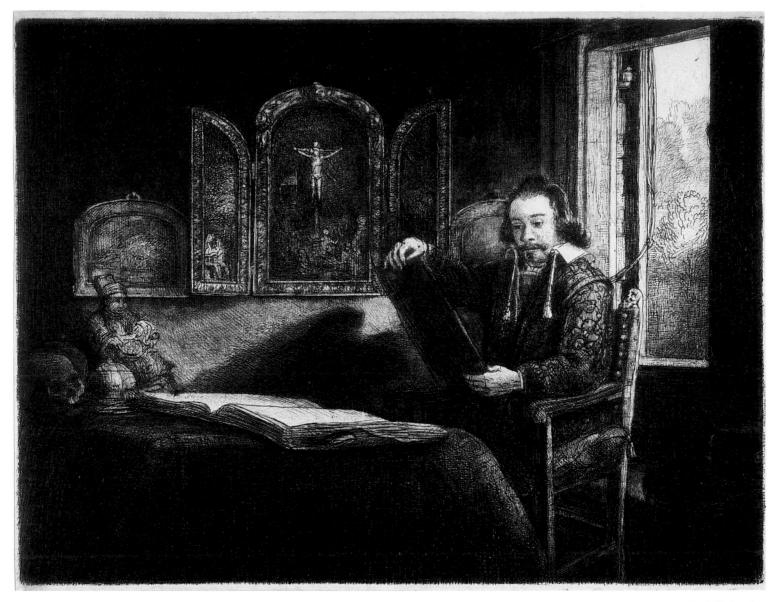

the paintings on the wall. He highlighted the frames against the darkness of the wall by making a few minor changes, but mainly through the judicious application of ink to the plate and the sparing use of surface tone.

The image was left unchanged after the fifth state, although the plate was reworked several times to conceal signs of deterioration. Though this was probably done by someone other than Rembrandt, the watermarks suggest that these changes are seventeenth-century.

EH

1 The sculpture represents an unidentified Taoist deity. Taoist Chinese in both China and Taiwan placed statues of this kind on altars in their homes. I am grateful to Pauline Lunsingh Scheurleer and Jan van Campen of the Asiatic Art Department of the Rijksmuseum in Amsterdam, and to Ming Wilson of the Far Eastern Department of the Victoria and Albert Museum in London, for their kind efforts to identify the statue.

85

St Francis beneath a tree praying 1657

Drypoint and etching, 180 × 244 mm; signed and dated twice, lower right corner: *Rembrandt f. 1657* (in the first state in drypoint, in the second state etched over the top of it, the 'd' reversed).

Hind 292; White & Boon 107 I and II (of II)

I Amsterdam★ (Van Leyden RP-P-OB-171; on Japanese paper)

I London★ (Cracherode 1973.U.1118; on vellum)

II London★ (Cracherode 1973.U.1120; on Japanese paper)

SELECTED LITERATURE: Van Gelder & Van Gelder-Schrijver 1938, p. 13; Stechow 1952, p. 3; Boston–New York 1969, no. 23; Donahue Kuretsky 1974, pp. 571–80; Boston–St Louis 1980–81, no. 171; Schneider 1990, no. 44; White 1999, pp. 251–3.

Among Rembrandt's prints with 'Roman Catholic' subjects there are two that so strongly resemble objects of private devotion that

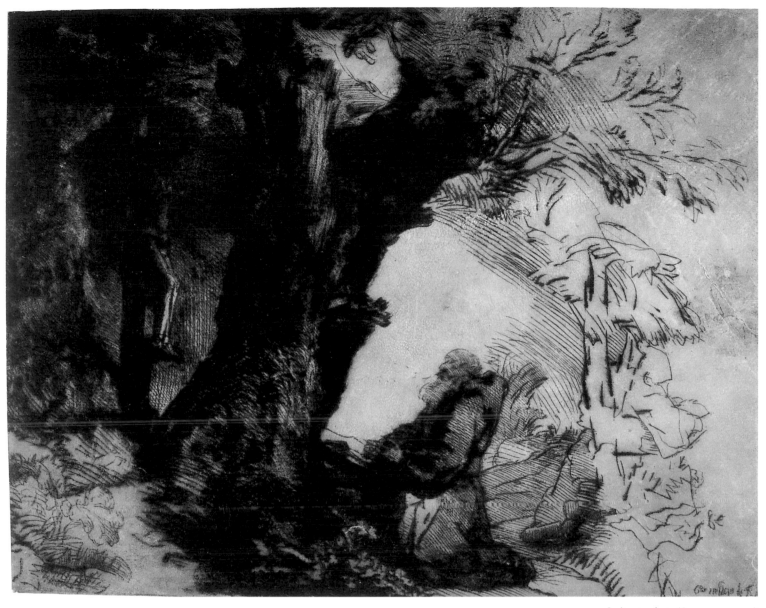

we can ask ourselves whether the artist made them to order, or at least in response to a request. They are the small etching of the *Virgin with the instruments of Christ's Passion* (B.85) and the superb *St Francis beneath a tree praying*.

In catalogues dating from the first half of the eighteenth century, the saint in the etching is identified as St Jerome; Gersaint was the first to refer to him as St Francis of Assisi. Rembrandt depicted him as an aged, white-bearded monk, kneeling at the foot of a tree with a huge split trunk. His eyes are closed and his folded hands rest on a large book. Further to the left is an almost life-sized crucifix. According to the legend, Francis's reverence for the crucified Christ was so infinitely great that one day, when deep in prayer, Christ appeared to him in a vision and impressed on his body the *stigmata* – the same wounds suffered by Christ on the cross. Rembrandt chose to show the

moment prior to the miracle of stigmatization. Francis' constant companion in depictions of the miracle, the Franciscan monk Leo, is a retiring presence: he sits to the right in the middle ground, in a sort of primitive hut, engrossed in his reading, the cowl of his robe pulled over his head. Rembrandt's portrayal of St Francis as a very old man conflicts with the biographical reality – the saint did not live beyond forty-four or forty-five – but is not without precedent in art. In an engraving by Cornelis Cort after Girolamo Muziano, which Rembrandt could have known, St Francis is likewise shown as an old man.[1] It is also possible that Rembrandt took an anonymous engraving after Titian as the point of departure for his composition[2] – we know that he had a great many prints after this master from the inventory of his property drawn up in 1656. It lists 'A ditto [book] very large with almost all the works of Titian.'[3]

341

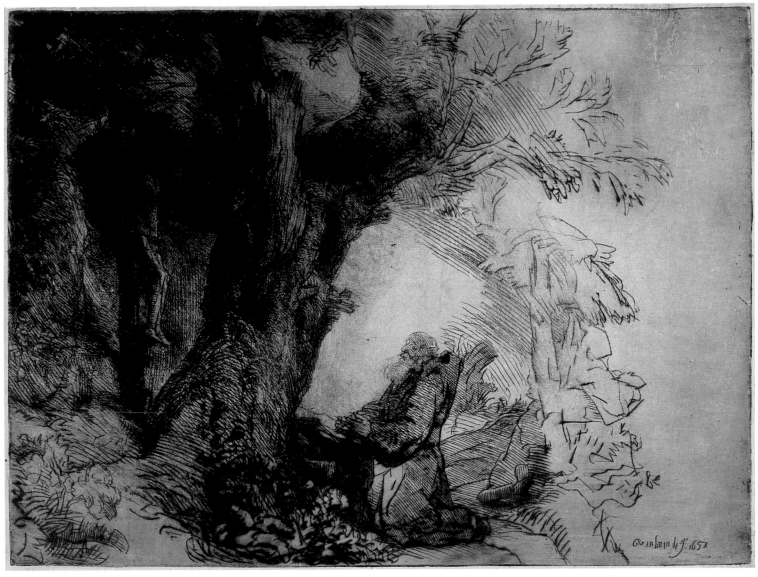

1 London (vellum)

Rembrandt initially executed many of his prints using the etching technique alone, only later enhancing certain areas in drypoint. In the *St Francis praying* he worked in the reverse order. He scratched the whole of the main action – the kneeling saint, the tree, the crucifix and its surroundings, and Brother Leo, seen obliquely from behind – directly on to the copper plate in drypoint. It was not until a later stage that he completed the scene in pure etching: the plants in the left foreground, details in the trunk of the great tree, its foliage, the area behind St Francis, which had until then been entirely blank, and the whole landscape with the squat church tower at the top right. Perhaps the most striking change is to be seen in the saint's face. The later etching work has dramatically altered Francis's expression. Whereas in the first state

the old man is shown as if sunk in peaceful, silent contemplation, in the second state Rembrandt made changes to the mouth and turned the head slightly, so that Francis has become a much more active presence, almost as if he were talking to the crucifix. The Francis of the first state is a gentle, introspective hermit; in the second he is a militant advocate of the faith.

Two impressions of the first state, executed in drypoint alone, are shown here. The one from London is of a heavily inked plate, printed on vellum. Because the vellum absorbs less ink, the result is a brilliant impression with strong contrasts and deep black areas. The Amsterdam impression was made on thin, light ivory-coloured paper, and is more transparent in tone. The fact that there are impressions of the first, incomplete state on a material as

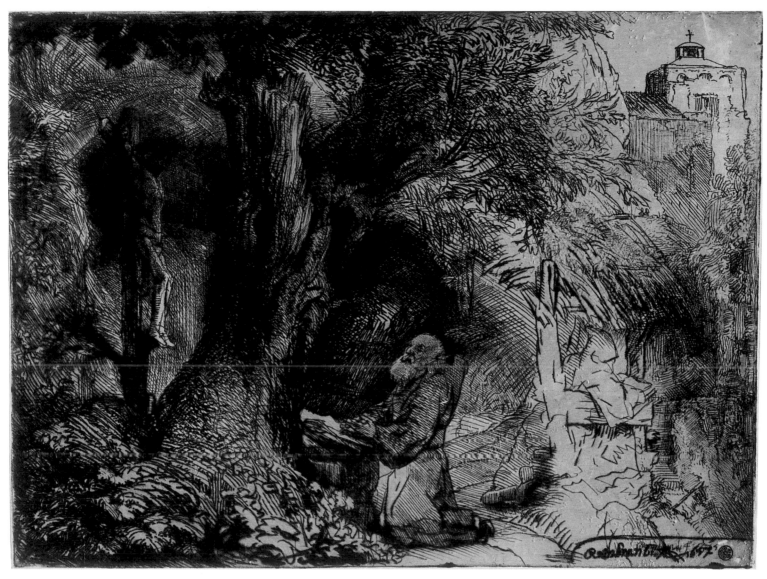

II London

costly as vellum, and moreover that the artist actually signed and dated this first state, is further evidence that there were collectors in Rembrandt's day who were interested in unusual proofs like this. Impressions of the second state also differ appreciably depending on how lightly or heavily the plate was inked and the degree of surface tone – few of Rembrandt's plates were subject to greater variety. In slightly later impressions, the fragile areas in drypoint have evidently worn down rather rapidly.

MS

1 The New Hollstein, *Cornelis Cort*, 108.
2 Illustrated in Clark 1966, p. 119, fig. 109.
3 Strauss & Van der Meulen 1979, p. 371.

86

The Phoenix 1658

Etching and drypoint, 179 × 183 mm; signed and dated, lower right:
Rembrandt f. 1658 (the last two figures in drypoint)

Hind 295; White & Boon 110 (only state)

Amsterdam (De Bruijn RP-P-1962-53; on Japanese paper); London★
(Cracherode 1973.U.1127; on Japanese paper)

SELECTED LITERATURE: Zwarts 1926, pp. 107–8; Cornelissen 1941;
Schmidt-Degener 1942, pp. 7–34; Emmens 1979, pp. 237–42; Carstensen
1993, pp. 124–34.

One of Rembrandt's last and most intriguing prints is this
allegory dated 1658, which the collector Valerius Röver described
in 1731 as 'the rare emblematic image with the phoenix'.[1] The
etching is executed in a highly schematic style that the artist also
employed in a number of other prints from this period, such as
the *St Francis beneath a tree praying* (cat. 85) and the *Agony in the
garden* (B.75) of around 1657. Far more striking than the style,
however, is the subject. From a high, slightly dilapidated pedestal,
flanked by skulls, a rather unprepossessing phoenix rises from its
still-smouldering ashes. It stands on a bunch of foliage that is held
aloft by two trumpeting *putti*. Behind, powerful rays beat down
from the rising sun. At the base of the structure lies the foreshort-
ened figure of a naked man. Around him, a small crowd surveys
the scene in astonishment. A toddler has been lifted up to gain a
better view, and on the right a startled figure raises her arm. The
scene is set in an area with simple houses and trees, and a woman
watches the spectacle from a window on the left.

The presence of the onlookers and the setting make an
anomalous impression. The phoenix was not an uncommon
sight in the seventeenth century in an emblematic context, and
apparitions of birds rising from their ashes were to be understood

fig. b Marinus van der Goes after Peter Paul Rubens, *The miracle of
St Ignatius of Loyola*. Engraving, detail. Amsterdam, Rijksmuseum

strictly in a metaphorical sense (fig. a). But here it is as though a
miracle were taking place before the eyes of the common people.
In this regard the etching is related to the theatrical Counter-
Reformation miracle scenes found in works by Rubens, which
Rembrandt certainly knew in print and from which he probably
drew inspiration for the man shown in strong perspective on the
ground (fig. b).[2]

That Rembrandt would have made the etching for the sheer
delight of rendering its inviting motif is improbable. Several
readings of the image exist, each one a pattern of inventiveness.[3]
Frederik Schmidt-Degener saw the print as a personal testimony:
Rembrandt was expressing the idea that although his art was not
appreciated during his lifetime – he did go bankrupt, after all – he
would one day rise as a master of eternal fame.[4] This historically
completely untenable interpretation was largely based on a belief
in the Romantic myth of Rembrandt as an unsung genius and all
sorts of projections around this idea were spun by the generation
of art historians that wrote about Rembrandt at the beginning of
the twentieth century.[5] Others linked the iconography to politi-
cal events, to Marshall de Turenne's defeat of the Spaniards in the
Battle of the Dunes in 1658 and to the election of the German
emperor in Frankfurt that same year.[6] Jan Emmens sought an
explanation closer to home, connecting the print to the tensions
in the Republic, in particular to the enmity between Orangists
and Republicans. The phoenix was used at the time on coins as an
Orangist symbol for the young prince William III (1650–1702).
So Emmens conjectured that the Oranges commissioned the

fig. a *Vita mihi mors est.*
Emblem from Joachim
Camerarius, *Symbolorum
& Emblematum ex
Volatilibus et insectis*,
Nuremberg 1596.

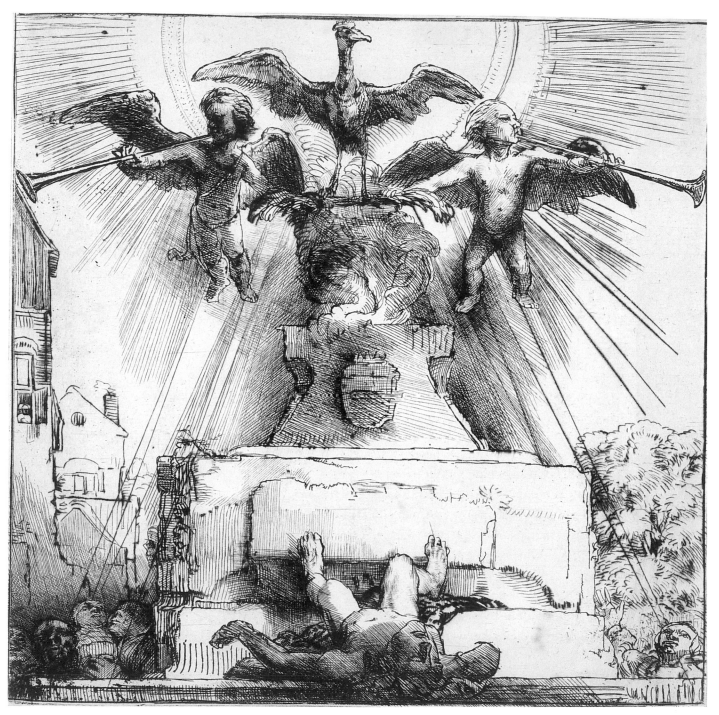

Amsterdam

print from Rembrandt during the First Stadholderless Period to focus attention on their resurrection.[7] One objection to this theory is that the drypoint technique used by Rembrandt was not very suitable for the large editions that would usually be published of a propaganda print. Moreover, the fact that many impressions of this rare etching occur on precious Japanese paper undermines the plausibility of this explanation.

The phoenix was a fairly common symbol, and in the seventeenth century was found not only on the façades of houses but also, for instance, in heraldry. The fabulous bird, which was described by a succession of classical writers from Herodotus onwards, was also borne as the arms of the Portuguese Jewish community from 1612 onwards (fig. c) and is displayed on their gravestones.[8] For this reason it has been suggested that Rembrandt's etching may have been a Sephardic commission. Many who had escaped to Amsterdam were anxious about the fate of those they had left behind in Spain and Portugal, and the mass burning of Jews in Cordoba and Santiago de Compostela in particular, in 1655, caused turmoil among the exiles. Amsterdam's Sephardic community commemorated the dead by publishing a volume of laudatory poems in which the motif of the phoenix reappeared. Rembrandt made portraits of several members of the Portuguese Jewish community. According to this theory, the first owners of the etching would have been among them, and it has been suggested that they would have kept it in the commemorative book.[9] This would explain the de luxe edition of the print; but without any documentation the theory remains purely hypothetical.

Reading the image itself is also fraught with problems. Did Rembrandt truly intend to depict a place of execution in southern Europe?[10] What is the significance of the crowned shield? For a long time the print was known as 'The statue overthrown'. It has

rightly been pointed out that a sculpture that fell to the ground from such a height would be shattered. But is the figure that has fallen to earth really the personification of Envy, overcome by the rebirth of the miraculous bird? This would depend on whether a small line by its right wrist really represents a serpent. Envy is usually an old woman with sagging breasts, whereas here we see a naked muscular youth lying on a long fur cloak. Does he represent the Spanish Fury? Details that may have been perfectly transparent to seventeenth-century beholders are no longer clear to us today.

As the import of the print remains a mystery, many modern commentators have found it hard to appreciate Rembrandt's *Phoenix*; nor has the design attracted undiluted admiration.[11] Not all works of art, perhaps, are made for eternity.

GL

1 Van Gelder & Van Gelder-Schrijver 1938, p. 13: 'het raare zinnebeeld van de phenix'.
2 This was noted by Carstensen 1993, p. 132.
3 An enumeration of all these interpretations can be found in Cornelissen 1941, pp. 126–9.
4 Schmidt-Degener published his essay 'Rembrandts Vogel Phoenix' in 1925; it was reprinted in Schmidt-Degener 1942, pp. 7–34.
5 Emmens 1979, p. 237; for the myth surrounding the public's supposed failure to appreciate Rembrandt, see ibid., pp. 7–37 and Emmens 1981, I, pp. 123–8.
6 Cornelissen 1941, pp. 130–34.
7 Emmens 1979, pp. 239–42. He first published his theory in the dissertation version of this book in 1964.
8 See Zwarts 1926 and Carstensen 1993, pp. 128–30.
9 Ibid., p. 131.
10 Ibid., p. 130.
11 For an anthology of this criticism, see Carstensen 1993, pp. 131–2.

fig. c Coat of arms of the Portuguese Jewish community in Amsterdam, 1612.

87

Woman sitting half-dressed beside a stove 1658

Etching with drypoint and burin, 228 × 187 mm; signed and dated on the stove, upper right: *Rembrandt f. 1658*

Hind 296; White & Boon 197 I, III, V and VI (of VII)

I Amsterdam★ (Van Leyden RP-P-OB-255; on Japanese paper); London (1848-9-11-99; on Japanese paper)

III Amsterdam★ (De Bruijn RP-P-62-74; on Japanese paper)

V Amsterdam★ (De Bruijn RP-P-62-75; on Japanese paper); London (1848-9-11-101; on Japanese paper)

VI Amsterdam (Van Leyden RP-P-OB-258; on Japanese paper); London★ (1910-2-12-365; on Japanese paper)

SELECTED LITERATURE: Houbraken 1718–21, I, p. 271; De Bruijn 1932, p. 187; Robinson 1980, p. 168, no. 10; Paris 1986, no. 138; Cambridge 1996–7, nos 32–7; White 1999, pp. 202–4.

Rembrandt etched a number of female nudes around 1631, among them the *Diana at the bath* (cat. 10) and the *Naked woman seated on a mound* (cat. 11). In the second half of the 1650s he returned to the theme. Initially this renewed interest manifested itself in some drawings that he made from about 1655 onwards,[1] but in 1658 he also produced four etchings of the nude. The print shown here is the largest in the series, and also the only one in which the model is not completely unclothed. She sits in a chair, naked to the waist, with her right hand resting lightly on a small heap of clothes, and looks to one side. Behind her there is an alcove, and to the right a stove bearing a medallion with a representation of the mourning Mary Magdalene at the foot of the Cross.

The print is a fine example of Rembrandt's late etching style, in which technical extremes are sometimes combined in a single work. In this instance, the woman's torso and the shift beside her are set down with swift, almost schematic etched lines. These light passages stand out in sharp contrast against the skirt and the background, which have been made dark by means of a web of etched lines enhanced with drypoint and burin. Aside from the stove, there are no points of reference to tell us where the model is, but a drawing dating from around 1652 gives us some idea of the way Rembrandt posed his models in the house – with particular attention to the light (fig. a).

We know of no fewer than seven states of this etching. Unusually for Rembrandt, however, they were not all intended to work out the composition. The rare first state provides an enlightening insight into the way the print was made. The work was essentially complete, but in the impression shown here it is obvious that the background is still too light and it gives a dingy, grimy effect because the copper plate did not take the ink properly. The alcove behind the model has also not been clearly defined.[2] This state can therefore be regarded as a proof, although Rembrandt certainly sold the impressions: the five known examples are printed on expensive Japanese paper.

In the similarly rare second state (not shown here) Rembrandt merely strengthened the shadows on the woman's body, and it was only in the third state that he focused on the other areas. He sharpened the definition of the alcove, darkened the wall, added more hatching to the woman's skirt, as also to the stove, and enhanced details in other areas. After this operation, the plate needed no further work and it seems likely that at this stage Rembrandt considered the print as complete. A significant number of impressions were made: we know of at least twenty-four, most of which are on Japanese paper, although there are also some on Chinese and European papers.

It may well have been wear that prompted Rembrandt to work on the plate again after this but, as in the case of the *Ecce Homo* of 1655 (cat. 78), he did not confine himself to restoring worn

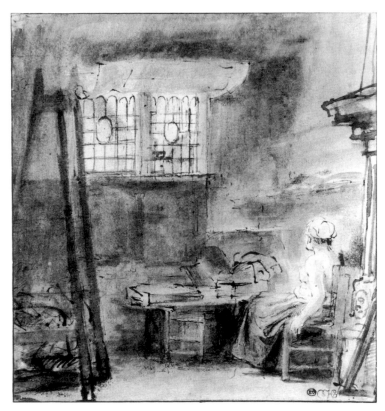

fig. a Rembrandt, *A model in the artist's studio*, c.1652. Pen and brush in brown ink, brush in white, 205 × 190 mm. Oxford, Ashmolean Museum (Benesch 1161)

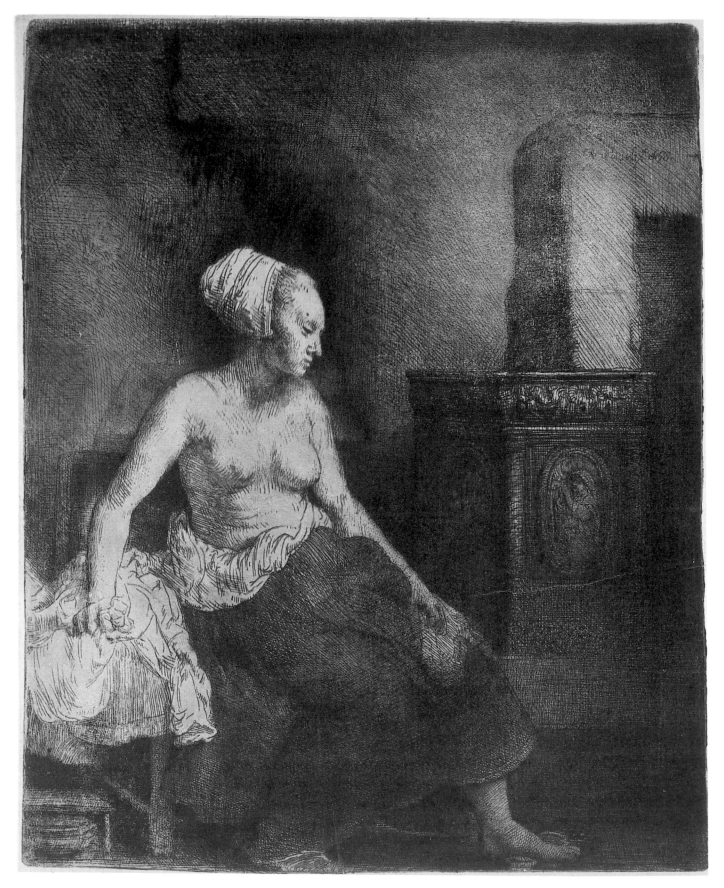

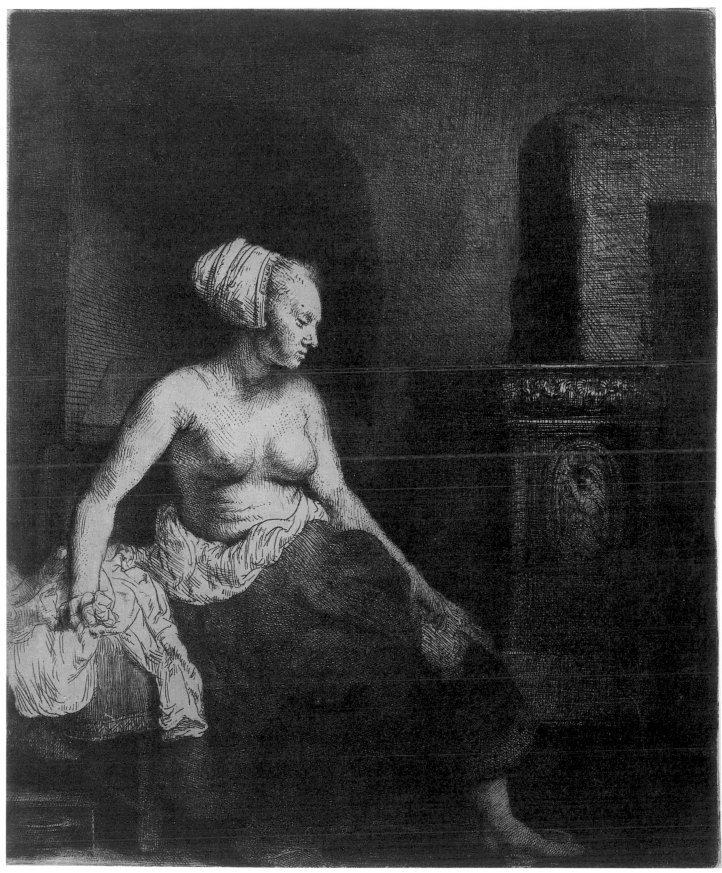

III Amsterdam

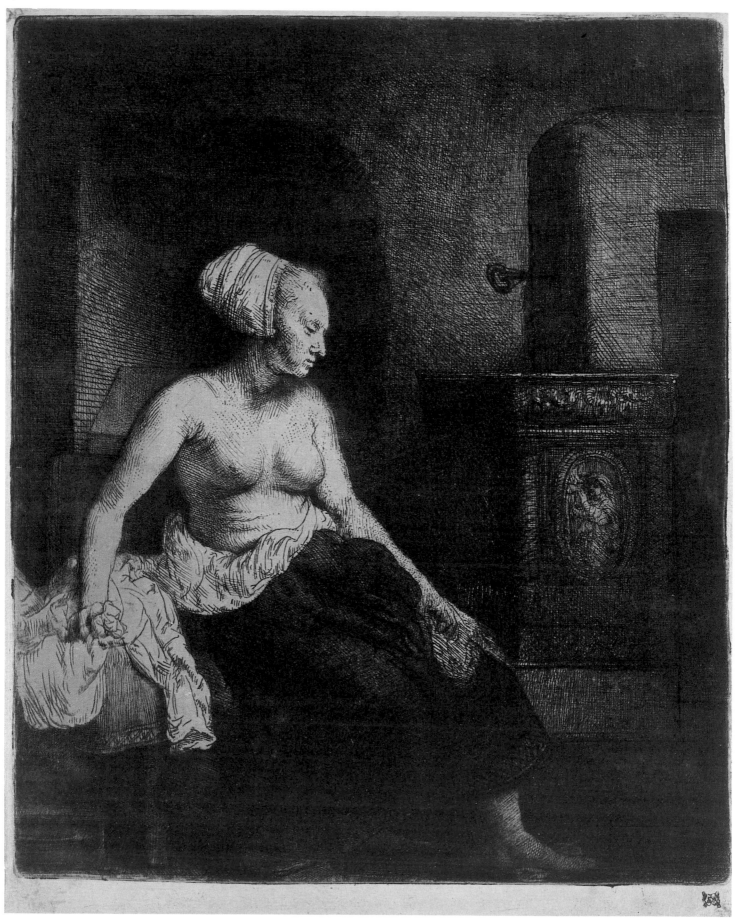

V Amsterdam

350

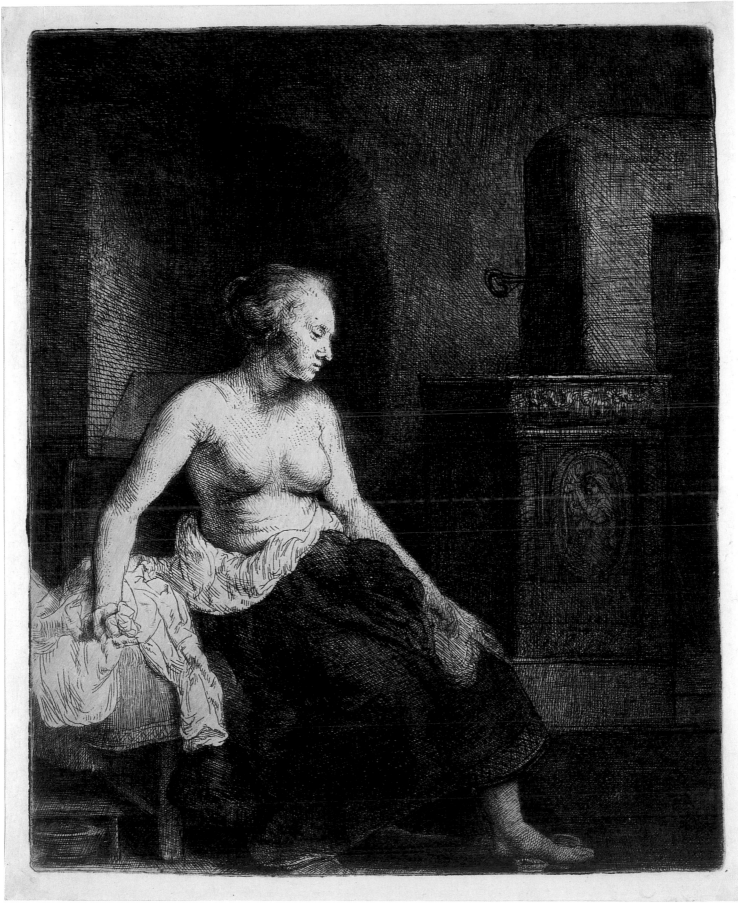

VI London

areas. In the unique impression of the fourth state (not shown),[3] he enlivened the image by adding a damper in the flue that leads from the stove, and in the fifth state he added new lines to darken the woman's skirt again. He left the background untouched; in the impression shown here the progressively worsening wear can be seen clearly – particularly above the damper. Nevertheless impressions of this state are frequently found on Japanese paper. In the sixth state, finally, which also occurs on western paper, he removed the model's cap. The reason for this move is unclear, particularly since the cap had previously been such a welcome highlight in an otherwise dark setting.[4]

EH

1 See Schatborn 1987, for a discussion of these drawings.

2 Christopher White has pointed out that Rembrandt may already have made earlier impressions, because the outlines of the woman's stomach and right leg can be seen under her skirt, suggesting that she was originally depicted nude. See White 1999, p. 204.

3 The only known impression is in Paris, Bibliothèque Nationale de France.

4 The seventh state differs from the sixth only in that a scratch has appeared above the woman's left breast. The copper plate, which has survived, was also repeatedly worked up after Rembrandt's death.

88

Naked woman, bathing her feet at a brook 1658

Etching, 160 × 80 mm; signed and dated, upper left: *Rembrandt f. 1658*

Hind 298; White and Boon 200 (only state)

Amsterdam (Van Leyden RP-P-OB-263; on Japanese paper); London★ (1910-2-12-366; on Japanese paper)

SELECTED LITERATURE: De Bruijn 1939, p. 15; Boston-New York 1969, no. 25; Vienna 1970–71, no. 286; Cambridge 1996–7, nos 40–41.

Had Rembrandt not signed and dated this print in the upper left-hand corner, it would still have been evident that he etched this nude in around 1658, as the stylistic similarities between this work and *Woman sitting half-dressed beside a stove* (cat. 87) of the same year are unmistakable. The figure is modelled by means of an open system of parallel lines and cross-hatching, strengthened with numerous stipples. In contrast to the dense webs of lines in earlier nudes, like *Diana at the bath* of 1631 (cat. 10), these barely dissolve before the eyes into gradations of grey tones, giving the composition something of a drawing-like effect, without sacrificing any of its power.[1] This approach does, however, reinforce the contrasts, so that the model appears to have been placed in a rather harsh light. In early impressions like the one shown

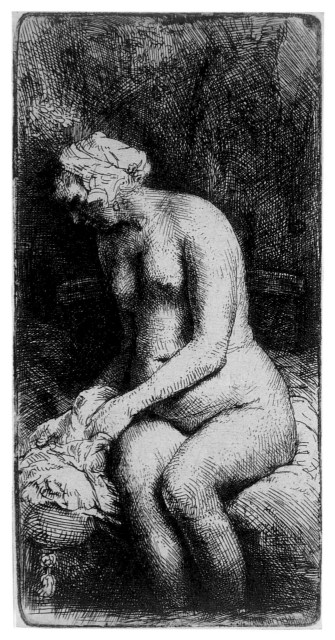

London

here, this effect is softened because they were printed with light surface tone on yellowish Japanese or Chinese paper, and sometimes even on vellum.

In 1751 Gersaint described the print as a *Baigneuse*, and subsequently the work was also referred to as the *Naked woman, bathing her feet at a brook*.[2] These titles accord with what we see, but they do not explain certain contradictory elements in the composition. The woman's feet are not shown and this, in conjunction with the foliage that can be seen in the background, mainly on the left, creates the impression that she is sitting outdoors at the water's edge. And yet this nude study has every appearance of having been done in the studio. Judging from the chair-back behind her, the woman is seated in a chair, on which there are what look like clothes or a cushion. Beside her we see a crumpled shift, and we find the same motifs not only in the *Woman sitting half-dressed beside a stove* (cat. 87), but also in the *Woman at the bath with a hat beside her* (fig. a), which also dates from 1658. The cap that the woman wears also immediately places her among the

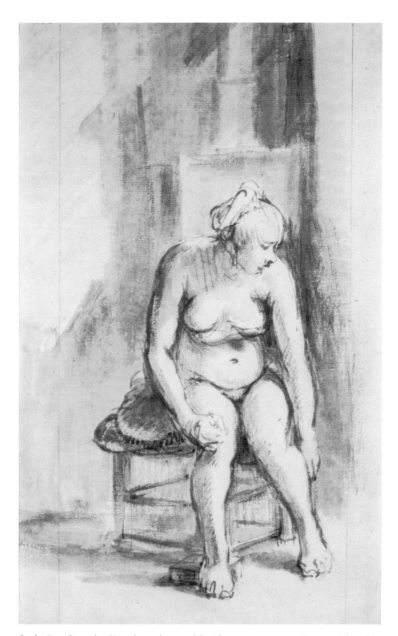

fig. b Rembrandt, *Female nude seated beside a stove*, c.1661. Pen and brush in brown, with black chalk, 292 × 175 mm. Amsterdam, Rijksmuseum (Benesch 1142)

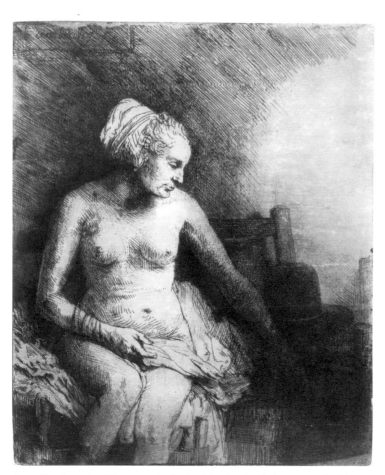

fig. a Rembrandt, *Woman at the bath with a hat beside her*, 1658. Etching and drypoint, 156 × 129 mm. Amsterdam, Rijksmuseum (B.199 II)

etched and drawn nude studies that Rembrandt made at around this time (fig. b).[3] If Rembrandt really did intend this plate to show his model out of doors, he put her outside chair and all.

Only one state of this etching is known, and its evolution can be reconstructed only in part. The occurrence of both broad and fine lines indicates that the plate was etched first and then reworked. Among the passages added later, for example, are the fine lines on the woman's shoulder and neck. Similar additions are also easily distinguished elsewhere, and these lines do not appear to have been etched, although it is not possible to say with

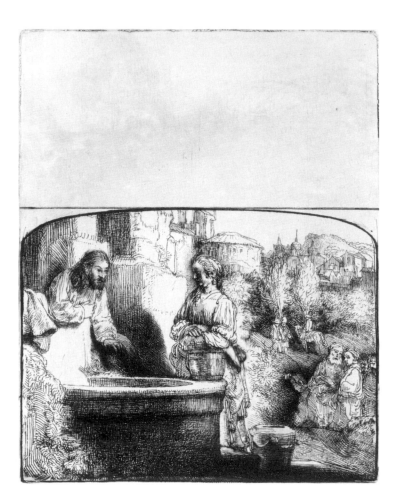

fig. c Rembrandt, *Christ and the Samaritan woman*, 1657. Etching and drypoint, 205 × 160 mm. Amsterdam, Rijksmuseum (B.70 I)

89

Lieven Willemsz. van Coppenol, the larger plate
*c.*1658

Etching, drypoint and burin, 340 × 290 mm

Hind 300; White & Boon 283 I, II and V (of VI)

I London★ (Cracherode 1973.U.1132; on Japanese paper)

II London★ (1848-9-11-146; on Japanese paper)

V Amsterdam (Van Leyden RP-P-OB-630; inscribed below in pen and brown ink in calligraphy: *Op de Afbeeldinge van Mr. Lieven van Coppenol / Faenix Schrijver van zijnen tijdt. / Dit's Coppenol, die wonderlijcke Schrijver, / van Rembrants hant: wiens oude vuijst en yver / loopt al wat schrijft om kunst, zo wijt verbij, / Als 't Snelst vaertuig 't loomste, in 't zeijlrijcke Y.*[1] */S.H. Acvo.t / Lieven van Coppenol / scripsit. Anno 1661 / Aetatis Suae 62*; watermark: Countermark IHS [Ash & Fletcher 25, C.a.]); London★ (Cracherode 1973.U.1135; inscribed below in pen and brown ink in calligraphy: *Op d'Afbeeldinge vanden Onwedergaelicken Schrijver Lieven van Coppenol / Zoeckt ghij een Dedalus die noch op Aerde Leeft / Aanziet maer Coppenol, die op zijn Pennen sweeft / Hij vliecht het beste puijck van Schrijvers over thooft / Van veelen nooit gezien, van veelen nooit gelooft / Ai! Schrijvers wilt hem niet met Icarus na vliegen, / Ghy zoud u zelven light door ydle waan bedriegen.*[2] *J.v.Laen / Lieven van Coppenol scrips / Anno 1661 AEtatis suae 62*; watermark: none)

Watermarks: the IHS countermark is found in the third, fourth and fifth states of this print, which indicates that they all followed one another in quick succession. It is not found in other Rembrandt prints.

SELECTED LITERATURE: Wijnman 1933; Broos 1970–71; Amsterdam 1986, pp. 78–83; New York 1995, II, pp. 226–7, no. 97.

any certainty whether they were made with the drypoint or the burin. We do, however, know something of the origins of the copper plate. Rembrandt had etched *Christ and the Samaritan woman* a year earlier, and we can see from the first state of that print that he did not use the whole of the plate for the image (fig. c). The measurements of the blank strip at the top correspond very closely with those of the etching *Naked woman, bathing her feet at a brook*. The copper plates of both etchings have survived, and they are exactly the same thickness.[4]

EH

1 The most important difference between this etching and *Woman sitting half-dressed beside a stove* is that in the latter work Rembrandt worked up the background and the woman's skirt with drypoint and burin – something he did not do in this print.

2 Gersaint 1751, no. 192.

3 For these studies see Schatborn 1985, nos 52, 55, 68 and 69. Also Schatborn 1987, and Berlin-Amsterdam-London 1991–2, nos 38 and 48–51.

4 See De Bruijn 1939, p. 15. In the second state of *Christ and the Samaritan woman* the blank strip was removed. See Hinterding 1993–4, pp. 292 and 300.

Constantijn Huygens referred in a panegyric to the 'healthy cheeks' of Lieven van Coppenol (1598– after 1667), and the fact that this Flanders-born calligrapher, who was head of the French school in Amsterdam, had a round face (and an impressive double chin) is also apparent in the portrait print that Rembrandt made of him in around 1658.[3] He was clearly a portly man, and this is emphasized all the more by the tight clothes he wears in this etching. His health at this time was, in fact, none too good. In 1650 he was afflicted by a severe attack of insanity from which he never fully recovered. He had to give up his post as a teacher and devoted himself full time to calligraphy. He was able to afford this thanks to two successive marriages to wealthy women.[4] Van Coppenol was pathologically vain and sent the products of his penmanship to all sorts of literary figures asking them for an ode. Poets of renown (Constantijn Huygens, Jacob Cats and Joost van den Vondel) as well as lesser lights all obliged.[5] He then wrote out these verses in flamboyant lettering under printed likenesses of himself – the reason why so many impressions of Rembrandt's etching have an unusually large margin at the bottom.

In the print literature a distinction is drawn between this

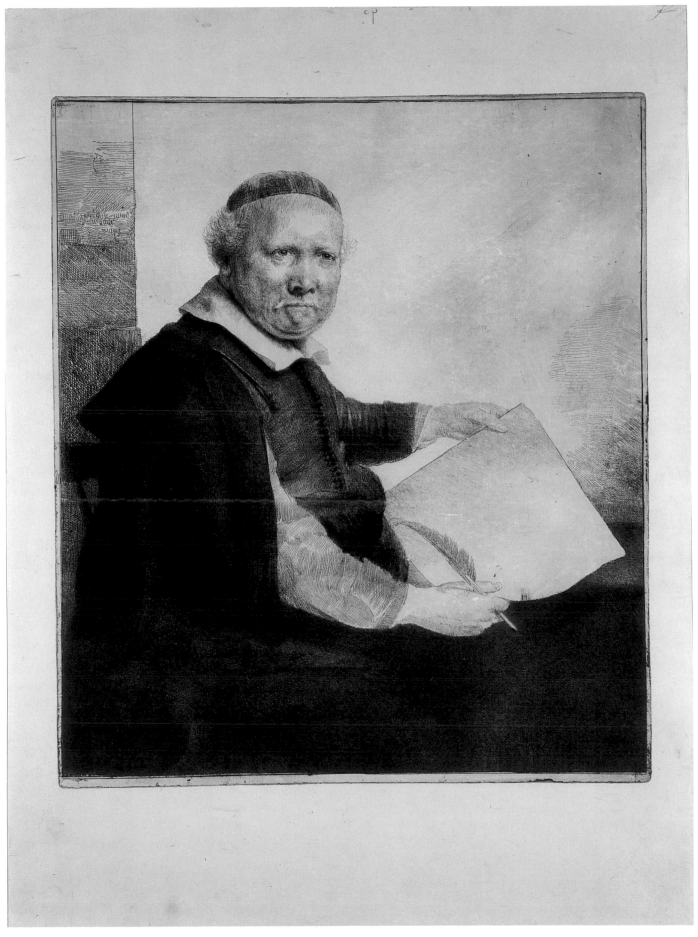

I London

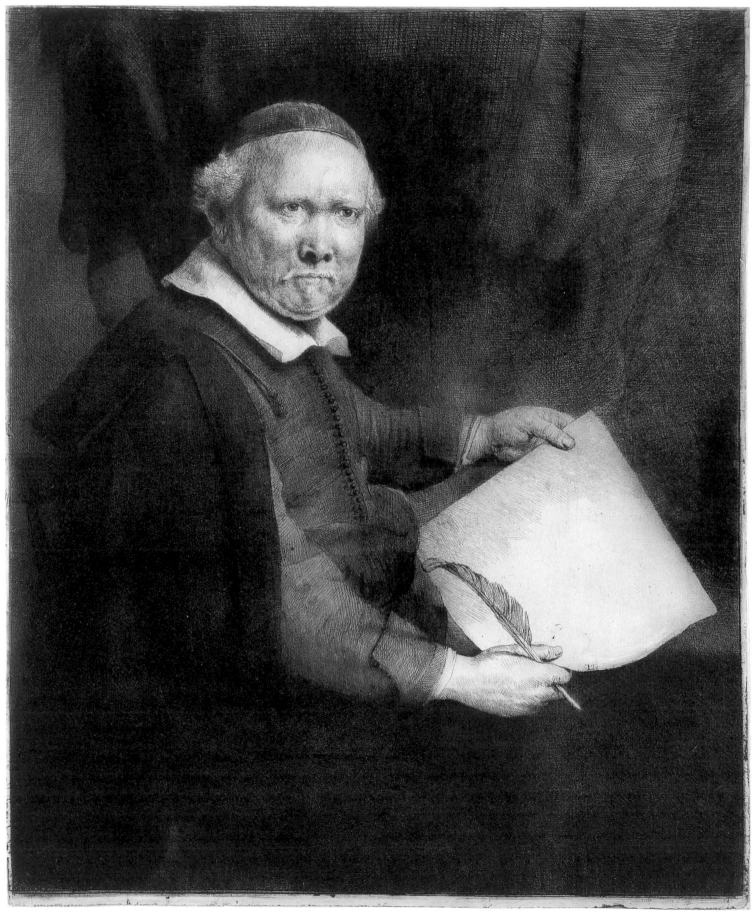

II London

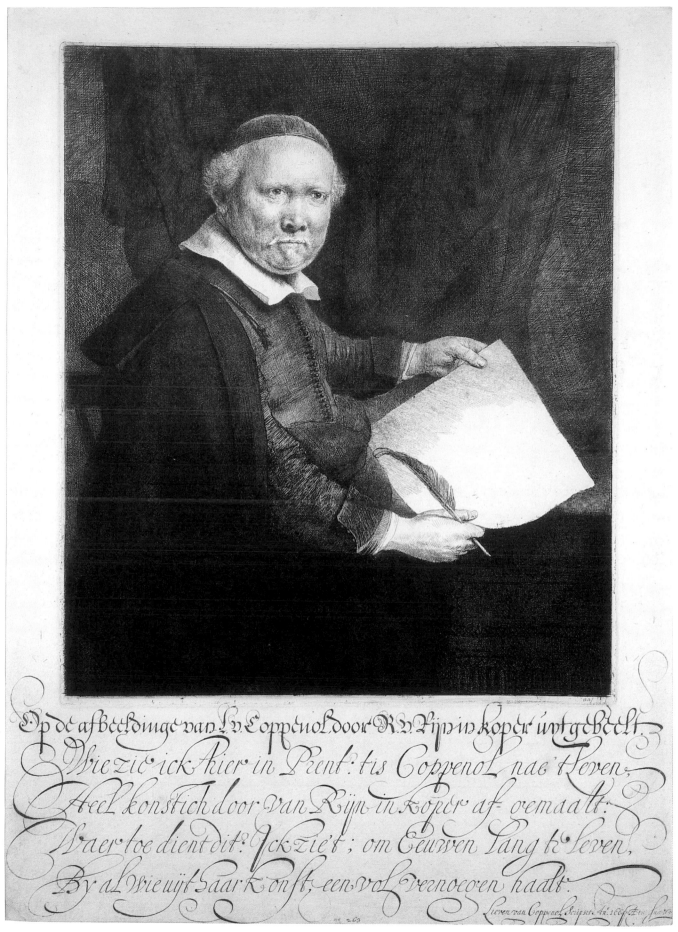

Op de afbeeldinge van L. v. Coppenol door R. v. Rijn in koper uÿt gebeelt.

Wie zie ick hier in Prent: tis Coppenol nae 't leven,
Heel konstich door Van Rijn in koper af-gemaalt:
Waer toe dient dit? Ick zie 't; om Eeuwen lang te leven,
By al wie uÿt saar konst, een vol vernoegen haalt.

Lieven van Coppenol Scripsit An: 1658 Ætis suæ 58

V London

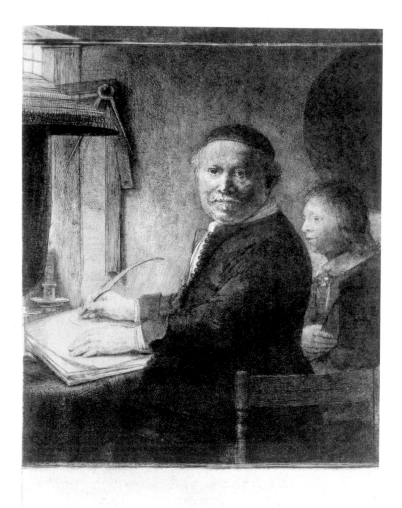

fig. a Rembrandt, *Lieven Willemsz. van Coppenol*, c.1658. Etching, drypoint and burin, 258 × 190 mm. Amsterdam, Rijksmuseum (B.282 III)

based on an oil sketch (fig. b). Although the assessment of this painting is hampered by later overpainting, its authenticity has now been accepted.[9] Rembrandt took into account the fact that the image in the etching would be reversed and gave the calligrapher a goose quill pen in his left hand. The blank sheet of paper, a motif that occurs regularly in artists' portraits (fig. d), is an important formal element in the dark surroundings.[10] In the first state of the print, the desired expressiveness has yet to be achieved because the background is still blank. Since white on white does not produce a shape, Rembrandt drew a heavy – and slightly obtrusive – outline around the sheet of paper. Aside from the background, there are other areas that still require attention, among them the right sleeve and the hands. There are seven impressions of the incomplete state on Japanese paper; they appear to have been made for collectors who were keen to get their hands on such oddities. The superb impression shown here clearly reveals why they were so sought after.[11]

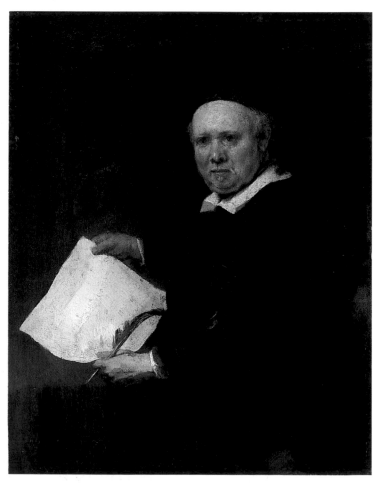

fig. b Rembrandt, *Lieven Willemsz. van Coppenol*, c.1658. Oil on panel, 365 × 289 mm. New York, Metropolitan Museum of Art, bequest of Mary Stillman Harkness, 1950 (50.145.33; exh.)

work – the 'Large Coppenol' – and the 'Small Coppenol', a rather shadowy etching in which the calligrapher can be seen, this time with his grandson (fig. a). Since it is unusual for two portrait prints of the same person to be made within such a short space of time, it has been suggested that Van Coppenol was dissatisfied with the result. Nevertheless Rembrandt printed a number of impressions on Japanese paper.[6] Certainly Van Coppenol's figure does not emerge clearly and his face remains in shadow in this smaller version – despite the fact that Rembrandt prepared the plate in a preliminary sketch.[7] The lighting is so specific that he may even have drawn the broad outlines of the portrait directly on to the plate. This obviously entails a risk in terms of the likeness. There is not a single known impression of the *Small Coppenol* on which the sitter has penned one of his self-glorifying panegyrics.[8]

The Large Coppenol, Rembrandt's largest portrait etching, is

fig. c Cornelis Visscher,
Lieven Willemsz. van Coppenol,
1658. Engraving,
293 × 233 mm.
Amsterdam, Rijksmuseum

fig. d Robert van Voerst after Anthony van Dyck, *Inigo Jones*, c.1634.
Engraving, 255 × 177 mm. Amsterdam, Rijksmuseum

In the second state, also included here, a large, dark curtain has been lowered behind Van Coppenol, allowing his silhouette to emerge much more clearly and throwing his face into greater relief. The sleeve is complete and work has been done on the hands: the left thumb has acquired a nail. Adding the curtain must have been a fairly mechanical job, but here and there deft touches were used – for instance on the writing instrument which, by means of a few accents with the drypoint, is transformed into a palpable feather. The changes in the second and third states were made in fairly rapid succession. Indeed the watermarks suggest that Rembrandt worked on the plate almost without interruption up until the fifth state, and the existence of impressions of this latter state with calligraphy dated 1661 confirms that little time had passed. The impressions of all these states vary, many of them being on Japanese paper or vellum, and it is not clear whether any one particular state was singled out for

an edition of many dozens of impressions. This would not really accord with the fact that the making of this print was probably a private enterprise. The plates of portrait prints of this kind were usually kept by the person who commissioned them, and impressions not put on the market in large numbers.

Van Coppenol commissioned another print of himself at the same period, this time from Cornelis Visscher (1629–58), who made a preliminary drawing for it (fig. c). Visscher's engraving allows us to study the likeness more closely, but the most striking difference is that Rembrandt gave Van Coppenol something of a contemplative look, whereas Visscher endowed him with a blank expression. Visscher also showed clearly the model's white eyelashes, characteristic of someone with very fair hair. The inscription states that Visscher completed the engraving just three days before the artist's death (16 January 1658).[12] Yet again, Van Coppenol used this image to blow his own trumpet, but not by means of his own calligraphy but by grouping a series of odes in letterpress around the print.[13]

GL

1 'On the portrait of Mr. Lieven van Coppenol/ Phoenix penman of his time./ This is Coppenol, that wondrous calligrapher,/ by Rembrandt's hand: whose renowned fist and industry/ surpass all who write as art, by so far/ As the Swiftest vessel leaves the slowest behind, on the sail-filled IJ.'

2 'On the portrait of the incomparable Calligrapher Lieven van Coppenol/ Seek ye a Daedalus who yet lives on this Earth/Then see Coppenol, who floats on his Quills/ He flies over the heads of the best Calligraphers/ By many never seen, by many never believed/ O! Penmen do not attempt like Icarus to fly with him/ Ye would deceive yourself by vain delusion.'

3 In the J. E. Rudge collection there was an impression with the handwritten inscription: *R.v.Rijn fecit anno 1658* (see the auction catalogue, London, Christie's, 16–17 December 1924, lot 275, and Münz II, p. 70, repr.).

4 For Van Coppenol's life and work, see Wijnman 1933.

5 A number of panegyrics are discussed by Broos 1970–71, pp. 174–7.

6 See White & Boon, I, pp. 133–34; also Broos 1970–71, pp. 163–77 and White 1999, pp. 165–8.

7 See the essay by Martin Royalton-Kisch, pp. 80–81, fig. 25.

8 In the Metropolitan Museum of Art in New York there is an impression on which one of these odes has been copied in ordinary writing by another hand; see New York 1995, II, p. 227, fig. 117.

9 *Op. cit.*, I, pp. 28–9, and II, pp. 120–22, no. 34, where the authenticity of the work is still rejected; but see Ernst van de Wetering's essay in the present catalogue, pp. 59–61.

10 For the engraving by Robert van Voerst, see Antwerp-Amsterdam 1999–2000, no. 25.

11 Particulars of the provenance of this example and the high price paid for it at the time can be found in Griffiths *et al.* 1996, pp. 61–4, no. 19.

12 The Latin text reads: *Tribus diebus ante morte[m] ultimam manum imposuit.* For the description of the states, see Hollstein 143.

13 There are impressions in Rotterdam (Atlas van Stolk) and in the Rijksprentenkabinet; see Amsterdam 1986, pp. 81–2, no. 60, repr.

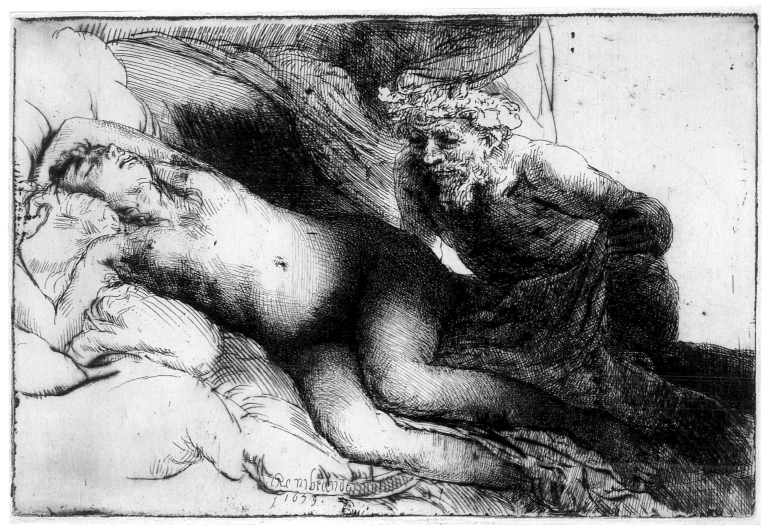

I London

90

Jupiter and Antiope, large plate 1659

Etching, drypoint and burin, 138 × 205 mm; signed and dated below, left of centre: *Rembrandt f 1659*

Hind 302; White & Boon 203 I (of II)

I London* (1855-4-14-266; on Japanese paper)

SELECTED LITERATURE: Graffon 1950, pp. 143–5; Boston-New York 1969, no. 27; Haverkamp-Begemann 1980, pp. 168–70; Berlin-Amsterdam-London 1991–2, no. 40; Cambridge 1996–7, nos 30–31; Melbourne-Canberra 1997–8, no. 122; White 1999, pp. 207–9.

In this etching, in which a satyr approaches a sleeping nude, Rembrandt revisits a subject that he had tackled in 1631 (fig. a). Together the two works are a telling illustration of what almost thirty years of artistic endeavour had brought him. The early

version shows a sleeping woman, stretched out on a bed, set down in fine outlines but otherwise barely modelled. In consequence she seems to be lying in broad daylight. The background has been darkened with a tangle of lines, and it is only upon a second look that we discern a man with a beard standing there. Rembrandt sets about his task very differently in the later work. Here is a mature artist who does not hesitate to set down the subject on the plate rapidly and with a minimum of etched lines, and then follows this up by increasing the homogeneity of the composition with deft accents in drypoint and burin. Both figures are clearly modelled and harmonize into a direct and convincing unit.

The origin of Rembrandt's composition was almost certainly Annibale Carracci's *Jupiter and Antiope* of 1592 (fig. b). The figures in this etching are similarly posed to those in Rembrandt's work.

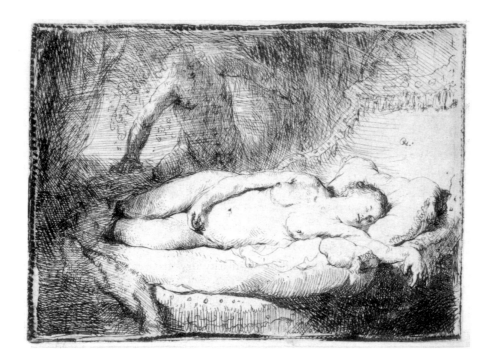

fig. a Rembrandt,
Jupiter and Antiope,
*c.*1631. Etching,
84 × 114 mm.
Amsterdam,
Rijksmuseum
(B.204 II)

fig. b Annibale Carracci, *Jupiter and Antiope*, 1592. Etching, 151 × 224 mm. Amsterdam, Rijksmuseum

fig. c Hendrick Goltzius, *Reclining nude*, 1594. Black chalk, 258 × 302 mm. Private collection

However, there are also differences which suggest that, while Rembrandt was undoubtedly echoing the Italian's work, he was nonetheless searching for a personal interpretation of the subject. In Carracci's Renaissance iconography, the Cupid holding a bow was an inescapable element; Rembrandt, the greater realist, needed no little love gods to make the lust that was the focus here abundantly clear. Rembrandt also omitted the landscape, thereby adding to the immediacy of the image, and the areas that are hatched only sparsely, if at all, strengthen its monumental character. The position of the sleeping woman is also different, with one arm above her head and the other beside it. This is a somewhat stereotypical pose that was also used by other artists (fig. c),[1] and its popularity may have been fostered by the classical example for this pose, the marble *Sleeping Ariadne* in the Vatican. While Rembrandt may have seen a reproduction of this sculpture, it seems more probably that, like Hendrick Goltzius before him, he employed a model to pose for him. We do not know of a preliminary drawing that is indubitably connected with the print, but some related studies of the nude have survived (fig. d). Rembrandt's rendition of sleep in this etching is so convincing – the mouth open, the left arm completely relaxed – that one might almost suppose that he drew from a model who really was fast asleep.

Whether contemporaries recognized the compositional affinity with Annibale Carracci's print is open to debate, although there were certainly connoisseurs on whom such a reworking of an admired prototype would not have been lost. The fact that in

fig. d Rembrandt,
*Reclining nude, c.*1658.
Pen and brush with
brown wash, brush with
white body colour,
136 × 283 mm.
Amsterdam, Rijksmuseum
(Benesch 1137)

1731 the Delft collector Valerius Röver described Rembrandt's etching as 'Nymph [and] Satyr, etched in the Italian manner'[2] is revealing. It is possible that Rembrandt's source was the reason for this description, although it could equally have been prompted by Rembrandt's open style of hatching, which was also used by Annibale and his followers of the Bolognese school. The technique of leaving light areas unworked, like those on the shoulder of the ogling satyr and on the woman's body, can also be found in Annibale's work.

The print has acquired several different titles over the centuries. Before Röver suggested the neutral 'nymph and satyr', Clement de Jonghe's inventory of 1679 referred to it as a 'Venus and Satyr'. It is debatable whether the precise mythological subject really mattered much in such a scene. Since the Renaissance, the depiction of silent enjoyment, the suggestion of lechery and the visualization of how it was incited had been a challenge for many an ambitious artist.[3] The literary theme often served as the legitimization of such images. But it was not really Rembrandt's style to add a line of text with an allusion to or explanation of the subject. This omission was made good later, when a text was added in the upper right corner of the plate. Its anonymous author thought he knew who Rembrandt's satyr was, and saw the dangers of his lust: 'Jupiter, when he opens the female lock, Becomes a devil or beast or winged creature or fool.'[4]

EH

1 For the drawing by Goltzius, see Peter Schatborn in Amsterdam-Washington 1981–2, no. 54.

2 Van Gelder and Van Gelder-Schrijver 1938, p. 12. When Samuel van Huls's collection was auctioned in 1735, the etching was described in the catalogue, independently of Röver, in virtually the same words. See Samuel van Huls sale catalogue, The Hague 26 September 1735, no. 1005.

3 See Antwerp-Amsterdam 1999–2000, no. 46.

4 *Jupyn, als hij ontsluit het Vrouwelijk slot, Word Droes of beest of vleugeldier of zot.* Below this text, which was added in the second state, there is also a French version: *Jupin, ouvrant serrure feminine, Fait Satirique ou autre enorme mine.* There are impressions of this state in Amsterdam and Vienna.

Watermarks

cat. 2 I Amsterdam

cat. 13 VII London

cat. 5 London

cat. 14 I Amsterdam

cat. 9 I Amsterdam

cat. 16 I Amsterdam

cat. 17 III [II] London

cat. 17 VIII [V] London

cat. 21 I London

cat. 24 III London

cat. 29 I Amsterdam

cat. 37 I London

cat. 30 I London

cat. 40 Amsterdam

cat. 31 II London cat. 36 II Amsterdam

cat. 47 I London

cat. 58 II Amsterdam

cat. 60 I Amsterdam

cat. 68 London

cat. 82 I London

cat. 83 I London

Bibliography

Conference papers are listed here by town; exhibition and other museum catalogues of multiple authorship are listed separately at the end, by town and date.

Ackley 1995
Clifford S. Ackley, 'A Rediscovered Touched Proof of a Rembrandt Etching', in: C. P. Schneider, W. W. Robinson and A. I. Davies [eds], *Shop Talk. Studies in Honor of Seymour Slive. Presented on His Seventy-Fifth Birthday*, Cambridge (Mass.), 1995, pp. 25–7

Alpers 1988
Svetlana Alpers, *Rembrandt's Enterprise. The studio and the market*, London 1988

Van Altena 1997
De jongeman met twaalf vrouwen. Boerten uit de twaalfde en dertiende eeuw, ed. E. van Altena, Amsterdam 1997

d'Argenville 1745
Dézallier d'Argenville, *Abrégé de la Vie des Plus Fameux Peintres*, Paris 1745

Ash 1986
N. Ash, 'Watermark research: Rembrandt prints and the development of a watermark archive', *The paper conservator* 10 (1986), pp. 64–9

Ash & Fletcher
Nancy Ash & Shelley Fletcher, *Watermarks in Rembrandt's prints*. With a contribution by Jan Piet Filedt Kok, Washington 1998

Ash & Fletcher 1990
Nancy Ash en Shelley Fletcher, 'Watermarks in Rembrandt's Landscape Etchings', in: C. Schneider 1990, pp. 263–81

Aurenhammer 1959
Hans Aurenhammer, *Lexikon der Christlichen Ikonographie*, I, Vienna 1959

Baldinucci 1686
Filippo Baldinucci, *Cominciamento, e progresso dell'arte dell'intagliare in rame, colle vite di molti de' più eccelenti maestri della stessa professione*, Florence 1686

Bangs 1985
J. D. Bangs, 'Rembrandt's *Le Petit Orfèvre*, possible additional sources', *Source* I/4 (1985), pp. 16–19

Baroni Vannucci 1997
A. Baroni Vannucci, *Jan Van Der Straet detto Giovanni Stradano flandrus pictor et inventor*, Milan 1997

Bartsch
Adam Bartsch, *Le peintre graveur*, 21 vols, Vienna 1803–21

Bartsch 1797
Adam Bartsch, *Catalogue raisonné de toutes les estampes qui forment l'oeuvre de Rembrandt, et ceux de ces principaux imitateurs*, Vienna 1797

Van Bastelaer 1908
R. van Bastelaer, *Les estampes de Peter Bruegel l'ancien*, Brussels 1908

Bauch 1933
K. Bauch, *Die Kunst des jungen Rembrandt*, Heidelberg 1933

Bauch 1960
Kurt Bauch, *Der frühe Rembrandt und seine Zeit. Studien zur geschichtlichen Bedeutung seines Frühstils*, Berlin 1960

Bauer 1999
L. & G. Bauer, 'Artists' inventories and the language of the oil sketch', *Burlington Magazine* 141 (1999), pp. 520–30

Behling 1964
L. Behling, 'Rembrandts sog. 'Dr. Faustus', Johann Baptista Portas Magia Naturalis und Jacob Böhne', *Oud Holland* 79 (1964), pp. 49–77

Becker 1994
J. Becker, 'Puff, Passion und Pilgerfahrt: zu Bildthemen des Braunschweiger Monogrammisten', *Wallraf-Richartz-Jahrbuch* 55 (1994), pp. 21–41

Beets 1915
N. Beets, 'Herscheppingen', *Feestbundel Dr Abraham Bredius*, Amsterdam 1915, I, pp. 1–7

Van Bemmelen 1929
J. F. van Bemmelen, 'Identificatie van familie-portretten', *Jaarboek Amstelodamum* 26 (1929), pp. 59–77

Benesch
Otto Benesch, *The drawings of Rembrandt*, 6 vols, 2nd edn enlarged and edited by Eva Benesch, London and New York 1973

Benesch 1926
Otto Benesch, 'Neue Plattenzustände bei Mocetto, Nicoletto da Modena, Lukas van Leyden und Rembrandt', *Mitteilungen der Gesellschaft für vervielfältigende Kunst (Beilage der 'Graphischen Künste')* (1926) 1, pp. 5–9

Benesch 1927
Otto Benesch, 'Zur Frage der Plattenzustände bei Lucas van Leyden und Rembrandt', *Mitteilungen der Gesellschaft für vervielfältigende Kunst (Beilage der 'Graphischen Künste')* (1927), pp. 19–22

Benesch 1943
Otto Benesch, *Artistic and intellectual trends from Rubens to Daumier*, Cambridge (Mass.) 1943

Van Berge-Gerbaud 1997–8
Mària van Berge-Gerbaud, *Rembrandt et son école. Dessins de la Collection Frits Lugt*, Paris (Institut Néerlandais), Haarlem (Teyler Museum) and Zwolle 1997

Benz 1969
Die Legenda aurea des Jacobus de Voragine aus dem Lateischen übersetzt von Richard Benz, Cologne and Olten 1969

Bierens de Haan 1948
J. C. J. Bierens de Haan, *L'oeuvre gravé de Cornelis Cort, graveur Hollandais 1533–1578*, The Hague 1948

Bille 1967
Clara Bille, 'Rembrandt and Burgomaster Jan Six. Conjectures as to their relationship', *Apollo* (1967) 85, pp. 260–65

Bisschop 1671
Jan de Bisschop, *Paradigmata Graphices variorum Artificum*, The Hague 1671

Blanc 1859–61
Charles Blanc, *L'Oeuvre complet de Rembrandt*, 2 vols, Paris 1859–61

Blankert 1967
A. Blankert, 'Heraclitus en Democritus', *Nederlands Kunsthistorisch Jaarboek* 18 (1967), pp. 31–124

Boeck 1953
Wilhelm Boeck, 'Rechts und Links in Rembrandts Druckgraphik', *Wallraf-Richartz Jahrbuch* 15 (1953), pp. 179–219

Bojanowski 1938
M. Bojanowski, 'Das Anagramm in Rembrandts "Faust"', *Deutsche Vierteljahrsschrift für Literaturwissenschaft und Geistesgeschichte* 16 (1938), pp. 527–30

Bojanowski 1940
M. Bojanowski, 'Der Spiegel in Rembrandts Faustradierung', *Deutsche Vierteljahrsschrift für Literaturwissenschaft und Geistesgeschichte* 18 (1940), pp. 467–9

Bolten 1985
J. Bolten, *Dutch and Flemish drawing books. Method & practice 1600–1750*, Landau 1985

Boon 1956
K. G. Boon, 'De herkomst van Rembrandts prenten in het Rijksprentenkabinet', *Bulletin van het Rijksmuseum* 4 (1956), pp. 42–54

Boon 1956b
K. G. Boon, *Rembrandt. Tentoonstelling ter herdenking van de geboorte van Rembrandt op 15 juli 1606*, Amsterdam (Rijksmuseum) and Rotterdam (Museum Boymans-Van Beningen) 1956

Boon 1964
K. G. Boon, 'Een vroege studie voor de Honderdtguldenprent', *Bulletin van het Rijksmuseum* 12 (1964), pp. 85–90

Boon 1970
K. G. Boon, 'Abraham Francen of Otto van Cattenburgh', *Kroniek van het Rembrandthuis* 24 (1970), pp. 89–91

Boon 1978
K. G. Boon, *Catalogue of Dutch and Flemish Drawings in the Rijksmuseum. Netherlandish Drawings of the Fifteenth and Sixteenth Centuries*, 2 vols, The Hague 1978

Van Breda 1997
Jacobus van Breda, 'Rembrandt's etchings on oriental papers: papers in the collection of the National Gallery of Victoria', *Art Bulletin of Victoria* 38 (1997), pp. 25–38

Bredius
A. Bredius, revised by H. Gerson, *Rembrandt, the complete edition of paintings*, London 1969

Bredius 1909
A. Bredius, 'Uit Rembrandt's laatste levensjaar', *Oud Holland* 27 (1909), pp. 238–40

Brinkman 1993
P. W. F. Brinkman, *Het geheim van Jan van Eyck: Aantekeningen bij de uitvinding van het olieverven*, diss., Zwolle 1993

Brom 1926
Gerard Brom, 'De traditie in Rembrandt's Dood van Maria', *Oud Holland* 43 (1926), pp. 112–16

Broos 1970–71
B. P. J. Broos, 'The 'O' of Rembrandt', *Simiolus* 4 (1970–71), pp. 150–84

Broos 1977
B. P. J. Broos, *Index to formal sources of Rembrandt's Art*, Maarssen 1977

Broos 1981–2
B. P. J. Broos, 'Book reviews: Walter L. Strauss and Marjon van der Meulen (with the assistance of S. A. C. Dudok van Heel and P. J. M. de Baar), Rembrandt documents, New York (Abaris Books) 1979', *Simiolus* 12 (1981–2), pp. 245–62

Broos 1985
B. P. J. Broos, *Rembrandt en zijn voorbeelden*, Amsterdam (Rembrandthuis) 1985

Broughton 1590
Hugh Broughton, *A concent of scripture*, London 1590

De Bruijn 1926
I. de Bruijn, 'Rembrandt's portret van Abraham Francen', *Oud Holland* 43 (1926), pp. 39–44

De Bruijn 1932
I. de Bruijn, *Catalogus van de verzameling etsen van Rembrandt in het bezit van I. de Bruijn en J. G. de Bruijn-van der Leeuw*, The Hague 1932

De Bruijn 1939
I. de Bruijn, 'De namen van Rembrandt's etsen', *Oud Holland* 56 (1939), p. 15

Bruyn 1990
J. Bruyn, 'An unknown assistant in Rembrandt's workshop in the early 1660s', *Burlington Magazine* 132 (1990), pp. 715–18

Bruyn 1991–2
J. Bruyn, 'Rembrandt's werkplaats: functie en productie', in: Berlin-Amsterdam-London 1991–2, pp. 69–89

Burchard 1917
L. Burchard, *Die Holländischen Radierer vor Rembrandt*, Berlin 1917

Busch 1971
Werner Busch, 'Zu Rembrandts Anslo-Radierung', *Oud Holland* 86 (1971), pp. 196–9

Busch 1983
Werner Busch, 'Rembrandts 'Ledikant' – der Verlorene Sohn in Bett', *Oud Holland* 97 (1983), pp. 257–65

Vanden Bussche 1880
Emile vanden Bussche, 'Un évêque bibliophile. Notes sur la bibliothèque et le cabinet de gravures de Charles Vanden Bosch, neuvième évêque de Bruges; ses relations avec Elzévirs, Meyssens, etc.', *La Flandre: revue des monuments d'histoire et d'antiquites* 13 (1880), pp. 345–63

Cailleux 1975
J. Cailleux, 'Les artistes Français du dix-huitième siècle et Rembrandt', *Etudes d'art français offertes à Charles Sterling*, Paris 1975, pp. 287–305

Campbell 1971
Colin Campbell, *Studies in the formal sources of Rembrandt's figure compositions*, diss., London University 1971

Campbell 1980
Colin Campbell, 'Rembrandts etsen "Het sterfbed van Maria" en "De drie bomen"', *Kroniek van het Rembrandthuis* 32 (1980) 2, pp. 2–33

Carasso-Kok 1975
M. Carasso-Kok, *Amsterdam Historisch*, Bussum 1975

Carstensen & Henningen 1988
H. T. Carstensen & W. Henningen, 'Rembrandts sog. Dr. Faustus. Zür Archäologie eines Bildsinns', *Oud Holland* 102 (1988), pp. 290–312

Carstensen 1993
H. T. Carstensen, *Empirie als Bildsprache: überlegungen zum jüdischen Einfluss auf Rembrandts Kunst*, diss., Ammersbeck bei Hamburg 1993

Cayeux 1965
Jean de Cayeux, 'Watelet et Rembrandt', *Bulletin de la Société de l'histoire de l'art Français* (1965), pp. 131–61

De la Chapelle & Le Prat 1996
A. de la Chapelle & A. Le Prat, *Les relevés de filigranes*, Paris 1996

Chapman 1990
H. Perry Chapman, *Rembrandt's Self-Portraits. A Study in Seventeenth-Century Identity*, Princeton 1990

Chicago 1973
Deirdre C. Stam [ed.], *Rembrandt after three hundred years: A symposium*, Chicago 1973

Clark 1966
K. Clark, *Rembrandt and the Italian Renaissance*, London 1966

Claussin 1824
J. J. de Claussin, *Catalogue raisonné de toutes les estampes qui forment l'oeuvre de Rembrandt, et des principales pièces de ses élèves, composé par les sieurs Gersaint, Helle, Glomy et Yver. Nouvelle Edition, corrigée et considérablement augmentée par M. le Chev. de Claussin*, Paris 1824

Cohn 1992
Marjorie B. Cohn, 'The Three Trees (continued)', *Print Quarterly* 9 (1992), pp. 386–7

Collins 1952
Leo C. Collins, *Hercules Seghers*, Chicago and London 1952

Le Comte 1700
Florent le Comte, *Cabinet du Singularitez d'Architecture, Peinture, Sculpture, et Gravure ou Introduction à la Connoissance des plus beaux Arts, figurez sous les Tableaux, les Statuës & les Estampes*, Paris 1700

Coppier 1917
A. C. Coppier, *Les eaux-fortes de Rembrandt*, Paris 1917

Cornelis & Filedt Kok 1998
B. Cornelis & J. P. Filedt Kok, 'The taste for Lucas van Leyden prints', *Simiolus* 26 (1998), pp. 18–86

Cornelissen 1941
J. D. M. Cornelissen, 'Twee allegorische etsen van Rembrandt', *Oud Holland* 58 (1941), pp. 126–34

Corpus
J. Bruyn, B. Haak, S. H. Levi, P. J. J. van Thiel and E. van de Wetering, *A corpus of Rembrandt paintings*, The Hague, Boston and London, I (1982) II (1986) III (1989) (IV and V forthcoming)

Corpus Rubenianum
J. R. Judson, C. van de Velde, *Corpus Rubenianum Ludwig Burchard Part XXI; Book illustrations and Titlepages*, London and Philadelphia 1978

Daulby 1796
Daniel Daulby, *A Descriptive Catalogue of the Works of Rembrandt and of his Scholars, Bol, Livens, and Van Vliet, compiled from the original Etchings, and from the Catalogues of De Burgy, Gersaint, Helle and Glomy, Marcus and Yver*, Liverpool 1796

DeGrazia Bohlin 1979
D. DeGrazia Bohlin, *Prints and related drawings by the Carracci Family*, Washington (National Gallery of Art) 1979

Deutsch-Carroll 1981
M. Deutsch-Carroll, 'Rembrandt as meditational printmaker', *Art Bulletin* 63 (1981), pp. 587–610

Dickey 1986
Stephanie S. Dickey, '"Judicious Negligence": Rembrandt Transforms an Emblematic Convention', *Art Bulletin* 68 (1986), pp. 253–62

Dickey 1994
Stephanie S. Dickey, *Prints, portraits and patronage in Rembrandt's work around 1640*, UMI diss., New York 1994

Donahue Kuretsky 1974
Susan Donahue Kuretsky, 'Rembrandt's Tree Stump: an iconographic attribute of St. Jerome', *Art Bulletin* 54 (1974), pp. 571–80

Donahue Kuretsky 1997
S. Donahue Kuretsky, 'Rembrandt at the threshold', in: R. E. Fleischer, S. C. Scott [ed.], *Rembrandt, Rubens, and the art of their time: recent perspectives* (Papers in art history from the Pennsylvania State University XL), Pennsylvania 1997

Dubiez 1959
F. J. Dubiez, 'Rembrandt als boekillustrator', *Ons Amsterdam* 11 (1959) 3, pp. 66–74

Duchesne 1826
J. Duchesne the elder, *Description des objets d'arts qui forment le cabinet de feu M. Le Baron V. Denon. Estampes et ouvrages à figures*, Paris 1826

Dudok van Heel 1978
S. A. C. Dudok van Heel, 'Mr Joannes Wtenbogaert (1608–1680): Een man uit remonstrants milieu en Rembrandt van Rijn', *Jaarboek Amstelodamum* 70 (1978), pp. 146–69

Dudok van Heel 1993
S. A. C. Dudok van Heel, 'Rembrandt en Menasseh Ben Israël', *Kroniek van het Rembrandthuis* (1993) 1, pp. 22–9

Duits 1997
Rembrandt Duits, 'De mouw als statussymbool', *Kunstschrift* (1997) 5, pp. 20–25

Dunand & Lemarchand 1977
L. Dunand & Ph. Lemarchand, *Les amours des dieux*, Paris-Lausanne 1977

Dutuit 1883
E. Dutuit, *L'oeuvre complet de Rembrandt*, Paris 1883

Duverger
E. Duverger, *Antwerpse kunstinventarissen uit de zeventiende eeuw* (Fontes Historiae Artis Neerlandicae 1), Brussels 1984– (10 vols published so far)

Dijkstra 1990
J. Dijkstra, *Origineel en kopie; een onderzoek naar de navolging van de Meester van Flemalle en Rogier van der Weyden*, diss., Amsterdam 1990

Van Eeghen 1956
I. H. van Eeghen, 'De Familie de la Tombe en Rembrandt', *Oud Holland* 71 (1956), pp. 43–8

Van Eeghen 1969
I. H. van Eeghen, 'Het pourtrait van mijn vaeder', *Maandblad Amstelodamum* 56 (1969), pp. 244–8

Van Eeghen 1969b
I. H. van Eeghen, 'Het Amsterdamse Sint Lucasgilde in de 17e eeuw', *Jaarboek Amstelodamum* 61 (1969), pp. 65–102

Van Eeghen 1969c
I. H. van Eeghen, 'Handboogstraat 5', *Maandblad Amstelodamum* 65 (1969), pp. 169–76

Van Eeghen 1985
I. H. van Eeghen, 'Rembrandt en de veilingen (Titus van Rijn, Clement de Jonghe en Samuel Smijters)', *Jaarboek Amstelodamum* 77 (1985), pp. 54–69

Eeles 1998
Adrian Eeles, 'Rembrandt's 'Ecce Homo': A Census of Impressions', *Print Quarterly* 15 (1998), pp. 290–96

Eeles 2000
Adrian Eeles, 'Rembrandt's 'Ecce Homo': the census [amendments and additions]', *Print Quarterly* 17 (2000), p. 49

Eisler 1918
Max Eisler, *Rembrandt als Landschafter*, Munich 1918

Elias 1963
Johan E. Elias, *De vroedschap van Amsterdam 1578–1795*, II, Amsterdam 1963

Emmens 1956
J. A. Emmens, 'Ay Rembrandt, maal Cornelis stem', *Nederlands Kunsthistorisch Jaarboek* (1956), pp. 133–65

Emmens 1964
J. A. Emmens, *Rembrandt en de regels van de kunst*, Amsterdam 1964

Emmens 1979
J. A. Emmens, *Rembrandt en de regels van de kunst* (Verzameld Werk 2), Amsterdam 1979

Emmens 1981
J. A. Emmens, *Kunsthistorische opstellen*, 2 vols (Verzameld Werk 3–4), Amsterdam 1981

Enklaar 1941
D. Th. Enklaar, *Uit Uilenspiegel's Kring*, Assen 1941

Enschedé 1913
J. W. Enschedé, 'Een gelijktijdige waardeering van Rembrandt's etsen in het buitenland (1659)', *Oud Holland* 31 (1913), pp. 132–4

Filedt Kok 1972
J. P. Filedt Kok, *Rembrandt etchings and drawings in the Rembrandt House*, Amsterdam 1972

Filedt Kok 1992
Jan Piet Filedt Kok, 'Bij een aanwinst. De tweede staat van Rembrandts ets *De aanbidding der herders: een nachtstuk*', *Bulletin van het Rijksmuseum* 40 (1992), pp. 161–71

Filedt Kok, Hinterding and Van der Waals 1994
J. P. Filedt Kok, E. Hinterding and J. van der Waals, 'Jan Harmensz. Muller as Printmaker-II', *Print Quarterly* 11 (1994), pp. 351–78

Fontaine Verwey 1956
H. de la Fontaine Verwey, 'Rembrandt als illustrator', *Maandblad Amstelodamum* 43 (1956), pp. 108–10

Forssman 1976
Erik Forschman, 'Rembrandts Radierung "Der Triumph des Mordechai"', *Zeitschrift für Kunstgeschichte* 39 (1976), pp. 297–311

Franken
D. Franken, *L'oeuvre gravé des Van de Passe*, Amsterdam and Paris 1881

Frerichs 1969
L. C. J. Frerichs, 'De schetsbladen van Rembrandt voor het schilderij van het echtpaar Anslo', *Maandblad Amstelodamum* 56 (1969), pp. 206–11

Frey 1956
Dagobert Frey, 'Die Pietà-Rondanini und Rembrandts "Drei Kreuze"', *Kunstgeschichtliche Studien für Hans Kauffmann*, Berlin 1956, pp. 208–32

Fuchs 1909
E. Fuchs, *Illustrierte Sittengeschichte. Renaissance*, Munich 1909

Van Gelder & Van Gelder-Schrijver 1938
J. G. van Gelder & N.F. van Gelder-Schrijver, 'De 'memorie' van Rembrandt's prenten in het bezit van Valerius Röver', *Oud Holland* 55 (1938), pp. 1–16

Van Gelder & Van Gelder-Schrijver 1939
J. G. van Gelder & N. F. Van Gelder-Schrijver, 'De namen van Rembrandt's etsen', *Oud Holland* 56 (1939), pp. 87–8

Van Gelder 1943
H. E. van Gelder, 'Marginalia bij Rembrandt. II. Rembrandts geëtste zelfportret "teekenend aan een lessenaar"', *Oud Holland* 60 (1943), pp. 34–5

Gersaint 1751
Edmé François Gersaint, *Catalogue raisonnée de toutes les pièces qui forment l'oeuvre de Rembrandt, composé par feu M. Gersaint, & mis au jour, avec les Augmentations nécessaires, par les sieurs Helle & Glomy*, Paris 1751

Gersaint 1752
Edmé François Gersaint, *A catalogue and description of the etchings of Rembrandt Van-Rhyn, with some account of his life. To which is added a list of the best pieces of this Master*, London 1752

Gerson 1968
H. Gerson, *Rembrandt's paintings*, Amsterdam 1968

Gerzi 1982
Teréz Gerzi, *Paulus van Vianen. Handzeichnungen*, Hanau 1982

Giltaij 1988
Jeroen Giltaij, *The drawings of Rembrandt and his school in the Museum Boymans-Van Beuningen*, Rotterdam 1988

Giltaij 1989
Jeroen Giltaij, 'The function of Rembrandt's drawings', *Master Drawings* 27 (1989), pp. 111–17

Von Graevenitz 1973
Antje-Maria von Graevenitz, *Das Niederländische Ohrmuschel-Ornament. Phänomen und Entwicklung dargestellt an den Werken und Entwürfen der Goldschmiedefamilien van Vianen und Lutma*, Bamberg 1973

Graffon 1950
Mercedes Graffon, *Die Radierungen Rembrandts, Originale und Drucke. Studien über Inhalt und Komposition*, Mainz 1950

Gregory & Zdanowicz 1988
John Gregory & Irena Zdanowicz, *Rembrandt in the Collections of the National Gallery of Victoria*, Melbourne 1988

Griffiths 1996
A. Griffiths, *Prints and Printmaking*, Los Angeles 1996

Griffiths et al. 1996
A. Griffiths et al., *Landmarks in Print Collecting. Connoisseurs and Donors at the British Museum since 1753*, London and Houston 1996

Grosse-Stoltenberg 1965
R. Grosse-Stoltenberg, 'Beiträge zur Wasserzeichenforschung. Technische Varianten bei der Fertigung der Drahtform', *Papiergeschichte* 15 (1965) 5–6, pp. 73–9

Grothues 1992
Bernard Grothues, 'Faust is een kabbalist: een nieuwe verklaring van de zogenaamde Faust van Rembrandt', *Kroniek van het Rembrandthuis* 44 (1992), 2–9

Guratzsch 1980
Herwig Guratzsch, *Die Auferweckung des Lazarus in der niederländischen Kunst von 1400 bis 1700: Ikonographie und Ikonologie*, Kortrijk 1980

Gutbrod 1996
Helga Gutbrod, *Lievens und Rembrandt. Studien zum verhältnis ihrer Kunst*, Frankfurt am Main, Berlin, Bern, New York, Paris and Vienna 1996

Haak 1969
Bob Haak, *Rembrandt, His life, his work, his time*, New York 1969

Halewood 1993
William H. Halewood, 'Rembrandt's Low Diction', *Oud Holland* 107 (1993), pp. 287–95

Hausmann 1861
B. Hausmann, *Albrecht Dürer's Kupferstiche, Radirungen, Holzschnitte und Zeichnungen, unter besonderer Berücksichtigung der dazu verwandten Papiere und deren Wasserzeichen*, Hannover 1861 (reprinted Wurzburg 1922)

Haverkamp Begemann 1954
E. Haverkamp Begemann, 'Rubens schetsen', *Bulletin Museum Boymans* 5 (1954), pp. 2–21

Haverkamp Begemann 1961
E. Haverkamp Begeman, 'Review of Benesch, The Drawings of Rembrandt. First complete Edition in six Volumes, London, The Phaidon Press (1954–1957) (3. Teil)', *Kunstchronik* 14 (1961) I, pp. 85–91

Haverkamp Begemann 1967
E. Haverkamp Begemann, 'Purpose and Style: Oil Sketches of Rubens, Jan Brueghel, Rembrandt', in: *Stil und Überlieferung in der Kunst des Abendlandes. Akten des 21. Internationalen Kongresses für Kunstgeschichte in Bonn*, III, Berlin 1967, p. 104–13

Haverkamp Begemann 1973
E. Haverkamp Begemann, *Hercules Seghers: the complete etchings*, Amsterdam and The Hague 1973

Haverkamp Begemann 1980
E. Haverkamp Begemann, 'Creative Copies', *Print Collector's Newsletter* 11 (1980), pp. 168–70

Heawood 1950
Edward Heawood, *Watermarks, mainly of the 17th and 18th centuries*, Hilversum 1950

Held 1980
Julius Held, 'Was Abraham left-handed?', *Print Collector's Newsletter* 11 (1980), pp. 161–4

Held 1980b
J. S. Held, *The oil sketches of Peter Paul Rubens: A critical catalogue*, 2 vols, Princeton 1980

Held 1991
Julius Held, 'Rembrandt's Interest in Beggars (1984)', *Rembrandt Studies*, Princeton 1991, pp. 153–63

Hermesdorf, Van de Wetering & Giltaij 1986
P. F. J. M.. Hermesdorf, E. van de Wetering & J. Giltaij, 'Enkele nieuwe gegevens over Rembrandts 'De Eendracht van het Land'', *Oud Holland* 108 (1986), pp. 35–49

Hilber 1937
P. Hilber, *Der Totentanz auf der Spreuerbrücke in Luzern*, Lucern 1937

Hind
Arthur M. Hind, *A catalogue of Rembrandt's etchings, chronologically arranged and completely illustrated*, 2 vols, London 1924 (reprinted New York 1967)

Hind 1905–6
A. M. Hind, 'The portraits of Rembrandt's father', *Burlington Magazine* 8 (1905–6), pp. 427–9

Hind 1931
A. M. Hind, *Catalogue of drawings by Dutch and Flemish artists in the British Museum*, IV, London 1931

Hind 1932
A. M. Hind, *Rembrandt: being the substance of the Charles Eliot Norton lectures delivered before Harvard University 1930–31*, Oxford and London 1932

Hinterding 1993–4
Erik Hinterding, 'The history of Rembrandt's copperplates, with a catalogue of those that survive', *Simiolus* 22 (1993–4), pp. 253–315 (also published as: Erik Hinterding, *The history of Rembrandt's copperplates, with a catalogue of those that survive*, Zwolle 1995)

Hoff 1975
Ursula Hoff, 'Rembrandt's Shell – Conus Marmoreus L.', *Art Bulletin of Victoria* (1975), pp. 16–19

Hoffmann 1990
K. Hoffmann, 'Holbeins Todesbilder', *Ikonographia. Anleitung zum Lesen von Bildern. Festschrift Donat de Chapeaurouge*, Munich 1990, pp. 97–110

Hofstede de Groot 1906
Cornelis Hofstede de Groot, *Die Urkunden über Rembrandt (1575–1721)*, The Hague 1906

Hofstede de Groot 1912
Cornelis Hofstede de Groot, 'Meeningsverschillen omtrent Werken van Rembrandt: I. Rembrandts "Vroutgen met een Pappotgen"', *Oud Holland* 30 (1912), pp. 70–74

Holl.
See Hollstein

Hollstein
F. W. H. Hollstein's Dutch & Flemish etchings, engravings and woodcuts ca. 1450–1700, Amsterdam 1949–87; Roosendaal 1988–1994; Rotterdam 1995– (in progress)

Hollstein, *German*
F. W. H. Hollstein's German engravings, etchings and woodcuts ca. 1400–1700, Amsterdam 1954–87; Roosendaal 1988–94; Rotterdam 1995– (in progress)

The New Hollstein
The New Hollstein. Dutch & Flemish etchings, engravings and woodcuts ca. 1450–1700, Roosendaal 1993–5; Rotterdam 1996– (in progress)

Hollander 1975
Anne Hollander, *Looking through clothes*, New York and London 1975

Hoogstraten 1678
Samuel van Hoogstraten, *Inleyding tot de Hooghe Schoole der Schilderkonst*, Rotterdam 1678

De Hoop Scheffer & Boon 1971
D. de Hoop Scheffer & K. G. Boon, 'De inventarislijst van Clement de Jonghe en Rembrandts etsplaten', *Kroniek van het Rembrandthuis* 25 (1971), 1–17

De Hoop Scheffer 1972
D. de Hoop Scheffer, 'Nogmaals de inventarislijst van Clement de Jonghe', *Kroniek van het Rembrandthuis* 26 (1972), pp. 126–34

De Hoop Scheffer 1976
D. de Hoop Scheffer, 'De boerenhoeve in het geboomte', *Kroniek van het Rembrandthuis* 28 (1976), pp. 12–18

Houbraken 1718–21
Arnold Houbraken, *De groote Schouburgh der Nederlantsche Konstschilders en Schilderessen*, 2 vols, Amsterdam 1718

d'Hulst 1968
R.-A. d'Hulst, *Olieverfschetsen van Rubens uit Nederlands en Belgisch openbaar kunstbezit*, n.p. 1968

Hunter 1978
Dard Hunter, *Papermaking. The history and technique of an ancient craft*, New York 1978

Jaffé 1994
Michael Jaffé, 'Abraham's Sacrifice: a Rembrandt of the 1660's', *Artibus et Historiae* 15 (1994) 30, pp. 193–210

Jensen Adams 1985
A. Jensen Adams, *The paintings of Thomas de Keyser (1596/7–1667): A study of portraiture in seventeenth-century Amsterdam*, diss., Cambridge (Mass.) 1985

Jones Hellerstedt 1981
K. Jones Hellerstedt, 'A traditional motif in Rembrandt's etchings: the Hurdy-Gurdy Player', *Oud Holland* 95 (1981), pp. 16–30

De Jongh 1969
E. de Jongh, 'The spur of wit: Rembrandt's response to an Italian challenge', *Delta* 12 (1969), pp. 49–67

De Jongh 1995
E. de Jongh, *Kwesties van betekenis: thema en motief in de Nederlandse schilderkunst van de zeventiende eeuw*, Leiden 1995

De Jongh 1997
E. de Jongh, 'De mouw van de cavalier', *Kunstschrift* (1997) 5, pp. 26–30

Josi 1810
C. Josi, *Beredeneerde catalogus der werken van Rembrandt van Rhyn, en van zyne leerlingen en navolgeren, herkomende uit het kabinet van wylen den Heer C. Ploos van Amstel, J.Cz. welke in het openbaar zullen verkogt worden, (Op Dingsdag den 31 Julij 1810) ten huize en onder directie van C. Josi, graveur en Kunsthandelaar te Amsterdam*, Amsterdam 1810

Kahr 1966
M. Kahr, 'Rembrandt's Esther; a painting and an etching newly interpreted and dated', *Oud Holland* 81 (1966), pp. 228–44

Kannegieter 1925
J. Z. Kannegieter, 'Een nieuwe hypothese betreffende het "Bruggetje van Six"', *Oud Holland* 42 (1925), pp. 71–4

Kempers 2000
B. Kempers, 'Allegory and symbolism in Rembrandt's *De eendracht van het land*. Images of concord and discord in prints, medals and paintings', in: *1648. Paix de Westphalie. L'Art entre la guerre et la paix./Westphälischer Frieden. Die Kunst zwischen Krieg und Frieden. Acts du Colloque Paris, Musée du Louvre 1998*, Paris 2000, pp. 71–113

Von Kieser 1940
E. von Kieser, 'Zur Deutung von Rembrandts Faust', *Deutsche Vierteljahrsschrift für Literaturwissenschaft und Geistesgeschichte* 18 (1940), pp. 112–15

Kirsch 1991
Bob Kirsch, 'Rembrandt's "The three trees"', *Print Quarterly* 8 (1991), pp. 436–8

Kloek 1992
Wouter Th. Kloek, 'Over Rembrandts *Portret van Uyttenbogaert*, nu in het Rijksmuseum', *Bulletin van het Rijksmuseum* 40 (1992), pp. 346–52

Köhler 1982
Brunhilde Köhler, 'Das Mensch-Welt verhältnis und die Lichtsymbolik im Rembrandts werk', *Bildende Kunst* 30 (1982) 11, pp. 7–12

Kornfeld 1979
Eberhard W. Kornfeld & Christine E. Stauffer, *140 Radierungen von Rembrandt. Der Jahre 1629 bis 1665*, Bern 1979

L.
Frits Lugt, *Les Marques de collections de dessins et d'estampes*, Amsterdam 1921 (*Supplement*, The Hague 1956)

Labarre 1937
E. J. Labarre, *A dictionary of paper and paper-making terms. With equivalents in French, German, Dutch and Italian*, Amsterdam 1937

Lambert & Séveno 1997
Gisèle Lambert & Roger Séveno, 'La restauration du fonds Rembrandt de la Bibliothèque Nationale de France', *Nouvelles de l'estampe* (1997) 151, pp. 37–41

Lammertse 1998
F. Lammertse, *Nederlandse genreschilderijen uit de zeventiende eeuw. Eigen collectie Museum Boijmans Van Beuningen*, Rotterdam 1998

Landsberger 1946
F. Landsberger, *Rembrandt, the Jews and the Bible*, Philadelphia 1946

Laurentius [et al.] 1992
Theo Laurentius, Harry M. M. van Hugten, Erik Hinterding and Jan Piet Filedt Kok, 'Het Amsterdamse onderzoek naar Rembrandts papier: radiografie van de watermerken in de etsen van Rembrandt', *Bulletin van het Rijksmuseum* 40 (1992) pp. 353–84

Laurentius 1993
Theo Laurentius, *Rembrandt's Etchings in a New Light*, Machida (Kawamura Memorial Museum of Art) 1993

Laurentius 1996
Th. Laurentius, *The Maecenas Collection. Etchings by Rembrandt. Reflections of the Golden Age. An investigation into the paper used by Rembrandt*, Amsterdam and Zwolle 1996

Lawner 1988
I modi. The sixteen pleasures, an erotic album of the Italian Renaissance, edited, translated from the Italian, and with a commentary by L. Lawner, Evanston (Ill.) 1988

Leendertz 1921
P. Leendertz, 'Nederlandsche Faust-illustraties', *Oud Holland* 39 (1921), pp. 132–48

Leendertz 1923–4
P. Leendertz., 'Rembrandt's Faust en Medea', *Oud Holland* 41 (1923–4), pp. 14–18, 68–82

Lehmann & Ettlinger 1958
O. H. Lehmann & E. Ettlinger, 'Contributions to the interpretation of Rembrandt's etching known as "Faust in his studio"', *The Connoisseur* (1958), pp. 118–19

Leiden 1983
W. J. Wieringa et al. [eds], *The interactions of Amsterdam and Antwerp with the Baltic region, 1400–1800./ De Nederlanden en het Oostzeegebied, 1400–1800. Papers presented at the 3rd international conference of the 'Association Internationale d'Histoire des Mers Nordiques de l'Europe'*, Leiden 1983

Lieure
J. Lieure, *Jacques Callot*, 4 vols, Paris 1924–7

Lindenborg 1976
I. Lindenborg, 'Did the execution of Charles the first influence Rembrandt's etching "Ecce Homo"? A tentative investigation', *Print Review* 6 (1976), pp. 18–26

Loeber 1982
E. G. Loeber, *Paper mould and mouldmaker*, Amsterdam 1982

de Lorm 1999
Jan Rudolph de Lorm, *Amsterdams Goud en Zilver (Catalogi van de verzameling kunstnijverheid van het Rijksmuseum te Amsterdam)*, Amsterdam (Rijksmuseum) and Zwolle 1999

Lugt 1915
Frits Lugt, *Wandelingen met Rembrandt in en om Amsterdam*, Amsterdam 1915

Lugt 1920
Frits Lugt, *Mit Rembrandt in Amsterdam. Die Darstellungen Rembrandts vom Amsterdamer Stadtbilde und von der unmittelbarebn Landschaftlichen Umgebung*, Berlin 1920

Lugt 1933
Frits Lugt, *Musée du louvre. Inventaire général des dessins des écoles du nord. École hollandaise. III.*, Paris 1933

Lugt 1938
Frits Lugt, *Repertoire des catalogues de ventes publiques*, I, The Hague 1938

Van Mander 1604
Karel van Mander, *Het Schilder-boeck*, Haarlem 1604

Mariette 1857
P. J. Mariette, *Abecedario de P. J. Mariette et autres notes inédites de cet amateur sur les arts et les artistes. Ouvrage publié d'après les manuscrits autographes conservés au Cabinet des Estampes de la Bibliothèque Nationale, et annoté par MM. Ph. de Chennevières et A. de Montaiglon*, Paris 1857

Martin 1913
W. Martin, *Gerard Dou. Des Meisters Gemälde (Klassiker der Kunst)*, Stuttgart and Berlin 1913

Mauquoy-Hendrickx
M. Mauquoy-Hendrickx, *L'iconographie d'Antoine van Dyck. Catalogue raisonné*, 2 vols, Brussels 1991

Mauquoy-Hendrickx, *Wierix*
M. Mauquoy-Henrickx, *Les estampes des Wierix*, 4 vols, Brussels 1978–83

McNeil Kettering 1977
Alison McNeil Kettering, 'Rembrandt's *Flute player*: a unique treatment of pastoral', *Simiolus* 9 (1977), pp. 19–44

McNeil Kettering 1983
Alison McNeil Kettering, *The Dutch Arcadia. Pastoral art and its audience in the Golden Age*, Montclair (N.J.) 1983

Meadow 1992
M. Meadow, 'The observant pedestrian and Albrecht Dürer's *Promenade*', *Art History* 15 (1992), pp. 197–222

Meijer 1991
Bert W. Meijer, *Rondom Rembrandt en Titiaan. Artistieke relaties tussen Amsterdam en Venetië in prent en tekening*, 1991

Middleton 1878
C. H. Middleton, *Descriptive catalogue of the etched work of Rembrandt van Rhyn*, London 1878

Minder 1997
N. Minder, *Rembrandt. Les collections du Cabinet des Estampes de Vevey*, Vevey (Musée Jenesch) 1997

Moltke 1994
J. W. Moltke, *Arent de Gelder, Dordrecht 1645–1727*, Doornspijk 1994

Müller 1997
M. Müller, *Bilder von Liebe und Eros in Spätmittelalter und Früher Neuzeit*, Braunschweig (Herzog Anton Ulrich-Museum) 1997

Münz 1952
Ludwig Münz, *Rembrandt's Etchings*, London 1952

Münz 1953
Ludwig Münz, 'Rembrandts Bild von Mutter und Vater', *Jahrbuch der Kunsthistorischen Sammlungen in Wien* 50 (1953), pp. 141–90

Musper 1935
T. Musper, 'Die Datierung des späten Zustandes der "Drei Kreuze" von Rembrandt', *Kunst- und Antiquitäten-Rundschau* 6 (1935), p. 137

Neurdenburg 1948
E. Neurdenburg, *De zeventiende eeuwsche beeldhouwkunst in de Noordelijke Nederlanden*, Amsterdam 1948

Nevitt 1997
H. Rodney Nevitt, 'Rembrandt's hidden lovers', *Nederlands Kunsthistorisch Jaarboek* 48 (1997), pp. 162–91

Noomen & Van den Boogaard 1983–99
W. Noomen & N. van den Boogaard [eds], *Nouveau Recueil Complet des Fabliaux*, 10 vols, Assen 1983–99

Noszlopy 1994
George T. Noszlopy, 'Via Salutis et Glorificatonis. Note on Rembrandt's "The Three Crosses", Longinus and the Gonzaga', *Müvészettörténeti értesítő* (1994), pp. 241–6

Oldewelt 1930
W. F. H. Oldewelt, 'Rembrandt's etsen "de oude" en "de jonghe haaringh"', *Jaarboek Amstelodamum* 27 (1930), pp. 175–8

Ovid
Ovid, *Metamorphoses* (translated and with an introduction by Mary M. Innes), Harmondsworth, New York, Ringwood, Markham and Auckland 1983 (1st edn 1955)

Panofsky 1955
E. Panofsky, *The life and art of Albrecht Dürer*, 2 vols, Princeton N.J. 1955

Parke-Bernet Galleries 4-4-1946
Parke-Bernet Galleries Inc., *Auction collection Eldridge R. Johnson (Moorestown, New Jersey), Part II*, New York 4 April 1946

Pels 1681
Andries Pels, *Gebruik en misbruik des tooneels*, Amsterdam 1681

Pennington
Richard Pennington, *A descriptive catalogue of the etched work of Wenceslaus Hollar 1607–1677*, Cambridge 1982

Perlove 1993
Shelley Perlove, 'An Irenic Vision of Utopia: Rembrandt's "Triumph of Mordechai" and the New Jerusalem', *Zeitschrift für Kunstgeschichte* 56 (1993), pp. 38–60

Pigler 1974
A. Pigler, *Barock-Themen*, 3 vols, Budapest 1974

De Piles 1699
Roger de Piles, *Abregé de la Vie des Peintres. Avec des reflexions sur leurs Ouvrages*, Paris 1699

Plomp 1997
Michiel C. Plomp, *The Dutch drawings in the Teyler Museum*, Haarlem (Teyler Museum) 1997

Posèq 1989
A. W. G. Posèq, 'Left and Right in Rembrandt's "Defeat of Goliath"', *Studia Rosenthaliana* 23 (1989) 1, pp. 8–27

Rand 1991
Richard Rand, *Masterpiece in focus: The raising of Lazarus by Rembrandt*, Los Angeles 1991

Van Regteren Altena 1948–9
I. Q. van Regteren Altena, 'Rembrandt's Way to Emmaus', *Kunstmuseets Årsskrift* 35–36 (1948–9), pp. 1–26

Van Regteren Altena 1954
I. Q. van Regteren Altena, 'Retouches aan ons Rembrandt-beeld: het landschap van den Goudweger', *Oud Holland* 69 (1954), pp. 1–17

Van Regteren Altena 1961
I. Q. van Regteren Altena, 'Een onbekende eerste staat van Rembrandts "Vieillard à la grande Barbe" (B.260)', *Bulletin van het Rijksmuseum* 9 (1961), pp. 3–10

Van Regteren Altena 1977
I. Q. van Regteren Altena, *Peter Paul Rubens. Tekeningen naar Hans Holbeins Dodendans*, 2 vols, Amsterdam 1977

Van Regteren Altena 1983
I. Q. van Regteren Altena, *Jacques de Gheyn, three generations*, 3 vols, The Hague, Boston and London 1983

Rehorst 1950
A. J. Rehorst, 'Rembrandt's toovercirkel, of zijn zoogenaamde Faust-prent', *Historia* 15 (1950), pp. 3–7

Reznicek 1961
E. K. J. Reznicek, *Die Zeichnungen von Hendrick Goltzius*, 2 vols, Utrecht 1961

Reznicek 1977
E. K. J. Reznicek, 'Opmerkingen bij Rembrandt', *Oud Holland* 91 (1977), pp. 75–107

Rifkin 1972
B. A. Rifkin, 'Problems in Rembrandt's Etchings', *Print Collector's Newsletter* 2 (1972), pp. 123–5

Ripa 1611
Cesare Ripa, *Iconologia*, Rome 1611

Robinson 1974
F. W. Robinson, *Gabriel Metsu (1629–1667). A study of his place in Dutch genre painting of the Golden Age*, New York 1974

Robinson 1980
Franklin W. Robinson, 'Puns & Plays in Rembrandt's Etchings', *Print Collector's Newsletter* 11 (1980), pp. 165–8

Roscam Abbing 1994
M. Roscam Abbing, 'Houbrakens onbeholpen kritiek op de Rembrandt-ets "De zondeval" (B.28)', *Kroniek van het Rembrandthuis* (1994) 2, pp. 15–23

Rosenberg 1959
Jacob Rosenberg, Review of Benesch vols 3–6, *Art Bulletin* 41 (1959), pp. 108–19

Rosenberg 1968
Jacob Rosenberg, *Rembrandt Life & Work*, London and New York 1968 (first edn 1948)

Rotermund 1957
Hans-Martin Rotermund, 'Untersuchungen zu Rembrandts Faustradierung', *Oud Holland* 72 (1957), pp. 151–68

Rovinski 1890
D. Rovinski, *L'oeuvre gravé de Rembrandt*, 4 vols, St Petersburg 1890

Rowlands 1979
John Rowlands, *Hercules Seghers*, London 1979

Royalton-Kisch 1984
Martin Royalton-Kisch, 'Over Rembrandt en van Vliet', *Kroniek van het Rembrandthuis* 36 (1984), pp. 3–23

Royalton-Kisch 1988
Martin Royalton-Kisch, *Adriaen van de Venne's Album in the Department of Prints and Drawings in the British Museum*, London 1988

Royalton-Kisch 1990
Martin Royalton-Kisch, Review of Starky 1988–89, *Burlington Magazine* 132 (1990), pp. 131–6

Royalton-Kisch 1991
Martin Royalton-Kisch, 'Rembrandt's Self-Portraits', *Print Quarterly* 8 (1991) pp. 304–8

Royalton-Kisch 1992
Martin Royalton-Kisch, *Drawings by Rembrandt and his Circle in the British Museum*, London 1992

Royalton-Kisch 1992b
Martin Royalton-Kisch, 'Letter [about the Raising of Lazarus]', *Master Drawings* 30 (1992), pp. 336–7

Royalton-Kisch 1993
Martin Royalton-Kisch, 'Rembrandt, Zomer, Zanetti and Smith', *Print Quarterly* 10 (1993), pp. 111–22

Royalton-Kisch 1993b
Martin Royalton-Kisch, 'Rembrandt's Drawings for his Prints: some Observations', in: G.. Cavalli-Biörkmann [ed.], *Rembrandt and his Pupils. Papers given at a Symposium in Nationalmuseum Stockholm, 2–3 October 1992*, Stockholm 1993, pp. 173–92

Royalton-Kisch 1994
Martin Royalton-Kisch, 'Some further thoughts on Rembrandt's "Christ before Pilate"', *Kroniek van het Rembrandthuis* (1994) 2, pp. 3–13

Royalton-Kisch 1995
Martin Royalton-Kisch, 'Rembrandt's Clock', in: C. P. Schneider, W. W. Robinson and A. I. Davies [eds], *Shop Talk. Studies in Honor of Seymour Slive. Presented on His Seventy-Fifth Birthday*, Cambridge (MA) 1995, pp. 216–18

Royalton-Kisch 1999
Martin Royalton-Kisch, 'Optica bij Descartes en Rembrandt', in: A. Strackie-Kater and M. van der Tweel [eds], *Van Hooft en Hart: Henk van Tweel 1915–1997*, Amsterdam 1999, pp. 245–9

Ryckevorsel 1932
J. L. A. A. M. van Ryckevorsel, *Rembrandt en de traditie*, Rotterdam 1932

Salman 1997
J. Salman, *Een handdruk van de tijd. De almanak en het dagelijks leven in de Nederlanden 1500–1700*, Zwolle 1997

Sandrart 1675–80
J. von Sandrart, *Teutsche Academie der Bau-, Bild- und Mahlerey-Künste*, 3 vols, Nuremberg 1675–80

Sandrart 1928
J. von Sandrart, Academie der Bau-, Bild- und Mahlerey-Künste von 1675. Leben der berühmten Maler, Bildhauer und Baumeister (ed. A. R. Peltzer), Munich 1925

Saxl 1910
F. Saxl, 'Zur Herleitung der Kunst Rembrandts', *Mitteilungen der Gesellschaft für vervielfätigende Kunst*, 2–3 (1910), pp. 41–8

Scallen 1990
Catherine B. Scallen, *Rembrandt and Saint Jerome*, diss., Ann Arbour (MI) 1990

Scallen 1992
Catherine B. Scallen, 'Rembrandt's Etching St. Jerome Reading in an Italian Landscape', *Delineavit et Sculpsit* (1992) 8, pp. 1–11

Schabaelje 1634
J. Phz. Schabaelje, *Gulden Iuweel inhoudende verscheijden schoone stucken. noijt ghedruckt*, 1634

Schapelhouman 1987
Marijn Schapelhouman, *Nederlandse tekeningen omstreeks 1600 / Netherlandisch drawings circa 1600. Catalogus van de Nederlandse tekeningen in het Rijksprentenkabinet, Rijksmuseum, Amsterdam, III.*, The Hague 1987

Schatborn 1977
Peter Schatborn, 'Beesten nae't leven', *De kroniek van het Rembrandthuis* 29 (1977), nr. 2, pp. 3–32

Schatborn 1985
Peter Schatborn, *Tekeningen van Rembrandt in het Rijksmuseum*, The Hague 1985

Schatborn 1986
Peter Schatborn, 'Tekeningen van Rembrandt in verband met zijn etsen', *Kroniek van het Rembrandthuis* (1986) pp. 4–5

Schatborn 1987
Peter Schatborn, 'Rembrandt's late tekeningen van vrouwelijke naaktfiguren', *Kroniek van het Rembrandthuis* 39 (1987) 2, pp. 28–40

Schatborn 1989
Peter Schatborn, 'Notes on early Rembrandt drawings', *Master Drawings* 27 (1989), pp. 118–27

Schatborn 1990
Peter Schatborn, 'Met Rembrandt naar buiten', *Kroniek van het Rembrandthuis* 42 (1990) 1–2, pp. 31–9.

Schatborn 1991
Peter Schatborn, '"Papieren kunst" van Rembrandt en Lievens', in: Chr. Vogelaar [ed.], *'Een jong en edel schildersduo'· Rembrandt en Lievens in Leiden*, Leiden (Museum De Lakenhal) and Zwolle 1991, pp. 60–79

Schatborn 1993
Peter Schatborn, 'Rembrandt from life and from memory', in: G. Cavalli-Björkman [ed.], *Rembrandt and his pupils. Papers given at a symposium in Nationalmuseum Stockholm, 2–3 October 1992 (Nationalmusei Skriftserie N.S. 13)*, Stockholm 1993, pp. 156–72

Schatborn 1994
Peter Schatborn, Review of Royalton-Kisch 1992, *Oud Holland* 108 (1994), pp. 20–24

Schatborn & De Winkel 1996
Peter Schatborn & Marieke de Winkel, 'Rembrandts portret van de acteur Willem Bartolsz. Ruyter', *Bulletin van het Rijksmuseum* 44 (1996), pp. 382–93

Scheller 1969
R. W. Scheller, 'Rembrandt en de encyclopedische verzameling', *Oud Holland* 84 (1969), pp. 81–147

Van Schendel 1963
A. van Schendel, 'Het portret van Constantijn Huygens door Jan Lievens', *Bulletin van het Rijksmuseum* 11 (1963), pp. 5–10

Schmidt-Degener 1925
F. Schmidt-Degener, 'Over Rembrandt's Vogel Phoenix', *Oud Holland* 42 (1925), pp. 191–208

Schmidt-Degener 1942
F. Schmidt-Degener, *Phoenix. Vier essays*, Amsterdam 1942

Schneider 1990
Cynthia P. Schneider, *Rembrandt's Landscapes: drawings and Prints*, Washington (National Gallery of Art) 1990

Schneider 1990a
Cynthia P. Schneider, *Rembrandt's Landscapes*, New Haven and London 1990

Scholte 1941
J. H. Scholte, 'Rembrandt's 'Faust' bij Goethe', *Oud Holland* 58 (1941), pp. 75–84

Scholte 1946
J. H. Scholte, 'Rembrandt en Vondel; parts I and II', *Apollo. Maandschrift* 5–6 (1946) April–May, pp. 2–14; 40–47

Scholz 1985
H. Scholz, *Brouwer invenit. Druckgraphische Reproduktionen des 17.–19. Jahrhunderts nach Gemälden und Zeichnungen Adriaen Brouwers (Studien zur Kunst- und Kulturgeschichte 3)*, Marburg 1985

Schwartz 1985
Gary Schwartz, *Rembrandt, his life, his paintings*, Middlesex and New York 1985

Seymour Haden 1877
Francis Seymour Haden, *Catalogue of the Etched Work of Rembrandt Selected for Exhibition At the Burlington Fine Arts Club with Introductory Remarks by a Member of the Club*, London 1877

Silver 1976
L. A. Silver, 'Of beggars – Lucas van Leyden and Sebastian Brandt', *Journal of the Warburg and Courtauld Institutes* 39 (1976), pp. 253–7

Simons 1539
Menno Simons, *Dat Fundament des Christelycken Leers* (1539), ed. H. W. Meihuizen, The Hague 1967

Six 1908
J. Six, 'Rembrandt's voorbereiding van de etsen van Jan Six en Abraham Francen', *Onze Kunst* 14 (1908), pp. 53–64

Six 1909
J. Six, 'Gersaints lijst van Rembrandts prenten', *Oud Holland* 27 (1909), pp. 65–110

Six 1921
J. Six, *Rembrandt's etswerk*, Utrecht 1921

Slatkes 1973
L. Slatkes, 'Review of C. White and K. Boon, "Rembrandt Etchings" and C. White, "Rembrandt as an Etcher"', *Art Quarterly* 36 (1973), pp. 250–63

Slatkes 1980
L. J. Slatkes, 'Rembrandt's Elephant', *Simiolus* 11 (1980), pp. 7–13

Slive 1953
Seymour Slive, *Rembrandt and his critics*, The Hague 1953

Slive 1970–74
Seymour Slive, *Frans Hals*, 3 vols, New York and London 1970–74

Smith 1836
J. Smith, *A catalogue raisonné of the works of the most Eminent Dutch, Flemish and French painters*, vol. 7, London 1836

Smith 1985
David R. Smith, 'Towards a Protestant Aesthetics: Rembrandt's 1655 "Sacrifice of Isaac"', *Art History* 8 (1985), pp. 290–302

Smith 1987
David R. Smith, 'Raphael's creation, Rembrandt's fall', *Zeitschrift für Kunstgeschichte* 50 (1987), pp. 496–508

Smith 1988
David R. Smith, '"I Janus": privacy and the gentlemanly ideal in Rembrandt's portraits of Jan Six', *Art History* 11 (1988), pp. 43–63

Von Sonnenburg 1976
H. von Sonnenburg, 'Maltechnische Gesichtspunkte zur Rembrandtforschung', *Maltechnik* 82 (1976), pp. 9–24

Spaans 1997
J. Spaans, *Armenzorg in Friesland*, Hilversum 1997

Springer 1908
Jaro Springer, 'Von neuen Erwerbungen des Berliner Kupferstichkabinetts', *Monatshefte fuer Kunstwissenschaft* 1 (1908), pp. 799–800

Starcky 1988–9
Emmanuel Starcky, *Rembrandt et son école: dessins du Musée du Louvre*, Paris (Musée du Louvre) 1988–9

Stechow 1950
Wolfgang Stechow, 'Review of Jacob Rosenberg, *Rembrandt*, Cambridge, Mass., 1948', *Art Bulletin* 32 (1950), pp. 252–5

Stechow 1952
Wolfgang Stechow, 'Rembrandt's Etching of St. Francis', *Allen Memorial Art Museum Bulletin, Oberlin College*, X, 1 (Fall 1952), pp. 2–12

Steland 1989
Anne Charlotte Steland, *Die Zeichnungen des Jan Asselijn*, Fridingen 1989

Stevenson 1951–2
Alan Stevenson, 'Watermarks are twins', *Studies in Bibliography* 4 (1951–2), pp. 57–91

Van Stipriaan 1996
R. van Stipriaan, *Leugens en vermaak. Boccaccio's novellen in de kluchtliteratuur van de Nederlandse renaissance*, Amsterdam 1996

Stogdon 1996
Nicolas Stogdon, 'Captain Baillie and "The Hundred Guilder Print"', *Print Quarterly* 13 (1996), pp. 53–7

Stone-Ferrier 1985
Linda Stone-Ferrier, 'Views of Haarlem: a reconsideration of Ruysdael and Rembrandt', *Art Bulletin* 67 (1985), pp. 417–36

Van Straten 1992
H. van Straten [ed.], *Razernij der liefde. Ontuchtige poëzie in de Nederlanden van Middeleeuwen tot Franse tijd*, Amsterdam 1992

Sträter 1886
A. Sträter, 'Rembrandt's Radierungen', *Repertorium für Kunstwissenschaft* 9 (1886), pp. 253–9

Stratton 1986
Suzanne Stratton, 'Rembrandt's Beggars: Satire & Sympathy', *Print Collector's Newsletter* 17 (1986) 3, pp. 78–82

Strauss 1984
Walter L. Strauss, 'Rembrandt: de koperen slang', *Kroniek van het Rembrandthuis* 36 (1984), pp. 24–35

Strauss & van der Meulen 1979
Walter L. Strauss & Marjon van der Meulen et al., *The Rembrandt Documents*, New York 1979

Sudeck 1931
E. Sudeck, *Bettlerdarstellungen vom Ende des XV. Jahrhunderts bis zu Rembrandt* (Studien zur deutschen Kunstgeschichte CCLXXIX), Strasbourg 1931

Sumowski
W. Sumowski, *Drawings of the Rembrandt School*, New York 1979– (in progress)

Sumowski, *Gemälde*
W. Sumowski, *Gemälde der Rembrandt-Schüler*, 6 vols, Landau-Pfalz 1983–92

Sumowski 1957–58
W. Sumowski, 'Nachträge zum Rembrandtjahr 1956', *Wissenschaftliche Zeitschrift der Humboldt-Universität zu Berlin. Gesellschafts- und Sprachwissenschaftliche Reihe* 6 (1957–8) 4, pp. 255–81

Talvacchia 1999
B. Talvacchia, *Taking positions. On the Erotic in Renaissance Culture*, Princeton, N.J. 1999

Taylor 1964
E. W. Taylor, *Nature and art in Renaissance Poetry*, New York-London 1964

Van Tol 1983
D. van Tol, 'Een portret van dr. Arnout Tholinx (1607–1679)', *Jaarboek van het Centraal Bureau voor Genealogie en het Ikonografisch Bureau* 37 (1983), pp. 139–50

Trautscholdt 1961
E. Trautscholdt, 'De oude Koekebakster, Nachtrag zu Adriaen Brouwer', *Pantheon* 19 (1961), pp. 187–95

Tümpel 1968
C. Tümpel, 'Studien zur Ikonographie der Historien Rembrandts: Deutung und Interpretation der Bildinhalte', *Nederlands Kunsthistorisch Jaarboek* 20 (1969), pp. 107–98

Tümpel 1968b
C. Tümpel, 'Ikonographische Beiträge zu Rembrandt I und II', *Jahrbuch der Hamburger Kunstsammlungen* 13 (1968), pp. 95–126

Twisck 1632
P. J. Twisck, *Bybelsch Naem- ende Cronijck-Boeck Wesende het tweede deel der Concordantie der Heyliger Schrifture*, Hoorn 1632

Uffenbach 1753
Zacharias Conrad von Uffenbach, *Merkwürdige Reisen durch Niedersachsen, Holland und Engelland*, Ulm 1753

Valentiner 1951
W. R. Valentiner, 'Rembrandt's landscape with a Country House', *Art Quarterly* 14 (1951), pp. 341–7

Vandenbroeck 1985
P. Vandenbroeck, 'Bubo Significans. Die Eule als Sinnbild von Schletigkeit und Torheit, vor allem in der niederländischen und deutschen Bilddarstellungen und bei Jheronimus Bosch I', *Jaarboek Koninklijk Museum voor Schone Kunsten Antwerpen* 1985, pp. 19–135

Van Dyke 1927
John C. Van Dyke, *The Rembrandt drawings and etchings*, New York and London 1927

Vasari 1878–85
Giorgio Vasari, *Le Vite de' più eccellenti Pittori Scultori ed Architettori*, ed. G. Milanesi, 9 vols, Florence 1878–85

Verberckmoes 1998
J. Verberckmoes, *Schertsen, schimpen en schateren. Geschiedenis van het lachen in de Zuidelijke Nederlanden, zestiende en zeventiende eeuw*, Nijmegen 1998

Visser 1988
P. Visser, *Broeders in de geest: De doopsgezinde bijdragen van Dierick en Jan Philipsz. Schabaelje tot de Nederlandse stichtelijke literatuur in de zeventiende eeuw*, Deventer 1988

Visser 't Hooft 1956
W. A. Visser 't Hooft, *Rembrandts weg tot het Evangelie*, Amsterdam 1956

Vondel 1644
Joost van den Vondel, *Verscheide gedichten Bestaande in Zegezangen, Klinkdichten, Lof- en Eerrijmen, Bruilofdichten, Lijk- en Grafdichten, Mengelrijm en Zangen*, Amsterdam 1644

Voorn 1960
Henk Voorn, *De papiermolens in de provincie Noord-Holland*, Haarlem 1960

Voorn 1986
Henk Voorn, 'Lombards en Troys, Frans en Bovenlands papier. Een bijdrage tot de geschiedenis van de Amsterdamse papierhandel', in: P. A. Tichelaar [ed.], *Opstellen over de Koninklijke Bibliotheek en andere studies*, Hilversum 1986, pp. 312–27

Vosmaer 1868
Carel Vosmaer, *Rembrandt Harmens van Rijn, sa vie et ses oeuvres*, The Hague 1868

Voûte 1987
J. R. Voûte, 'Clement de Jonghe exit', *Kroniek van het Rembrandthuis* 39 (1987) 1, pp. 21–7

De Vries 1883
A. D. de Vries, 'Aanteekeningen naar aanleiding van Rembrandt's etsen', *Oud Holland* 1 (1883), pp. 292–310

De Vries 1998
Lyckle de Vries, 'Rembrandts ets B.270: Faust of Paulus?', *Kroniek van het Rembrandthuis* (1998), 1–2, pp. 33–6

Van de Waal 1954–55
H. van de Waal, 'Rembrandts Radierungen zur Piedra Gloriosa des Mennaseh ben Israel', *Imprimatur* 12 (1954–5), pp. 52–60

Van de Waal 1964
H. van de Waal, 'Rembrandt's Faust Etching, a Socinian document and the iconography of the inspired Scholar, *Oud Holland* 79 (1964), pp. 7–48

Van de Waal 1973
Henri van de Waal, Enige mogelijke bronnen voor Rembrandts ets Ecce Homo (1655)', *Nederlands Kunsthistorisch Jaarboek* 23 (1973), pp. 95–113

Van de Waal 1974
Henri van de Waal, *Steps towards Rembrandt. Collected articles 1937–1972*, Amsterdam and London 1974

Van der Waals 1988
Jan van der Waals, *De prentschat van Michiel Hinloopen. Een reconstructie van de eerste openbare papierkunstverzameling in Nederland*, Amsterdam (Rijksmuseum), The Hague 1988

Wentzlaff-Eggebert 1975
F.-W. Wentzlaff-Eggebert, *Der triumfierende und der besiegte Tod in Wordt und Bildkunst des Barock*, Berlin and New York 1975

Werbke 1989
Axel Werbke, 'Rembrandts 'Landschaftsradierung mit drei Bäume' als visuell gedankliche herausforderung', *Jahrbuch der Berliner Museen* 31 (1989), pp. 225–50

Wescher 1960
P. Wescher, *La prima idea. Die Entwicklung der Ölskizze von Tintoretto bis Picasso*, Munich 1960

Van de Wetering 1997
Ernst van de Wetering, *Rembrandt. The Painter at Work*, Amsterdam 1997

Wheelock 1983
Arthur K. Wheelock, 'The Influence of Lucas van Leyden on Rembrandt's Narrative Etchings', *Essays in Northern European Art Presented to Egbert Haverkamp-Begemann on his Sixtieth Birthday*, Doornspijk 1983, pp. 291–6

White & Boon
Christopher White & Karel G. Boon, *Rembrandt's etchings. An illustrated critical catalogue* (2 vols), Amsterdam, London and New York 1969

White 1969
Christopher White, *Rembrandt as an Etcher. A Study of the Artist at Work*, London 1969

White 1999
Christopher White, *Rembrandt as an Etcher. A Study of the Artist at Work*, 2nd edn, New Haven and London 1999

Wibiral 1877
F. Wibiral, *L'iconographie d'Antoine van Dyck, d'après les Recherches de H. Weber*, Leipzig 1877

Wijnman 1933
H. F. Wijnman, 'Mr. Lieven van Coppenol, schoolmeester, Calligraaf', *Jaarboek Amstelodamum* 30 (1933), pp. 92–187

Winternitz 1969
E. Winternitz, 'Rembrandt's "Christ presented to the people" 1655. A meditation on justice and collective guilt', *Oud Holland* 84 (1969), pp. 177–90

Woordenboek der Nederlandsche Taal
M. de Vries et al. [eds], *Woordenboek der Nederlandsche Taal*, 29 vols, The Hague etc. 1882–1998

Wuestman 1995
G. Wuestman, 'The mezzotint in Holland: 'easily learned, neat and convenient', *Simiolus* 23 (1995), pp. 63–89

Wuestman 1998
G. Wuestman, *De Hollandse schilderschool in prent*, diss., Utrecht 1998

Wurzbach 1876
Alfred von Wurzbach, 'Ein dekaliertes Porträt der Saskia', *Zeitschrift für bildende Kunst* 11 (1876), p. 287

Wyckoff 1998
E. Wyckoff, *Innovation and popularization: printmaking and print publishing in Haarlem during the 1620s*, diss., New York, Ann Arbor 1998

Yver 1756
Pieter Yver, *Supplément au catalogue raisonné de M. M. Gersaint, Helle et Glomy*, Amsterdam 1756

Ziemba 1987
Antoni Ziemba, 'Rembrandts Landschaft als Sinnbild. Versuch einer ikonologischen Deutung', *Artibus et Historiae* 15 (1987), pp. 109–34

Zschelletzschky 1975
H. Zschelletzschky, *Die 'drei gottlosen Maler' von Nürnberg*, Leipzig 1975

Zwaan 1965
E. J. Zwaan, *Links en rechts in waarneming en beleving*, Utrecht 1965

Zwarts 1926
J. Zwarts, 'Rembrandt's Phoenix en het oude wapen van de Portugeesch-Joodsche gemeente van Amsterdam', *Oud Holland* 43 (1926), pp. 61–72

Exhibitions and other museum catalogues

(listed by place and date)

Aachen 1984
Iris Zilkens, *Rembrandt (1606–1669) und sein Kreis – Radierungen*, Aachen (Suermondt-Ludwig-Museum) 1984

Amsterdam 1976
E. de Jongh et al., *Tot Lering en Vermaak. Betekenissen van Hollandse genrevoorstellingen uit de zeventiende eeuw*, Amsterdam (Rijksmuseum) 1976

Amsterdam 1981
Eva Ornstein-Van Slooten en Peter Schatborn, *Werk in uitvoering. Etsen van Rembrandt in verschillende staten*, Amsterdam (Museum het Rembrandthuis) 1981

Amsterdam 1983
Peter Schatborn & Eva Ornstein-Van Slooten, *Landschappen van Rembrandt en zijn voorlopers*, Amsterdam (Museum het Rembrandthuis) 1983

Amsterdam 1984–5
Peter Schatborn & Eva Ornstein-Van Slooten, *Bij Rembrandt in de leer/Rembrandt as teacher*, Amsterdam (Museum het Rembrandthuis) 1984–85

Amsterdam 1985
J. P. Filedt Kok, *'s Levens Felheid. De Meester van het Amsterdams Kabinet of de Hausbuch-meester ca. 1470–1500*, Amsterdam (Rijksmuseum) 1985

Amsterdam 1986
R. E. O. Ekkart & Eva Ornstein-van Slooten, *Oog in oog met de modellen van Rembrandts portret-etsen*, Amsterdam (Museum het Rembrandthuis) 1986

Amsterdam 1988–9
Peter Schatborn & Eva Ornstein-van Slooten, *Jan Lievens 1607–1674; Prenten en tekeningen*, Amsterdam (Museum het Rembrandthuis) 1989

Amsterdam 1991
Astrid Tümpel & Peter Schatborn, *Pieter Lastman: leermeester van Rembrandt*, Amsterdam (Museum het Rembrandthuis) and Zwolle 1991

Amsterdam 1992
E. Bergvelt & R. Kistemaker [eds], *De Wereld binnen Handbereik. Nederlandse kunst- en rariteitenverzamelingen, 1585–1735*, Amsterdam (Amsterdams Historisch Museum) 1992

Amsterdam 1993
Boudewijn Bakker & Huigen Leeflang, *Nederland naar 't leven: Landschapsprenten uit de gouden eeuw*, Amsterdam (Museum het Rembrandthuis) 1993

Amsterdam 1993–4
G. Luijten, A. van Suchtelen et.al. [eds], *Dawn of the Golden Age. Northern Netherlandish art 1580–1620*, Amsterdam (Rijksmuseum) 1993–4

Amsterdam 1996
C. Schuckman, M. Royalton-Kisch, E. Hinterding, *Rembrandt & Van Vliet: a collaboration on copper*, Amsterdam (Museum het Rembrandthuis) 1996

Amsterdam 1997
Eddy de Jongh en Ger Luijten, *Spiegel van Alledag. Nederlandse genreprenten 1550–1700*, Amsterdam (Rijksmuseum) and Gent 1997

Amsterdam 1998
B. Bakker, M. van Berge-Gerband, E. Schmitz and J. Peeters, *Landscapes of Rembrandt. His favourite walks*, Amsterdam (Gemeentearchief) and Paris (Institut Néerlandais) 1998

Amsterdam 1999–2000
Bob van den Boogert, Ben Broos, Roelof van Gelder and Jaap van der Veen, *Rembrandts schatkamer*, Amsterdam (Museum het Rembrandthuis) and Zwolle 1999

Amsterdam-Washington 1981–2
Peter Schatborn, *Figuurstudies. Nederlandse tekeningen uit de 17e eeuw*, Amsterdam (Rijksmuseum), Washington (National Gallery of Art) and The Hague 1981

Amsterdam-Stockholm-Los Angeles 1998–2000
F. Scholten, *Adriaen de Vries 1556–1626*, Amsterdam (Rijksmuseum), Stockholm (Nationalmuseum), Los Angeles (J. Paul Getty Museum) 1998–2000

Amsterdam-Salzburg-Freiburg 1998–99
L. Heenk, *Rembrandt and his influence on Eighteenth-century German and Austrian Printmakers*, Amsterdam (Museum het Rembrandthuis), Salzburg (Carolino Augusteum), Freiburg im Breisgau (Augustinermuseum) 1998–9

Antwerp 2000
Rubens' beelden van de dood. Rubens kopieert Holbein, Antwerp (Rubenshuis) 2000

Antwerp-Amsterdam 1999–2000
C. Depauw, G. Luijten, *Antoon van Dyck en de prentkunst*, Antwerp (Museum Plantin-Moretus), Amsterdam (Rijksmuseum) 1999–2000

Berlin 1970
Chr. Tümpel & A. Tümpel, *Rembrandt legt die Bibel aus*, Berlin (Staatliche Museen Preussischer Kulturbesitz) 1970

Berlin-Regensburg 1988
H. Mielke, *Albrecht Altdorfer. Zeichnungen, Deckfarbenmalerei, Druckgraphik*, Berlin (Kupferstichkabinett Staatliche Museen Preussischer Kulturbesitz), Regensburg (Museen der Stadt Regensburg) 1988

Berlin-Amsterdam-London 1991–2
Holm Bevers, Peter Schatborn & Barbara Welzel, *Rembrandt, De Meester & zijn Werkplaats: Tekeningen & Etsen*, Berlin (Staatlichen Museen Preussischer Kulturbesitz), Amsterdam (Rijksmuseum), London (National Gallery) and Zwolle 1991

Boston-New York 1969
Felice Stampfle, Eleanor A. Sayre, Sue W. Reed, Clifford S. Ackley, *Rembrandt Experimental Etcher*, Boston (Museum of Fine Arts) and New York (Pierpont Morgan Library) 1969

Boston-St. Louis 1980–81
Clifford S. Ackley, *Printmaking in the Age of Rembrandt*, Boston (Museum of Fine Arts) and St Louis (St Louis Art Museum) 1980

Braunschweig 1979
Jan Bialostocki, Sabine Jacob & Rudolf E. O. Ekkart, *Jan Lievens, ein maler im Schatten Rembrandts*, Braunschweig (Herzog Anton Ulrich-Museum) 1979

Braunschweig 1993–4
Bilder von alten Menschen in der niederländischen und deutschen Kunst 1550–1750, Braunschweig (Herzog Anton Ulrich-Museum) 1993–4

Bremen-Lübeck 1986–7
A. Röver, *In Rembrandts Manier. Kopie, Nachahmung und Aneignung in den graphischen Künsten des 18.Jahrhunderts*, Bremen (Kunsthalle), Lübeck (Museum für Kunst und Kulturgeschichte) 1986–7

Cambridge 1996–7
Craig Hartley, *Rembrandt and the nude. Prints by Rembrandt van Rijn (1606–1669)*, Cambridge (Fitzwilliam Museum) 1996

Copenhagen 1983–4
V. Woldbye & B. von Meyenburg, *Konkylien og Mennesket*, Kopenhagen (Kunstindustrimuseet) 1983–4

Delft-Cambridge-Fort Worth 1988–9
S. Segal, *A prosperous past. The sumptuous still life in the Netherlands 1600–1700*, Delft (Stedelijk Museum Het Prinsenhof), Cambridge, Mass. (Fogg Art Museum), Fort Worth (Kimbell Museum) 1988–9

Dordrecht-Cologne 1998–9
Arent de Gelder (1645–1727), Rembrandts laatste leerling, Dordrecht (Dordrechts Museum), Cologne (Wallraf-Richartz-Museum) 1998–9

Karlsruhe 1984
Neuerwerbungen für die Gemäldegalerie 1972–1984, Karlsruhe (Staatliche Kunsthalle) 1984

Cologne-Rotterdam 1970
Sammlung Herbert Girardet. Holländische und Flämische Meister, Cologne (Wallraf-Richartz-Museum), Rotterdam (Museum Boymans-Van Beuningen) 1970

Lawrence-New Haven-Austin 1983–4
L. A. Stone-Ferrier, *Dutch prints of daily life: Mirror of life or masks of morals?*, Lawrence (The Spencer Museum of Art), New Haven (The Yale University Art Gallery), Austin (The Huntington Gallery) 1983–4

Lawrence-New Haven-Minneapolis-Los Angeles 1988–9
S. Goddard [ed.], *The World in Miniature. Engravings by the German Little Masters 1500–1550*, Lawrence (Spencer Museum of Art), New Haven (Yale University Art Gallery), Minneapolis (Minneapolis Institute of Arts), Los Angeles (Grunwald Center for the Graphic Arts) 1988–9

Leiden 1991–2
Christiaan Vogelaar [ed.], *'een jong en edel schildersduo'; Rembrandt & Lievens in Leiden*, Leiden (Museum de Lakenhal) 1991–2

London 1988
David Bomford, Christopher Brown, Ashok Roy, *Art in the Making*, London (National Gallery) 1988

London-The Hague 1999–2000
Chr. White & Q. Buvelot [eds], *Rembrandt by Himself*, London (National Gallery) and The Hague (Mauritshuis) 1999–2000

London 1986
C. Brown, *Dutch landscapes. The early years*, London (National Gallery) 1986

Melbourne-Canberra 1997–8
Albert Blankert et al., *Rembrandt. A genius and his impact*, Melbourne (National Gallery of Victoria), Canberra (National Gallery of Australia), Sydney and Zwolle 1997–8

Michigan 1975–6
W. R. Levin, *Images of Love and Death in late Medieval and Renaissance art*, Michigan (The University of Michigan Museum of Art) 1975–6

Munich 1982
K. Renger & D. Schmidt, *Graphik in Holland. Esaias und Jan van de Velde, Rembrandt, Ostade und ihr Kreis. Radierung, Kupferstich, Schabkunst*, Munich (Staatliche Graphische Sammlung) 1982

Munich 1997–8
K. Renger, *Die Pranke des Löwen. Rubens-Skizzen aus St. Petersburg und München*, Munich (Neue Pinakothek) 1997–8

Nancy 1992
Jacques Callot 1592–1635, Nancy (Musée historique lorrain) 1992

Nantes 1996
M. Weemans, *Rhyparographes*, Nantes (Ecole Régionale des Beaux-Arts) 1996

New Haven 1983
Christopher White, David Alexander and Ellen d'Oench, *Rembrandt in eighteenth-century England*, New Haven (Yale Center for British Art) 1983

New Haven 1994
R. T. Godfrey, *Wenceslaus Hollar. A Bohemian Artist in England*, New Haven (Yale Center for British Art) 1994

New York 1967
Masters of the loaded brush, Oil Sketches from Rubens to Tiepolo, New York (Knoedler) 1967

New York-Boston 1980–81
The Painterly Print. Monotypes from the Seventeenth to the Twentieth Century, New York (Metropolitan Museum of Art), Boston (Museum of Fine Arts) 1980–81

New York 1995
Hubertus von Sonnenburg (vol. 1); Walter Liedtke, Carolyn Logan, Nadine M. Orenstein & Stephany S. Dickey (vol. 2), *Rembrandt/Not Rembrandt in the Metropolitan Museum of Art*, 2 vols, New York (Metropolitan Museum of Art) 1995

Nuremberg 1978
Vorbild Dürer. Kupferstiche und Holzschnitte Albrecht Dürers im Spiegel der europäischen Druckgraphik des 16. Jahrhunderts, Nuremberg (Germanisches Nationalmuseum) 1978

Paris 1969–70
Frits Lugt & Maurice Serullaz, *Les plus belles eaux-fortes de Rembrandt, choisies dans les quatre principales collections de Paris*, Paris (Musée du Louvre) 1969–70

Paris 1986
Sophie de Bussierre, *Rembrandt, Eaux-fortes. Musée Petite Palais – Collection Dutuit*, Paris (Musée du Petit Palais) 1986

Paris-Rotterdam 1974–5
Willem Buytewech 1591–1624, Rotterdam (Museum Boymans-Van Beuningen), Paris (Institut Néerlandais) 1974–5

Rotterdam-Braunschweig 1983–4
J. Giltaij et.al., *Schilderkunst uit de eerste hand. Olieverfschetsen van Tintoretto tot Goya*, Rotterdam (Museum Boymans-Van Beuningen) and Braunschweig (Herzog Anton Ulrich-Museum) 1984

Rotterdam-Washington 1985–6
Jacques de Gheyn II als tekenaar, Rotterdam (Museum Boymans-Van Beuningen) and Washington (National Gallery of Art) 1985–6

Strasbourg-Aachen 1997
M.-C. Heck, *Sébastien Stoskopff 1597–1997. Un maître de la nature morte*, Strasbourg (Musée de l'Oeuvre Notre-Dame), Aachen (Suermondt Ludwig Museum) 1997

Utrecht 1981
Geloof en satire anno 1600, Utrecht (Catharijneconvent) 1981

Utrecht-Frankfurt-Luxembourg 1993–4
Het Gedroomde Land. Pastorale schilderkunst in de Gouden Eeuw, Utrecht (Centraal Museum), Frankfurt (Schirn Kunsthalle), Luxembourg (Musée National d'Histoire et d'Art) 1993–4

Vienna 1970–71
Erwin Mitsch, *Kunst der Graphik IV. Rembrandt. Radierungen aus dem Besitz der Albertina*, Vienna (Graphische Sammlung Albertina) 1970

Washington-Boston 1983
E. S. Jacobowitz & S. L. Stepanek, *The prints of Lucas van Leyden & his contemporaries*, Washington (National Gallery of Art) and Boston (Museum of Fine Arts) 1983

Concordance of Bartsch and Hind numbers

Bartsch nos	Cat. nos	Hind nos	Bartsch nos	Cat. nos	Hind nos	Bartsch nos	Cat. nos	Hind nos
7	13	54	107	85	292	222	70	263
10	7	30	109	33	165	223	64	244
21	34	168	110	86	295	226	40	178
22	58	229	114	42	181	233	41	179
28	30	159	121	18	97	234	65	249
35	77	283	123	80	285	262	15	92
36	79	284	124	28	141	270	69	260
37	31	160	157	47	204	271	45	187
39	20	118	158	37	174	272	66	251
40	44	172	159	62	248	273	84	291
44	21	120	174	6	11	274	81	287
46	67	255	176	60	233	276	83	290
47	74	274	177	19	114	277	56	227
54	2	17	178	19	115	278	55	226
56	71	266	186	52	223	279	26	128
59	1	307	187	53	224	280	54	225
61	43	186	188	46	200	281	35	167
67	68	256	190	12	45	283	89	300
73	17	96	191	12	46	284	82	289
74	61	236	192	36	231	285	57	228
76	78	271	194	51	222	289	27	134
77	24	143	197	87	296	292	9	23
78	73	270	198	11	43	320	8	32
81A	22	102	200	88	298	338	4	4
81B	23	103	201	10	42	340	25	127
83	75	280	203	90	302	343	14	52
86	76	281	208	49	209	352	3	2
95	5	5	209	50	210	363	16	90
99	32	161	210	39	176	367	29	153
103	59	232	212	48	205	369	38	163
104	72	267	217	63	246			